AMERICAN PAINTINGS AND SCULPTURE
IN THE UNIVERSITY ART MUSEUM COLLECTION

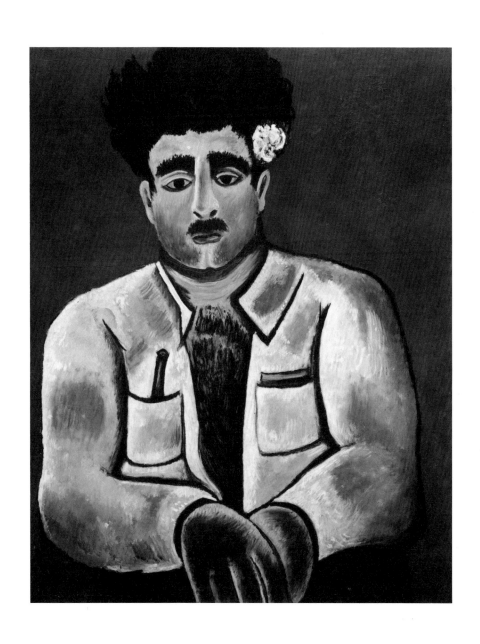

UNIVERSITY OF MINNESOTA MINNEAPOLIS, MINNESOTA

Library of Congress Catalog Card Number: 86-50618
ISBN 0-938713-00-0

Cover: Marsden Hartley, *Adelard the Drowned, Master of the "Phantom"*
1938-1939
Bequest of Hudson Walker from the Ione and Hudson Walker collection,
78.21.236

The University Art Museum is grateful for the support of the Benefactors and Sustaining Members of the Colleagues of the University Art Museum:

Benefactors

Mrs. Julius E. Davis
Mr. and Mrs. Leo A. Hodroff
Paul and Ellen Fahy Lett
George and Frances Reid
William G. and Mary Shepherd
Dr. and Mrs. Roby C. Thompson

Sustaining Members

Anonymous Donors
Dr. David and Sandra M. Brown
Sally Brown and Brad Breckenridge
Mr. and Mrs. Patrick Butler
Margey and Russell Cowles
Sage F. Cowles
Dr. and Mrs. Robert J. Forsyth
Erwin and Beverly Goldfine
Dr. Robert and Marilyn Gorlin
George and Cissy Gosko
Mr. and Mrs. Max B. Green
Joan Hanson
Gloria Cherne Hogan
Stanley S. Hubbard
Mr. and Mrs. Donald W. Judkins
Dr. John E. and Colles Larkin, Jr.
Mr. and Mrs. Richardson B. Okie
Leonard Parker
Sally W. Pillsbury
Ralph and Mary Rapson
Josephine Lutz Rollins
Rochelle and Burton Ross
Mr. and Mrs. Jay Saunders
Robert D. Schmidt
Carl D. Sheppard
Bonita F. Sindelir and Kenneth Keller
Penny Winton
Mr. and Mrs. Louis N. Zelle
Sharon and Jerry Zweigbaum

The support of the following contributors to the University Art Museum is gratefully acknowledged:

Anonymous Donors
John R. Beckwith
Professor Timothy T. Blade
Dr. David and Sandra M. Brown
Champion Paper Corporation
Alfred and Elizabeth Cook
Mrs. Rex W. Cox
Mrs. Beatrice Delue
Harry M. Drake
Dolly Fiterman
Mr. and Mrs. James Gesell
Mary R. Gould
Lorene G. Holl
Roger W. Hollander
Robert T. Holt
Kemper E. Kirkpatrick
Sarah Elizabeth McBride
Laura H. Miles
Mrs. William King Nelson
Laurel O'Gorman
Thomas O'Sullivan
Bela Petheo
Sally B. Polk
Samuel H. and Evelyn Popper
Barbara and Harry Sarbach
Dr. and Mrs. Carl D. Sheppard
Richard and Roberta Simmons
Frank J. Sorauf
Kenneth O. Stonesifer
Bonnie Sussman
Willard and Mabel Thompson
Mrs. Ruth Thorstenson
Mr. and Mrs. Dimitri Tselos
Lee. W. Twite
George P. Webinger
Lee Wickstrom
Roberta and Arthur Williams
Elena Wilsey

The publication of this catalogue was made possible through support from the following:

Foundations

Elmer L. and Eleanor J. Andersen Foundation
 St. Paul
Patrick and Aimee Butler Family Foundation
 St. Paul
Dellwood Foundation Inc., St. Paul
Driscoll Foundation, St. Paul
National Endowment for the Arts
Archie D. and Bertha H. Walker Foundation
 Minneapolis

Individuals

Josef L. Altholz
Elmer L. Andersen
Dolly Fiterman
Charles Helsell
Mr. and Mrs. William King Nelson
David and Andrea Scott
James W. Stegbauer

THE HISTORY OF THE AMERICAN COLLECTION AT THE UNIVERSITY ART MUSEUM

It is fitting that the first collection catalogue published by the University Art Museum should be of its American painting and sculpture. American art has been the Museum's focus since its founding in 1934; both its first curator, Hudson D. Walker, and its second curator/director, Ruth Lawrence, set it firmly on this path. The first painting acquired by the Museum was a Georgia O'Keeffe, followed quickly by a B.J.O. Nordfeldt, another O'Keeffe, an Arthur Dove, and a Lyonel Feininger. Today the Museum is best known for its Marsden Hartley collection—the largest single collection of Hartleys in the world. That came much later in the chronology, but no museum director with a treasure like that in the storeroom should be expected to keep quiet about it for long!

Even by the time of the second O'Keeffe, however, we're ahead of the beginning, and chronology does have its uses, especially when the directions laid down at the start are still relevant 52 years later—to the Museum's mission as well as its collection. Let us go back, therefore, and work forward more slowly through the waves and ripples of guiding principles and acquisitions. But be warned that this chronicle of the American collection at the University of Minnesota Art Museum is not all inclusive, and not strictly chronological. It would have been impossible to name every donor; some arbitrary judgments had to be made to include only individuals who had made gifts of collections or of important paintings or sculptures. And, while following a rough chronology, it seemed logical to mention some paintings that were acquired rather late with material of similar date or subject rather than in strict chronological isolation.

The catalogue is arranged by individual artist. This introduction attempts to give some background to the collection from a somewhat different perspective—that of its growth, and the growth of the Museum itself.

The Museum was apparently the inspiration of University President Lotus Coffman and his assistant Malcolm Willey. On January 16, 1934, Dr. Coffman wrote to Dr. F.P. Keppel of the Carnegie Corporation about his dreams for the University:

> The first of these dreams relates to the promotion, development and extension of the cultural ideals and the cultural life of the people of this country, and particularly, of course, to the enhancement of the cultural ideals and the

cultural life of the people of the region in which the University of Minnesota is located. This is a dream of long standing on my part. It dates back to my boyhood experiences. I was born and reared in a country community in southern Indiana where there was no music, no art and little culture. I had almost no opportunities for seeing.... I saw none of the great paintings of the world; no great works of art of any kind; music was confined to the singing of gospel hymns, and a knowledge of painting to an occasional reprint or crude sketch. As time passed, I realized that something was lacking in the scheme of education.... I would have every student at the University of Minnesota and every individual in this community exposed as frequently as possible to the things that make life worth living, to the cultural inheritances of the race. I would send our students away from the University as unconscious missionaries for a better civilization. There is need for new values to sustain the morale of individuals in the days ahead. The arts are a source for such values, and I want this University to play a leading part in instilling them.[1]

Ruth Lawrence confirmed to Malcolm Willey that the students at the University, particularly those from outside the Twin Cities, "come from pioneering stock, and these peoples did not attempt to carry many art treasures so far inland, even if they knew of them before. They have, therefore, been little exposed to fine things...."[2] With the high ideal that art is for everyone, the University opened its art gallery.

The Museum was first called the "Little Gallery," a name which bespoke the affection of the people who created it, but which was claimed by a local antique dealer. It was changed to University Gallery in 1935 and in 1983 to University Art Museum to more accurately reflect the growth and importance of its collections.

Hudson D. Walker, just 27 years old at the time, grandson of Twin Cities collector and lumber magnate T. B. Walker, agreed to be the Museum's first curator (and the only staff member) on a part-time basis. The first exhibition, which Walker arranged from various galleries, dealers, and private collections, was intended to show the history of art in the nineteenth and twentieth centuries. Walker left the Museum after only a few months, but not before he had admonished the president to assist the Museum in starting a collection. It would not be advisable to attempt an encyclopedic general collection, Walker went on to say, but one emphasizing *American* art—particularly *contemporary* American art—would provide a unique resource for the University and the community.[3]

The ingenuity and energy of Ruth Lawrence, combined with her good taste, set the American collection at the Museum off on the best possible track. Mrs. Lawrence, who had received her B.A. from

the University in 1933, was the widow of James Lawrence, a young dean who had died suddenly and tragically. Determined to find employment at the University for the young widow, the administration wavered between making her a dormitory counselor or the director of the gallery, and finally decided on the latter. Though the members of the art faculty were initially against the choice, it proved to be most fortunate for the growth of the American collection. Ruth Lawrence's energy and enthusiasm were contagious. She was able to convince the administration to buy art, even art they didn't understand, and charmed Alfred Stieglitz into becoming a partner in the "experiment" that was the University of Minnesota's art gallery.

The O'Keeffe *Oak Leaves, Pink and Gray*, the first painting bought for the collection, was purchased especially for a wonderfully idealistic and relatively short-lived experiment: the American Art Room. It was designed to fulfill the dream of Coffman and Willey to give students a firsthand, everyday experience with real works of art. Willey had a theory, as he wrote to Keppel in June of 1935, that "appreciation, real love and understanding of fine art can best be engendered through contact under an approximation to ideal conditions."[4] He went on to explain that he had in mind the Japanese practice of setting aside one place in the home for the contemplation of a single object of beauty. He anticipated a place "into which one may retreat and sit quietly in the presence of one fine thing...." Mrs. Lawrence agreed that "one does not come to a love of music by reading of it historically, or by playing dozens of pieces in rapid succession or simultaneously.... The conditions for presentation...are not right for full emotional participation.... The beauty of a single picture has the best chance to make its imprint upon the inner emotional life and experience of the individual if the circumstances are such that the individual and the picture come into emotional rapport."[5]

The room would feature contemporary furniture and have in it a few books and art periodicals, but not textbooks, the point being that it would be used only for the contemplation of beauty and not for any "useful" activity.

President Coffman set aside $3,000 to try the fine arts room—a remarkable amount considering that the budget for running the Museum for a year, exclusive of Ruth Lawrence's part-time curator's salary, was $270. With this commitment, Mrs. Lawrence set off for New York to find a painting to hang in the room. She and Malcolm Willey and Mrs. Willey made contact with Stieglitz, and under his tutelage Mrs. Lawrence chose the *Oak Leaves* as that one beautiful object for students to contemplate. One can surmise from the early correspondence that the $3,000 included $1,500 to purchase the O'Keeffe and $1,500 to purchase the furniture, wall

coverings, carpet—all the rest of the expenses for outfitting the room. Stieglitz wrote to Malcolm Willey that he was sure it would be a "triumphal success."[6]

Although seven hundred people attended the opening of the room in February 1936 (in thirty-degree-below-zero weather), University students, unfortunately, did not reward the administration's faith in "The American Art Room," or "The Fine Arts Room," as it was also called, and books and other small *objets d'art* began to disappear. It is a miracle that the O'Keeffe or other paintings displayed there were not lost from the open, usually unattended room. Apparently students also began to use this quiet, remote room on the third floor of Northrop Auditorium for purposes other than the contemplation of art, and it was closed in the early 1940s, never to be reopened.

John Sherman, the critic at the *Minneapolis Star*, wrote when the room opened that the Museum was "well on its way toward fulfilling its destiny as chief advocate and haven for modern art in Minneapolis…. The opening of its new fine arts room—a tasty arrangement along modern lines, harboring a newly acquired painting by Georgia O'Keeffe…constitutes the most vigorous bell-ringing for modern American art this town has heard."[7]

When the Gallery began its crusade for American art, few others in the region were interested. The Walker Art Center, then the Walker Art Gallery, had not yet changed its focus to contemporary art, and The Minneapolis Institute of Arts was more interested in the old masters of Europe than brash young American artists. The University was practically the only place in town to see national and international practitioners of contemporary art.

Mrs. Lawrence's enthusiasm for O'Keeffe was unbounded. She wrote in 1935 that she thought the Museum should get a lot of her work and have examples of all her subjects. Lawrence established a warm relationship with Stieglitz and, through him, with O'Keeffe herself. A mass of correspondence between Stieglitz and Lawrence, and between Stieglitz and Willey, attests to the affection of their relationship. In 1936 Stieglitz wrote to Lawrence, "The Place [An American Place] remains very alive in the spirit in which you met it. Remember you are ever of its Spirit [*sic*] and part of my strength is due to what I feel about you. This is literal."[8]

In 1935 he wrote, "O'Keeffe reports good news about herself. The 'event' has undoubtedly done something for her. The 'event' being what I call the University of Minneapolis [*sic*]—translated meaning you and Dr. Willey and all appertaining hereto, etc. In short the beautiful spirit of it all."[9]

That same year, Mrs. Lawrence purchased *The Green Hills* by

B.J.O. Nordfeldt from the Harriet Hanley Gallery in Minneapolis. Not much is recorded about this acquisition, but it probably was made because Nordfeldt had been teaching at the Minneapolis School of Art (now the Minneapolis College of Art and Design) in 1934 and 1935.

In February of 1937 Mrs. Lawrence opened an exhibition of 45 paintings loaned by Stieglitz, including works by Charles Demuth, Georgia O'Keeffe, John Marin, Marsden Hartley, and Arthur Dove. According to Lawrence's letters to Stieglitz, visitors to the exhibit voted on their favorite works. The O'Keeffe *Oriental Poppies* won and was purchased for the collection. The Dove also received many votes; *The Gale* had been purchased for the collection in 1936. Hartley, Mrs. Lawrence wrote Stieglitz, was enjoyed only by the initiated, and Marin was exclaimed over but did not get the votes O'Keeffe got.[10]

Mrs. Lawrence had purchased a Marin watercolor from Stieglitz shortly after she bought the *Oak Leaves*. Unfortunately, the Museum did not purchase a Demuth. Although Mrs. Lawrence reported that many people were amazed at the Demuth, it is not clear whether a purchase was ever contemplated.

As much as Stieglitz disliked haggling over prices, Ruth Lawrence did find herself having to try to bargain with him. She wrote about the purchase of the Dove: "We have taught the administration too well, I think, for they believe and rightly that O'Keeffe is the greatest painter living today. It is therefore difficult for them to bring them selves [*sic*] to a frame of mind where they would be willing to pay more for a Dove than an O'Keeffe."[11]

President Coffman apparently continued his support for the Museum collection by providing University funds to buy works of art. At the end of every fiscal year, unspent funds (those were the years when such existed instead of retrenchments) were returned to central administrative coffers, and apparently a certain percentage was allocated to the Museum for purchases of works of art. Regrettably, this enlightened scheme ceased after the 1938 acquisition of a Lyonel Feininger painting, *Dröbsdorf I*, which was purchased from the artist shortly after he returned to the States after several years in Germany. The Museum mounted the first retrospective show of Lyonel Feininger in America in 1938, and the *Dröbsdorf I* was purchased from that exhibition. The death of President Coffman late that year was very likely a factor in the termination of University funding for art.

Although Hudson Walker had set the course and Ruth Lawrence had made inspired selections, President Coffman and Malcolm Willey had provided the support, both financial and emotional, to make the collection happen. While Coffman had joked with

Lawrence and Willey that they should buy "a picture of a pasture with a brook and some cows—just for me!,"[12] he clearly countenanced the direction the Museum was taking. When Coffman agreed to provide extra money to buy the Marin, Willey wrote to Stieglitz that the president added, "… some comment about Ford trucks costing more, and with the implication that they were less enduring.… the vitality of a great University will come more from O'Keeffe's [sic] and Marins than from trucks. My ears are still ringing, for again, it was totally unexpected. I even imagine I can hear Mrs. Lawrence cheering from New York. Anyway, we have the President to thank, and his sympathy and understanding."[13]

The extraordinary relationship between the Museum and the New Deal was the subject of an article in the *Midwest Museums Quarterly* in 1980. This relationship was important during the Museum's first years. In 1934 the PWAP (Public Works of Art Project) gave the Museum 32 oil paintings by Dewey Albinson, Arnold Klagstad, Earle Loran, Bennet Swanson, and Elof Wedin, plus a large number of watercolors. The University continued to receive federal allocations of paintings during the 1930s and 1940s, including works by artists such as Robert Brown, Elsie Driggs, Gertrude Abercrombie, Aaron Bohrod, Jerome Kamarowski, Dorothea Lau, Mac LeSueur, Alice Hugy, Bernie Quick, Glen Ranney, and many others. A Nicolai Cikovsky, a Joseph Pandolfini, and a Paul Sample which are related stylistically to the above group were not a part of the federal allocation, but were purchased from general Museum funds in the years 1936 to 1938.

When the PWAP project terminated in 1934, Lawrence, Willey, and Coffman suggested that a group of artists be brought to the University and engaged by the University itself in a program organized along the lines of the federal one. The program would have three objectives: to challenge undergraduate students by allowing them to see artists at work on the campus painting familiar scenes; to encourage younger local artists; and to acquire a collection of interesting and decorative paintings to be hung on the walls of various buildings on campus. Seven artists—Dewey Albinson, Cameron Booth, Stanford Fenelle, Sydney Fossum, Arnold Klagstad, Earle Loran, and Elof Wedin—worked on the campus over a two-month period, as a result of which the University acquired 43 watercolors, 24 sketches, and 14 finished oil paintings. A committee of University officials plus Russell Plimpton, director of The Minneapolis Institute of Arts, met weekly to review the sketches the artists had done that week and to decide which ones should be worked up into full-fledged oil paintings.

From 1934 to 1938, the federal WPA (Works Progress Administration) project also provided funding for workers to prepare catalogues and publicity releases, mount a picture file, prepare an index of all printed materials on art in the Twin Cities, inventory all "lantern slides" on campus, and perform numerous other museum and art education projects. During the heyday of WPA support, the staff stood at 60 people—the largest to date in the Museum's history. WPA assistance also made possible the student loan collection which opened in 1936 and rented reproductions and original prints to students for 25 cents per quarter. The rental service still exists. Now it rents only original prints (no reproductions) to students, and prints and paintings to staff and faculty for about $25 per year.

In 1943 Frederick J. Wulling, the first dean of the School of Pharmacy and a patron of local artists, gave the Museum 21 works of art, primarily portraits. Though of uneven quality, they included an Eastman Johnson portrait of William Moody Kimball, a pioneer Minnesotan and early regent of the University. Robert Koehler, the second director of the Minneapolis School of Art, was commissioned by the College of Pharmacy Alumni Association to paint Wulling's portrait and that, too, became part of the collection.

Although some 19th-century paintings were included in the Wulling gift, the selection of 19th-century American paintings at the Museum is not as strong as that of early 20th-century works because the emphasis during the Museum's infancy was primarily on contemporary art. The area best represented in the 19th-century collection is landscape, though most of those entered the collection later. For example, although the Alexis Jean Fournier *Great Oaks from Little Acorns Grow* (1902) was a gift of Philip R. Brooks in 1939, his *Minneapolis from the University of Minnesota Campus* (1888) was not donated by Daniel S. Feidt until 1972. The Archie B. and Bertha H. Walker Fund (now called the Fine Arts Fund), established in 1939, purchased the David Johnson *West Cornwall, Connecticut* (1875) in 1968 and the Alfred Bricher *Barn Bluff on the Mississippi at Red Wing, Minnesota* (1866) in 1976. The Albert Bierstadt *Minnehaha Falls* (1886) came as a gift from Ione Walker in 1978.

In 1947, for reasons of economics, the Museum was consolidated with other arts teaching units into one department. H. Harvard Arnason took on the herculean task of acting as chairman of the combined art departments—studio arts, art history, and the Museum—and director of the Walker Art Center. Though the art history and studio arts departments were separated again a few years after Arnason left the University in 1961, the Museum remained a part of the art history department until 1973. In that year it was made a separate department and shortly thereafter was

transferred to an administrative position under the office of the Vice President for Academic Affairs, a place similar to the one it held in the 1930s. It remains in that situation today and has, in effect, returned to the role for which it was founded—to be an all-university museum providing *all* students, not just art students, with an opportunity for a daily, on-campus experience with art.

Although the return to its original administrative position did not bring a return of central funds for building the collection, the Museum has continued to be the beneficiary of important gifts from individuals. The American collection has been enriched most through the generosity of one person: Hudson D. Walker, the Museum's first curator, who remained its patron throughout his life. Walker trained at the Fogg Museum at Harvard in Paul Sachs's famous museum course that produced so many outstanding directors and curators. He left the Museum after only a few months as its first curator to open a gallery in New York, which he operated from 1936 to 1940. His gallery provided exposure, patronage, and moral support to artists such as Marsden Hartley, Carl Sprinchorn, Will Barnet, Mervin Jules, Harry Sternberg, Everett Spruce, and many others.

Hudson Walker's gifts and the bequest of the collection he formed with his wife, Ione, are responsible for the fact that the Museum has the largest collection of works by Marsden Hartley in the world. It seems that Walker first became interested in Marsden Hartley when he saw Hartley's 1937 show at Stieglitz's An American Place gallery. He took Hartley on in his gallery when Stieglitz, Hartley's long-time patron, finally became disillusioned with the artist's inability to concentrate his time and energy in one place or on one artistic direction. Hartley was 60 at the time; Walker was half his age, full of enthusiasm and sympathy for the older man. He took an active interest in Hartley and all of his other artists, vigorously promoting their work, writing them encouraging letters, and sending them money while he himself was financially strapped and dependent on his father for support to keep his gallery open.

After assuming the role of Hartley's dealer, Walker gave him three one-man shows, one each year his gallery was open. In 1938 Walker showed paintings and drawings executed in Maine during 1937 and 1938. In March of 1939 Walker showed the "Archaic Portraits," two of which are in the Museum's collection. *Adelard the Drowned, Master of the "Phantom"* and *Marie Ste. Esprit* represent members of the Mason family with whom Hartley had lived in Nova Scotia. The portraits are his emotional outpouring after the tragic drowning deaths of young Donny and Alty Mason

and their cousin. The "Archaic Portraits" were a critical success but didn't sell well; in fact, all of Hartley's paintings sold very poorly.

When Walker closed his gallery in 1940, he was left with a number of Hartley's paintings, as well as paintings by other artists. In spite of Walker's continued efforts even after he closed his gallery, Hartley sales didn't exactly boom, and at the artist's death in 1943 Walker took on partial responsibility for settling the estate, much of which he purchased. In 1949 Walker also purchased a large number of works from the estate of Alfred Stieglitz, including more Hartleys. The complete story of Walker's relationship to Marsden Hartley and to the University of Minnesota is related in the catalogue essay for the traveling retrospective exhibition *Marsden Hartley 1908-1942: The Ione and Hudson D. Walker Collection*, organized by the Museum and toured by the Art Museum Association of America in 1984 and 1985.

Walker never gave up believing that Hartley was one of the most important American artists of this century. Though his faith was not totally vindicated during his lifetime, Hartley began to claim his place in the history of American art shortly after Walker's death, particularly after the Whitney Museum of American Art in New York honored him with a retrospective exhibition in 1980.

Walker was also interested in Alfred Henry Maurer, believing that his position in American art, like Hartley's, was unrecognized and his importance unappreciated. In 1941 Walker purchased Maurer's estate from his sister, Eugenia Furstenberg, for $1,500. It included more than 400 works of art. This catalogue includes our 68 Maurer paintings out of the more than 500 Maurer works in the collection, many of them drawings and oil studies and all of which came to us through Hudson Walker.

In 1950 Walker put his collection "at the service of the University" through a long-term loan of more than 1,000 works of art. It seems that he remembered his early advice to President Coffman that the Museum should have a permanent collection and that American art should be its focus, because he wrote to President Morrill upon placing his collection at the University that his "series of American paintings, particularly those by Hartley and Maurer, would be the backbone of a collection to show the development of American art between 1893 and 1943.... Those two artists neatly summarize most of the stylistic developments of those years."[14]

In 1951 and 1952 Walker gave the Museum 320 works of art, including Maurer's *Girl in White* and *Still Life with Cup* among other works by Maurer and paintings by Arthur B. Carles, Ben Benn, and Preston Dickinson, to name just a few. Over the years he removed some of the Hartleys and Maurers on loan to the

University, presenting them to other Museums or to family members or sending them off for sale at galleries. Parts of the collection were given intermittently to the University as gifts by Hudson Walker and his wife, Ione, and at his death in 1976 his bequest to the University included approximately 1,200 works of art. The Hartley gifts and the Hartleys included in the Walker bequest give a complete representation of Hartley's career, as do the Maurers of that artist's work.

In addition to Hartley and Maurer, the Walker bequest included paintings by Milton Avery, Ben Benn, Hyman Bloom, Oscar Bluemner, Frank Burty, Arthur B. Carles, Arthur Dove, Louis Eilshemius, Philip Evergood, Lee Gatch, Robert Gwathmey, Samuel Halpert, Charles Hawthorne, Eugene Higgins, Joseph Hirsch, Mervin Jules, Jacob Lawrence, Ernest Lawson, George Luks, Stanton Macdonald-Wright, George F. Of, Guy Pène du Bois, Anton Refregier, Raphael Soyer, Carl Sprinchorn, Abraham Walkowitz, Max Weber, Elof Wedin, and Marguerite Zorach, among others.

When the Walker gifts and bequest are added to the early purchases by Ruth Lawrence, they establish the collection as important to the study of early 20th-century American art, especially as it concerns those artists who considered themselves "moderns." The paintings from the federal art project and from the Minnesota art project in the 1930s give the Museum a good sampling of the more representational work of the period. The real gap in the collection is the absence of any major paintings by the so-called "regionalist" painters. There are also no significant paintings by artists such as Stuart Davis or by Charles Sheeler or other "precisionists." They are well represented in our graphics collection but not in major oils.

The Walker family has remained supportive of the Museum. In addition to gifts by Hudson and Ione Walker, the Fine Arts Fund (originally the Archie B. and Bertha H. Walker Fund) has assisted in the purchase of several works of art, and Hudson Walker's sister, Louise McCannel, and her husband, Dr. Malcolm McCannel, have made numerous gifts to the Museum.

In 1952 John Rood, who had taught sculpture at the University since 1944, and his wife Dorothy founded the John Rood sculpture collection. The plan was that the Roods would make an annual contribution to the University, and a committee composed of the chairman of the art department, the director of the Museum, and Mr. and Mrs. Rood would select a piece of contemporary sculpture for purchase. Eight sculptures were acquired; David Smith's *Star Cage*, an important early work, was the first. Other sculptors whose works were bought included Harry Bertoia, Germaine Richter, Saul Baizerman, Harold Tovish, Bernard Meadows, Paul Granland, and

John Rood. The Roods, writing in 1959, said that their aim was to "be alert to new talents and to buy at a time when the purchase may be a real benefit to the career of the artist."[15] In 1964 Mr. Rood gave the Museum a selection of 11 of his own sculptures.

The sculpture collection was further augmented by the 1964 gift of Alexander Liberman's *Prometheus* and *A Windy Autumn Day* by Peter Agostino from the New York World's Fair. Professor Carl Sheppard, chairman of the Art History Department, was responsible for these works coming to the Museum. At the same time he also arranged for gifts from James Rosenquist and Roy Lichtenstein of murals they did for the fair. The sculpture collection has not grown as rapidly as the paintings and prints. Gifts in this area have not been sought because the Museum's present facilities do not allow for the significant display of sculpture and because storage space for large pieces is very limited.

In 1952 Katherine Ordway gave the Museum a 1950 painting by Robert Motherwell entitled *Mural Fragment*. It is interesting that when the painting was displayed in 1956 at the University's Duluth campus, it caused a great furor; a violent anti-abstract art petition was circulated to have the painting removed from the student union where it was displayed. A newspaper article entitled "Students Object to Nonobjective Art" said that the petition called for removal before graduation ceremonies because "we wouldn't want our parents and guests to get the wrong idea about the kind of education we are getting here...this crude daub that looks like a deformed octopus alongside of two decayed dinosaur eggs."[16]

It is equally interesting to compare this with the response to the Museum's displays of abstractions during the 1930s and 1940s—a time when abstract art was *really* new in the United States. According to the copious clipping books prepared by the WPA workers at the Museum, viewers were more puzzled than angry. University students getting their first look at surrealism and dada at the Museum in 1937 labeled it "bizarre" and "weird" but discussed it seriously. An article on an international abstract art exhibition at the Museum in 1938 was titled "Abstract Art Weird but Cold and Logical Experts Assert," while other articles grappled with the problem of how to understand abstract art. While some critics suggested that there was nothing to understand, all treated the subject in the spirit of intellectual discussion. A 1940 exhibit of American abstraction prompted two undergraduates to substitute their own painting, which they called *Distraction*, for one of the paintings in the exhibit as a joke, but no one called for the exhibit to be closed.

In 1967 Emily Abbott Nordfeldt, widow of the artist B.J.O. Nordfeldt, whose painting was the second to enter the collection,

established a fund for the acquisition of works of art. *Battery Park* (1895) by Abraham Walkowitz was purchased with Nordfeldt funds in 1968, Frank Benson's *The Hillside* (1921) in 1975, and Edwin M. Dawes's *The Origin of the Mississippi* in 1978. Ilya Bolotowsky's *Study for World's Fair Mural* (1938) was purchased in 1981 with Nordfeldt funds combined with those from the Ione and Hudson Walker Fund and others from Dr. John E. Larkin, Jr. Mrs. Nordfeldt has also given the Museum a retrospective of her husband's work which includes paintings dating from 1928 to 1951.

Several other donors have made important additions to the American painting collection at the Museum. In addition to work by Hugh Henry Breckenridge, Howard Chandler Christy, and Jonas Lie, Dr. John E. Larkin, Jr., has given the Museum several paintings by Cameron Booth to add to those purchased by the Museum or given by the artist. Donald Judkins presented the Museum with a painting by Minnesota artist John Anderson and arranged for gifts from the First Bank Southdale and the First Bank System. Professor Samuel Popper has given a Philip Evergood painting, among other works, including several Walkowitz drawings. Louis W. Hill, Jr., donated 29 paintings including a work by the American impressionist Richard Miller and Indian scenes by Maynard Dixon from 1917. Mrs. Abby Weed Gray and the Abby Weed Gray Trust have given the Museum several paintings by Minnesota painter Clara Mairs, among other works. Eleanor Quirt and her family gave three paintings by her late husband, Walter Quirt, who worked in New York in the 1930s and came to the University in 1947, to add to those donated by the artist during his lifetime and those given by other donors. Dr. H. Lynn Ault, Jane and David Soyer, and Harmony Hammond have also added to the American collection. Evelyn Payne Hatcher gave the Museum 17 paintings by her father, Edgar Alwin Payne, a popular landscape painter of the West in the 1920s. Mr. and Mrs. Julius E. Davis donated paintings by Howard Jones and Paul Jenkins. Mr. and Mrs. Roy R. Neuberger added a Milton Avery, *Fantastic Rock, California*, to the Avery included as part of the Hudson Walker bequest. These names represent only a few of the individuals who have made gifts to the collection. It would be impossible to name every donor here, but each catalogue entry mentions the name of the donor of the painting or sculpture.

Funds for purchases of works by young artists and local artists are provided by the income from the art rental program, which continues to flourish. In addition, the Jerome Foundation has provided funds for two juried competitions for Minnesota artists under age 30. Those funds have added 21 works to the collection to date, many of them graphics or photographs. The second

competition has not yet been held, but it is anticipated that it will result in a similar number of acquisitions. We hope that the Jerome Foundation will continue to support this program. The works purchased by these funds are allocated first to the rental program, thus helping to fulfill some of the original goals of the collection. Their purchase takes a chance on artists not yet established and at the same time provides students with an opportunity to live with real works of art on a daily basis, contemplate them, and develop an appreciation for them.

Gifts by former and current Studio Arts Department faculty and MFA graduates in honor of the Museum's 50th anniversary in 1984 have also increased the collection of paintings by contemporary American artists. None of these gifts are in this catalogue because they entered the collection too late to be included. We also wish to recognize those patrons whose important American collections are not yet represented in the Museum, but who have indicated that their American collections or parts of their collections may someday be added to the Museum's: Rev. Richard Hillstrom and Professor Benjamin Lippincott are but two.

In recent years the collection has diversified to include decorative arts, African art, and antiquities, among other collections. All of our collections are used for University teaching, but we have always kept in mind that the Museum should consider itself a resource for the whole region and should complement collections held by other arts institutions in the area. The American collection is still the most important at the Museum, in terms of both quality and quantity. Our holdings in American art from the first half of the 20th century are unique in the region, and we hope to be able to fill in gaps in this area. We also will continue to make purchases for the rental collection from young, relatively unknown artists, believing that both students and the artists will benefit from this policy. If some of those artists are selected by history to become prominent, the collection will profit as well; if they are not, the Museum will still have fulfilled its goals.

We are grateful to the several student research assistants who labored for years on essential research, and to Dr. Rena Coen, Dr. Percy North, Dr. Mary Swanson, Dr. Robert Gambone, Rebecca Keim, Charles Helsell, Colleen Sheehy, Lenore Aaseng, Susan Brown, and Sue Kendall, all of whom wrote entries for the catalogue. Valerie Tvrdik, Museum editor, left the staff before the project was finished, but she and assistant curator Lenore Aaseng spent a great deal of time organizing the catalogue and doing research to close gaps and provide additional material. It was Susan Brown, the Museum's associate director, who took over the project of coordinating the final editing and production of the catalogue, and it is her intelligence, persistence, and good judgment that are

responsible for seeing this publication in print. The National Endowment for the Arts provided the first encouragement and financial support for this project, and the creative encouragement given by Sandra Butler of the Patrick and Aimee Butler Family Foundation is responsible for closing the final funding gap. The names of all those who contributed in some way to the catalogue are far too numerous to include here, but I have attempted to give them credit in the lists following. I apologize in advance to those who will be inadvertently omitted—not because their contribution was unimportant, but because it was not recorded in a way that made it possible to retrieve it for this publication.

Finally, we are most indebted to those people whose vision and faith inspired and formed the Museum's collection of American paintings and sculpture: Hudson and Ione Walker, Ruth Lawrence, Emily Abbott Nordfeldt, John and Dorothy Rood, and all of those individuals who have given the Museum works of American art or funds to purchase American art.

It is unfortunate that the dream they all shared of a new home for the collection has still not been realized and the Museum remains on the upper floors of Northrop Auditorium, where it was at its founding in 1934. Our storage rooms have been expanded from the one allowed in the beginning, but our exhibition space remains inadequate to pursue both a vigorous exhibition program and an ongoing display of our collection. Scholars and visitors from around the country and the world express surprise and dismay when they visit our Museum and do not find some examples from our fine American collection on permanent display. Our goal is to build soon a new facility on the campus, on a site already reserved for us overlooking the Mississippi and facing both the University and the community, thus symbolizing our role in University teaching and in presenting the University's ideas in the humanities to the community at large. This new facility will accommodate both our exhibitions program and our permanent collection. Meanwhile we have undertaken to publish this research catalogue of our American collection to give scholars a tool for their work in American art and to make our American collection more visible to the public at large. We hope that in the near future we will be able to begin research on a companion publication to document the more than 5,000 American prints, drawings, and watercolors in our collection.

Of all the men and women named above and credited in the catalogue that follows, the late Hudson Walker and the late Ruth Lawrence must be recognized as the first of those who believed in American art and believed in the University of Minnesota as a viable place for the arts to flourish. It is to them that this catalogue is dedicated, and it is to their credit that this collection stands.

Lyndel King
Director

Notes

1. Letter from President Lotus Coffman to F.P. Keppel at the Carnegie Corporation, 16 January 1934 (University of Minnesota Archives).

2. Letter from Ruth Lawrence, Curator, to Malcolm Willey, 15 June 1935 (University of Minnesota Archives).

3. Letter from Hudson Walker to Malcolm Willey, 5 June 1934 (University of Minnesota Archives).

4. Letter from Malcolm Willey to F. P. Keppel at the Carnegie Corporation, 26 June 1935 (University of Minnesota Archives).

5. "Fine Arts Projects at the University of Minnesota (1933-1935): a memorandum for the file of the President's Office," 20 July 1935, by Mrs. Ruth Lawrence (University of Minnesota Archives).

6. Letter from Alfred Stieglitz to Malcolm Willey, 10 July 1935. While the original Stieglitz correspondence was transferred to Yale University in 1963, copies remain on file in the University Art Museum.

7. John K. Sherman, "'U' Gallery Opens Fine Arts Room in Northrop Hall," *Minneapolis Star*, 2 February 1936.

8. Letter from Alfred Stieglitz to Ruth Lawrence, 18 April 1936.

9. Letter from Alfred Stieglitz to Ruth Lawrence from Lake George, 7 August 1935.

10. Letter from Ruth Lawrence to Alfred Stieglitz, 21 February 1936.

11. Letter from Ruth Lawrence to Alfred Stieglitz, 23 March 1936.

12. Letter from Malcolm Willey to Ruth Lawrence, 3 August 1935 (University of Minnesota Archives).

13. Letter from Malcolm Willey to Alfred Stieglitz, 26 July 1935.

14. Letter from Hudson Walker to Malcolm Willey, 18 December 1950 (Archives of American Art).

15. Unpublished manuscript signed "Dorothy and John Rood" and dated March 1959 (University Art Museum files).

16. Earl Finberg, "Students Object to Nonobjective Art," *Duluth News Tribune*, 16 April 1956.

Credits

The following people were in some way helpful in researching, assembling, or producing this catalogue. We wish to thank them here for their contribution. Large or small, it was essential.

Lenore Aaseng
Toni Adelinis
Leslee Avchen
Melissa Herrick Berman
Sarah Blick
Jack Bolger
Susan Brown
Rena Neumann Coen
Cindy Collins
Sue Denning
Elizabeth Diamond
Ian Dudley
Pamela Espeland
Robert Gambone
Merlin Garlid
Laura Gardner
Jean Harrer
Lisa Hartwig
Charles Helsell
John Jenswold
Rebecca Keim
Sue Kendall
Blaine King
Mark Kriss
Cori Kulzer

William Lampe
Karen Lovaas
Robert Manthey
Karal Ann Marling
Melanie Marshall
Jerry Mathiason
Ann Milbradt
Gary Mortenson
Emily Abbott Nordfeldt
Percy North
Herbert Scherer
Carol Smith
Kim Reichert Smith
Colleen Sheehy
John Sonderegger
Mary Swanson
Abigail Terrones
Valerie Tvrdik
Berta Walker
Ione Walker
Judy Wert
Sally Wheaton-Hushcha
Julie Yanson
Paul Yule

Dr. Percy North wishes to thank the following who aided her research:

Harry Bertoia	Lee Manso
Leland Bjorklund	Herman Maril
Robin Bolton-Smith	Virginia Mechlenburg
Cameron Booth	M. Daniel Mieg
Ruth Cloudman	Hans Moller
Wanda Corn	Robert Motherwell
Carolyn Clark DeCato	Carol Nathanson
Alberta Donlan	Georgia O'Keeffe
Elsie Driggs	Kathy Ratzenberger
Mrs. Richard Elliott	Sheldon Reich
Betsy Fahlman	Louis Ribak
Donald Gallup	Kurt Roesch
Frank Gervasi	Jane Rothlind
Norman Geske	Richard Rubenfield
Paul Granlund	Louis Schanker
Dorothea Greenbaum	Patricia Schwartzmann
George Gurney	Wilford Scott
William Halsey	Kent Smith
Duayne Hatchett	Raphael Soyer
Alonzo Hauser	Jeffrey Spaulding
Charles Helsell	Harry Sternberg
William I. Homer	Roberta Tarbell
Dave Hostetler	Gudmund Vigtel
Douglas Hyland	Bruce Weber
Mervin Jules	Barbara Wolanin
Gail Levin	Virginia Zabriskie
John McCarty	Judith Zilczer
Garnett McCoy	

University Art Museum Staff:

Lyndel King, Director
Susan Brown, Associate Director
Colleen Sheehy, Assistant Director for Touring Programs
Robert Gambone, Curator of American Art
Timothy Rigdon, Curator of Decorative Arts
Willard B. Moore, Special Curator for Folk Arts
Paul Larson, Special Curator for Architecture
John Jenswold, Editor
Karen Lovaas, Registrar
Lisa Hartwig, Public Information/Special Events Coordinator
Cori Kulzer, Accounts Supervisor
Ann Milbradt, Touring Exhibitions Assistant
Elizabeth Diamond, Assistant to the Registrar
William Lampe, Technical Director
Ian Dudley, Preparator
John Sonderegger, Preparator
Melanie Marshall, Acting Principal Secretary

The publication of this catalogue was made possible through support from the following:

Foundations

Elmer L. and Eleanor J. Andersen Foundation, St. Paul
Patrick and Aimee Butler Family Foundation, St. Paul
Dellwood Foundation Inc., St. Paul
Driscoll Foundation, St. Paul
National Endowment for the Arts
Archie D. and Bertha H. Walker Foundation, Minneapolis

Individuals

Josef L. Altholz
Elmer L. Andersen
Dolly Fiterman
Charles Helsell
Mr. and Mrs. William King Nelson
David and Andrea Scott
James W. Stegbauer

Contributors to the catalogue:

L.A.A. LENORE A. AASENG was formerly assistant curator and acting curator/editor at the University Art Museum.

S.M.B. SUSAN M. BROWN is associate director of the University Art Museum.

R.N.C. DR. RENA NEUMANN COEN is professor of art history at St. Cloud State University (Minnesota) and has written *Painting and Sculpture in Minnesota 1820-1914* and *In the Mainstream: The Art of Alexis Jean Fournier (1865-1948)*.

R.L.G. DR. ROBERT L. GAMBONE, former curator of American art at the University Art Museum, is now assistant professor of art at the University of Georgia, Athens.

C.P.H. CHARLES PAUL HELSELL was formerly curator at the University Art Museum and is presently curator of corporate collections at the 3M Company, St. Paul.

R.L.K. REBECCA L. KEIM, former assistant director for touring programs at the University Art Museum, is director of extension classes at the Minneapolis College of Art and Design.

S.K. SUE KENDALL was a National Endowment for the Arts researcher at the University Art Museum during the preparation of the catalogue.

L.K. DR. LYNDEL KING is director of the University Art Museum and author of *The Industrialization of Taste: Victorian England and the London Art Union*.

P.N. DR. PERCY NORTH is currently a visiting faculty member in the Art Department of Emory University, Atlanta. She has written widely on American artists of the first decades of the twentieth century with a particular focus on the work of Max Weber.

C.H.S CAROL HYNNING SMITH, a researcher at the University Art Museum, is a free-lance art historian and arts consultant.

M.T.S. DR. MARY TOWLEY SWANSON is assistant professor of art history at the College of St. Thomas, St. Paul, Minnesota.

Catalogue Note

All dimensions are given in both inches and centimeters; height precedes width precedes depth.

Prior to 1983, the University Art Museum was called the University Gallery. In 1983 the Regents approved a change in name to recognize the importance of the Museum's collections and the scope of its exhibitions and activities. Any references in the text to the University Gallery should be understood to mean the University Art Museum.

Exhibitions held at either the University Gallery (prior to 1983) or at the University Art Museum (since 1983) are listed with the entries by title and date only. All other institutions and cities where works in the University Art Museum's collection have been exhibited are identified along with the title and date of the exhibition.

Works in the collection with the same titles are distinguished in the text by numbers in italics in parentheses following the titles. These numbers are for the purpose of clarity only and are not part of the works' titles.

For purposes of cross-referencing, the last names of artists who are represented in this catalogue with complete biographical entries and who are mentioned within the context of another artist's entry appear in capital letters.

The author of an artist's biography and the commentary following on work by that artist is identified by initials at the end of the biography. In instances where one author wrote the biography and another author provided the commentary on the work or works, the initials of the second author appear after the commentary.

THE PAINTINGS

ANONYMOUS

Colonel William M. Liggett, *late 19th or early 20th century*

Oil on canvas, 43¾ x 34 in.
(111.1 x 86.4 cm.)
Unsigned
Gift of the St. Paul Campus Library,
University of Minnesota
54.42
Not illustrated

PROVENANCE: Dean Clyde H. Bailey,
University of Minnesota Institute of
Agriculture

One of several "boardroom" portraits in the collection, this likeness of Colonel William M. Liggett, a member of the University of Minnesota Board of Regents and first dean of the School of Agriculture, was probably painted around the turn of the century.

Liggett was born in Union City, Ohio in 1846. He was educated in the local schools and at the University of Ohio and taught for two years before joining the 96th Ohio Regiment during the Civil War. Following the war he farmed in Ohio for several years before moving to Minnesota in 1884. There he quickly became active in civic affairs, serving as county treasurer, railroad commissioner, and member of the University Board of Regents from 1888 to 1906. In 1895 he was appointed dean of the School of Agriculture and director of the state agricultural experiment stations by University President Cyrus Northrop. Liggett died in St. Paul in 1909.

This full-length profile portrait shows Liggett as a handsome, white-haired gentleman with a thick moustache, seated and holding an open book in his right hand while gazing out of a window. The steep perspective of the narrow room, the two-dimensionality of the figure, and the way in which the figure is crowded against the window wall indicate that the anonymous artist was probably self-taught. Nevertheless the effort was an earnest one and portrays with dignity and some degree of truth a university officer who "was a firm but diplomatic disciplinarian, [who] pushed the claims of his department vigorously [but] who knew how to control the jurisdictional disputes between the school and the college" (James Gray, *The University of Minnesota 1851-1951* [Minneapolis: University of Minnesota Press, 1951], p. 81). *R.N.C.*

ANONYMOUS

George Henry Partridge, *c. 1915-1930*

Oil on canvas, 40 x 30 in.
(101.6 x 76.2 cm.)
Unsigned
Anonymous gift
51.53
Not illustrated

Among the several anonymous paintings in the University Art Museum's collection is this portrait of University of Minnesota regent George Henry Partridge (1856-1932).

Although Partridge was of old New England stock and proud of his membership in the Massachusetts Society of Mayflower Descendants, he was actually born in Medford, Minnesota. Educated in the public schools of Steele County and at Winona State Normal School and the University of Minnesota, from which he graduated in 1879, he belonged to the first generation of "homegrown" University regents; before then, they had been newcomers from the East.

Left with the responsibility of providing for his family when his father was killed in the Civil War, Partridge early evidenced the drive and energy that would enable him to earn a fortune and then devote himself to civic affairs. He went to work in the Wyman Dry Goods company in Minneapolis, married his boss's daughter, and eventually became president of Wyman-Partridge and Company. The newlyweds' first home was an imposing residence on Nicollet Island, then one of the choicest residential districts in Minneapolis. They later moved into an even finer home on Groveland Terrace; their Japanese sunken garden was for many years one of the showplaces of the city.

Partridge served as a regent of the University of Minnesota from 1914 to 1931. He was chairman of the buildings and grounds committee during the period of the University's greatest physical expansion. Through his efforts, and after some struggle with the railroad, the Northern Pacific tracks which ran through the middle of the campus were removed. Northrop Memorial Auditorium was built under his supervision.

His portrait, a typical "boardroom" painting, reflects the business success and social position earned over a lifetime of diligence and civic devotion. *R.N.C.*

ANONYMOUS
(formerly attributed to Henry Inman)

Part of the large gift of nineteenth-century paintings made by Dean Frederick J. Wulling in 1944, these two landscapes, while unsigned, appear to be by the same hand. Wulling purchased them as works of Henry Inman, but this attribution is probably incorrect. The small size, delicacy of touch, and soft autumnal colors suggest a kinship with Inman, but they are simply not accomplished enough to be his.

Both landscapes represent river scenes. One shows a rustic cottage in the foreground and a distant view of mountains; in the other, a shallow stream flows between verdant banks into a larger river or lake. In *Landscape with a Stream*, in particular, the distant, sunlit hills, the luminous water flecked with white sails, and the hazy, golden light suggest a poetic temperament allied, unfortunately, to an insufficiently trained hand. *R.N.C.*

Oil on canvas on masonite, 16 x 20 in.
(40.6 x 50.8 cm.)
Unsigned
Gift of Frederick J. Wulling
44.16
Not illustrated

EXHIBITION: Tweed Gallery, University of Minnesota-Duluth, *A Survey of American Painting*, 1955.

PROVENANCE: Frederick J. Wulling

Landscape with Cottage
mid-19th century

Oil on canvas, 16 x 20 in.
(40.6 x 50.8 cm.)
Unsigned
Gift of Frederick J. Wulling
44.15
Illustration: Appendix

EXHIBITION: Tweed Gallery, University of Minnesota-Duluth, *A Survey of American Painting*, 1955.

PROVENANCE: Frederick J. Wulling

Landscape with a Stream
mid-19th century

ANONYMOUS

Of indeterminate date, these two decorative floral compositions were probably painted by female artists. Such subject matter was considered fitting for women in the nineteenth and early twentieth centuries, since an appreciation of both art and flowers was thought to indicate "finer sensibilities." Flowers were also a safe subject, easily found in the sheltered nest and convenient to turn to during a break in the domestic routine. Of course men painted flowers, too, but since male artists usually had academic training, they almost always placed them within the context of still-life studies of texture, form, and composition.

These two paintings suggest a self-taught, albeit skillful, hand in their sharp colors, flat backgrounds, two-dimensional frontality, and large, uniformly ripe blossoms. The lush blooms which fill the canvases emerge from similar jardinières decorated with Chinese landscapes, reinforcing the paintings' rather naive character and essentially ornamental purpose. *R.N.C.*

Oil on canvas, 20 x 14⅛ in.
(50.8 x 35.9 cm.)
Unsigned
Gift of Mrs. C.C. Bovey
43.738
Illustration: Appendix

EXHIBITIONS: New York Historical Society, 1952 ▪ *Selections from the Permanent Collection*, 1968.

PROVENANCE: Mrs. C.C. Bovey

Floral Composition *(1)*
late 19th century

Oil on canvas, 20⅛ x 14 in.
(51.1 x 35.6 cm.)
Unsigned
Gift of Mrs. C.C. Bovey
43.739
Illustration: Appendix

EXHIBITIONS: New York Historical Society, 1952 ▪ *Selections from the Permanent Collection*, 1968.

PROVENANCE: Mrs. C.C. Bovey

Floral Composition *(2)*
late 19th century

ANONYMOUS

Unknown Man in Uniform, *c. 1880-1890*

Oil on canvas, 11 x 7½ in.
(27.9 x 19.1 cm.)
Unsigned
Gift of University of Minnesota Libraries
36.82
Illustration: Appendix

EXHIBITION: New York Historical Society,
1952.

PROVENANCE: University of Minnesota
Libraries

This portrait of an unknown man in uniform is the work of a self-taught painter. The flat, linear image and the emphasis on ornamental pattern and color are evidence of a hand untrained in the academic rules of perspective and three-dimensional modeling.

In imitation of the standard formula for aristocratic portraiture, this unknown gentleman stands with one hand resting on his sword hilt and the other on a table. He is shown at three-quarter length, with his head in profile and the rest of his figure facing front, providing a splendid field for the display of large, gold-tasseled epaulets, a broad silk sash, and gleaming medals. Despite its lack of illusionist sophistication, its awkward articulation of the arms and shoulders, and its decorative rather than lifelike features, this painting projects an air of military importance, of a uniform proudly worn and decorations honorably won. *R.N.C.*

ANONYMOUS
(formerly attributed to August Klagstad)

Samuel W. Melendy, *early 20th century*

Oil on canvas, 24¼ x 20 in.
(61.6 x 50.8 cm.)
Signed lower right: Klagstad
Gift of Frederick J. Wulling
44.28
Illustration: Appendix

PROVENANCE: Frederick J. Wulling

This portrait of Samuel W. Melendy, a founder of the Minnesota State Pharmaceutical Association, was given to the University of Minnesota by Dean Frederick J. Wulling, Melendy's friend and professional colleague. Formerly attributed to August KLAGSTAD, the painting's flatness and harshness of color point to a less accomplished artist.

Born in Lowell, Massachusetts in 1841, Melendy graduated from Woodstock Academy in Vermont at age 15. He then moved to Stoughton, Wisconsin, where he clerked in a drugstore for 11 years before buying out one of its partners. In 1870 he moved to Minneapolis and in time became the senior partner of the pharmaceutical firm of Melendy and Lyman. As a member of the state Pharmaceutical Association's legislative committee, he was influential in the passage of laws protecting the public against harmful or impure drugs. *R.N.C.*

GERTRUDE ABERCROMBIE
1909-1977

SELECTED BIBLIOGRAPHY: "Gertrude Abercrombie, Hyde Park Art Center," *Artforum* 15 (Summer 1977): 77-78.

Gertrude Abercrombie was born in Austin, Texas on February 27, 1909. After graduating from the University of Illinois in studio arts, she settled in Chicago. Her early works were self-portraits painted in warm, intense colors. In the mid-thirties, however, she began to incorporate figures of lone women, cats, doors, and horses into her canvases, and this use of enigmatic, autobiographical symbols became her hallmark for the next four decades.

Leader of Chicago's fantasist school during the 1940s, Abercrombie added images of stuffed owls, empty gloves, and monochromatic rooms to her private symbolism. The rough textures appearing in her paintings of the thirties and forties gave way to immaculately smooth surfaces by the 1950s, a decade in which she was also known as the "Queen of Bop" because of her interest in music and her marriage to Chicago music critic Frank Sandiford. Symbols centering around figures of women continued to inhabit Abercrombie's canvases throughout the 1960s and on into the 1970s; she died in 1977. *M.T.S.*

White Horse, *1938*

Oil on canvas, 30 x 40⅛ in.
(76.2 x 101.9 cm.)
Signed lower left: Abercrombie 38
WPA Art Project, Washington, D.C.
43.736
Illustration: Appendix

EXHIBITION: *Original Paintings from the University Collection*, 1946, cat. 1.

PROVENANCE: WPA Art Project, Washington, D.C.

The white horse, a frequent figure in Abercrombie's very personal symbolic language, usually appeared as a stand-in for man or as his silent companion. Although this horse simply strolls across the landscape, horses in other works by the artist are shown living in towers, kneeling to observe the moon, or poking their heads into empty interiors.

The White Plume, *c. 1933-1941*

Oil on canvas, 30 x 36 in.
(76.2 x 91.4 cm.)
Signed lower right: Abercrombie
WPA Art Project, Illinois
41.78
Illustration: Appendix

EXHIBITION: *Original Paintings from the University Collection*, 1946, cat. 2.

PROVENANCE: WPA Art Project, Illinois

Women and articles of their clothing were among the many images Abercrombie used throughout the 1930s and 1940s to symbolize sexual conflict. This painting, completed by 1941, focuses on the shadowy figure of a woman in a white-plumed hat who gestures provocatively with her white-gloved right hand.

DEWEY ALBINSON

1898-1971

SELECTED BIBLIOGRAPHY: Grace E. Polk, "Albinson of Minnesota," *International Studio* 77, no. 315 (August 1923): 416-420 • Mary T. Swanson, "A Study of Dewey Albinson," unpublished paper, University of Minnesota, Minneapolis, 1975 • Nancy Johnson, *Accomplishments: Minnesota Art Projects in the Depression Years* (Duluth, Minnesota: Tweed Museum of Art, 1976), p. 15.

The son of Swedish immigrant parents, Dewey Albinson was born in Minneapolis, Minnesota on March 9, 1898. In 1915 he entered the Minneapolis School of Art, where he studied with Vaclav Vytlacil and Mary Moulton Cheney. After graduating in 1919 he spent the summer attending painting classes given by members of the artists' colony in Woodstock, New York, and subsequently studied at the Art Students League. He then returned to Minnesota, where he lived until 1947. From time to time he went elsewhere to study and paint; he was in France from 1923 to 1925, in Italy from 1929 to 1931, in New York again in 1932, and in Quebec from 1939 to 1941.

While in Minnesota, Albinson painted scenes from Taylors Falls, the Mesabi Iron Range, Grand Portage, and the ethnic communities in Minneapolis and St. Paul. During the 1930s he exhibited at the Delphic Gallery and the Museum of Modern Art in New York and at the Art Institute of Chicago. His work was shown at the Harriet Hanley Gallery (Minneapolis) from 1934 to 1955.

Albinson served as director of the St. Paul School of Art from 1926 to 1929. From 1933 to 1934 he was one of approximately 30 Minneapolis artists who took part in the PWAP, and during the summer of 1934 the University of Minnesota commissioned him to paint scenes of the campus. He was director of the educational division of the WPA/FAP in Minnesota from 1935 to 1937. A member of the Minnesota Artists Union, he also helped to found the Minnesota Artists Association and was its president from 1937 to 1939 and from 1941 to 1942.

Albinson moved his family to Stockton, New Jersey in 1947 and settled near his friend, the painter B.J.O. NORDFELDT. In 1953 they moved again, to Nayarit, Jalisco, Mexico, where Albinson painted the rugged mountain landscape and continued to work on a series of scenes from Cervantes' *Don Quixote* until his death in 1971. *M.T.S.*

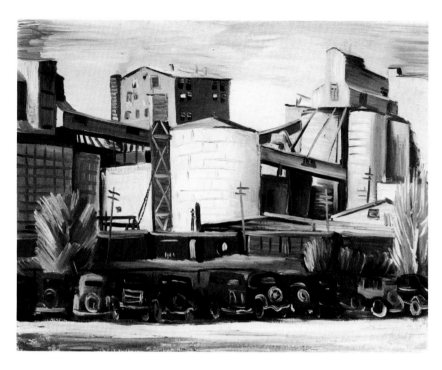

Mills, *1934* ▪ *Figure 1*

Mills, *1934*

Oil on canvas, 27¾ x 36 in.
(70.5 x 91.4 cm.)
Unsigned
University of Minnesota commission
34.128
Illustration: Figure 1

REFERENCE: Syd Fossum, interview with
Mary T. Swanson, 6 March 1975.

EXHIBITIONS: *Original Paintings from the
University Collection,* 1946, cat. 3 ▪ Tweed
Museum of Art, University of Minnesota-
Duluth, *Accomplishments: Minnesota Art
Projects in the Depression Years,* 1976, cat.
4 ▪ American Swedish Institute,
Minneapolis, *Dewey Albinson,* 1977 ▪
Minneapolis College of Art and Design,
Minnesota Painters, 1977 ▪ *Contact:
American Art and Culture 1919-1939,*
1981, cat. 1 ▪ The St. Paul Companies, Inc.
(Art Acquisitions, Inc.), St. Paul, *American
Scene Painting: Minnesota Art in the 1930s
and 1940s,* 1982 ▪ *Images of the American
Worker 1930-1940: An Undergraduate
Honors Seminar Exhibition,* 1983.

PROVENANCE: the artist

These grain elevators and factories are still in existence near the University of Minnesota campus. Albinson completed this scene during the early summer of 1934, when he was employed by the University to paint views of the campus and the surrounding area. While his emphasis on distinctly Minnesota scenes allied Albinson to regionalist painters of the time, his use of underlying geometric forms to depict the mill also linked him to the Precisionists of the 1920s and 1930s.

1000 University Avenue, *1934*

Oil on canvas, 40⅛ x 34¼ in.
(101.9 x 87.0 cm.)
Unsigned
University of Minnesota commission
34.130
Illustration: Appendix

EXHIBITION: *Original Paintings from the University Collection*, 1946, cat. 4.

PROVENANCE: the artist

This apartment complex still stands at 1000 University Avenue Southeast in Minneapolis. Albinson painted it from approximately May 1 through June 15, 1934, when he shared a loft with Elof WEDIN, Arnold KLAGSTAD, Stanford FENELLE, and Syd FOSSUM, all of whom had been commissioned by the University of Minnesota to paint campus scenes. During this time University dean Malcolm Willey, University Art Museum (then University Gallery) curator Hudson Walker, and artist Cameron BOOTH were assigned the task of evaluating Albinson's weekly PWAP quota of three watercolors, three gouaches, or one oil painting.

River Flats, *1934*

Oil on canvas, 34⅛ x 39⅞ in.
(86.7 x 101.3 cm.)
Unsigned
University of Minnesota commission
34.129
Illustration: Appendix

EXHIBITION: *Original Paintings from the University Collection*, 1946, cat. 5.

PROVENANCE: the artist

River Flats, also called *Bohemian Flats*, was another work Albinson painted as part of his University commission during the summer of 1934. The Flats, since razed, were located in the area now occupied by a parking lot near the Studio Arts Building on the University of Minnesota's West Bank campus. Albinson had often painted the Flats during the 1920s and wrote about their picturesque quality: "These 'shack towns' or in some cases called 'shanty towns,' were usually built in some hollow or along a river on government land, though sometimes near a railroad terminal or roundhouse. Some of these have nothing in common with slums but were built by poor immigrants. Minneapolis had one such place called the 'Bohemian Flats' under the Washington Avenue Bridge. Humble as these people were, they lived their lives as orderly as any. Above them the heavy traffic passed all day, while below along the riverbank was the village, a quaint setting with its little church in the center. The people were not Bohemians, but Czechoslovakians. During the spring, high waters would occasionally flood the lower part of the village" (Albinson, unpublished memoirs, c. 1965-1971, pp. 97-98).

University Bridge, *1934*

Oil on canvas, 34 x 40 in.
(86.4 x 101.6 cm.)
Unsigned
University of Minnesota commission
34.131
Illustration: Appendix

REFERENCE: John K. Sherman, "Lyric Quality is Noted in Recent Oils by Albinson," *The Minneapolis Star Journal,* 12 January 1935.

EXHIBITIONS: *Original Paintings from the University Collection,* 1946, cat. 6 • Tweed Museum of Art, University of Minnesota-Duluth, *Accomplishments: Minnesota Art Projects in the Depression Years,* 1976, cat. 3 • American Swedish Institute, Minneapolis, *Dewey Albinson,* 1977 • Alumni Club, Minneapolis, *75th Anniversary Exhibition,* 1979-1980 • The St. Paul Companies, Inc. (Art Acquisitions, Inc.), St. Paul, *American Scene Painting: Minnesota Art in the 1930s and 1940s,* 1982.

PROVENANCE: the artist

University Bridge is another of the campus scenes Albinson painted while employed by the University of Minnesota during the summer of 1934. The intense colors and liquid brushstrokes in this work are similar to those he used later that summer in painting scenes from the iron-range towns of northern Michigan. John K. Sherman, then the art and music critic for *The Minneapolis Star Journal,* wrote that he could see in this period "elements of a new-found freedom, a something which can only be described as a painter's joy....The style is more brushy than before, the color more strokey and less merged."

Untitled, *c. 1953-1971* (from the *Don Quixote* series)

Oil on canvas, 20⅛ x 20⅛ in.
(51.1 x 51.1 cm.)
Signed lower left: Dewey Albinson
Gift of John E. Larkin, Jr.
79.9.1
Not illustrated

PROVENANCE: John E. Larkin, Jr.

ADAM E. ALBRIGHT
1862-1957

SELECTED BIBLIOGRAPHY: Minnie Bacon Stevenson, "A Painter of Childhood," *The American Magazine of Art* 11 (October 1920): 432-434 • Adam Emory Albright, *For Arts Sake* (Chicago: The Lakeside Press, 1953) • Michael Croydon, *Ivan Albright* (New York: Abbeville Press, 1978), *passim.*

At the age of 91, Adam Albright privately published his autobiography, *For Arts Sake.* In it he recorded a life which, while sometimes erratic, nurtured the artistic careers of his twin sons, Ivan Le Lorraine and Malvin Marr Albright, and produced idyllic images of childhood.

Albright was born in Green County, Wisconsin on August 15, 1862. Although three generations of the men in his family had worked as master gunsmiths, his father (himself a frustrated artist) encouraged young Adam to leave home to study art. On November 1, 1880, Albright left the family farm for Lamar, Missouri, where

he worked in his older brothers' general store and taught art on the side. A year later he enrolled at the Chicago Academy of Fine Arts. He remained there until 1883, when he transferred to the Pennsylvania Academy of Fine Arts to study with Thomas Eakins for three years. In 1886 he traveled to Munich and then to Paris, where he joined the Académie Roland and studied with Benjamin Constant.

Albright returned to Lamar in 1888 to marry Clara Amelia Wilson, after which he went back to Europe to try to make his living as an artist. Failing at that, he moved to Chicago with his bride and set up a log-cabin studio and home in the northern suburbs. He specialized in sentimental, idealized portrayals of children, painted with the realism of Eakins and the impressionistic brushwork he had seen in Europe. He taught his twin sons, born in 1897, to draw from an early age and took them on sketching tours to California, Arizona, Maine, and New Mexico. By the 1930s Albright had amassed a sizable fortune in real estate, and he and his sons shared a studio in Warrenville, Illinois.

Albright served as president of the Chicago Watercolor Club and the Chicago Society of Artists and exhibited with the New York Watercolor Club and the American Watercolor Society. *M.T.S.*

Children of the Desert, *c. 1910*

Oil on canvas, 26 x 36⅛ in.
(66.0 x 91.8 cm.)
Unsigned
Gift of Louis W. Hill, Jr.
56.2
Illustration: Appendix

PROVENANCE: Chicago Galleries Association;
Louis W. Hill, Jr.

Albright specialized in painting children, usually in pairs and in picturesque natural settings. His own sons, Ivan and Malvin, often modeled for his earlier works, but he also made sketching trips throughout the United States and South America to draw children in rural areas. Albright's Eakins-like realism and impressionist brushwork are evident in this painting of two children riding through the desert on a white horse.

ARTHUR ALLIE
1872-1953

Arthur Allie was born in De Pere, Wisconsin, the second youngest in a family of ten children. He drew and painted in his spare time but was not able to study art formally until his late forties, when he moved to New York. There he studied with Robert Henri between 1920 and 1922. Upon returning to the Midwest, he settled in St.

Paul and began painting signs for a living. During the Depression he taught art for the WPA/FAP and exhibited paintings at the Minnesota State Fair throughout the 1930s. *M.T.S.*

Selby Tunnel, *c. 1933-1943*

Oil on canvas, 24 x 28 in.
(61.1 x 71.1 cm.)
Signed lower right: Arthur Allie
WPA Art Project, Minneapolis
43.770
Not Illustrated

REFERENCE: Interview with Arthur Allie, Jr., 1 August 1980.

PROVENANCE: WPA Art Project, Minneapolis

Arthur Allie and his family lived on Laurel Street in St. Paul, a block away from the Selby streetcar tunnel. The streetcar, part of the old Selby-Lake line, would travel down the tunnel to Pleasant Avenue and on to Seven Corners near the present West Bank campus site of the University of Minnesota Law School.

Study of an Old Man, *c. 1933-1943*

Oil on canvas, 28¼ x 22 in.
(72 x 56 cm.)
Signed lower right: Arthur Allie
WPA Art Project, Minneapolis
56.17
Illustration: Appendix

REFERENCE: Interview with Arthur Allie, Jr., 1 August 1980.

PROVENANCE: WPA Art Project, Minneapolis; Minnesota Historical Society

Allie did more than one portrait of this old man, whom he found picking up cigarette butts on Seventh Street in St. Paul. The man was hired to model daily for the WPA/FAP art classes, but he often forgot to come and Arthur Allie, Jr., who was in his father's class, would be sent to find him.

JOHN E. ANDERSON
1923-1971

SELECTED BIBLIOGRAPHY: "Modern Painters in Minnesota," *Notes and Comments from the Walker Art Center* (April 1949), unpaged • *16 Younger Minnesota Artists* (Minneapolis: Walker Art Center, 1960), cats. 5 and 6 • Donald W. Judkins, *John E. Anderson: Minnesota Abstractionist* (Minneapolis: University Art Museum, University of Minnesota, 1986).

In both their sophisticated composition and their technique, John Anderson's works show evidence of his years of study in Paris and his early success in New York galleries. Born in Mankato, Minnesota, Anderson served in the Navy from 1943 to 1945. He graduated from the Walker Art School in Minneapolis in 1948 and went on to study at the Académie de la Grande Chaumière in Paris from 1948 to 1950. When he returned to the States, paintings and collages from his years in Paris were exhibited first at Walker Art Center (Minneapolis) and then in a one-man show at the Hacker Gallery (New York) in November of 1951. The reviews were favorable, and critics praised Anderson's sensitive play of color and texture within a rigid geometric framework.

To achieve the granular surfaces of his paintings, the artist borrowed techniques used in his collages. After coating pieces of paper with pigment, he pressed them down onto the canvas in a

manner similar to the surrealists' use of décalcomanie, the point of which was to produce pictures with no preconceived notions of subject or form. He also scored his canvases with fine lines, further enhancing their marbleized appearance.

Anderson used these same techniques in larger works shown at the Hacker Gallery in a group exhibition in 1952 and a second one-man show in 1953. Rectangles of color now appeared to swing arbitrarily through space rather than flatly dividing the canvas, as they had done in earlier works. One critic remarked that at times the tactile quality of the paint overpowered the images, resulting in everything becoming a uniform gray.

Anderson was an instructor at the Colorado Springs Fine Arts Center from 1952 to 1953, an exhibition assistant at Walker Art Center from 1953 to 1957, and an instructor in the University of Minnesota Extension Division from 1954 to 1957. His work appeared in the "New Talent in the USA" feature of *Art in America* in 1956, the same year during which he created a mural for the Southdale shopping mall in Minneapolis. He painted in New York from 1958 to 1959 and then returned to Minnesota in the summer of 1960 to participate in the Walker Art Center exhibition, *16 Younger Minnesota Artists*. He died in Battle Lake, Minnesota. M.T.S.

The Slide Rule, *1951*

Casein and oil on gesso on masonite, 20 x 24 in.
(50.8 x 61.0 cm.)
Signed (incised) lower right: john anderson 1951
Bequest of Hudson Walker from the Ione and Hudson Walker Collection
78.21.244
Illustration: Appendix

EXHIBITIONS: Drew Fine Arts Center, Hamline University, St. Paul, 1952 ▪ *Selections from the Permanent Collection*, 1957 ▪ *Abstract USA/1910-1950*, 1981 ▪ Carleton College, Northfield, Minnesota, *American Abstraction: 20th Century American Paintings from the University of Minnesota*, 1983 ▪ *John E. Anderson: Minnesota Abstractionist*, 1986.

PROVENANCE: Ione and Hudson Walker

The geometric shapes of this painting reinforce its mathematical title, and the lines and rectangles appear to float in a logical order within the space of the canvas. Typical of the works in Anderson's first one-man show at the Hacker Gallery in 1951, the surface of *The Slide Rule* is heavily scored with small lines. One critic, intrigued by the artist's technique, wrote: "His collages and oils are richly textured assemblages of rectangular shapes, cooly and deliberately placed in original and well-balanced relationships. A classicist, he keeps his forms simple, and elaborates within by scratching and overlaying colors, thereby giving the shapes a density compatible with their ordered arrangement and achieving deceptively subdued colors" ("Reviews," *Art News* 50, November 1951, p. 53).

Railroad Crossing, *1953*

Oil on masonite, 24 x 42 in.
(61.0 x 106.7 cm.)
Unsigned
Gift of Donald W. Judkins
82.15
Illustration: Appendix

EXHIBITIONS: The American Federation of
Arts, *New Talent in the U.S.A*, circulating
exhibition, May 1956-June 1957 • *John E.
Anderson: Minnesota Abstractionist*, 1986.

PROVENANCE: Donald W. Judkins

In *Railroad Crossing*, Anderson continued to experiment with large shapes placed upon a granular surface composed of pigment-coated pieces of paper. The marbleized appearance of this collage base, particularly effective in this scene of railroad tracks, conveys a feeling for the vast distances traversed by the geometricized iron rails. The tracks sweep across the surface of the picture plane in tones of brilliant red, orange, and green. The viewer's eye moves along the surface until momentarily brought to rest by the bright yellow disc of the crossing switch. In this way the artist skillfully alludes to the title of his painting while simultaneously suggesting images and metaphors of travel, motion, space, and time. *R.L.G.*

All Tabs Trimmed, *1957*

Oil on masonite, 23¼ x 47 in.
(59.1 x 119.4 cm.)
Signed lower right: john anderson 57
Gift of Lawrence D. Steefel
75.2.1
Illustration: Figure 2

EXHIBITION: *John E. Anderson: Minnesota
Abstractionist*, 1986.

PROVENANCE: Lawrence D. Steefel

In paintings completed after 1952, Anderson increased the size of the geometric shapes, which now appeared to move off through the canvas space at tremendous speed. He continued to use the décalcomanie technique, its spattered textures adding to his intriguing manipulation of the background. In *All Tabs Trimmed*, the painted surface fluctuates in appearance between a hazy mist and an immeasurable galaxy in space. The title may refer to the strong interest in space exploration that followed the Soviet launching of the first Sputnik in 1957.

Untitled, *1964*

Oil on masonite, 24 x 47 in.
(61.0 x 119.4 cm.)
Signed lower right: john anderson 64
Bequest of Hudson Walker from the Ione
and Hudson Walker Collection
78.21.919
Illustration: Appendix

PROVENANCE: Ione and Hudson Walker

During the 1960s Anderson introduced into his paintings recognizable objects tightly held within geometrically ordered compositions. He also returned to a use of collage; in *Untitled* he juxtaposed an actual piece of paper, held down by a painted wire from the image of a toy airplane, with a can of Coca-Cola and the painted features of a portrait intended as a mirror reflection.

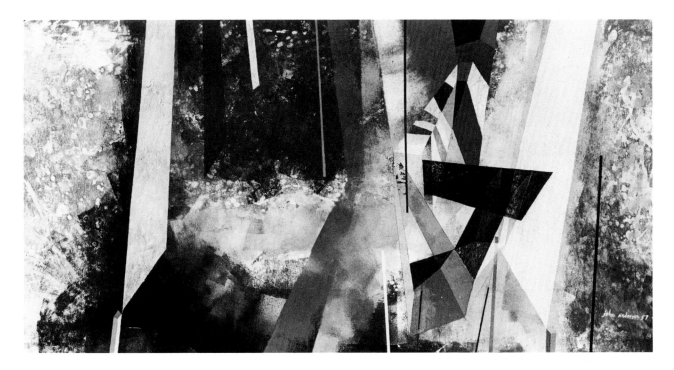

All Tabs Trimmed, *1957 • Figure 2*

MILTON AVERY
1893-1965

SELECTED BIBLIOGRAPHY: Frederick S. Wight, *Milton Avery* (Baltimore: Baltimore Museum of Art, 1952) • Clement Greenberg, "Milton Avery," *Arts* (December 1957): 41-45 • Adelyn D. Breeskin, *Milton Avery* (New York: American Federation of the Arts, 1960) • *Milton Avery: Paintings 1930-1960*, introduction by Hilton Kramer (New York: Thomas Yoseloff, 1962) • *Milton Avery*, introduction by Adelyn D. Breeskin, essay by Mark Rothko (Washington, D.C.: National Collection of Fine Arts, 1969) • M. Kangas, "Infinity Beach: Milton Avery," *Vanguard* 10, no. 3 (April 1981): 6-9 • Marsden Hartley, "On the Persistence of Imagination: The Painting of Milton Avery," *On Art* (New York: Horizon Press, 1982), 201-207 • Barbara Haskell, *Milton Avery* (New York: Whitney Museum of American Art, 1982).

Milton Avery's significant contribution to American art has been increasingly acknowledged and appreciated with the passage of time. His multifaceted oeuvre displays his wry sense of humor and his celebration of life's simple pleasures.

Born in Altmar, New York, Avery grew up in Hartford, Connecticut, where his family moved in 1905. During his early twenties he worked a factory night shift so as to have his days free for painting and sketching in the countryside. He studied briefly under Charles Noël Flagg at the Connecticut League of Art Students in 1923, but he was essentially self-taught. In 1925 he spent the summer painting at the artists' colony in Gloucester, Massachusetts, where he met artist and illustrator Sally Michel, whom he married the following year. He moved to New York in the autumn of 1925 and resided there the rest of his life.

15

Avery's work was first exhibited in 1928 at Opportunity Gallery (New York). In 1929 he received the Logan Prize at the Art Institute of Chicago; in 1930 he was awarded the Connecticut Academy of Fine Arts Atheneum Prize. His first one-man show at Valentine Gallery (New York) in 1935 marked the beginning of a steady succession of one-man and group exhibitions. His only child, a daughter named March, was born in 1932, and she appeared so frequently in her father's paintings that in 1947 Durand-Ruel Gallery (New York) devoted an entire show to his portraits of her. The Baltimore Museum of Art organized a major Avery retrospective in 1952, as did the Whitney Museum of American Art in 1960 and the National Collection of Fine Arts (now the National Museum of American Art) a decade later.

A lyrical abstractionist, Avery was noted for his greatly simplified compositions. His penchant for spatial ambiguity is evident in his forms, which are rendered in soft, vibrating colors with indistinct contours devoid of extraneous detail. As they interact with the surrounding background hues, they appear to float across the canvas. Avery was both friend and mentor to the abstract expressionists Mark Rothko and Adolph Gottlieb, who also experimented with floating, simplified abstract shapes in thinly washed fields of color; unlike these younger artists, Avery retained literal and frequently narrative subjects. Adelyn Breeskin wrote that Avery, like Henri Matisse, used "color as the mainspring of his art, and both artists treated figures and landscape primarily as patterns in harmonious arrangements" (Breeskin, 1969, p. 2). *P.N.*

Still Life, *c. 1935-1939*

Oil on canvas, 27¾ x 36½ in.
(70.5 x 92.7 cm.)
Signed (incised) lower left: Milton Avery
Bequest of Hudson Walker from the Ione
and Hudson Walker Collection
78.21.28
Illustration: Figure 3

EXHIBITIONS: *Selections from the Collection of Mr. and Mrs. Hudson D. Walker*, 1950 ▪ Drew Fine Arts Center, Hamline University, St. Paul, *Exhibition of Paintings by Some American Individuals*, 1950 ▪ *Selected Works from the Collection of Ione and Hudson Walker*, 1959 ▪ *Art and the University of Minnesota*, 1961 ▪ *Works from the Permanent Collection*, 1972 ▪ *Hudson D. Walker: Patron and Friend*, 1977, cat. 1 ▪ *Selections from the*

Still Life demonstrates Avery's formal debts to Paul Cézanne and Henri Matisse. As in Cézanne's work, objects are distributed across the surface of a tilted table-top, creating a tension that forces the viewer to evaluate the internal structure that prevents the objects from cascading out of the picture plane. The floating table reaches out into the viewer's space in a subtle reorganization of three-dimensional perceptions. The startling color pays homage to Matisse's passion for the complementary hues of lavender and green, but Avery uses them in a distinctly personal way. His reduction of objects to their essential forms and outlines approaches a childlike naivete, but the subtle modeling of the pears and the incised lines suggesting floorboards combine with the broad, flat planes of color to give the illusion of volume and depth. This intriguing balance between total abstraction and visual reality is the strength of *Still Life* and of Avery's work in general.

Permanent Collection, 1980 • Abstract USA/
1910-1950, 1981 • Carleton College,
Northfield, Minnesota, *American*
Abstraction: 20th Century American
Paintings from the University of Minnesota,
1983 • The Dolly Fiterman Gallery,
Minneapolis, *Exhibition of Milton Avery,*
1983 • *The First Fifty Years 1934-1984:*
American Paintings and Sculpture from the
University Art Museum Collection, 1984.

PROVENANCE: Ione and Hudson Walker

Still Life, *c. 1935-1939 • Figure 3*

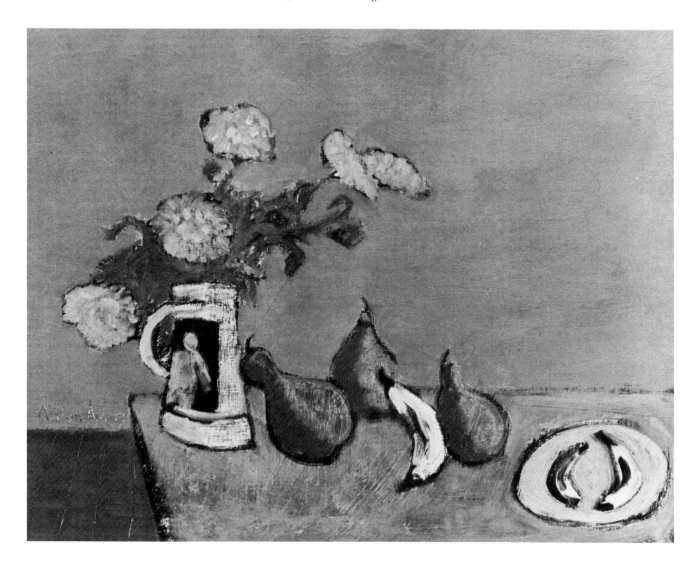

17

Fantastic Rock, California, *1941*

Oil on canvas, 28 x 36 in.
(71.1 x 91.4 cm.)
Signed (incised) lower left: Milton Avery
Gift of Mr. and Mrs. Roy R. Neuberger
53.343
Illustration: Colorplate II

EXHIBITIONS: Rosenberg Galleries, New
York, 1941 ▪ Walker Art Center,
Minneapolis, *Contemporary American
Painting and Sculpture: Collection of Mr.
and Mrs. Roy R. Neuberger*, 1952, cat. 5 ▪
Baltimore Museum of Art traveling
exhibition, *Milton Avery*, 1952-53, cat. 22 ▪
Selections from the Permanent Collection,
1954 ▪ Brooks Memorial Union, Marquette
University, Milwaukee, *75 Years of
American Painting*, 1956 ▪ *Selections from
the Permanent Collection*, 1957 ▪ Minnesota
State Fair, St. Paul, *American Art in the
Twentieth Century from the Collection of
the University of Minnesota*, 1957 ▪
Rochester Art Center, Rochester,
Minnesota, *Significant American Painters*,
1959 ▪ *Selections from the Permanent
Collection*, 1968, 1969, 1970 ▪ The
Minneapolis Institute of Arts, Artmobile
traveling exhibition, *American Art: 1930-
1970*, 1970-71 ▪ *Works from the Permanent
Collection*, 1972 ▪ Committee on
Institutional Cooperation and Member
Universities, Traveling Exhibition, *Paintings
from Midwestern Collections: 17th-20th
Centuries*, 1973-75, cat. 60 ▪ The
Minneapolis Institute of Arts, *American
Arts: A Celebration*, 1976 ▪ Minnesota
Museum of Art, St. Paul, *American Style:
Early Modernist Works in Minnesota
Collections*, 1981, cat. 2 ▪ The Dolly
Fiterman Gallery, Minneapolis, *Exhibition
of Milton Avery*, 1983 ▪ *The First Fifty
Years 1934-1984: American Paintings and
Sculpture from the University Art Museum
Collection*, 1984.

PROVENANCE: Rosenberg Galleries, New
York; Valentine Gallery, New York; Mr.
and Mrs. Roy R. Neuberger

Avery spent his winters in New York City painting still-lifes, interiors, and portraits; in the summers he fled to the New England seashore, where his subjects were culled from the ocean and the beach. In 1941 he traveled to California and drew inspiration from the Pacific coast. Painted from a sketch made at Laguna Beach, *Fantastic Rock, California* typifies the artist's style of seductively simplified abstraction.

The painting documents Avery's fascination with the sea as a presence that is dense but also opaque—sometimes flat and at other times full of depth. Here it is quiet, reduced to two horizontal bands, and its static calm is broken by the spectacular jagged rock form that appears to float over the water in defiance of its own heaviness and mass. The ambiguous relationships of weight and depth are the painterly problems in this work. Although the amorphous female figure and the buoy (possibly a visual pun on "girl" and "boy") provide a certain narrative interest, the landscape itself is a brilliant abstraction of intriguing spatial relationships manipulated through the interaction of thin washes of color. Avery's daughter March, one of his most frequent models, is probably the figure in the painting.

Natural phenomena were popular subjects in nineteenth-century paintings, and a comparison of *Fantastic Rock, California* with Georges Seurat's *Le Bec du Hoc, Grandcamp* of 1885 (Tate Gallery, London) reveals some interesting features in common. Specifically, Seurat's point of view, simplification of landscape forms, stippling, and natural coastal formations are similar to Avery's in this seascape.

MATTHEW BARNES

1880-1951

SELECTED BIBLIOGRAPHY: "Paints 25 Years, and Never Sells a Picture," *Art Digest* (1 February 1929): 9 ▪ James Thrall Soby and Dorothy C. Miller, *Romantic Paintings in America* (New York: The Museum of Modern Art, 1943), 44-45 ▪ *Fifteen Paintings by Matthew Barnes* (New York: Martha Jackson Gallery, 1955).

A self-taught romantic artist, Matthew Barnes sold his first painting at the age of 50. Born in Kilmarnock, Scotland on September 23, 1880, he apprenticed as an ornamental plasterer before immigrating to the United States in 1904 and settling in New York. When the 1906 San Francisco earthquake created a need for plasterers, he moved there and began to paint in a boarded-up studio on the second floor of the famous Montgomery block, interrupting his periods of painting with museum and gallery visits. He exhibited his work occasionally but did not hold his first important one-man show until February of 1929, when his paintings appeared at the East West Gallery (San Francisco).

Barnes's early work depended on the mysterious iconography of night romanticism developed by Albert Pinkham Ryder. He filled his canvases with repeated images of ghostly homes, lonely figures, and roads bathed in moonlight. Some critics also drew a connection between Barnes and Marsden HARTLEY. Toward the end of his career, Barnes attempted to eradicate all outside artistic influence from his painting; he even destroyed canvases that he felt showed color or design passages reminiscent of other artists.

Barnes participated in the WPA/FAP easel program during the late 1930s, but he never taught. It was around this time that a few patrons began to avidly collect his works, some of which may now be found in the collections of the San Francisco Museum of Art, the California Palace of the Legion of Honor (San Francisco), and the Museum of Modern Art. *M.T.S.*

Nocturne, *c. 1935*

Oil on canvas, 37⅛ x 44¼ in.
(94.3 x 112.4 cm.)
Signed verso: M. Barnes
WPA Art Project, Washington, D.C.
43.735
Illustration: Appendix

PROVENANCE: WPA Art Project, Washington, D.C.

Titles were unimportant to Matthew Barnes, yet the ones he assigned to his paintings often evoked the mysterious moods he attempted to convey. *Nocturne*, with its dark and vacuous background, is typical of his work; it was designed to be exhibited in an area with dim illumination. Like all of the 200 paintings Barnes completed in the last 35 years of his life, this work will seem to glow on its own when placed in a room that is faintly lit.

WILL BARNET
1911-

SELECTED BIBLIOGRAPHY: James T. Farrell, *The Paintings of Will Barnet* (New York: Press Eight, 1950) • Una E. Johnson, *Will Barnet: Prints, 1932-1964* (New York: The Brooklyn Museum, 1965) • Richard J. Boyle, *Will Barnet in the Sixties* (Philadelphia: Pennsylvania Academy of Fine Arts, 1970) • *Will Barnet: Etchings, Lithographs, Woodcuts, Serigraphs, 1932-1972*, compiled and edited by Sylvan Cole, Jr., foreword by Robert Doty (New York: Associated Artists Gallery, 1972) • Winthrop Neilson, "The Complete Individualist: Will Barnet," *American Artist* 37 (June 1973): 33-45, 72 • Susan E. Meyer, *Will Barnet, 27 Master Prints* (New York: Harry N. Abrams, 1979) • S. Williams, *Will Barnet: Twenty Years of Painting and Drawing* (Purchase, New York, 1980).

Born in Beverly, Massachusetts on May 25, 1911, Will Barnet first studied art at the age of 16 at The School of the Museum of Fine Arts in Boston. He once remarked that while his instructors encouraged the students to study Michelangelo, he chose Giotto. In 1930 he went to New York on a scholarship to the Art Students League; by 1934 he was the League's official printer. He began teaching there in 1936 and maintains that affiliation today.

Barnet's home and family have always been the primary content of his paintings and prints. His works from the 1930s focused additionally on the children, laborers, and tradesmen in his neighborhood. With their emphasis on linearity and flattened forms, the prints of family members resemble early folk prints. This approach carried through to the paintings he completed in the 1940s, clearly indicating that compositional developments in his prints often presaged those in his paintings.

Una E. Johnson, a curator at the Brooklyn Museum and personal friend of the artist, described the interrelationship of content, technique, and personal life in his work: "Barnet's personal life and his professional life are deeply entwined—one cannot exist without the other. Barnet has never found it feasible to maintain a studio outside the confines of his family quarters. He has always gained inspiration in the milieu of children growing up and among the pleasant confusion and color of a succession of parrots, tropical fish, sedate cats, and the exotic greenery of a variety of flourishing plants" (Johnson, 1965, p. 10).

By the late 1940s Barnet's paintings had become abstract yet still included recognizable forms from nature. He reintroduced the figure into compositions in the late 1950s, using evenly colored shapes which reiterated the two-dimensionality of his canvases. Since 1938 Barnet has had more than 20 one-man exhibitions, and his works are in the collections of major American museums. *M.T.S.*

The Cupboard *(Child Playing)*, *1944*

Oil on canvas, 18 x 24 in.
(45.7 x 61 cm.)
Signed lower left: W. Barnet
Bequest of Hudson Walker from the Ione
and Hudson Walker Collection
78.21.22
Illustration: Figure 4

EXHIBITIONS: *Selections from the Collection
of Mr. and Mrs. Hudson D. Walker*, 1950 •
Institute of Contemporary Art, Boston, *Will
Barnet*, 1961, cat. 7 • *Selections from the
Permanent Collection*, 1968 • *Hudson D.
Walker: Patron and Friend*, 1977, cat. 2 •
Abstract USA/1910-1950, 1981 • Carleton
College, Northfield, Minnesota, *American
Abstraction: 20th Century American
Paintings from the University of Minnesota*,
1983 • *The First Fifty Years 1934-1984:
American Paintings and Sculpture from the
University Art Museum Collection*, 1984.

PROVENANCE: Bertha Shaefer Gallery, New
York; Ione and Hudson Walker

Throughout his career, Barnet has drawn his subject matter from intimate family scenes; from the late 1930s through the mid-1940s his two children figured prominently in his prints and paintings. He painted heavy-lidded, large-headed infants in thick impastos in flat, intensely colored shapes.

Barnet typically explored subjects and compositions in prints before he painted them. A composition similar to the one in this painting appeared in his 1941 lithograph, *The Cupboard*, and it is possible that this canvas was first exhibited at the Bertha Shaefer Gallery (New York) in January, 1945. Here is how one critic described the main subject of that show: "Having a new one himself, it isn't surprising that Will Barnet, of graphic fame, devotes himself to babies in this show. His flatly-painted designs come to life unexpectedly. A pudgy infant, in the process of wiggling out of his clothes, struggles to turn over and reach a ball. A youngster stretches up to a table, gets into a cupboard, or just looks appealing in a large-eyed, wistful fashion" ("Reviews," *Art Digest*, 15 January 1945, p. 23).

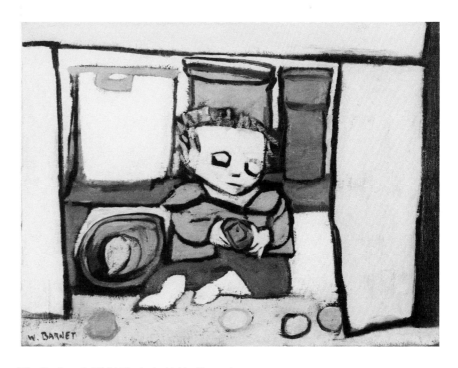

The Cupboard *(Child Playing), 1944* • *Figure 4*

21

JENNIE E. BARTLETT
(Active 1870-1879)

SELECTED BIBLIOGRAPHY: *American Paintings: A Complete Illustrated Listing of Works in the Museum's Collection* (Brooklyn: The Brooklyn Museum, 1979), p. 18.

Jennie E. (Jane) Bartlett is one of the many women artists of the nineteenth century about whom almost nothing is known. She may have been a student of William Morris Hunt and seems to have been active as a painter in the decade of the 1870s, specializing in portraits of professors of Eastern colleges. Her connection to the state of Minnesota is obscure, although University of Minnesota President William Watts Folwell apparently knew her quite well; she painted portraits of two of his daughters, Adelaide Young Folwell and Sarah Heywood Folwell, which are in the collection of the Minnesota Historical Society and show Jennie Bartlett to have been an accomplished painter. *R.N.C.*

Old Main, *1876*

Oil on canvas, 24¼ x 36 in.
(61.6 x 91.4 cm.)
Signed lower right: Jennie E. Bartlett 1876
Gift of May Heywood Folwell
51.46
Illustration: Appendix

REFERENCE: Letter from May Heywood Folwell to Thomas F. Wallace, president, Greater University Corporation, 13 February 1925 (Snyder Collection, University of Minnesota Archives).

PROVENANCE: May Heywood Folwell

The first building on the University of Minnesota campus, Old Main burned down in a spectacular fire in the early morning hours of September 24, 1904. Photographs and records contemporary with Jennie Bartlett's painting indicate that it was a four-story granite structure topped by a rather heavy domed cupola on the roof. The oldest part, the west wing and its extension, was built between 1856 and 1864. Following a period of neglect and disrepair during the Civil War, when Old Main became a squatters' haven, it was reopened in October 7, 1864. Between 1873 and 1876 the impressive facade was erected; President Folwell himself reportedly helped to haul the stone and mortar so that the enlarged building would be ready in time for the beginning of the academic year.

Bartlett's *Old Main* is rather harsh in color and tightly drawn, possessing none of the fluidity and three-dimensionality of her portraits of the Folwell sisters (Minnesota Historical Society). Half a century after this work was executed, President Folwell's daughter May, then an elderly lady of uncertain memory, wrote that her father had commissioned the painting of the Old Main in 1876 from Jane Bartlett, intending to show it at the University of Minnesota's booth at the Centennial Exposition of 1876 in Philadelphia (Folwell to Wallace, 13 February 1925).

DAVID BEKKER
1899-1956

SELECTED BIBLIOGRAPHY: Marilyn Robb, "Art News from Chicago," *Art News* 48 (December 1949): 50 ▪ *Scrapbook of Art and Artists of Chicago* (Chicago: The Art Institute of Chicago, Ryerson and Burnham Libraries, 1955), p. 43 ▪ *Scrapbook of Art and Artists of Chicago* (Chicago: The Art Institute of Chicago, Ryerson and Burnham Libraries, 1956), p. 4.

David Bekker painted images from Jewish and Russian folklore in the manner of Marc Chagall and Max WEBER. Born in Vilna, Russia on May 1, 1899, he emigrated to Palestine before World War I and studied at the Academy of Art there with Boris Schatz and Abel Panne. After the war he immigrated to the States and settled in Chicago, where he became active in the Jewish community and the Artists Union of Chicago. During the Depression he worked as an art instructor at Hull House with the financial support of the WPA/FAP.

Bekker derived most of his subject matter from the Old Testament and painted in an expressionistic style. He also designed stained-glass windows for Chicago-area synagogues and sculpted in ivory. Stranded in Rumania for a short time during World War I, Bekker carved ivory plaques for the tomb of King Carol I and an ivory portrait of Queen Marie of Rumania. During the 1930s he painted murals for Marshall High School in Chicago and Oak Forest Hospital in Oak Forest, Illinois. *M.T.S.*

Strange Interlude, *c. 1936*

Oil on canvas, 26 x 35 in.
(66.2 x 89 cm.)
Unsigned
WPA Art Project, Washington, D.C.
43.734
Illustration: Appendix

EXHIBITIONS: *Original Paintings from the University Collection*, 1946, cat. 7 ▪ Corcoran Gallery of Art, Washington, D.C., *17th Biennial Exhibition of Contemporary American Oil Painting*, 1941.

PROVENANCE: WPA Art Project, Washington, D.C.

From the hunched image of the old rabbi sitting in the background to the looming face of the ancient king and the oddly shaped doorway leading to the stairs, Bekker's distortion of figures and environments shows varying influences, ranging from surrealism to the style of his countryman Marc Chagall. One critic noted that Bekker painted his Old Testament subject matter "in a strong realistic manner with a spiritual intensity that saves [them] from being merely illustrations of religious themes" (*Scrapbook of Art and Artists of Chicago*, Ryerson and Burnham Libraries, The Art Institute of Chicago, 1955, p. 43).

BEN-ZION
1897-

SELECTED BIBLIOGRAPHY: Ralph M. Pearson, *The Modern Renaissance in American Art* (New York: Harper and Brothers, 1954), 136-140 • Stephen S. Kayser, *Ben-Zion, 1933-1959: A Retrospect* (New York: The Jewish Museum, 1959).

Born in the Ukraine, Ben-Zion went to the Volkshaus in Vienna to study art at the age of 17. Finding the academic training intellectually confining, he abandoned art for a literary career and wrote poetry, plays, short stories, and fairy tales in the ancient language of his Jewish heritage. He immigrated to the United States in 1920, settled in New York, and supported himself as a teacher of Hebrew. He returned to painting in the 1930s and despite the fact that he was essentially self-taught managed to secure commissions from the WPA's art projects as early as 1933.

Ben-Zion's painting was primarily symbolic, with themes derived from the Bible, his religious training, and nature. He employed heavy black outlines, blocky forms, and pure or slightly modified primary colors to interpret the universal dream of human existence. Although his art possesses elements similar to the work of Marc Chagall and Georges Rouault, and the emphatic linear structure of his compositions reveals links to expressionism, his deeply personal spiritual convictions made his vision uniquely his own.

In 1936 he held his first one-man show at the Artists Gallery in New York. A founding member of The Ten (not to be confused with the impressionist group of the same name formed in 1898), he exhibited with them regularly during the late 1930s; other members included Mark Rothko and Adolph Gottlieb. In 1948 the Jewish Museum (New York) held an exhibition of his biblical paintings, many of which Ben-Zion subsequently translated into a cycle of published etchings. After 1956 he concentrated primarily on landscapes and scenes from nature.

Ben-Zion is represented in many collections, among them the Museum of Modern Art, the Hirshhorn Museum and Sculpture Garden, and the Phillips Collection. *P.N.*

Farm at Night, *1938*

Oil on canvas, 28 x 34⅛ in. (71.1 x 86.7 cm.)
Signed lower right: Ben-Zion
Bequest of Hudson Walker from the Ione and Hudson Walker Collection
78.21.26
Illustration: Figure 5

Variously titled *Farm at Night, Cow and Moon, One Night on the Little Farm,* and *Night on the Farm,* this painting was the popular success of the 1938 exhibition of The Ten at the Georgette Passedoit Gallery (New York). As one critic of the time commented: "[This] exhibition of paintings by a group of artists intent upon pursuing expressionistic forms whether abstract or quasi-

24

REFERENCE: "New Experiments by 'The Ten' Group in Its Seasonal Show," *Art News* 38 (21 May 1938): 16.

EXHIBITIONS: Walker Art Center, Minneapolis, *92 Artists*, 1943 • *Selections from the Collection of Mr. and Mrs. Hudson D. Walker*, 1950 • Drew Fine Arts Center, Hamline University, St. Paul, *Exhibition of Paintings by Some American Individualists*, 1950 • The Jewish Museum, New York, *Ben-Zion, 1933-1959: A Retrospect*, 1959, cat. 8 (listed as *Cow and Moon*) • *Selected Works from the Collection of Ione and Hudson Walker*, 1959 • *Abstract USA/1910-1950* • Carleton College, Northfield, Minnesota, *American Abstraction: 20th Century American Paintings from the University of Minnesota*, 1983.

PROVENANCE: Bonestell Gallery, New York; Ione and Hudson Walker

illusionistic, is dominated by Ben-Zion's *One Night on the Little Farm*, a Mother Goose fantasy revolving around a cow licking the crescent moon. The painting has wit and artistic achievement. It is painted in the artist's familiar style, the forms being modeled by the position of the brushstroke, boldly and clearly arranged in a design and outlined in heavy lines of black which contrast, refreshingly, with the high keyed greens and the brilliant whites of Ben-Zion's individual palette" ("New Experiments," p. 16). It typifies Ben-Zion's style and technique, and the symbolic motifs—cow, star, and crescent moon—appear frequently in his work. Here, as in other of the artist's works, the close proximity of celestial bodies to the earth and its creatures depicts transitory, terrestrial existence as a reflection of the eternal.

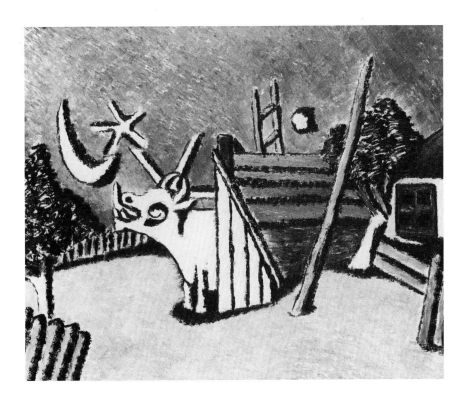

Farm at Night, *1938 • Figure 5*

BEN BENN

1884-1983

SELECTED BIBLIOGRAPHY: Sidney Geist, "Ben Benn," *Art Digest* 28 (1 October 1953): 15, 25-28 • Hilton Kramer, "The Achievement of Ben Benn," *Arts* 30 (April 1956): 24-27, 29 • *BB: Painter* (New York: The Jewish Museum, 1965) • *The Forum Exhibition of Modern American Painters* (New York: Arno Press, 1969—reprint), 44-45 • Martha B. Scott, "Ben Benn," *Arts* (May 1983): 20.

Ben Benn was born in Russia on December 27, 1884 and immigrated to New York with his family in 1894. He drew as a child but remained largely unaware of painting and sculpture until the age of 13, when he first visited the American Museum of Natural History. From 1904 to 1908 he attended the National Academy of Design, where he studied under demanding instructors trained in Munich. He and his fellow students (including William Zorach and Leon Kroll) spent their mornings and evenings drawing, their afternoons painting, and their free hours at the Metropolitan Museum of Art studying works by Rembrandt, Frans Hals, Velázquez, and Van Dyck.

From 1912 to 1913 Benn participated in group exhibitions with Max WEBER, Abraham WALKOWITZ, Arthur DOVE, Stanton MACDONALD-WRIGHT, and Man Ray. He was one of 17 artists in the Forum Exhibition of Modern American Painters, organized in 1916 by Alfred Stieglitz and Willard Huntington Wright as a modern and strictly American counterpart to the 1913 Armory Show.

Both the Armory Show and, especially, an exhibition of paintings by El Greco at M. Knoedler & Co., Inc. (New York) in 1915 had an impact on Benn's work. He was also influenced by ancient American sculpture, vases, and textiles in the collection of the American Museum of Natural History, which he continued to visit regularly.

Following their marriage in 1915, he and his wife Velida rented a large studio apartment which became a gathering place for Eugene O'Neill, Marsden HARTLEY, Charles Demuth, e.e. cummings, and Elie Nadelman. It was during this period that Benn composed several symbolic portraits similar to those being done by Hartley and Demuth. In the 1920s the Benns spent their summers on the south Jersey coast, where Benn painted canvases of the sea, boats, and sailors. Several of these were shown in his first one-man exhibition at the J.B. Neumann Gallery (New York) in 1925. The mid-1930s found him in Woodstock, New York painting landscape scenes. From that point on, landscapes, still-lifes, figures, self-portraits, and city scenes—all done in fresh, vivid colors—formed the primary content of his work.

In 1933 Holger Cahill included him in the American Sources of Modern Art exhibition at the Museum of Modern Art. To date he has been the subject of two major retrospectives, one at Walker Art Center (Minneapolis) in 1953 and the other at the Jewish Museum (New York) in 1965. *M.T.S.*

Portrait of M.H. *(Marsden Hartley), 1915*

Oil on canvas, 27 x 22¼ in. (68.6 x 56.5 cm.)
Signed lower right: Ben Benn. 15
Gift of Ione and Hudson Walker
53.289
Illustration: Figure 6

REFERENCE: Sidney Geist, "Ben Benn," *Art Digest* 28 (1 October 1953): 26.

EXHIBITIONS: *Marsden Hartley—German Period, 1959* ▪ ACA Heritage Gallery, Inc., New York, *Exhibition Commemorating the 50th Anniversary of the Forum Exhibition, 1916,* 1966 ▪ The University Galleries of the University of Southern California and the University Art Museum of the University of Texas at Austin traveling exhibition, *Marsden Hartley, Painter/Poet,* 1968-69, cat. 51 ▪ *Hudson D. Walker: Patron and Friend,* 1977, cat. 3 ▪ *Abstract USA/1910-1950,* 1981 ▪ Joseph and Margaret Muscarelle Museum of Art, College of William and Mary, Williamsburg, Virginia, *Into the Melting Pot,* 1984-85.

PROVENANCE: Ione and Hudson Walker

Benn and Hartley were friends until Hartley's death in 1943. This abstract work, which may have been influenced by the symbolic portraiture painted at around the same time by Hartley and Charles Demuth, is concerned more with the subject's personality traits than his physical features. During this period Benn's palette, like those of Hartley, Demuth, and Dove, was subdued and included earth colors, viridian, and black.

Portrait of M.H. *(Marsden Hartley), 1915* ▪ *Figure 6*

Marsden Hartley, *1924*

Oil on canvas, 36 x 30⅛ in.
(91.4 x 76.5 cm.)
Signed lower left: Benn 24
Gift of Ione and Hudson Walker
53.290
Illustration: Figure 7

REFERENCES: Sidney Geist, "Ben Benn," *Art Digest* 28 (1 October 1953): 26 • Hilton Kramer, "The Achievement of Ben Benn," *Arts* 30 (April 1956): 26.

EXHIBITIONS: Walker Art Center, Minneapolis, *Benn Exhibition*, 1953 • *Man and Mountain*, 1958 (organized by the University of Nebraska Art Galleries, Lincoln, 1957) • Babcock Galleries, New York, *Benn Benn, Figures and Portraits 1908-1955*, 1963, cat. 5 • The Jewish Museum, New York, *Ben Benn Retrospective*; 1965, cat. 5 • *100 Paintings, Drawings, and Prints from the Ione and Hudson D. Walker Collection*, 1965, cat. 4 • The Gallery of Modern Art, New York, *The Twenties Revisited*, 1965 • *Selections from the Permanent Collection*, 1970 • *Hudson D. Walker: Patron and Friend*, 1977, cat. 4 • Carleton College, Northfield, Minnesota, *American Abstraction: 20th Century American Paintings from the University of Minnesota*, 1983.

PROVENANCE: Ione and Hudson Walker

Hartley sat for this portrait after he had become a regular dinner guest of the Benns. In recalling these evenings, Benn said of his friend: "He was always gracious and witty. When he came to our house he would bring Velida a little bouquet of flowers or a book of poetry. He wasn't at all interested in his stature as an artist; he cared more about his food and clothes" (Geist, p. 26).

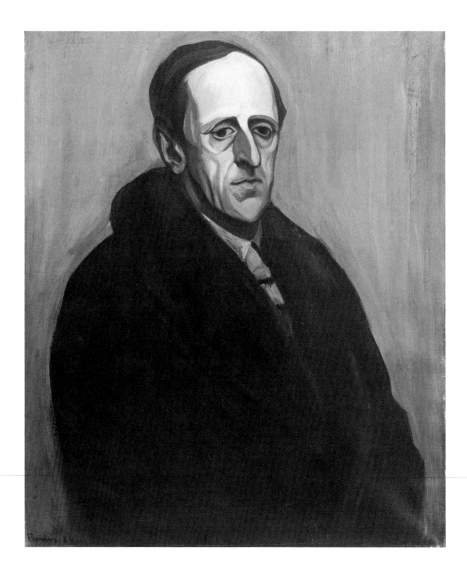

Marsden Hartley, *1924* • *Figure 7*

Oil on canvas, 30 x 24⅞ in.
(76.2 x 63.2 cm.)
Signed lower right: Ben Benn. 26
Bequest of Hudson Walker from the Ione
and Hudson Walker Collection
78.21.307
Illustration: Appendix

EXHIBITION: *Selections from the Permanent
Collection*, 1968.

PROVENANCE: Ione and Hudson Walker

Oil on canvas, 25¼ x 30 in.
(64.1 x 76.2 cm.)
Signed lower right: Benn 36
Bequest of Hudson Walker from the Ione
and Hudson Walker Collection
78.21.823
Illustration: Appendix

REFERENCE: Sidney Geist, "Ben Benn," *Art
Digest* 28 (1 October 1953): 25.

PROVENANCE: Ione and Hudson Walker

Oil on canvas, 24¼ x 14 in.
(61.6 x 35.6 cm.)
Signed lower right: Benn 48
Bequest of Hudson Walker from the Ione
and Hudson Walker Collection
78.21.228
Illustration: Appendix

EXHIBITIONS: *Selections from the Collection
of Mr. and Mrs. Hudson D. Walker*, 1950 ▪
Temple of Aaron, St. Paul, *Dedication Art
Exhibit*, 1957.

PROVENANCE: The Artists Gallery, New
York; Ione and Hudson Walker

Oil on canvas, 20 x 24⅛ in.
(50.8 x 61.3 cm.)
Signed lower right: Benn 48
Bequest of Hudson Walker from the Ione
and Hudson Walker Collection
78.21.29
Illustration: Appendix

EXHIBITIONS: Drew Fine Arts Center,
Hamline University, St. Paul, 1952 ▪ *Art
and the University of Minnesota*, 1961 ▪
Carleton College, Northfield, Minnesota,
American Art 1900-1940, 1977.

PROVENANCE: Ione and Hudson Walker

Self-Portrait, *1926*

Benn admired Rembrandt, Frans Hals, and Van Dyck, and their
influence is evident in this and other works. With its freely applied
brushstrokes, this painting prefigures Benn's technique in later self-
portraits.

Landscape, *1936*

Benn probably painted this during one of the summers he and
Velida spent at Woodstock; it is similar to other works from that
period. The sky is broadly painted with a loaded brush, and trees
and fields are filled with different greens. "You start with the
form," Benn once commented, "and soon find that color is endless.
And after a while the color dictates form" (Geist, p. 25).

Dahlias, *1948*

Typical of other flower pieces Benn painted during the late 1940s,
this appears to have a quivering life of its own. Benn often used the
vertical format of a vase holding a few blossoms and leaves.

Still Life with Fruit, *1948*

Benn painted this traditional still-life, in which the fruit bowl is
positioned at the center on a Cézanne-like, tilted tabletop, with
vigorous sweeps of his brush. Although this technique gives the
appearance of ease, Benn once commented that he experienced a
feeling of hesitancy whenever he began a new canvas. He would lay
the motif in one session, wait a day for the paint to firm, and then
work in new layers of paint. The colors in the canvases from this
period are intense, and forms are often overwritten with a
calligraphic black line which reflects light into the picture.

Hudson D. Walker, *1955*

Oil on canvas, 30⅛ x 25 in.
(76.5 x 63.5 cm.)
Signed lower right: Benn. 55
Gift of Ione Walker
79.7.2
Illustration: Appendix

PROVENANCE: Ione and Hudson Walker

Hudson D. Walker, grandson of Minnesota lumber magnate T.B. Walker, attended the University of Minnesota from 1925 to 1928. He later studied under Paul Sachs at the Fogg Museum, Harvard University, and returned to Minnesota in 1934 to become the first curator of what was then called the University Gallery. Although his tenure as curator was brief, Hudson Walker remained a lifelong patron and friend of the University Gallery, bequeathing the bulk of his collection to the University in 1978. A lifelong patron of the arts in general, Walker collected works by Benn and other notable American modernists including Marsden HARTLEY and Alfred H. MAURER. *R.L.G.*

FRANK WESTON BENSON
1862-1951

SELECTED BIBLIOGRAPHY: Anna Seaton-Schmidt, "Frank W. Benson," *American Magazine of Art* (November 1921): 365-372 • *Etchings and Drypoints by Frank W. Benson. An Illustrated and Descriptive Catalogue with an Original Drypoint by Mr. Benson and Reproductions of the Plates not hitherto catalogued*, with a foreword by Arthur William Heintzelman (Boston and New York: Houghton Mifflin Company, 1959). Volume 5 of a 5-volume set, this includes a chronological list of all prints from 1882 to 1959. Volumes 1-4 were published between 1917 and 1929 and arranged by Adam E.M. Paff • Moussa M. Domit, *American Impressionist Painting* (Washington, D.C.: National Gallery of Art, 1973), 42-43, 55 • Patricia Jobe Pierce, *The Ten* (Hingham, Massachusetts: Pierce Galleries, Inc., 1976), 39-52 • William H. Gerdts, *American Impressionism* (Seattle: The Henry Art Gallery, University of Washington, 1980), 93-94 • Michael Quick, Marvin Sadik, and William H. Gerdts, *American Portraiture in the Grand Manner, 1720-1920* (Los Angeles: Los Angeles County Museum of Art, 1981), 71 and 198.

Frank W. Benson was renowned during his lifetime both as a member of the Boston group of impressionists and as a wildlife artist. Born in Salem, Massachusetts, he studied at the Boston Museum School, where his classmates included Robert Reid and Edmund C. Tarbell. In 1883 Benson traveled to Paris with Tarbell and continued his artistic training at the Académie Julian under Gustave Boulanger and Jules-Joseph Lefebvre.

Both Benson and Tarbell returned to the States in January of 1886; both began teaching at the Boston Museum School in 1889; and both resigned their positions in 1912 to protest administrative policies. Meanwhile Benson won numerous awards at academy exhibitions and expositions across the country. In 1898 he became a founding member of The Ten, a group of American painters organized by John Twachtman (not to be confused with the expressionist group of the same name formed in 1935). Strongly influenced by impressionism, they withdrew from the Society of American Artists to exhibit independently and free themselves from the academic jury process.

After 1912 Benson took a new turn into printmaking. His etchings and drypoints of wild fowl, particularly ducks in water or in flight, are elegant impressions which reflect his great love of nature and sport while demonstrating his powers of observation and consummate draftsmanship. Benson's art, most notably his prints, had great popular appeal, and his career was both successful and lucrative. *R.L.K.*

The Hillside (Reading in Sun and Shade), 1921

Oil on canvas, 25⅛ x 30¼ in.
(63.8 x 76.8 cm.)
Signed lower left: F.W. Benson '21
Purchase, Nordfeldt Fund for Acquisition of
Works of Art
76.4
Illustration: Colorplate I

EXHIBITIONS: The Grand Central Art
Galleries, New York, *Exhibitions of
Paintings and Sculpture Contributed by the
Founders of the Galleries*, 1925, cat. 54 •
M. Knoedler & Co., Inc., New York, *The
American Impressionists*, 1975, cat. 20
(listed as *Reading in Sun and Shade*) • The
Minneapolis Institute of Arts, *The American
Arts: A Celebration*, 1976 • *Recent
Acquisitions*, 1976 • Gallery 101, University
of Wisconsin, River Falls, *The American
Progression: The 1830s to the 1950s*, 1978
• *Selections from the Permanent Collection*,
1980 • *Interplay '80: The Roots of Conflict*,
1980 • O'Shaughnessy Auditorium, The
College of St. Catherine, St. Paul, *Abe Feder
Dialogue with Light*, a symposium in which
painting was used as a prop for lighting
techniques, 1981 • *The First Fifty Years
1934-1984: American Paintings and
Sculpture from the University Art Museum
Collection*, 1984 • Madison Art Center,
Madison, Wisconsin, *The Seasons:
American Impressionist Painting*, 1983-84.

PROVENANCE: Private collection; M.
Knoedler & Co., Inc., New York

Like his close friend Edmund Tarbell, Benson is best known for his paintings of healthy, well-bred, attractive young women playing or relaxing in sun-filled, verdant landscapes with blue skies and billowy clouds. (The two artists' works were so similar during their early years that Benson was often labeled a "Tarbellite.") This painting, completed in 1921, is characteristic of the genre. A young woman dressed in white reclines on a sunlit, grassy hillside, holding a parasol to shade the book she is reading. Benson's impressionistic interest in the effects of light is evident in his colorful, staccato brushwork, particularly in the grass in the foreground, and in the cool, purple shadows cast by the parasol. His models were most often members of his own family; according to his niece Gertrude, the woman pictured here is the artist's eldest daughter Eleanor.

LESTER W. BENTLEY
1908-

SELECTED BIBLIOGRAPHY: *Chicago Art
Institute Scrapbook* (Chicago: The Art
Institute of Chicago, Ryerson and Burnham
Libraries, 1935), p. 166 • *Chicago Art
Institute Scrapbook* (Chicago: The Art
Institute of Chicago, Ryerson and Burnham
Libraries, 1937), p. 146.

Lester Bentley studied at the Art Institute of Chicago with Carl Buehr, Louis Ritman, Boris Anisfield, and Valetine Vedauretta. He was the first Wisconsin painter ever to be invited to participate in the All-American exhibition at the Art Institute of Chicago in 1935. He also showed paintings at the Annual Exhibitions of American Painting and Sculpture at the Art Institute in 1936, 1937, and 1938.

While most of the scenes in Bentley's canvases depict his native area of Two Rivers, Wisconsin, some came out of occasional sketching trips he took through the South during the Depression. *M.T.S.*

Georgia Tornado, *c. 1937*

Oil on canvas, 25¾ x 31⅞ in.
(65.5 x 81 cm.)
Signed lower right: L.W. Bentley
WPA Art Project, Washington, D.C.
43.733
Not illustrated

PROVENANCE: WPA Art Project,
Washington, D.C.

Bentley made sporadic sketching trips through the South during the Depression. *Georgia Crackers*, a painting similar to this one, was included in the Annual Exhibition of American Painting and Sculpture at the Art Institute of Chicago in 1937. Typical of other painters from the 1930s, Bentley tended to use texture and varied patterns within compositions, often creating a surrealistic environment resembling a set of stage flats.

LOUIS BETTS
1873-1961

SELECTED BIBLIOGRAPHY: W.H. de B. Nelson, "A Painter's Painter: Louis Betts," *The International Studio* (May 1918): lxxi-lxxviii ▪ W.B. M'Cormick, "Louis Betts—Portraitist," *The International Studio* (September 1923): 523-525 ▪ Helen L. Earle, *Biographical Sketches of American Artists*, 5th edition (Charleston: Garnier and Company, 1924) ▪ Hans Vollmer, *Künstler-Lexicon des Zwanzigsten Jahrhunderts*, volume 1 (Leipzig: A. Seemann, 1953) ▪ Louis Betts, "Experiences of a Portrait Painter," *The Artist* (December 1956): 78-80; (January 1957): 114-116; (February 1957): 138-140 ▪ T. Schwarz, "The Santa Fe Railway and Early Southwest Artists," *American West* 19, no. 5 (September/October 1982): 32-41.

Born in Little Rock, Arkansas and raised in Chicago, Louis Betts first studied painting with his father, the landscape artist Edwin Daniel Betts. At age 14 he made his first "sale"—trading a painted portrait for violin lessons. After studying briefly with William Merritt Chase at his summer school in Shinnecock, Long Island, Betts attended the Pennsylvania Academy of the Fine Arts for one term, again working under Chase; this ended his formal artistic training.

In 1902 he won the Pennsylvania Academy's first Cresson Traveling Scholarship, which provided for two years of study in Europe. He went first to Paris, but instead of attending art classes he rented a studio, hired models, and painted. His next stop was Haarlem, where he studied the works of Hals before moving on to Madrid to copy the paintings of Velázquez. (He was doubtless steered toward these two artists by Chase, who had studied them extensively on his frequent trips to Europe.) Bett's rendering of Velázquez's *Queen Mariana* so impressed the Prado's director that he termed it the best copy ever to leave the museum.

Betts had turned from landscape to portraiture as his preferred subject matter in the 1890s, and this decision served him well. His considerable ability as a portraitist brought him prizes and awards throughout his career, along with many commissions—so many, in fact, that he was rarely able to devote time to other subjects. He was elected an Associate of the National Academy of Design in 1912 and became a full Academician in 1915. He died in Bronxville, New York in 1961. *C.P.H.*

Dr. George E. Vincent, *c. 1917-1918*

Oil on canvas, 70⅛ x 42¼ in.
(178.1 x 107.3 cm.)
Signed upper left: Louis Betts
Gift of the Faculty through contributions
39.114
Illustration: Appendix

EXHIBITION: New York Historical Society,
1952.

PROVENANCE: University of Minnesota
faculty commission

George Edgar Vincent (1864-1941) served as the University of Minnesota's third president from 1911 to 1917. He received his doctorate in sociology from the University of Chicago in 1896 and began teaching at the University of Minnesota shortly thereafter; he became a full professor in 1904. In 1917 he left to become president of the Rockefeller Foundation, which he headed until his retirement in 1929. He returned to Minneapolis in 1938 for the dedication of Vincent Hall, where this portrait is permanently installed.

It is typical of Betts's commissioned paintings in its depiction of a single figure, centered on the canvas and placed in a plain interior. The paint is handled in a broad, loose manner, a technique advocated by his teacher Chase and characteristic of American portraiture at around the turn of the century (see, for example, the work of James Abbott McNeill Whistler, John Singer Sargent, Robert Henri, and George B. LUKS). The color tones are warm and almost monochromatic. Probably commissioned late in 1917, this portrait was painted between then and June 19, 1918, when it was given to the University of Minnesota by the faculty.

Under Flickering Leaf Shadows, *c. 1934*

Oil on canvas, 22 x 19⅛ in.
(55.9 x 48.6 cm.)
Signed lower left: Louis Betts
56.4
Illustration: Appendix

PROVENANCE: Grand Central Art Galleries,
New York; Louis W. Hill, Sr.; Louis W.
Hill, Jr.

Betts turned to painting the nude as a diversion from his career-long stream of portrait commissions. His earliest appears to be *The Sea Shell*, c. 1928 (The Art Institute of Chicago); others followed, including *A Modern Eve*, *The Scarlet Throw*, and *Repose*. In these works the figure dominates the canvas, and Betts has carefully rendered the model's form in an idealized, academic manner. *Under Flickering Leaf Shadows* is somewhat different in that the two nudes are smaller in relationship to the overall composition and are less meticulously executed. Another figure study, *The Bathers*, is very similar to it in composition, rendering, and style; in both works Betts has brushed in the figures while applying the thick impasto background with a palette knife. *The Bathers* is first listed in a 1934 catalogue from Grand Central Art Galleries in New York, lending credence to the proposed date for *Under Flickering Leaf Shadows*. The colors here are lighter and brighter than in the majority of Betts's portraits and lean strongly toward the high-keyed palette used by the American impressionists Childe Hassam, Frank W. BENSON, and Frederick Carl Frieseke.

ALBERT BIERSTADT
1830-1902

SELECTED BIBLIOGRAPHY: Florence Lewison, "The Uniqueness of Albert Bierstadt," *American Artist* (September 1964): 28-33, 72, 74 ▪ John K. Howat, *The Hudson River and Its Painters* (New York: Viking Press, 1972), 44, 47-48, 51 ▪ Gordon Hendricks, *Albert Bierstadt, Painter of the American West* (New York: Harry N. Abrams, 1974) ▪ Phillip Drennon Thomas, "Bierstadt of Dusseldorf: Painter of America's Western Vision," *Montana, The Magazine of Western History* (Spring 1976): 2-17 ▪ John Maass, "The Cinemascopic West of Bierstadt," *Nineteenth Century* 3 (Autumn 1977): 55-59 ▪ Matthew Baigell, *Albert Bierstadt* (New York: Watson-Guptill, 1981).

One of the best-known painters of the landscape of the American West, Albert Bierstadt was born in Düsseldorf, Germany and immigrated with his family to New Bedford, Massachusetts in 1832. He became interested in art at an early age and exhibited with the New England Art Union of Boston in 1851. In 1853 he traveled to Düsseldorf to improve his painting technique; after four years in Düsseldorf and Rome, he returned to the States.

In 1859 Bierstadt joined Colonel Frederick W. Lander's South Pass Wagon Road Expedition, sent by the Federal government to map an overland route to the Pacific. He brought back numerous sketches of the Rocky Mountains and other western scenes and a passionate admiration for the grandeur of the American wilderness. The large, panoramic landscapes he subsequently painted displayed the precise draftsmanship and penchant for dramatic effects characteristic of Düsseldorf-trained artists, but he also produced several smaller, more loosely painted pictures that reveal a freshness and informality not seen in his larger works.

Bierstadt was elected to the American Academy of Design in 1860. By the mid-1860s his work was receiving great critical acclaim and commanding the highest prices ever paid an American painter. Over the next several decades, he and his wife Rosalie traveled extensively in Europe, Canada, and the western United States. His career took a downward turn by the late 1880s, and the death of his wife in 1893 affected him deeply. Although he continued to paint until his death, he traveled only occasionally and spent his last years in New York. *R.N.C.*

Minnehaha Falls, *1886*

Oil on canvas on wood panel, 6¼ x 5⅛ in. (15.9 x 13 cm.)
Signed lower right: AB
Gift of Ione Walker
78.25.1
Illustration: Figure 8

One of several works Bierstadt painted of Minnehaha Falls in Minneapolis, this small panel was intended as a gift for Archie Walker, the young son of Thomas Barlow Walker, Bierstadt's friend and an early patron of the arts in that city. The inscription on the back reads: "Painted for Archie Walker by Albert Bierstadt—August 27, 1886, Archie aged 4 years and 3 months Bierstadt being a guest at our house Cor 8th and Hennepin for 10 days or more as both shown here. T. Walker." Archie is shown as a tiny, straw-hatted figure sitting on the bank of the stream below the falls in this light-filled and lighthearted sketch of Minnesota's famous landmark.

34

REFERENCE: Rena N. Coen, *Painting and Sculpture in Minnesota, 1820-1914* (Minneapolis: University of Minnesota Press, 1976), 40, 41, 67.

EXHIBITIONS: *A Bicentennial Exhibition of Minnesota Art and Architecture*, 1976 ▪ *Selected Gifts and Acquisitions*, 1979 ▪ *The First Fifty Years 1934-1984: American Paintings and Sculpture from the University Art Museum Collection*, 1984.

PROVENANCE: Ione and Hudson Walker

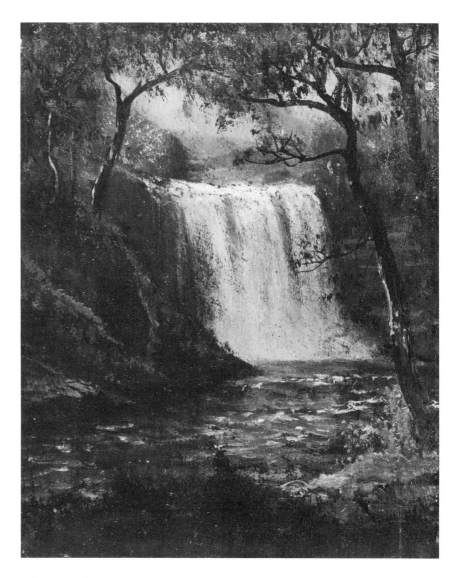

Minnehaha Falls, *1886* ▪ *Figure 8*

LEE (LELAND) BJORKLUND
1940-

SELECTED BIBLIOGRAPHY: Philip Larson, *Akagawa, Byrne, Kahn, Leicester, Axelrod, Bjorklund, Herdegen, Sorman* (Minneapolis: Walker Art Center, 1975) ▪ Mike Steele, "Practitioners Explore the Modern Art Mystique," *Minneapolis Tribune*, 18 May 1975.

Born in Wadena, Minnesota, Lee Bjorklund received his M.F.A. from the University of Minnesota in 1973 and is currently an associate professor at the Minneapolis College of Art and Design. Committed to the advancement of art in his native state, he has served as visual arts coordinator for the Minnesota State Arts Board and was cofounder of the Minnesota Artists Exhibition Program at the Minneapolis Institute of Arts. He has received numerous awards, including Minnesota State Arts Board grants in 1972 and 1979 and a Ford Foundation Faculty Enrichment Grant in 1977.

Since his first show at Walker Art Center in 1966, Bjorklund has exhibited widely in Minnesota, Wisconsin, and Virginia. His early works, conceived as reductions in the creative process, are primarily large-scale paintings realized through the use of monochromatic metallic pigments. In subsequent prints and paintings he has achieved a more decorative effect through repeated motifs and increased coloration. *P.N.*

Durations I, *1971*

Oil on canvas, 67 x 90 in.
(170.2 x 228.6 cm.)
Signed on verso: Bjorklund/7-71/Durations I
Gift of the artist
72.12
Illustration: Appendix

REFERENCE: Letter from Lee Bjorklund to Percy North at the University Gallery, 21 August 1978.

EXHIBITION: *Leland Bjorklund: MFA Exhibition*, 1971.

PROVENANCE: the artist

This large painting was included in Bjorklund's MFA thesis exhibition at the University Art Museum (then the University Gallery). About it, the artist wrote: "In *Durations I* the paint is commercial aluminum paint thinned with different solvents to control its reflective quality. This was applied (with a scrub brush) as directly as possible to the canvas with little or no manipulation after the initial act. It is, what I considered, a direct result of the physical activity of painting—perhaps constituting an attitude? There was also a conscious effort to eliminate 'decorative elements' and anything that was not absolutely needed" (Bjorklund to North, 21 August 1978).

Painted within the confines of a limited range of colors, materials, and techniques, *Durations I* exemplifies Bjorklund's minimalist or reductivist aesthetic. His division of the canvas into six gestures— actually one action repeated five times—indicates that the ritual act or process of creation is important to him. The serialization, in conjunction with the use of metallic paint, results in a variety of reflective surfaces and suggests the methods and materials of modern technology. The grid pattern and silver-gray coloration form a rational scientific construct, which is then marked by human intrusion in the visible brushstrokes and runny drips of paint.

HYMAN BLOOM
1913-

SELECTED BIBLIOGRAPHY: Frederick S. Wight, *Hyman Bloom* (Boston: The Institute of Contemporary Art, 1954) • Percy North, *Hudson D. Walker: Patron and Friend* (Minneapolis: University Gallery, University of Minnesota, 1977), 17 • Piri Halasz, "Figuration in the 40's: The Other Expressionism," *Art in America* 70, no. 11 (December 1982): 110-119, 145.

Hyman Bloom was born in the village of Brunoviski in Lithuania. His family, trapped by World War I, was unable to emigrate until 1920. During that year they settled in Boston, joining two older brothers who had arrived before the war and started a leather goods business.

By the age of 14 Bloom was taking art classes at the West End Community Center. There he met Harold Zimmerman, an art teacher, and another young pupil named Jack Levine. Zimmerman taught both boys to work from imagination and memory; Bloom regards him as one of the most formative influences on his painting. Zimmerman introduced Bloom and Levine to Denman Ross, who taught in the Fine Arts department at Harvard, and provided them with weekly stipends and working space until they set up their own studios.

Part of the WPA/FAP during the 1930s, Bloom described this experience: "PWA—WPA—I was in all of them. I was used to getting off them and then on again....Nonetheless, whatever painting there is in America today is due to WPA" (Wight, 1954, p. 18).

While his early work from the 1930s and 1940s had to do primarily with the self-discovery of his Jewish ethnic identity, later canvases, which use densely packed surface details drawn from nature, are preoccupied with themes of life's transience and decay. *M.T.S.*

Untitled *(Boxer), c. 1935*

Oil on canvas, 14 x 10 in.
(35.6 x 25.4 cm.)
Unsigned
Bequest of Hudson Walker from the Ione and Hudson Walker Collection
78.21.902
Illustration: Appendix

EXHIBITION: *Hudson D. Walker: Patron and Friend*, 1977, cat. 5.

PROVENANCE: Ione and Hudson Walker

Although the somber colors suggest themes of solitude and pathos which inhabit Bloom's later canvases, this painting probably dates from his early period. The muscular figure is reminiscent of those painted by Michelangelo, whom Bloom greatly admired as a young man.

OSCAR FLORIANUS BLUEMNER
1867-1938

SELECTED BIBLIOGRAPHY: *Oscar Bluemner in Retrospect*, introduction by the artist (Minneapolis: University Gallery, University of Minnesota, 1939) ▪ *Oscar Bluemner: American Colorist* (Cambridge, Massachusetts: Fogg Art Museum, Harvard University, 1967) ▪ *Oscar Bluemner, Paintings, Drawings* (New York: New York Cultural Center, 1969) ▪ Betsy Fahlman, "Oscar Bluemner (1867-1938), *Avant-Garde Painting and Sculpture in America*, edited by W.I. Homer (Wilmington: Delaware Art Museum, 1975), 34-35 ▪ Judith Zilczer, *Oscar Bluemner* (Washington, D.C.: Hirshhorn Museum and Sculpture Garden, Smithsonian Institution Press, 1979) ▪ Frank Gettings, "The Human Landscape: Subjective Symbolism in Oscar Bluemner's Painting," *Archives of American Art Journal* 19, no. 3 (1979): 8-14.

The son and grandson of architects, Oscar Bluemner augmented architectural studies in his native Germany with classes in painting. He was named a Royal Academician in architecture in 1892 and immigrated to the United States in 1893, hoping to secure a commission at the World's Columbian Exposition in Chicago. Failing at this, and unable to set up a successful architectural practice in that city, he went to New York. Here, too, he met with disappointment when his 1902 commission for the Bronx borough courthouse was stolen by his partner, who erected the building using Bluemner's specifications.

Bluemner turned away from architecture and went to Europe in 1912 to paint. Upon his return, he exhibited five landscape paintings in the Armory Show. In 1915 he held his first one-man exhibition in America at Alfred Stieglitz's 291 Gallery (New York); in 1916 he was included in the Forum exhibition. By the 1920s he was recognized as a member of the select coterie of advanced modern artists associated with Stieglitz.

Following the death of his wife in 1926, Bluemner moved his family to Braintree, Massachusetts, where he lived in relative isolation for the final 12 years of his life. Despite the fact that he had another one-man show at Stieglitz's Intimate Gallery in 1928, he grew increasingly embittered and depressed due to poor sales and the lack of public recognition for his work, and he committed suicide at the age of 71.

Color held a prominent place in Bluemner's artistic vocabulary throughout his career. He once described his belief in its emotional power: "Look at my work in a way as you listen to music—look at the space filled with colors and try to feel; do not insist on 'understanding' what seems strange. When you 'FEEL' colors, you will understand the 'WHY' of their forms. It is so simple" (*Oscar Bluemner in Retrospect*, unpaged). *P.N.*

Farm Scene, *c. 1915-1916*

Oil on gesso panel, 15 x 20 in.
(38.1 x 50.8 cm.)
Signed lower right: O BLUEMNER

Bluemner's early experimental paintings combined brilliant, symbolic color with prismatic cubist forms. Architectural motifs dominated his work then and later, as if he were making an almost

Gift of Dr. and Mrs. M.A. McCannel
54.33
Illustration: Figure 9

EXHIBITIONS: Tweed Gallery, University of Minnesota-Duluth, *A Survey of American Painting*, 1955 ▪ *Selections from the Permanent Collection*, 1968, 1969 ▪ Carleton College, Northfield, Minnesota, *American Art: 1900-1940*, 1977 ▪ Carleton College, Northfield, Minnesota, *American Abstraction: 20th Century American Paintings from the University of Minnesota*, 1983 ▪ Joseph and Margaret Muscarelle Museum of Art, College of William and Mary, Williamsburg, Virginia, *Into the Melting Pot*, 1984-85.

PROVENANCE: Dr. and Mrs. M.A. McCannel

literal attempt to translate the principles of his first profession to the two-dimensional canvas. While *Farm Scene* evidences his concern with pictorial three-dimensionality, it is also a study of the deceptive visual effects of snow. Few modernist painters explored winter motifs as extensively as Bluemner did in this painting. Dispensing with the grid effect he had been using until then, he created here a more literal rendering of the rural setting, made even more stark by the juxtaposition of pervasive white tones, cool blues, and vivid reds.

Farm Scene, *c. 1915-1916* ▪ *Figure 9*

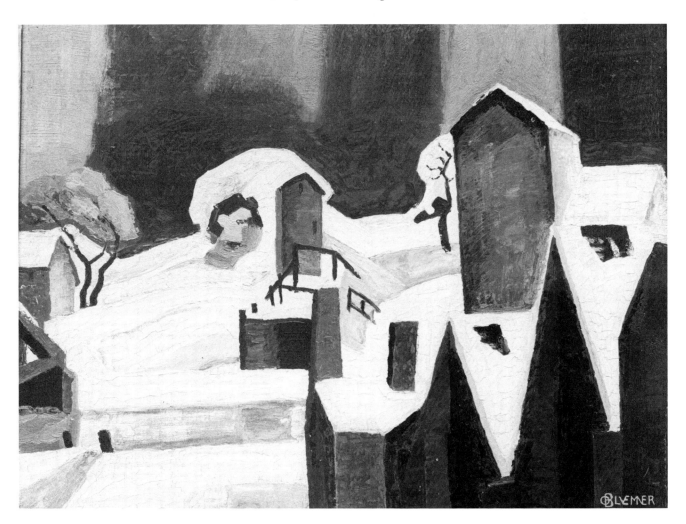

Solitude, *1927*

Oil on wood panel, 10½ x 14⅛ in.
(26.7 x 35.9 cm.)
Signed lower left: BLUEMNER; signed and
dated verso
Bequest of Hudson Walker from the Ione
and Hudson Walker Collection
78.21.824
Illustration: Figure 10

EXHIBITIONS: Intimate Gallery, New York,
*Twenty-eight New Paintings by Oscar
Bluemner*, 1928 • *100 Paintings, Drawings,
and Prints from the Ione and Hudson D.
Walker Collection*, 1965, cat. 5 • *Selections
from the Permanent Collection*, 1970 •
Hudson D. Walker: Patron and Friend,
1977, cat. 6 • *Selections from the
Permanent Collection*, 1980 • Minnesota
Museum of Art, St. Paul, *American Style:
Early Modernist Works in Minnesota
Collections*, 1981, cat. 8 • Joseph and
Margaret Muscarelle Museum of Art,
College of William and Mary,
Williamsburg, Virginia, *Into the Melting
Pot*, 1984-85.

PROVENANCE: The Intimate Gallery, New
York; The Downtown Gallery, New York;
Ione and Hudson Walker

After Bluemner's wife died in 1926, his paintings grew more somber as a reflection of his melancholic mood. The empty house—the focal point of this work—symbolizes his emotional emptiness and enforced solitude. The house can be seen as a metaphor for the human condition; left alone, it becomes dark, gloomy, and spiritually bereft. The disturbing colors and barren tree add to the sense of isolation. Although the painting exhibits a conscious ordering of space through the use of architecture, the iconography takes on greater significance here than in his earlier works.

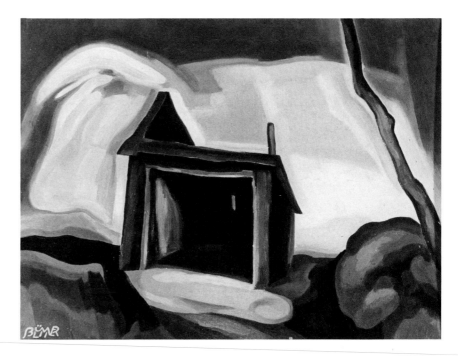

Solitude, *1927 • Figure 10*

FREDERIC WILLIAM BOCK

1876-death date unknown

SELECTED BIBLIOGRAPHY: Minneapolis
History Collection, Minneapolis Public
Library.

Frederic Bock was well known in Minnesota during his lifetime for his drawings of rabbits humorously symbolizing humankind and its foibles. Born in Manitowoc, Wisconsin, he moved to St. Paul in 1900, where he received training in drawing and painting from private instructors. He first worked as an illustrator for the *St. Paul Globe*, then left to study art at the National Academy of Design and the Art Students League in New York. After maintaining a studio there for several years, he returned to St. Paul to open a commercial art studio. It was around this time that he began privately illustrating human life changes and habits in the guise of sensitively drawn rabbits.

In 1926, Bock traveled and sketched throughout Europe. He enrolled in the WPA/FAP easel project in Minnesota in the 1930s and taught at Walker Art Center in 1938 after its renovation by the WPA. *M.T.S.*

Old Minneapolis River Front, *c. 1936*

Oil on canvas, 22 x 26 in.
(55 x 65 cm.)
Signed lower right: F.W. Bock
WPA Art Project, Minneapolis
43.771
Illustration: Appendix

PROVENANCE: WPA Art Project, Minneapolis

Project artists such as Bock, who worked on mural and easel compositions during the 1930s, often used carefully defined edges to separate forms into underlying geometric shapes. They then usually placed a realistic scene (of, for example, local landscape or history) over this compositional grid. The final painting resembled a localized version of a surrealistic scene by Giorgio de Chirico. Many of Bock's paintings depict scenes of rural Minnesota and his childhood in Wisconsin.

AARON BOHROD

1907-

SELECTED BIBLIOGRAPHY: Aaron Bohrod, *A Decade of Still Life* (Madison: University of Wisconsin Press, 1966) • *Master of Trompe L'Oeil* (New York: Danenberg and Roman Galleries, 1971) • Marlene Schiller, "Aaron Bohrod: The Definitive Still Life," *American Artist* (December 1975): 44-46, 71-74.

A native of Chicago, Aaron Bohrod attended Crane Technical College, where he studied mechanical and freehand drawing from 1925 to 1926. He continued his studies at the Art Institute of Chicago from 1927 to 1929 and at the Art Students League in New York from 1930 to 1932 under Boardman Robinson, John Sloan, and Kenneth Hayes Miller. Returning to Chicago, he tramped the city's streets and alleys, sketching, as Sloan had done in New York 25 years earlier; his wife, Ruth, supported them both on her teaching salary.

In the mid-1930s Bohrod received two successive Guggenheim fellowships. He used the first to make a sketching tour of the western states, and the second to repeat this experience in the East. In the late 1930s he also joined the WPA/FAP easel project. In the early 1940s he held the position of artist-in-residence at Southern Illinois University in Carbondale before being sent with the U.S. Engineers in a War Artists Unit to the Pacific front. He later worked as an artist for *Life* magazine with Patton's Third Army at the Battle of Normandy.

Following the death of John Steuart Curry in 1946, Bohrod succeeded him as artist-in-residence at the University of Wisconsin-Madison, for which he had been recommended by Grant Wood. He continued to paint scenes from his environment, and he designed pottery and textiles. In the summer of 1953 he was hired by North Michigan University-Marquette to teach a five-week summer session. Intrigued by the dramatic boulders on northern Michigan's Lake Superior shore, he began producing paintings which examined the pits, depressions, and subtle color nuances of this landscape; smaller rocks and pebbles were his models. He soon supplemented this motif with dolls, curios, and odd objects salvaged from junkyards, using them to make prearranged still-lifes. First he employed the *trompe-l'oeil* device of a frontal plane and a shallow pictorial space; later he painted all the elements in the same scale as the objects themselves.

Bohrod is a member of the National Academy of Design and the National Academy of Arts and Letters. *M.T.S.*

Steamboat—Illinois River, *c. 1941*

Oil on composition board, 24 x 30 in.
(61 x 76.2 cm.)
Signed lower right: Bohrod
WPA Art Project, Illinois
41.79
Illustration: Figure 11

REFERENCES: Letter from Aaron Bohrod to
Mark Kriss at the University Gallery, 9
November 1978 • Letter from Aaron
Bohrod to Susan Kendall at the University
Gallery, 14 July 1979.

EXHIBITIONS: *Original Paintings from the
University Collection*, 1946, cat. 10 • Drew
Fine Arts Center, Hamline University, St.
Paul, *Exhibition of Paintings by Some
American Individualists*, 1950 • *Selections
from the Collection*, 1954 • Tweed Hall,
University of Minnesota-Duluth, *Exhibition*,
1957 • *The American Scene: Urban and
Rural Regionalists of the '30s and '40s*,
1976, cat. 33 • *Ruth Lawrence
Remembered*, 1978 • *Selections from the
Permanent Collection*, 1980.

PROVENANCE: WPA Art Project, Illinois

Bohrod completed this painting under the WPA/FAP easel project, which he credited with keeping "a whole generation of artists alive physically and aesthetically" (Bohrod to Kriss, 9 November 1978). The landscapes he produced during this period had picturesque appeal with flickering highlights applied to the canvas in a Vlaminck-like style.

About the year of execution, Bohrod wrote, "[The] subject leads me to believe...that it was probably done in 1940 or 1941 at a time when I had illustrated a book in the *Rivers of America* series...by James Gray...and one of the illustrations (on the end papers) contains this same river boat in another context" (Bohrod to Kendall, 14 July 1979).

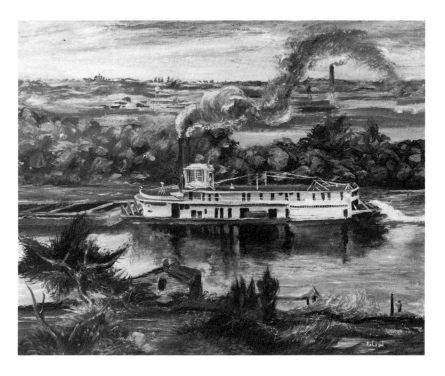

Steamboat—Illinois River, *c. 1941* • *Figure 11*

ILYA BOLOTOWSKY
1907-1981

SELECTED BIBLIOGRAPHY: Ilya Bolotowsky, "On Neoplasticism and my own work: a memoir," *Leonardo* (July-August 1969): 221-230 • Adelyn D. Breeskin, *Ilya Bolotowsky* (New York: Solomon R. Guggenheim Museum, 1974) • Susan Carol Larsen, "Going Abstract in the '30s," *Art in America* (September 1976): 70-79 • Greta Berman, *The Lost Years: Mural Painting in New York City Under the WPA Federal Art Project, 1935-1943* (New York: Garland Publishing, 1978), *passim* • Paul Cummings, *Dictionary of Contemporary American Artists*, 4th edition (New York: St. Martin's Press, 1982), 113-114 • Ilya Bolotowsky, "Adventures with Bolotowsky," *Archives of American Art Journal* 22, no. 1 (1982): 8-29.

As a child in St. Petersburg (now Leningrad), Russia, Ilya Bolotowsky was given his first art instruction by his mother, a painter. Around 1921 the family moved to Constantinople (now Istanbul), where Bolotowsky attended the Collège St. Joseph; in 1923 they immigrated to the United States and settled in New York City. Bolotowsky attended the National Academy of Design from 1924 to 1930 and studied with Ivan Olinsky, one of its more liberal teachers. In 1931 he traveled to France, Italy, Germany, and Denmark. The paintings from this period show that he was experimenting with expressionism.

Bolotowsky credited his abrupt move to pure abstraction to the influence of Piet Mondrian, Joan Miro, and Kasimir Malevich, whose works he saw in New York in the early 1930s. His association with the Federal art programs began in 1934, when he was hired as a PWAP teacher. When the WPA Art Project replaced the PWAP in 1935, Bolotowsky continued teaching until he was transferred to the Mural Division directed by Burgoyne Diller, a fellow abstract artist. In 1936 Bolotowsky designed and executed one of the first abstract murals in the country for the Williamsburg Housing Project in Brooklyn, New York. He completed two more murals for the WPA/FAP: one for the 1939-40 New York World's Fair, and another for the Hospital for Chronic Diseases, Welfare Island, New York.

He and other abstract artists such as Carl HOLTY, Byron BROWNE, and Josef Albers began meeting in 1936 and formed the American Abstract Artists group to exhibit their works and foster appreciation for this new direction in painting and sculpture. By late 1934 Bolotowsky was painting pure abstractions—works devoid of nature-derived imagery that incorporated suprematist, biomorphic, and neoplastic forms. By the early 1940s, however, he had moved toward a more personal style that was closely allied to Mondrian's neoplasticism but included tints and shades of colors. His later paintings took the forms of diamonds, tondos, ellipses, or elongated rectangles; in the 1960s he constructed columns and prisms that used the linear structures and colors of his paintings.

In addition to being a painter and a sculptor, Bolotowsky was a filmmaker, playwright, author, and translator. His career included numerous one-man exhibitions, three retrospectives, and teaching

positions at several colleges and universities, among them Black Mountain College and Southhampton College of Long Island University. *C.P.H.*

Study for Mural for the 1939-40 New York World's Fair, Hall of Medicine and Public Health, *1938*

Oil on gesso on masonite, 15⅛ x 27 in. (38.4 x 68.6 cm.)
Signed lower right: Ilya Bolotowsky 1938
Purchase, Nordfeldt Fund for Acquisition of Works of Art; Ione and Hudson Walker Fund (by exchange); and Gift of Funds from John E. Larkin, Jr.
82.6
Illustration: Colorplate XIX

EXHIBITIONS: Washburn Gallery, New York, *Ilya Bolotowsky, Paintings from 1935 to 1945*, 1980 • Zabriskie Gallery, New York, *Abstract and Constructivist Works*, 1981 • *Abstract USA/1910-1950*, 1981 • *The First Fifty Years 1934-1984: American Paintings and Sculpture from the University Art Museum Collection*, 1984 • *The First Fifty Years, 1934-1984: Recent Acquisitions and Promised Gifts to the University Art Museum*, 1984.

PROVENANCE: Stephan Lion; Washburn Gallery, New York

Bolotowsky's design elegantly disperses simple, linear, geometric, and biomorphic forms onto a shallow picture plane. Painted in 1938, when the artist was still strongly influenced by Miro and Kasimir Malevich, this sketch is one of five known studies for the mural, which in itself was one of four abstract murals created for the Fair. It was most likely the final version completed before the proportions of the mural were changed—from 10' x 22' to 10' x 16'—just before the fair was to open.

Other studies for this mural are in the Metropolitan Museum of Art and the Art Institute of Chicago. While the Chicago study incorporates the revised proportions of the mural, it is quite similar in color tonalities to the Art Museum's painting, which reinforces the latter's position in the development of the studies. Two additional sketches for the mural are in the estate of the artist.

Here Bolotowsky combined pure primary colors and scattered shapes to achieve a highly energetic painting. The shallow spatial depth, consciously produced, stands in contrast to the artist's subsequent single-plane surfaces. This depth is enhanced by the bold contrast between the brilliant blue, red, yellow, green, black, and white forms, the warm gray center rectangle, and the cooler, more distant gray background. The mural was installed on an overhead transom in the Hall of Medicine and Public Health at the Fair, and it appears that the combination of bright colors against a neutral background was chosen to increase the painting's carrying power to viewers below.

In the Art Museum's study, the elongated rectangle serves perfectly as a ground for the dispersed forms; in the Chicago sketch and in the mural itself, the six-foot reduction in width caused a crowding of the elements. The original mural was lost or destroyed. In 1980 Bolotowsky recreated a full-scale version of it, which is now installed in the Houston International Airport. *C.P.H.*

45

CAMERON BOOTH
1892-1980

SELECTED BIBLIOGRAPHY: F.A. Whiting, Jr., "Cameron Booth," *American Magazine of Art* (February 1938): 67-69 ▪ H.H. Arnason, *Cameron Booth* (Minneapolis: Minneapolis Institute of Arts, 1958) ▪ H.H. Arnason, *Cameron Booth* (New York: Thistle Press for the American Federation of Arts, 1961) ▪ H.H. Arnason, *Cameron Booth* (New York: The American Federation of Arts, 1961) ▪ Nina Marchetti Archabal, "In Memoriam: Cameron Booth, 1892-1980, A Chronicle from His Scrapbooks," *Minnesota History* (Fall 1980): 100-110.

Most artists educated in Minnesota over the past 50 years point to Cameron Booth as their visual mentor. He firmly established his relationship with Minnesota artists by teaching—at the Minneapolis School of Art (now the Minneapolis College of Art and Design), the University of Minnesota, and the St. Paul School of Art, which he later directed.

Booth was born in Erie, Pennsylvania, the son of a Presbyterian minister who served parishes in Canada, New York, Iowa, and North Dakota before finally settling in Moorhead, Minnesota. From 1912 to 1917 Booth studied at the Art Institute of Chicago under H.M. Walcott, who encouraged his interest in the works of Cézanne, the Italian primitives, and cubism. After serving in World War I, he stayed on in France to work with the Red Cross and study under a traveling fellowship from the Art Institute of Chicago. Visits to major museums to view the works of Cézanne (and other modern painters); meetings with Georges Rouault, Fernand Léger, and Kees Von Dongen; and lengthy discussions on cubism with the Mexican painter Angelo Zarraga only strengthened his commitment to well-structured compositions in his own paintings.

In 1919 Booth returned to the States to paint in Provincetown, Massachusetts. He subsequently worked as a designer for an outdoor advertising company in Ohio until he was offered a position at the Minneapolis School of Art, where he taught from 1921 to 1929. During these years he sketched and painted constantly, basing his realistic depictions of rural life and Indian reservations on the geometrical compositions of early Renaissance masters as well as Cézanne and the cubists.

In 1927 he went to Europe to study painting, first with André L'Hôte in Paris and then with Hans Hofmann on the Italian island of Capri. Afterward his forms, composition, and color were simpler and, at the same time, more carefully structured. From 1929 to 1942 Booth headed the Art School of the small but innovative St. Paul Gallery. Still drawing and painting, always attempting to modify his shapes within geometrically conceived compositions, Booth focused on scenes from the suburban countryside.

In 1942 he received a Guggenheim grant to travel and paint in the American West; he exhibited the works completed during this time at the Mortimer Brandt Gallery (New York) in 1943. When the critics labeled him a regionalist, he began placing more emphasis on the geometric structure underlying his compositions. While teaching at the Art Students League from 1944 to 1948 and at Queens College from 1946 to 1947, he started working with black lines against textured rectangles of color. The figure was still apparent, but now it was an abstract form which acted as a directional thrust.

By 1953 Booth was painting geometric color forms which had their basis in landscape shapes. His paintings from the mid-1950s were also based on horizontal landscapes, but by the end of the decade his works were more suggestive of moods than scenes. At around this time he switched to acrylic polymer and to painting directly on the canvas; the action of the brush became a subject in itself. Paintings and sketches from the mid-1940s through the early 1960s were shown almost annually in one-man exhibitions at the Bertha Schaefer Gallery (New York).

In the mid-1960s Booth returned to painting more realistic subjects, once again balancing geometrical building and landscape forms in a well-ordered canvas. Competently painted horses, probably a link with his childhood, were usually included in these compositions. *P.N.*

William Watts Folwell, *1925*

Oil on canvas, 40 x 32 in.
(101.6 x 81.3 cm.)
Signed upper right: Cameron Booth 1925
Gift of the artist
41.80
Illustration: Appendix

EXHIBITION: *Cameron Booth*, 1950-51, cat. 2.

PROVENANCE: the artist

William Watts Folwell was the first president of the University of Minnesota. He sat for this portrait at the age of 92, four years before his death. The portrait commemorates his receiving the University's first honorary degree and also coincided with his election to president emeritus. Booth represented the august man in a traditional formal pose, holding a book representative of his role as a scholar. *(For more detailed biographical information on Folwell, see Emily Dana MCMILLAN, "William Watts Folwell.")* *P.N.*

Julia Anna Norris, *1942*

Oil on canvas, 28½ x 17½ in.
(59.7 x 44.5 cm.)
Signed lower right: 42
Gift of Alumnae, Staff, and Friends of Dr.
Norris
43.737
Illustration: Appendix

PROVENANCE: commissioned from the artist

Born in Massachusetts, Julia Anna Norris graduated from the Boston Normal School of Gymnastics in 1895; five years later she received her M.D. degree from the Women's Medical School at Northwestern University. She directed physical education programs in New York, Massachusetts, and Illinois before coming to the University of Minnesota in 1912, where she headed the University's Health and Physical Education Department at the Minneapolis campus until her retirement in 1941. *P.N.*

Still Life: Flowers, *c. 1940-1945*

Oil on composition board, 24 x 18 in.
(61 x 45.7 cm.)
Signed lower left: Cameron Booth
Bequest of Hudson Walker from the Ione
and Hudson Walker Collection
78.21.231
Illustration: Appendix

EXHIBITION: *Hudson D. Walker: Patron and Friend*, 1977, cat. 7.

PROVENANCE: Ione and Hudson Walker

Although the precise year in which this work was completed is not known, it dates stylistically from the early 1940s, when Booth taught at the Art Students League in New York. It is similar to other still lifes and room interiors that he painted during this period and shows his increasing interest in an abstract compositional basis. *M.T.S.*

Pirot *(The Clown), c. 1945*

Oil on Upson board, 13½ x 17¼ in.
(34.3 x 43.8 cm.)
Unsigned
Gift of Abby Grey
79.11.2
Not illustrated

PROVENANCE: the artist; Ben and Abby
Grey

In the mid-1940s, Booth drew countless clown figures. They may be interpreted as symbols of protest against his own past work and painting in New York at the time. *M.T.S.*

Vespers, *1952*

Oil on canvas, 30 x 40 in.
(76.2 x 101.6 cm.)
Signed lower middle left: B
Gift of the artist
79.19.4
Illustration: Appendix

PROVENANCE: the artist

Although painted at a time when Booth was focusing on geometric color forms, *Vespers* nevertheless contains a figural remnant. The abstract image is defined by black lines balanced against irregular rectangles of color scumbled over grays, a configuration typically found in the artist's work from 1946 to 1952. After tying areas of color together with black lines, Booth added upswept colored lines that led the forms with them. *M.T.S.*

Everett Fraser, *1953*

Tempera and oil on canvas, 52 x 46 in.
(132.1 x 116.8 cm.)
Signed upper right: Cameron Booth 1953
Gift of the Law School Council
57.1
Illustration: Appendix

PROVENANCE: the artist

A native of Canada and graduate of Harvard University, Everett Fraser (1879-1971) came to the University of Minnesota in 1917. He was promoted to Dean of the Law School three years later and held that post until 1948. Fraser became a leading scholar in property law and guided the University of Minnesota Law School as it grew to be the fifth largest in the United States. He also developed a law course that became a national model. In 1951, the University awarded him an honorary Doctor of Law degree. Booth emphasized the dean's scholarly role by posing him at his desk, pencil poised as if about to write. The bookshelves behind him allude to his academic status, while the African violet on his desk suggests the humanity and love of nature that endeared him to his students. *P.N.*

Silver Black Configuration, *1954*

Oil on linen, 26 x 19 in.
(66 x 48.3 cm.)
Signed lower left: Cameron Booth 1954
Gift of the artist
66.7.1
Illustration: Appendix

PROVENANCE: the artist

After 1953 the figure disappeared completely from Booth's paintings. In its place were brushed lines and rectangles of color, possibly inspired by the artist's landscape compositions from the 1930s which, although realistic, had been organized in such a way that the colored areas functioned as abstract shapes on a two-dimensional surface. Here the forms are loosely brushed so that the edges are ragged; the composition appears to have just come together while still hinting at landscape forms. *M.T.S.*

June Day, *1955*

Oil on linen, 20 x 24½ in.
(50.8 x 62.2 cm.)
Signed lower right: CB 55
Gift of the artist
66.7.2
Illustration: Appendix

EXHIBITIONS: *Selections from the Permanent Collection,* 1975 ▪ *The First Fifty Years 1934-1984: American Paintings and Sculpture from the University Art Museum Collection,* 1984.

PROVENANCE: the artist

Oil on canvas, 36 x 48 in.
(91.4 x 121.9 cm.)
Signed lower right: C.B. 57
Gift of the artist
79.19.1
Illustration: Appendix

EXHIBITION: *Twelve Faculty Members*, 1958.

PROVENANCE: the artist

Beyond, *1957*

Oil on canvas, 48 x 36 in.
(121.9 x 91.4 cm.)
Signed lower right: CB 57
Gift of the artist
79.19.2
Illustration: Appendix

EXHIBITIONS: *Twelve Faculty Members*,
1958 ▪ *Art and the University of Minnesota*,
1961 ▪ *Selections from the Permanent
Collection*, 1962.

PROVENANCE: the artist

Fourth of July, *1957*

Oil on canvas, 60¼ x 72½ in.
(153 x 183.5 cm.)
Signed lower center: CB 1957-1961
Gift of the artist
66.7.3
Illustration: Colorplate XXV

EXHIBITIONS: *Selections from the Permanent
Collection*, 1968, 1969, 1970.

PROVENANCE: the artist

Halloween, *1957-1961*

Painted over a period of four years, *Halloween* demonstrates
Booth's mature abstract style while revealing a continuity with his
earlier landscape paintings of the 1930s. Overtly abstract in form—
the heavily charged brush is spread across the canvas in thick
rectangles and squares of paint—this work manages to evoke a
feeling of autumn through the use of highly keyed oranges, reds,
and browns. *R.L.G.*

Oil on canvas, 26½ x 33½ in.
(66.7 x 85.1 cm.)
Signed lower right: CB 57
Gift of the artist
79.19.3
Illustration: Appendix

EXHIBITION: *Twelve Faculty Members*, 1958.

PROVENANCE: the artist

Red and Green, *1957*

Oil on canvas, 30¼ x 38 in.
(76.8 x 96.5 cm.)
Signed lower center: CB 57
Gift of the artist
79.19.5
Illustration: Appendix

EXHIBITION: *Twelve Faculty Members,* 1958.

PROVENANCE: the artist

Acrylic on linen, 72 x 72 in.
(182.9 x 182.9 cm.)
Signed lower center and left center edges:
CB 58
Gift of the artist
66.7.4
Illustration: Appendix

PROVENANCE: the artist

Oil on linen, 48 x 60 in.
(121.9 x 152.4 cm.)
Signed lower left: CB 1959
Gift of the artist
66.7.5
Illustration: Figure 12

EXHIBITION: The American Federation of
Arts Traveling Exhibition, New York,
Cameron Booth, 1961, cat. 34.

PROVENANCE: the artist

Yellow and White, *1957*

Mid-Summer, *1958*

Although Booth's increasing use of acrylics enabled him to forgo preparatory sketches, his forms were still rectangular and held together in a tightly planned and centralized structure. He carefully considered the logical placement of all shapes in the composition. A critic of the time described his work as "action painting as seen through the classicism of the early Hofmann and tempered by the sumptuousness of Bonnard" ("Reviews," *Art News,* April 1958, p. 48). *M.T.S.*

Marin County, *1959*

Marin County, *1959* ▪ *Figure 12*

51

Oil over acrylic on linen, 48 x 59¾ in.
(121.9 x 151.8 cm.)
Signed lower right: CB 1960
Gift of the artist
66.7.6
Illustration: Appendix

EXHIBITION: *Selections from the Permanent Collection*, 1980.

PROVENANCE: the artist

Mauve, *1960*

James Lewis Morrill, *1960*

Oil on canvas, 49½ x 39½ in.
(125.7 x 100.3 cm.)
Signed lower right: B 1960
Purchase
63.1
Not Illustrated

PROVENANCE: the artist

James Lewis Morrill received his B.A. from Ohio State University in 1913 and worked for several years on a Cleveland newspaper before switching to an academic career. He was appointed junior dean of Ohio State University in 1928 and vice president in 1932; he came to Minnesota in 1945 to succeed Walter Coffey as president of the University. He was awarded seven honorary degrees over his lifetime. Morrill sat for Booth at the age of 72, holding papers attesting to his administrative endeavors. *P.N.*

Booth's compositions remained abstract throughout the early 1960s. He seemed to delight in calm, lyrical works. Most of these paintings were done in a great spurt of creative activity that both preceded and resulted from his well-received retrospective touring exhibition sponsored by the American Federation of Arts in 1961. Reviewers were not as favorable three years later, after his last New York show at the Howard Wise Gallery; they felt then that his brushstrokes were becoming facile and his compositions repetitive. *M.T.S.*

Acrylic on Upson board, 24 x 36 in.
(61 x 91.4 cm.)
Signed lower right: CB 60
Gift of the artist
66.7.7
Illustration: Appendix

PROVENANCE: the artist

Untitled *(No. 9), 1960*

Acrylic on linen, 24 x 32 in.
(61 x 81.3 cm.)
Signed lower left: CB 61
Gift of the artist
66.7.8
Illustration: Appendix

PROVENANCE: the artist

Black and Green, *1961*

Acrylic on canvas, 48½ x 60 in.
(123.2 x 152.4 cm.)
Signed lower center: CB
Gift of the artist
66.7.9
Illustration: Appendix

EXHIBITION: Minneapolis, Lutheran
Brotherhood Insurance, *Paintings by
Cameron Booth*, 1983.

PROVENANCE: the artist

Red with Embellishment, *1958, 1960-61*

Winter, *1961*

Acrylic on canvas, 45⅛ x 72⅛ in.
(114.6 x 183.2 cm.)
Signed lower right: CB 61
Gift of the artist
66.7.10
Illustration: Figure 13

PROVENANCE: the artist

Winter, *1961* ▪ *Figure 13*

Acrylic on linen, 72 x 72 in.
(182.9 x 182.9 cm.)
Signed lower left: CB
Gift of the artist
66.7.11
Illustration: Appendix

EXHIBITION: New York, Howard Wise
Gallery, 1964.

PROVENANCE: the artist

Red and Blue, *1961-62*

Dairy Herd, *1959, 1966*

Oil on canvas, 36 x 72 in.
(91.4 x 182.9 cm.)
Signed lower right: CB 1966
Gift of John E. Larkin, Jr.
79.9.2
Illustration: Appendix

PROVENANCE: the artist; John E. Larkin, Jr.

In the mid-1960s, Booth returned to painting realistically. While this return to figurative subjects may seem at first imitative of his western landscapes from the late 1930s and early 1940s, these later works were infused with more complexly handled color forms and a facile brushing-on of paint. Booth's compositions continued to be planned out abstractly, but houses, roads, fields, horses, and barns were the primary subject matter. *M.T.S.*

White Sox, *1974*

Oil on canvas, 32 x 36 in.
(81.3 x 91.4 cm.)
Signed lower right: CB 74
Gift of John E. Larkin, Jr.
76.20.4
Illustration: Appendix

PROVENANCE: the artist; John E. Larkin, Jr.

Spring *(After Rain), 1975*

Acrylic on canvas, 30 x 40 in.
(76.2 x 101.6 cm.)
Signed lower right: CB 1975
Gift of the artist in memory of Ruth Lawrence
78.4
Illustration: Appendix

EXHIBITION: *Selected Gifts and Acquisitions*, 1979

PROVENANCE: the artist

JESSIE ARMS BOTKE
1883-1971

SELECTED BIBLIOGRAPHY: "Art in Chicago," *American Magazine of Art* (March 1918): 207 • "Jessie Arms Botke, A Painting Career That Has Revolved Around Peacocks," *American Artist* (June 1949): 27-30 • Nancy Dustin Wall Moure, *Painting and Sculpture in Los Angeles, 1900-1945* (Los Angeles: Los Angeles County Museum of Art, 1980), 69-70.

Born in Chicago, Jessie Arms Botke attended the School of the Art Institute of Chicago. She then moved to New York where she studied under John C. Johansen, Charles Woodbury, and Albert Herter and painted in the studio of Herter Looms. It was while working there that she was commissioned to paint mural panels for actress Billie Burke's house at Hastings-on-Hudson.

Burke specified that she wanted blue-and-white peacocks in the mural, so Botke went to the Bronx Zoo to sketch. She devoted the rest of her career to painting decorative pictures of birds. She had her own aviary and also sketched in zoos in New York, Chicago, San Francisco, San Diego, Paris, and Amsterdam.

Although she worked primarily in oils over an egg tempera base, Botke turned to watercolors in the 1940s to keep her technique fresh and her work based directly on the object. She received several prizes in exhibitions at the Art Institute of Chicago and won numerous awards in Califoria exhibitions. She and her husband, the painter and printmaker Cornelius Botke, shared studios and mural commissions throughout their careers. *M.T.S.*

White Peacock on Fountain, *c. 1925*

Oil on masonite, 39⅜ x 31⅞ in. (100 x 81 cm.)
Signed lower right: Jessie Arms Botke
Gift of Louis W. Hill, Jr.
56.5
Illustration: Appendix

PROVENANCE: Louis W. Hill, Jr.

Botke's specialty was white peacocks, usually painted as a pair against a background of carefully studied but stylized trees, plants, or flowers. Preferring to work on a hard surface, she painted on gessoed masonite panels underpainted with tempera. The underpainting was done in cool tones when the final oil layer was in predominantly warm hues, and in warm colors when the final painting contained mainly cool colors.

ALVAH BRADISH
1806-1901

SELECTED BIBLIOGRAPHY: George C. Groce and David H. Wallace, *The New York Historical Society's Dictionary of Artists in America, 1564-1860* (New Haven: Yale University Press, 1966), p. 75.

Alvah Bradish was born in Sherburne, New York and worked in Rochester, New York from 1837 to 1847. During this period he made several trips west, stopping in the city of St. Paul in 1858 and again in 1876, when he is known to have painted the portraits of Governor Cushman K. Davis and Episcopal Bishop Henry B. Whipple. He exhibited at the National Academy (New York) in 1846-1847 and 1851.

Bradish moved to Detroit in the early 1850s and was a professor of art at the University of Michigan from 1852 to 1863. The author of several literary works as well, he was for many years one of Detroit's most successful portrait painters. *R.N.C.*

Edward D. Neill, *1870*

Oil on canvas, 27 x 22 in.
(68.6 x 55.9 cm.)
Signed lower left: A Bradish—artist—1870
Anonymous gift
51.49
Illustration: Appendix

PROVENANCE: University of Minnesota
Archives

Perhaps the most colorful personality ever to serve on the University of Minnesota Board of Regents, Rev. Edward D. Neill was appointed the University's first chancellor in 1858.

He was born in Philadelphia in 1823, graduated from Amherst College in 1842, and then studied theology before coming to St. Paul in 1849 as a Presbyterian minister. In addition to his ministerial duties and his activities as University chancellor, he was the first territorial superintendent of public education, the second secretary of the Minnesota Historical Society, a founder of Macalester College in St. Paul, chaplain of the First Minnesota Infantry during the Civil War, and author of the first history of Minnesota.

Neill's devotion to the University did not prevent him from resigning at least once because "the extreme poverty of the University made it impossible for him to be supplied with sufficient stamps and paper to conduct its business" (James Gray, *History of the University of Minnesota 1851-1951* [Minneapolis: University of Minnesota Press, 1951], p. 23). He subsequently thought better of his impetuous action, withdrew his resignation, and, according to a contemporary observer, "indulged in wild, prophetic visions of the University's rejuvenation" (Gray, p. 23). It was through Neill's persistence that the United States Congress eventually granted the University of Minnesota two additional townships of land.

In this quarter-length portrait, Bradish represented Neill as a man of both substance and humor. The painting is typical of the artist's forthright and unpretentious style.

SAMUEL BRECHER
1897-1982

SELECTED BIBLIOGRAPHY: Margaret Breuning, "Samuel Brecher," *Art Digest* (15 February 1944): 11.

Born in Borgslaw, Austria, Samuel Brecher immigrated to the United States to study art at Cooper Union and the National Academy of Design in New York. He also studied with Charles W. HAWTHORNE at his Cape Cod School of Art in Provincetown. Unlike Hawthorne, who concentrated on portraits and figures, Brecher's main interest was painting land and coastal views along the eastern seaboard.

Although dark hues dominated his palette throughout the 1930s, bright spots of color do show through the heavily applied, grayed areas of paint. After the mid-1940s Brecher enlivened his colors with more saturated hues, but he continued to paint scenes of the Provincetown and Maine seacoast in heavy impasto.

Brecher exhibited with various New York galleries, including the ACA Gallery, the Hudson D. Walker Gallery, and the Kraushaar Gallery in the 1940s and the Babcock Gallery and the Merrill Gallery into the 1960s. He taught painting at the Newark School of Fine and Industrial Arts from 1946 to 1974. *M.T.S.*

Figure Study No. 1, *1939*

Oil on canvas, 16 x 11 in.
(40.6 x 27.9 cm.)
Signed lower right: S. Brecher; dated on stretcher
Bequest of Hudson Walker from the Ione and Hudson Walker Collection
78.21.106
Illustration: Appendix

PROVENANCE: Ione and Hudson Walker

Brecher was noted more for his landscapes and still-life canvases than for figure studies such as this one, which contemporary critics felt lacked the intensity of his portrayals of coastal towns. The monochromatic tonality of *Figure Study No. 1* is similar to other works he painted during this period.

Backyards, *c. 1945*

Oil on canvas, 13⅛ x 16⅛ in.
(33.3 x 41.0 cm.)
Signed lower right: S. Brecher
Bequest of Hudson Walker from the Ione and Hudson Walker Collection
78.21.825
Illustration: Appendix

PROVENANCE: Ione and Hudson Walker

Buildings simplified to cubic shapes typified Brecher's depictions of East Coast villages throughout the 1940s and 1950s.

Carnival *(Clown), c. 1950*

Oil on canvas, 15⅞ x 8 in.
(40.3 x 20.3 cm.)
Signed lower left: S. Brecher
Bequest of Hudson Walker from the Ione and Hudson Walker Collection
78.21.826
Illustration: Appendix

PROVENANCE: Ione and Hudson Walker

While this clown is pictured more abstractly than most of Brecher's other characterizations of circus people, the heavy application of the pigment is certainly representative of his impasto technique.

Hudson D. Walker, *1949*

Oil on canvas, 29⅞ x 25 in.
(75.9 x 63.5 cm.)
Signed lower right: S. Brecher
Gift of Ione Walker
79.7.1
Illustration: Appendix

PROVENANCE: Ione and Hudson Walker

Brecher's portrait of Hudson D. Walker, first curator of the University of Minnesota Art Museum and generous benefactor, shows Walker in a relaxed posture casually smoking a cigarette. This informal portrait reveals the cordial relationship the two men shared, both personally and professionally. Brecher frequently exhibited at Walker's New York gallery. *R.L.G.*

HUGH HENRY BRECKENRIDGE
1870-1937

SELECTED BIBLIOGRAPHY: Margaret Vogel, *The Paintings of Hugh H. Breckenridge (1870-1937)* (Dallas: Valley House Gallery, 1967) • Richard J. Boyle, *Pennsylvania Academy Moderns* (Washington: National Collection of Fine Arts, 1975) • Gerald L. Carr, "Hugh Henry Breckenridge: A Philadelphia Modern," *American Art Review* (May 1978): 92-99, 119-122.

A native of Leesburg, Virginia, Hugh Henry Breckenridge entered the Pennsylvania Academy of Fine Arts in Philadelphia in 1887, won its major prize for study abroad in 1892, and returned to teach there from 1894 until his death. While in Paris he studied with William Adolphe Bouguereau, Gabriel Ferrier, and Lucien Doucet, but his personal notes of his stay in Europe reveal an enthusiastic interest in burgeoning modern movements and styles. His own style moved through realism to a period influenced by French impressionism to his final abstract painting. Color was always an emotional factor in his work and his primary means of expression.

In addition to teaching at the Academy, Breckenridge cofounded (with Thomas Anschutz) the Darby Summer School of Painting outside Philadelphia in 1900. In 1919 he established the Breckenridge School of Art in Gloucester, Massachusetts and was appointed Director of Fine Arts at the Maryland Institute in Baltimore. Much respected for his knowledge, taste, and unprejudiced attitude toward varied artistic styles, he was often selected to serve on art committees and exhibition juries. He remained popular in Philadelphia despite his adherence to modernistic painting techniques. In 1934 the Pennsylvania Academy honored his 40 years there with a major retrospective. *P.N.*

Woods, *c. 1902-1910*

Oil on canvas, 20 x 26⅛ in.
(50.8 x 66.4 cm.)
Signed lower right: Hugh H. Breckenridge
Gift of John E. Larkin, Jr.
76.20.3
Illustration: Figure 14

PROVENANCE: John Castano; John E. Larkin, Jr.

The resonant color of the forest glade in *Woods* indicates that it was probably painted during the first decade of the twentieth century, when Breckenridge intensified his palette. Although the techniques of impressionism are reflected in the small, dash-like strokes of paint and the flickering patterns of light, the emphasis on the confined natural setting also suggests a debt to the Barbizon school.

Breckenridge knew color theory and studied the writings of Michael Eugéne Chevreul and Ogden Rood. He believed that innovation was essential to art, and this is evident in his lively palette and the active

surface of the composition. Writing on the stretcher identifies the artist's address at the time as Fort Washington, Pennsylvania, and it is likely that the woodland setting shown here was in the vicinity of "Phloxdale," his year-round home and studio and the site of the Darby Summer School after 1902.

A painting by Breckenridge titled *Woods* was exhibited at the Worcester Art Museum (Worcester, Massachusetts) in December of 1907 and may be the same work now in the University Art Museum collection. Unfortunately, the exhibition catalogue lists only the painting's title and none of its specifics.

Woods, *c. 1902-1910* ▪ *Figure 14*

RAYMOND BREININ
1910-

SELECTED BIBLIOGRAPHY: Dorothy C. Miller, *Americans 1942: 18 Artists From 9 States* (New York: Museum of Modern Art, 1942), 24-29 • "Breinin: Practical Dreamer," in "Art News Who's Who," *Art News* 41, no. 17 (January 15-31 1943): 12 • Emily Genauer, *Best of Art* (New York: Doubleday and Company, Inc., 1948), 88-90 • John I.H. Baur, *Revolution and Tradition in Modern American Art* (Cambridge, Massachusetts: Harvard University Press, 1951), 113, 133.

The mysterious imagery of Marc Chagall and Raymond Breinin grew out of common roots; as young artists, both studied with Uri Penn in Vitebsk, Russia. Born in Vitebsk, Breinin often recalled the exotic scenes of his homeland in enigmatic landscapes painted long after he had left Russia.

His family immigrated to the United States in 1922 and settled in Chicago, where Breinin worked as a poster painter for movie theaters and as a printer in a commercial lithography shop. He attended classes at the Art Institute of Chicago and the Chicago Academy of Art. The WPA afforded him the opportunity to paint full-time, and he began with a 70-foot mural for a high school in Winnetka, Illinois. In 1936 Edith Gregor Halpert discovered his work among 5,000 paintings being judged for a WPA exhibition in Washington, D.C. and gave him his first one-man show at the Downtown Gallery (New York) in 1939. His works were characterized by a surrealistic, brooding quality. Throughout the late 1940s and early 1950s he continued to make his city scenes into places where moonlit visions, winged horses, and Oriental steeples could exist alongside apartment buildings and subways.

Breinin has taught at Southern Illinois University, the University of Minnesota, the Breinin School of Art in Chicago, and the Art Students League and the National Academy of Design in New York. He also created costumes and settings for a production of the ballet, *Undertow*. M.T.S.

The Speaker, *1940*

Oil on canvas, 40 x 30 in.
(101.6 x 76.2 cm.)
Signed lower left: Breinin—40
WPA Art Project, Washington, D.C.
43.732
Illustration: Appendix

EXHIBITIONS: *Original Paintings from the University Collection*, 1946, cat. 18 • Drew Fine Arts Center, Hamline University, St. Paul, *Exhibition*, 1952.

John I.H. Baur has commented that Breinin combined the folk fantasy of Chagall with the distended figures of El Greco, an observation which can be applied to this work (Baur, pp. 113, 133). The dramatic lighting is typical of Breinin's paintings from between 1935 and 1950, and probably stems from his interest in theatrical design. Of a portrait similar to this one, the artist wrote, "It is to some degree because our art today has become too intellectual for my pleasure. We have drifted away from the element of warmth that at one time existed between the artist and the subject he chose

PROVENANCE: WPA Art Project,
Washington, D.C.

to paint. I draw very little inspiration from the cold, calculated
'isms' of today. I am thinking in terms of portraiture because one
cannot generalize the physiognomy of individuals, and I don't know
that the world has ever found a more intriguing subject than the
face of man" (Genauer, p. 88).

THÉODORE BRENSON
1893-1959

SELECTED BIBLIOGRAPHY: Théodore Brenson,
"Abstract Art and Christianity," *Liturgical
Arts* (May 1954): 77 • *Light Into Color,
Light Into Space* (Douglas College Art
Gallery, Rutgers State University, New
Brunswick, New Jersey, 1959) • "Théodore
Brenson," *College Art Journal*
(Fall 1959): 74.

Born in Riga, Latvia, Théodore Brenson attended the Fine Arts
Academy in Leningrad (then St. Petersburg), the University of Riga
(where he studied architectural design), and the University of
Moscow. He emigrated to Paris as a young man and then moved to
the United States in 1941, bringing with him portrait etchings of
famous French literary figures of the day: Jean Cocteau, Robert
Briffault, Charles Morgan, André Gide, André Maurois, Henry di
Montherlant. During his first year in New York he etched portraits
of American writers Robert Frost, Mark and Carl Van Doren, and
Archibald MacLeish.

In 1949 he won a purchase prize in the Brooklyn Museum's 1949
Print Annual and made his New York painting debut. Most of his
canvases were large abstractions, but some were depictions of
Maine rocks and waves that resembled architectural friezes in
composition. By 1952 Brenson's abstract works contained
multihued whites and grays spliced with zigzagging black lines. In
the late 1950s he gradually added primary colors to his quickly
brushed abstractions.

Brenson taught at the College of Wooster in Ohio and was
chairman of the Art Department of Douglas College, Rutgers. He
was one of 18 artists and the first American abstractionist to be
awarded the Prix de la Critique in Paris in 1954. He served on
several UNESCO committees, promoting active participation among
other artists, and was chairman for visual arts for the Institute of
International Education. *M.T.S.*

61

Upsurging, *c. 1952*

Oil on canvas, 44 x 28 in.
(111.8 x 71.1 cm.)
Signed lower right: Brenson
Bequest of Hudson Walker from the Ione
and Hudson Walker Collection
78.21.810
Illustration: Appendix

PROVENANCE: Ione and Hudson Walker

Characteristic of abstractions Brenson created in 1952, this work contains assertive, heavy black lines zigzagging across areas of thickly painted whites and grays. Reviewers wrote that Brenson's canvases of this period had impact and recorded movement through space with meteoric speed.

ALFRED THOMPSON BRICHER
1837-1908

SELECTED BIBLIOGRAPHY: George C. Croce and David H. Wallace, *The New York Historical Society's Dictionary of Artists in America, 1564-1860* (New Haven: Yale University Press, 1966), p. 80 • Jeffrey R. Brown and Ellen W. Lee, *Alfred Thompson Bricher, 1837-1908* (Indianapolis: Indianapolis Museum of Art, 1973) • Jeffrey R. Brown, "Alfred Thompson Bricher," *American Art Review* (January/February 1974): 69-75 • Rena N. Coen, *Painting and Sculpture in Minnesota, 1820-1914* (Minneapolis: University of Minnesota Press, 1976), 46, 132 • Rena N. Coen, "Alfred Thompson Bricher's Early Minnesota Scenes," *Minnesota History* (Summer 1979): 233-236.

Although he grew up in Newburyport, Massachusetts, Alfred Thompson Bricher was a native of Portsmouth, New Hampshire. He may have studied art at the Lowell Institute in Massachusetts, but he was largely self-taught when in 1858 he decided to pursue a career as a painter. After spending a few years in Boston, he moved to New York in 1868 and opened a studio in the Association Building, which already housed a number of American landscape painters.

Throughout his life, Bricher made extensive sketching trips to upper New York State and to the New England coast, painting numerous views of the land, sea, and shore and perfecting his talent for suggesting the effects of light and atmosphere. He was elected an associate member of the National Academy of Design (New York) in 1879 and, after a very productive professional life, died on Staten Island. *R.N.C.*

Barn Bluff on the Mississippi River at Red Wing, Minnesota, *1866*

Oil on composition board, 9 x 17⅞ in.
(22.9 x 45.4 cm.)
Signed lower left (difficult to decipher):
ATB 66
Signed lower right: A.T. Bricher
Purchase, Fine Arts Fund
76.28
Illustration: Colorplate III

REFERENCE: Rena N. Coen, "Alfred Thompson Bricher's Early Minnesota Scenes," *Minnesota History* (Summer 1979): 236.

Excursions up the Mississippi were popular in the 1860s, especially among young artists seeking adventure and "picturesque" new subjects for their brushes; it was on one such trip to Minnesota during the summer of 1866 that Bricher painted this scene. Here Red Wing's distinctive landmark—a rocky, moundlike hill—rises steeply from a curve in the river. The palette is a muted one of greens and browns applied with a brush technique that is sketchier than the one the artist would later use. Although the painting possesses neither the glowing, sunlit quality nor the tonal subtleties

EXHIBITIONS: *A Bicentennial Exhibition of Art and Architecture in Minnesota*, 1976 • *Recent Acquisitions*, 1976 • The St. Paul Companies, Inc., St. Paul, *The Mighty Mississippi*, 1983 • *The First Fifty Years 1934-1984: American Paintings and Sculpture from the University Art Museum Collection*, 1984.

PROVENANCE: Berry-Hill Galleries, New York

SELECTED BIBLIOGRAPHY: John I.H. Baur, *Revolution and Tradition in Modern American Art* (New York: Frederick A. Praeger, 1951), 66, 73 • *Byron Browne* (Springfield, Massachusetts: Murial Latow Interiors, 1954) • Dore Ashton, *The New York School* (New York: Viking Press, 1972), *passim* • Francis O'Connor, *The New Deal Art Projects: An Anthology of Memoirs* (Washington, D.C.: Smithsonian Institution Press, 1972), 225, *passim* • Greta Berman, "Byron Browne: Builder of American Art," *Arts* (December 1978): 98-102 • Microfilm roll NBB1, Archives of American Art, Smithsonian Institution, Washington, D.C. • April J. Paul, "Byron Browne in the Thirties: the Battle for Abstract Art," *Archives of American Art Journal* 19, no. 4 (1979): 9-24 • Greta Berman, "Abstractions for Public Spaces, 1935-1943," *Arts* 56, no. 10 (June 1982): 81-87.

of Bricher's mature works, its freshness and clarity anticipate the luminous New England shore scenes on which his reputation justly rests.

Bricher suggests a far frontier, silent and remote, while unobtrusively referring to white civilization by means of the arched stone railroad bridge at the right—a symbol, perhaps, of the opening of the West. If this youthful work is a more pragmatic statement of the American landscape than the more poetic works yet to come, it still reflects that blend of realism and romanticism, of vision and fact, that would soon become evident in his paintings.

(GEORGE) BYRON BROWNE
1907-1961

Born in Yonkers, New York, Byron Browne studied painting with Charles W. HAWTHORNE at the National Academy of Design. While still in his early twenties, he developed a personal style based on cubism. In 1933 he had his first exhibition at the New School for Social Research (New York), a suitable avant-garde forum for his progressive work. During the mid-1930s Browne became acquainted with other abstract artists through the Artists' Union and Hans Hofmann's school on East 57th Street, where many of them studied. He was a founding member of American Abstract Artists, organized in 1936 as a cooperative exhibition society.

An experimental artist who occasionally produced representational canvases, Browne was one of a small group of painters who created abstract works under the sponsorship of New Deal art programs. He designed an abstract mosaic mural for the United States Passport Office in Rockefeller Center as well as murals for radio station WNYC and the Science and Health Building at the 1939 World's Fair. In 1948 he began teaching at the Art Students League, and during the 1950s he was associated with the abstract expressionists. *P.N.*

Still Life with Music, *1953*

Browne once said, "I believe a picture is successful because of careful considerations of color, space, design, imagery.... is my firm belief that all pictures must answer a definite space question. I do not submit to the idea of non-objective versus objective since I have

Oil on canvas, 47¾ x 35¾ in.
(121.3 x 90.8 cm.)
Signed lower center: Byron Browne
Gift from the Childe Hassam Fund,
American Academy of Arts and Letters
55.3
Illustration: Figure 15

EXHIBITIONS: New York, *Audubon Artist
12th Annual*, 1954 • New York, American
Academy of Arts and Letters, 1955 • Tweed
Gallery, University of Minnesota-Duluth, *A
Survey of American Painting*, 1955 • *Music
and Art*, 1958; also Grand Rapids Art
Gallery, Grand Rapids, Michigan • *Abstract
USA/1910-1950*, 1981 • Carleton College,
Northfield, Minnesota; *American
Abstraction: 20th Century American
Paintings from the University of Minnesota*,
1983.

PROVENANCE: Grand Central Galleries, New
York

found that any shape, form, or object that enters into a painting has
its counterpart in nature" (*Byron Browne* [Springfield,
Massachusetts: Murial Latow Interiors, 1954]).

In 1953 he departed from his hard-edged, abstract style in a series
of paintings created with brilliant splashes of pigment. *Still Life
with Music*, like other works from this period, links him to the
emotionally expressive and process-oriented concepts of action
painting. As the title suggests, Browne here poses a possible parallel
between the abstract configurations of music and visual imagery,
translating musical concepts into pictorial equivalents: line for beat,
color for tone. An almost audible sound suffuses the space of the
painting. Although Browne arranges a collection of discernible
objects on the semblance of a table—the most traditional pattern
for a still-life—the painting is far from traditional in form and
relates to the most intellectually expressive works of its decade.

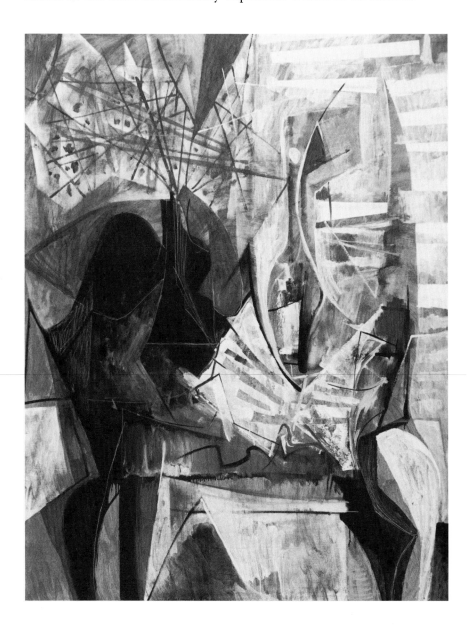

Still Life with Music, *1953 • Figure 15*

S. CHATWOOD BURTON
1881-1947

SELECTED BIBLIOGRAPHY: Samuel Chatwood Burton, *Spain Poised, An Etcher's Record* (Minneapolis: University of Minnesota Press, 1937) • *Who's Who in American Art*, volume II (Washington, D.C.: American Federation of Arts, 1938-39) • *Who's Who in American Art*, volume IV (1947).

Samuel Chatwood Burton was born in Manchester, England, attended the Royal College of Arts in London, and studied in Paris with Jean-Paul Laurens and at the Académie Julian. He immigrated to the United States in 1911 and arrived in Minneapolis by 1915, where he taught at the University of Minnesota until his death by suicide in 1947. Burton represented the School of Architecture in the fine arts section, a committee which held general responsibility for the University Art Museum (then University Gallery) when it was first established in 1934.

Primarily an etcher, Burton executed sketches of local midwestern scenes. Some of these picturesque views were published in the *Minneapolis Tribune*. He also designed scenery for theatrical productions at the University. *C.H.S.*

Both *Landscape* and *Wharf* portray picturesque architectural motifs. Burton used short dabs of brightly colored pigments and heavy impasto to represent the transitory effects of light. These visions of forms observed in brilliant sunlight recall the paintings of the French impressionists.

Untitled *(Wharf)*, 1917

Oil on canvas, 36 x 22 in.
(91.4 x 55.9 cm.)
Signed lower left: S. Chatwood Burton
1917
Gift from President's Office, Administration
Building
54.45
Illustration: Appendix

PROVENANCE: University of Minnesota
Administration

Untitled *(Landscape), 1917*

Oil on canvas, 40¼ x 26⅛ in.
(102.2 x 66.4 cm.)
Signed lower right: S. Chatwood Burton
1917
Transferred from University Administration
Building
58.31
Illustration: Figure 16

PROVENANCE: University of Minnesota
Administration

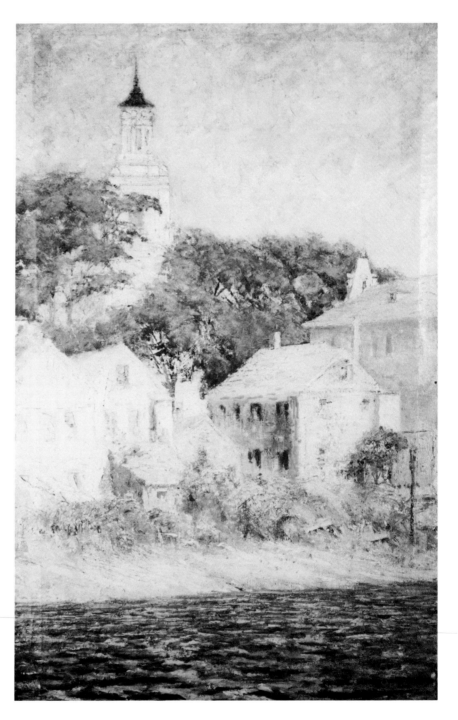

Untitled *(Landscape), 1917* ▪ *Figure 16*

Untitled *(Peasant Group), c. 1937*
Verso: **Untitled** *(Walled Spanish Town), c. 1940*

Oil on canvas, 50 x 40 in.
(127.0 x 101.6 cm.)
Signed lower right on painting on verso: S.
Chatwood Burton
Gift from President's Office, Administration
Building
54.4
Not illustrated

PROVENANCE: University of Minnesota
Administration

The verso of *Peasant Group* portrays a walled town in Burton's beloved Spain. He executed numerous etchings of Spanish subjects, gave public lectures about his travels there, and published a book, *Spain Poised: An Etcher's Record* in 1937.

Although Burton's signature appears at lower right, this view of a Spanish town seems unfinished since only the basic architectural structure, thinly painted and devoid of details, has been put down on canvas.

Peasant Group was apparently painted later. Here the artist appears to have experimented with a brash, expressionistic style. The dark colors and heavy forms are in marked contrast to the light and airy vistas Burton more typically portrayed.

ARTHUR BEECHER CARLES
1882-1952

SELECTED BIBLIOGRAPHY: *An Exhibition of Paintings by Arthur B. Carles* (Philadelphia: Pennsylvania Academy of the Fine Arts, 1966) ▪ Henry G. Gardiner, *Arthur B. Carles* (Philadelphia: Philadelphia Museum of Art, 1970) ▪ Paul D. Schwetzer, "Arthur B. Carles (1882-1952)," in *Avant-Garde Painting and Sculpture in America*, edited by William I. Homer (Wilmington, Delaware: Delaware Art Museum, 1975), 40-41 ▪ B.B. Wolanin, *The Arthur B. Carles Collection of the Hirshhorn Museum and Sculpture Garden* (Washington, D.C.: Smithsonian Institution Press, 1977) ▪ William H. Gerdts, *Painters of the Humble Truth: Masterpieces of American Still Life 1801-1939* (Columbia, Missouri: Philbrook Art Center with the University of Missouri Press, 1981), 244-247 ▪ B.B. Wolanin, *Arthur B. Carles: "Painting with Color"* (Philadelphia: Pennsylvania Academy of the Fine Arts, 1983).

Philadelphia native Arthur B. Carles studied intermittently from 1901 to 1907 at the Pennsylvania Academy of the Fine Arts under Thomas Anschutz and William Merritt Chase. He won several key prizes as a student, including the Cresson Traveling Scholarship; this, along with a commission to reproduce Raphael's *Transfiguration* for a Philadelphia church, enabled him to journey to Europe in June of 1907. While in Paris he became a close friend of both Alfred MAURER and Edward Steichen and was acquainted with Gertrude and Leo Stein. Steichen introduced Alfred Stieglitz to Carles's art, and in 1910 Stieglitz began exhibiting his work at the 291 Gallery (New York). In 1912 Carles had his first one-man show at Stieglitz's gallery, and in 1913 he was represented in the Armory Show.

Fascinated by the fauvism of Henri Matisse, Carles displayed an intense response to color. His paintings from the early 1900s reflect a joy in the sensuous aspects of life: the lushness of flowers and gardens; the grace, beauty, and sensuality of clothed and naked women; the brilliance of sunlight on landscapes.

From 1917 through 1925, Carles taught at the Pennsylvania Academy of the Fine Arts, taking almost a year off during 1921-22 to return to France. His brief stay abroad proved revitalizing; his works after this period—abstractions marked by a new spontaneity and an expressionist character—are interesting precursors of the New York School. Unfortunately, mounting personal problems took their toll on his health, and Carles spent much of the last ten years of his life in a nursing home. *P.N.*

Landscape, *c. 1910*

This piece is typical of a series of small landscapes that Arthur Carles painted in France around 1910. American artists attracted to fauvism often chose the landscape as their primary subject, and they preferred a small format because paintings this size were easy to carry around and ship overseas. A French tag on the canvas stretcher provides a further clue to its origin, and a stamp on the frame indicates that it was once in the collection of Alfred Stieglitz.

Oil on canvas board, 7¾ x 9¾ in. (19.7 x 24.8 cm.)
Signed lower right: Carles (possibly not the artist's hand)
Gift of Ione and Hudson Walker
53.293
Illustration: Figure 17

EXHIBITIONS: *Selections from the Permanent Collection*, 1970 ▪ *Hudson D. Walker: Patron and Friend*, 1977, cat. 9 ▪ *Selections from the Permanent Collection*, 1980 ▪ Carleton College, Northfield, Minnesota, *American Abstraction: 20th Century American Paintings from the University of Minnesota*, 1983 ▪ Pennsylvania Academy of Fine Arts, Philadelphia, *Arthur B. Carles: Painting with Color*, 1983.

PROVENANCE: Alfred Stieglitz; Ione and Hudson Walker

The heavy impasto in dashes of brilliant color suggests rather than delineates the shimmering of a sunset field, illustrating the influence of Henri Matisse. The large areas of unmodulated color, the intense play of light on forms, the reduction of shapes to essentials, and an emotional response to nature are characteristic of Carles's early works.

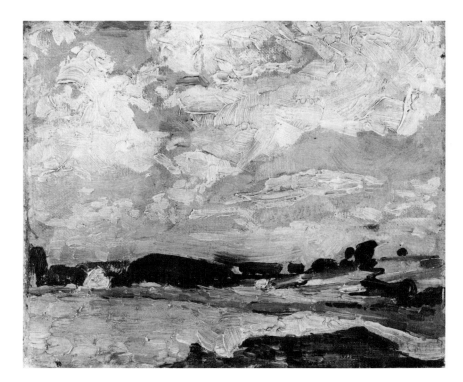

Landscape, *c. 1910* ▪ *Figure 17*

ETTORE CASER
1880-1944

SELECTED BIBLIOGRAPHY: F. Newlin Price, "Caser," *American Magazine of Art* 15 (March 1924): 145-149 ▪ "E. Caser, Obituary," *Art News* 43 (15 March 1944): 43.

Born in Venice, Ettore Caser studied both drawing and the violin in his home city; the former at the Academy of Fine Arts, and the latter at the Conservatory of Music. Although he was virtually self-taught as a painter, the Italian Mario del Mario was his mentor and taught him both the chemistry of color and glazing techniques.

When he was unable to make a living at painting in Italy, Caser immigrated to Boston at the age of 30. There he became known for his work with tempera glazes and his building up of the ground with white pigment to achieve a three-dimensional effect. When the ground was dry, he proceeded to cover the white panels with transparent or semitransparent tempera pigments and then oil colors, usually achieving an overall grayish haze.

He won a silver medal at the Panama-Pacific Exposition in San Francisco in 1915 and exhibited at the Corcoran Gallery (Washington, D.C.), the Art Institute of Chicago, and the National Academy of Design (New York), of which he was an associate member. In addition to painting, Caser completed murals for the state house in Boston and for several banks and other public buildings in that area. *M.T.S.*

Old Yellow Gown, *c. 1925*

Oil on composition board, 40½ x 30 in. (103 x 76 cm.)
Signed lower right: E. Caser
Gift of Louis W. Hill, Jr.
56.6
Not illustrated

PROVENANCE: Louis W. Hill, Jr.

Caser was known as a painter who used a full range of colors in decorative treatments of romantic subjects such as *Old Yellow Gown*. Other canvases of adolescents which Caser painted in the 1920s and which had similar sentimental appeal included *Flirtation* and *Boy Playing Flute*.

LOUISE CASSIDY
1900-1969

Selected Bibliography: Alumni files, Minneapolis College of Art and Design.

Louise Cassidy graduated from the Minneapolis School of Art in 1922. She exhibited *Out of the Old Ariseth the New* and *Old Drury Corner in the Rain*, which won fourth prize in oil painting, at the Fourteenth Annual Exhibition of Minneapolis and St. Paul Artists at the Minneapolis Institute of Arts in 1928. Cassidy was a member of the Minnesota Artists Association. *M.T.S.*

Chaska's Balconies, *c. 1936*

Oil on canvas, 20 x 24 in.
(50.8 x 61 cm.)
Unsigned
WPA Art Project, Minneapolis
43.769
Not illustrated

PROVENANCE: WPA Art Project, Minneapolis

In 1936, Daniel Catton Rich, then associate director of painting and sculpture at the Art Institute of Chicago, remarked that he saw a prevalence of pattern in the canvases of Minnesota artists. This painting of the 120-year-old Minnesota River town uses the pattern of shingles, brickwork, wooden balcony slats, and varied shapes of the false fronts of the old stores to create a richly textured composition.

Seats Upstairs, *c. 1936*

Oil on canvas, 20 x 24 in.
(50.8 x 61 cm.)
Unsigned
WPA Art Project, Minneapolis
43.772
Not illustrated

PROVENANCE: WPA Art Project, Minneapolis

GIORGIO CAVALLON
1904-

Selected Bibliography: Frank O'Hara, "Cavallon Paints a Picture," *Art News* 57 (December 1958), 42-45, 66 • John Ashbery, *Giorgio Cavallon: Paintings 1937-77* (Purchase, New York: Neuberger Museum, 1977).

Born in Sorio near Venice, Giorgio Cavallon came to the United States at age two but returned to Italy when his mother died four years later. In 1920 he immigrated to Springfield, Massachusetts and worked in the Westinghouse factory while studying painting with a private instructor. He attended the National Academy of Design (New York) from 1925 to 1930, studying under Charles W. HAWTHORNE.

The Depression drove him back to Italy from 1930 to 1933, where he painted portraits and landscapes in a post-impressionist style. Upon his return to the States he studied with Hans Hofmann from 1934 to 1936. It was in Hofmann's studio that he first began to understand and create abstract art, and in 1936 he became a charter member of the American Abstract Artists, exhibiting annually with that group into the 1950s. He worked as Arshile Gorky's assistant on a WPA/FAP mural project, and during the late 1930s and early 1940s his paintings were similar to the eclectic synthetic cubist and constructionist works of his contemporaries Gorky, Willem de Kooning, and John Graham.

From the 1940s into the early 1950s, Cavallon was influenced by Mondrian and neo-plasticism, yet his works incorporated a tactile surface within the vertical gridwork of the composition. Throughout the 1950s he enlarged individual color blocks, alternating layers of paint density on an almost purely white surface. During the 1960s darker hues began to permeate large areas of canvas, and in the 1970s these changed into subtle hues overlaid with veils of differing whites.

Cavallon has taught at Pratt Institute, the University of North Carolina, Yale University, and Columbia University. In 1966 he received a Guggenheim Fellowship. *M.T.S.*

Abstraction No. 2, *1938*

Oil on canvas, 20 x 24¼ in.
(50.8 x 61.6 cm.)
Signed lower right: Giorgio Cavallon . 38
Purchase
39.111
Illustration: Appendix

PROVENANCE: Federal Art Project, Central Allocations Division, New York

Cavallon completed this canvas while working on the easel project of the WPA/FAP. According to poet-critic Frank O'Hara, Cavallon's biomorphic still-lifes from this period seemed to be made "into a wall with imbedded form" (O'Hara, p. 43). Similarities to the works of Gorky, de Kooning, and Graham are evident in the curved, straight-edged shapes placed within a shallow background space. Cavallon has acknowledged another strong influence on his work at this time: the French purist painter Jean Helion, who lived in New York in the mid-1930s, exhibited at Gallatin's Gallery of Living Art, and lectured on the suitability of abstract art to express the abstract thought of a technical age.

EDWARD CHAVEZ
1917-

SELECTED BIBLIOGRAPHY: Edward Chavez, "The Artist and His Environment," *The Art of the Artist*, compiled by Arthur Zaidenberg (New York: Crown Publishers, Inc., 1951), 124-127 • Jacinto Quirate, *Mexican American Artists* (Austin, Texas: University of Texas Press, 1973), 58-62.

Edward Chavez's career is a microcosm of the history of American art over the last four decades. It began by reflecting the regionalist tone of the federal projects during the 1930s (he worked on the WPA/FAP easel and mural projects in the Colorado Rockies); was strongly influenced by the New York School in the 1940s; embodied the primitive, expressive qualities of quattrocento Italian painters in the 1950s; and combined aspects of all three of these during the 1960s and 1970s, after his interest in his Mexican ethnicity had been reawakened.

Born in Wagonmound, New Mexico, Chavez claims to be self-taught, although he studied for a short time at the Colorado Springs Fine Arts Center with Boardman Robinson, Frank Mechau, Arnold Blanch, and Peppino Mangravite. He was involved with the Federal Arts Projects from 1937 to 1940, completing five murals in the Southwest. During this period he painted western scenes with hard-edged forms and earthen colors. Moving to New York in 1940, he was introduced to the paintings of the New York School. Although abstract expressionism has continued to have the most visible effect on his canvases, it was tempered by journeys to Italy in 1951 and Mexico in 1954.

Traveling to Italy on a Fulbright grant, he was attracted to the works of Giotto and the quattrocento painters Paolo Uccello and Piero della Francesca. A three-month jeep tour through Mexico led to paintings reminiscent of slightly abstracted rock formations, which evolved in the 1960s and 1970s into more two-dimensional color abstractions which glitter like mosaics.

Chavez, who has exhibited widely, taught at the Art Students League from 1954 to 1958, Colorado College (Colorado Springs) from 1959 to 1960, and Syracuse University from 1960 to 1962. *M.T.S.*

Dead Bluejay in Snow, *c. 1937-1940*

Oil and tempera on composition board,
15½ x 17½ in.
(39.4 x 44.5 cm.)
Signed lower right: Edward Chavez
Bequest of Hudson Walker from the Ione
and Hudson Walker Collection
78.21.827
Illustration: Appendix

REFERENCE: Letter from Edward Chavez to
Mark R. Kriss at the University Gallery, 17
January 1979.

EXHIBITIONS: Art Institute of Chicago,
Annual Exhibition, 1942 • Drew Fine Arts
Center, Hamline University, St. Paul, 1952.

PROVENANCE: Ione and Hudson Walker

This painting was completed under the auspices of the WPA/FAP between 1937 and 1940. About it, Chavez writes: "…I was residing and working in the Colorado Rockies on the Western Slope of the divide in what was at that time a little known and sparsely inhabited area in the deserted ghost town named Redstone. The painting reflects this environmental source and my preoccupation with nature and the elements" (Chavez to Kriss, 17 January 1979).

HOWARD CHANDLER CHRISTY
1873-1952

SELECTED BIBLIOGRAPHY: Howard Chandler
Christy, *The Christy Girl* (New York:
Moffat, Yard & Co., 1906) • Howard
Chandler Christy, *Our Girls, Poems in
Praise of the American Girl* (New York:
Moffat, Yard & Co., 1906) • Howard
Chandler Christy, *The American Girl as
Seen and Portrayed by Howard Chandler
Christy* (New York: Moffat, Yard & Co.,
1906) • Mimi C. Miley, *Howard Chandler
Christy, Artist/Illustrator of Style*
(Allentown, Pennsylvania: Allentown Art
Museum, 1977) • Walt Reed, *Great
American Illustrators* (New York: Abbeville
Press, 1979), 28-29.

Howard Chandler Christy is best known for his many representations of the ideal American girl, famous as the "Christy Girl" during the early years of this century. He also painted portraits and landscapes.

Raised in rural Duncan Falls, Ohio, Christy traveled to New York City in 1890 to pursue an artistic career. He enrolled at the Art Students League and studied with William Merritt Chase. He went back to Ohio when his funds ran out but was able to return to New York in 1892. For two and a half years he worked in Chase's glamorous 10th Street studio and was one of his most promising pupils.

Much to his teacher's dismay, Christy turned to commercial art in 1895, illustrating for leading magazines such as *Scribner's* and *Harper's*. He worked for the Army during the Spanish-American War, and his drawings of that conflict were used to illustrate *Wright's Official History of the Spanish-American War*, published in 1900. Meanwhile Christy became friends with Colonel Theodore Roosevelt and encouraged the future President to submit his Rough Riders story to *Scribner's* for publication.

He created his "Christy Girl" in the early years of the twentieth century. Her image was soon in great demand for posters and magazine illustrations, and the artist also presented her to the public in books such as *Our Girls, Poems in Praise of the American Girl*.

With the advent of World War I, Christy once again donated much of his time and talent to the war effort, designing at least 40 posters encouraging American men to join the military. Following the war he began a second successful career as a portrait painter, and many notable people sat for him, including William Randolph Hearst, Lillian Russell, Presidents Harding and Coolidge, Benito Mussolini, and Amelia Earhart. He also painted a number of murals, creating large compositions of female nudes in idyllic settings as decorations for the Park Lane Hotel and the Café des Artists in New York. *C.H.S.*

Summer Orchard, *1925*

Oil on canvas, 23½ x 28½ in. (59.7 x 72.4 cm.)
Signed lower left: Howard Chandler Christy/(indecipherable)/Aug 1925
Gift of John E. Larkin, Jr.
79.9.3
Illustration: Appendix

EXHIBITIONS: *Selected Gifts and Acquisitions*, 1979 • *Selections from the Permanent Collection*, 1980.

PROVENANCE: John E. Larkin, Jr.

During his student years, Christy attended William Merritt Chase's summer classes at Shinnecock on Long Island. Chase encouraged his many students to draw and paint outdoors, and over the years Christy continued to execute paintings *en plein air*. The fresh colors and misty atmosphere of *Summer Orchard* present an impressionist view of nature. The painting, which shows a woman sitting under trees with a river in the distance, was once a larger work; painted edges, including date and description, have been wrapped over the edge of the stretcher.

WILLIAM W. CHURCHILL
1858-1926

SELECTED BIBLIOGRAPHY: Mantle Fielding, *Dictionary of American Painters, Sculptors, and Engravers*, with addendum by James F. Carr (New York: James F. Carr, 1965), 65-66.

An obscure though quite able artist, William W. Churchill was born in Jamaica Plain, Massachusetts. He studied in Paris under Léon Bonnat and later settled in Boston, where he specialized in genre pictures and portraits. It is not known when he traveled to the Twin Cities of Minneapolis and St. Paul, but he painted a portrait of University President Cyrus Northrop as well as the portrait of Judge Greenleaf Clark now in the Art Museum collection. *R.N.C.*

75

Greenleaf Clark, *c. 1890*

Oil on canvas, 29⅞ x 23⅛ in.
(75.9 x 58.7 cm.)
Signed lower left: W.W. Churchill
Anonymous gift
51.50
Not illustrated

PROVENANCE: University of Minnesota
Archives

Judge Greenleaf Clark had a reputation for persistence and drive strong enough to earn him the description of "a man who used a sledge hammer to drive in a tack" (*Minnesota Alumni Weekly*, 16 December 1901, p. 3). Son of an old New England family, he was born in Plaistow, New Hampshire in 1835 and was educated at Dartmouth and Harvard. In 1858, with law degree in hand, Clark arrived in Minnesota and, except for a brief appointment to the Minnesota Supreme Court, practiced law in St. Paul until 1888. He became one of the most prominent members of the Minnesota bar and was the leading counsel for the state railroads. A member of the University of Minnesota Board of Regents from 1879 to 1904, he also served as its president from 1901 until his death in 1904.

NICOLAI CIKOVSKY
1894-

SELECTED BIBLIOGRAPHY: "Naturalized Russo-Fauve," *Art News* (March 1946), 47 ▪ *Nicolai Cikovsky: Oil Paintings* (New York: Associated American Artists Galleries, 1952) ▪ Helen A. Harrison, *Nicolai Cikovsky* (Southampton, New York: Parrish Art Museum, 1980).

Born in Pinsk, Russia near the Polish border, Nicolai Cikovsky received his early training in art at the Royal Art School in Vilna, where he studied with classmate Chaim Soutine, and completed his education at the Technical Institute of Arts in Moscow. It was at the Museum of Modern Western Art in Moscow that he first saw paintings by Cézanne and Matisse, the latter of whom influenced the color in Cikovsky's very earliest and latest works.

After immigrating to New York in 1923, he supported himself with odd jobs while continuing to paint. His first important patron was the art critic Christian Brinton, who purchased one of his works in 1924. By 1928 the Daniel Gallery (New York) was handling his paintings, and he had exhibitions there in 1930 and 1931. In 1932 he won the coveted Logan Prize in the Art Institute of Chicago's Annual Exhibition of Painting and Sculpture. During this period he was praised by critics as a "good American artist who created typically American subjects."

In the early 1930s Cikovsky attended meetings of the art section of the John Reed Club with his friend Raphael SOYER. Meeting participants were encouraged to depict social issues affecting American life during the Depression. Cikovsky was employed by the WPA/FAP during the 1930s, executing murals for the Department

of Interior Building in Washington, D.C. and several area post offices. After his move to eastern Long Island in the 1940s his subjects reverted to landscapes and interior scenes.

A member of the National Academy of Design, Cikovsky has taught at the St. Paul School of Art, the Art Academy of Cincinnati, the Corcoran School of Art, and the School of the Art Institute of Chicago. *M.T.S.*

On the East River, *1934*

Oil on canvas, 38½ x 45 in.
(97.8 x 114.3 cm.)
Signed lower right: N. Cikovsky 34
Purchase, General Budget Fund
36.83
Illustration: Figure 18

EXHIBITIONS: *Original Paintings from the University Collection*, 1946, cat. 27 • Tweed Gallery, University of Minnesota-Duluth, *A Survey of American Painting*, 1955 • *Contact: American Art and Culture, 1919-1939*, 1981, cat. 3 • *Images of the American Worker 1930-1940: An Undergraduate Honors Seminar Exhibition*, 1983.

PROVENANCE: The Downtown Gallery, New York

Cikovsky's interest in Chardin, Courbet, and Daumier influenced the tonality of his palette in the 1930s. Explaining his interest in the social condition of man, he wrote: "The trend towards reality, revolutionary content, and emancipation from Paris influences towards a pure American style, I consider an important development. I believe the future of American art will be more closely identified with the working class; that it will tend to the realistic and will gradually evolve more and more of its own form as well as its content" [Martha Candler Cheney, *Modern Art in America* (New York: McGraw-Hill Book Company, Inc., 1939), pp. 133-134].

On the East River, *1934* • *Figure 18*

ALEXANDER CORAZZO
1908-1971

SELECTED BIBLIOGRAPHY: "Modern Painters in Minnesota," *Notes and Comments from the Walker Art Center* (April 1949) ▪ *Alexander Corazzo/LeRoy Turner, American Abstraction-Creation* (Ann Arbor, Michigan: Museum of Art, University of Michigan, 1976).

A native of Lyon, France, Alexander Corazzo studied at the Ecole des Travaux Publiques from 1926 to 1928 and at the St. Paul School of Art from 1929 to 1935, where he studied with Cameron BOOTH. He was employed by the WPA/FAP in St. Paul in the mid-1930s. In 1938 he moved to Chicago, where he again worked for the WPA/FAP and attended the new Bauhaus School for a year. After serving for two years in the Burma-China theater during World War II he enrolled at the Illinois Institute of Technology in 1945 and studied architecture under Mies Van Der Rohe; he graduated with honors in 1947. He later worked in Mies Van Der Rohe's Chicago office, and then for Skidmore, Owings and Merrill until his death. *M.T.S.*

While studying at the St. Paul School of Art, Corazzo discovered Albert Gleize's *La Forme et l'Histoire: Vers une Conscience Plastique*, published in 1932, which led to the gradual abstracting of his compositions. Works in the University Art Museum collection show a progression from fluidly painted forms in a shallowly defined space to flat, geometric shapes with pristine edges and surfaces.

Abstraction, *c. 1936*

Oil on canvas, 30¾ x 36¼ in. (78.1 x 92.1 cm.)
Unsigned
WPA Art Project, Minneapolis
43.713
Illustration: Appendix

EXHIBITION: *Original Paintings from the University Collection*, 1946, cat. 28.

PROVENANCE: WPA Art Project, Minneapolis

Abstraction No. 6, *c. 1936*

Oil on canvas, 20 x 14⅛ in. (50.8 x 35.9 cm.)
Unsigned
WPA Art Project, Minneapolis
43.712
Illustration: Appendix

PROVENANCE: WPA Art Project, Minneapolis

Abstraction No. 10, *c. 1936*

Oil on canvas, 19¼ x 25 in.
(48.9 x 63.5 cm.)
Unsigned
WPA Art Project, Minneapolis
43.762
Illustration: Appendix

EXHIBITION: Walker Art Center,
Minneapolis, *Modern Painting in
Minnesota*, 1949.

PROVENANCE: WPA Art Project, Minneapolis

Abstraction No. 12, *c. 1936-1937*

Oil on canvas, 22 x 36 in.
(55.9 x 91.4 cm.)
Signed upper right: A. Corazzo
WPA Art Project, Minneapolis
43.711
Illustration: Appendix

EXHIBITION: *Original Paintings from the
University Collection*, 1946, cat. 29.

PROVENANCE: WPA Art Project, Minneapolis

Abstraction No. 13, *1937*

Oil on canvas, 22 x 36 in.
(55.9 x 91.4 cm.)
Signed lower right: A. Corazzo 37
WPA Art Project, Minneapolis
43.710
Illustration: Appendix

EXHIBITIONS: *Abstract USA/1910-1950*,
1981 • Carleton College, Northfield,
Minnesota, *American Abstraction: 20th
Century American Paintings from the
University of Minnesota*, 1983.

PROVENANCE: WPA Art Project, Minneapolis

Abstraction No. 16, *1937*

Oil on canvas, 27 x 36 in.
(68.6 x 91.4 cm.)
Signed lower right: A. Corazzo 37
WPA Art Project, Minneapolis
43.709
Illustration: Appendix

PROVENANCE: WPA Art Project, Minneapolis

Abstraction No. 17, *c. 1937*

Oil on canvas, 22 x 35¾ in.
(55.9 x 90.8 cm.)
Signed upper right: A. Corazzo
WPA Art Project, Minneapolis
43.708
Illustration: Figure 19

PROVENANCE: WPA Art Project, Minneapolis

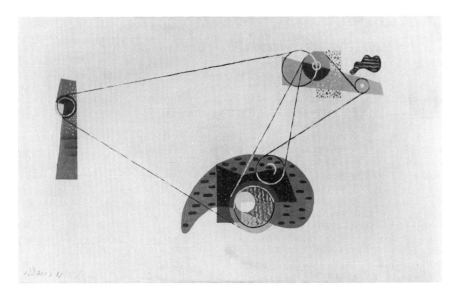

Abstraction No. 17, *c. 1937* ▪ *Figure 19*

URBAN COUCH
1927-

SELECTED BIBLIOGRAPHY: Felt Lair, "The Very Urbane Urban Couch," *Select* (May 1961), 22-24 ▪ Letter from Urban Couch to Mark Kriss at the University Gallery, Fall 1978 ▪ Minneapolis History Collection, Minneapolis Public Library.

Born in Minneapolis, Urban Couch received his BFA from the Minneapolis School of Art (now the Minneapolis College of Art and Design) in 1951 and returned there to teach from 1955 to 1971. In 1959 he took a leave from teaching to pursue an MFA at Cranbrook Academy in Bloomfield Hills, Michigan. After a year of study, fields of color on life-sized canvases replaced the semiabstract landscapes he had painted up until then. Gradually his work evolved into grids of hard-edged color patterns. Only his sensuous palette made the transition from painterly abstraction to this more decorative, immaculately painted style.

Couch had several one-man exhibitions locally and participated in national group shows. In 1971 he took a position as professor and chairman of the Division of Art, Creative Arts Center, West Virginia University, Morgantown, West Virginia. *M.T.S.*

Deep Six, *1962*

Oil on canvas, 40 x 40 in.
(101.6 x 101.6 cm.)
Signed verso: Urban Couch Deep Six
Purchase, Fine Arts Fund
64.5
Illustration: Figure 20

EXHIBITION: Minneapolis Institute of Arts,
Urban Couch: Recent Paintings, 1962, cat.
13.

PROVENANCE: the artist

After 1959, Couch's canvases became larger in scale with saturated areas of color playing off of strong black forms. Although recognizable subjects disappeared after 1960, Couch refused to have his works labeled as nonobjective, saying, "Never in my life have I seen a *non-objective* painting. There is always an event that takes place....The whole arrangement of a painting expresses life and in turn becomes a fragment of the objective world. After it is accomplished it is an existent thing, a part of reality" (Lair, p. 23).

Deep Six, *1962 ▪ Figure 20*

RUSSELL COWLES
1887-1979

SELECTED BIBLIOGRAPHY: Ernest W. Watson, "Russell Cowles," *American Artist* (November 1945), 12-17 • Donald Bear, *Russell Cowles* (Los Angeles: Dalzell Hatfield, 1946) • Russell Cowles, "Russell Cowles Talks to Young Painters," *American Artist* (April 1949), 26-31 • Ralph M. Pearson, *The Modern Renaissance in American Art* (New York: Harper & Row, 1954), 63-66.

An artist who believed that spirit and discipline were integral to the creative process, Russell Cowles was born in Iowa and educated first at Dartmouth and subsequently at the Art Students League and the National Academy of Design. After winning the Academy's Prix de Rome in 1915, he spent five years at the American Academy in Rome, where he absorbed the classicism of the Italian masters.

Although he was intrigued by modernism upon viewing the Armory Show in 1913, he worked in a realist manner until the mid-1940s. Following eight years in Santa Fe, he began experimenting with modernist precepts, and by 1950 he achieved a synthesis of the abstract and the real and a resultant artistic maturity which he maintained throughout the rest of his career. *P.N.*

Philodendron and Fruit, *c. 1947-1949*

Probably painted toward the end of the 1940s, *Philodendron and Fruit* demonstrates Cowles's mid-career venture into modernism. Although not as abstract as some of his later works, the alteration of the perspective and space of the still-life elements reflects the artist's investigation of cubist principles. The active curvilinear outlines of the fruit and the plant counteract the flat surfaces of the architecture and the furniture as studies in volume, texture, and composition.

Philodendron and Fruit, *c. 1947-1949 • Figure 21*

Oil on canvas, 20 x 32 in.
(50.8 x 81.3 cm.)
Signed lower left: Cowles
Bequest of Hudson Walker from the Ione
and Hudson Walker Collection
78.21.309
Illustration: Figure 21

EXHIBITIONS: The Downtown Gallery, New
York, *Skowhegan School of Painting and
Sculpture Benefit Exhibition*, 1954, cat. 1 ▪
Dartmouth College, Hanover, New
Hampshire, *Russell Cowles: 75th
Anniversary Retrospective*, 1963, cat. 14 ▪
Selections from the Permanent Collection,
1968 ▪ St. John's University/College of St.
Benedict, Collegeville, Minnesota,
University of Minnesota Art Exhibit, 1971 ▪
Abstract USA/1910-1950, 1981 ▪ Carleton
College, Northfield, Minnesota, *American
Abstraction: 20th Century American
Paintings from the University of Minnesota*,
1983.

PROVENANCE: Kraushaar Galleries, New
York; Ione and Hudson Walker

EINAR DAHL
Active 1930-1955

SELECTED BIBLIOGRAPHY: Minneapolis Historical Collection, Minneapolis Public Library • Elizabeth McCausland papers, Archives of American Art, Smithsonian Institution, Washington, D.C., #371.

Born in Norway, Einar Dahl immigrated to Lennox, South Dakota at age 17. He worked at various odd jobs until moving to Minneapolis six years later, where he studied painting privately with Knute Heldner, Otto Moillan, and Carl O. Erickson.

As a member of the WPA/FAP easel program in Minnesota, Dahl exhibited works at Walker Art Center and served on their board of trustees in 1940. He also exhibited at the Minnesota State Fair in 1941, 1949, 1951, and 1955. He was a member of the Minnesota Artists Union and served on the board of the Minnesota Artists Association. *M.T.S.*

City Hall, Robbinsdale, *1940*

Oil on canvas, 30 x 36 in.
(76.3 x 91.6 cm.)
WPA Art Project, Minneapolis
43.759
Not illustrated

PROVENANCE: WPA Art Project, Minneapolis

Einar Dahl moved to Robbinsdale, a Minneapolis suburb, in 1940 and completed this painting that same year. He sketched and painted several scenes of the area in the reconverted milk wagon-studio he towed behind his car. His working style was very eclectic; in other canvases from this time, he alternated geometrically abstract compositions with realistic still-life arrangements and street scenes.

EDWIN M. DAWES
1872-1934

SELECTED BIBLIOGRAPHY: Zenobia B. Ness and Louise Orwig, *Iowa Artists of the First 100 Years* (Des Moines: Wallace-Homestead Comp., 1939), 59-60 • Rena N. Coen, *Painting and Sculpture in Minnesota, 1820-1914* (Minneapolis: University of Minnesota Press, 1976), 119, 133.

Though little known, Edwin Dawes deserves to be counted among those American artists who painted successfully in the Barbizon mode. Born in Boone, Iowa, he studied briefly under William L. Lathrop in New Hope, Pennsylvania, but was mostly self-taught. He worked in Illinois, Minnesota, and his native state, later traveling to the West and Southwest. Between 1914 and 1917, four of his paintings of the Grand Canyon were purchased by the Atchison, Topeka and Santa Fe Railway for promotional purposes. Dawes eventually moved to California, where he died. *R.N.C.*

Itasca: Origin of the Mississippi, *c. 1915*

Oil on masonite, 12 x 16 in.
(30.5 x 40.6 cm.)
Signed lower left: Edwin M. Dawes
Purchase, Nordfeldt Fund for the
Acquisition of Works of Art
79.4.1
Illustration: Figure 22

REFERENCE: Peter Bermingham, *American Art in the Barbizon Mood* (Washington, D.C.: Smithsonian Institution Press, 1975), 10.

EXHIBITIONS: *Selections from the Permanent Collection*, 1980 • *The First Fifty Years 1934-1984: American Paintings and Sculpture from the University Art Museum Collection*, 1984.

PROVENANCE: Antiques Americana, Bethel, Minnesota

This work reveals the artist's ability to communicate intimately and poetically with nature. Although Dawes painted a number of large canvases, he appears to have been at his best in small landscapes such as this one. The modest stream that is the source of the Father of Waters flows between the grassy banks of a gently rolling meadow; at the right, a breeze stirs the leaves of a few shrubs and a small stand of birches growing at the river's edge. The golden light and the barely foliated trees hint at the end of summer, the fleeting change of seasons, and the transience of a sunny moment in northern Minnesota.

Itasca: Origin of the Mississippi, *c. 1915* • *Figure 22*

Similar in subject matter and style, *Evening* and *Trees by a Stream* depict quiet rivulets in unpeopled and remote summer woodland settings. Both of these large canvases reveal the loose, sketchy style Dawes adopted in his later work. They seem like studies of nature rather than finished representations; in contrast to *Itasca: Origin of the Mississippi* (described above), they are generalized and lack any identifying feature of time or place. The soft, muted tonalities are typical of the American Barbizon painters.

Oil on canvas, 48 x 38 in.
(121.4 x 96.5 cm.)
Signed lower left: Edwin M. Dawes
Anonymous gift
79.17.3
Not illustrated

PROVENANCE: Anonymous gift

Harbor at Night, *c. 1925*

Oil on canvas, 28½ x 33½ in.
(72.5 x 85.1 cm.)
Signed lower right: Dawes
Anonymous gift
79.17.2
Illustration: Appendix

PROVENANCE: Anonymous gift

Evening, *c. 1930*

Oil on canvas, 40 x 30 in.
(101.6 x 76.2 cm.)
Signed lower left: Edwin M. Dawes
Anonymous gift
79.17.1
Illustration: Appendix

PROVENANCE: Anonymous gift

Trees by a Stream, *c. 1930*

JULIO DE DIEGO
1900-1979

SELECTED BIBLIOGRAPHY: Emily Genauer,
Best of Art (Garden City, New York:
Doubleday and Company, Inc., 1948), 145-
146 • Ralph M. Pearson, *The Modern
Renaissance in American Art* (New York:
Harper and Brothers, 1954), 97-104 • Don
Anderson, "Julio De Diego—the Original
Hippie," *Art Scene* (Winter 1968): 17-18.

Born in Madrid, Julio de Diego left home at age 15 to apprentice as
an opera scene painter. He joined the army at 19 and at 22 moved
to Paris to study painting. Immigrating to the United States in 1924,
he illustrated fashion magazines, painted portraits of movie stars,
and performed with a Spanish-American theater company. Works
completed in the 1930s had realistic details but often contained
small, enigmatic scenes which were probably surrealistic in content.

De Diego seems to have been influenced by each new national and
personal event. The advent of World War II inspired a series,
Desastres del Alma (Disasters of the Soul), which caricatured
humankind's ability to become a machine of destruction. This was
followed by a series on the life cycle and natural laws of insects and
animals, which the artist treated as extensions of humankind at its
most destructive. In 1947 he completed another group of paintings,
Altitude, on the subject of the landscape panorama viewed from an
airplane. After this came still more series: on the evils of atomic
energy, the life of Mexican-Americans, scenes from Gloucester,
classical images. Meanwhile he became an American citizen (in
1941) and traveled and exhibited widely.

86

De Diego taught at the Art Institute of Chicago, the University of Denver, and Artist Equity Workshop. Throughout the 1960s he worked on jewelry and mural commissions from his studio in Woodstock, New York. He is represented in several important collections, including the Metropolitan Museum of Art, the Art Institute of Chicago, and Walker Art Center. *M.T.S.*

Meeting in the Unknown, *1944*

Oil on masonite, 16 x 22 in. (40.6 x 55.9 cm.)
Signed lower left: de Diego 44
Gift of Dr. and Mrs. M.A. McCannel
54.34
Illustration: Appendix

EXHIBITION: Tweed Gallery, University of Minnesota-Duluth, *A Survey of American Painting*, 1955.

PROVENANCE: Nierendorf Gallery, New York; Dr. and Mrs. M.A. McCannel

During the mid-1940s de Diego painted a series about deadly combats between insects and animals. In this work, fantastic creatures in battle formation rush to meet one another. The artist had recently completed a series on the atrocities of war, and to him the plan of nature seemed more humane: "I thought of the eternal fight for survival in the animal kingdom...Animals, birds, insects kill each other when they are hungry. Somehow, I thought, there is a certain nobility in this attitude" (Pearson, 1954, p. 100).

JOSEPH DE MARTINI
1896-

SELECTED BIBLIOGRAPHY: Martha Candler Cheney, *Modern Art in America* (New York: McGraw-Hill Book Company, Inc., 1939), 79 ▪ John I.H. Baur, *Revolution and Tradition in Modern American Art* (Cambridge, Massachusetts: Harvard University Press, 1951), 43.

Joseph de Martini was born in Mobile, Alabama and studied at the National Academy of Design (New York) with Leon Kroll and Ivan Olinsky. He was on the rolls of the WPA/FAP easel painting section for the project's duration. Portraits completed during the 1930s were influenced by a modified cubism and by African wood sculpture.

In the late 1930s and 1940s, de Martini also painted landscapes and industrial scenes. Ryder-like in mood, his landscapes were often distilled from memory and imagination and are simultaneously poetic and restrained. Reflecting an interest in the works of Mexican muralists and early twentieth-century German and French expressionism, they are similar to those of Everett SPRUCE and John HELIKER.

De Martini received a Guggenheim Fellowship in 1951 and won the gold medal at the Pennsylvania Academy of the Fine Arts in 1952. He taught at the University of Georgia from 1952 to 1953. *M.T.S.*

Industrial Landscape, *c. 1938-1939*

Oil on composition board, 10⅞ x 13 in.
(27.6 x 33 cm.)
Signed lower right: Joseph De Martini
Bequest of Hudson Walker from the Ione
and Hudson Walker Collection
78.21.120
Illustration: Appendix

EXHIBITION: Drew Fine Arts Center,
Hamline University, St. Paul, 1952.

PROVENANCE: Ione and Hudson Walker

Probably completed during the late 1930s to early 1940s, when de Martini's work was handled by Hudson Walker, this canvas is typical of others from this period: detail is eliminated, and flat areas of color achieve a near-abstract composition. De Martini created a glowing tonality by using a restricted palette of dark hues and by building up layers of warm colors over cool ones.

(WILLIAM) PRESTON DICKINSON
1891-1930

SELECTED BIBLIOGRAPHY: Milton Brown, *American Painting from the Armory Show to the Depression* (Princeton, New Jersey: Princeton University Press, 1955), 128-129 • Martin Friedman, *The Precisionist View in American Art* (Minneapolis: Walker Art Center, 1960), 54 • Catherine Turrill, "Preston Dickinson (1891-1930)," in *Avant-Garde Painting and Sculpture in America 1910-1925*, edited by William I. Homer (Wilmington: Delaware Art Museum, 1975), 64-65 • Ruth Cloudman, *Preston Dickinson 1889-1930* (Lincoln, Nebraska: Sheldon Memorial Art Gallery and Nebraska Art Association, 1979) • William H. Gerdts, *Painters of the Humble Truth: Masterpieces of American Still Life 1801-1939* (Columbia, Missouri: Philbrook Art Center with the University of Missouri Press, 1981), 260 • Karen Tsujimoto, *Images of America: Precisionist Painting and Modern Photography* (Seattle: University of Washington Press for the San Francisco Museum of Modern Art, 1982), 187-188.

Born in New York City, William Preston Dickinson (whose family early dropped his first name) followed the example of his father by attending art school. From 1906 to 1910 he studied at the Art Students League, where he won awards in William Merrit Chase's portrait classes in 1908 and 1909. In late 1910 or early 1911 he went to Paris, like many other progressive young Americans of the time, and remained there until the outbreak of World War I forced him to return home in 1914. While in Paris he studied at the Ecole des Beaux-Arts and the Académie Julian and exhibited at both the Salon des Indépendants and the Salon des Artistes Français.

He participated in many group shows in New York beginning in 1915 and had his first one-man show in 1923 at the gallery of his long-time patron and dealer, Charles Daniel. Meanwhile he lived and worked at his sister's home in Valley Stream, Long Island. Travels in Quebec in 1925 and 1926 yielded a rich variety of subjects. In June of 1930 he sailed for Europe and settled along the border between France and Spain, near the seacoast and the Pyrenees. Late in November of that year he contracted pneumonia; he died in Irun, Spain.

During his brief life Dickinson attacked an array of artistic styles, ranging from the elegant mannerism of American impressionism to Cézanne-inspired landscapes, cubistic still-lifes, and realistic scenes. The delicacy of line and decorative quality of form and color in his work reflect a serious study of Japanese prints. His numerous compositions of bridges, factories, and grain elevators have resulted in his often being linked with the Precisionist movement, but his oeuvre displays accomplishments in both variety and style that assert his individuality and personal creativity. *P.N.*

Still Life with Vase of Flowers, *c. 1929-1930*

Oil and graphite on paper, 8¾ x 6¾ in.
(22.2 x 17.1 cm.)
Signed lower left: Dickinson; inscribed
below image: To Oronzo from Preston
Gift of Ione and Hudson Walker
53.295
Illustration: Figure 23

EXHIBITIONS: *Selections from the Collection
of Mr. and Mrs. Hudson D. Walker*, 1950 •
Tweed Gallery, University of Minnesota-
Duluth, *A Survey of American Painting*,
1955 • American Federation of Arts
Traveling Exhibition, *A University Collects:
Minnesota*, 1961-1962 • *One Hundred
Paintings, Drawings, and Prints from the
Ione and Hudson D. Walker Collection*,
1965, cat. 6 • Minnesota Museum of Art,
St. Paul, *American Style: Early Modernist
Works in Minnesota Collections*, 1981, cat.
16.

PROVENANCE: Oronzo Gasparo; Ione and
Hudson Walker

Here Preston Dickinson transforms the traditional still-life into a
carefully constructed composition of interwoven interior and
exterior space. Spatial ambiguities and shifting perspectives are
cleverly masked by the interplay of hard-edged geometric and
curvilinear forms and in the overlapping of transparent planes
of harmonious blues, greens, and browns. The flat, cubistlike
components of the tilted tabletop find their more logical
counterparts in the background architectural elements.

As evident in the numerous still-lifes Dickinson produced in the
1920s, the artist strives—and succeeds—in synthesizing the real
and the abstract. A small but enlightening study, this work must
have held special significance for Dickinson, as it is inscribed as a
gift to close friend and fellow artist Oronzo Gasparo, who was with
him in Spain at the time of his death.

Still Life with Vase of Flowers,
c. 1929-1930 • Figure 23

MAYNARD DIXON

1875-1946

SELECTED BIBLIOGRAPHY: Ruth Pielkovo, "Dixon, Painter of the West," *International Studio* 78:322 (March 1924): 468-472 • Grant Wallace, *Maynard Dixon: Painter and Poet of the Far West* (San Francisco: California Art Research Project, 1937) • Wesley M. Burnside, *Maynard Dixon: Artist of the West* (Provo, Utah: Brigham Young University Press, 1974) • *Maynard Dixon* (Fresno, California: Fresno Arts Center, 1975) • Wesley M. Burnside, "Maynard Dixon: Chronicler of the Old West," *Southwest Art Magazine* (April 1979): 34-41 • E. Hamlin, "Maynard Dixon: Painter of the West," *American West* 19:6 (1982): 50-58 • A. Marechal-Workman, "Modernism and the Desert: Maynard Dixon," *Vanguard* 11:2 (March 1982): 22-25.

Maynard Dixon's early years, spent on his grandfather's ranch on the treeless plains of the San Joaquin Valley, provided images for the western landscapes he would eventually paint. Born in Fresno, California, he began sketching horses and scenes from ranch life at age seven. On camping trips into the High Sierras and the San Joaquin River basin in the late 1880s he saw Indian tribes indigenous to the area; he was moved by the sad plight of these once-proud peoples, and in later years the motif of a lone Indian and pony (or ponies) against a barren landscape often appeared in his canvases.

Dixon enrolled in the San Francisco School of Design in 1893 but left after only three months to wander and sketch throughout California, explore Yosemite National Park, and live with and draw the Indians. His first published illustrations appeared in the December 1893 issue of *Overland Monthly*. During the next ten years he continued to publish drawings of cowboys and Indians for stories in the *Land of Sunshine* monthly, the *Morning Call*, the *San Francisco Examiner*, and *Sunset* and *Cosmopolitan* magazines. He made frequent excursions out of San Francisco to sketch among the Indians in New Mexico; the resulting drawings and paintings were also influenced by the German design periodicals *Jugend* and *Simplicissimus*.

A New York resident from 1907 to 1912, he published still more illustrations in *Century*, *Scribner's*, *Collier's*, *McClures*, and *Munsey's* magazines. His longing for uninhabited open spaces drove him back to California in 1912 to do illustrations and murals of Indian life. Between 1920 and 1930 he completed a series of mural commissions for several public buildings in California. His sketching tours to Navajo reservations yielded subjects for these as well as for the over 50 canvases he exhibited at the Macbeth Gallery (New York) in 1923.

Dixon joined the WPA/FAP mural project in 1935 and did a series on the various phases of construction of the Hoover Dam in Nevada. Meanwhile he privately completed a number of canvases focusing on the life of migrant and unemployed workers. These and many of his later landscapes, which revealed a flattened, cubist-realist style, were featured in a retrospective at Scripps College in Claremont, California one year before his death. *M.T.S.*

In the summer of 1917 Dixon was commissioned by Louis W. Hill of the Great Northern Railroad to do a series on the life of the Blackfeet Indians and scenes in Montana's Glacier National Park. He camped with the Blackfeet on Cutback Creek until winter began. He returned to San Francisco with 43 sketches and paintings, among them *Blackfeet Camp*, *The Dream Pipe*, and *Split Mountain*. Hill then purchased 12 of these works for Glacier Lodge in Glacier National Park.

Blackfeet Camp, *1917*

Oil on canvas, 39⅞ x 36¼ in.
(101.3 x 92.1 cm.)
Signed lower right: Maynard Dixon,
Blackfeet Ind. Res. Montana, Oct. 1917
Gift of Louis W. Hill, Jr.
56.8
Illustration: Appendix

REFERENCE: Wesley M. Burnside, *Maynard Dixon: Artist of the American West* (Provo, Utah: Brigham Young University Press, 1974), 66, 220.

EXHIBITION: *The First Fifty Years 1934-1984: American Paintings and Sculpture from the University Art Museum Collection*, 1984.

PROVENANCE: Louis W. Hill, Sr.; Louis W. Hill, Jr.

The Dream Pipe, *1917*

Oil on canvas, 39⅞ x 49⅞ in.
(101.3 x 126.7 cm.)
Signed lower right: Maynard Dixon,
Blackfeet Ind. Res. Montana, Oct. 1917
Gift of Louis W. Hill, Jr.
56.9
Illustration: Figure 24

REFERENCE: Wesley M. Burnside, *Maynard Dixon: Artist of the American West* (Provo, Utah: Brigham Young University Press, 1974), 66, 220.

PROVENANCE: Louis W. Hill, Sr.; Louis W. Hill, Jr.

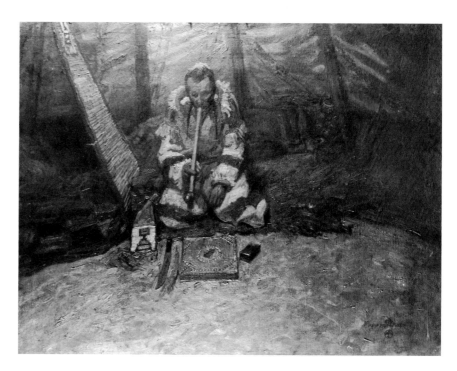

The Dream Pipe, *1917* ▪ *Figure 24*

Oil on canvas, 40 x 30⅛ in.
(101.6 x 76.5 cm.)
Signed lower right: Maynard Dixon, Glacier
National Park, Montana, Sept. 1917
Gift of Louis W. Hill, Jr.
56.10
Illustration: Appendix

REFERENCE: Wesley M. Burnside, *Maynard
Dixon: Artist of the American West* (Provo,
Utah: Brigham Young University Press,
1974), 66, 220.

PROVENANCE: Louis W. Hill, Sr.; Louis W.
Hill, Jr.

Split Mountain, *1917*

ARTHUR GARFIELD DOVE
1880-1946

SELECTED BIBLIOGRAPHY: A.R. Solomon, *Arthur G. Dove, 1880-1946* (Ithaca, New York: Cornell University, 1954) ▪ Frederick S. Wight, *Arthur G. Dove* (Los Angeles: University of California, 1958) ▪ Dorothy Rylander Johnson, *Arthur Dove: The Years of Collage* (College Park, Maryland: University of Maryland Art Gallery, 1967) ▪ Barbara Haskell, *Arthur Dove* (San Francisco: San Francisco Museum of Art, 1974) ▪ William Innes Homer, *Alfred Stieglitz and the American Avant-Garde* (Boston: New York Graphic Society, 1977), 108-123, 209-215 ▪ Sasha M. Newman, *Arthur Dove and Duncan Phillips: Artist and Patron* (Washington, D.C.: The Phillips Collection, 1981) ▪ Susan Fillin Yeh, "Innovative Moderns: Arthur G. Dove and Georgia O'Keeffe," *Arts* 56:10 (June 1982): 68-72.

One of the artists closely associated with art impresario Alfred Stieglitz, Arthur Dove was a revolutionary abstractionist whose earliest nonobjective paintings were contemporaneous with the more famous works of Wassily Kandinsky. Born into a wealthy family near Geneva, New York, Dove rebelled against pressure to become involved in their mercantile pursuits. He was educated at Hobart College and Columbia University and in 1903 began working as a commercial illustrator in New York City.

Restless and uninspired, he went to Europe in 1907 to study painting. There he came into contact with fauvism and other progressive movements in art; he was particularly influenced by the work of Cézanne, which he first saw in Paris. Dove exhibited in the advanced Parisian salons and became acquainted with the young American expatriate artistic community, which included Arthur B. CARLES, Max WEBER, Patrick Henry Bruce, and Alfred MAURER, who became a lifelong friend. Returning to the States, he was included in Stieglitz's 1910 Younger American Painters exhibition along with Carles, Weber, and Maurer.

Dove was to become one of the most radical and influential painters of this illustrious group. He held his first one-man exhibition at Stieglitz's 291 Gallery in 1912 and was one of the few avant-garde American painters absent from the 1913 Armory Show. He was, however, represented in the 1916 Forum exhibition and the first annual Society of Independent Artists exhibition in 1917. From 1912 to 1918 he painted while farming in Connecticut; from 1920 to 1927 he lived and worked on a houseboat on the Harlem river. These experiences provided him with his dominant themes: country landscape and the sea. He finally settled in Centerport, Long Island in 1938.

Throughout his career, Dove was fascinated by the basic organic shapes of plants and animals, seeing them as symbols of process and change. His landscapes, rendered in planar shapes and simple harmonic color patterns, express a strong personal pantheism. *P.N.*

Tree Study, *c. 1925* • *Figure 25*

Oil on canvas board, 10¼ x 8⅜ in.
(26 x 21.3 cm.)
Unsigned
Bequest of Hudson Walker from the Ione
and Hudson Walker Collection
78.21.328
Illustration: Figure 25

EXHIBITIONS: Whitney Museum of American
Art, New York, *Pioneers of Modern Art in
America*, 1946 • Tweed Gallery, University
of Minnesota-Duluth, *A Survey of American
Painting*, 1955 • American Federation of
Arts Traveling Exhibition, *Pioneers of*

Tree Study, *c. 1925*

A tiny painting balancing between realism and abstraction, *Tree
Study* illustrates Arthur Dove's use of nature's minutiae to
symbolize the elemental forces of change in the universe. The
realistic, albeit microscopic, focus on the most particularized
portion of the tree suggests a turning away from the abstract nature
symbols of his early experimental paintings. During the late 1920s
he increasingly explored realism, caricature, and anthropomor-
phism, and while his major themes remained constant a playfulness
emerged that remained evident well into the 1930s.

American Abstract Art, 1955-1956 • Art and the University of Minnesota, 1961 • Selections from the Permanent Collection, 1970 • Artmobile, Minneapolis Institute of Arts traveling exhibition, Painters and Photographers of Gallery 291, 1973-1974 • Hudson D. Walker: Patron and Friend, 1977, cat. 10 • Minnesota Museum of Art, St. Paul, American Style: Works from Minnesota Collections, 1981, cat. 18.

PROVENANCE: C. Philip Boyer; Ione and Hudson Walker

Oil on canvas, 25¾ x 35¾ in. (65.4 x 90.8 cm.)
Signed lower right: Dove
Purchase, General Budget Fund
36.84
Illustration: Colorplate V

REFERENCE: Louis Chapin, "Whirling Wind and Water into Brief, Forceful Images," The Christian Science Monitor (23 January 1974): F7.

EXHIBITIONS: Rockefeller Center, New York, First Municipal Air Exhibition, 1934 • Five Painters, 1937 • Traveling exhibition, Some Individuals, 1941-1942 • Original Paintings from the University Collection, 1946, cat. 33 • Drew Fine Arts Center, Hamline University, St. Paul, Exhibition of Paintings by Some American Individualists, 1950 • Tweed Hall, University of Minnesota-Duluth, 1951 • Selections from the Permanent Collection, 1954 • Tweed Gallery, University of Minnesota-Duluth, A Survey of American Painting, 1955 • Brooks Memorial Union, Marquette University, Milwaukee, 75 Years of American Painting, 1956 • Joslyn Art Museum, Omaha, Notable Paintings from Midwestern Collections, 1956-1957 • Minnesota State Fair, St. Paul, American Art of the Twentieth Century from the Collection of the University Gallery, University of Minnesota, 1957 • Selections from the Permanent Collection, 1957 • University of North Carolina, Chapel Hill, Inaugural Exhibition—Ackland Art Center, 1958 • Rochester Art Center, Rochester, Minnesota, Significant American Painters, 1959 • Kresge Art Center, Michigan State University, East Lansing, American Painting Since 1900, 1960 • Selections from the

Georgia O'KEEFFE shared Dove's fascination with the process of change as revealed through close inspection of natural forms. Since the two of them knew each other and occasionally painted together, it is quite possible that the tree in O'Keeffe's *Birch and Pine Tree No. 1* from 1925 shows the same limb as the one featured in *Tree Study*. (For a reproduction of *Birch and Pine Tree No. 1*, see page 113 of *Avant-Garde Painting in America*, edited by William Innes Homer [Wilmington, Delaware: Delaware Art Museum, 1975].) This connection suggests that Dove's painting, otherwise undated, was completed in the same year.

Gale, *1932*

Dating from a brief period of realism in Dove's career during the early 1930s, *Gale* is one of many variations on marine themes which grew out of the artist's personal experiences. From 1920 to 1927 he lived on a houseboat, the "Mona," and in 1929 he moved into the Ketewomoke Yacht Club in Halesite, Long Island with his second wife, the painter Helen Torr. Dove's turn to a more realistic, narrative approach during the late 1920s and early 1930s was characteristic of the majority of artists who had espoused radical modernist causes and styles at the beginning of the century. His excursion into painting recognizable elements was short-lived, however; soon after painting *Gale*, his style reverted to a hard-edged abstraction.

In contrast to the lyrical, pastoral tone of works produced during the early phase of Dove's career, *Gale* has a menacing, almost demonic quality. Nature is no longer presented as a haven, but as the personification of human anxiety: violent winds and an angry sea pummel an abandoned boat. Like many of the marine paintings Dove produced in the 1930s, this one evokes the mysterious, anthropomorphic moods of the sea. The heavy sky seems a spectral, grasping creature, while openings resembling serpents' eyes give the sea an evil, leering cast. Dull colors intensify the overall gloom—undoubtedly a reflection of Dove's own state of mind in the wake of the Depression, a particularly harsh and trying period for those artists who, like Dove, eschewed the government work projects.

Permanent Collection, 1962 • Rochester Art
Center, Rochester, Minnesota, *Minnesota
Art Sources*, 1963 • Tweed Museum of Art,
University of Minnesota-Duluth, 1965, cat.
49 • Northern Arizona University Art
Gallery, Flagstaff, *The Colleges and
Universities Collect*, 1966 • University of
Maryland Fine Arts Gallery, College Park,
Arthur Dove, 1967 • Museum of Modern
Art Traveling Exhibition, *Arthur Dove*,
1968-1969 • Artmobile, Minneapolis
Institute of Arts traveling exhibition,
American Art: The Early Moderns, 1969-
1970 • *Selections from the Permanent
Collection*, 1970 • Artmobile, Minneapolis
Institute of Arts traveling exhibition,
American Art, 1930-1970, 1970-1971 •
Works from the Permanent Collection,
1972 • Committee on Institutional
Cooperation Traveling Exhibition, *Paintings
from Midwestern University Collections,
17th-20th Centuries*, 1973-1975, cat. 55 •
Heckscher Museum, Huntington, New
York, *The Drama of the Sea*, 1975 • *Ruth
Lawrence Remembered, 1890-1977*, 1978 •
*Contact: American Art and Culture, 1919-
1939*, 1981, cat. 4 • Minnesota Museum of
Art, St. Paul, *American Style: Works from
Minnesota Collections*, 1981, cat. 17 •
Carleton College, Northfield, Minnesota,
*American Abstraction: 20th Century
American Paintings from the University of
Minnesota*, 1983 • *The First Fifty Years
1934-1984: American Paintings and
Sculpture from the University Art Museum
Collection*, 1984 • *New York and American
Modernism*, 1984.

PROVENANCE: Alfred Stieglitz

Figure One, *c. 1915-1920* • *Figure 26*

CHARLES W. DUNCAN
1892-

SELECTED BIBLIOGRAPHY: William H. Gerdts, Jr., *Painting and Sculpture in New Jersey*, volume 24 in *The New Jersey Historical Series* (Princeton, New Jersey: D. Van Nostrand Co., Inc., 1964), 218 • William Innes Homer, *Alfred Stieglitz and the American Avant-Garde* (Boston: New York Graphic Society, 1977), 307 • John Marin Papers, Miscellaneous Manuscript Collection, Archives of American Art, Smithsonian Institution, Washington, D.C.

Oil on canvas, 30 x 22 in.
(76.2 x 55.9 cm.)
Signed on stretcher in ink: C. Duncan
Gift of Ione and Hudson Walker
53.310
Illustration: Figure 26

EXHIBITIONS: *Hudson D. Walker: Patron and Friend*, 1977, cat. 13 • *Abstract USA/ 1910-1950*, 1981 • Carleton College, Northfield, Minnesota, *American Abstraction: 20th Century American Paintings from the University of Minnesota*, 1983.

PROVENANCE: Alfred Stieglitz; Ione and Hudson Walker

The modernist painter Charles W. Duncan is a mysteriously elusive figure in the annals of American art. According to *Camera Work*, he was a resident of New York City in 1916, the year he exhibited with Georgia O'KEEFFE and René Lafferty at Alfred Stieglitz's gallery 291 (New York); included in that show were two of his watercolors and one drawing. Through the Stieglitz connection, Duncan became friendly with John Marin, and their relationship is documented by correspondence from Marin to Duncan during the 1940s, when Duncan was living in New Jersey. A painter and lithographer, Duncan exhibited several times at 291; he also published poetry and was reported to have earned his living as a sign painter. He should not be confused with Charles Stafford Duncan (1892-1952), who lived and worked in San Francisco. *P.N.*

Figure One, *c. 1915-1920*

The ambiguous figure in this painting (once owned by Alfred Stieglitz) is similar in subject to Duncan's late work, although considerably more provocative in form. The undulating pattern of curves and countercurves can be perceived as either a primitive mask face (*figure* in French) or a seated woman with her head thrown back and her left arm draped over her knee; the title allows for either interpretation.

While the use of pinkish skin tones may prompt a literal reading of the subject as a female figure, closer examination reveals a mask face glaring out of the torso. The peculiar pose, unsubtle color, equivocal title, and application of paint in broad, unmodulated areas link Duncan to the advanced ideas prevalent during his early career. His studies of the intricacies of visual perception and pictorial space align him with other modernists associated with Alfred Stieglitz and his progressive gallery 291.

LOUIS MICHEL EILSHEMIUS
1864-1941

SELECTED BIBLIOGRAPHY: William Schack, *And He Sat Among the Ashes* (New York: American Artists Group, 1939) • *The High Kitsch of Eilshemius* (New York: Sidney Janis Gallery, 1970) • Paul J. Karlstrom, *The Romanticism of Eilshemius* (New York: Bernard Danenberg Galleries, 1973) • Paul J. Karlstrom, *Louis Michel Eilshemius* (New York: Harry N. Abrams, 1978) • Paul J. Karlstrom, *Louis M. Eilshemius: Selections from the Hirshhorn* (Washington, D.C.: Hirshhorn Museum, 1978) • Paul J. Karlstrom, "Eilshemius' Pursuit of Fame: A Tragic Story," *Smithsonian* 9:8 (November 1978): 98-105.

A poetic painter with romantic tendencies, Louis Michel Eilshemius produced almost 3,000 paintings of bathers, landscapes, religious subjects, and genre scenes. He is an enigmatic figure in American art—a creator of fantasies, idylls, and nightmares.

Born into a wealth family living outside New York City, Eilshemius received his early education in Dresden, Germany. Following two years at Cornell University, he studied painting at the Art Students League and the Académie Julian in Paris. While his early work in the manner of the Barbizon and Hudson River schools was well received, his unique and seemingly bizarre mature style was misunderstood and ignored. Melancholy and bitter from public neglect, he persisted in trying to gain recognition, going so far as to vary the spelling of his name.

He was finally "discovered" at the Society of Independent Artists in 1917, reputedly by Marcel Duchamp, and was given a one-man show at the Société Anonyme in 1920 and again in 1924. His stay in the limelight was short-lived, however; although he received another burst of attention in the 1930s, he died in relative obscurity. Considered a primitive for many years, Eilshemius is now appreciated for his subtlety and sophistication and is regarded as an important figure in the continuation of the romantic tradition in American art. *P.N.*

Sunset, *c. 1913-1916*

A small land and seascape encircled by a painted frame within the actual frame, *Sunset* was probably painted between 1913 and 1916, as it relates to several other works Eilshemius produced during that time. The painted frame device, first used by the artist in 1911, creates a decorative porthole effect and serves to distance the viewer.

Oil on gesso on wood panel, 8½ x 16¾ in. (21.6 x 42.5 cm.)
Signed lower left: Eilshemius
Bequest of Hudson Walker from the Ione and Hudson Walker Collection
78.21.320
Illustration: Figure 27

EXHIBITIONS: Tweed Gallery, University of Minnesota-Duluth, *A Survey of American Painting*, 1955 • *Hudson D. Walker: Patron and Friend*, 1977, cat. 14.

PROVENANCE: Ione and Hudson Walker

Like Albert Pinkham Ryder, Eilshemius was fascinated by the mysterious and the romantic and often painted sunsets or moonlit nights to convey mood. In this work, a small flick of the brush created an apparition. The figure on shore and the distant lighthouse—or perhaps it is a sailboat reflecting the setting sun—are purposefully undefined, leaving the interpretation of the painting to the imagination. The haunted, dreamlike aura of the scene and its enigmatic narrative prefigure surrealism. The landscape, simplified into two horizontal bands of color broken by a jutting rock, displays a strong sense of abstract design.

Sunset, *c. 1913-1916* • *Figure 27*

99

PHILIP C. ELLIOTT
1903-

SELECTED BIBLIOGRAPHY: "Reviews," *Art Digest* (1 October 1944): 10 • "57th Street in Review," *Art Digest* (June 1952): 15.

Oil on canvas, 36¼ x 30⅛ in.
(92.1 x 76.5 cm.)
Signed lower right: Philip Elliott '47
Bequest of Hudson Walker from the Ione
and Hudson Walker Collection
78.21.314
Illustration: Appendix

EXHIBITIONS: National Academy of Design,
New York, *Pepsi-Cola Fourth Annual Art
Competition & Exhibition*, 1947 • Albright
Art Gallery, Buffalo, New York, *Annual
Exhibition at Buffalo by Artists of Western
New York*, 1947 • Charles Burchfield
Center, Buffalo, New York, *Retrospective:
Virginia Cuthbert and Philip Elliott*, 1971.

PROVENANCE: Virginia I. Cuthbert; Ione and
Hudson Walker

Born in Minneapolis, Philip Elliott attended the University of Minnesota before receiving his BFA from Yale in 1926. After studying photography for four years in Paris on the Chaloner Fellowship from Yale, he returned to teach at the University of Pittsburgh from 1934 to 1940, was director of the Albright Art School from 1941 to 1954, and taught at the State University of New York at Buffalo from 1954 to 1971.

Elliott's compositions from the 1940s appear to have been influenced by the abrupt foreshortening of the camera. Their heightened geometric shadows are reminiscent of architectural forms in the paintings of Edward Hopper. Because Elliott's canvases were meticulously executed, his output during that time was small. By 1963 his paintings had become entirely abstract, with small rectangular passages of color placed within broad geometric forms.

Elliott exhibited in one-man and group shows at the Carnegie Institute, the Museum of Modern Art, and the Albright-Knox Art Gallery and the Charles Burchfield Center (both Buffalo, New York). *M.T.S.*

Children at Play, *1947*

From 1944 to 1952 Elliott painted New England scenes in which compositional forms were abstracted into sharp-edged rectangles and triangles. The similarities between his work and Hopper's may be due to the interest both men had in prints and photography, and to the many photographs of foreshortened views of factories and city buildings which appeared in art and literary magazines during the 1920s and 1930s.

PHILIP EVERGOOD
1901-1973

SELECTED BIBLIOGRAPHY: *Evergood, 20 Years* (New York: ACA Gallery, 1946) ▪ Lucy R. Lippard, *The Graphic Work of Evergood, Selected Drawings and Complete Prints* (New York: Crown Publishers, 1966) ▪ Alfredo Valente, *Philip Evergood, A Painter of Ideas* (New York: The Gallery of Modern Art, 1969) ▪ John I.H. Baur, *Philip Evergood* (New York: Harry N. Abrams, 1975) ▪ Kendall Taylor, "The Philip Evergood Papers," *Archives of American Art Journal* 3 (1978): 2-11.

Born Philip Blaski in New York City, Philip Evergood grew up in the studio atmosphere of his artist father. His mother, who came from a wealthy New England family, insisted that her son be educated in England and sent him to Eton and Cambridge. At Eton, Evergood was encouraged to draw and paint from his imagination. After two years at Cambridge he transferred to the Slade School to study art with Henry Tonks, a careful draftsman who had his pupils copy drawings and paintings of the old masters.

Evergood studied and painted in Paris from 1924 to 1926 and again from 1929 to 1931, when he returned to New York. While working at the Gallery of American Indian Art on Madison Avenue, he met Dolly and John Sloan, who not only encouraged him during his early career but also introduced him to Juliana Force. She in turn invited him to show in the annual exhibitions of the Whitney Museum of American Art through the 1930s. When the Gallery closed in 1935, Evergood joined the WPA/FAP, acting as managing supervisor for New York's easel division.

Evergood's subject matter, allegorical and biblical throughout the 1920s and early 1930s, took a sharp turn toward social problems during the mid-1930s. The artist became personally and militantly involved with social causes: he attended meetings of the John Reed Club; signed the call for the American Artists Congress; demonstrated on behalf of Negro rights, the Spanish Loyalist cause, and Russian war relief; and in 1936 participated in the 219 Strike in which 291 artists protested layoffs from the WPA.

Starting in the mid-1930s, Evergood exhibited widely. He appeared in the first Whitney annual in 1934 and in each subsequent one and at the Carnegie International in Pittsburgh. From 1940 on he participated in most important annual and biennial exhibitions throughout the country. After the demise of the WPA/FAP he took various odd jobs to support himself and his wife. Then, while working at the Midtown Frame shop, he met Joseph Hirshhorn, who became one of his most important patrons during the 1940s.

Evergood continued to paint social and racial themes into the early 1950s, when he was drawn toward more fantastic and sensuous subjects. After his large retrospective at the Whitney in 1960, his paintings grew increasingly fanciful and often related to earlier experiences and to reading.

Evergood taught at the American Artists School in New York from 1936 to 1937, Kalamazoo College in Kalamazoo, Michigan from 1940 to 1942, and Muhlenburg College in Allentown, Pennsylvania from 1942 to 1944. He received numerous awards during his career, including a grant for painting from the American Academy of Arts and Letters in 1958, the Temple Gold Medal at the Pennsylvania Academy of the Fine Arts in 1971, and the Benjamin Altman prize at the National Academy of Design in 1971. *M.T.S.*

Wheels of Victory, 1944

Conflicts between man and machine as well as between the races were recurrent themes in Evergood's work from the mid-1930s into the early 1940s. This canvas won a second prize of $2,000 in the Portrait of America exhibition sponsored by the Pepsi-Cola Company in 1944. Although Evergood claimed to feel guilty about using capitalist means to increase this sum, he invested the entire amount in mining stock on a tip from his patron, Joseph Hirshhorn. When his investment reached $9,000, he sold the stock to buy a studio-home in Greenwich Village.

Oil on panel, 37¾ x 42½ in.
(95.9 x 108 cm.)
Signed lower left: Philip Evergood
Bequest of Hudson Walker from the Ione and Hudson Walker Collection
78.21.830
Illustration: Colorplate XX

EXHIBITIONS: *Portrait of America, Pepsi-Cola Exhibition, New York, 1944* ▪ *Tweed Gallery, University of Minnesota-Duluth, Evergood Retrospective, 1955* ▪ *Selections from the Permanent Collection, 1968* ▪ The Gallery of Modern Art, New York, *Philip Evergood Retrospective, 1969,* cat. 85 ▪ Tweed Museum of Art, University of Minnesota-Duluth, *Twentieth Anniversary Exhibition, 1970* ▪ St. John's University/College of St. Benedict, Collegeville, Minnesota, *University of Minnesota Art Exhibit, 1971* ▪ Norton Gallery and School of Art, West Palm Beach, Florida, *Philip Evergood: A Retrospective, 1976,* cat. 12 ▪ *Hudson D. Walker: Patron and Friend, 1977,* cat. 15 ▪ The Academy of Fine Arts (Neue Gesellschaft fur Bildende Kunst), West Berlin, *The American Scene, 1920-1940, 1980* ▪ Kuntstverein, Hamburg, West Germany, *The American Scene, 1920-1940, 1981* ▪ *The First Fifty Years 1934-1984: American Paintings and Sculpture from the University Art Museum Collection, 1984.*

PROVENANCE: Ione and Hudson Walker

The New Maid, *c. 1949*

Gouache on gesso on masonite, 19½ x 16 in.
(49.5 x 40.6 cm.)
Signed lower right: Philip Evergood
Gift of Professor and Mrs. Samuel H.
Popper
79.8.4
Illustration: Appendix

PROVENANCE: *Seventeen Magazine*; Professor
and Mrs. Samuel H. Popper

This work appeared in the January 1950 issue of *Seventeen Magazine* as an illustration for the short story, "Mrs. Kochinsky and the Problem Child."

A Question of Ethics or Aesthetics (Self-Portrait), *1954*

Evergood's work from the 1950s probed humankind's inner fantasies and resources. His self-portraits emphasized minute imperfections and the effects of aging on his face and hands, which were often expressively distorted.

Oil on panel, 16 x 12 in.
(40.6 x 30.5 cm.)
Signed lower left: Philip Evergood (dated
verso)
Bequest of Hudson Walker from the Ione
and Hudson Walker Collection
78.21.829
Illustration: Figure 28

EXHIBITIONS: *100 Paintings, Drawings, and
Prints from the Ione and Hudson D.
Walker Collection*, 1965, cat. 11 •
Selections from the Permanent Collection,
1970 • Tweed Museum of Art, University of
Minnesota-Duluth, *Twentieth Anniversary
Exhibition*, 1970 • *Hudson D. Walker:
Patron and Friend*, 1977, cat. 16.

PROVENANCE: Ione and Hudson Walker

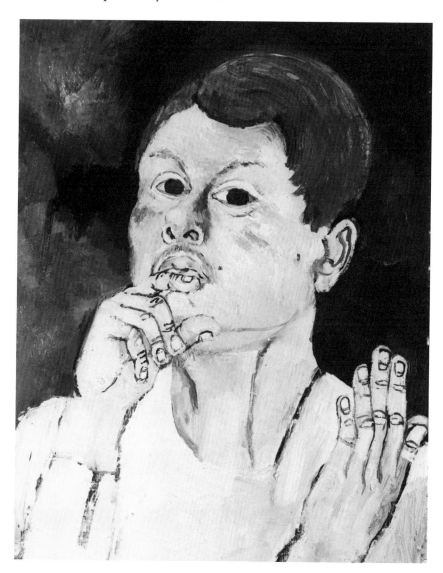

A Question of Ethics or Aesthetics (Self-Portrait), *1954 • Figure 28*

REMO MICHAEL FARRUGGIO
1906-

SELECTED BIBLIOGRAPHY: *Remo Farruggio* (Milan: Nuova Sagittario Gallery, 1974).

Remo Farruggio emigrated from his native Sicily to the United States in 1918. In New York he studied at the National Academy of Design, the Beaux Arts Institute, and the Educational Alliance and Industrial Art School before joining the WPA/FAP easel project. While he was enrolled in the project, his paintings of barren land and seascapes were similar to those of other American surrealists influenced by the metaphysical cityscapes of Giorgio de Chirico and the surrealist landscapes of Salvador Dali. In 1939 his fantasy scenes were exhibited at the prestigious Julien Levy Gallery (New York).

Farruggio left New York in 1942 to work as a machinist and to teach at the Federation of Artists school in Detroit; in 1943 he received first prize for a painting exhibited at the Detroit Art Institute. By 1949, when he returned to New York for an exhibition of his work at the Salpeter Gallery, his paintings had become more expressionistic and decorative. The visual influences of landscapes he sketched during vacations in Mexico and Italy further brightened his palette, and by the mid- to late-1950s he was indicating scenes by abstracted rectangles of color. Human figures were always female nudes in decorative poses and colors that recalled the playful fantasies of Joan Miró and Paul Klee.

The sensuous nude and abstracted landscape continued as subjects in his paintings throughout the 1960s and 1970s. Farruggio returned for longer periods to Sicily, and paintings completed there through the 1970s reflect Italy's ochre and umber landscape tones. *M.T.S.*

Nostalgia, *1937*

Oil on canvas, 24 x 30 in.
(61 x 76.2 cm.)
Signed lower right: Remo Farruggio 1937
WPA Art Project, Washington, D.C.
43.731
Illustration: Appendix

REFERENCE: Scrapbook compiled by the artist on file at the University Art Museum.

PROVENANCE: WPA Art Project, Washington, D.C.

Farruggio was employed by the WPA/FAP easel project when he completed this canvas; exhibited at the Federal Art Gallery in New York, it was described by Jerome Klein of the *New York Post* as filled with "strange fantasy." Paintings he showed at the Julien Levy Gallery in 1939 were still based on the formats and titles of paintings by European surrealists in which lone figures inhabit empty land or seascapes. The hot dog on the small sign to the left may have been symbolic; frankfurters served as enigmatic images in other fantasy scenes Farruggio painted during this period.

LYONEL CHARLES ADRIAN FEININGER
1871-1956

SELECTED BIBLIOGRAPHY: *Lyonel Feininger—Marsden Hartley*, edited by Dorothy Miller (New York: Museum of Modern Art, 1944) • Hans Hess, *Lyonel Feininger* (New York: Harry N. Abrams, 1961) • T. Lux Feininger, *Lyonel Feininger—City at the Edge of the World* (New York: Frederick A. Praeger, 1965) • *Lyonel Feininger*, edited by June L. Ness (New York: Praeger, 1974) • Leona E. Prasse, *Lyonel Feininger, A Definitive Catalogue of his Graphic Work: Etchings, Lithograph, Woodcuts* (Cleveland: Cleveland Museum of Art, 1972).

Internationally acclaimed as a leading abstract artist during his lifetime, Lyonel Feininger (born Charles Leonell Feininger in New York City) began his artistic training at the Kunstgewerbeschule in Hamburg, Germany in 1887. After continued study in Berlin, Liège, and Paris, he returned to Berlin in 1893 and gained recognition as an illustrator and cartoonist. In 1906 he originated the comic strips "The Kinder-Kids" and "Wee Willie Winkie's World" for the *Chicago Sunday Tribune*, displaying his sophistication as a comic draftsman.

Turning to painting in 1907, Feininger began to evolve his unique style after encounters with post-impressionism in 1907, cubism in 1911, and German expressionism, most notably the *Blau Reiter* group, with whom he exhibited in 1913. His many landscapes, often marine or urban in subject, bear a relation to cubism, although his use of faceted, overlapping planes and radiating lines construct form rather than dissolve it. They possess a futuristic quality while simultaneously evoking a sense of drama and spirit reminiscent of late nineteenth-century German romanticism.

In 1919 Feininger was invited to become a professor at the Weimar Bauhaus, where he taught until 1925; in that year he also became artist-in-residence at Dessau. Increasingly aware of the unfavorable artistic climate and mounting tension in prewar Nazi Germany, Feininger returned to New York in 1937 and remained there until his death at age 84. *P.N.*

Dröbsdorf I, *1928*

Oil on canvas, 32⅛ x 39¾ in. (81.6 x 101 cm.)
Signed lower left: Feininger
Purchase, General Budget Fund
39.97
Illustration: Colorplate XXII

REFERENCES: Hans Hess, *Lyonel Feininger* (New York: Harry N. Abrams, 1961), 112-113, 135 (also no. 301 in Julia Feininger, "Oeuvre Catalogue").

From 1924 to 1935 Feininger spent his summers in a village on the Baltic Sea. The neighboring towns provided fertile subjects for him; he favored small villages with medieval churches topped by soaring spires, which formed the focal point for his paintings just as they did for the towns. *Dröbsdorf I* epitomizes the drama and spirit of these landscapes and demonstrates the artist's mature personal style in delicately washed overlapping cubist planes. The evenness of construction in the paintings gives the same density and mass to the sky as to the architecture.

EXHIBITIONS: *Lyonel Feininger: A Retrospective Exhibition at the University of Minnesota*, 1938, cat. 11 ▪ Traveling Exhibition, *Some Individuals*, 1941-1942 ▪ *Original Paintings from the University Collection*, 1946, cat. 36 ▪ University of Indiana, Bloomington, 1949 ▪ Rochester Art Center, Rochester, Minnesota, 1950 ▪ Drew Fine Arts Center, Hamline University, St. Paul, *Exhibition of Paintings by Some American Individualists*, 1950 ▪ Allen Memorial Art Museum, Oberlin, Ohio, *College and University Owned Paintings*, 1953 ▪ *Selections from the Permanent Collection*, 1953, 1954 ▪ Centro Internazionale di Arte e di Cultura, Bordighera, Italy, *III Mostra di Pittura Americana*, 1955, cat. 23 ▪ Brooks Memorial Union, Marquette University, Milwaukee, *75 Years of American Painting*, 1956 ▪ Joslyn Art Museum, Omaha, *Notable Paintings from Midwestern Collections*, 1956-1957 ▪ Minnesota State Fair, St. Paul, *American Art of the Twentieth Century from the Collection of the University Gallery, University of Minnesota*, 1957 ▪ *Selections from the Collection*, 1957 ▪ University of Kansas Museum of Art, Lawrence, *Masterworks from University and College Art Collections*, 1958, cat. 57 ▪ Ackland Museum, University of North Carolina, Chapel Hill, *American College and University Collections*, 1958, cat. 85 ▪ University of California, Berkeley, *From Ingres to Pollack: Painting and Sculpture Since Neoclassicism*, 1960 ▪ Milwaukee Art Center, Milwaukee, *Ten Americans*, 1961, cat. 21 ▪ *Selections from the Permanent Collection*, 1962 ▪ Rochester Art Center, Rochester, Minnesota, *Minnesota Art Sources*, 1963 ▪ Tweed Gallery, University of Minnesota-Duluth, *Dedicatory Exhibition Honoring Mrs. Alice Tweed Tuohy*, 1965, cat. 45 ▪ *Selections from the Permanent Collection*, 1968, 1969, 1970, 1972 ▪ Haus der Kunst, Munich, *Lyonel Feininger*, 1973 ▪ *Ruth Lawrence Remembered: 1890-1977*, 1978 ▪ *Selections from the Permanent Collection*, 1980 ▪ *Abstract USA/1910-1950*, 1981 ▪ Carleton College, Northfield, Minnesota, *American Abstraction: 20th Century American Paintings from the University of Minnesota*, 1983 ▪ *The First Fifty Years 1934-1984: American Paintings and Sculpture from the University Art Museum Collection*, 1984.

PROVENANCE: the artist

Writing for the catalogue of Feininger's 1944 joint exhibition with Marsden HARTLEY, Alois J. Schardt commented: "Churches, standing alone or surrounded by houses, become another and still more fruitful motive....They are again the means to demonstrate the theme of rising and falling, of ascending and descending. There are numerous variations on this theme....The tower stands guard; and at the same time it reaches upward. It is a symbol of striving toward security and freedom" (Miller, editor, 1944, p. 17).

STANFORD FENELLE
1909-

Stanford Fenelle, who was born in Minneapolis and studied with Cameron BOOTH at the Minneapolis School of Art and the St. Paul School of Art, began as a painter of local scenes. During the summer of 1934 he was employed by the University of Minnesota to paint views of the Minneapolis campus to hang in University buildings. Under the WPA/FAP he taught watercolor and sketching classes at the Minneapolis Art Center and Walker Art Center in 1940.

Dogs were Fenelle's favorite subjects, and the champion dogs he raised won many prizes during the 1930s. In 1937 a special exhibition of paintings of his show dogs was held at the Downtown Gallery (New York). He also exhibited at Minnesota State Fair shows, winning first prize in 1931, 1932, and 1935; in the Local Artists Exhibitions at the Minneapolis Institute of Arts, winning first prizes in 1937 and 1939; and at Walker Art Center in 1942. His work was shown nationally in the International Watercolor Society Exhibition at the Art Institute of Chicago, the Brooklyn

SELECTED BIBLIOGRAPHY: Nancy Johnson, *Accomplishments: Minnesota Art Projects in the Depression Years* (Duluth: Tweed Museum of Art, University of Minnesota-Duluth, 1978) • Minneapolis History Collection, Minneapolis Public Library.

Oil on canvas, 28 x 36 in.
(71.1 x 91.4 cm.)
Signed lower left: Fenelle '37
WPA Art Project, Minneapolis
43.760
Illustration: Appendix

EXHIBITION: *Original Paintings from the University Collection*, 1949, cat. 49.

PROVENANCE: WPA Art Project, Minneapolis

Museum Watercolor Exhibition, the Corcoran Gallery of Art (Washington, D.C.), and the Golden Gate Exposition in San Francisco.

Since his retirement from the art department of St. Paul's Brown and Bigelow company in 1974, Fenelle has concentrated on preserving scenes of buildings from America's past. *M.T.S.*

Mining Pit, *1937*

Like Dewey ALBINSON, Fenelle seemed to focus on the homelier aspects of his environment during the mid- to late-1930s; toward the end of that period, however, he preferred more idyllic scenes.

LOUIS GOODMAN FERSTADT
1900-1954

SELECTED BIBLIOGRAPHY: "Reviews," *Art News* (28 January 1939): 14 • "Louis Ferstadt," *Art Digest* (September 1954): 27.

Born in Russia, Louis Ferstadt immigrated to the United States and studied at the Art Students League with Harry I. Stickroth and Kenneth Hayes Miller in the 1920s. His paintings gradually evolved from realistic compositions using subdued color to canvases which incorporated elements of abstraction and surrealism, showing some influence from the works of Marc Chagall.

By the time he exhibited at the Hudson D. Walker Gallery (New York) in 1937 and 1939, his focus had shifted to a more realistic style that probed the social injustices of our governmental system. As the recording secretary of the Mural Artists Guild, he fought to unionize mural painters working under contract for the 1939 New York World's Fair. He himself completed a mural for the fair on the Fifth Avenue subway entrance facing Times Square; his figures, who overpowered their allotted space, are reminiscent of David Alfaro Siqueiros. Ferstadt continued to paint canvases espousing social causes, but over time the images became more symbolic and ambiguous.

He was a director of the National Society of Mural Painters, an illustrator for the *Chicago Tribune*, and an editor and art director for a comic book publishing firm. His work is in the collections of the Whitney Museum of American Art and the Art Students League, among others. *M.T.S.*

David, *1926*

Oil on canvas, 15¾ x 12¼ in.
(40 x 31.1 cm.)
Signed upper left: Louis G. Ferstadt, 1926
Purchase
38.51
Illustration: Appendix

REFERENCE: "Ferstadt, Organizer," *Art Digest* (September 1938): 20.

EXHIBITION: *Original Paintings from the University Collection*, 1946, cat. 58.

PROVENANCE: Hudson D. Walker Gallery, New York

Like many of his later paintings, *David* is comprised of collagelike juxtapositions of symbolic scenes. The hard-edged forms typify methods used by other painters during the 1930s to highlight and separate figures from their scenic backgrounds. This painting was illustrated in the September, 1938 *Art Digest* with this commentary: "It is considered a typical example of the brush work of the man who, under the innocuous sounding title of the 'Acting Recording Secretary' of the Mural Artists Guild, has been battling to unionize the mural artists of the country under the banner of the A.F. of L." ("Ferstadt, Organizer," p. 20).

EMIL FOERSTER
1822-1906

SELECTED BIBLIOGRAPHY: George C. Groce and David H. Wallace, *The New York Historical Society's Dictionary of Artists in America* (New Haven, Connecticut: Yale University Press, 1966), 232.

According to contemporary accounts, Emil Foerster painted over 600 portraits of prominent figures in Pittsburgh, Philadelphia, and New York. Born in Giessen, Germany, he came to the United States as a child and, like his better-known contemporary Albert BIERSTADT, later returned to his native land to study art at the Düsseldorf Academy. The precise draftsmanship and meticulous attention to detail taught there are apparent in his portrait of Minnesota businessman and politician John Nicols. *R.N.C.*

John Nicols, *1851*

Oil on canvas, 27⅛ x 23⅞ in.
(68.9 x 60.6 cm.)
Signed verso: E. Foerster 1851
Anonymous gift
51.51
Illustration: Appendix

PROVENANCE: University of Minnesota Archives

The earliest portrait in the University Art Museum's collection, this work was painted in the year John Nicols (1811-1873), a native of Talbot County, Maryland, came to the bustling pioneer town of St. Paul to engage in the iron trade. When his business prospered and his economic future was assured, he entered politics and was a Minnesota state senator in 1864 and again from 1871 until his death in 1873. A regent of the University of Minnesota from 1864 to 1873, Nicols served on a special board appointed to save the University from its creditors, traveling all over the southern parts of the state to search out creditors and arrange settlements with them.

His portrait was probably painted in Pittsburgh, where Nicols worked in the grocery business before heading west to the Minnesota Territory. According to an enthusiastic Pittsburgh critic,

Foerster's portraits were "not only capital likenesses but admirable works of art...beautifully finished and surpassing anything of the kind in their exquisite fidelity to nature" (*The Daily Pittsburgh Gazette* [17 August 1852], 3).

SYDNEY GLEN FOSSUM
1909-1978

SELECTED BIBLIOGRAPHY: *Syd Fossum, A Memorial (1909-1978)* (Minneapolis: University Gallery, University of Minnesota, 1978) • Minneapolis History Collection, Minneapolis Public Library.

Throughout his 50-year career as an artist, Syd Fossum actively fought the causes of social injustice. Born in Aberdeen, South Dakota, he attended Northern State Teachers College in Aberdeen, graduated from the Minneapolis School of Art in 1933, and subsequently studied at the Art Students League in New York. He was enrolled in the PWAP and the WPA/FAP easel project, taught at Walker Art Center under WPA funding, was one of the founders of the Minnesota Artists Union in the 1930s, and worked as an officer of Artists Equity on a state and national level before retiring to California in the mid-1970s.

In 1939 Fossum and other project artists picketed outside the state office of the WPA to protest the layoffs of 27 artists. He and several others were jailed and later released. In a 1942 court action, he successfully defended the right of artists to complete and exhibit a work before submitting it to fulfill official WPA allotments.

Fossum created backdrops for labor union rallies promoting war production in the early 1940s. While serving as an artilleryman in Germany during World War II, he set up makeshift studios wherever possible. Several paintings from sketches made during this time were shown at the opening of Walker Art Center's Minnesota Gallery in 1946 in a program designed to publicize state artists and craftsmen. Others were shown in Europe in 1945, an exhibition organized by the Minneapolis Institute of Arts to record the effects of war.

Fossum also taught at the Minneapolis School of Art from 1945 to 1950, Washington University in Seattle from 1950 to 1955, the Des Moines Art Center from 1953 to 1957, and the Duluth Art Center from 1960 to 1962. *M.T.S.*

Amoungst Ourselves, *1938*

Oil on canvas, 24⅛ x 28⅛ in.
(61.3 x 71.4 cm.)
Signed lower right: Fossum—38
WPA Art Project, Minneapolis, transferred
from the Minnesota Historical Society
56.18
Illustration: Figure 29

EXHIBITIONS: Tweed Museum of Art
(University of Minnesota-Duluth) Traveling
Exhibition, *Accomplishments: Minnesota
Art Projects in the Depression Years*, 1976-
1979, cat. 19 • American Swedish Institute,
Minneapolis, *Minnesota Artists 50 Years
Ago, 50 Works of Minnesota Artists of
1929*, 1979.

PROVENANCE: WPA Art Project,
Minneapolis, transferred from the
Minnesota Historical Society

This work is similar in content to *Bureau of Relief*, a painting Fossum completed in 1939 which was among 31 works of art purchased that year by the New York World's Fair. Both depict people wearily waiting in assembly halls. Fossum's canvases from the 1930s have been likened to those of Raphael SOYER, who also composed crowd scenes in which the viewer's eye is drawn to the haggard faces of individuals.

Amoungst Ourselves, *1938* • *Figure 29*

View of Duluth, *1939*

Oil on canvas, 29⅝ x 35¾ in.
(75.2 x 90.8 cm.)
Signed lower left: Fossum—39
WPA Art Project, Minneapolis
43.756
Illustration: Appendix

According to Fossum, artists enrolled in the WPA/FAP were encouraged to paint landscapes and industrial scenes. He didn't question this subtle censorship at the time because "I just loved to do rural landscapes, street scenes, or industrial scenes and most of the other artists were doing the same thing" (Syd Fossum, interview with George Reid, p. 5).

REFERENCE: Syd Fossum, interview with George Reid, University Gallery, University of Minnesota, Minneapolis (4 August 1977), p. 5.

EXHIBITIONS: *Original Paintings from the University Collection*, 1946, cat. 74 ▪ Tweed Museum of Art (University of Minnesota-Duluth) Traveling Exhibition, *Accomplishments: Minnesota Art Projects in the Depression Years*, 1976-1979, cat. 21.

PROVENANCE: WPA Art Project, Minneapolis

ALEXIS JEAN FOURNIER
1865-1948

SELECTED BIBLIOGRAPHY: Rena Coen, *Painting and Sculpture in Minnesota, 1820-1914* (Minneapolis: University of Minnesota Press, 1976), 112-119 ▪ Martin Friedman, "From the Ideal to the Real," *Design Quarterly* 101, 102 (1976): 35-41.

When Alexis Jean Fournier was born in St. Paul, the nation had not yet celebrated its centennial and Minnesota had been a state for fewer than ten years. At the time of his death, critical attention was firmly fixed on the exciting canvases of the abstract expressionists. His style throughout remained conservative, which may help to explain the relative obscurity in which he died and the subsequent neglect of his work. He is now being rediscovered and deserves recognition as one of America's most sensitive painters in the Barbizon mode.

Of French-Canadian descent, Fournier spent his boyhood in St. Paul, Milwaukee, and Fond du Lac, Wisconsin. By age 17 he was living in Minneapolis, where he was employed first as a shop sign painter and then as an assistant to a stage scene designer, a common apprenticeship for aspiring young artists of his day. He was also busy sketching and painting the Twin Cities and their environs. He showed enough promise to attract the attention of a number of local patrons, among them the railroad and lumber baron James J. Hill. Around 1886 Fournier studied briefly under Douglas Volk, the first director of the newly founded Minneapolis Academy of Arts (now the Minneapolis College of Art and Design). In 1887 he opened his own studio, and soon his paintings of the local scene were in great demand.

He longed to travel and study in Europe, and the generosity of friends enabled him to go to Paris in 1893. There he enrolled in the Académie Julian, studying under Jean Paul Laurens, Jean Joseph Benjamin-Constant, Gustave Courtois, and other French academicians. But it was Henri Joseph Harpignies who would have the most lasting influence on the young artist. Admiration for the work of this kindred spirit led Fournier to take up residence in the

village of Barbizon on another trip to France in 1907. He stayed in the house in which the artist François Daubigny had lived, spending his evenings with the son of François Millet and his days sketching the village and nearby countryside. These sketches served as preparation for a series of 20 paintings he called *The Haunts and Homes of the Barbizon Masters.*

In 1903 Fournier went to East Aurora, New York, to join the growing Roycroft Arts and Crafts community founded by the charismatic Elbert Hubbard. He also maintained a home in South Bend, Indiana for many years. *R.N.C.*

Minneapolis from the University of Minnesota Campus, *1888*

Oil on canvas, 16¼ x 28¼ in.
(41.3 x 71.8 cm.)
Signed lower right: Alex Fournier July 88
Gift of Daniel S. Feidt
73.8.2
Illustration: Figure 30

REFERENCE: Rena Coen, *Painting and Sculpture in Minnesota, 1820-1914* (Minneapolis: University of Minnesota Press, 1976), 114.

EXHIBITIONS: *Selections from the Permanent Collection,* 1975 ▪ *A Bicentennial Exhibition of Minnesota Art and Architecture,* 1976 ▪ Minneapolis College of Art and Design, *The Urban Muse: Painters Look at the Twin Cities,* 1977 ▪ Alumni Club, Minneapolis, *75th Anniversary Exhibition,* 1979 ▪ *Selections from the Permanent Collection,* 1980.

PROVENANCE: Daniel S. Feidt

Prior to his first trip to France in 1893, Fournier painted many local scenes in his Minneapolis studio that reveal a deliberately descriptive and matter-of-fact style. This is one such work. The strong horizontal of the skyline and the broad expanse of the Mississippi River lend a feeling of stability, of firm and steady progress, to this representation of the industrial heart of the city.

This view looks looks toward the north and west from what is today the University's East Bank campus. Buildings of the flour milling industry—the source of Minneapolis's early prosperity—line the river bank to the west.

Minneapolis from the University of Minnesota Campus, *1888* ▪ *Figure 30*

Great Oaks from Little Acorns Grow, *1902*

Oil on canvas, 28⅞ x 36 in.
(73.3 x 91.4 cm.)
Signed lower right: Alex • Fournier • 1902
Gift of Philip R. Brooks in memory of his
father, Lester R. Brooks
39.99
Illustration: Figure 31

EXHIBITIONS: St. Louis, Missouri, *Minnesota
Exhibit*, 1903 ▪ *A Bicentennial Exhibition
of Minnesota Art and Architecture*, 1976 ▪
Alumni Club, Minneapolis, *75th
Anniversary Exhibition*, 1979 ▪ *Selections
from the Permanent Collection*, 1980.

PROVENANCE: Philip R. Brooks

Another of Fournier's paintings of the local scene, this work shows
the early University of Minnesota campus. On the left is the old
Law School Building (now Pattee Hall); on the right, the old
YMCA building (now Music Education). Both reveal the strong
influence of the Romanesque revival style of Henry Hobson
Richardson, especially fashionable during the early 1890s when the
University of Minnesota (and the Twin Cities generally) experienced
a period of expansion. The landscape setting of wet, muddy
pathways and barely budding trees suggests a day in early spring,
perhaps to emphasize the allegory implied in the title.

As in his urban scenes of the early 1890s, Fournier here evokes a
response of instant recognition—an immediate, almost tangible
relationship between the observer and the pictured scene. There is a
sense of rawness, of new beginnings, that contrasts strongly with
the mellow landscapes of the artist's later Barbizon period.

Great Oaks from Little Acorns Grow, *1902* ▪ *Figure 31*

Morning Gold, *c. 1925*

Oil on canvas board, 6¼ x 9½ in.
(15.9 x 24.1 cm.)
Signed lower right: Alex • Fournier •
Purchase, Fine Arts Fund
78.6
Illustration: Figure 32

EXHIBITION: *The First Fifty Years 1934-
1984: American Painting and Sculpture
from the University Art Museum Collection,*
1984.

PROVENANCE: Rathbun Studios, Inc.,
Minneapolis

This tiny landscape is a lyrical view of a sunny meadow under a
blue summer sky. Its size and sketchy brushwork indicate that it
may have been a study for a larger work. Lacking are the detail and
sense of specific locale typical of Fournier's urban scenes, which
suggests that the painting may have been an impression done from
memory.

In a simple composition of balanced verticals and horizontals, the
large trees and foreground grasses effectively frame the gently
rolling meadow that recedes toward the distant horizon. A mellow
golden light enhances the mood of peace and happy tranquility. The
impressionistic sense of form and tonal value predict a period later
in Fournier's career when the artist understood and, to a large
extent, had assimilated the pastoral poetry of the Barbizon masters.

Morning Gold, *c. 1925* ▪ *Figure 32*

FREDERICK LYDER FREDERICKSON
1905-

SELECTED BIBLIOGRAPHY: "Roundabout the
Galleries: Four New Exhibitions," *Art
News* (6 May 1939): 15 ▪ "Reviews," *Art
News* (December 1963): 55.

A native of Mandal, Norway, Frederick Lyder Frederickson
attended the University of Oslo before emigrating to America to
study at the Art Students League under Leon Kroll and Raphael
SOYER.

In 1937 and 1939 he had one-man exhibitions at the Hudson D.
Walker Gallery (New York); reviewers praised his ability to express
a mood with color. He continued to paint still-life scenes and
Cézannesque portraits into the 1940s, but he excelled with his
freshly brushed landscapes. He also exhibited polychromed wooden
sculpture in 1944. His paintings did not appear in New York
galleries again until 1963, when his land and seascapes were
partially constructed with abstract forms. *M.T.S.*

Still Life, *c. 1939*

Oil on canvas board, 24 x 18 in.
(61.0 x 45.7 cm.)
Signed upper right: F. Lyder
Bequest of Hudson Walker from the Ione
and Hudson Walker Collection
78.21.122
Illustration: Appendix

PROVENANCE: Ione and Hudson Walker

Frederickson handled paint almost like a sculptural medium,
creating atmospheric color with broadly brushed areas of pigment.
In reviews written around the time this canvas was completed,
critics singled out his ability to handle still-life compositions
tastefully and with a "robust and direct" concentration
("Roundabout the Galleries," p. 15).

LEE GATCH
1902-1968

SELECTED BIBLIOGRAPHY: Duncan Phillips, "Lee Gatch," *Magazine of Art* (December 1949): 282-287 • Dorothy Gees Secklen, "Lee Gatch," *Art in America* (Fall 1956): 28-32, 59-60 • Martica Sawin, "Paintings of Lee Gatch," *Arts* (May 1958): 30-33 • Perry T. Rathbone, *Lee Gatch* (New York: American Federation of Arts, 1960) • Adelyn D. Breeskin, *Lee Gatch* (Washington, D.C.: National Collection of Fine Arts, 1971).

An abstract painter who depicted landscape motifs with an intimate lyricism, Lee Gatch was born in Baltimore, where he attended the Maryland Institute of Art. His style developed from a Precisionistic realism through an assimilation of formal cubist vocabulary, the result of study with André L'hôte in Paris. Eventually his own personal expressionism evolved as he explored and amplified the role of color and form in his work.

Like his friend Milton AVERY, with whom he exhibited in 1959, Gatch was concerned with the essence of experience, and the subjects of his paintings were often suggested by nature. By 1938 he was exhibiting at the New Art Circle gallery (New York) and with the independent group The Ten. Toward the end of his career he planned an experimental group of paintings he referred to as the *Jurassic Series* because they were to be painted on stone.

Gatch and his wife, artist Elsie Briggs, lived for many years in rural Lambertville, New Jersey. *P.N.*

Saratoga (Horse Race), *1949*

Oil on canvas fixed to wood frame,
6⅜ x 24⅞ in.
(16.2 x 63.2 cm.)
Signed lower left: Gatch
Bequest of Hudson Walker from the Ione and Hudson Walker Collection
78.21.831
Illustration: Figure 33

EXHIBITIONS: Drew Fine Arts Center, Hamline University, St. Paul, *Exhibition*, 1952 • American Federation of Arts Traveling Exhibition, *Major Works in Minor Scale*, 1957-1958, cat. 2 • *100 Paintings, Drawings, and Prints from the Ione and Hudson D. Walker Collection*, 1965 • *Selections from the Permanent Collection*, 1968, 1969, 1975 • *Hudson D. Walker: Patron and Friend*, 1977, cat. 17 • *Selections from the Permanent Collection*, 1980.

PROVENANCE: J.B. Neumann; Ione and Hudson Walker

Gatch loved horse racing, and it appears as a recurrent theme in his work. He preferred to portray the essence and spirit of the horses rather than merely rendering their physical appearance.

In *Saratoga (Horse Race)*, he captures the movement and excitement of the racing event. Colors swirl along the narrow horizontal canvas as if the artist were following the action with a pair of binoculars. Known for his creative framing devices, Gatch accentuates the horizontal thrust of the composition by mounting the canvas on a long, richly grained board. The dynamism of each horse and rider appears as a series of circular motions in a haze of flying dust, while the spectator is set apart by a series of horizontal and vertical bands reminiscent of a viewing stand. The abstract patterning and bright evocative colors are typical of Gatch's painting of the 1950s.

Saratoga (Horse Race), *1949 • Figure 33*

HERBJØRN GAUSTA
1854-1924

SELECTED BIBLIOGRAPHY: Marion J. Nelson, "Herbjørn Gausta, Norwegian-American Painter," *Studies in Scandinavian-American Interrelations* (1971): 1-24 • Rena Coen, *Painting and Sculpture in Minnesota, 1820-1914* (Minneapolis: University of Minnesota Press, 1976), 71-72, 74, 113 • Mary T. Swanson, *The Divided Heart: Scandinavian Immigrant Artists, 1850-1950* (Minneapolis: University Gallery, University of Minnesota, 1982), 21.

In the latter part of the nineteenth century, a few painters of real ability began to emerge among the immigrant settlers of rural Minnesota. One of the more outstanding was Herbjørn Gausta, a native of Telemark, Norway, who had immigrated with his family in 1867 to a farm near Harmony, Minnesota.

When his father died two years later, 15-year-old Herbjørn found himself responsible for the support of his mother and sisters. Despite these straitened circumstances, he nevertheless managed to complete a three-year course of study at Luther College in Decorah, Iowa. With the help of friends, he went abroad to study art in Oslo and Munich from 1874 to 1881. After several years of restless wandering, he returned to the United States in 1888 and settled in Minneapolis, where he remained until his death. *R.N.C.*

Dr. Edward Robinson Squibb, *1923*

Oil on canvas, 24 x 20 in.
(61 x 50.8 cm.)
Signed verso: H. Gausta 1923
Gift of Frederick J. Wulling
44.29
Illustration: Appendix

REFERENCE: Letter from Edward H. Squibb
to Frederick J. Wulling, 17 May 1922
(University of Minnesota Archives).

PROVENANCE: Frederick J. Wulling

University of Minnesota Dean Frederick J. Wulling collected portraits of well-known men of medicine and pharmacy; in 1922, he commissioned Gausta to paint Dr. Edward Robinson Squibb, the founder of the pharmaceutical firm bearing his name.

Squibb was born in Wilmington, Delaware in 1819 and graduated from Jefferson Medical College in Philadelphia in 1845. He served as a United States Navy surgeon from 1847 to 1857. While assigned to the Brooklyn Naval Hospital in 1852, he was authorized by the navy to establish a laboratory for the manufacture of high-grade pharmaceuticals. Four years later he formed his own firm, which subsequently became a leader in the industry. He continued to do independent research in chemistry and pharmacy until his death in 1900.

This posthumous portrait is based on the only photograph ever taken of Squibb. An accomplished work that doubtless resembles its subject, it lacks the sense of tangible presence that a painting from life could have achieved.

LLOYD GILCHRIST
(dates unknown)

SELECTED BIBLIOGRAPHY: "24th Annual Local
Artists Show," *The Bulletin of the
Minneapolis Institute of Arts* (12 November
1938): 155.

Lloyd Gilchrist worked on the WPA/FAP program in Minneapolis during the late 1930s and exhibited an industrial landscape, *Factory*, in the Twenty-Fourth Annual Local Artists Show at the Minneapolis Institute of Arts in 1938. Other than this very sketchy information, little is known about him. *M.T.S.*

Like many painters in the 1930s, Gilchrist seems to have been influenced by the painterly romanticism of Albert Pinkham Ryder. His canvases show a naive, almost awkward portrayal of the human form and landscape.

Oil on canvas, 36¼ x 30⅛ in.
(92.1 x 76.5 cm.)
Signed verso: Lloyd Gilchrist 2-16-40
WPA Art Project, Minneapolis
43.752
Illustration: Appendix

PROVENANCE: WPA Art Project, Minneapolis

Northern Minnesota Landscape, *1940*

Oil on canvas, 36¼ x 30⅛ in.
(92.1 x 76.5 cm.)
Signed verso: L. Gilchrist
WPA Art Project, Minneapolis
43.755
Illustration: Appendix

PROVENANCE: WPA Art Project, Minneapolis

Night Scene No. 1, *c. 1940*

Oil on masonite, 24 x 30⅛ in.
(61 x 76.5 cm.)
Signed verso: L. Gilchrist
WPA Art Project, Minneapolis
43.785
Illustration: Appendix

PROVENANCE: WPA Art Project, Minneapolis

Tearing Down the Circus, *c. 1940*

HENRY J. GLINTENKAMP
1887-1946

SELECTED BIBLIOGRAPHY: William Innes
Homer, *Robert Henri and His Circle*
(Ithaca, New York: Cornell University
Press, 1969), 150, 182 ▪ Sandra Leff, *Henry
Glintenkamp: Ash Can Years to
Expressionism* (New York: Graham
Gallery, 1981).

An elusive figure in American art, Henry Glintenkamp was born in August, New Jersey and studied at the National Academy of Design and at the New York School of Art with Robert Henri. He exhibited in the 1910 Independents Exhibition and in the monumental 1913 Armory Show.

Somewhat of an activist, Glintenkamp contributed regularly to *The Masses* from 1913 to 1917 along with other artists from Henri's circle such as John Swan and George Bellows. Around 1917 he and Stuart Davis, with whom he had shared a studio, edited *Spawn*, a short-lived, portfolio-like periodical which reproduced works by contemporary artists.

Between 1917 and 1927 Glintenkamp lived in Mexico, and during the early 1930s he traveled in Europe gathering material for his book, *A Wanderer in Woodcuts*, published in 1932. Upon returning to the States he worked briefly for the WPA/FAP in 1934, taught at the American Artists School in New York, and in 1936 became an early member of the American Artists Congress, serving as chairman for the exhibition committee in 1937 and as executive secretary in 1940. *P.N.*

Cloud Shadow, *1911*

Oil on jute canvas, 20⅛ x 26 in.
(51.1 x 66 cm.)
Signed lower left: -Glintenkamp- ; dated
verso
Bequest of Hudson Walker from the Ione
and Hudson Walker Collection
78.21.315
Illustration: Figure 34

PROVENANCE: Juliana Force; Ione and
Hudson Walker

The influence of Glintenkamp's teacher Robert Henri is evident in the broad handling of paint and heavy impasto of *Cloud Shadow*. Unlike his fellow students, Glintenkamp also produced cityscapes and landscapes devoid of people. This work explores the expressive possibilities of a desolate landscape dominated by a hillside. The limiting of color to a single tone of green typifies the artist's early style.

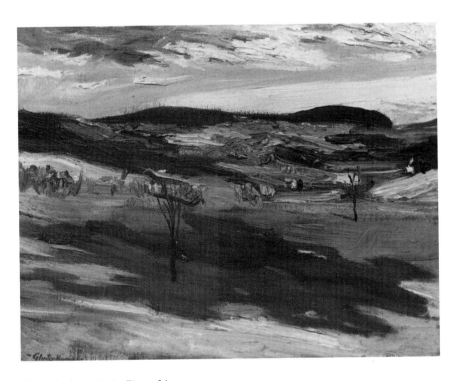

Cloud Shadow, *1911* • *Figure 34*

120

ALBERT GOLD
1916-

SELECTED BIBLIOGRAPHY: Henry C. Pitz, "Albert Gold," *American Artist* (November 1956): 37-41 • Letter from Albert Gold to Mark Kriss at the University Gallery, 10 November 1978.

Albert Gold has been painting detailed observations of his native Philadelphia and its populace for the past four decades. He received a scholarship to the Philadelphia College of Art, where he studied with Franklin Watkins, Earl Horter, and Henry C. Pitz and from which he graduated in 1939. While still a student he exhibited nationally, winning the John Gribbel Award at the Philadelphia Print Club in 1939. In 1942 he won the Prix de Rome.

During World War II Gold spent three years as an army artist in the European theater. Because conditions there were difficult, he often had to observe, draw, and paint rapidly. His palette brightened when he returned to Philadelphia and began focusing on city dwellers, their lives, and the resulting metropolitan clutter.

In 1947 Gold was one of 14 American painters chosen to portray the state of Pennsylvania for the art collection at the University of Pennsylvania. He has continued to win numerous prestigious prizes and awards, including two successive Tiffany Grants in 1947 and 1948; the Sesnan Gold Medal in 1950 for his painting at the Pennsylvania Academy of the Fine Arts; the American Artist Citation from the American Watercolor Society in 1954; the Woodmere Endowment Fund Grant in 1968; and the Philadelphia Watercolor Club Prize in 1977 from the Philadelphia Art Alliance. He began teaching at the Philadelphia College of Art in 1947 and became director of the illustration department in 1959. *M.T.S.*

Three Men in Disguise, *c. 1940*

Oil on canvas, 40⅛ x 29⅞ in. (101.9 x 75.9 cm.)
Unsigned
WPA Art Project, Washington, D.C.
43.730
Illustration: Appendix

EXHIBITIONS: *Abstract USA/1910-1950*, 1981 • Carleton College, Northfield, Minnesota, *American Abstraction: 20th Century American Paintings from the University of Minnesota*, 1983.

PROVENANCE: WPA Art Project, Washington, D.C.

Although Gold usually based his realistic depictions of city life on direct observation, he experimented with surrealism for a short time after his student years. In this composition the enigmatic shadows and vacuous background compete with his typically meticulous surface.

ROBERT GOODNOUGH
1917-

SELECTED BIBLIOGRAPHY: Martin H. Bush and Kenworth Moffett, *Goodnough* (Wichita, Kansas: University Art Museum, Wichita State University, 1973) • James Harithas, *Robert Goodnough* (Syracuse: Everson Museum of Art, 1974) • Martin Bush, *Goodnough* (New York: Abbeville Press, 1982) • Martin H. Bush, "Robert Goodnough's Collages," *Arts* (April 1982): 89-91.

Although critics have referred to Robert Goodnough as a second-generation abstract expressionist, his more recent works contain small shapes revealing little trace of the brushstroke. Born in Cortland, New York, Goodnough enrolled in Walter Long's art school in nearby Auburn while still in high school. Long, formerly an art professor at Syracuse University, helped his young pupil win a scholarship to Syracuse. After graduating Goodnough was drafted into the army and spent most of his service painting murals at various military installations.

Following World War II he settled in New York and studied first with Amédée Ozenfant, a founding member of the French purist movement, and then with Hans Hofmann. During the 1960s he taught art at New York University, reviewed exhibitions for *Art News*, managed a soda fountain and a newsstand, and in his spare time earned a master's degree in art education from NYU.

While living in New York during the late 1940s, Goodnough became a member of the "Club" (Studio 35), a center for the abstract expressionist movement in New York. He was introduced in 1950 at the New Talent exhibition at the Kootz Gallery along with Franz Kline, Alfred Leslie, Grace Hartigan, and Larry Rivers. His paintings from this period combine areas of raw canvas with patches of freely brushed color shapes which appear to move frantically through the composition. In works from the 1960s, color shapes are calligraphically woven into massive configurations. These were often based on old master compositions or objects from nature distilled into abstractions. Paintings and collages from the late 1960s through the 1970s display muted, silvery colors within pristinely defined shapes.

Goodnough won a Ford Foundation grant in 1962 and a Guggenheim fellowship in 1972. He has represented the United States at the Venice Biennale. *M.T.S.*

Countdown, *1961-1962*

Oil on canvas, 80 x 90 in.
(203.2 x 228.6 cm.)
Signed lower right: Goodnough 61-62
Purchase with funds from Special Projects
Program, and partial gift of the artist
68.1
Illustration: Figure 35

REFERENCE: *Arts and Architecture* (May
1962): 7.

EXHIBITIONS: Arts Club of Chicago in
cooperation with the Tibor De Nagy
Gallery, New York, Traveling Exhibition,
Robert Goodnough, 1964, cat. 8 •
Selections from the Permanent Collection,
1968, 1969, 1970.

PROVENANCE: the artist

Goodnough used webs of paint strokes resembling large-scale calligraphy to energetically move across this canvas. Drips and smudges have been laid over color shapes which derive their forms from Goodnough's paper and paint collage. The artist left the composition roughly finished, saying that "once you've gotten the idea, why try to polish it too much?" (Bush and Moffett, p. 36).

To finance its purchase, *Countdown* was placed on display in the lobby of the First Minneapolis Bank in 1967 and contributions were solicited from the public.

Countdown, *1961-1962* • *Figure 35*

DAVID M. GRANAHAN
1909-

SELECTED BIBLIOGRAPHY: Letter from David M. Granahan to Mary Swanson at the University Gallery, 14 August 1980 • Minneapolis History Collection, Minneapolis Public Library.

Born in Litchfield, Minnesota, David M. Granahan graduated from the Minneapolis School of Art in 1932 after studying under Glen Mitchell and Edmund Kopietz. He illustrated *101 Best Stories of Minnesota* by Merle Potter in 1931 and jointly illustrated W. Havighurst's *Upper Mississippi* with his wife, Lolita WADMAN. Using studio space in the Walker Gallery from 1933 to 1938, he designed and painted three murals for post offices in Rochester, Hopkins, and St. Cloud, Minnesota for the WPA/FAP. He took part in several Local Artists Exhibitions at the Minneapolis Institute of Arts, taking a second prize in watercolor in 1931, first prize in oils in 1932, and second and third prizes in watercolor in 1933.

In 1938 Granahan and Wadman moved to Kentucky and then to Washington, D.C., where he was employed in the U.S. Department of Agriculture's Office of Communication. Until his retirement in 1976, he designed exhibits for the department in the United States as well as in several foreign countries and lectured on visual communication to evening classes at the Department of Agriculture Graduate School. *M.T.S.*

Untitled (Factory and Stream), *1932*

Oil on canvas, 28 x 24¼ in.
(71.1 x 61.6 cm.)
Signed lower right: Granahan
Bequest of Hudson Walker from the Ione and Hudson Walker Collection
78.21.820
Illustration: Appendix

REFERENCE: Letter from David M. Granahan to Mary Swanson at the University Gallery, 14 August 1980.

PROVENANCE: Ione and Hudson Walker

It seems likely that Hudson D. Walker purchased this painting from Granahan during the mid-1930s, while Granahan and Wadman were using studio space in the Walker Gallery. About it, Granahan writes, "*Factory and Stream* was probably done while Lolita and I were in Bruges, Belgium in 1932. We both received Minneapolis School of Art Van Derlip Traveling Scholarships for that year for study in Europe" (Granahan to Swanson, 14 August 1980).

Raspberry Picking Mural, *1936*

Oil on canvas, 54 x 138 in.
(137.2 x 350.5 cm.)
Unsigned
Gift of the Hopkins Historical Society
79.23
Not illustrated

REFERENCE: David M. Granahan
correspondence, Treasury Relief Art Project
file RG-121 (entry 119) Box 15, National
Archives, Washington, D.C.

PROVENANCE: Hopkins Historical Society

Originally part of a four-panel mural done for the Hopkins, Minnesota post office for the WPA/FAP, this single canvas panel is all that survived when the post office was demolished in 1968. A contemporary newspaper account of the installation provides this description: "[The] illustrations show the artist's conception of berry patches nestling among the hills and wooded plots of 'Little Switzerland,' southwest of the village." In a letter written five days after the installation, Granahan himself commented, "[The] Hopkins murals are now all installed. I believe they look very fine, it is quite a thrill to see the different panels in place. The townspeople are generally very much impressed, the post office employees tell me. It is amusing to hear the discussions which develop as the people select whose farms are pictured..." (Granahan to Cecil H. Jones, 6 February 1937).

FRANCES CRANMER GREENMAN
1890-1981

SELECTED BIBLIOGRAPHY: Frances Cranmer
Greenman, *Higher Than the Sky* (New
York: Harper and Brothers Publishers,
1954) ▪ Rebecca L. Keim, *Three Women
Artists: Gag, Greenman, and Mairs*
(Minneapolis: University Gallery, University
of Minnesota, 1980).

Frances Cranmer Greenman was born in Aberdeen, South Dakota. After attending the Corcoran School of Art (Washington, D.C.) from 1905 to 1909, she went to New York and studied first with William Merritt Chase and then with Robert Henri. In 1911 she journeyed to Europe and attended classes at the Académie de la Grande Chaumière. She worked as a designer for a garment manufacturer in New York during 1913-1914, a time when she was having difficulty establishing herself as a portrait painter. In 1915 she moved to Minneapolis, where her parents lived, and married banker John Greenman.

From 1915 to 1926 she painted portraits of many notable Twin Cities personalities, including actress Lynn Fontanne and artist Dewey ALBINSON. A portrait of her daughter was exhibited by invitation at the World's Fair Century of Progress Exhibition at the Art Institute of Chicago in 1933. Following a second trip to Europe in 1924 and her first New York show at the New Gallery in 1925, Greenman moved to New York, where she joined the Whitney

Studio Club and exhibited regularly at Marie Sterner's gallery. During the 1930s she traveled widely throughout the United States, receiving portrait commissions from business and political leaders as well as Hollywood celebrities.

After 1940, except for visits to Florida and California, Greenman made her home in Minneapolis, where she taught at the Minneapolis School of Art. In the later years of her career she executed many floral still lifes, but portraiture remained her primary interest. *S.K.*

Richard M. Elliott, *1956*

Oil on canvas, 47½ x 35 in.
(120.7 x 88.9 cm.)
Signed lower left: Frances Greenman 1956
Gift of faculty, former students, and friends
as a lasting tribute
57.2
Illustration: Figure 36

REFERENCES: "U Will Get Portrait of Retired Psych Department Head," *Minnesota Daily* (11 December 1956) ▪ "Dr. R.M. Elliott's Portrait Presented to U," *St. Paul Dispatch* (18 December 1956) ▪ "Richard M. Elliott Portrait Presented to U," *Minnesotan* (February 1957): 7, 14 ▪ Mrs. Richard M. Elliott, conversation with Sue Kendall, 8 November 1980.

EXHIBITIONS: Golden Rule Department Store, St. Paul, 1958 ▪ *Three Women Artists: Gag, Greenman, and Mairs,* 1980.

PROVENANCE: the artist

Richard Maurice Elliott became the first chairman of the Department of Psychology at the University of Minnesota in 1919 and held that position until 1951. Under his guidance the department soon became one of the country's leading centers for graduate study.

Elliott achieved international recognition as the editor of the Century Psychology Series of textbooks. In 1930, under the auspices of the Employment Stabilization Research Institute, he was among those who turned their attention to the problems of the unemployed. *Men, Women, and Jobs*, the report of the Institute's findings published in 1936, has done much to set the pattern for the vocational guidance of adults in the United States.

This portrait, which was commissioned to hang in the main hallway of the Department of Psychology in the building that now bears Elliott's name, marks the point of tangency between the sitter's public and private lives. Greenman, a longtime friend of Elliott and his wife, chose not to surround him with traditional accouterments of academe; instead, she opted for symbols that would evoke wider associations. The head of a Buddha visible above his shoulder alludes to the collection of bronze Siamese Buddha heads dating from the fifteenth through seventeenth centuries which Elliott acquired on an extended trip from Beirut to Saigon in 1927-1928. By including the sculpture, Greenman made reference to Elliott's love of art, his fondness for world travel, and his lifelong interest in Buddhism. Then she framed his head with the hazy suggestion of a bookcase, a fitting symbol for a man whose intellectual curiosity encompassed disciplines ranging from astronomy to ornithology.

By combining a cubo-realistic manipulation of space with brushwork inspired by her teacher, William Merritt Chase, Greenman managed to create a visual tension between the painting's two-dimensional and three-dimensional qualities.

Richard M. Elliott, *1956 ▪ Figure 36*

DOROTHY GROTZ
1906-

SELECTED BIBLIOGRAPHY: *Sid Deutsch Gallery Bulletin* (6 April 1983) • *Who's Who in American Art* (New York: R.R. Bowker, 1982), 373.

A native of Philadelphia, Dorothy Grotz studied at the Free University of Berlin and at Columbia University, where she received a Master of Science degree in 1945. Her interests in art led her to the Art Students League, from which she graduated in 1947. She has since resided in New York, with frequent trips to Europe and the Orient.

Grotz, who works almost exclusively in oils, has had one-woman exhibitions at the Columbia School of Architecture, the Galerie Moderne, Revel Gallery, and the Bodley Gallery (all New York) as well as various colleges and art centers around the country. Her paintings are held by several collections, including those of the Santa Barbara Museum of Fine Arts, the Chrysler Museum, and the Dresden Museum. *R.L.G.*

Elizabeth McCausland, *c. 1981*

Oil on canvas, 30 x 24 in.
(76.2 x 61 cm.)
Signed lower left: D. Grotz
Gift of the artist
83.27
Illustration: Appendix

REFERENCE: Letter from Sid Deutsch Gallery to Charles Helsell at the University Gallery (6 April 1983).

EXHIBITION: *The First Fifty Years, 1934-1984: Recent Acquisitions and Promised Gifts to the University Art Museum,* 1984

PROVENANCE: the artist

Art critic and free-lance art historian Elizabeth McCausland had a long association with the University Art Museum. A friend to both Ione Walker (who pronounced this portrait "an interesting and good likeness") and her husband Hudson D. Walker, first University Art Museum curator, McCausland often looked to them for support in her efforts to publish monographs on artists represented in the museum's collections. With the assistance of Hudson Walker, she produced the first major study on the work of Marsden HARTLEY (Minneapolis: University of Minnesota Press, 1952). She also researched the careers of Alfred MAURER and Charles W. HAWTHORNE.

Arts magazine contributing editor James Marston Fitch likened Grotz's work to that of the American writer Theodore Dreiser, noting that it displayed the "same somber-hued love of life, the same urgent need for expressing it, [and] the same impatience with grammatical niceties in the struggle of communication" (Letter from Sid Deutsch Gallery to Charles Helsell, 6 April 1983).

ROBERT GWATHMEY

1903-

SELECTED BIBLIOGRAPHY: Elizabeth McCausland, "Robert Gwathmey," *Magazine of Art* (April 1946): 148-152 • *Robert Gwathmey* (St. Mary's City, Maryland: St. Mary's College of Maryland, 1976).

The majority of the paintings of Robert Gwathmey, a white southerner and eighth-generation Virginian, portray the aspirations and contributions of black men and women. Born in Richmond, Gwathmey studied art at North Carolina State College from 1924 to 1925, the Maryland Institute from 1925 to 1926, and the Pennsylvania Academy of the Fine Arts from 1926 to 1930. He won Cresson travel fellowships in 1929 and 1930 and journeyed throughout Europe before settling down to teach at Beaver College in Jenkintown, Pennsylvania from 1930 to 1937.

Because he was employed, Gwathmey was not eligible for WPA/FAP project funds, but he worked with several other artists from the projects to establish an Artists Union in Philadelphia. He later became vice president of the union, which sponsored a publication, weekly meetings, lectures, and exhibitions. He credits his involvement with the Artists Union for his interest in racial issues; it was there, he says, that he "met Negroes on an equal plane....Then I went home again. There I was always conscious of the contrast between Negroes and whites" (McCausland, p. 149).

Gwathmey created his flat and intensely colored forms from life. He made yearly summer visits to the South, and in 1944 he won a Rosenwald fellowship to live on a tobacco farm and work with sharecroppers. These experiences inspired a series of canvases which were exhibited in major New York galleries and won several awards, including the second prize at the Carnegie Institute Annual in 1943, the Joseph S. Isidor Gold Medal at the National Academy of Design in 1971, the Saltus Gold Medal in 1977, and the Adolph and Clara Obrig prize at the National Academy in 1978.

Gwathmey taught at the Carnegie Institute of Technology from 1939 to 1947 and at the Cooper Union from 1942 to 1978. *M.T.S.*

Nobody Around Here Calls Me Citizen, *1943*

Oil on canvas, 14½ x 17 in.
(36.2 x 43.2 cm.)
Unsigned
Bequest of Hudson Walker from the Ione
and Hudson Walker Collection
78.21.34
Illustration: Colorplate XVIII

REFERENCE: Letter from Robert Gwathmey
to Paul Yule at the University Gallery, 9
December 1969.

EXHIBITIONS: Drew Fine Arts Center,
Hamline University, St. Paul, *Exhibition of
Paintings by Some American Individualists,*
1950 • *Selections from the Collection of Mr.
and Mrs. Hudson D. Walker,* 1950 •
Selections from the Permanent Collection,
1957 • *Selected Works from the Collection
of Ione and Hudson Walker,* 1959 •
Selections from the Permanent Collection,
1968, 1969, 1970, 1975 • *Hudson D.
Walker: Patron and Friend,* 1977, cat. 18 •
Selections from the Permanent Collection,
1980 • *The First Fifty Years 1934-1984:
American Paintings and Sculpture from the
University Art Museum Collection,* 1984.

PROVENANCE: Ione and Hudson Walker

This painting corresponds to another from the same year, *Bread and Circuses,* in which a black sharecropper stands beside a billboard advertising the circus set against a bleak landscape. About *Nobody Around Here Calls Me Citizen,* Gwathmey wrote, "The lion is just a circus symbol—'bread and circuses' if you will. The share cropper and his limited cultural resources" (Gwathmey to Yule, 9 December 1969).

SAMUEL HALPERT

1884-1930

SELECTED BIBLIOGRAPHY: Helen Comstock, "Samuel Halpert—Post-Impressionist," *International Studio* (April 1922): 145-50 • *Samuel Halpert, 1884-1930: A Pioneer of Modern Art in America* (New York: Bernard Black Gallery, 1969).

Born in Bialystok, then a Russian village near the Polish border, Samuel Halpert was brought to the United States in 1889. He received early training in art through the Educational Alliance, a social agency which assisted immigrants and sponsored an art school on New York's Lower East Side from 1891 to 1905. It was there, in 1899, that he met the sculptor Jacob Epstein, who befriended him and introduced him to museums around the city. In that same year Halpert began studying at the National Academy of Design and continued until leaving for Paris in 1902.

Upon his arrival he started working under Léon Bonnat at the École des Beaux Arts. Within the year he left Bonnat's studio to travel in France, Italy, Spain, Portugal, and England. In this he was not unlike his contemporaries Alfred MAURER, Bernard Karfiol, Max WEBER, Maurice Sterne, and Abraham WALKOWITZ, who also spurned formal instruction and the traditional academies in favor of independently studying the old and new European masters. He came under the influence of impressionistic and then fauvist painters in Paris and of Giorgione and El Greco while in Italy.

Returning to New York in 1912, Halpert submitted two canvases to the Armory Show. During the summer of 1913 he shared a cottage with Man Ray at the art colony in Ridgefield, New Jersey, which led to contacts with modern American painters. In 1914 he had the first of several one-man shows at the Charles Daniel Gallery (New York). Critics were enthusiastic about his eclectic modernism; one wrote: "It is very worthwhile for the public to see Mr. Halpert's exhibition if only to note how possible it is for a man to break with the conventions and still keep to the great traditions, to be individual without becoming eccentric, to play in the same garden with other modernists and maintain sanity and a muscular style" (Elizabeth Luther Cary, *New York Times*, 2 February 1919).

Most of his paintings completed during the 1920s fuse a fauvist palette with a compositional structure reminiscent of Cézanne. Until his death in 1930, Halpert exhibited at the Downtown Gallery (New York), which was founded by his wife, Edith Gregor Halpert, in 1925. He taught at the Art School of the Society of Arts and Crafts in Detroit from 1926 to 1930. *M.T.S.*

Park, *1910*

Oil on canvas, 16¼ x 20¼ in.
(41.3 x 51.4 cm.)
Signed lower left: S. Halpert
Bequest of Hudson Walker from the Ione
and Hudson Walker Collection
78.21.58
Illustration: Figure 37

EXHIBITIONS: *Selected Works from the
Collection of Ione and Hudson Walker,
1959* ▪ *Selections from the Permanent
Collection,* 1968, 1969 ▪ St. John's
University/College of St. Benedict,
Collegeville, Minnesota, *University of
Minnesota Art Exhibit,* 1971 ▪ *Hudson D.
Walker: Patron and Friend,* 1977, cat. 19.

PROVENANCE: Alfred Stieglitz; Ione and
Hudson Walker

Although this landscape was probably painted from an upper-story window looking out over a New York City park, it exhibits the same modified fauvist color and cubist structure seen in Halpert's 1902 Paris paintings. He was influenced by Matisse, Marquet, and Cézanne, as well as by Robert Delaunay's architectural studies of St. Severin Cathedral. Halpert and Bernard Karfiol, who also incorporated a more conservative fauvism in his work, helped to introduce the ideas of modern art to a reticent American public.

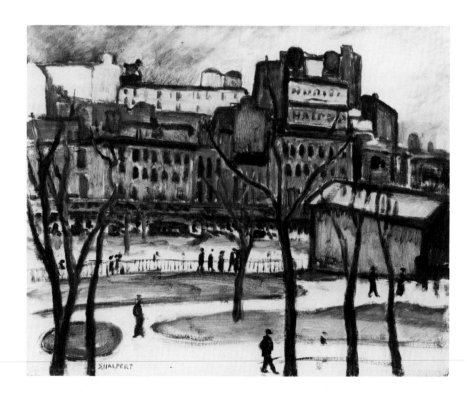

Park, *1910* ▪ *Figure 37*

WILLIAM MELTON HALSEY
1915-

SELECTED BIBLIOGRAPHY: Jack A. Morris,
Contemporary Artists of South Carolina
(Greenville, South Carolina: Greenville
County Museum of Art, 1970) ▪ Jack A.
Morris, *William A. Halsey* (Greenville,
South Carolina: Greenville County Museum
of Art, 1972).

A native of Charleston, South Carolina, William Halsey has exhibited principally in the South since his first one-man exhibition in 1939. Although his early works from the 1930s were realistic and included many portraits, Halsey later developed an abstract and expressionistic mode of painting. He received his bachelor's degree from the University of South Carolina in 1936 and subsequently studied at the Boston Museum School, the Academy of San Carlo in Mexico City, and with Karl ZERBE. He was artist-in-residence at several southern colleges and taught at the College of Charleston from 1972 to 1975.

In addition to his easel paintings, Halsey produced fresco murals for the Berkshire Museum and the synagogue of the Baltimore Hebrew Congregation. He and his wife, Corrie McCallum, co-authored *A Travel Sketchbook* and *Maya Journal*, inspired by excursions to Mexico. *P.N.*

Clown, *1951*

Oil on masonite, 32¼ x 25 in.
(81.9 x 63.5 cm.)
Signed lower right: Halsey
Bequest of Hudson Walker from the Ione
and Hudson Walker Collection
78.21.310
Illustration: Figure 38

EXHIBITION: Greenville County Museum of
Art (Greenville, South Carolina) Traveling
Exhibition, *William M. Halsey
Retrospective,* 1972-1973.

PROVENANCE: Bertha Schaefer Gallery, New
York; Ione and Hudson Walker

Clown is derived from the portrait Halsey painted in 1948 of his son costumed for Halloween. He returned to the subject again in 1959 and 1965. Halsey's brightly rendered figure sitting in front of a circus tent is thoroughly amusing, with none of the tragic overtones often associated with the clown character. Contrasting with the delightfully childlike simplicity of the outline patterns, the complex spatial effects indicated a sophisticated awareness of pictorial problems. The small scale and flattened, abstract geometric design are typical of Halsey's work of the late 1940s and early 1950s.

Clown, *1951 ▪ Figure 38*

HARMONY (LYNN) HAMMOND
1944-

SELECTED BIBLIOGRAPHY: Colin Naylor and Genesis P. Orridge, *Contemporary Artists* (New York: St. James Press, 1977), 380-381 • *Who's Who in American Art* (New York: R.R. Bowker, 1982), 388 • Lucy R. Lippard, *Harmony Hammond, Ten Years, 1970-1980* (Minneapolis: The Women's Art Registry of Minnesota, 1981) • Lucy Lippard, "Binding/Bonding," *Art in America* 70:4 (April 1982): 112-118 • Sandra L. Langer, "Harmony Hammond: Strong Affections," *Arts* 57:6 (February 1983): 122-123.

Born in Chicago, Harmony Hammond studied art at the Junior School of the Art Institute of Chicago and later at Millikin University in Decatur, Illinois. After three years at the University of Minnesota, she received a BFA in painting in 1967. In 1969 she moved to New York and two years later became a founding member of A.I.R. Gallery, the first women's cooperative gallery in the country. Her first one-woman exhibition in New York was held there in 1973.

Hammond became a serious spokeswoman and writer for the women's art movement. Besides exhibiting at A.I.R., she has had several other one-woman shows and has participated in numerous group exhibitions, including Soft as Art at the New York Cultural Center in 1973, Primitive Presence in the '70s at the Vassar College Art Gallery in 1975, Consciousness and Content at the Brooklyn Museum in 1977, and International Feminist Art at the Haags Gemeentemuseum, The Hague, 1980. In recent years she has spent part of her time as a visiting artist or faculty member at various institutions, among them the School of the Art Institute of Chicago, State University of New York College at Purchase, the University of Colorado in Boulder, Tyler School of Art of Temple University in Philadelphia, and the University of New Mexico in Albuquerque. *C.P.H.*

Alhambra, *1968*

Acrylic on canvas, 63 x 180 in.
(160 x 457.2 cm.)
Signed verso, in pen and ink on stretcher:
Harmony Hammond
Gift of the artist, 1969
69.34
Not illustrated

EXHIBITION: Walker Art Center, Minneapolis, *1968 Biennial of Painting and Sculpture*, 1968, cat. 14.

PROVENANCE: the artist

Alhambra is composed of two symmetrical, shaped canvases joined end to end. Three broad, nearly black bands of purple, brown, and bluish-green flat acrylic paint follow the outline of each canvas and have been applied so evenly that no brushwork is evident, giving a mechanically produced appearance that is typically minimalistic. From the outer edge inward, the sequence of color bands is from purple to bluish-green on the left and in reverse order on the right, creating a subtle but vital tension between the two halves. The scale of the work is imposing—it fills the viewer's field of vision—and its architectonic shape and depth relate it to sculpture. These markedly sculptural qualities are also evident in later works by the artist, including her *Bag* and *Presence* series of the early 1970s.

Coloristically, *Alhambra* owes a great deal to Ad Reinhardt's "black paintings" of the 1960s. Its shape, which vaguely resembles the geometric motifs decorating the fourteenth-century Moorish fortress of the same name, is the painting's only allusion to content.

Hammond has acknowledged that her early works followed the male-dominated currents of the late 1960s. After moving to New York in 1969, however, she began to create sculpture out of rags, hair, and thread—"female" materials. In subsequent works, such as *Swaddles*, *Hunker*, and *Arc*, she has continued to incorporate and extend the boundaries of her feminist sensibility by choosing materials, shapes, and colors which evoke very personal aspects of sensuality, maternity, friendship, softness, strength, and vulnerability.

LEON HARTL
1889-1960

SELECTED BIBLIOGRAPHY: Lloyd Goodrich, "Leon Hartl," *The Arts* (January 1926): 23-27 ▪ Leslie Katz, "Three Exemplary Painters," *Arts* (April 1964): 46-47 ▪ Allen Ellenzweig, "Art Reviews....Leon Hartl," *Arts* (March 1977): 24-25.

Leon Hartl emigrated from his native Paris to the United States in 1912, a time when many young American artists were doing just the opposite. An expert in aniline dyes, he had established himself in Paris as a dyer of feathers for then-fashionable women's plumes. In painting, he concentrated on simple nature motifs and became known for his quiet, straightforward, table-top still-lifes of fruits and flowers. A Sunday painter of the countryside surrounding New York City, he also painted lyrical and meticulously drawn bathers, landscapes, and wildflowers in his characteristically muted tones.

Hartl was a fine observer, and his works pay homage to the simple beauties of nature; one critic termed them "naive, but with a precise and delicate naiveté that is next door to extreme sophistication" (Goodrich, p. 23). Upon meeting Juliana Force, Hartl was given a one-man exhibition at the Whitney Studio Club (New York) in 1925 and another in 1926. Later in his career he taught at the Brooklyn Museum School of Art and was a frequent fellow at the artistic communities of Yaddo and the MacDowell Colony. *P.N.*

Spring Bouquet, *1928 • Figure 39*

Spring Bouquet, *1928*

Oil on canvas, 22⅛ x 18¼ in.
(56.2 x 46.4 cm.)
Signed lower left: Leon Hartl '28
Bequest of Hudson Walker from the Ione
and Hudson Walker Collection
78.21.24
Illustration: Figure 39

PROVENANCE: Studio Galleries, New York;
Ione and Hudson Walker

This effusive floral still-life is typical of Hartl's oeuvre in theme and technique. The profuse but delicately painted mass of wildflowers placed against a neutral background presses to the edges of the canvas and seems to overflow the pictorial space. The bountiful bouquet conveys the artist's love of nature, while the careful delineation of simple floral forms reveals a quiet but honest reverence for the season of growth and rebirth.

137

EDMUND MARSDEN HARTLEY
1877-1943

SELECTED BIBLIOGRAPHY: Marsden Hartley, *Adventures in the Arts* (New York: Boni and Liveright, 1921) • Elizabeth McCausland, *Marsden Hartley* (Minneapolis: University of Minnesota Press, 1952) • Robert Burlingame, *Marsden Hartley: A Study of His Life and Creative Achievement* (Providence: Brown University, 1954) • Elizabeth McCausland and M.B. Cowdrey, "Marsden Hartley," *Journal of the Archives of American Art* (January 1968): 9-21 • Charles Eldredge, *Marsden Hartley, Lithographs and Related Works* (Lawrence: University of Kansas Museum of Art, 1972) • William I. Homer, editor, *Avant-Garde Painting and Sculpture in America, 1910-1925* (Wilmington: Delaware Art Museum, 1975), 80-83 • S. Gail Levin, *Wassily Kandinsky and the American Avant-Garde, 1912-1950* (Ann Arbor, Michigan: University Microfilms, 1976) • William I. Homer, *Alfred Stieglitz and the American Avant-Garde* (Boston: New York Graphic Society, 1977), 147-163, 220-223 • Percy North, *Hudson D. Walker: Patron and Friend* (Minneapolis: University of Minnesota Gallery, 1979), 12-13, 23-24 • Barbara Haskell, *Marsden Hartley* (New York: Whitney Museum of American Art, 1980) • Marsden Hartley, *Cleophas and His Own: A North Atlantic Tragedy* (Halifax, Nova Scotia: A Press Publication, 1982).

NOTE: *Barbara Haskell's 1980 exhibition and accompanying catalogue have greatly added to the body of information on Hartley initiated by the research of Elizabeth McCausland. McCausland began the chronological arrangement of Hartley's work, and her chronology was tightened and improved upon by Haskell. The dates given for the works in the University Art Museum collection reflect Dr. Percy North's assimilation of information from both sources.*

Marsden Hartley's life and art reflected a particularly twentieth-century consciousness. He was born and died in Maine but spent most of the intervening years wandering through America and Europe in a constant search for a physical, spiritual, and emotional home. Place was as important to his work as to his sense of well-being, and landscapes comprised a large part of his oeuvre—some depicting where he was at the time they were created, others drawing on memories of where he had been. He sought to express a basic concern for understanding the order of the universe, extracting ideas from Christianity and mysticism to explain the cosmic solitude of humanity and the melancholic depths of the soul.

He was born Edmund Hartley but later adopted his stepmother's maiden name, Marsden, as his middle name and in 1906 started calling himself simply Marsden Hartley. He had already begun studying art, first in Cleveland, where his family had moved, and then in New York at the Chase School for a year and the National Academy of Design for four years. Sometime during the first decade of this century he encountered the brooding, mystical painting of Albert Pinkham Ryder, with whom he felt a spiritual kinship; his early New England landscapes were inspired by the older artist's technique. Many of these were scenes of winter mountains displaying a melancholy mood tinged with nineteenth-century Romanticism. The reflections on spirituality, the sublime power of nature, and the evanescence of the human experience evident in these works lingered in Hartley's oeuvre throughout his career.

In 1909 he met Alfred Stieglitz, an encounter which affected the rest of his artistic career and led to his lifelong friendship with Hudson Walker, a founder and major patron of the University Art Museum. Due to Walker's dedication to art and artists in general, and to Hartley in particular, the museum now holds the largest single group of Hartley's works in the United States and doubtless in the world.

Hartley's long and often stormy relationship with Stieglitz, dealer and mentor for a whole circle of American avant-garde artists during the early decades of this century, is well documented. Briefly, Stieglitz was so taken with Hartley on meeting him that he kept his gallery 291 open past its planned summer closing date to accommodate a one-man Hartley show. In 1910 Stieglitz included him in his momentous Younger American Painters exhibition, and

in 1912 he arranged to send him to Paris, where Hartley participated in Gertrude Stein's salon. Like most other artists of his day, Hartley looked to Paris as the wellspring of revolutionary artistic activity, but he found himself drawn more strongly to the pageantry and psychology he found in Germany. He lightened his palette and evolved a symbolic, mystical vocabulary consisting of numerals, stars, and geometric shapes that would reapper at sporadic intervals throughout his life.

Two of his paintings appeared in the 1913 Armory Show. A large exhibition of his work held at gallery 291 the following year was poorly received due to its blatantly Germanic imagery. Hartley had stayed in Germany after the outbreak of World War I but was forced to return to the United States in 1915. He was deeply affected by the death in combat of a close personal friend, a German soldier, and many of his works from this period reveal a preoccupation with mortality, the fragility of life, and the tragedy of human beings struck down in their prime.

Hartley lived in New York, Massachusetts, and Bermuda before moving in 1918 to Taos, New Mexico, home of a thriving art colony. He found the claustrophobic community unsettling and by 1921 had returned to Europe on the money he had received from a large auction of his works sponsored by Stieglitz. Throughout the 1920s he was an expatriate in Germany and France. He continued the themes and subjects of his earlier years in his paintings, returning repeatedly to identifiable objects and scenes. Enchanted by Cézanne, Hartley visited the south of France and painted Mt. Ste. Victoire and Cézannesque still-lifes.

Back in the United States in 1930, he applied for and received a Guggenheim Fellowship. To comply with the stipulation that work be done outside the United States, he went to Mexico in March of 1932, where he reverted to the mysticism of his German years. In New York in 1934 he worked for a brief time for the WPA Art Project. Continually changing locales with the seasons, he revisited Bermuda in 1935 and traveled to Nova Scotia during the autumn of that year. Hartley's Canadian experiences were the basis for the consciously rural American subjects and primitive techniques of his later work.

In 1937 Hartley finally returned to Maine; he would alternate between his native state and New York City for the last six years of his life. His late works feature the landscapes of Nova Scotia and Maine and the aquatic life that sustained the inhabitants of these rugged regions. Archaic portraits of these individuals pay tribute to the simplicity and sympathy of rural people.

In 1938 Hartley began his association with Hudson Walker. Walker and his wife, Ione Avery Gaul, had opened the Hudson D. Walker

Gallery in the heart of New York's gallery district in 1936. Apparently he first became interested in Hartley when he saw his 1937 show at Stieglitz's An American Place gallery. The show was a financial disaster, and Hartley, who had not sold anything in over a year, contemplated suicide (Haskell, p. 102). Stieglitz, finally disillusioned with Hartley's inability to concentrate his time and energy either in one place or on one artistic direction, was only too happy to bow out of the picture (Haskell, p. 102). Hartley gratefully welcomed the young Walker's enthusiastic support.

Walker had an unswerving belief in Hartley's talent, and he helped to sustain the aging and fragile painter for the rest of his days—haggling with others over the cost of framing his works, asking for advances on his drawings (Walker to Nelson Goodman, 4 October 1938, Archives of American Art [AAA]), and concealing from him the fact that he sometimes lowered the prices on his paintings and absorbed the difference himself (Walker to Henry Reed, 7 May 1940, AAA).

The Walker Gallery gave Hartley three one-man shows, one during each of the years that the two men were associated. The first, in 1938, consisted of paintings and drawings executed in Maine during 1937 and 1938. In March of 1939 Walker showed the Archaic Portraits, likenesses of the Mason family with whom Hartley had lived in Nova Scotia in 1936. The portraits, which included *Adelard the Drowned, Master of the "Phantom"* (illustrated on cover) and *Marie Ste. Esprit* (Colorplate VII), were part of Hartley's emotional outpouring after the tragic drowning deaths of young Donny and Alty Mason and their cousin Allan. *Adelard the Drowned* is a portrait of Alty Mason, with whom Hartley had had a strong liaison (and probable sexual relationship); *Marie Ste. Esprit* is a portrait of Alty's mother. The Archaic Portraits were a great critical success but generated only $100 in sales. Walker also managed to trade a painting for a set of dentures for Hartley (Haskell, p. 116).

Hartley's last show with Walker, in 1940, included Mount Katahdin scenes, his Lincoln portraits (one is now in the collection of the Nebraska Art Association), and a series of portraits of wrestlers, called Madawaska figures. The sales from this show are not recorded, but it may be assumed that they were disappointing because Walker was forced to close his gallery later that same year. Earlier he had written to his father, Minneapolis lumber magnate and art collector T.B. Walker, that "Hartley may come through...Everyone speaks of Hartley as being the top painter in the country so he will eventually do well" (Letter from H. Walker to A. Walker, 19 April 1940, AAA). In September, after closing his gallery and taking a place in his father's lumber company, he wrote

to Stieglitz that "the business of handling Hartley was certainly the highlight of our being a gallery" (Walker to Stieglitz, 15 September 1940, AAA).

Walker made a great effort to place all of his artists with appropriate New York dealers when his gallery closed; Hartley went to Macbeth Gallery but did not stay there long. In 1942 he was asked to show at Paul Rosenberg's new New York gallery, and Walker wrote in his diary on December 7 of that year that he had been to see Rosenberg, who "told me with great Gallic intensity and with flailing hands that Marsden is the greatest American artist of all time—a true American with a universal appeal. Did I cluck like a hen with a new laid egg!" (Walker diary entry dated 7 December 1942, AAA). Walker continued to keep in close touch with Hartley and to offer financial and "family" support. In 1941 he bought 23 paintings for $5,000—a sum which might have given the artist some financial security had he not placed it in savings in the National City Bank and left it there (Haskell, p. 123).

In mid-July of 1943, Hartley went to Corea, Maine and on September 2 died of heart failure in the hospital at Ellsworth. Walker later remarked that he believed "Hartley had eaten himself to death, driven by a fear of dying in poverty, instilled by his father" (Elizabeth McCausland, interview with Hudson Walker, McCausland Papers, AAA; quoted in Haskell, p. 126). Barbara Haskell commented that it was more likely that years of inadequate nutrition, marginal medical assistance, and unresolved nervous anxieties hastened his death. At the time he had $500 in cash and $10,000 in savings (Haskell, p. 126), undoubtedly more money than at any other moment in his life.

Hartley left no will, but because Walker was named in a "Document of Identification" the artist had written shortly before his death that specified which persons to notify in that event, he took on partial responsibility for settling the estate, much of which he purchased. In January of 1950 he made the University a long-term loan of approximately 1,000 works of art, at least 124 of them by Hartley. In 1950 he pledged to underwrite part of the research and publication costs for a monograph on Hartley by Elizabeth McCausland, which was published by the University of Minnesota Press in 1952 and until recently stood as the major monograph on the artist. At his death in 1976, Hudson Walker's bequest to the University of Minnesota Art Museum included over 1,200 works of art. The Hartley works in the collection stand today at 61 paintings and 54 drawings, prints, and watercolors, which taken together represent a complete picture of Hartley's artistic career.

In 1981 the Whitney Museum of American Art mounted a major retrospective of the work of Marsden Hartley which firmly established his reputation as an American twentieth-century master. The catalogue for the exhibition by Barbara Haskell examined, documented, and analyzed his life and work in great detail; readers wanting to know more about him are referred to that source. *P.N. and L.K.*

Summer, *1908*

Oil on academy board, 9 x 11⅞ in. (22.9 x 30.2 cm.)
Signed lower left: Marsden Hartley
Bequest of Hudson Walker from the Ione and Hudson Walker Collection
78.21.239
Illustration: Appendix

REFERENCE: Elizabeth McCausland, *Marsden Hartley* (Minneapolis: University of Minnesota Press, 1952), 64.

EXHIBITIONS: *Marsden Hartley Retrospective*, 1952 ▪ *100 Paintings, Drawings, and Prints from the Ione and Hudson D. Walker Collection*, 1965, cat. 24 ▪ Bernard Danenberg Galleries, New York, *Marsden Hartley, A Retrospective*, 1969, cat. 2 ▪ Carleton College, Northfield, Minnesota, *American Art 1900-1940*, 1977.

PROVENANCE: Charles Daniel Gallery, New York; Ione and Hudson Walker

The mountains which fill Hartley's canvases after 1906 show the beginning of the artist's lifelong commitment to an exploration of this natural phenomenon. In *Summer*, as in other early Maine landscapes, mountains stippled with patches of color dominate the painting, leaving only a thin ribbon of sky. The dense mass of shapes has been purged of extraneous details and reduced to a single plane to emphasize the two-dimensional nature of the medium. As evidenced by the seasonal titles given many of these early works, Hartley was fascinated by mountains as symbols of permanence amid the flux of cyclical change. Taken in series, these paintings reveal a succession of emotional states. The tiny foreground buildings, peacefully sheltered by the mountain, and the pervasive, pleasant greens give this painting a tone entirely different from Hartley's somber 1909 landscapes. *P.N.*

Autumn *(1), 1908*

Oil on academy board, 12 x 14 in. (30.5 x 35.6 cm.)
Signed lower right: M.H.
Bequest of Hudson Walker from the Ione and Hudson Walker Collection
78.21.238
Illustration: Appendix

REFERENCE: Elizabeth McCausland, *Marsden Hartley* (Minneapolis: University of Minnesota Press, 1952), 64.

This is the smaller of two works of the same name dating from 1908. Here the glittering colors appear stitched to the canvas in a patchwork of small brushstrokes. This technique of separating colors into small, isolated areas reflects Hartley's awareness of the work of the Italian painter Giovanni Segantini. By placing intense colors individually against the dark ground, Hartley achieved a vibrant prismatic surface not unlike stained glass. Uncharacteristically, he signed the work with his initials, an indication that it was probably exhibited early in his career. *P.N.*

EXHIBITIONS: *Marsden Hartley Retrospective*, 1952 • *100 Paintings, Drawings, and Prints from the Ione and Hudson D. Walker Collection*, 1965, cat. 16 • *Hudson D. Walker: Patron and Friend*, 1977, cat. 22 • University Art Gallery, University of South Dakota, Vermillion, *A Memorial Exhibition, Marsden Hartley, 1877-1943*, 1978 • Salander-O'Reilly Galleries,Inc., New York, *Marsden Hartley: Paintings and Drawings*, 1985 • *Marsden Hartley 1908-1942: The Ione and Hudson Walker Collection*, 1986.

PROVENANCE: Ione and Hudson Walker

Oil on canvas, 30¼ x 30¼ in. (76.8 x 76.8 cm.)
Unsigned
Bequest of Hudson Walker from the Ione and Hudson Walker Collection
78.21.98
Illustration: Appendix

REFERENCES: Elizabeth McCausland, *Marsden Hartley* (Minneapolis: University of Minnesota Press, 1952), 13, 14, 64 • Sam Hunter and John Jacobus, *American Art of the Twentieth Century* (Englewood Cliffs, New Jersey: Prentice-Hall, 1973), 120.

EXHIBITIONS: *Marsden Hartley Retrospective*, 1952 • Department of Fine Arts Gallery, Louisiana State University, Baton Rouge, *Marsden Hartley*, 1957 • *Marsden Hartley: Landscapes*, 1957 • Huntington Galleries, West Virginia, *Marsden Hartley*, 1957 • Roswell Museum and Art Center, New Mexico, Traveling Exhibition, *Marsden Hartley, Early Paintings from 1908 to 1920*, 1958 • Western Association of Art Museums Traveling Exhibition, *Marsden Hartley*, 1958-1960 • The Century Association, New York, *Paintings by Marsden Hartley from the Collection of the Hudson Walker Family*, 1970 • Art Museum Association of America and the University Art Museum, Traveling Exhibition, *Marsden Hartley 1908-1942: The Ione and Hudson Walker Collection*, 1984-1985, cat. 2 • *Marsden Hartley 1908-1942: The Ione and Hudson Walker Collection*, 1986.

PROVENANCE: Ione and Hudson Walker

Autumn *(2), 1908*

Hartley demonstrated a freer technique and more emotional response to painting throughout the fall and winter of 1908-1909. The surfaces of his landscapes became more densely woven and the forms less distinguishable. In this, the larger of the two *Autumn*s from 1908, suggestions of trees—lingering remnants of topical landscape elements—carve up the space. Although Hartley explored the moods of all seasons, he particularly responded to the dramatic power of autumn and winter—times of the year that suited his despondent nature. Either one or both of the *Autumn* paintings may have been shown under the generic title *Songs of Autumn* in Hartley's first exhibition at gallery 291 in 1909. *P.N.*

Two paintings titled *Late Autumn* and a third, *Trees in Autumn*, continue Hartley's preoccupation with the mountain motif. The flattened spaces, thin line of sky, and active brushwork typical of his early Maine landscapes are still apparent, as is the progression toward a more expressive, painterly style. All three works are similar in format: a mountain framed by trees extends across the canvas and is silhouetted against an inconsequential sliver of sky that serves as a point of reference. *Late Autumn* (1), with its more distinguishable imagery and controlled technique, appears to be the earliest work in this group. In the later two, spatial distinctions are blurred, the plane of the mountain is the same as the sky, and the whole surface is enlivened by tense, expressive brushwork. *P.N.*

Late Autumn *(1), 1908*

Oil on academy board, 12 x 14 in.
(30.5 x 35.6 cm.)
Unsigned
Bequest of Hudson Walker from the Ione and Hudson Walker Collection
78.21.19
Illustration: Appendix

REFERENCE: Elizabeth McCausland, *Marsden Hartley* (Minneapolis: University of Minnesota Press, 1952), 64.

EXHIBITIONS: *Marsden Hartley Retrospective*, 1952 • *100 Paintings, Drawings, and Prints from the Ione and Hudson D. Walker Collection*, 1965, cat. 21 • University Art Gallery, University of South Dakota, Vermillion, *A Memorial Exhibition, Marsden Hartley, 1877-1943*, 1978 • Henry Art Gallery, University of Washington, Seattle, Traveling Exhibition, *American Impressionist Exhibition*, 1979-1980.

PROVENANCE: Ione and Hudson Walker

Late Autumn *(2), 1908*

Oil on academy board, 14 x 12 in.
(35.6 x 30.5 cm.)
Signed lower left: Marsden Hartley
Bequest of Hudson Walker from the Ione and Hudson Walker Collection
78.21.252
Illustration: Appendix

REFERENCE: Elizabeth McCausland, *Marsden Hartley* (Minneapolis: University of Minnesota Press, 1952), 64.

EXHIBITIONS: *Marsden Hartley Retrospective*, 1952 • Huntington Galleries, West Virginia, *Marsden Hartley*, 1957 • The

Century Association, New York, *Paintings by Marsden Hartley from the Collection of the Hudson Walker Family*, 1970.

PROVENANCE: Ione and Hudson Walker

Trees in Autumn, *1908*

Oil on academy board, 12 x 14 in.
(30.5 x 35.6 cm.)
Signed lower left: Marsden Hartley
Bequest of Hudson Walker from the Ione and Hudson Walker Collection
78.21.240
Illustration: Appendix

REFERENCE: Elizabeth McCausland, *Marsden Hartley* (Minneapolis: University of Minnesota Press, 1952), 65.

EXHIBITIONS: *Marsden Hartley Retrospective*, 1952 • *100 Paintings, Drawings, and Prints from the Ione and Hudson D. Walker Collection*, 1965 • The Century Association, New York, *Paintings by Marsden Hartley from the Collection of the Hudson Walker Family*, 1970 • C.W. Post Art Gallery, Long Island University, Greenvale, Long Island, New York, *Marsden Hartley, 1877-1943*, 1977, cat. 3 • University Art Gallery, University of South Dakota, Vermillion, *A Memorial Exhibition, Marsden Hartley, 1877-1943*, 1978 • *Marsden Hartley 1908-1942: The Ione and Hudson Walker Collection*, 1986.

PROVENANCE: Ione and Hudson Walker

Landscape #18, *1908*

Oil on academy board, 12 x 12 in.
(30.5 x 30.5 cm.)
Signed verso: Marsden Hartley
Bequest of Hudson Walker from the Ione and Hudson Walker Collection
78.21.41
Illustration: Appendix

REFERENCE: Elizabeth McCausland, *Marsden Hartley* (Minneapolis: University of Minnesota Press, 1952), 64.

EXHIBITIONS: *Marsden Hartley Retrospective*, 1952 • *100 Paintings, Drawings, and Prints from the Ione and Hudson D. Walker Collection*, 1965, cat. 20 • Artmobile, The Minneapolis Institute of Arts Traveling Exhibition, 1969-1970.

PROVENANCE: Alfred Stieglitz; Ione and Hudson Walker

Maine Snowstorm, *1908*

Oil on canvas, 30⅛ x 30⅛ in.
(76.5 x 76.5 cm.)
Signed verso: Marsden Hartley
Gift of Ione and Hudson Walker
61.1
Illustration: Figure 40

REFERENCES: Elizabeth McCausland,
Marsden Hartley (Minneapolis: University
of Minnesota Press, 1952), 13, 64 • Gorham
Munson, "The Painter from Maine," *Arts*
(February 1961): 34.

EXHIBITIONS: Tweed Gallery, University of
Minnesota-Duluth, *Marsden Hartley
Exhibition*, 1952 • *Marsden Hartley
Retrospective*, 1952 • Museum of Modern
Art Traveling Exhibition, *Three Modern
Masters: Feininger, Hartley, Beckmann*,
1955-1957 • Department of Fine Arts
Gallery, Louisiana State University, Baton
Rouge, *Marsden Hartley*, 1957 • *Marsden
Hartley: Landscapes*, 1957 • *Selections from
the Collection*, 1957 • *Selected Works from
the Collection of Ione and Hudson Walker*,
1959 • American Federation of Arts
Traveling Exhibition, *Marsden Hartley
Retrospective*, 1960-1962, cat. 1 • American
Federation of Arts Traveling Exhibition,
American Impressionists: Two Generations,
1963-1964, cat. 14 • Tweed Gallery,
University of Minnesota-Duluth, *Dedicatory
Exhibition Honoring Mrs. Alice Tweed
Tuohy*, 1965, cat. 35 • *Selections from the
Permanent Collection*, 1968, 1969, 1975 •
Art Museum Association of America and
the University Art Museum, Traveling
Exhibition, *Marsden Hartley 1908-1942:
The Ione and Hudson Walker Collection*,
1984-1985, cat. 2 • *Marsden Hartley 1908-
1942: The Ione and Hudson Walker
Collection*, 1986.

PROVENANCE: Alfred Stieglitz; Ione and
Hudson Walker

In *Maine Snowstorm* Hartley evoked the raw, blustery force of
winter. Winds bend trees into curvilinear patterns and snow distorts
visibility. Objects and ground are virtually indistinguishable and
literal references are all but eliminated. *P.N.*

Maine Snowstorm, *1908* • *Figure 40*

Songs of Winter, *c. 1908*

Oil on academy board, 8⅞ x 11⅞ in.
(22.5 x 30.2 cm.)
Signed lower right and verso: Marsden
Hartley
Bequest of Hudson Walker from the Ione
and Hudson Walker Collection
78.21.834
Illustration: Appendix

REFERENCES: Sadakichi Hartmann,
"Unphotographic Paint: The Texture of
Impressionism," *Camera Work* (October
1909): 20 • Elizabeth McCausland, *Marsden
Hartley* (Minneapolis: University of
Minnesota Press, 1952), 64.

EXHIBITIONS: American Association of
University Women Traveling Exhibition,
Marsden Hartley, 1950-1951 • *100
Paintings, Drawings, and Prints from the
Ione and Hudson D. Walker Collection*,
1965, cat. 23.

PROVENANCE: Ione and Hudson Walker

In his 1909 exhibition at gallery 291, Hartley exhibited a series of seven oil paintings titled *Songs of Winter* and fifteen titled *Songs of Autumn*; *Songs of Winter* in the University Art Museum Collection certainly belongs to the former series. Of it, critic Sadakichi Hartmann wrote: "They represented winter scenes agitated by snow and wind, 'proud music of the storm,' wood interiors, strange entanglements of tree trunks; and mountain slopes with autumn woods with some island-dotted river winding along the base" (Hartmann, p. 20).

Indicative of Hartley's lyrical approach to the moods of nature, the titles also suggest sounds associated with particular seasons. Aural sensations are thus as important as visual and tactile ones. Typical of other landscapes from this period, the mountain in *Songs of Winter* pushes to the edges of the canvas and strains against the foreground plane. *P.N.*

Landscape #36, *c. 1908-1909*

Oil on canvas, 30⅛ x 34 in.
(76.5 x 86.4 cm.)
Unsigned
Bequest of Hudson Walker from the Ione
and Hudson Walker Collection
78.21.66
Illustration: Appendix

REFERENCES: Elizabeth McCausland,
Marsden Hartley (Minneapolis: University
of Minnesota Press, 1952), 65 • Hilton
Kramer, "Hartley and Modern Painting,"
Arts (February 1961): 43.

EXHIBITIONS: *Marsden Hartley
Retrospective*, 1952, and Traveling
Exhibition, 1952-1954 • Department of Fine
Arts Gallery, Louisiana State University,
Baton Rouge, *Marsden Hartley*, 1957 •
Marsden Hartley: Landscapes, 1957 •
Huntington Galleries, West Virginia,
Marsden Hartley, 1957 • Roswell Museum
and Art Center, New Mexico, Traveling
Exhibition, *Marsden Hartley, Early
Paintings from 1908 to 1920*, 1958 •
Western Association of Art Museums
Traveling Exhibition, *Marsden Hartley*,
1958-1960 • American Federation of Arts

Although Hartley frequently dramatized the breadth and power of mountains in his landscapes of 1908 and 1909, in *Landscape #36* the trees framing the composition occupy the largest portion of the canvas and crowd the mountain into a small wedge shape. As in other early landscapes, Hartley eliminated traditional distinctions between the foreground and background and the relative density of objects by incorporating hills, trees, and clouds into a rhythmic curvilinear pattern of choppy, directional brushstrokes. Clouds as solid as trees form a plane with the mountain and silhouette its shape; the looming trees create a foreground plane, pushing the hillside into the background.

In *Landscape #36*, nature is more contained and comprehensible than in the majority of Hartley's works from this period. Here he emphasized the similarities between trees, clouds, and hills—all elements of the same generative force. *P.N.*

Traveling Exhibition, *Marsden Hartley
Retrospective*, 1960-1962, cat. 6 ▪ Western
Art Gallery, Western Washington State
College, Bellingham, *Marsden Hartley*, 1967
▪ The Century Association, New York,
*Paintings by Marsden Hartley from the
Collection of the Hudson Walker Family*,
1970 ▪ The Minneapolis Institute of Arts,
Painters and Photographers of Gallery 291,
1973-1974 ▪ University of Kansas Museum
of Art, Lawrence, *Inaugural Exhibition—
Spencer Museum of Art*, 1978 ▪ Art
Museum Association of America and the
University Art Museum, Traveling
Exhibition, *Marsden Hartley 1908-1942:
The Ione and Hudson Walker Collection*,
1984-1985, cat. 6 ▪ *Marsden Hartley 1908-
1942: The Ione and Hudson Walker
Collection*, 1986.

PROVENANCE: Alfred Stieglitz; Ione and
Hudson Walker

Deserted Farm and *Mountainside* belong to a series of "black
landscapes" (an appellation accorded these works when several of
them were exhibited at gallery 291 in the 1910 Younger American
Painters exhibition) which Hartley created at the end of the first
decade of this century in response to the works of Albert Pinkham
Ryder.

Sanford Schwartz explained Hartley's emulation of Ryder: "In
Deserted Farm, 1909, there is nothing to relieve the depression: the
mountains go up from the narrow valleys like walls, giving the
night sky and clouds almost no room to breathe. Ryder isn't ever
terse like this: he is gentler, he gets lost in his rhythms, there is
always buttery yellow, mahogany brown and purple in his black.
Hartley, prompted by Ryder to add more somber colors and
feelings to his art, went off in another direction from his model: he
makes black suffocating" (Schwartz, p. 73).

Yet Hartley achieved the mysteriousness of Ryder's murky night
scenes and utilized Ryderesque curvilinear arabesques in composing
this landscape. As nature's constant, the mountain once again
dominates all other matter. Remnants of human habitation appear
insignificant, overpowered by foreground trees and rocks. Carol
Rice perceived this work to be an intensely personal expression:
"Hartley painted *Deserted Farm* (*c.* 1909) to express his sense of
abandonment and his fears of the mysterious and powerful
environment. The scale of nature—the ominous mountain looming
over the small house—dwarfs the significance of man....The image
of the abandoned farm house parallels Hartley's fear of his total
environment" (Rice, not paged). *P.N.*

Oil on composition board, 24 x 20 in.
(61 x 50.8 cm.)
Signed lower left: Marsden Hartley
Gift of Ione and Hudson Walker
61.2
Illustration: Figure 41

REFERENCES: Herbert J. Seligmann, "The
Elegance of Marsden Hartley Craftsman,"
International Studio (October 1921): LII •
Dorothy C. Miller, editor, *Lyonel Feininger
and Marsden Hartley* (New York: Museum
of Modern Art, 1944), 68 • Hudson
Walker, "Marsden Hartley," *Kenyon
Review* (Spring 1947): 249 • Elizabeth
McCausland, *Marsden Hartley*
(Minneapolis: University of Minnesota
Press, 1952), 16, 18, 65 • Elizabeth
McCausland, "The Return of the Native,"
Art in America (Spring 1952): 61 • Gorham
Munson, "The Painter from Maine," *Arts*
(February 1961): 34 • Peter Plagens,
"Marsden Hartley Revisited," *Artforum*
(May 1969): 42 • Irma Jaffe, "Cubist
Elements in the Painting of Marsden
Hartley," *Art International* (April 1970): 37
• Sanford Schwartz, "A Northern Seascape,"
Art in America (January-February 1976): 73
• Carol Rice, *The Mountains of Marsden
Hartley* (Minneapolis: University of
Minnesota Gallery, 1979), not paged.

EXHIBITIONS: American Association of
University Women Traveling Exhibition,
Marsden Hartley, 1950-1951 • *Marsden
Hartley Retrospective*, 1952, and Traveling
Exhibition, 1952-1954 • Baltimore Museum
of Art, *Man and His Years*, 1954 • Museum
of Modern Art Traveling Exhibition, *Three
Modern Painters: Feininger, Hartley,
Beckmann*, 1955-1957 • University of
Nebraska Art Galleries, Lincoln, *Man and
Mountain*, 1957 • Roswell Museum and Art
Center, New Mexico, Traveling Exhibition,
*Marsden Hartley, Early Paintings from
1908 to 1920*, 1958 • Western Association
of Art Museums Traveling Exhibition,
Marsden Hartley, 1958-1960 • American
Federation of Arts Traveling Exhibition,
Marsden Hartley Retrospective, 1960-1962,
cat. 5 • *100 Paintings, Drawings, and Prints
from the Ione and Hudson D. Walker
Collection*, 1965, cat. 26 • *Selections from
the Permanent Collection*, 1968 • University
Galleries of the University of Southern
California and the University Art Museum
of the University of Texas at Austin,
Traveling Exhibition, *Marsden Hartley—
Painter/Poet*, 1968-1969, cat. 45 •

Deserted Farm, *1909*

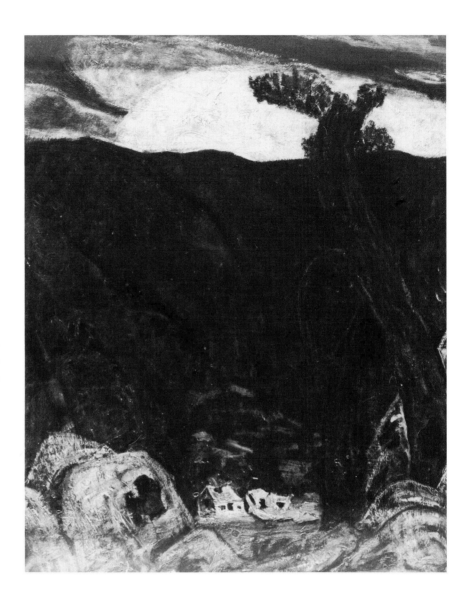

Deserted Farm, *1902* • *Figure 41*

Artmobile, The Minneapolis Institute of
Arts Traveling Exhibition, 1969-1970 •
Tyler Museum of Art, Tyler, Texas,
American Paintings 1900-Present, 1971 •
Carleton College, Northfield, Minnesota,
American Art 1900-1940, 1977 • University
Art Gallery, University of South Dakota,
Vermillion, *A Memorial Exhibition,
Marsden Hartley, 1877-1943*, 1978 • *The
Mountains of Marsden Hartley*, 1979 •
Whitney Museum of American Art, New
York, *Marsden Hartley Retrospective*, 1980,
cat. 6 • Art Museum Association of America
and the University Art Museum, Traveling
Exhibition, *Marsden Hartley 1908-1942:
The Ione and Hudson Walker Collection*,
1984-1985, cat. 7 • *Marsden Hartley 1908-
1942: The Ione and Hudson Walker
Collection*, 1986.

PROVENANCE: Charles Daniel Gallery, New
York; Robert Laurent; Paul Rosenfeld; Ione
and Hudson Walker

Mountainside, *1909*

Oil on academy board, 12 x 14 in.
(30.5 x 35.6 cm.)
Unsigned
Bequest of Hudson Walker from the Ione
and Hudson Walker Collection
78.21.231
Illustration: Figure 42

REFERENCE: Elizabeth McCausland, *Marsden
Hartley* (Minneapolis: University of
Minnesota Press, 1952), 65.

EXHIBITIONS: American Association of
University Women Traveling Exhibition,
Marsden Hartley, 1950-1951 • *Marsden
Hartley Retrospective*, 1952 • Isaac Delgado
Museum of Art, New Orleans, *The World
of Art in 1910*, 1960 • *100 Paintings,
Drawings, and Prints from the Ione and
Hudson D. Walker Collection*,
1965, cat. 28.

PROVENANCE: Ione and Hudson Walker

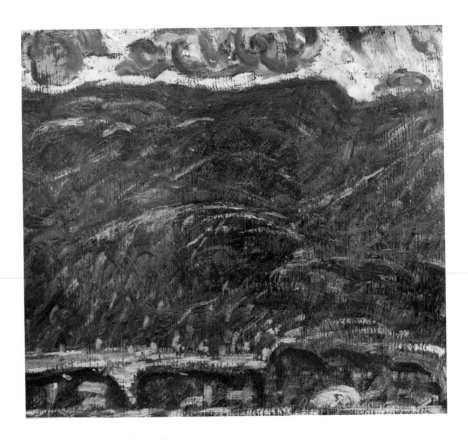

Mountainside, *1909* • *Figure 42*

Landscape #14, *1909*

Oil on academy board, 12 x 14 in.
(30.5 x 35.6 cm.)
Unsigned
Bequest of Hudson Walker from the Ione
and Hudson Walker Collection
78.21.43
Illustration: Appendix

REFERENCE: Elizabeth McCausland, *Marsden Hartley* (Minneapolis: University of Minnesota Press, 1952), 65.

EXHIBITIONS: *Marsden Hartley Retrospective*, 1952 • Huntington Galleries, West Virginia, *Marsden Hartley*, 1957 • *100 Paintings, Drawings, and Prints from the Ione and Hudson D. Walker Collection*, 1965, cat. 27 • Carleton College, Northfield, Minnesota, *American Art 1900-1940*, 1977.

PROVENANCE: Alfred Stieglitz; Ione and Hudson Walker

A variation of Hartley's Maine mountainscapes of 1909, *Landscape #14* uses compositional devices common to others in the series. Thin lines of trees frame the central space of the composition, and rolling clouds echo the shape of the mountain. This work is distinguished, however, by a thinner application of paint and by a more delicate, pastoral quality. *P.N.*

Landscape #28, *1909*

Oil on academy board, 14 x 12 in.
(35.6 x 30.5 cm.)
Unsigned
Bequest of Hudson Walker from the Ione
and Hudson Walker Collection
78.21.42
Illustration: Appendix

REFERENCE: Elizabeth McCausland, *Marsden Hartley* (Minneapolis: University of Minnesota Press, 1952), 65.

EXHIBITIONS: *Marsden Hartley Retrospective*, 1952 • Isaac Delgado Museum of Art, New Orleans, *The World of Art in 1910*, 1960.

PROVENANCE: Alfred Stieglitz; Ione and Hudson Walker

Although it is possible to discern the shapes of trees, clouds, and a mountain in *Landscape #28*, these elements are less clearly defined here than in the majority of Hartley's Maine mountain scenes. Freely painted forms—harbingers of Hartley's personal abstract style—create a decorative pattern which encircles the canvas and echoes the undulating lines of the landscape. An irregular, inverted triangle of trees and clouds encloses the composition so the viewer cannot escape being drawn to the mountain. *P.N.*

Flowers, *1910*

Oil on canvas, 20½ x 16⅛ in.
(52.1 x 41.0 cm.)
Unsigned
Bequest of Hudson Walker from the Ione
and Hudson Walker Collection
78.21.293
Illustration: Appendix

EXHIBITION: Western Art Gallery, Western
Washington State College, Bellingham,
Marsden Hartley, 1967.

PROVENANCE: Carl Sprinchorn; Bertha
Schaefer Gallery; Ione and Hudson Walker

Although Hartley did not visit Europe until 1912, by 1910 he had become familiar with European modernist techniques through his association with American artists who had been in Paris and by viewing the European exhibitions at gallery 291. In *Flowers* Hartley explored a conception of pictorial space introduced by Cézanne in defiance of traditional compositional alignment. The lush colors, dark and heavy outlines, and distinct brushstrokes also show the influence of Matisse and his quest for direct and immediate visual sensations. Consciously inelegant, the unspecified flowers and fruit retain a vigorous beauty and hearty grace. The active paint surface adds vibrancy to the image. *P.N.*

Waterfall, *1910*

Oil on academy board, 12 x 12 in.
(30.5 x 30.5 cm.)
Unsigned
Bequest of Hudson Walker from the Ione
and Hudson Walker Collection
78.21.835
Illustration: Appendix

REFERENCE: Elizabeth McCausland, *Marsden Hartley* (Minneapolis: University of
Minnesota Press, 1952), 65.

EXHIBITIONS: *100 Paintings, Drawings, and
Prints from the Ione and Hudson D.
Walker Collection*, 1965, cat. 29 •
University Art Gallery, University of South
Dakota, Vermillion, *A Memorial
Exhibition, Marsden Hartley, 1877-1943*,
1978 • Salander-O'Reilly Galleries, Inc.,
Marsden Hartley: Paintings and Drawings,
1985 • High Museum of Art, Atlanta,
Traveling Exhibition, *The Advent of
Modernism: Post-Impressionism and North
American Art, 1900-1918*, 1986.

PROVENANCE: Ione and Hudson Walker

After the 1910 Matisse exhibition at gallery 291, Hartley was stimulated by the fauvist techniques of European modernism. Although he remained essentially a painter of landscapes, he began to vary his subjects as well as his forms. A highly decorative composition, *Waterfall* exemplifies his incipient fauvist style in its use of intense, aggressive, nonliteral colors thickly applied in broad brushstrokes intermingled with residues of the Segantini-inspired stitch. The meandering, serpentine shape of the flowing water creates an intriguing sense of depth that is more sophisticated than the shallow space of the 1908 and 1909 mountain paintings.

Waterfall explodes with the richness of autumn foliage reflected in the water and portrays nature in a more joyous mood than do any of Hartley's paintings produced during the two preceding years. A similar composition by the artist, *Landscape*, is in the Fogg Art Museum of Harvard University (Cambridge, Massachusetts). *P.N.*

Abstraction, *1911*

Oil on cardboard, 16¼ x 13 in.
(41.3 x 33 cm.)
Unsigned
Gift of Ione and Hudson Walker
61.3
Illustration: Figure 43

REFERENCES: Belle Krasne, "The Modern
Presents 37 Years of Abstraction in
America," *Art Digest* (1 February 1951): 11
▪ Elizabeth McCausland, *Marsden Hartley*
(Minneapolis: University of Minnesota
Press, 1952), 19, 65 ▪ Elizabeth
McCausland, *Marsden Hartley* (San
Antonio: Marion Koogler McNay Art
Institute, 1960) ▪ William I. Homer, editor,
*Avant-Garde Painting and Sculpture in
America (1910-1925)* (Wilmington,
Delaware: Delaware Art Museum, 1975),
81 ▪ Judith Zilczer, *The Aesthetic Struggle
in America, (1913-1918), Abstract Art and
Theory in the Stieglitz Circle* (Newark:
University of Delaware, 1975), 175-176,
356 ▪ S. Gail Levin, *Wassily Kandinsky and
the American Avant-Garde, 1912-1950*
(New Brunswick: Rutgers University, 1976),
100 ▪ William I. Homer, *Alfred Stieglitz and
the American Avant-Garde* (Boston: New
York Graphic Society, 1977), 156 ▪ S. Gail
Levin, "Marsden Hartley and the European
Avant-Garde," *Arts* (September 1979): 158
▪ Barbara Haskell, *Marsden Hartley* (New
York: Whitney Museum of American Art,
1980), 22.

EXHIBITIONS: *Marsden Hartley
Retrospective*, 1952, and Traveling
Exhibition, 1952-1954 ▪ American
Federation of Arts Traveling Exhibition,
Pioneers of American Abstract Art, 1955-
1956 ▪ Dallas Museum for Contemporary
Arts, *Marsden Hartley*, 1957 ▪ Roswell
Museum and Art Center, New Mexico,
Traveling Exhibition, *Marsden Hartley,
Early Paintings from 1908 to 1920*, 1958 ▪
Western Association of Art Museums
Traveling Exhibition, *Marsden Hartley*,
1958-1960 ▪ American Federation of Arts
Traveling Exhibition, *Marsden Hartley*,
1960-1962, cat. 8 ▪ *100 Paintings,
Drawings, and Prints from the Ione and
Hudson D. Walker Collection*, 1965, cat.
31 ▪ *Selections from the Permanent
Collection*, 1968 ▪ University Galleries of
the University of Southern California and
the University Art Museum of the
University of Texas at Austin, Traveling

A very early example of nonobjective painting and probably
Hartley's first effort in that genre, *Abstraction* remains a curious
and unique work in the artist's oeuvre. Although it is related to his
pictorial experiments of 1914, it was also undoubtedly influenced
by the modernist ideas espoused by Arthur DOVE and other
intimates of Stieglitz's gallery 291. It also bears a resemblance to a
series of abstract studies of nature Dove produced at around the
same time.

This painting is almost a pictograph that investigates the subtle
relationships of figure and ground. The enigmatic, hieroglyphic
forms lend themselves to multiple interpretations as small animals
and landscape elements seem to emerge from the contrast of flat,
curved shapes and angular lines. The small scale of this painting is
typical of early experiments by American moderns. On the reverse
of the little panel is the fragment of a nude that probably dates
from Hartley's student period. *P.N.*

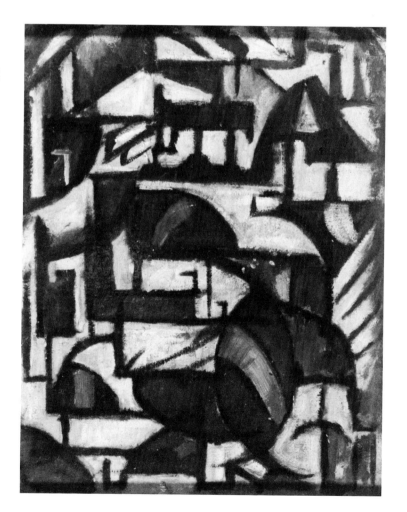

Abstraction, *1911* ▪ *Figure 43*

153

Exhibition, *Marsden Hartley—Painter/Poet*,
1968-1969, cat. 40 ▪ Delaware Art
Museum, Wilmington, *Avant-Garde
Painting and Sculpture in America, 1910-
1925*, 1975 ▪ *Hudson D. Walker: Patron
and Friend*, 1977, cat. 25 ▪ University Art
Gallery, University of South Dakota,
Vermillion, *A Memorial Exhibition,
Marsden Hartley, 1877-1943*, 1978 ▪
Detroit Institute of Arts Statewide Services
Program Traveling Exhibition, *Paris and the
American Avant-Garde, 1900-1925*, 1980-
1981 ▪ Art Museum Association of America
and the University Art Museum, Traveling
Exhibition, *Marsden Hartley 1908-1942:
The Ione and Hudson Walker Collection*,
1984-1985, cat. 8 ▪ *Marsden Hartley 1908-
1942: The Ione and Hudson Walker
Collection*, 1986.

PROVENANCE: Ione and Hudson Walker

Landscape #10, *1911*

Oil on wood panel, 9⅜ x 5¼ in.
(23.8 x 13.3 cm.)
Signed verso: Marsden Hartley
Bequest of Hudson Walker from the Ione
and Hudson Walker Collection
78.21.40
Illustration: Appendix

REFERENCE: Elizabeth McCausland, *Marsden
Hartley* (Minneapolis: University of
Minnesota Press, 1952), 65.

EXHIBITIONS: *Marsden Hartley
Retrospective*, 1952 ▪ Huntington Galleries,
West Virginia, *Marsden Hartley*, 1957 ▪
Hudson D. Walker: Patron and Friend,
1977, cat. 23.

PROVENANCE: Alfred Stieglitz; Ione and
Hudson Walker

This tiny oil painting is one of several works from 1911 in which Hartley extracted the salient rhythms and colors from specific landscapes and reduced them to lyrical abstract patterns symbolizing the processes of change in nature. It is similar to his frequently exhibited and better known watercolor, *Landscape #32*, also in the University Art Museum collection. Both landscape abstractions suggest influences from the coterie of artists associated with Alfred Stieglitz. From 1910 to 1914, Arthur DOVE was experimenting with similar works he referred to as "nature symbolized." Max WEBER was also analyzing landscape elements in 1910 and 1911 after having seen modernist works in France. Yet *Landscape #10* is more highly keyed than works by these and other members of Stieglitz's circle—probably a residual influence of Matisse.

For several years prior to 1911 Hartley had attempted to capture the underlying moods and pulsations in nature through studies of Maine mountains. Although quite different in scale, the mountain paintings are similar to his earliest experimental abstractions in their flattened spaces, heavy paint applications in broad areas of color, and heavy outlines. *Landscape #10* is more subtle and enigmatic than the expansive mountain paintings, and its minute inspection of interlocking landscape elements is more complex and challenging. The spatial ambiguities in this work predict a direction that Hartley would pursue further in his most personal paintings of abstract symbols. *P.N.*

Pears, *1911*

Oil on wood, 16 x 12½ in.
(40.6 x 31.8 cm.)
Signed lower right: Marsden Hartley
Bequest of Hudson Walker from the Ione
and Hudson Walker Collection
78.21.18
Illustration: Appendix

REFERENCES: Elizabeth McCausland,
Marsden Hartley (Minneapolis: University
of Minnesota Press, 1952), 65 • Irma Jaffe,
"Cubist Elements in the Painting of
Marsden Hartley," *Art International* (April
1970): 34.

EXHIBITIONS: *Marsden Hartley
Retrospective*, 1952, and Traveling
Exhibition, 1952-1954 • Huntington
Galleries, West Virginia, *Marsden Hartley*,
1957.

PROVENANCE: Paul Rosenfeld; Ione and
Hudson Walker

As indicated by a stamp on verso, *Pears* was one of the paintings auctioned in 1921 to finance Hartley's return to Europe. *P.N.*

In Maine during the summer of 1911, Hartley created a series of still-lifes based on the technical innovations of Paul Cézanne; among these were *Still Life: Fruit* and *Still Life #11*. Tilted planes, distorted forms, and large areas of directional brushstrokes generated a pictorial tension, suggesting movement and the illusory nature of mass and volume. Hartley's interest in formal concerns paralleled that of Max WEBER, who held a one-man show at gallery 291 in February of 1911 that included still-lifes similar to Hartley's. The dark color of Hartley's 1911 paintings recall his work of the two preceding years, as do the heavily modeled forms, thick outlines, and large brushstrokes.

Paul Rosenfeld explained these still-life paintings: "[Hartley] sets up distinct limits to which everything in the canvas, every line, every brushstroke, every shape, and every hue is related, and through which relationship it begets special significance. On the materials of the exterior cosmos he establishes a little sealed world declarative of his own inward human order. And through this superimposed order he manages to escape from the literalness of the facts with which as the product of a material universe he has to deal; and succeeds as

does every artist, in making objects register the double significance which they have for him, at once the animal, and the man product of civilization....And so, in the paintings of Hartley, these great dark pears, for instance, bedded upon hospital-white linen on a background of severe dry black, are both the magnificent fruits shown against ascetic noble stuffs, and the entire world as a certain grim experience of life has proven it to the painter. In their doubleness, they satisfy the entire organism" (Rosenfeld, pp. 86-87). *P.N.*

Still Life: Fruit, *1911*

Oil on canvas, 20¼ x 20¼ in.
(51.4 x 51.4 cm.)
Signed lower right: M.H.
Bequest of Hudson Walker from the Ione and Hudson Walker Collection
78.21.117
Illustration: Appendix

REFERENCES: Paul Rosenfeld, *Port of New York* (New York: Harcourt, Brace and Company, Inc., 1924), 86-87 ▪ Elizabeth McCausland, *Marsden Hartley* (Minneapolis: University of Minnesota Press, 1952), 19, 65 ▪ Gorham Munson, "The Painter from Maine," *Arts* (February 1961): 35.

EXHIBITIONS: *Marsden Hartley Retrospective*, 1952, and Traveling Exhibition, 1952-1954 ▪ Department of Fine Arts Gallery, Louisiana State University, Baton Rouge, *Marsden Hartley*, 1957 ▪ Art Museum Association of America and the University Art Museum, Traveling Exhibition, *Marsden Hartley 1908-1942: The Ione and Hudson Walker Collection*, 1984-1985, cat. 10 ▪ *Marsden Hartley 1908-1942: The Ione and Hudson Walker Collection*, 1986.

PROVENANCE: Ione and Hudson Walker

Still Life #11, *1911*

Oil on canvas, 9½ x 7½ in.
(24.1 x 19.1 cm.)
Unsigned
Bequest of Hudson Walker from the Ione
and Hudson Walker Collection
78.21.38
Illustration: Figure 44

REFERENCES: Elizabeth McCausland,
Marsden Hartley (Minneapolis: University
of Minnesota Press, 1952), 65 ▪ Barbara
Haskell, *Marsden Hartley* (New York:
Whitney Museum of American Art,
1980), 22.

EXHIBITIONS: *Marsden Hartley
Retrospective*, 1952 ▪ University Art
Gallery, University of South Dakota,
Vermillion, *A Memorial Exhibition,
Marsden Hartley, 1877-1943*, 1978.

PROVENANCE: Ione and Hudson Walker

Still Life #11, *1911* ▪ *Figure 44*

157

Woods, *1911*

Oil on academy board, 12 x 13⅞ in.
(30.5 x 35.2 cm.)
Unsigned
Bequest of Hudson Walker from the Ione
and Hudson Walker Collection
78.21.241
Illustration: Appendix

REFERENCE: Elizabeth McCausland, *Marsden
Hartley* (Minneapolis: University of
Minnesota Press, 1952), 65.

EXHIBITIONS: Museum of Modern Art, New
York, *Marsden Hartley Exhibition*, 1944-
1945 ▪ *Marsden Hartley Retrospective*,
1952 ▪ *Selections from the Collection*, 1957
▪ *100 Paintings, Drawings, and Prints from
the Ione and Hudson D. Walker Collection*,
1965, cat. 30.

PROVENANCE: Ione and Hudson Walker

Woods is one of Hartley's landscape abstractions that apparently arose out of his association with the modernist tendencies of the Stieglitz circle. Although it is difficult to distinguish them as such, the title specifies the abstract shapes as foliage and branches. How filtered light distorts perception, and how small elements combine to form a unified pattern, are the underlying concerns of the painting. Shadows and light define the interior space of a woods; distinctions between foreground and background are confused, and light patterns stretch indefinitely to the unseen edges of the forest. Here the artist's point of view is a complete reversal from that seen in his earlier paintings of distant mountains. Hartley is in the midst of *Woods*—no longer a spectator but a participant. *P.N.*

Still Life, *1912*

Oil on composition board, 32⅛ x 25⅝ in.
(81.6 x 65.1 cm.)
Unsigned
Bequest of Hudson Walker from the Ione
and Hudson Walker Collection
78.21.25
Illustration: Colorplate XI

REFERENCES: Elizabeth McCausland,
Marsden Hartley (Minneapolis: University
of Minnesota Press, 1952), 65 ▪ Gorham
Munson, "The Painter from Maine," *Arts*
(February 1961): 32 ▪ S. Gail Levin, *Wassily
Kandinsky and the American Avant-Garde,
1912-1950* (New Brunswick: Rutgers
University, 1976), 80 ▪ S. Gail Levin,
"Marsden Hartley and the European Avant-
Garde," *Arts* (September 1979): 158-159.

EXHIBITIONS: Whitney Museum of American
Art, New York, *Pioneers of Modern Art in
America*, 1946 ▪ American Association of
University Women Traveling Exhibition,
Marsden Hartley, 1950-1951 ▪ *Marsden
Hartley Retrospective*, 1952, and Traveling
Exhibition, 1952-1954 ▪ Department of Fine
Arts Gallery, Louisiana State University,
Baton Rouge, *Marsden Hartley*, 1957 ▪
Selections from the Collection, 1957 ▪

Believed to have been Hartley's first painting after his arrival in Paris (Levin, p. 80), this brightly colored tabletop still-life reflects his increasing awareness of modernist movements in painting and marks a new direction in his career as an innovative and experimental artist. Cézanne's influence can be seen in the tilted table and distorted shapes, while the highly keyed colors are in the manner of Matisse. The work's most obvious ties, however, are to Hartley's American colleagues, who had absorbed the new ideas of the French masters during the first decade of the century. Arthur DOVE and Max WEBER were producing similar still-life compositions prior to Hartley's *Still Life* and had been included with Hartley in Stieglitz's Young American Painters show at gallery 291 in 1910. This painting bears a resemblance to Dove's *The Lobster*, which was exhibited in 1910, while its broad-brushed techniques and tense perspective are closely related to the works of Weber. *P.N.*

Roswell Museum and Art Center, New Mexico, Traveling Exhibition, *Marsden Hartley, Early Paintings from 1908 to 1920*, 1958 ▪ Western Association of Art Museums Traveling Exhibition, *Marsden Hartley*, 1958-1960 ▪ American Federation of Arts Traveling Exhibition, *Marsden Hartley Retrospective*, 1960-1962, cat. 9 ▪ *100 Paintings, Drawings, and Prints from the Ione and Hudson D. Walker Collection*, 1965, cat. 33 ▪ The Century Association, New York, *Paintings by Marsden Hartley from the Collection of the Hudson Walker Family*, 1970 ▪ *Hudson D. Walker: Patron and Friend*, 1977, cat. 26 ▪ Whitney Museum of American Art, New York, *Marsden Hartley Retrospective*, 1980, cat. 12 ▪ Art Museum Association of America and the University Art Museum, Traveling Exhibition, *Marsden Hartley 1908-1942: The Ione and Hudson Walker Collection*, 1984-1985, cat. 11 ▪ *Marsden Hartley 1908-1942: The Ione and Hudson Walker Collection*, 1986.

PROVENANCE: Alfred Stieglitz; Ione and Hudson Walker

Oil on canvas, 39½ x 31⅞ in.
(100.3 x 81.0 cm.)
Unsigned
Bequest of Hudson Walker from the Ione and Hudson Walker Collection
78.21.67
Illustration: Appendix

REFERENCES: Elizabeth McCausland, *Marsden Hartley* (Minneapolis: University of Minnesota Press, 1952), 21, 66 ▪ Gorham Munson, "The Painter from Maine," *Arts* (February 1961): 35.

EXHIBITIONS: *Marsden Hartley Retrospective*, 1952 ▪ Department of Fine Arts Gallery, Louisiana State University, Baton Rouge, *Marsden Hartley*, 1957 ▪ *Selected Works from the Collection of Ione and Hudson Walker*, 1959 ▪ Western Art Gallery, Western Washington State College, Bellingham, *Marsden Hartley*, 1967 ▪ The Century Association, New York, *Paintings by Marsden Hartley from the Collection of the Hudson Walker Family*, 1970 ▪ C.W. Post Art Gallery, Long Island University, Greenvale, Long Island, New York,

Painting #2, *1913*

Late in 1912 Hartley initiated an innovative series of paintings combining synthetic cubist forms with mystical symbols and intuitive philosophy; among these were *Painting #2* and *Abstraction with Flowers*. Henry Bergson's theories of intuition and Wassily Kandinsky's mystical and spiritual concerns were especially influential in the development of his new style. Signs and symbols to which he was to return throughout his career first appeared at this time. The earliest paintings in the series contained analogies to music, and later references included abstract symbolic mountains.

Hartley described this series in his unpublished autobiography: "I had stopped doing pears and apples—and thought that I would just take some canvases and begin more or less in the style of automatic writing and let my hand be guided as it were—and I made lines and curves—stars and various images and coloured them lightly so that the whole effect came to have an inspirational and transcendent quality. I found after I had done one, I could do more and they began to be sort of portraits of moments—they were of good size, about 30 x 40 inches and I did at least 20 of them" (Judith K. Zilczer, *The Aesthetic Struggle in America, 1913-1918: Abstract Art and Theory in the Stieglitz Circle* [Newark: University of Delaware, 1975], p. 181).

Marsden Hartley, 1877-1943, 1977, cat. 7 • University Art Gallery, University of South Dakota, Vermillion, *A Memorial Exhibition, Marsden Hartley, 1877-1943*, 1978 • *The Mountains of Marsden Hartley*, 1979 • *Selections from the Permanent Collection*, 1980 • *The First Fifty Years 1934-1984: American Painting and Sculpture from the University Art Museum Collection*, 1984 • *New York and American Modernism*, 1984.

PROVENANCE: Alfred Stieglitz; Ione and Hudson Walker

Oil on canvas, 39¼ x 31½ in. (99.7 x 80 cm.)
Unsigned
Bequest of Hudson Walker from the Ione and Hudson Walker Collection
78.21.243
Illustration: Figure 45

REFERENCES: Elizabeth McCausland, *Marsden Hartley* (Minneapolis: University of Minnesota Press, 1952), 21, 66 • Gorham Munson, "The Painter from Maine," *Arts* (February 1961): 35 • William I. Homer, *Alfred Stieglitz and the American Avant-Garde* (Boston: New York Graphic Society, 1977), 163.

EXHIBITIONS: *Marsden Hartley Retrospective*, 1952 • Museum of Modern Art Traveling Exhibition, *Three Modern Masters: Feininger, Hartley, Beckmann*, 1955-1957 • *Marsden Hartley—German Period*, 1959 • *Selected Works from the Collection of Ione and Hudson Walker*, 1959 • *Art and the University of Minnesota*, 1961 • Bertha Schaefer Gallery, New York,

Both *Painting #2* and *Abstraction with Flowers* are painted in thin washes of primary and secondary colors with the images bordered by heavy black lines that give weight to the shapes they partially define. Like its predecessor, *Painting #1* (purchased by Gertrude Stein and now in the collection of the University of Nebraska, Lincoln), *Painting #2* is designed as an imaginary landscape similar in image and spirit to Kandinsky's abstract mountain scenes. It also resembles the swirling visions of New York City which Abraham WALKOWITZ was producing at around the same time.

In *Painting #2*, circles, triangles, trapezoids, and eight-pointed asterisks are interspersed with arcane calligraphic markings, including mathematical, musical, and linguistic notations. The abstract marks and geometric shapes read as conceptual symbols for a scientific or spiritual language that transcends literal visual representation. They presuppose a level of consciousness beyond mere description. The nonspecific nature of the markings encourages a variety of interpretations. *P.N.*

Abstraction with Flowers, *1913*

Brighter and more explosive than *Painting #2*, *Abstraction with Flowers* was probably painted slightly later. Divided along a diagonal axis that breaks it into two triangular realms, it is a contrast of rigid mathematical triangles, circles, and free-form flowers. Swirling linear filaments link the organic and geometric shapes.

Although the triangle had a distinctly spiritual connotation for Kandinsky, Hartley treats them as mechanical devices for accurate reproduction in drafting. The triangle at the top of the canvas is even superimposed on a protractor. Hartley's melange of symbols appears to be an intuitive response to the intellectual balance between the rational and the irrational, the precision of science and the organic profusion in nature. *P.N.*

Early Works by Hartley, Maurer, and Barnet, 1962 • *100 Paintings, Drawings, and Prints from the Ione and Hudson D. Walker Collection*, 1965, cat. 34 • La Jolla Museum of Art, La Jolla, California, *Marsden Hartley—John Marin*, 1966, cat. 3 • University of New Mexico, Albuquerque, Traveling Exhibition, *Cubism: Its Impact in the United States*, 1967 • *Hudson D. Walker: Patron and Friend*, 1977, cat. 27 • University Art Gallery, University of South Dakota, Vermillion, *A Memorial Exhibition, Marsden Hartley, 1877-1943*, 1978 • *The Mountains of Marsden Hartley*, 1979 • Whitney Museum of American Art, New York, *Marsden Hartley Retrospective*, 1980, cat. 15 • *Abstract USA/1910-1950*, 1981 • Carleton College, Northfield, Minnesota, *American Abstraction: 20th Century American Paintings from the University of Minnesota*, 1983 • *Early Modernism in America: The Stieglitz Circle*, 1983 • Art Museum Association of America and the University Art Museum, Traveling Exhibition, *Marsden Hartley 1908-1942: The Ione and Hudson Walker Collection*, 1984-1985, cat. 12 • *Marsden Hartley 1908-1942: The Ione and Hudson Walker Collection*, 1986.

PROVENANCE: Charles Daniel; Parke-Bernet Galleries, New York; Ione and Hudson Walker

Abstraction with Flowers, *1913 • Figure 45*

One Portrait of One Woman, *c. 1913*

Oil on composition board, 32 x 21⅜ in.
(81.3 x 54.3 cm.)
Unsigned
Bequest of Hudson Walker from the Ione
and Hudson Walker Collection
78.21.64
Illustration: Colorplate VIII

REFERENCES: Elizabeth McCausland,
Marsden Hartley (Minneapolis: University
of Minnesota Press, 1952), 22-23, 32, 66 ▪
Gorham Munson, "The Painter from
Maine," *Arts* (February 1961): 35 ▪ S. Gail
Levin, *Wassily Kandinsky and the American
Avant-Garde, 1912-1950* (New Brunswick:
Rutgers University, 1976), 84 ▪ William I.
Homer, *Alfred Stieglitz and the American
Avant-Garde* (Boston: New York Graphic
Society, 1977), 158 ▪ William H. Gerdts,
*Painters of the Humble Truth: Masterpieces
of American Still Life, 1801-1939*
(Columbia, Missouri: University of Missouri
Press, 1981), 244-245.

EXHIBITIONS: *Marsden Hartley
Retrospective*, 1952 ▪ Department of Fine
Arts Gallery, Louisiana State University,
Baton Rouge, *Marsden Hartley*, 1957 ▪
Marsden Hartley—German Period, 1959 ▪
La Jolla Museum of Art, La Jolla,
California, *Marsden Hartley—John Marin*,
1966, cat. 2 ▪ Western Art Gallery, Western
Washington State College, Bellingham,
Marsden Hartley, 1967 ▪ *Selections from the
Permanent Collection*, 1975 ▪ *Hudson D.
Walker: Patron and Friend*, 1977, cat. 28 ▪
University Art Gallery, University of South
Dakota, Vermillion, *A Memorial
Exhibition, Marsden Hartley, 1877-1943*,
1978 ▪ Museum of Art and Archaeology,
University of Missouri, Columbia, *Six from
Minneapolis*, 1978 ▪ Stadtische Kunsthalle
Düsseldorf, Traveling Exhibition, *Two
Decades of American Painting, 1920-1940*,
1979 ▪ Whitney Museum of American Art,
New York, *Marsden Hartley Retrospective*,
1980, cat. 43 ▪ Philbrook Art Center, Tulsa,
Traveling Exhibition, *Painters of the
Humble Truth: Masterpieces of American
Still Life*, 1981-1982 ▪ The Whitney
Museum of American Art, Downtown
Gallery, New York, *The Forum Exhibition:
Selections and Additions*, 1983 ▪ Art
Museum Association of America and the

One Portrait of One Woman is a precursor of Hartley's elegiac German officer portraits in its use of flat, decorative patterns painted in thin washes of color to convey a symbolic meaning. Carefully chosen objects are incorporated to evoke the spirit and character of the sitter. This work appears to be an homage to Gertrude Stein, whom Hartley met on his first trip to Paris. She was a champion of his work—a distinction which Hartley treasured—and also used him as the subject of some of her prose, including a literary symbolic portrait. In her writing Gertrude Stein repeated words and phrases to set a mood and to reinforce the specifics of individual personality; the title *One Portrait of One Woman* reflects her literary style.

Known for her afternoon teas, Stein is well represented by a teacup resting on a typically French red-checked tablecloth. Candles flank the teacup, endowing the experience of taking tea with religious significance. A cross superimposed on the cup reiterates the sacramental or mystical nature of the ritual. Inscribed beneath the cup and saucer, the French personal pronoun *moi* serves as an emphatic statement of a dominant ego. The five mandorla (shapes signifying the holiness of Christ in Christian iconography) and the flames (used to represent the burning of the Sacred Heart) are further evidence of Hartley's commingling of Christian symbolism with a personal credo of self-glorification. Even the choice of colors is revealing: the dominant red, white, and blue are the patriotic colors of both the United States and France, the two countries of Stein's allegiance. *P.N.*

University Art Museum, Traveling Exhibition, *Marsden Hartley 1908-1942: The Ione and Hudson Walker Collection*, 1984-1985, cat. 13 • *Marsden Hartley 1908-1942: The Ione and Hudson Walker Collection*, 1986.

PROVENANCE: Alfred Stieglitz; Estate of Alfred Stieglitz; Ione and Hudson Walker

Oil on canvas, 32¼ x 21½ in. (81.9 x 54.6 cm.)
Unsigned
Bequest of Hudson Walker from the Ione and Hudson Walker Collection
78.21.234
Illustration: Colorplate XXVII

REFERENCES: Elizabeth McCausland, *Marsden Hartley* (Minneapolis: University of Minnesota Press, 1952), 26, 66 • Elizabeth McCausland, "Return of the Native," *Art in America* (Spring 1952): 63 • Abraham Davidson, "Cubism and the Early American Modernist," *Art Journal* (Winter 1966-67): 123, 128, 129 • "Hartley's Heroes," *Apollo* (December 1969): 534 • S. Gail Levin, *Wassily Kandinsky and the American Avant-Garde, 1912-1950* (New Brunswick: Rutgers University Press, 1976), 129.

EXHIBITIONS: American Association of University Women Traveling Exhibition, *Marsden Hartley*, 1950-1951 (exhibited as *Berlin Abstraction*, 1916) • *Marsden Hartley Retrospective*, 1952, and Traveling Exhibition, 1952-1954 • Department of Fine Arts Gallery, Louisiana State University, Baton Rouge, *Marsden Hartley*, 1957 • Huntington Galleries, West Virginia, *Marsden Hartley*, 1957 • Roswell Museum and Art Center, New Mexico, Traveling Exhibition, *Marsden Hartley, Early Paintings from 1908 to 1920*, 1958 • Western Association of Art Museums Traveling Exhibition, *Marsden Hartley*, 1958-1960 • American Federation of Arts Traveling Exhibition, *Marsden Hartley Retrospective*, 1960-1962 • *100 Paintings, Drawings, and Prints from the Ione and Hudson D. Walker Collection*, 1965, cat. 35 • Davis Art Gallery, Stephens College, Columbia, Missouri, *American Paintings, Selected Works from Mid-Western Galleries*

Portrait, *c. 1914-1915*

During his first trip to Europe from 1912 to 1915, Hartley produced a series of paintings based on German military regalia which proved to be the most spectacular of his career. Having gone to Berlin with Arnold Rönnebeck, Hartley struck up a friendship with the young sculptor's cousin, Karl von Freyburg. Both of the Germans were in the military, and Hartley became so enchanted by their camaraderie and the pageantry around him that he remained in Berlin even after war was declared in August of 1914.

The works from this period proved to be a disappointment to Hartley. After his return to the United States, when 40 of them were exhibited at gallery 291 in the spring of 1916, they were vilified by the American public as being pro-German. Hartley felt that he had been denied the acclaim he deserved for these brilliant and stirring creations.

Portrait is an excellent example of a series that pays tribute to the drama and patriotic fervor of the German militia. Robert J. Cole, critic for the *New York Evening Sun*, correctly perceived the artist's romantic temperament when he wrote: "In this time of modern warfare the very modern artist has gone back to the glory of chivalry—trappings and heraldry" (reproduced in *Camera Work* [October 1916], p. 60).

These paintings contained techniques derived from European sources—French synthetic cubism filtered through German expressionism, for example—yet they are personal, expressive, and highly innovative. Glittering decorations extol the soldier's youthful glory while the black background tempers the glamor with a reminder of the ever-present reality of the battlefield. The death of beauty and talent in its prime was a subject that haunted Hartley throughout his career.

Covering 200 Years of American Painting, 1966, cat. 14 • Western Art Gallery, Western Washington State College, Bellingham, *Marsden Hartley,* 1967 • Bernard Danenberg Galleries, New York, *Marsden Hartley, A Retrospective Exhibition,* 1969, cat. 7 • Artmobile, The Minneapolis Institute of Arts Traveling Exhibition, 1969-1970 • *Selections from the Permanent Collection,* 1970 • *Works from the Permanent Collection,* 1972 • The Upper Mid-West Regional Arts Council Traveling Exhibition, *Artrain,* 1975, cat. 48 • The Minneapolis Institute of Arts, *The American Arts: A Celebration,* 1976 • *Hudson D. Walker: Patron and Friend,* 1977, cat. 29 • University Art Gallery, University of South Dakota, Vermillion, *A Memorial Exhibition, Marsden Hartley, 1877-1943,* 1978 • *Selections from the Permanent Collection,* 1980 • *Interplay '80: The Roots of Conflict,* 1980 • Minnesota Museum of Art, St. Paul, *American Style: Works from Minnesota Collections,* 1981, cat. 27 • Terra Museum of American Art, Evanston, Illinois, *American Masters of the Twentieth Century,* 1982 • Art Museum Association of America and the University Art Museum, Traveling Exhibition, *Marsden Hartley 1908-1942: The Ione and Hudson Walker Collection,* 1984-1985, cat. 14 • *Marsden Hartley 1908-1942: The Ione and Hudson Walker Collection,* 1986.

PROVENANCE: Ione and Hudson Walker

Although Hartley was loathe to attribute any specific symbolism to these paintings, the insignias were explained by Arnold Rönnebeck in a letter to collector Duncan Phillips: "There is a very personal and emotional connection between this picture and myself, because I am partly symbolized in it. I am one half of the Prussian officer. The other half is a cousin of mine. May I analyze this painting with a view on Hartley's symbolism of forms of that period? Rather dominating is the Iron Cross. My cousin was killed in action in France on the 24th of October, 1914 (24). He was an active officer in the 4th regiment of the Kaiser's guards (center) 4 on blue ground (of shoulder straps). He received the Iron Cross a day before his death. Next to the 4 is an E and I am certain that it is in red on yellow ground which stands for the Queen Elizabeth of Greece or the patroness of the third regiment of the grand-grenadiers in which I then served. The E appears again in the lower middle right on my 'full dress epaulettes' and the long tassels next to 24 represent the heavy silver wire tassels I wore as an aid-de-camp in the guards. in the lower left corner we distinguish the innitials K.V.F. My cousin's name was Karl von Freyburg. The triangle symbolizes the friendship and the understanding between 3 men: Hartley, Karl v. Freyburg and myself. During the winter 1914/15 I was hospitalized, wounded and battered, in Berlin, but the Iron Cross had already been awarded to me. Hartley admired its beautiful shape, designed by the great German architect Schinckel in 1813 and asked me to leave it on his palette-table as something of a silent friend who had left us....Karl loved to play chess which explains the black and white squares" (Levin, p. 120).

The dominant image in *Portrait* is the disembodied military helmet with fur plumage bearing the number 8 encircled by concentric bands of blue and yellow. Although the number has a Christian significance associated with resurrection, Hartley's interest in mysticism, as Barbara Haskell has pointed out, may well have led him to incorporate the number to suggest cosmic transcendence. The helmet is topped by a wheel resembling the Buddhist symbol of the Eight Fold Path. At its center is the number 9, the angelic number in Christianity and a mystical symbol of regeneration. Further, the dominant circular motif could well be seen as a Christian reference to eternity. In view of this, the work takes on an almost eulogistic tone; the dead soldier is memorialized in the art of his friend. *P.N.*

Hartley spent the summer and fall of 1916 in Provincetown, Massachusetts. Here he continued to explore the abstract forms of synthetic cubism, but his palette changed from the vibrant tones of his German paintings to more subdued hues of pink and beige. Fascinated by the sea and its association with travel and adventure, he turned to painting portraits of ocean-going vessels. In a series of works which includes *Elsa* and its variation, *Elsa Kobenhavn*, the interaction of flat planes of color floating on an amorphous pale ground conveys the dense volumes and rectilinear forms of these massive ships. "Elsa" would have been the name lettered on the stern of the Danish ship out of Copenhagen, so designated by the Danish flag. In *Elsa* Hartley arranged the flag so that its cross presents a subtle spiritual motif. A smokestack decorated with a truncated cross arises to the top of the canvas as a pivot for the composition and a dramatic symbol for the ship. *P.N.*

Elsa, *1916*

Oil on paper mounted on cardboard, 20 x 16 in.
(50.8 x 40.6 cm.)
Unsigned
Bequest of Hudson Walker from the Ione and Hudson Walker Collection
78.21.46
Illustration: Colorplate XXVI

REFERENCE: Elizabeth McCausland, *Marsden Hartley* (Minneapolis: University of Minnesota Press, 1952), 28, 66.

EXHIBITIONS: *Selections from the Collection of Mr. and Mrs. Hudson D. Walker*, 1950 ▪ *Marsden Hartley Retrospective*, 1952 ▪ *Marsden Hartley—German Period*, 1959 ▪ The Katonah Gallery, Katonah, New York, *Bicentennial Exhibition of American Painting*, 1976, cat. 15 ▪ C.W. Post Art Gallery, Long Island University, Greenvale, Long Island, New York, *Marsden Hartley, 1877-1943*, 1977, cat. 10 ▪ University Art Gallery, University of South Dakota, Vermillion, *A Memorial Exhibition, Marsden Hartley, 1877-1943*, 1978 ▪ Museum of Art and Archaeology, University of Missouri, Columbia, *Six from Minneapolis*, 1978 ▪ Whitney Museum of American Art, New York, *Marsden Hartley Retrospective*, 1980, cat. 39 ▪ *Abstract USA/ 1910-1950*, 1981 ▪ Carleton College, Northfield, Minnesota, *American Abstraction: 20th Century American Paintings from the University of Minnesota*, 1983 ▪ Art Museum Association of America and the University Art Museum, Traveling Exhibition, *Marsden Hartley 1908-1942:*

The Ione and Hudson Walker Collection,
1984-1985, cat. 15 • *Marsden Hartley*
1908-1942: The Ione and Hudson Walker
Collection, 1986.

PROVENANCE: Ione and Hudson Walker

Oil on composition board, 24 x 20 in.
(61 x 50.8 cm.)
Unsigned
Bequest of Hudson Walker from the Ione
and Hudson Walker Collection
78.21.69
Illustration: Figure 46

REFERENCE: Elizabeth McCausland, *Marsden*
Hartley (Minneapolis: University of
Minnesota Press, 1952), 28, 66.

EXHIBITIONS: *Marsden Hartley*
Retrospective, 1952 • Department of Fine
Arts Gallery, Louisiana State University,
Baton Rouge, *Marsden Hartley,* 1957 •
Huntington Galleries, West Virginia,
Marsden Hartley, 1957 • Roswell Museum
and Art Center, New Mexico, Traveling
Exhibition, *Marsden Hartley, Early*
Paintings from 1908 to 1920, 1958 •
Western Association of Art Museums
Traveling Exhibition, *Marsden Hartley,*
1958-1960 • Bertha Schaefer Gallery, New
York, *Early Works by Hartley, Maurer, and*
Barnet, 1962 • American Federation of Arts
Traveling Exhibition, *American Still-Life*
Painting, 1913-1967, 1967-1968 •
Selections from the Permanent Collection,
1969 • The Century Association, New York,
Paintings by Marsden Hartley from the
Collection of the Hudson Walker Family,
1970 • *Works from the Permanent*
Collection, 1972, 1975 • *Hudson D.*
Walker: Patron and Friend, 1977, cat. 30 •
University of Kansas Museum of Art,
Lawrence, *Inaugural Exhibition—Spencer*
Museum of Art, 1978 • Whitney Museum of
American Art, New York, *Marsden Hartley*
Retrospective, 1980 • Grand Rapids Art
Museum, Michigan, *Pioneers: Early 20th*
Century Art from Midwestern Museums,
1981, cat. 13 • *The First Fifty Years 1934-*
1984: American Painting and Sculpture
from the University Art Museum Collection,
1984 • *New York and American Modernism*
1984 • Salander-O'Reilly Galleries, Inc.,
New York, *Marsden Hartley: Paintings and*
Drawings, 1985.

PROVENANCE: Alfred Stieglitz; Ione and
Hudson Walker

Elsa Kobenhavn, *1916*

Elsa Kobenhavn, *1916 • Figure 46*

166

Movement #11, *c. 1917*

Oil on composition board, 19½ x 15½ in.
(49.5 x 39.4 cm.)
Unsigned
Bequest of Hudson Walker from the Ione
and Hudson Walker Collection
78.21.47
Illustration: Appendix

REFERENCE: Elizabeth McCausland, *Marsden Hartley* (Minneapolis: University of Minnesota Press, 1952), 66.

EXHIBITIONS: *Marsden Hartley Retrospective*, 1952 • Huntington Galleries, West Virginia, *Marsden Hartley*, 1957 • *Marsden Hartley—German Period*, 1959 • Western Art Gallery, Western Washington State College, Bellingham, *Marsden Hartley*, 1967.

PROVENANCE: Alfred Stieglitz; Ione and Hudson Walker

The simplified compositional structure of *Movement #11* reflects an attempt to synthesize the important elements in still-life painting. Although the title, floating circular table, and minimum color scheme relate to the abstract paintings that Hartley produced in 1917, *Movement #11* also shows similarities to a still-life in the Hirshhorn Museum ascribed to 1920, as well as to a work titled *Color Analogy* in the Howald Collection of the Columbus Museum of Art (Ohio). Both the Hirshhorn still-life and the Minnesota painting were in the collection of Alfred Stieglitz, the former having been purchased at Hartley's 1921 sale.

In discussing Hartley's works of 1920, Barbara Haskell writes: "In format, his paintings that summer generally presented isolated, vertical images of single vases of flowers on tabletops, rendered primarily in tones of green, tan, and brown. Most often Hartley centralizes his images on flat, monochromatic backgrounds, although on occasion he fractures the entire structure into planar color areas. Shallow spatial recession is suggested through perspectively rendered tabletops and fabric" (Barbara Haskell, *Marsden Hartley* [New York: Whitney Museum of American Art, 1980], p. 60).

Hartley's use of neutral colors of similar tone reduce spatial interaction. The pattern juxtaposes angles and curves and pivots between two and three dimensions. Texture has been transformed; the pliable drapery appears hard and the solid goblet less so. Hartley once again demonstrates the illusory nature of appearances. *P.N.*

Still Life #9, *1917*

Oil on beaver board, 24 x 20 in.
(61 x 50.8 cm.)
Unsigned
Bequest of Hudson Walker from the Ione
and Hudson Walker Collection
78.21.70
Illustration: Figure 47

REFERENCES: Paul Rosenfeld, *Port of New York* (New York: Harcourt, Brace and Co., Inc. 1924), 84-85 • Elizabeth McCausland, *Marsden Hartley* (Minneapolis: University of Minnesota Press, 1952), 67 • Barbara Haskell, *Marsden Hartley* (New York: Whitney Museum of American Art, 1980), 56.

In 1924 Paul Rosenfeld offered his explanation of the morbid beauty of Hartley's langorous white callas: "He has always painted flatly, subtley; left one perfectly conscious that it is a surface he is decorating. The volumes of space he translates into the idiom of surface; a feat doubtlessly permitted him and other painters by the circumstance that the eye, so it seems, knows only two dimensions, and that perception of the third is performed strictly by reason as a result of experience. Planes to be sure, break his canvas, represent spatial extension. This regal white lily with its wickedly horned leaves, erect between butter-yellow draperies, is felt as a volume against the lustrous purplish-blue sweep of bay, as that is felt against the curve of sandy shore, and the shore in turn felt against the rim of violet peaks and they against the white-clouded summer sky....But there is no imitation of nature in the representation. You

EXHIBITIONS: *Marsden Hartley Retrospective*, 1952, and Traveling Exhibition, 1952-1954 • Huntington Galleries, West Virginia, *Marsden Hartley*, 1957 • University Art Gallery, University of South Dakota, Vermillion, *A Memorial Exhibition, Marsden Hartley, 1877-1943*, 1978 • Richard York Gallery, New York, *The Natural Image: Plant Forms in American Modernism*, 1982, cat. 19 • Art Museum Association of America and the University Art Museum, Traveling Exhibition, *Marsden Hartley 1908-1942: The Ione and Hudson Walker Collection*, 1984-1985, cat. 16 • *Marsden Hartley 1908-1942: The Ione and Hudson Walker Collection*, 1986.

PROVENANCE: Alfred Stieglitz; Ione and Hudson Walker

are not snared by violent lights and shades into believing you have before you the solids of sculpture. You are left, but the subtlety and lightness of the painting, in wide-eyed awareness that each object is the symbol of a volume, and that every plane is as sheer as a sheet of tissue paper" (Rosenfeld, pp. 84-85).

These lush flowers were popular during the early decades of this century and also appear in paintings by Hartley's contemporary Arthur B. CARLES. *P.N.*

Still Life #9, *1917 • Figure 47*

168

Santos, New Mexico, *c. 1918-1919*

Oil on composition board, 31¾ x 23¾ in.
(80.6 x 60.3 cm.)
Unsigned
Bequest of Hudson Walker from the Ione
and Hudson Walker Collection
78.21.68
Illustration: Colorplate XIII

REFERENCES: Elizabeth McCausland,
Marsden Hartley (Minneapolis: University
of Minnesota Press, 1952), 23, 32, 67 •
Barbara Haskell, *Marsden Hartley* (New
York: Whitney Museum of American Art,
1980), 59.

EXHIBITIONS: *Marsden Hartley
Retrospective*, 1952 • Huntington Galleries,
West Virginia, *Marsden Hartley*, 1957 •
Western Art Gallery, Western Washington
State College, Bellingham, *Marsden Hartley*,
1967 • *Selections from the Permanent
Collection*, 1969 • The Century Association,
New York, *Paintings by Marsden Hartley
from the Collection of the Hudson Walker
Family*, 1970 • The Art Galleries, University
of California, Santa Barbara, *O'Keeffe,
Hartley, and Marin in the Southwest*, 1975
• *Hudson D. Walker: Patron and Friend*,
1977, cat. 32 • University Art Gallery,
University of South Dakota, Vermillion, *A
Memorial Exhibition, Marsden Hartley,
1877-1943*, 1978 • Stadtische Kunsthalle
Düsseldorf, Traveling Exhibition, *Two
Decades of American Painting, 1920-1940*,
1979 • Whitney Museum of American Art,
New York, *Marsden Hartley Retrospective*,
1980 • Art Museum Association of America
and the University Art Museum, Traveling
Exhibition, *Marsden Hartley 1908-1942:
The Ione and Hudson Walker Collection*,
1984-1985, cat. 17 • National Museum of
American Art, Smithsonian Institution,
Washington, D.C., Traveling Exhibition,
*Art in New Mexico, 1900-1945, Paths to
Taos and Santa Fe*, 1986, figure 141.

PROVENANCE: Alfred Stieglitz; Ione and
Hudson Walker

During his sojourn in the Southwest (1918-1919), Hartley was attracted by the primitive simplicity of the native American Indian and immigrant Spanish cultures. Fascinated by Indian ritual, he wrote an article for the January 1920 issue of *Art and Archaeology* called "Red Man Ceremonials: An American Plea for American Aesthetics," later included in his anthology *Adventures in the Arts* as "The Red Man."

Santos, common Spanish religious artifacts, dominated Hartley's southwestern paintings. He was drawn not only to their Christian symbolism but also to their bright colors and simple forms. Collectors such as Mabel Dodge, whose Taos residence served as Hartley's studio, were at that time purchasing these painted panels or carvings of saints originally designed for church altars. In *Santos, New Mexico* the artist combined the images of a painted panel, or *retablo*, and three *bultos*, or carved and painted wooden figurines. In addition to its spiritual interpretation, the subject of the painting involves the distinction between painting and sculpture. As Barbara Haskell explained: "Hartley's attraction to the simple religious expressiveness of the *santos* altar pieces paralleled his earlier fascination with Bavarian glass paintings and votive pictures. Equally appealing was the visual relationship between the primitive characters of the *santos* and that of American folk art. The flat design arrangements and religious imagery of Hartley's *santos* pieces recalled his 1914 symbolic still lifes, although the impenetrable symbolism of his earlier pieces has been replaced by accessible Christian meaning" (Haskell, p. 59).

Although the truncated shape behind the figurines might be a painting of the Virgin Mary, it appears to represent the Holy Ghost who, with the Father and the infant Son, form the Trinity. The amorphous gray apparition of hand and drapery is suitably ethereal for this interpretation. The triangular composition enforces the theme of the trinity as the spiritual and mystical realm of Jesus Christ. His earthly life is represented by the inclusion of the smaller male and female figures, Mary and Joseph. Symbolic flowers suggest a rebirth at the nativity of Christ. *P.N.*

New Mexico Landscape, *1919*

Oil on canvas, 18⅛ x 24⅛ in.
(46 x 61.3 cm.)
Unsigned
Bequest of Hudson Walker from the Ione
and Hudson Walker Collection
78.21.235
Illustration: Figure 48

REFERENCES: Elizabeth McCausland,
Marsden Hartley (Minneapolis: University
of Minnesota Press, 1952), 67 ▪ Barbara
Haskell, *Marsden Hartley* (New York:
Whitney Museum of American Art,
1980), 60.

EXHIBITIONS: American Association of
University Women Traveling Exhibition,
Marsden Hartley, 1950-1951 ▪ *Marsden
Hartley Retrospective*, 1952 ▪ Department
of Fine Arts Gallery, Louisiana State
University, Baton Rouge, *Marsden Hartley*,
1957 ▪ Huntington Galleries, West Virginia,
Marsden Hartley, 1957 ▪ The Art Galleries,
University of California, Santa Barbara,
*O'Keeffe, Hartley, and Marin in the
Southwest*, 1975 ▪ C.W. Post Art Gallery,
Long Island University, Greenvale, Long
Island, New York, *Marsden Hartley, 1877-
1943*, 1977, cat. 13 ▪ University Art
Gallery, University of South Dakota,
Vermillion, *A Memorial Exhibition,
Marsden Hartley, 1877-1943*, 1978 ▪ *The
Mountains of Marsden Hartley*, 1979 ▪ Art
Museum Association of America and the
University Art Museum, Traveling
Exhibition, *Marsden Hartley 1908-1942:
The Ione and Hudson Walker Collection*,
1984-1985, cat. 18 ▪ *Marsden Hartley
1908-1942: The Ione and Hudson Walker
Collection*, 1986.

PROVENANCE: The Downtown Gallery, New
York; Ione and Hudson Walker

While in New Mexico during 1918 and 1919, Hartley was
captivated by the breadth, beauty, and intransigence of nature. In
the West, he returned to the topical transcription of the landscape
that he had abandoned in Europe in favor of formal experimenta-
tion. His first studies of the exotic terrain were pastel sketches, and
much of their fragility and delicacy remained in Hartley's initial oil
paintings of this subject. Vibrant sun-dappled colors disguise the
massive bulk of the hills in *New Mexico Landscape* and make them
appear ephemeral. The uninhabited vista is beautifully picturesque,
decorative, and shallow. It evokes the glory of the West but lacks
its grandeur. *P.N.*

New Mexico Landscape, *1919* ▪ *Figure 48*

Floral Life: Debonaire, *c. 1920*

Oil on canvas, 22 x 16 in.
(56 x 40.6 cm.)
Signed lower right: Marsden Hartley 1920
Bequest of Hudson Walker from the Ione
and Hudson Walker Collection
78.21.50
Illustration: Appendix

REFERENCE: Elizabeth McCausland, *Marsden Hartley* (Minneapolis: University of Minnesota Press, 1952), 32, 67.

EXHIBITIONS: *Marsden Hartley Retrospective*, 1952 • University Art Gallery, University of South Dakota, Vermillion, *A Memorial Exhibition, Marsden Hartley, 1877-1943*, 1978 • Art Museum Association of America and the University Art Museum, Traveling Exhibition, *Marsden Hartley 1908-1942: The Ione and Hudson Walker Collection*, 1984-1985, cat. 19 • *Marsden Hartley 1908-1942: The Ione and Hudson Walker Collection*, 1986.

PROVENANCE: Ione and Hudson Walker

Still-life painting as an exercise in color, texture, and design occupied a major portion of Marsden Hartley's career. Although symbolic content, a vestige of the nineteenth century, lingers in these compositions, their iconographic content is frequently obscure.

Floral Life: Debonaire is a perfect example of Hartley's enigmatic still-life compositions. Spatially, the arrangement floats unimpeded by gravity. The sensuously curved feminine flowers are a foil for the spear-shaped masculine leaves, but it is difficult to ascertain their species. Although the configuration under the vase may be simple drapery, it does suggest a more symbolic Buddhist lotus blossom. The inclusion of the word "debonaire" in the title denotes good breeding and urbanity, but as a play on the literal French translation—"of good air"—it alludes to the aroma of the flowers. The elegance of the lush colors and stylized pattern indicate sophistication, grace, and artistic refinement. Compatible with popular taste of the 1920s and 1930s, this effete style is vastly different from that of other Hartley still-lifes of 1920. *P.N.*

Rubber Plant, *c. 1920*

Oil on canvas, 28¼ x 18 in.
(71.8 x 45.7 cm.)
Unsigned
Bequest of Hudson Walker from the Ione
and Hudson Walker Collection
78.21.237
Illustration: Appendix

REFERENCE: Elizabeth McCausland, *Marsden Hartley* (Minneapolis: University of Minnesota Press, 1952), 67.

EXHIBITIONS: Museum of Modern Art, New York, *Exhibition of Painting and Sculpture by Living Americans*, 1930 • American Association of University Women Traveling Exhibition, *Marsden Hartley*, 1950-1951 • *Marsden Hartley Retrospective*, 1952.

PROVENANCE: Ione and Hudson Walker

In his still-lifes, Hartley tried to see flowers and plants in new ways in an effort to extract their essential characteristics and to re-present them as a reflection of his personal vision. In *Rubber Plant* he explored the relationship between volume, mass, and the inherently two-dimensional surface of the canvas. The indelicate, inelegant, and sturdy rubber plant is an abstract pinwheel design rather than a beauteous reflection of the harmony in nature.

About Hartley's early formal still-life concerns, Paul Rosenfeld wrote: "A group of dark pears, a rubber-plant, a New Mexico mountain, a calla lily, will be painted with relish and verve. But the rest of the canvas, which under the brush of a Renoir or a Cézanne would have been no less important, will by Hartley be left half alive, treated with an irritating scantiness of attention. In consequence, most of his work is not quite finely balanced, exhales a sort of spirit of violence and restlessness which at instants recalls Van Gogh's. The developed portions for want of counterweight advance a little too far. Minor planes are like to be dismissed with a grand cavalierly offhandedness. Large phallic shapes brandish themselves over the spectator as heavy crucifixi might be brandished, in all dignity and still with indubitable fanaticism, by

zealous priests over dying sinners or burning heretics. Great full-sailed flaunting shapes take possession, with a certain insolence not entirely obliterated by grace, of the entire situation as might a person who manages by insistent manoeuvers to replete with his own person the scene to the exclusion of all others....He is always doing something original....His motifs are taken freshly and directly from the life about him" (Paul Rosenfeld, *Port of New York* [New York: Harcourt, Brace and Co., 1924]).

A similar cubistic still-life painting by Hartley from 1920, also titled *Rubber Plant*, is in the collection of the Yale University Art Gallery.

Still Life #7, *1920*

Oil on canvas board, 16 x 12 in.
(40.6 x 30.5 cm.)
Unsigned
Bequest of Hudson Walker from the Ione and Hudson Walker Collection
78.21.71
Illustration: Appendix

REFERENCE: Elizabeth McCausland, *Marsden Hartley* (Minneapolis: University of Minnesota Press, 1952), 67.

EXHIBITIONS: *Marsden Hartley Retrospective*, 1952 ▪ Huntington Galleries, West Virginia, *Marsden Hartley*, 1957.

PROVENANCE: Alfred Stieglitz; Ione and Hudson Walker

The intersecting two-dimensional planes in *Still Life #7* were directly inspired by the principles of analytical cubism. The evocative but identifiable still-life elements (candle, flower, seashell) are reduced to flat planes defined by angles and sharp edges. Hartley distorted the traditional tabletop format, tilting the plane of the table toward the viewer in a Cézannesque manner. The heavy impasto and dense planes create an effect that is more massive and primitive than his refined planar cubist movements of 1916 and 1917, as if he were trying to initiate a more painterly and volumetric type of cubism. *P.N.*

Western Flame, *1920*

Oil on canvas, 22 x 31⅞ in.
(55.9 x 81.0 cm.)
Signed lower right: Marsden Hartley 1920
Bequest of Hudson Walker from the Ione and Hudson Walker Collection
78.21.51
Illustration: Figure 49

In New York during 1920, Marsden Hartley continued to paint the New Mexico terrain. By distancing himself from the landscape he was able to capture more of its strength and symbolic power. A retreat from his European-inspired works of the preceding decade, these western landscapes are distinctly American in their forms and quality of light.

REFERENCE: Elizabeth McCausland, *Marsden Hartley* (Minneapolis: University of Minnesota Press, 1952), 67.

EXHIBITIONS: Tweed Gallery, University of Minnesota-Duluth, *Marsden Hartley Exhibition*, 1952 ▪ *Marsden Hartley Retrospective*, 1952 ▪ *Marsden Hartley: Landscapes*, 1957 ▪ University of Nebraska Art Galleries, Lincoln, *Man and Mountain*, 1957 ▪ Roswell Museum and Art Center, New Mexico, Traveling Exhibition, *Marsden Hartley, Early Paintings from 1908 to 1920*, 1958 ▪ Western Association of Art Museums Traveling Exhibition, *Marsden Hartley*, 1958-1960 ▪ Western Art Gallery, Western Washington State College, Bellingham, *Marsden Hartley*, 1967 ▪ The Century Association, New York, *Paintings by Marsden Hartley from the Collection of the Hudson Walker Family*, 1970 ▪ *Hudson D. Walker: Patron and Friend*, 1977, cat. 33 ▪ University Art Gallery, University of South Dakota, Vermillion, *A Memorial Exhibition, Marsden Hartley, 1877-1943*, 1978 ▪ Flint Institute of Arts, Michigan, *Art of the Twenties*, 1978-1979 ▪ *The Mountains of Marsden Hartley*, 1979 ▪ Art Museum Association of America and the University Art Museum, Traveling Exhibition, *Marsden Hartley 1908-1942: The Ione and Hudson Walker Collection*, 1984-1985, cat. 20 ▪ *Marsden Hartley 1908-1942: The Ione and Hudson Walker Collection*, 1986.

PROVENANCE: Alfred Stieglitz; Ione and Hudson Walker

Attracted by the irregularly shaped mountains and mesas, Hartley portrayed the peaks silhouetted against the sunset in *Western Flame*. They dominate his composition as they do the uninhabited terrain. A horizontal band of road stretches in front of the mountain scene as a sign of human intervention and an intimation of the American passions for expansion and travel. The title alludes to the vivid, flaming colors characteristic of the desert as well as to the sun setting in the west. The pale yellow roadway echoes the color of the sky in contrast to the darker, more solid and stationary hills and shadowy bushes. *P.N.*

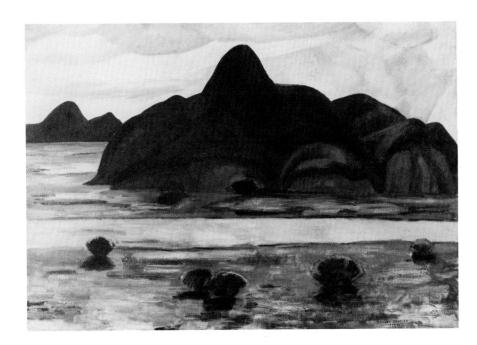

Western Flame, *1920* ▪ *Figure 49*

Basket and Napkin, *1923*

Oil on canvas, 14 x 25½ in.
(35.6 x 64.8 cm.)
Unsigned
Bequest of Hudson Walker from the Ione
and Hudson Walker Collection
78.21.195
Illustration: Figure 50

REFERENCE: Elizabeth McCausland, *Marsden Hartley* (Minneapolis: University of Minnesota Press, 1952), 67.

EXHIBITIONS: *Selections from the Collection of Mr. and Mrs. Hudson D. Walker*, 1950 • Tweed Gallery, University of Minnesota-Duluth, *Marsden Hartley Exhibition*, 1952 • Department of Fine Arts Gallery, Louisiana State University, Baton Rouge, *Marsden Hartley*, 1957 • Huntington Galleries, West Virginia, *Marsden Hartley*, 1957 • College of St. Theresa, Winona, Minnesota, *The American Twenties*, 1958 • *Selected Works from the Collection of Ione and Hudson Walker*, 1959 • Western Art Gallery, Western Washington State College, Bellingham, *Marsden Hartley*, 1967 • *Marsden Hartley 1908-1942: The Ione and Hudson Walker Collection*, 1986.

PROVENANCE: Ione and Hudson Walker

The motif of the basket of fruit, symbolic of nature's bounty, appeared in a series of lithographs that Hartley produced in Berlin in 1923. *Basket and Napkin* is a painterly equivalent of the graphic works, but the basket is more curvilinear than the one shown in the prints. The circular woven volume of the basket instigates the swirling rhythms of the drapery and the spherical shapes of the fruit, and the movement spinning from this central vortex challenges the traditional generic description of still-life. The primitively rendered forms in *Basket and Napkin* predict Hartley's later primitivistic style of painting American scenes. *P.N.*

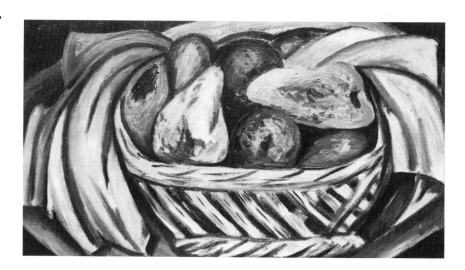

Basket and Napkin, *1923 • Figure 50*

Pears in White Compote, *1923*

Oil on canvas, 21¼ x 25⅝ in.
(54 x 65.1 cm.)
Unsigned
Bequest of Hudson Walker from the Ione
and Hudson Walker Collection
78.21.265
Illustration: Appendix

REFERENCE: Elizabeth McCausland, *Marsden Hartley* (Minneapolis: University of Minnesota Press, 1952), 37, 68.

EXHIBITIONS: *Marsden Hartley Retrospective*, 1952 • Department of Fine Arts Gallery, Louisiana State University, Baton Rouge, *Marsden Hartley*, 1957 • American Federation of Arts Traveling Exhibition, *Marsden Hartley Retrospective*, 1960-1962, cat. 24 • The University of Kansas Museum of Art, Lawrence, *Marsden Hartley: Lithographs and Related Works*, 1972, cat. 19 • Art Museum Association of America and the University Art Museum, Traveling Exhibition, *Marsden Hartley 1908-1942: The Ione and Hudson Walker Collection*, 1984-1985, cat. 22 • *Marsden Hartley 1908-1942: The Ione and Hudson Walker Collection*, 1986.

PROVENANCE: Ione and Hudson Walker

The white dish shown here appears in many of the still-lifes Hartley produced during the 1920s. As Elizabeth McCausland has pointed out, Hartley's peripatetic existence and poverty precluded his acquisition of many material possessions. He cherished some ceramic pieces, however, including this white compote, which is also featured in a series of lithographs dating from 1923. *Pears in White Compote* is a rare late excursion into cubism for Hartley and may be attributable to the influence of a reencounter with the work of Georges Braque in Paris in 1921 and 1922. The black outlines, flattened shapes, and stippled decorative surfaces of the painting particularly reflect Braque's style. *P.N.*

Still Life, *1923*

Oil on canvas, 20½ x 24¼ in.
(52.1 x 61.6 cm.)
Unsigned
Bequest of Hudson Walker from the Ione
and Hudson Walker Collection
78.21.53
Illustration: Appendix

REFERENCE: Elizabeth McCausland, *Marsden Hartley* (Minneapolis: University of Minnesota Press, 1952), 37, 68.

EXHIBITIONS: *Marsden Hartley Retrospective*, 1952, and Traveling Exhibition, 1952-1954 • University of Kansas Museum of Art, Lawrence, *Marsden Hartley: Lithographs and Related Works*, 1972, cat. 20.

PROVENANCE: Alfred Stieglitz; Ione and Hudson Walker

Cézannesque still-life compositions, motifs, and forms dominated Hartley's paintings in Berlin and Paris during the early 1920s. His beloved (and frequently replicated) white compote serves as the focal point for the painting, a pyramidal tabletop arrangement of fruit nested in a crisp white cloth. The heavy application of paint, broad shadows, and outlined forms typify these paintings. Hartley also produced a series of lithographs of similar still-lifes. *P.N.*

Still Life with Flowers, *c. 1923*

Oil on wood, 16 x 11¾ in.
(40.6 x 29.8 cm.)
Unsigned
Bequest of Hudson Walker from the Ione
and Hudson Walker Collection
78.21.232
Illustration: Appendix

REFERENCE: Elizabeth McCausland, *Marsden Hartley* (Minneapolis: University of Minnesota Press, 1952), 66.

EXHIBITIONS: American Association of University Women Traveling Exhibition, *Marsden Hartley*, 1950-1951 • Department of Fine Arts Gallery, Louisiana State University, Baton Rouge, *Marsden Hartley*, 1957 • *Selections from the Collection*, 1957 • *Marsden Hartley—German Period*, 1959 • *Selected Works from the Collection of Ione and Hudson Walker*, 1959.

PROVENANCE: Adelaide Kuntz; Ione and Hudson Walker

Although "1913" is inscribed on a label on the verso, *Still Life with Flowers* relates to a series of lithographs that Hartley produced in 1923 of spiky flowers arranged in isolated goblets, and the inscribed date seems to be a later addition. It is also similar to his other European still-lifes of the 1920s in its dark colors and conscious ruggedness. The vitality of the pinwheel flowers facing in opposite directions is enhanced by the heavy modeling and bold application of paint. Hartley altered the traditional tabletop still-life composition by indicating a circular sweep of the table that increases the depth of the space and emphasizes the curvilinear pattern of the goblet. *P.N.*

Paysage, *1924*

Oil on canvas, 31⅞ x 31⅞ in.
(81 x 81 cm.)
Signed lower center: M.H.
Bequest of Hudson Walker from the Ione
and Hudson Walker Collection
78.21.99
Illustration: Appendix

REFERENCE: Elizabeth McCausland, *Marsden Hartley* (Minneapolis: University of Minnesota Press, 1952), 18, 67.

EXHIBITIONS: *Selections from the Collection of Mr. and Mrs. Hudson D. Walker*, 1950 • *Marsden Hartley Retrospective*, 1952, and Traveling Exhibition, 1952-1954 • *Marsden Hartley: Landscapes*, 1957 • *Selections from the Collection*, 1957 • University of Nebraska Art Galleries, Lincoln, *Man and Mountain*, 1957 • *Selected Works from the Collection of Ione and Hudson Walker*, 1959 • *Art and the University of Minnesota*, 1961 • *100 Paintings, Drawings, and Prints from the Ione and Hudson D. Walker Collection*, 1965, cat. 38 • The Gallery of Modern Art, New York, *The Twenties Revisited*, 1965 • C.W. Post Art Gallery,

After a sojourn in the American Southwest in 1918 and 1919, Hartley longed for Europe, and a sale of his paintings was held in New York in 1921 to facilitate his return to Paris, a city which was always for him a haven of culture and sophistication. Once in Europe, however, Hartley went back to the subject of the distant southwestern landscape and produced a series of remembrances of it. His ambivalence about his own solitary life is particularly evident in these gloomy works. Although he loathed New Mexico when he was there, he mythicized it after he left.

The mood of all these recollections is typified by the dark, brooding quality of *Paysage*. Nature is a forbidding, abstract design of curvilinear patterns, carefully balanced and framed. The rolling clouds in the sky echo the boulders in the bottom foreground. A sameness of texture flattens the landscape elements. This procedure of abstraction and the heavy impasto enhance the unreality of the scene, which is more a nightmare than a dream. The morose mood of this landscape, with its prominent mountains, recalls *Deserted Farm* and the other dark New England landscapes that Hartley produced in 1909. *P.N.*

Long Island University, Greenvale, Long Island, New York, *Marsden Hartley, 1877-1943*, 1977, cat. 15 ▪ University Art Gallery, University of South Dakota, Vermillion, *A Memorial Exhibition, Marsden Hartley, 1877-1943*, 1978 ▪ *The Mountains of Marsden Hartley*, 1979 ▪ Art Museum Association of America and the University Art Museum, Traveling Exhibition, *Marsden Hartley 1908-1942: The Ione and Hudson Walker Collection*, 1984-1985, cat. 23 ▪ *Marsden Hartley 1908-1942: The Ione and Hudson Walker Collection*, 1986.

PROVENANCE: Ione and Hudson Walker

Oil on canvas, 10½ x 18¼ in. (26.7 x 46.4 cm.)
Unsigned
Bequest of Hudson Walker from the Ione and Hudson Walker Collection
78.21.254
Illustration: Appendix

REFERENCE: Elizabeth McCausland, *Marsden Hartley* (Minneapolis: University of Minnesota Press, 1952), 68.

EXHIBITION: *Marsden Hartley Retrospective*, 1952.

PROVENANCE: Ione and Hudson Walker

Four Red Fish, *1924*

In 1924 Hartley returned to Paris from the south of France. He continued painting still-lifes and became fascinated with the subject of fish, a familiar item in many nineteenth-century still-lifes. Dead fish, like dead game, were the stillest form of life and also, of course, a source of food, another common still-life subject.

Barbara Haskell explained Hartley's motivation for painting fish: "In addition to resuming his New Mexico themes, he worked on a group of fish still lifes which he called 'Chez Prunier' after the fish he observed in Prunier's fish market window. Seen from above and disposed vertically against a painterly background, the depictions of fish continue the style of the 1923 Berlin still lifes" (Barbara Haskell, *Marsden Hartley* [New York: Whitney Museum of American Art, 1980], p. 73).

Four Red Fish is a less distinct variant of Hartley's fishmarket window series. The background is less specified than in the others of the series and is devoid of the decorative fruit that adds color contrast. As a result, the market window is less obvious. The image is more general and perhaps more symbolic. The alternately left- and right-facing fish interlock in a stylized decorative pattern. *P.N.*

Three Blue Fish with Lemons and Limes, *1924*

Oil on canvas, 10¾ x 18½ in. (27.3 x 47 cm.)
Unsigned
Bequest of Hudson Walker from the Ione and Hudson Walker Collection
78.21.253
Illustration: Appendix

In *Three Blue Fish with Lemons and Limes* the shape of the canvas perfectly replicates that of the store window, and Hartley has included elements that would have been part of the display for merchandising the fish. Although he may not have been aware of the Christian significance of the lemon in its reference to the Virgin Mary and fidelity in love, Hartley was undoubtedly aware of the fish as a symbol of Christ. *P.N.*

REFERENCE: Elizabeth McCausland, *Marsden Hartley* (Minneapolis: University of Minnesota Press, 1952), 68.

EXHIBITIONS: *Marsden Hartley Retrospective*, 1952, and Traveling Exhibition, 1952-1954 ▪ *Fish Forms in Art*, 1955, cat. 43 ▪ Art Museum Association of America and the University Art Museum, Traveling Exhibition, *Marsden Hartley 1908-1942: The Ione and Hudson Walker Collection*, 1984-1985, cat. 24 ▪ *Marsden Hartley 1908-1942: The Ione and Hudson Walker Collection*, 1986.

PROVENANCE: Ione and Hudson Walker

Oil on canvas, 14 x 25⅝ in. (35.6 x 65.1 cm.)
Unsigned; inscribed on verso, right side, center, "O'Keeffe for Lake George"
Bequest of Hudson Walker from the Ione and Hudson Walker Collection
78.21.255
Illustration: Figure 51

REFERENCES: Elizabeth McCausland, *Marsden Hartley* (Minneapolis: University of Minnesota Press, 1952), 68 ▪ Barbara Haskell, *Marsden Hartley* (New York: Whitney Museum of American Art, 1980), 73.

EXHIBITIONS: *Marsden Hartley Retrospective*, 1952 ▪ *Fish Forms in Art*, 1955, cat. 44 ▪ *Selections from the Collection*, 1957.

PROVENANCE: Ione and Hudson Walker

Three Red Fish with Lemons, *1924*

This is another painting from Hartley's Chez Prunier series of fishmarket windows. The three fish, probably salmon, face in the same direction and are balanced by two carefully positioned lemons, implying the relationship between sea and land, animal and plant. *P.N.*

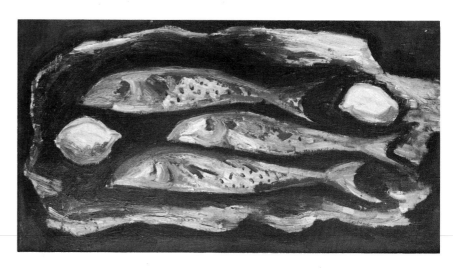

Three Red Fish with Lemons, *1924* ▪ *Figure 51*

178

Still Life with Artichoke, *1924-1925*

Oil on canvas, 13⅞ x 25¾ in.
(35.2 x 65.4 cm.)
Unsigned
Bequest of Hudson Walker from the Ione
and Hudson Walker Collection
78.21.233
Illustration: Appendix

REFERENCE: Elizabeth McCausland, *Marsden
Hartley* (Minneapolis: University of
Minnesota Press, 1952), 68.

EXHIBITIONS: American Association of
University Women Traveling Exhibition,
Marsden Hartley, 1950-1951 • *Marsden
Hartley Retrospective*, 1952, and Traveling
Exhibition, 1952-1954 • Huntington
Galleries, West Virginia, *Marsden Hartley*,
1957 • American Federation of Arts
Traveling Exhibition, *Marsden Hartley
Retrospective*, 1960-1962, cat. 246.

PROVENANCE: Ione and Hudson Walker

One of the most erotic of Hartley's still-life paintings, *Still Life with Artichoke* is a curious arrangement of disparate kitchen items spread across an amorphous and indecipherable background. The central green artichoke is joined by a calla lily, a lemon, three eggs, and what appear to be two Jerusalem artichoke roots. Every element of the cycle of growth from seed to fruit is represented, although the circular pattern has no cyclical coherence. The indefinite floating backdrop and rich paint application are similar to Hartley's paintings of fish from 1924. *P.N.*

Landscape, Vence, *1925-1926*

Oil on canvas, 25⅝ x 31⅞ in.
(65.1 x 81 cm.)
Unsigned
Bequest of Hudson Walker from the Ione
and Hudson Walker Collection
78.21.256
Illustration: Figure 52

REFERENCES: Elizabeth McCausland,
Marsden Hartley (Minneapolis: University
of Minnesota Press, 1952), 38, 39, 68 • Gail
R. Scott, *On Art by Marsden Hartley* (New
York: Horizon Press, 1982), 143-184.

EXHIBITIONS: Tweed Gallery, University of
Minnesota-Duluth, *Marsden Hartley
Exhibition*, 1952 • *Marsden Hartley
Retrospective*, 1952 • *Marsden Hartley:
Landscapes*, 1957 • University of Nebraska
Art Galleries, Lincoln, *Man and Mountain*,
1957 • American Federation of Arts
Traveling Exhibition, *Marsden Hartley
Retrospective*, 1960-1962, cat. 26 • Bernard
Danenberg Galleries, New York, *Marsden
Hartley: A Retrospective Exhibition*, 1969,
cat. 17 • The Century Association, New
York, *Paintings by Marsden Hartley from
the Collection of the Hudson Walker
Family*, 1970 • C.W. Post Art Gallery, Long

In the summer of 1925 Hartley leased La Petite Maison in Vence above the Riviera on the south coast of France. The brilliant light and romantic hillsides of the area inspired him to paint in a more highly keyed palette than he had used since he was in New Mexico, and the glowing color and cheerful mood of *Landscape, Vence* and the other works in this series clearly separate them from most of his other nature scenes.

The high vantage point of this painting dwarfs the mountains, reversing the dominant position they usually hold over the viewer. Nature appears more harmonious and knowable here than the malignant, oppressive force which pervades Hartley's early mountainscapes. The crisp, beautiful mountains, echoed by the curvilinear shadow that leads through the composition, also evidence an emotional distancing that is rare in the artist's oeuvre; it is as if he felt overwhelmed by the beauty of the scene, or isolated from it by his foreignness. As is usual in Hartley's work, human presence is merely hinted at, in this case by the road winding through the mountains which symbolizes the transcience of human passage. *P.N.*

179

Island University, Greenvale, Long Island,
New York, *Marsden Hartley, 1877-1943*,
1977, cat. 16 • University Art Gallery,
University of South Dakota, Vermillion, *A
Memorial Exhibition, Marsden Hartley,
1877-1943*, 1978 • *The Mountains of
Marsden Hartley*, 1979 • Stadtische
Kunsthalle Düsseldorf, Traveling Exhibition,
*Two Decades of American Painting, 1920-
1940*, 1979 • Whitney Museum of American
Art, New York, *Marsden Hartley
Retrospective*, 1980, cat. 56 • Art Museum
Association of America and the University
Art Museum, Traveling Exhibition,
*Marsden Hartley 1908-1942: The Ione and
Hudson Walker Collection*, 1984-1985, cat.
25 • *Marsden Hartley 1908-1942: The Ione
and Hudson Walker Collection*, 1986.

PROVENANCE: Adelaide Kuntz; Ione and
Hudson Walker

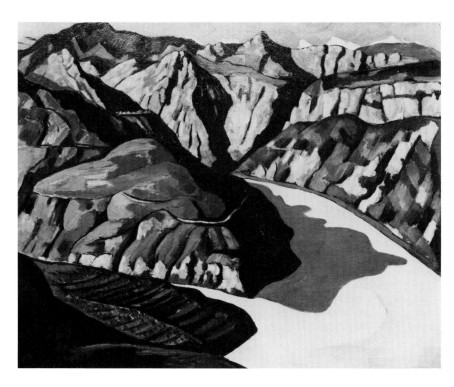

Landscape, Vence, 1925-1926 • *Figure 52*

Still Life #14, *1926*

Oil on canvas, 22¼ x 27⅞ in.
(56.5 x 70.8 cm.)
Unsigned
Bequest of Hudson Walker from the Ione
and Hudson Walker Collection
78.21.62
Illustration: Appendix

REFERENCE: Elizabeth McCausland, *Marsden
Hartley* (Minneapolis: University of
Minnesota Press, 1952), 68.

EXHIBITIONS: *Marsden Hartley
Retrospective*, 1952 • Museum of Art,
Ogunquit, Maine, *Exhibition*, 1953 •
Western Art Gallery, Western Washington
State College, Bellingham, *Marsden Hartley*,
1967 • University of Kansas Museum of
Art, Lawrence, *Marsden Hartley:
Lithographs and Related Works*,
1972, cat. 21.

PROVENANCE: Alfred Stieglitz; Ione and
Hudson Walker

This painting is a slight variation of *Still Life With Grapes* (1922-
1923) in the Howald Collection of the Columbus Museum of Art
(Ohio). The two contain similar arrangements of a compote,
pitcher, and glasses, and fruit spread across the tilted surface of a
table. In both works the central table setting is surrounded by a
dark circular aureole. *Still Life #14* differs from Hartley's earlier
still-lifes of 1922 and 1923 in that it includes a plate of two fish;
the fish motif became prevalent in his paintings of 1924, but in a
considerably different format. *Still Life #14* is typical of the rough-
hewn compositions of distorted table settings as studies of form and
volume that Hartley produced during his second sojourn in Europe.
P.N.

180

Peasant's Paradise, *1926-1927*

Oil on canvas, 19¾ x 24 in.
(50.2 x 61.0 cm.)
Signed lower right: Marsden Hartley
Bequest of Hudson Walker from the Ione
and Hudson Walker Collection
78.21.20
Illustration: Appendix

REFERENCES: Elizabeth McCausland,
Marsden Hartley (Minneapolis: University
of Minnesota Press, 1952), 68 • Barbara
Haskell, *Marsden Hartley* (New York:
Whitney Museum of American Art, 1980),
75.

EXHIBITIONS: *Selections from the Collection
of Mr. and Mrs. Hudson D. Walker*, 1950 •
Marsden Hartley Retrospective, 1952 •
American Federation of Arts Traveling
Exhibition, *Marsden Hartley Retrospective*,
1960-1962, cat. 27 • C.W. Post Art Gallery,
Long Island University, Greenvale, Long
Island, New York, *Marsden Hartley, 1877-
1943*, 1977, cat. 19 • University Art
Gallery, University of South Dakota,
Vermillion, *A Memorial Exhibition,
Marsden Hartley, 1877-1943*, 1978.

PROVENANCE: Ione and Hudson Walker

In the autumn of 1926 Hartley moved from Vence to Aix-en-Provence, Cézanne's native city. There he continued painting still-lifes and landscapes, not surprisingly emulating the revered French master. In *Peasant's Paradise*, the concentration on spatial order with the composition divided into two horizontal registers, and the contrast of kitchen elements to the curvilinear floral pattern, refer directly to Cézanne's work. The pyramidal composition, objects nestled in a white cloth, subtle visual distortions, and limited range of Hartley's palette also pay homage to the master's techniques. The rough forms of the still-life clarify the title: the peasant's dream of wine, bread, and onions—subsistence fare. Since Hartley always lived on the edge of poverty, it was his dream, too. The illogically placed, entwining vine expresses the sustained growth of the grapes as the source of the wine. *P.N.*

Fleurs d'Orphée, *1928*

Oil on canvas, 21¾ x 13⅛ in.
(55.2 x 33.3 cm.)
Unsigned
Bequest of Hudson Walker from the Ione
and Hudson Walker Collection
78.21.292
Illustration: Figure 53

EXHIBITIONS: Huntington Galleries, West
Virginia, *Marsden Hartley*, 1957 • Art
Museum Association of America and the
University Art Museum, Traveling
Exhibition, *Marsden Hartley 1908-1942:
The Ione and Hudson Walker Collection*,
1984-1985, cat. 26 • *Marsden Hartley
1908-1942: The Ione and Hudson Walker
Collection*, 1986.

PROVENANCE: The Downtown Gallery, New
York; Ione and Hudson Walker

The mythological title of this painting suggests that Hartley intended it to have a meaning beyond that of a simple appreciation of nature. A subtle and beautiful floral still-life, this composition would seem to continue the nineteenth-century romantic association of flowers with fleeting beauty and the swift passage of youth.

Orpheus, the Greek hero who rivaled the ancient gods in his skill with the lyre, charmed the maid Eurydice with his beautiful melodies and convinced her to marry him. On their wedding day she was attacked by a serpent and died tragically. She was transported to the underworld, and the most popular story about Orpheus concerns his unsuccessful attempt to rescue her from the land of the dead. In his despair over his lost love, Orpheus lamented, "The bud was plucked before the flower bloomed." Death before full growth and flowering was a prevalent theme in

Fleurs d'Orphée, *1928 ▪ Figure 53*

Hartley's oeuvre and would seem to have been his message here. In *Fleurs d'Orphée* he contrasts three buds with flowers in full bloom. Just as flowers die quickly after they are picked, so youth and beauty fade rapidly. The reflections in the glass jar present a distortion of perceptions as a comment on the fallacy of sight.

The French title of this painting indicates that Hartley painted it in France; the pale colors relate it to his still-lifes of 1917. *P.N.*

Eight Bells Folly: Memorial to Hart Crane, *1933*

Oil on canvas, 30⅝ x 39⅜ in.
(77.8 x 100 cm.)
Signed verso: Marsden Hartley Mexico 1933
Gift of Ione and Hudson Walker
61.4
Illustration: Colorplate IV

REFERENCES: Margaret Breuning, "The Rugged Intensity of Marsden Hartley," *Art Digest* (1 December 1945): 17 • Hudson Walker, "Marsden Hartley," *Kenyon Review* (Spring 1947): 255 • Elizabeth McCausland, *Marsden Hartley* (Minneapolis: University of Minnesota Press, 1952), 9, 46, 69 • Robert Burlingame, *Marsden Hartley: A Study of His Life and Creative Achievement* (Providence: Brown University, 1954), 334-335 • Gorham Munson, "The Painter from Maine," *Arts* (February 1961): 38 • Sanford Schwartz, "A Northern Seascape," *Art in America* (January-February 1976), 76.

EXHIBITIONS: Macbeth Galleries, New York, *Exhibition*, 1945 • *Marsden Hartley Retrospective*, 1952, and Traveling Exhibition, 1952-1954 • Baltimore Museum of Art, *Man and His Years*, 1954 • Department of Fine Arts Gallery, Louisiana State University, Baton Rouge, *Marsden Hartley*, 1957 • Huntington Galleries, West Virginia, *Marsden Hartley*, 1957 • American Federation of Arts Traveling Exhibition, *Marsden Hartley Retrospective*, 1960-1962, cat. 32 • 100 *Paintings, Drawings, and Prints from the Ione and Hudson D. Walker Collection*, 1965, cat. 39 • La Jolla Museum of Art, La Jolla, California, *Marsden Hartley—John Marin*, 1966, cat. 18 • American Federation of Arts Traveling Exhibition, *Late Works by Marsden Hartley*, 1966-1967, cat. 3 • Whitney Museum of American Art, New York, *The 1930s: Painting and Sculpture in America*,

Awarded a Guggenheim fellowship that required him to work outside the United States for a year, Hartley set out for Mexico early in 1932. There he renewed his acquaintance with the poet Hart Crane, who was also living in Mexico on a Guggenheim grant. Although Crane left Mexico shortly after Hartley's arrival, Hartley developed a kinship with the poet who, he felt, was seriously disturbed.

Hartley's fears were confirmed when he learned of Crane's suicide in March of 1933. Crane had jumped from the ship carrying him back to the United States and drowned off the coast of Cuba. Deeply affected, Hartley wrote an elegiac poem, "Un Recuerdo—Hart Crane Hermano," and painted *Eight Bells Folly*. Both poem and painting deal with the destruction of a talented artist in his prime, a prevalent theme throughout Hartley's oeuvre. Just prior to the incident, Hartley's own health had been tenuous, and painting apparently helped him to work out his fears about death.

Describing *Eight Bells Folly* to his patroness, Adelaide Kuntz, Hartley wrote: "One is a marine fantasy of Hart Crane's death by drowning—it has a very mad look as I wish it to have—there is a ship foundering—a sun, a moon, two triangular clouds—a bell with an '8' on it—symbolizing eight bells—or noon when he jumped off—and around the bell are a lot of men's eyes—that look up from below to see who the new lodger is to be—on one cloud will be the number 33—Hart's age—and according to some occult beliefs is the dangerous age of a man—for if he survives 33—he lives on—Christ was supposed to be 33—on the other cloud will be 2—the sum of the poet's product" (Burlingame, p. 335).

As Robert Burlingame points out, Hartley's explanation is generally faithful to the painting except that the 33 is not in the triangular, Gothic, window-shaped cloud, and the number 2 does not appear at all. Since there are two three-sided clouds, they perhaps stand for the double 3s and for Hartley's number 2. Elizabeth McCausland refers to the double 3s inscribed on the sails as two Bs denoting the Brooklyn Bridge—the subject of Hart Crane's masterpiece, *The*

1968 • Bernard Danenberg Galleries, *Marsden Hartley, A Retrospective Exhibition*, 1969, cat. 27 • Artmobile, Minneapolis Institute of Arts Traveling Exhibition, *American Art, 1930-1970*, 1970-1971 • *Works from the Permanent Collection*, 1972 • The Committee on Institutional Cooperation and Member Universities Traveling Exhibition, *Paintings from Mid-Western University Collections, 17th-20th Centuries*, 1975, cat. 56 • Virginia Museum of Fine Arts, Richmond, and the Mariners' Museum, Newport News, *Marine Painting in America*, 1976 • *Hudson D. Walker: Patron and Friend*, 1977, cat. 35 • Stadtische Kunsthalle Düsseldorf, Traveling Exhibition, *Two Decades of American Painting*, 1979 • Whitney Museum of American Art, New York, *Marsden Hartley Retrospective*, 1980, cat. 68 • Carleton College, Northfield, Minnesota, *American Abstraction: 20th Century American Paintings from the University of Minnesota*, 1983 • *Early Modernism in America: The Stieglitz Circle*, 1983 • Art Museum Association of America and the University Art Museum, Traveling Exhibition, *Marsden Hartley 1908-1942: The Ione and Hudson Walker Collection*, 1984-1985, cat. 29 • *Marsden Hartley 1908-1942: The Ione and Hudson Walker Collection*, 1986.

PROVENANCE: Adelaide Kuntz; Ione and Hudson Walker

Oil on masonite, 15⅞ x 23¾ in. (40.3 x 73 cm.)
Unsigned
Bequest of Hudson Walker from the Ione and Hudson Walker Collection
78.21.840
Illustration: Appendix

REFERENCES: Elizabeth McCausland, *Marsden Hartley* (Minneapolis: University of Minnesota Press, 1952), 30, 69 • Elizabeth McCausland, "Return of the Native," *Art in America* (Spring 1952): 71 • Barbara Haskell, *Marsden Hartley* (New York: Whitney Museum of American Art, 1980), 96.

Bridge, published in 1930. For Crane, the ship was the final bridge between life and death. The translation of the ship into a sailing vessel is intentional; its inclusion is reminiscent of nineteenth-century Romanticism, where the ship was interpreted as the ship of life. Rising out of the water, the shark conveys all the menace and terror of the deep, while the sun and moon represent the unchanging, cyclical rhythm of life.

Hartley used the number 8 in many ways. Eight bells signaled the time of day, but the number also appeared in his abstract German military paintings, symbolizing transcendence and/or regeneration. In a very real sense, the artist's work is his transcendence over his mortality. The eight-pointed stars seen here appear both in earlier paintings and in later works based on the death by drowning of two more of his friends. Asterisk stars were ancient mystical symbols of the great gods in the Near East. Inscribed in circles as they are in *Eight Bells Folly*, the stars look like Oriental mandalas or Buddhist wheels. Hartley was aware of this wide range of associations and may have intended them all. The garish colors of the painting and the heavily modeled forms enhance the pictorial mood of tension and melancholy.

After Hartley's death, Adelaide Kuntz sold the painting to Hudson Walker and gave the proceeds to Hartley's friend, the painter Carl SPRINCHORN. *P.N.*

Dogtown, *1934*

Dogtown, a moraine on Cape Ann in Massachusetts, attracted Hartley when he visited the artists' community in neighboring Gloucester in 1931. Working in three phases (during 1931, 1934, and 1936), Hartley produced a series of stark, haunting landscapes based on these fantastic rock formations.

Barbara Haskell claims that Hartley knew of Dogtown as early as 1920, although the site did not appear in his paintings until the following decade. In his unpublished autobiographical notes, the artist explained his fascination with the site: "Dogtown looks like a cross between Easter Island and Stonehenge—essentially druidic in its appearance. It gives the feeling that any ancient race might turn up at any moment and review an ancient rite there...sea gulls fly

EXHIBITIONS: American Association of University Women Traveling Exhibition, *Marsden Hartley*, 1950-1951 • *Marsden Hartley Retrospective*, 1952, and Traveling Exhibition, 1952-1954 • American Federation of Arts Traveling Exhibition, *Late Works by Marsden Hartley*, 1966-1967 • Bernard Danenberg Galleries, New York, *Marsden Hartley: A Retrospective Exhibition*, 1969, cat. 29 • *Selections from the Permanent Collection*, 1969 • The Century Association, New York, *Paintings by Marsden Hartley from the Collection of the Hudson Walker Family*, 1970 • Art Museum Association of America and the University Art Museum, Traveling Exhibition, *Marsden Hartley 1908-1942: The Ione and Hudson Walker Collection*, 1984-1985, cat. 33 • *Marsden Hartley 1908-1942: The Ione and Hudson Walker Collection*, 1986.

PROVENANCE: Ione and Hudson Walker

Oil on academy board, 18 x 24 in. (45.7 x 61 cm.)
Signed lower right: M.H.
Bequest of Hudson Walker from the Ione and Hudson Walker Collection
78.21.246
Illustration: Figure 54

REFERENCES: Elizabeth McCausland, *Marsden Hartley* (Minneapolis: University of Minnesota Press, 1952), 9, 45, 70 • Gail R. Scott, "Marsden Hartley at Dogtown Common," *Arts* (October 1979): 163.

over it on their way from the marshes to the sea; otherwise the place is forsaken and majestically lovely as if nature had at last formed one spot where she can live for herself alone" (Jeffrey Spalding, *Coasts, The Sea, and Canadian Art* [Stratford, Ontario: The Gallery, 1978], not paged).

The rugged forms and heavy colors in this painting, typical of Hartley's work in the 1930s, are linked to a conscious primitivism associated with his attempt to produce an American style of painting based on American motifs. The exoticism of these ancient geological deposits provided a romantic and American subject for him as he tried to reestablish his role as a New England artist. The massive, sculptural boulders, virtually unchanged for thousands of years, also represented permanence and stability to Hartley as a universal constant—in contrast to his own ephemeral life and the flux of nature.

This painting, usually referred to as *Dogtown* despite its label designating it *Dogtown Autumn*, is scratched with a pattern of hatchmarks characteristic of the 1934 Dogtown works. This curious technique adds texture and modeling to the forms and unifies the composition. *P.N.*

Dogtown, The Last of the Stone Wall, *1934*

The crumbling manmade stone wall at Dogtown was the last vestige of human habitation in that stark region during a brief period in the early eighteenth century. Disintegrating, composed of the same material as the moraine, it symbolized to Hartley humankind's useless efforts to order the cosmos. He gave the landscape density and solidity by massing the rocks and foliage in the foreground and modeling them with heavy areas of paint and thick outlines. *P.N.*

EXHIBITIONS: *Marsden Hartley
Retrospective*, 1952 ▪ Museum of Art,
Ogunquit, Maine, *Exhibition*, 1953 ▪
Museum of Modern Art Traveling
Exhibition, *Three Modern Masters:
Feininger, Hartley, Beckmann*, 1955-1957 ▪
*Selected Works from the Collection of Ione
and Hudson Walker*, 1959 ▪ *100 Paintings,
Drawings, and Prints from the Ione and
Hudson D. Walker Collection*, 1965, cat.
42 ▪ Davis Art Gallery, Stephens College,
Columbia, Missouri, *American Paintings,
Selected Works from Mid-Western Galleries
Covering 200 Years of American Painting*,
1966, cat. 15 ▪ American Federation of Arts
Traveling Exhibition, *Late Works of
Marsden Hartley*, 1966-1967 ▪ Bernard
Danenberg Galleries, New York, *Marsden
Hartley: A Retrospective Exhibition*, 1969,
cat. 30 ▪ The Century Association, New
York, *Paintings by Marsden Hartley from
the Collection of the Hudson Walker
Family*, 1970 ▪ *The Mountains of Marsden
Hartley*, 1979 ▪ Whitney Museum of
American Art, New York, *Marsden Hartley
Retrospective*, 1980, cat. 71 ▪ Art Museum
Association of America and the University
Art Museum, Traveling Exhibition,
*Marsden Hartley 1908-1942: The Ione and
Hudson Walker Collection*, 1984-1985, cat.
34 ▪ *Marsden Hartley 1908-1942: The Ione
and Hudson Walker Collection*, 1986.

PROVENANCE: Louis Schapiro; Childs
Gallery, Boston; Ione and Hudson Walker

Oil on academy board, 9¼ x 13 in.
(23.5 x 33 cm.)
Unsigned
Gift of Ione and Hudson Walker
61.5
Illustration: Appendix

REFERENCES: Elizabeth McCausland,
Marsden Hartley (Minneapolis: University
of Minnesota Press, 1952), 69 ▪ Hilton
Kramer, "Hartley and Modern Painting,"
Arts (February 1961): 42 ▪ Gail R. Scott,
"Marsden Hartley at Dogtown Common,"
Arts (October 1979): 159-165.

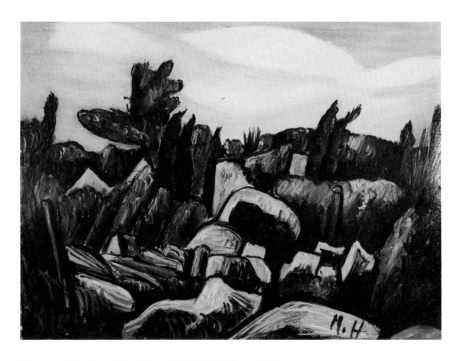

Dogtown, The Last of the Stone Wall, *1934* ▪ *Figure 54*

Dogtown Common, *1936*

Inhabited during the early eighteenth century, Dogtown had been
abandoned by 1750; it is a bleak area that resembles an English
moor. This painting is a continuation of Hartley's soliloquy on the
deserted town. The word "common" describes an eighteenth-
century concept of land held in common by all; here its use is
ironic, since Dogtown is common, or free, in the truest sense— the
land endures even though generations pass. *P.N.*

EXHIBITIONS: *Marsden Hartley Retrospective*, 1952 ▪ American Federation of Arts Traveling Exhibition, *Marsden Hartley Retrospective*, 1960-1962, cat. 37 ▪ *100 Paintings, Drawings, and Prints from the Ione and Hudson D. Walker Collection*, 1965, cat. 41 ▪ Western Art Gallery, Western Washington State College, Bellingham, *Marsden Hartley*, 1967.

PROVENANCE: Ione and Hudson Walker

Dahlias and Crab, *1936*

Oil on canvas board, 18 x 14 in.
(45.7 x 35.6 cm.)
Unsigned
Bequest of Hudson Walker from the Ione and Hudson Walker Collection
78.21.833
Illustration: Appendix

REFERENCE: Elizabeth McCausland, *Marsden Hartley* (Minneapolis: University of Minnesota Press, 1952), 50, 69.

EXHIBITIONS: American Association of University Women Traveling Exhibition, *Marsden Hartley*, 1950-1951 ▪ *Marsden Hartley Retrospective*, 1952, and Traveling Exhibition, 1952-1954 ▪ American Federation of Arts Traveling Exhibition, *Late Works of Marsden Hartley*, 1966-1967 ▪ The Century Association, New York, *Paintings by Marsden Hartley from the Collection of the Hudson Walker Family*, 1970 ▪ Art Museum Association of America and the University Art Museum, Traveling Exhibition, *Marsden Hartley 1908-1942: The Ione and Hudson Walker Collection*, 1984-1985, cat. 38 ▪ *Marsden Hartley 1908-1942: The Ione and Hudson Walker Collection*, 1986.

PROVENANCE: Ione and Hudson Walker

In contrast to the death and decay which pervades Hartley's 1924 still-lifes of sea creatures, *Dahlias and Crab* glows with life and beauty. Its nondescript setting and high vantage point, however, relate it compositionally to the earlier marine subjects. Once again, the animal and botanical forms juxtapose various stages in the life cycle—the incipient growth of the tiny crab with the mature blossoming of the dahlias. The stippled dabs of paint in the background appear stitched to the canvas in a technique that Hartley adopted around 1908 from the well-known Italian painter Giovanni Segantini.

In 1936 Hartley worked for several months for the WPA in New York City. *Dahlias and Crab* relates to a series of paintings that he produced for the WPA which Barbara Haskell has described as follows: "What Hartley did produce for the W.P.A. were paintings devoted to the flower and fish motifs begun earlier in Bermuda (1935). Because flowers had been scarce there, Hartley had invented his own floral motifs. He described the resultant brightly colored fantasies as imaginative portrayals of things 'seen or sensed in Bermuda.' The most striking feature of these Bermuda Fantasies is their color range, more brilliant now than any of Hartley's work since his 1908-1909 Neo-Impressionist landscape" (Barbara Haskell, *Marsden Hartley* [New York: Whitney Museum of American Art, 1980], p. 99). *P.N.*

Oil on academy board, 12 x 16 in.
(30.5 x 40.6 cm.)
Unsigned
Bequest of Hudson Walker from the Ione
and Hudson Walker Collection
78.21.127
Illustration: Appendix

REFERENCE: Elizabeth McCausland, *Marsden
Hartley* (Minneapolis: University of
Minnesota Press, 1952), 50, 70.

EXHIBITION: *Marsden Hartley Retrospective*,
1952.

PROVENANCE: Ione and Hudson Walker

Squid, *1936*

Part of the same series as *Dahlias and Crab*, *Squid* is a further
exploration of the myriad varieties of marine life in Hartley's
lexicon of the wonders of nature. The speckled background
highlighting the creature is typical of Hartley's reminiscences of
Bermuda marine life and suggests flickering patterns of light across
the surface of water. *P.N.*

Adelard the Drowned, Master of the "Phantom," *c. 1938-1939*

Oil on academy board, 28 x 22 in.
(71.1 x 55.9 cm.)
Unsigned
Bequest of Hudson Walker from the Ione
and Hudson Walker Collection
78.21.236
Illustration: Cover

REFERENCES: Hudson Walker, "Marsden
Hartley," *Kenyon Review* (Spring 1947):
258 • Elizabeth McCausland, *Marsden
Hartley* (Minneapolis: University of
Minnesota Press, 1952), 52, 71 • Sanford
Schwartz, "A Northern Seascape," *Art in
America* (January-February 1976): 76.

During the autumn of 1935 Hartley retreated to the isolation of
rural Nova Scotia. Here he was fortunate to find warmth and
companionship in the home of Francis Mason, where he lived for
several weeks. Although Hartley was forced to return to the United
States for the winter, he came back to the Mason household on
Eastern Points Island off the coast of Lunenberg the following
summer.

Hartley was especially fond of Mason's son Alty, a giant-like,
hearty mechanic with thick hair and a fiery personality. On a
stormy evening in September of 1936 the incautious Alty set out
from the mainland in his brightly colored punt with his brother
Donny and cousin Allan. Rough seas swamped the small craft and
the three men were drowned.

Hartley was profoundly shaken. Death by drowning had been the
fate of his friend Hart Crane only a few years earlier. The sea
became a menacing force for Hartley, and many of his late works
featured symbolic marine imagery.

Several years after the disaster, Hartley eulogized the Mason family
in a story, "Cleophas and His Own: A North Atlantic Tragedy" (a
series of prose poems he called "Postludes") and a series of archaic
portraits. By substituting French Canadian names throughout,
Hartley disguised the identity of the Mason family to shield them
from publicity. *Adelard, the Drowned* is a posthumous tribute to
the virility of Alty Mason. The exaggerated mass of hair, hirsute
chest, massive body, and wild rose tucked behind his ear are actual
personal details associated with the young man, although the rose
may be a symbolic love token. The crimson background highlights
his vibrant personality and provides an unnatural sense of space.

EXHIBITIONS: American Association of University Women Traveling Exhibition, *Marsden Hartley*, 1950-1951 ▪ *Marsden Hartley Retrospective*, 1952, and Traveling Exhibition, 1952-1954 ▪ Museum of Modern Art Traveling Exhibition, *Three Modern Masters: Feininger, Hartley, Beckmann*, 1955-1957 ▪ *Selected Works from the Ione and Hudson Walker Collection*, 1959 ▪ *Art and the University of Minnesota*, 1961 ▪ *100 Paintings, Drawings, and Prints from the Ione and Hudson D. Walker Collection*, 1965, cat. 45 ▪ La Jolla Museum of Art, La Jolla, California, *Marsden Hartley—John Marin*, 1966, cat. 23 ▪ American Federation of Arts Traveling Exhibition, *Late Works of Marsden Hartley*, 1966-1967, cat. 21 ▪ University Galleries of the University of Southern California and the University Art Museum of the University of Texas at Austin, Traveling Exhibition, *Marsden Hartley—Painter/Poet*, 1968-1969, cat. 41 ▪ The Century Association, New York, *Paintings by Marsden Hartley from the Collection of the Hudson Walker Family*, 1970 ▪ Tyler Museum of Art, Tyler, Texas, *American Paintings, 1900-Present*, 1971 ▪ Museum of Art, Pennsylvania State University, University Park, *Portraits USA, 1776-1976*, 1976 ▪ *Hudson D. Walker: Patron and Friend*, 1977, cat. 36 ▪ Whitney Museum of American Art, New York, *Marsden Hartley Retrospective*, 1980 ▪ Minnesota Museum of Art, Landmark Center, St. Paul, *American Style: Works from Minnesota Collections*, 1981, cat. 28 ▪ Art Museum Association of America and the University Art Museum, Traveling Exhibition, *Marsden Hartley 1908-1942: The Ione and Hudson Walker Collection*, 1984-1985, cat. 40 ▪ *Marsden Hartley 1908-1942: The Ione and Hudson Walker Collection*, 1986.

PROVENANCE: the artist; Ione and Hudson Walker

Hartley had been fascinated by Egyptian painting since 1931, and the primitive severity of the archaic portraits of the Mason family followed the traditional stylizations of posthumous mummy portraits from Coptic Faiyum with their rigid frontal poses, wide staring eyes, heavy impasto, thick outlines, and flattened space. The portraits were exhibited in 1939 at Hudson Walker's Gallery in New York.

In "Cleophas," Hartley weaves a legendary character for Alty in the guise of Alphonse Adelard: "What a spectacle is Adelard. If I hadn't known he was a human being, I should have thought him some devouring beast from the caverns and the caves, all of his thoughts emotionalised and dramatized by magnificent, opulent, voluminous body action. He is tall, huge, giantesque and his smoke black hair stands six inches above his low forehead, making him seem all the taller, almost spectral—he, the most Norman looking of them all. His eyes have the famished look of one never to be appeased, of an under-eaten over-ravenous wolf, sniffing at the mouth of dungeons, or at the edges of forest fires, loving the pungency of the burning vegetation, sniffing it all in with lustful eagerness. For Adelard, life must literally burn, to mean anything at all. He lives utterly for the consummate satisfaction of the flesh, the kind of flesh making no difference. With wrists thick as the butt end of an ox-yoke, for whatever it takes two to tear or lift, he says, 'Nonsense, give it to me.' And if it is a rock, out comes half of the world with it, the entrails of the earth lie bare. Beneath all his strength lies a heart as tender and as beautiful as that of a young girl, or boy. You must be prepared for the eruption of his Vesuvius, for his laval heats and flows will inevitably inundate your careful and calm city. You will be different somehow after he has left you, if it is only that he has said hello. Adelard is a beauty because he is powerful and as true as he is powerful. He has no common code, no inhibitions. He will give as much love to a man as to a woman and was totally loved by all of them up and down the coast. Because he was thrown over by the first woman, I think he has transferred his affections to his men friends, for he loves them and will do anything for them. With this, comes no mercy, love for him being the outpouring of his devastating energy—all flame, smoke, fire, steam and animal hissing, he is thunder and lightening in one and loves when he strikes—it is the measure of his common quietude" (Marsden Hartley, *Cleophas and His Own: A North Atlantic Tragedy* [Halifax, Nova Scotia: A Press Publication, 1982]). *P.N.*

Finnish-Yankee Sauna, *1938-1939*

Oil on academy board, 24 x 18 in.
(61 x 45.7 cm.)
Unsigned
Bequest of Hudson Walker from the Ione
and Hudson Walker Collection
78.21.248
Illustration: Figure 55

REFERENCES: Doris Brian, "Forceful
Paintings in a Twenty-Fifth Show by
Marsden Hartley," *Art News* (25 March
1939): 14 ▪ Elizabeth McCausland, *Marsden
Hartley* (Minneapolis: University of
Minnesota Press, 1952), 71.

EXHIBITIONS: *Marsden Hartley
Retrospective*, 1952 ▪ Huntington Galleries,
West Virginia, *Marsden Hartley*, 1957 ▪
Selections from the Permanent Collection,
1969 ▪ The Century Association, New York,
*Paintings by Marsden Hartley from the
Collection of the Hudson Walker Family*,
1970 ▪ *Hudson D. Walker: Patron and
Friend*, 1977, cat. 38 ▪ *Selections from the
Permanent Collection*, 1980 ▪ Art Museum
Association of America and the University
Art Museum, Traveling Exhibition,
*Marsden Hartley 1908-1942: The Ione and
Hudson Walker Collection*, 1984-1985, cat.
39 ▪ *Marsden Hartley 1908-1942: The Ione
and Hudson Walker Collection*, 1986.

PROVENANCE: Ione and Hudson Walker

The setting of the Finnish-Yankee Sauna afforded Hartley a rationale for portraying the male nude, an infrequent subject in American art, and he was one of the few modernists to explore this theme prior to the middle of the century. Although the painting is explicit as masculine camaraderie, the brawny bathers affect demure poses to mask their genitalia. This modesty is typical of Hartley's male nudes, as is the emphasis on overdeveloped musculature and a disregard for details and individual personalities. The Scandinavian ritual of the sauna, in which induced sweating is followed by flailing with birch switches to stimulate the flow of blood, demonstrates a concern for physical fitness through exercise. The role of the aging and corpulent painter, however, would have been that of voyeur rather than participant. *P.N.*

Finnish-Yankee Sauna, *1938-1939* ▪ *Figure 55*

Marie Ste. Esprit, *c. 1938-1939*

Oil on academy board, 30 x 24 in.
(76.2 x 61 cm.)
Unsigned
Bequest of Hudson Walker from the Ione
and Hudson Walker Collection
78.21.839
Illustration: Colorplate VII

REFERENCES: Hudson Walker, "Marsden
Hartley," *Kenyon Review* (Spring 1947):
258 • Elizabeth McCausland, *Marsden
Hartley* (Minneapolis: University of
Minnesota Press, 1952), 52, 71 • Henry T.
Hopkins, "Marsden Hartley's Lost Felice,"
*Los Angeles County Museum of Art
Bulletin* (1964): 8 • Barbara Haskell,
Marsden Hartley (New York: Whitney
Museum of American Art, 1980), 116.

EXHIBITIONS: American Association of
University Women Traveling Exhibition,
Marsden Hartley, 1950-1951 • Centro
Internazionale di Arte e di Cultura,
Bordighera, Italy, *III Mostra di Pittura
Americana*, 1955 • *100 Paintings,
Drawings, and Prints from the Ione and
Hudson D. Walker Collection*, 1965, cat.
46 • American Federation of Arts Traveling
Exhibition, *Late Works of Marsden
Hartley*, 1966-1967 • University Galleries of
the University of Southern California and
the University Art Museum of the
University of Texas at Austin, Traveling
Exhibition, *Marsden Hartley—Painter/Poet*,
1968-1969, cat. 48 • C.W. Post Art Gallery,
Long Island University, Greenvale, Long
Island, New York, *Marsden Hartley, 1877-
1943*, 1977, cat. 38 • University Art
Gallery, University of South Dakota,
Vermillion, *A Memorial Exhibition,
Marsden Hartley, 1877-1943*, 1978 •
Selections from the Permanent Collection,
1980 • Art Museum Association of America
and the University Art Museum, Traveling
Exhibition, *Marsden Hartley 1908-1942:
The Ione and Hudson Walker Collection*,
1984-1985, cat. 41 • *Marsden Hartley
1908-1942: The Ione and Hudson Walker
Collection*, 1986.

PROVENANCE: Ione and Hudson Walker

Marie Ste. Esprit is one of a series of archaic portraits that Hartley produced in memory of his sojourn with the Francis Mason family of Nova Scotia. In his descriptions of the family Hartley repeatedly used the word "archaic" to describe their directness and simplicity—personal qualities he valued. He referred to Mrs. Mason as "Marie Ste. Esprit," a possible symbolic reference to her spirituality and to her role as mother of Alty Mason, alias *Adelard the Drowned*. This portrait shows her in mourning for her two dead sons and was painted from memory after Hartley left Nova Scotia. The pose of the three-quarter length female figure with her arms crossed at her waist reiterates the poses of *Adelard the Drowned* and *Cleophas, The Master of the Gilda Gray* (Walker Art Center, Minneapolis); the latter is a portrait of her husband. The heavy paint application, rigid poses, and thick outlines are conscious stylizations Hartley employed to create a primitive, archaic simplicity. The attire of the figure is her only feminine attribute, for she shares the breadth and facial stylizations of her masculine counterparts.

Hartley described Marie Ste. Esprit in a brief chapter in his story "Cleophas and His Own: A North Atlantic Tragedy": "The mystical splendour of this woman was of an entirely practical quality. She did everything right because form is an inspiring thing in itself. She fed the pigs and the chickens, milked, fed, and bedded the cattle, cleaned after them, with this great sense of form and simplicity. She mended everything with the same precision of an oriental rug mender. It was as if she has swung some sort of a thurible as she passed. She cared for all her animals with a natural abundance, all things increased beneath the sway of her spirit. The troubled became calm with her and another life came to life out of her. She was the appointed Mother of us all. Sainte-Esprit, the gentle, the beautiful, bent over like a jacknife at the wash, after having had seven children, agile as a young beginning woman. She was always dressed in black satin relegated to the common day usages and out of her universal white apron, warm benefits came tumbling out into the lap of a grateful world. All animals rejoice and grow stronger—hoof and feather, at the lift of her soft voice, all things increase beneath the soft pressure of her warm spirit.

Even her giants and her flowers must be kept living and glowing with living; giants fed by heart and soul, clinging to her still, staying the escape of their youth, as trees cling to a cliff. The gentle thurible of the mother swings from morning until night, nothing does she disown, human or non-human. She rises with the men at two and sees them off, warmed for fishermen's struggle with the sea. Nothing will die so long as her rich heart lives, so willfully in love with every little thing and then some other little thing. She is the mystic woman, shape of her man and carries the burden of the spirit with him" (Marsden Hartley, *Cleophas and His Own: A North Atlantic Tragedy* [Halifax, Nova Scotia: A Press Publication, 1982]). *P.N.*

North Atlantic Harvest, *1938-1939*

Oil on academy board, 20½ x 26½ in. (52.1 x 67.3 cm.)
Signed: M.H.
Bequest of Hudson Walker from the Ione and Hudson Walker Collection
78.21.249
Illustration: Appendix

EXHIBITIONS: *Marsden Hartley Retrospective*, 1952 • Museum of Ogunquit, Maine, *Exhibition*, 1953 • American Federation of Arts Traveling Exhibition, *Late Works of Marsden Hartley*, 1966-1967 • The Century Association, New York, *Paintings by Marsden Hartley from the Collection of the Hudson Walker Family*, 1970 • Art Museum Association of America and the University Art Museum, Traveling Exhibition, *Marsden Hartley 1908-1942: The Ione and Hudson Walker Collection*, 1984-1985, cat. 42 • *Marsden Hartley 1908-1942: The Ione and Hudson Walker Collection*, 1986.

PROVENANCE: Ione and Hudson Walker

In this painting Hartley returned to the still-life subject of fish that had intrigued him in 1924 in France. In contrast to these earlier European still-lifes, however, his later marine images took on anthropomorphic characteristics with melancholy implications.

As in the past, he placed the fish in a simplified arrangement, but they are no longer the salmon and bluefish of a French market display: they evoke the toil of fishermen and the bounty of the sea in a less genteel fashion. The chubby fish in graduated sizes reiterate the triple motif of the earlier fish compositions. The three fish suggest a Christian reference to Jesus Christ as the dominant figure in the Trinity, but they may also symbolize the artist's three friends who died by drowning. *P.N.*

Chinese Sea Horse, *1941-1942*

Oil on academy board, 24 x 18 in.
(61.0 x 45.7 cm.)
Signed lower left: M.H.
Bequest of Hudson Walker from the Ione
and Hudson Walker Collection
78.21.247
Illustration: Figure 56

REFERENCE: Elizabeth McCausland, *Marsden Hartley* (Minneapolis: University of Minnesota Press, 1952), 71.

EXHIBITIONS: *Marsden Hartley Retrospective*, 1952 • Museum of Modern Art Traveling Exhibition, *Three Modern Masters: Feininger, Hartley, Beckmann*, 1955-1957 • American Federation of Arts Traveling Exhibition, *Late Works of Marsden Hartley*, 1966-1967, cat. 22 • *Selections from the Permanent Collection*, 1968 • The Century Association, New York, *Paintings by Marsden Hartley from the Collection of the Hudson Walker Family*, 1970 • *Hudson D. Walker: Patron and Friend*, 1977, cat. 37 • Salander-O'Reilly Galleries, Inc., New York, *Marsden Hartley: Paintings and Drawings*, 1985 • *Marsden Hartley 1908-1942: The Ione and Hudson Walker Collection*, 1986.

PROVENANCE: Ione and Hudson Walker

The dual subjects of death and sea imagery prevalent in Hartley's late painting signal his increasing meditations on the meaning of life as he approached the end of his career. He was intrigued by dead animals, particularly sea birds and fish, as the ultimate subject for still-life—"dead nature," as the genre is translated from the French. Hartley depicted the eerie and delicate calcified remains of the sea horse as a symbol of the isolation and evanescence of life and the inevitability of death as a passage in the cycle of nature. Sustained by the sea and washed up on the beach when they die, the skeletons of exotic sea creatures are haunting reflections of the beauty in death.

Like Georgia O'KEEFFE, Hartley employed a magnified scale to increase the importance of the object. In his later works he also reduced the colors and the imagery to a minimum, thus intensifying the visual experience. The Hirshhorn Museum and Sculpture Garden owns a *White Sea Horse* by Hartley dated 1942 that is similar to *Chinese Sea Horse*. In the Hirshhorn painting, however, the solitary skeleton is silhouetted against an amorphous red ground rather than a black one. *P.N.*

Chinese Sea Horse, *1941-1942* • *Figure 56*

WILLIAM STANLEY HASELTINE

1835-1900

SELECTED BIBLIOGRAPHY: Helen Haseltine Plowden, *William Stanley Haseltine, Sea and Landscape Painter* (London: Frederick Muller Ltd., 1947) ▪ *Travelers in Arcadia, American Artists in Italy, 1830-1875* (Detroit: The Detroit Institute of Arts and Toledo: Toledo Museum of Art, 1951), 39 ▪ *M. & M. Karolik Collection of American Water Colors and Drawings, 1800-1875*, volume 1 (Boston: Museum of Fine Arts, 1962), 177-180 ▪ Donelson F. Hoppes, *The Düsseldorf Academy and the Americans: An Exhibition of Drawings and Watercolors* (Atlanta: The High Museum of Art, 1972), 42 ▪ John K. Howat, *The Hudson River and Its Painters* (New York: Viking Press, 1972), *passim*.

Born in Philadelphia, landscape artist William Stanley Haseltine studied at the University of Pennsylvania with the German emigré artist Paul Weber. After graduating from Harvard in 1854 he accompanied Weber to Düsseldorf and studied with the noted landscape painter Andreas Achenbach. While abroad he made sketching trips up the Rhine and to Switzerland, Florence, and Rome, accompanied by one or more of his compatriots who were also studying art in Düsseldorf—Emanuel Leutze, Worthington WHITTREDGE, and Albert BIERSTADT. He returned to Philadelphia in 1858, where he sold several paintings before moving to New York City. There he lived and worked in the Studio Building on Tenth Street in between trips along the Savannah and Delaware Rivers and to the eastern seacoast, the subject of many of his sought-after pictures.

In 1866 Haseltine went back to Europe and stayed for three years, making occasional painting excursions to the forests near Barbizon from his home in Paris. From 1869 on he lived in Rome except for extended trips to the States in 1872, 1893, 1895, and 1899. He exhibited frequently at the National Academy (he had been elected an Associate in 1860 and an Academician in 1861), the Pennsylvania Academy of the Fine Arts, and the Salmagundi and Century Clubs. He was represented in the 1876 Centennial Exposition in Philadelphia and the World's Columbian Exposition held in Chicago in 1893. He died in Rome. *C.P.H.*

Roman Ruins in the Campagna Romana, *c. 1857*

Oil on canvas, 11⅜ x 17⅞ in.
(28.9 x 45.4 cm.)
Unsigned
Gift of Mrs. Helen Haseltine Plowden
62.5.2
Illustration: Figure 57

EXHIBITIONS: National Academy of Design, New York, *Memorial Exhibition: William Stanley Haseltine, N.A., 1835-1900,* cat. 49 ▪ *Works from the Permanent Collection,* 1972 ▪ *Selections from the Permanent Collection,* 1975, 1980 ▪ *The First Fifty Years 1934-1984: American Painting and Sculpture from the University Art Museum Collection,* 1984.

PROVENANCE: the artist; Mrs. Helen Haseltine Plowden

Like several American artists who traveled to Italy during the nineteenth century, Haseltine was drawn by its beautiful landscape, glorious past, agreeable climate, and affordable accommodations. While there he painted frequently in the *campagna romana*— Roman countryside—having first visited it on his initial trip to Rome in 1857. After settling there in 1869 he returned often on sketching trips.

Roman Ruins may have been painted during that first visit. It reveals Haseltine's considerable skill in rendering nature and was likely painted *en plein air*, as were many of his nature studies. Rocks and vegetation are executed in the clear, precise style for which he was acclaimed.

Roman Ruins in the Campagna Romana, *c. 1857 ▪ Figure 57*

CHARLES W. HAWTHORNE
1872-1930

SELECTED BIBLIOGRAPHY: Elizabeth McCausland, *Charles W. Hawthorne, An American Figure Painter* (New York: American Artists Group), 1947 • *Hawthorne Retrospective*, introduction by E.P. Richardson (Provincetown, Massachusetts: Chrysler Museum of Provincetown, 1961) • *The Paintings of Charles Hawthorne*, introduction by Marvin S. Sadik (Storrs, Connecticut: University of Connecticut Museum of Art, 1968) • *Charles Hawthorne (1872-1930)* (New York: Hirschl and Adler Galleries, Inc., 1972) • Michael Quick, Marvin Sadik, and William H. Gerdts, *American Portraiture in the Grand Manner* (Los Angeles, California: Los Angeles County Museum of Art, 1981), 75, 210 • Evan R. Firestone, "Color and Light: The Late Watercolors of Charles W. Hawthorne," *Arts* 57:9 (May 1983): 136-139.

Charles W. Hawthorne grew up in Richmond, Maine, where his father owned a merchant vessel. At age 18 he moved to New York to study at the Art Students League in the evenings while working during the days as a dockhand and in the Lamb stained-glass factory. In 1893 he studied with Vincent du Mond's evening class and in 1894-1895 at the Art Students League with George de Forest Bush and Siddons Mowbray. He first met William Merritt Chase at Shinnecock Summer School of Art in 1896 and subsequently helped him to organize his New York school, serving as his assistant in 1897.

During the summer of 1898 Hawthorne lived in Holland near Haarlem, studying the works of Frans Hals and painting villagers. The styles of both Chase and Hals influenced his work for several years, even after he founded his own Cape Cod School of Art in Provincetown, Massachusetts in 1899. Later, dissatisfied with the combination of impressionist color and John Singer Sargent's bravura brushwork, he taught his students to use a palette knife to achieve greater spontaneity.

When his realistic portrayals of Portuguese-American fisherfolk and old New England types shocked American critics, he gradually began depicting more acceptable New England matrons and children. Two years of study in Italy from 1905 to 1907 convinced him that Titian was the father of all painters and that modern paintings were "exhibition stunts." He began searching for more solid form and less painterly surfaces in his own work.

Hawthorne returned to America to win the Isidor gold medal in 1914-1915 and the Benjamin Altman prize at the National Academy of Design, of which he became an associate member at this time. He was elected an associé of the Société Nationale des Beaux-Arts in 1912 and a sociétaire in 1913. French critics wrote favorably about his work in the 1913 salon, but added that it was derivative of the old masters.

Following exhibitions in France, Hawthorne moved back to Provincetown, where he alternated portraits of wealthy society matrons with more spontaneous and sensitive portrayals of local characters and mother-and-child motifs. Toward the end of his life he also painted sensitive landscape studies and spontaneously executed watercolors of architectural views.

Hawthorne taught at the Cape Cod School of Art, the Art Students League, and the National Academy of Design. *M.T.S.*

Nellie, *1919*

Oil on canvas, 40½ x 40 in.
(102.2 x 101.6 cm.)
Unsigned
Bequest of Hudson Walker from the Ione and Hudson Walker Collection
78.21.94
Illustration: Colorplate XII

EXHIBITIONS: Provincetown Art Association, 1919, 1942, 1947 • Corcoran Gallery of Art, Washington, D.C., 1919 • Pennsylvania Academy of the Fine Arts, Philadelphia, 1920 • Ferargil Galleries, New York, 1921 • Milwaukee Art Institute, 1921 • Grand Central Galleries/Macbeth Galleries, New York, 1922 • Philadelphia Sesquicentennial Exhibition, 1926 • The Art Institute of Chicago, 1927 (one-man) • Carnegie Institute, Pittsburgh, 1928 (one-man) • City Art Museum, St. Louis, 1929 (one-man) • American Academy of Arts and Letters, New York, 1930-1931 • Walker Art Center, Minneapolis, 1946 • Grand Central Galleries, New York, 1947 (one-man) • American Artists Group, New York, *Charles W. Hawthorne 1872-1930*, 1947, cat. 25 • Provincetown Art Association, *Charles Hawthorne*, 1952, cat. 2 • Tweed

Hawthorne's studies of Dutch masters influenced this portrait of Nellie Barnes, a Provincetown character who owned a restaurant there from 1919 to 1932 and often fed local artists, asserting, "Damn it to hell, you don't need any money to eat in my place" ("Artist Painted Cape End People," *Provincetown Advocate*, 28 August 1952). She treated Hawthorne like a god, paying no attention to her other customers whenever he dropped in for lunch.

This portrait remained the favorite of critics. An unidentified newspaper clipping related one critic's appraisal of its worth in comparison to the majority of Hawthorne's portraits of society matrons: "It remained for Mr. Hawthorne to paint a serious portrait of Nellie Barnes of Provincetown. Now she is in a New York art gallery, surrounded by portraits of other women, delicate and fragile, done in the most delicate color tones, while she sits solidly complacent against her wonderful blue background, quite content, with that little-more-than-Mona-Lisa-smile" (McCausland, p. 69).

Gallery, University of Minnesota-Duluth, *A Survey of American Painting*, 1955 • *Selections from the Permanent Collection*, 1957 • Minnesota State Fair, St. Paul, *American Art of the Twentieth Century from the Collection of the University Gallery, University of Minnesota*, 1957 • *Selected Works from the Collection of Ione and Hudson Walker*, 1959 • The Chrysler Art Museum of Provincetown, *Hawthorne Retrospective*, 1961 • *Selections from the Permanent Collection*, 1962 • *100 Paintings, Drawings, and Prints from the Ione and Hudson D. Walker Collection*, 1965, cat. 51 • University of Connecticut Museum of Art, Storrs, Connecticut/Hirschl and Adler Gallery, New York, *The Paintings of Charles Hawthorne*, 1968, cat. 26 • *Selections from the Permanent Collection*, 1970 • St. John's University/College of St. Benedict, Collegeville, Minnesota, *University of Minnesota Art Exhibit*, 1971 • *Works from the Permanent Collection*, 1972 • Tweed Gallery, University of Minnesota-Duluth, *Charles Hawthorne: An Exhibition Commemorating the Centenary of the Artist's Birth*, 1972-1973 • *Selections from the Permanent Collection*, 1975 • *Hudson D. Walker: Patron and Friend*, 1977, cat. 41 • *Selections from the Permanent Collection*, 1980.

PROVENANCE: the artist; Marion C. (Mrs. Charles W.) Hawthorne; Joseph Hawthorne; Ione and Hudson Walker

JOHN E. HELIKER
1909-

SELECTED BIBLIOGRAPHY: C.E. Foeller, "A Discussion of the Work of John Heliker," *American Artist* (September 1955): 36-39 • Lloyd Goodrich and Patricia FitzGerald Mandel, *John Heliker* (New York: Whitney Museum of American Art, 1968) • Jed Perl, "John Heliker, Scenes from Memory," *American Artist* (April 1980): 44-49, 91-94 • Arline Meyer, "John Heliker," *Arts* 58:1 (September 1983): 22.

Images from the coast of Maine have inspired John Heliker since he was 16 and hopped an overnight steamer from New York to Bar Harbor. Born in Yonkers, Heliker returned to Maine intermittently from the mid-1920s on to finally settle near Penobscot Bay in 1958.

In January 1927 he joined the Art Students League to study with Kimon Nicolaides, whose emphasis on drawing influenced Heliker's later work. He also studied life drawing with Thomas Hart Benton and Boardman Robinson and painting with Kenneth Hayes Miller before leaving the League in 1929 to live and paint on his family farm in Stormville, New York. He returned to New York sporadically and began to incorporate pictures of street scenes and construction workers into his paintings. Moving up to Greenwich Village in 1938, he joined the WPA/FAP and submitted drawings to meet his monthly quota. Philip EVERGOOD, his supervisor on the easel project, became his mentor.

During the early 1940s Heliker lived and painted in the Vermont countryside. Critics and judges praised his work from this period as an honest transcription of the structure of Cézanne applied to American landscape. In 1948 he went to Naples to study on a Prix de Rome, where he shared a studio with Philip Guston; he returned to Italy again in 1951 on a Guggenheim Fellowship. While on one of his annual trips to Italy and Greece in the late 1950s, Heliker became homesick for the coast of Maine and returned to purchase an old sea captain's house near Mt. Desert. He continued to spend his summers there while teaching at Columbia University during the academic year.

Heliker never painted his coastal scenes directly from nature, but instead filtered compositions through memory and imagination before setting them down on canvas. Since the early 1970s he has painted abstract scenes of interiors and still lifes—compositions which, like those of his Maine landscape, have been based on rectilinear spatial divisions. *M.T.S.*

Isle au Haut, *1944*

Oil on canvas, 16⅛ x 20⅛ in. (41 x 51.1 cm.)
Signed lower right: Heliker 44
Bequest of Hudson Walker from the Ione and Hudson Walker Collection
78.21.287
Illustration: Figure 58

REFERENCES: Jo Gibbs, "John Heliker, in Latest Work, Forges Ahead," *Art Digest* (1 April 1945): 60.

EXHIBITIONS: Kraushaar Gallery, New York, *John Heliker*, 1945 • *Selections from the Collection of Mr. and Mrs. Hudson D. Walker*, 1950 • Drew Fine Arts Center, Hamline University, St. Paul, *Exhibition*, 1952 • *Selections from the Permanent Collection*, 1970 • St.John's University/ College of St. Benedict, Collegeville, Minnesota, *University of Minnesota Art Exhibit*, 1971 • *Selections from the Permanent Collection*, 1975 • *Hudson D. Walker: Patron and Friend*, 1977, cat. 42 • *Selections from the Permanent Collection*, 1980.

PROVENANCE: Ione and Hudson Walker

This work typifies Helikers's paintings from the mid-1940s, which usually feature configurations of striated rocks massed against grayed and cloudy skies. Heliker handled realistic elements like abstracted cubes, carefully arranging them in linear patterns. During this period his subtly colored structural shapes were particularly reminiscent of Cézanne.

Writing about this painting and another similar work at the Kraushaar Gallery in April of 1945, critic Jo Gibbs noted that "*Isle au Haut* and *Maine Coast* which in some ways puts one in mind of Hartley, catch the dramatic and ruggedly poetic spirit of the place" (Gibbs, p. 60).

Isle au Haut, 1944 • *Figure 58*

EUGENE HIGGINS
1874-1958

SELECTED BIBLIOGRAPHY: J.W. Lane, "Higgins: Dark Dramatist," *Art News* (1 March 1942): 32-33 • Milton W. Brown, *American Paintings from the Armory Show to the Depression* (Princeton, New Jersey: Princeton University Press, 1955), 28-30 • *Eugene Higgins* (New York: Hirschl and Adler Galleries, 1959) • William Innes Homer, *Alfred Stieglitz and the American Avant-Garde* (Boston: New York Graphic Society, 1977), 308.

The son of a stonecutter, Eugene Higgins was born in Kansas City, Missouri. He studied art at the Académie Julian and with Jean Paul Laurens and Jean Léon Gérôme at L'Ecole des Beaux-Arts in Paris from 1897 to 1904. Influenced by the French tradition of social satire, he used the peasants of Jean François Millet as models in his depictions of the urban poor. An entire issue of *Assiette au Beuvre* (9 January 1904), a militant journal of social satire in art, featured 16 of his drawings under the title *Les Pauvres*, which illustrated a poetic text by Jehan Rictus.

Higgins settled in New York in 1905, exhibiting at Alfred Stieglitz's gallery 291 and continuing to paint people living in the depths of poverty and despair; the monochromatic cast of his palette added to the feeling of depression. Although he initially drew from models, the figures in his latest canvases and prints were drawn from memory. Higgins became a member of the National Academy of Design in 1928 and won several prizes at its annual exhibitions, including the Benjamin Altman prize in 1931. *M.T.S.*

Night Shelter, *c. 1910*

Oil on canvas on board, 8 x 10 in.
(20.3 x 25.4 cm.)
Signed lower left: E. Higgins
Bequest of Hudson Walker from the Ione
and Hudson Walker Collection
78.21.105
Illustration: Figure 59

EXHIBITIONS: Tweed Museum of Art,
University of Minnesota-Duluth, *A Survey
of American Painting*, 1955 ▪ *Hudson D.
Walker: Patron and Friend*, 1977, cat. 43.

PROVENANCE: Ione and Hudson Walker

Although this painting is undated, it is possibly an early work, since Higgins's later paintings often portrayed idealized peasants against brooding skies and barren landscapes. *Night Shelter* is typical of earlier works which often over-dramatically showed slum derelicts shivering in the back alleys of cities. Milton Brown has compared Higgins's work from this period to that of Picasso's blue period, which reflected the ennui and poverty of Parisian city dwellers.

Night Shelter, *c. 1910* ▪ *Figure 59*

201

JOSEPH HIRSCH
1910-1981

SELECTED BIBLIOGRAPHY: *Joseph Hirsch* (Athens, Georgia: Georgia Museum of Art, 1970) ▪ *Joseph Hirsch, Recent Paintings* (New York: Kennedy Galleries, 1976) ▪ *Joseph Hirsch, Recent Paintings* (New York: Kennedy Galleries, 1978) ▪ *Joseph Hirsch, Recent Paintings and Drawings* (New York: Kennedy Galleries, 1980).

Joseph Hirsch's paintings have always been filled with scenes of men at work, celebrating the dignity of honest labor. The son of a Philadelphia physician, Hirsch began his studies at the Pennsylvania Museum School of Industrial Art on a four-year municipal scholarship. In 1932 he studied with George LUKS, whose painting technique influenced his facile brushstrokes and realistic descriptions of the common man. After winning a Wooley Fellowship for travel and study in Europe and the Orient in 1935, Hirsch returned to America to join the WPA/FAP in Pennsylvania in 1938. He painted murals for Benjamin Franklin High School in Philadelphia, for the Amalgamated Clothing Workers Building in 1939, and for the Philadelphia Municipal Court Building in 1940.

Serving as a war correspondent in 1942-1943, Hirsch documented activities of servicemen in England and Italy for the Army, and in the South Pacific for the Navy. He received Guggenheim Fellowships in 1942 and 1943 and a grant from the National Institute of Arts and Letters in 1947. A Fulbright Research Fellowship enabled him to study in France during 1949-1950. Hirsch was a member of the National Academy of Design and the National Institute of Arts and Letters. He has taught at the School of the Art Institute of Chicago, the Art Students League, the New York School for Art Studies, and the American Art School in New York.

The figure has remained the major motif in his canvases. At work or at rest, figures with trade tools pose singly or in groups in paintings completed through the early 1960s, after which their environments and actions become more ambiguous. Hirsch's paintings continue to be subtly judgmental, either criticizing governmental policies or satirizing educational or institutional systems. *M.T.S.*

Lobsterman, *1943*

Oil on canvas, 39⅜ x 19⅜ in. (100 x 49.2 cm.)
Signed lower right: Joseph Hirsch
Bequest of Hudson Walker from the Ione and Hudson Walker Collection
78.21.229
Illustration: Figure 60

Lobsterman was painted in Provincetown while Hirsch was working under a Guggenheim Fellowship. The brawny figure is typical of the artist's carefully designed portrayals of men at work from the 1940s. Appearing almost monumental, these figures are brushed in closely hued, saturated colors.

REFERENCES: Letter from Joseph Hirsch to Mark R. Kriss at the University Gallery, 11 November 1978.

EXHIBITIONS: Gallerie Georges Giroux, Brussels, *Exposition d'Art Americain Contemporain*, 1948, cat. 45 • Drew Fine Arts Center, Hamline University, St. Paul, *Exhibition of Paintings by Some American Individualists*, 1950 • *Selections from the Collection of Mr. and Mrs. Hudson D. Walker*, 1950 • *Selections from the Permanent Collection*, 1957 • Temple of Aaron, St. Paul, *Dedication Art Exhibit*, 1957 • Minnesota State Fair, St.Paul, *American Art of the Twentieth Century from the Collection of the University Gallery, University of Minnesota*, 1957 • *Selected Works from the Collection of Ione and Hudson Walker*, 1959 • *Art and the University of Minnesota*, 1961 • *100 Paintings, Drawings, and Prints from the Ione and Hudson D. Walker Collection*, 1965, cat. 54 • Forum Gallery, New York, *Joseph Hirsch*, 1967 • *Hudson D. Walker: Patron and Friend*, 1977, cat. 44.

PROVENANCE: Associated American Artists Galleries, New York; Ione and Hudson Walker

Lobsterman, *1943 • Figure 60*

203

MARGO HOFF

1912-

SELECTED BIBLIOGRAPHY: "Margo Hoff," *Art in America* (February 1955): 36-38 • "Margo Hoff," *Arts* (April 1968): 65.

Motifs from her native state of Oklahoma continued to fascinate Margo Hoff long after she moved to Chicago in 1945. She studied art at Tulsa University and the Art Institute of Chicago and gradually turned to subjects from her new Windy City environment: children, motorcycles, cloud formations, and neighborhood streets. Her wide interests within the arts have led her to mural commissions from the Mayo Clinic in Rochester Minnesota and the Home Federal Bank in Chicago, set designs for the Shadowlight Theatre in New York, and both set and costume designs for the Murray Louis Dance Troupe. Hoff has traveled extensively—always with a sketchbook—and produced images around the world for book illustrations, paintings, and collages. *M.T.S.*

Burnt Landscape, *c. 1945*

Oil and casein on panel, 19⅞ x 24 in. (50.5 x 61 cm.)
Signed lower right: M. Hoff
Gift of the artist
47.34
Illustration: Appendix

REFERENCES: Letter from Margo Hoff to Mark R. Kriss at the University Gallery, 12 November 1978.

EXHIBITIONS: *13 Chicago Artists*, 1947 • Drew Fine Arts Center, Hamline University, St. Paul, *Exhibition of Paintings by Some American Individualists*, 1950 • Tweed Hall, University of Minnesota-Duluth, *Exhibition*, 1951 • Minnesota State Fair, St. Paul, *American Art of the Twentieth Century from the Collection of the University Gallery, University of Minnesota*, 1957 • *Selections from the Permanent Collection*, 1957 • *Art and the University of Minnesota*, 1961.

PROVENANCE: the artist

Hoff wrote that the source of *Burnt Landscape* was "a sketch done on a train traveling through Oklahoma. It was late, hot summer when the land and vegetation were parched. Bonfires were set to burn paths and areas that needed protection against larger fires" (Hoff to Kriss, 12 November 1978). It is possible that the sketch was done when she was commissioned by the Container Corporation to do a series of pictures of several states to be used as ads in *Fortune*, *Time*, and *Life* magazines during the mid-1940s.

EDWIN HOLM
1911-

SELECTED BIBLIOGRAPHY: Elizabeth McCausland Papers, Archives of American Art, Smithsonian Institution, Washington, D.C., #371 • Minneapolis History Collection, Minneapolis Public Library.

Born in Jackson, Minnesota, Edwin Holm studied with Dewey ALBINSON and Cameron BOOTH at the St. Paul School of Art from 1927 to 1932. During the 1930s he participated in the WPA/FAP art project in Minneapolis. He had a one-man show at Walker Art Center in 1940 and was one of the participants in the Walker's exhibition, *Trends in Contemporary Painting—Seven Paintings by Seven Minnesota Artists* that same year.

While Holm's work was probably influenced by Salvador Dali and Giorgio de Chirico in its combination of surrealistic technique and neo-romantic subject matter, it was possibly also influenced by the painting of Cameron Booth during the late 1920s and early 1930s. Booth used basic geometric shapes to describe buildings and often placed them in front of a flatly textured backdrop. *M.T.S.*

Oil on canvas, 18 x 24 in.
(45.7 x 61.0 cm.)
Unsigned
WPA Art Project, Minneapolis
43.705
Illustration: Appendix

PROVENANCE: WPA Art Project, Minneapolis

Forgotten City, *c. 1937*

Oil on canvas, 36¼ x 30 in.
(92.1 x 76.2 cm.)
Unsigned
WPA Art Project, Minneapolis
43.704
Illustration: Appendix

PROVENANCE: WPA Art Project, Minneapolis

The Dancer, *c. 1938*

Oil on canvas, 20¼ x 24¼ in.
(51.4 x 61.6 cm.)
Signed lower left: E. Holm '38
WPA Art Project, Minneapolis
43.706
Illustration: Appendix

PROVENANCE: WPA Art Project, Minneapolis

Desolation, *1938*

Oil on canvas, 28 x 19¾ in.
(71.1 x 50.2 cm.)
Signed lower right: E. Holm '38
WPA Art Project, Minneapolis
43.702
Illustration: Appendix

PROVENANCE: WPA Art Project, Minneapolis

Mirage, *1938*

Oil on canvas, 36 x 30¼ in.
(91.4 x 76.8 cm.)
Unsigned
WPA Art Project, Minneapolis
43.701
Illustration: Appendix

PROVENANCE: WPA Art Project, Minneapolis

Melancholia, *c. 1939*

Oil on canvas, 24 x 30¼ in.
(61 x 76.8 cm.)
Unsigned
WPA Art Project, Minneapolis
43.707
Illustration: Appendix

PROVENANCE: WPA Art Project, Minneapolis

Reflections, *c. 1939*

Oil on canvas, 30¼ x 40 in.
(76.8 x 101.6 cm.)
Unsigned
WPA Art Project, Minneapolis
43.703
Illustration: Figure 61

EXHIBITIONS: New York World's Fair,
Queens, *Contemporary Arts Project*, 1940 •
*Original Paintings in the University
Collection*, 1946, cat. 84.

PROVENANCE: WPA Art Project, Minneapolis

Fantasy, *c. 1939*

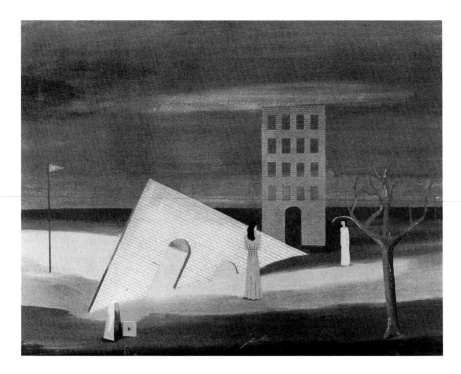

Fantasy, *c. 1939* • *Figure 61*

206

HENRY G. HOLMSTROM
1900-1981

SELECTED BIBLIOGRAPHY: "How Henry Holmstrom Learned to Paint While Hungry, and How an Accident Won a Prize for His Discarded Painting," *Minneapolis Journal*, c. 1928 (Minneapolis History Collection, Minneapolis Public Library) • Files on Swedish-American artists, The American Swedish Institute, Minneapolis • Henry Holmstrom, interview with Kristen Anderson, John Lofgren, and Mary Swanson (5 June 1980).

Minnesota's people and landscapes are the content of Henry Holmstrom's paintings. He emigrated from Sweden to Chicago at age 15, lived for a few years in Waseca, Minnesota, and finally settled in Minneapolis, where he attended the Minneapolis School of Art from 1924 to 1927 on scholarship. He studied with Cameron BOOTH and Anthony Angerola while he supported himself by working as a janitor at the Minneapolis Institute of Arts and the school. He then went on to study at the Art Institute of Chicago along with his friend and fellow Minnesotan, Elof WEDIN.

Holmstrom began showing his landscapes in local exhibitions in the late 1920s and had his first one-man exhibition in Mabel Ulrich's Bookshop (Minneapolis) in 1928. In the fall of 1927 he submitted a painting to the Thirteenth Annual Exhibition of Minneapolis and St. Paul Artists. The jury rejected the painting and then noticed one on the back, *Peasant Dance*; they voted to accept that canvas instead and awarded it second prize.

During the early 1930s Holmstrom directed the Municipal Sketch Club, operated under the Minneapolis Park Board. He also worked on the WPA/FAP mural and easel projects, designing and executing murals for the Marshall and Hopkins post offices. In the early 1940s he left for San Francisco and a pattern-making job in the shipping industry. He continued to paint when he returned to Minneapolis in 1944, submitting works to local exhibitions. Although the content of his canvases remained the same as the landscapes and portraits he completed early in his career, his technique gradually became looser and more facile while his painting application alternated between thick impastos of bright color and thinly applied swatches of pastel hues. *M.T.S.*

Near the Elevator, *c. 1938*

Oil on canvas, 30 x 36 in.
76.2 x 91.5 cm.
Signed lower right: H. Holmstrom
WPA Art Project, Minneapolis
43.761
Illustration: Appendix

PROVENANCE: WPA Art Project, Minneapolis

A romantic realist, Holmstrom believed that the artist had to hurry in order to capture the essence of a scene. He once remarked, "If you start to slow down you lose something. If you work fast and stop early enough you might have a chance" (Henry Holmstrom, interview with Kristen Anderson, John Lofgren, and Mary Swanson). In this canvas the fluidly applied paint was obviously brushed on quickly.

Old Farmyard, *c. 1938*

Oil on canvas, 30 x 36 in.
(76.2 x 91.5 cm.)
Signed verso: H. Holmstrom
WPA Art Project, Minneapolis
43.764
Illustration: Appendix

EXHIBITION: Walker Art Center,
Minneapolis, *Modern Painting in
Minnesota*, 1949.

PROVENANCE: WPA Art Project, Minneapolis

Holmstrom said that he painted this barn because it was one of the oldest in Minnesota. He imbued it with a feeling of darkness because this was one of the darkest periods in the midst of the Depression.

CARL ROBERT HOLTY
1900-1973

SELECTED BIBLIOGRAPHY: John I.H. Baur,
*Revolution and Tradition in Modern
American Art* (New York: Praeger, 1951),
p. 70 • Dore Ashton, *The New York School*
(New York: Viking Press, 1972), pp. 13,
35, 64, 75, 76, 101, 146, 168, and 184 •
Patricia Caplan, *Carl Holty: Fifty Years*
(New York: City University of New York,
1972) • Lawrence Campbell, "Carl Holty:
An Independent Course," *Art News* (May
1973): 30 • Romare Bearden, "A Painter in
the Fifties," *Arts* (April 1974): 36-37 •
Virginia Pitts Rembert, "Carl Holty," *Arts*
55:4 (December 1980): 11 • Romare
Bearden and Carl Holty, *The Painter's
Mind: A Study of the Relations of Structure
and Space in Painting* (New York: Garland
Publishing, Inc., 1981).

A devotee of abstraction since the early 1930s, Carl Holty was influenced by his close friends Piet Mondrian and Hans Hofmann before turning to the more painterly and lyrical style characteristic of his mature years. He was an original member of the American Abstract Artists, established in 1936 to promote recognition of abstract art in the United States. He served as its secretary in 1937 and in the following year assisted editor Balcomb Greene in the production of an ambitious yearbook, *American Abstract Artists 1938*.

Born in Germany, Holty was brought to Milwaukee as an infant. He studied at the Art Institute of Chicago, the National Academy of Design, and with Andre L'Hôte in Paris and Hans Hofmann in Germany. In Europe from 1925 to 1934, he became a member of the Paris Abstraction-Creation group in 1932. This prepared him for his political role in the American Abstract Artists and familiarized him with the abstract ideals of the so-called School of Paris, the group of American artists who worked abroad in the years between the two World Wars and were influenced by ideas of European modernism prevalent in Paris. Upon returning to the United States Holty settled in New York, where he exhibited widely and taught at Brooklyn College and the Art Students League. He also served as artist-in-residence at several American universities and coauthored a book with Romare Bearden, *The Painter's Mind*, published in 1981. *P.N.*

Boy and Dog, *1952*

Oil on canvas, 55 x 43⅞ in.
(139.7 x 111.4 cm.)
Signed verso: Carl Holty Boy and Dog,
1952
Gift of Mr. Lewis Galantiere in Memory of
Nancy Galantiere 73.17.1
Illustration: Figure 62

PROVENANCE: Lewis Galantiere

Holty's artistic career is marked by a progressive softening of his style. His Miró-influenced abstractions of the 1930s had, by the late 1950s, metamorphosed into decorative, cloud-shaped areas of thinly painted colors floating across the surface of his paintings. One of the first artists to suffuse the entire field of his canvas with abstract areas of even color, Holty has been acclaimed as the precursor of color field painting.

Although the imagery in Holty's paintings became increasingly vague, the figures in *Boy and Dog* are still discernible within the pattern of small rectangular spots of color, a compositional device partly inspired by the artist's interest in ancient mosaics.

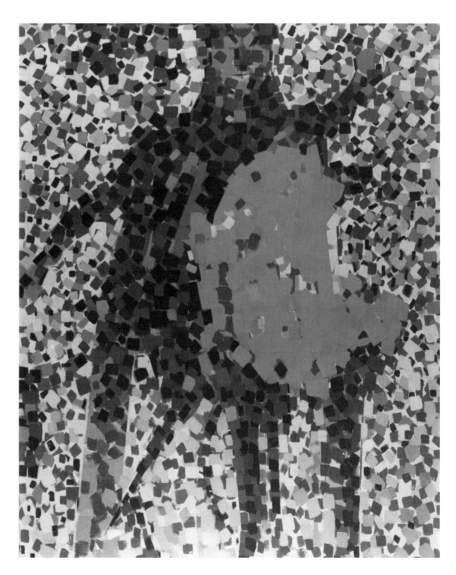

Boy and Dog, *1952 • Figure 62*

Evening, *1957*

Oil on canvas on board, 12 x 9 in.
(30.5 x 22.9 cm.)
Signed lower left: Holty 57
Gift of Mr. Lewis Galantiere through the
American Federation of Arts
73.17.2
Illustration: Appendix

PROVENANCE: Lewis Galantiere

Less literal than *Boy and Dog, Evening* evokes a reflective mood using forms suggesting clouds, sky, and sunset reflections on water which float across the surface of the canvas. The abstract massing of soft-edged areas of color is reminiscent of contemporaneous works by Mark Rothko, but the intimate scale and opacity of color distinguish this from other color field paintings.

THORVALD ARENST HOYER
1872-1949

SELECTED BIBLIOGRAPHY: *Chicago Art
Institute Scrapbook* 85 (Chicago: The Art
Institute of Chicago, Ryerson and Burnham
Libraries, 1950), 180 ▪ Mary T. Swanson,
*The Divided Heart: Scandinavian
Immigrant Artists, 1850-1950*
(Minneapolis: University of Minnesota
Gallery, 1982), 22-23.

Thorvald Arenst Hoyer divided his career between painting and acrobatics. Born in Denmark in 1872, he organized a strongman act which toured the major European capitals. While on tour he was able to visit art museums and use his hotel rooms as studios. He retired after 25 years to settle in Chicago and paint full time.

Hoyer first exhibited his work at the Grant Park Art Fair in 1933. In 1937 he showed paintings at the Theobold Gallery (Chicago), and in 1938 he was included in the Museum of Modern Art exhibition, *Masters of Popular Painting*. He was part of the WPA/ FAP easel project in the late 1930s. *M.T.S.*

Grazing Field, *1937*

Oil on canvas, 30 x 24 in.
(76.2 x 61 cm.)
Signed lower right: T.A. Hoyer 1937
WPA Art Project, Chicago
43.729
Illustration: Figure 63

EXHIBITIONS: *Original Paintings from the
University Collection,* 1946, cat. 87 ▪ Tweed
Gallery, University of Minnesota-Duluth, *A
Survey of American Painting,* 1955 ▪ *The
Divided Heart: Scandinavian Immigrant
Artists, 1850-1950,* 1982, cat. 28.

PROVENANCE: WPA Art Project, Chicago

Hoyer was a primitive painter whose meticulously detailed work was created on a very small scale; for this reason he was often compared to Grandma Moses. Here the field, houses, and sky are flatly patterned in subtle pastels. Hoyer's works were once described as "gentle passages of imagination, fit to illustrate the most delicate fairy tale" (*Chicago Art Institute Scrapbook,* p. 189).

Grazing Field, *1937* ▪ *Figure 63*

ALICE HUGY
1874-1971

SELECTED BIBLIOGRAPHY: Minneapolis History Collection, Minneapolis Public Library • Minnesota Historical Society Archives, file P512.

Born in Switzerland, Alice Hugy immigrated to St. Paul with her uncle, René Vilatte, and his family in 1882. Although she never finished grade school, she drew and painted from early childhood and entered St. Paul's first art class in the attic of the Old Metropolitan Building in 1893. By the end of the year she had been hired by the L. Banning agency, the first advertising agency in St. Paul, where she created trademarks, designed packaging, and illustrated brochures. She also did sketches of the Gibson Girl and the "Bunny Girl" at the turn of the century to sell to area magazines and newspapers.

Along with the sculptor Paul Manship and the painter Clem Haupers, Hugy formed a part of the St. Paul artists colony. During the 1920s and 1930s she taught classes in landscape painting, using parks, street corners, and cul de sacs throughout St. Paul as subject matter. She also painted scenes of crowds at the Minnesota State Fair, which she entered in both the 1937 and 1938 Local Artists Exhibitions at the Minneapolis Institute of Arts.

Hugy continued to paint scenes of her adopted city throughout the 1940s and 1950s and also helped to start the first St. Paul Gallery and School of Art. In 1967, at the age of 93, she showed her paintings and drawings in a retrospective exhibition at the Minnesota Historical Society. *M.T.S*

Tiger Lilies, *c. 1933*

Oil on canvas, 30 x 21¾ in.
(76.3 x 55.2 cm.)
Signed lower left: Alice Hugy
WPA Art Project, Minneapolis
43.750
Illustration: Appendix

PROVENANCE: WPA Art Project, Minneapolis

Hugy painted this flower piece as part of her WPA/FAP project allotment in the early 1930s. While this was not considered unusual subject matter in American painting during this period, it was somewhat atypical for Hugy, who most often painted scenes of St. Paul's parks and picturesque streets.

MIRIAM IBLING
1895-

SELECTED BIBLIOGRAPHY: Miriam Ibling, interview with George Reid at the University Gallery (23 September 1977) • Letter from Miriam Ibling to Mark R. Kriss at the University Gallery (17 November 1978) • Minneapolis History Collection, Minneapolis Public Library.

Miriam Ibling, who was born in Parkersburg, Iowa, lived in the Midwest for over 40 years, actively producing murals and landscape paintings before moving East for further study and then to California to retire. A graduate of Sioux Falls Baptist College, she studied under Cameron BOOTH and Vaclav Vitlacyl at the Minneapolis School of Art. After a year at the University of Minnesota she joined a group of advanced students to form the Art League of Minneapolis under the guidance of Edmund Kinzinger, a painter from Munich.

From 1933 to 1934 Ibling was employed by the PWAP in Minneapolis. While working on the WPA/FAP from 1935 to 1942 she completed five murals in Minnesota. The first, done for Stillwater High School, was painted in fresco secco and portrayed the history of Stillwater and education, using symbols for science, literature, and the fine arts. In 1940 she painted a mural for Galtier School in St. Paul illustrating the history of music in America. She also painted scenes from *Alice in Wonderland* for the Children's Hospital (later known as the Sister Kenny Hospital); a mural in the USO building in St. Paul; and a casein mural for the library at the State School for Dependent Children in Owatonna.

Ibling had her first one-woman exhibition at the Harriet Hanley Gallery (Minneapolis) in 1935, showing 16 paintings of the landscape in the Green Lake-Spicer area. She also participated in the annual Local Artists Exhibitions at the Minneapolis Institute of Arts. Her watercolor, *Moonlight in the Minnesota River Valley*, was purchased for the permanent collection of the Phillips Gallery (Washington, D.C.) Among other institutions, she has shown her oils and watercolors at the Museum of Modern Art, the San Francico Art Museum, and Walker Art Center in Minneapolis. *M.T.S.*

Both of these paintings were added to the University Art Museum collection under the WPA/FAP program. When interviewed, Ibling did not recall any discrimination toward women working on the projects in Minnesota, adding, "I can think of a good many women who worked on the project and if they didn't work on that there were women artists in Minneapolis and St. Paul, lots of them and very good ones" (Miriam Ibling, interview with George Reid).

The Park, *1939*

Oil on canvas, 24 x 30 inl.
(61 x 76.2 cm.)
Signed lower right: Miriam Ibling '39
WPA Art Project, Minneapolis
43.778
Illustration: Appendix
PROVENANCE: WPA Art Project, Minneapolis

Still Life with White Objects, *1939*

Oil on canvas, 35⅞ x 30 in.
(91.1 x 76.2 cm.)
Signed lower left: Miriam Ibling '39
WPA Art Project, Minneapolis
43.78
Illustration: Appendix
PROVENANCE: WPA Art Project, Minneapolis

GEORGE INNESS
1825-1894

SELECTED BIBLIOGRAPHY: George Inness, Jr., *Life, Art, and Letters of George Inness* (New York: The Century Co., 1917) ▪ Leroy Ireland, *The Works of George Inness, An Illustrated Catalogue Raisonné* (Austin: University of Texas Press, 1965) ▪ Nicolai Cikovsky, Jr., *George Inness* (New York: Praeger, 1971) ▪ Alfred Werner, *Inness Landscapes* (New York: Watson-Guptill Publications, 1973) ▪ Nicolai Cikovsky, Jr., *The Life and Work of George Inness* (New York: Garland Publishing, Inc., 1977) ▪ Marjorie Dakin Arkelian and George W. Neubert, *George Inness Landscapes: His Signature Years 1884-1894* (Oakland, California: Oakland Museum, 1978).

George Inness was a visionary among his contemporaries. His art invites the viewer into a dreamlike world based upon a profound study of nature interpreted in a completely personal way. Indeed, his work can be seen as the culmination of a longstanding philosophical battle in American art between the objective and the subjective, the real and the ideal. Inness devoted considerable thought to this problem, concluding that "knowledge must bow to spirit". Thus declaring for the primacy of poetry over prose and of vision over fact, he nevertheless insisted that his art was irrevocably based on a "universal principle of truth" (Peter Bermingham, *American Art in a Barbizon Mood* [Washington, D.C.: Smithsonian Institution Press, 1975], p. 150).

Inness was born on a farm near Newburgh, New York but grew up in New York City and New Jersey. At age 16 he was apprenticed to a company of map engravers. From the beginning, though, his interest lay in painting. He exhibited for the first time in 1844 at the National Academy of Design and showed there regularly for the next 50 years. In 1845 he exhibited at the American Art Union and also studied briefly with Regis F. Gignoux, a French painter living in America. Starting in the 1840s he made several trips to Europe

where he was most profoundly influenced by the landscapes of Jean Baptiste Camille Corot and the Barbizon painters. Elected a National Academician in 1868, he spent his working life in New York City, at Medfield, Massachusetts, and at Eaglewood, New Jersey. He died suddenly on a trip to Scotland. *R.N.C.*

Moonlight, *1885*

Moonlight is typical of the amorphous dream which can perhaps be traced to the first stirrings of romanticism in America at the beginning of the nineteenth century. In a theme Inness turned to more than once, a solitary woman is seen strolling through a shadowy forest. As insubstantial as the trees and shrubs around her, she seems to glide through the scene as though the force of gravity had no effect in this mysterious place. In the distance a lake glimmers with the moon's pale reflection, silhouetting the thin tree trunks and their wispy leaves. Nothing is precisely defined in this hushed world of delicate forms and muted tones. The effect is intensely personal, evoking a private world of silent revery.

Oil on canvas on wood panel, 14 x 16 in. (35.6 x 40.6 cm.)
Signed lower left: G. Inness 1885
Gift of Ione and Hudson Walker (by exchange)
69.18
Illustration: Figure 64

EXHIBITIONS: *Selections from the Permanent Collection*, 1970 • The Norman MacKenzie Art Gallery, University of Saskatchewan, Regina, *In Search of America: 19th-Century Painters and Writers*, 1971 • *Selections from the Permanent Collection*, 1975 • The Minneapolis Institute of Arts, *American Arts: A Celebration*, 1976 • *Selections from the Permanent Collection*, 1980.

PROVENANCE: Mrs. George C. Cannon, Fifth Avenue Art Galleries, New York; Babcock Gallery, New York

Moonlight, *1885* • *Figure 64*

PAUL JENKINS

1923-

SELECTED BIBLIOGRAPHY: Kenneth B. Sawyer, Pierre Restany, and James Fitzsimmons, *The Paintings of Paul Jenkins* (Paris: Editions Two Cities, 1961) ▪ Lee Nordness and Allen S. Weller, editors, *Art USA Now* (New York: Viking Press, 1962), 2:384-387 ▪ Jean Cassou, *Jenkins* (Paris: Editions de la Galerie Karl Flinker, 1963) ▪ George P. Elliot, *Lascaux and Jenkins, Fourteen Poems* (Lanthem, Maryland: Goosetree Press, 1964) ▪ Marshall Matusow, *The Art Collectors Almanac, No. 1, 1965* (Huntington, Long Island: Jerome E. Treisman, 1965), 276 ▪ *2e Salon International de Galeries Pilotes Lausanne* (Lausanne: Musée Cantonal des Beaux-Arts, 1966), 133, 140 ▪ Albert Elsen, *Paul Jenkins* (New York: Harry N. Abrams, 1973).

Born in Kansas City, Missouri, Paul Jenkins served as an Air Corpsman in the Naval Reserve during World War II before turning to a career in art. He studied at the Art Students League in New York from 1948 to 1952, toured Europe in 1953, and settled in Paris, where he held his first one-man exhibition at the Studio Paul Facchetti. He quickly won recognition in his native America following solo exhibitions at the Zoe Dusanne Gallery (Seattle) in 1955 and the Martha Jackson Gallery (New York) in 1956. In 1957 he participated in the Young America exhibition sponsored by the Whitney Museum, and in 1958 he took part in both the Corcoran Biennial (Washington, D.C.) and the Carnegie Institute's International Exhibition of Contemporary American Painting and Sculpture (Pittsburgh). In 1961 he again appeared in the Whitney Museum and Carnegie International shows.

Throughout this period Jenkins also remained a constant presence on the international art scene, holding one-man shows at the Galerie Stadler (Paris) in 1957, Arthur Tooth and Sons (London) in 1958 and 1960, Gallerie Toninelli (Milan) in 1962, and the Galerie Eva de Buren (Stockholm) in 1963. In 1964 he produced a film, *The Ivory Kite: Paul Jenkins*, in collaboration with the Martha Jackson Gallery; it subsequently won an award at the prestigious Venice Biennale. This was followed by a play, *Strike the Puma*, written in 1966. In that same year he received a silver medal at the Corcoran Gallery of Art's Thirteenth Biennial. He had his first retrospective showing at the Museum of Fine Arts (Houston) in 1971. Since the early 1970s, Jenkins has divided his work and his time between New York and Paris. *R.L.G.*

Eye of the Dove—Yellow Ting, *1959*

Oil on canvas, 30 x 40 in.
(76.2 x 101.6 cm.)
Signed lower right: Paul Jenkins
Gift of Mr. and Mrs. Julius E. Davis
84.12
Illustration: Figure 65

EXHIBITION: *The First Fifty Years, 1934-1984: Recent Acquisitions and Promised Gifts to the University Art Museum, 1984.*

PROVENANCE: Mr. and Mrs. Julius E. Davis

Jenkins employs a fluid, loose oil wash across the surface of this canvas to create an amorphous space. The colors weave and blend into one another, forming layers and depths of pigment that constantly shift as one's eye moves across the picture. This play of perspective is counteracted by the brilliant swatch of yellow paint—the "yellow ting" of the title. As the most solid area of pigment, and the most brilliantly colored, it creates a strong focal point that captures our attention as it strikes a vibrant note.

Eye of the Dove—Yellow Ting, *1959* • *Figure 65*

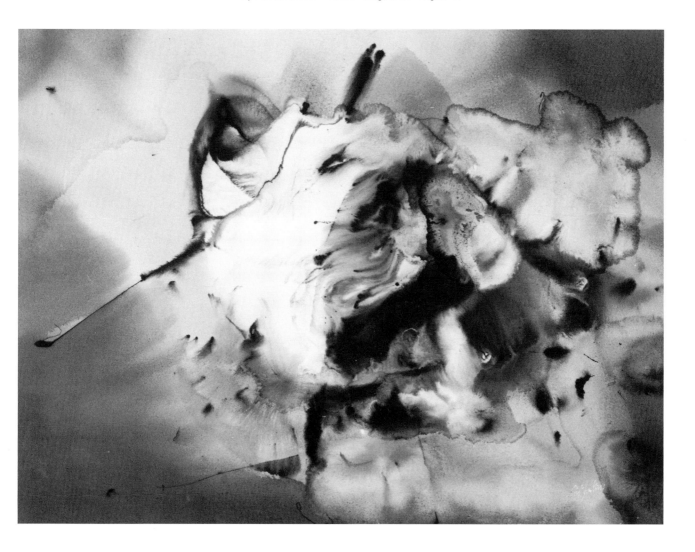

DAVID JOHNSON
1827-1908

SELECTED BIBLIOGRAPHY: Wolfgang Born, *American Landscape Painting, An Interpretation* (New Haven, Connecticut: Yale University Press, 1948), 59, 65, 100, 218 • George C. Groce and David H. Wallace, *The New York Historical Society's Dictionary of Artists in America, 1564-1860* (New Haven, Connecticut: Yale University Press, 1966), 353 • William H. Gerdts, *Revealed Masters, 19th-Century American Art* (New York: The American Federation of Arts, 1974), 88 142 • John I.H. Baur, "'…the exact brushwork of Mr. David Johnson,' An American Landscape Painter, 1827-1908," *The American Art Journal* (Autumn 1980): 32-65.

Often called "the American Rousseau," David Johnson is typical of the many artists who combined the literal and the poetic to portray the American scene during the second half of the nineteenth century. Something of a recluse, particularly during the final decades of his life, he was content to stay close to his home in New York City, where he had been born. Though he admired the works of the European masters, he never went abroad to study, and in fact sketching trips into New England and upstate New York were the sum of his travels. His only formal training consisted of a few lessons in 1852 with the American landscapist Jasper F. Cropsey.

Johnson was elected to the National Academy of Design in 1861 and was a medal winner at the Centennial Exposition of 1876 in Philadelphia and at the Massachusetts Charitable Mechanic Association of 1878 in Boston. His painting, *Housatonic River*, was exhibited in the Paris Salon of 1877, where it drew admiring notices from the French press—possibly because of its connections to the French Barbizon style. *R.N.C.*

West Cornwall, Connecticut, *1875*

Oil on canvas, 18 x 26⅛ in.
(45.3 x 66.3 cm.)
Signed lower left: D. 75
Purchase, Special Projects Program and Archie B. and Bertha H. Walker, 1968
69.13
Illustration: Figure 66

REFERENCES: John I.H. Baur, "'…the exact brushwork of Mr. David Johnson,' An American Landscape Painter, 1827-1908," *The American Art Journal* (Autumn 1980): 57, 59.

Here the artist gives us a glimpse of rural America a decade after the Civil War—the peaceful countryside celebrated in contemporary literature by Walt Whitman, John Greenleaf Whittier, and Mark Twain. The beautifully realized rock formation, rising abruptly from the river, is an example of Johnson's skillful draftsmanship and sensitive observation of nature. The overhanging cliff with its cover of pines conveys an atmosphere of cool, refreshing shade. The river, reflecting a cloudless sky, is a source of lazy pleasure for the little fisherman on its banks and the waders on the far shore.

EXHIBITIONS: *Selections from the Permanent Collection*, 1969, 1970 ▪ St. John's University/College of St. Benedict, Collegeville, Minnesota, *University of Minnesota Art Exhibit*, 1971 ▪ *Works from the Permanent Collection*, 1972 ▪ *Selections from the Permanent Collection*, 1975 ▪ The Minneapolis Institute of Arts, *American Arts: A Celebration*, 1976 ▪ Gallery 101, University of Wisconsin, River Falls, *The American Progression: The 1830s to the 1950s*, 1978 ▪ *Selections from the Permanent Collection*, 1980 ▪ *The First Fifty Years 1934-1984: American Paintings and Sculpture from the University Art Museum Collection*, 1984.

PROVENANCE: Hirschl and Adler Galleries, New York

West Cornwall, Connecticut, *1875* ▪ *Figure 66*

EASTMAN JOHNSON
1824-1906

SELECTED BIBLIOGRAPHY: John I.H. Baur, *Eastman Johnson, 1824-1906, An American Genre Painter* (Brooklyn: Institute of Arts and Science, 1940) ▪ Kenneth Ames, "Eastman Johnson: The Failure of a Successful Artist," *Art Journal* (Winter 1969-70): 174-183 ▪ Patricia Hills, *Eastman Johnson* (New York: Whitney Museum of American Art, 1972) ▪ Patricia Hills, *The Genre Painting of Eastman Johnson* (New York: Garland Publishing, Inc., 1977) ▪

Well known during his day as a painter of portraits and genre subjects, Eastman Johnson was born in Lovell, Maine. By age 18 he had already decided to become a portrait painter and (perhaps because of his father's position as Maine's Secretary of State) was receiving many commissions. He worked in Washington around 1845 and for several years afterward in Boston. From 1849 to 1851 he studied at the Düsseldorf Academy but apparently became dissatisfied with the course of instruction there. Criticizing the school for what he believed to be its deficiencies, especially in color, he traveled first to Holland and then to Paris to broaden his artistic horizons.

219

Michael Quick, Marvin Sadik, and William H. Gerdts, *American Portraiture in the Grand Manner: 1720-1920* (Los Angeles: Los Angeles County Museum of Art, 1981), 180 • Patricia Condon Johnston, *Eastman Johnson's Lake Superior Indians* (Afton, Minnesota: Johnston Publishing, Inc., 1983).

Oil on canvas, 30⅛ x 25 in. (76.5 x 63.5 cm.)
Unsigned
Gift of Charles P. Kimball
69.31
Illustration: Figure 67

PROVENANCE: Charles P. Kimball; University of Minnesota Archives

After returning to the States in October of 1855, he resided briefly in Washington, D.C. before making his first trip to the Duluth (Minnesota)-Superior (Wisconsin) area in the summer of 1856 to visit his sister and brother. He returned there the following year to sketch the Chippewa Indians in their native environment. It seems likely that his interest in the "noble savage" was strengthened by his friendship with Henry Wadsworth Longfellow and his admiration for the poet's recently published *Tales of Hiawatha*.

Johnson settled in New York in 1859 and in 1860 was elected a National Academician. During the 1860s he sought subjects in his native Maine and in Indian settlements in the Catskills and Murray Bay, Canada. From 1870 to 1887 he spent summers on Nantucket Island painting the local inhabitants. Afterward he concentrated almost exclusively on portraits, for which he was continually in demand. *R.N.C.*

William Moody Kimball, *c. 1857*

Although this portrait of William Moody Kimball is unsigned, family tradition ascribes it to Johnson, who was Kimball's nephew. This seems reasonable, since both Johnson and Kimball were in Minnesota in 1857—Johnson painting and sketching the Chippewa Indians of Grand Portage, Kimball having recently arrived from the East. Johnson's sister, her husband, and other Superior residents were sitting for Johnson at around that time, and these family connections may well have led to a commission from Kimball.

Kimball was born in Canterbury, New Hampshire in 1808. In 1832 he married Lucy Jane Johnson, sister of Eastman Johnson's father. From 1846 to 1857 Kimball lived in Lawrence, Massachusetts and prospered as the builder and owner of factories and mills. In 1857 he moved to the pioneer town of St. Anthony, Minnesota, which was later absorbed by the growing city of Minneapolis. Kimball quickly achieved prominence in the new state, serving as one of the first regents of the University of Minnesota from 1860 to 1864. In 1862 he also served as quartermaster for General Henry H. Sibley's expedition against the Sioux.

Kimball's portrait, enclosed in a painted oval frame, is quite different from the stiff, awkward representations of amateurs and is obviously the work of a trained and accomplished artist.

William Moody Kimball, *c. 1857* ▪ *Figure 67*

RAYMOND JONSON
1891-1982

SELECTED BIBLIOGRAPHY: Van Deren Coke, editor, *Raymond Jonson, A Retrospective Exhibition* (Albuquerque: University Art Gallery, University of New Mexico, 1964) • Ed Garman, *The Art of Raymond Jonson, Painter*, (Albuquerque, New Mexico: University of New Mexico Press, 1976) • Susan Ilene Fort, "Raymond Jonson," *Arts* 55:10 (June 1981): 18 • L. Sherman, "Raymond Jonson: Matter into Sensation," *Southwest Art* 11:4 (September 1981): 116-121.

Raymond Jonson pursued a single-minded devotion to art from the time he was a young man. He was born into a Swedish-American family in Chariton, Iowa; his father was a Baptist minister, and the family moved from parish to parish before settling for several years in Portland, Oregon. At age 18 he enrolled in the newly opened Portland Museum School and studied with Kate Simmons, whose teacher at Pratt Institute in Brooklyn had been Arthur Wesley Dow. A year later, in 1910, he entered the Chicago Academy of Fine Arts and later the Chicago Art Institute. B.J.O. NORDFELDT, who was his teacher in composition class, shared a studio area with him in Jackson Park. Nordfeldt recommended Jonson as a stage designer for Chicago's innovative Little Theatre, whose goal was a synthesis of the arts; his received further stimulation and inspiration from exhibitions of Arthur DOVE's paintings in Chicago in 1912 and the Armory Show in 1913.

Jonson's portraits of persons involved in the Little Theatre during 1913 through 1919 were similar to works by Nordfeldt, but his figures became more abstract and original after he left the theatre in 1919. In May of that year he received a scholarship to the MacDowell Colony in Peterborough, New Hampshire. The landscapes he painted there evoked moods of nature and qualities of atmospheric light. In 1924 he moved to Santa Fe, New Mexico. He was fascinated by the relationship between the Southwestern landscape and certain aspects of Indian design, and this became a major theme in his compositions of the 1930s and 1940s. In 1931 he made an extended visit to New York to prepare for a one-man exhibition at the Delphic Studios. Less than a year later he returned to Santa Fe via Chicago, where he saw an exhibition of mathematically derived constructions at the Chicago Century of Progress Exhibition. These designs, like the abstracted landscape and Indian motifs, influenced the content of subsequent canvases

and murals painted for the WPA/FAP in New Mexico. In 1938 Jonson adapted the airbrush to his method of applying colors in flat, decorative patterns. By 1960 he worked exclusively in acrylics which, combined with his airbrush and brayer techniques, enabled him to attach found objects to portions of his brightly colored canvases.

Jonson taught from 1917 to 1921 at the Chicago Academy of Fine Arts and from 1934 to 1964 at the University of New Mexico at Albuquerque, where he took the position of curator of the Jonson Gallery in 1965. He was over 90 when he died. *M.T.S.*

Polymer No. 8, *1968*

Acrylic polymer on masonite,
45⅛ x 36⅛ in.
(114.6 x 91.8 cm.)
Signed verso: Jonson, dated
verso on stretcher
Gift of the artist
70.2
Illustration: Appendix

REFERENCE: Letter from Raymond Jonson to Allen Davis at the University Gallery, 16 December 1969.

PROVENANCE: the artist

Jonson gave this work to the University Art Museum in memory of B.J.O. Nordfeldt. "Unlike his work though it is," Jonson wrote, "I think it adequate to represent my relationship with the man who so largely opened my eyes to the world of art some fifty-eight years ago" (Jonson to Davis, 16 December 1969). In an interview with Van Deren Coke in 1964, he remarked that "Nordfeldt's enthusiasm and vital spirit of experimentation had a genuine spark of what was then contemporary. This he instilled in me through his work and conversation" (*Raymond Jonson, A Retrospective Exhibition*, p. 8).

In works like *Polymer No. 8*, the acrylic medium and masterful airbrush technique are fused to produce paintings evoking qualities of light through the use of color, and of space through the placement of shapes and transparency of paint. Subsequent compositions continued to be based on the landscape and Indian design motifs of his earlier works.

MERVIN JULES
1912-

SELECTED BIBLIOGRAPHY: "Serious Statements at the Hudson Walker Gallery," *Art News* (13 November 1937): 18 ▪ *20th Century Americans* (New York: ACA Galleries, 1970).

Born in Baltimore, Mervin Jules studied at Baltimore City College, the Maryland Institute of Fine and Applied Arts, and the Art Students League. He was only twenty-five when he had his first one-man show at the Hudson D. Walker Gallery in New York; this was followed by two more over the next three years. Henry McBride, critic for *The Sun* (New York), described him as a painter of "the miseries of the forgotten man" (*Art Digest* 12, 15 November 1937, p. 22). He was also called a modern Bosch, a Daumier, and a Goya because of his ability to combine humor with serious satire.

In his exhibitions at Walker's gallery he represented political and societal ills by exaggerating the anatomies and facial expressions of his figures. To heighten the feeling of gloom, he limited his palette to grays, browns, and only a few bright reds. In 1943 he had another one-man show, this time at the ACA Gallery; about it, critics commented that his taffy-like figures had been modified, the greedy capitalists were gone, and more warmth and humor had been brought into his pictures of people and workers in everyday situations. Jules continued his melodramatic portrayals of the downtrodden through the 1970s, interspersing them with works of a more romantic and idyllic nature whose color schemes were both pleasing and intense.

Jules has taught in the War Veterans Art Center (New York) and the People's Art Center (New York), the University of Wisconsin, and Smith College and is professor emeritus of the Art Department at the City College of New York. He won both the Asian-African Study Program Grant to Japan and the Alfred Vance Churchill Foundation Grant in 1967, and the City College of New York Medal in 1973. His work has been shown in group exhibitions at the Corcoran Gallery (Washington, D.C.), the Whitney Museum of American Art, and the Carnegie Institute. *M.T.S.*

I

II

I FRANK WESTON BENSON
The Hillside, *1921*
76.4

II MILTON AVERY
Fantastic Rock, California, *1941*
53.343

III ALFRED THOMPSON BRICHER
 Barn Bluff at Red Wing, Minnesota, *1866*
 76.28

IV MARSDEN HARTLEY
 Eight Bells Folly: Memorial to Hart Crane,
 1933
 61.4

III

IV

V ARTHUR DOVE
Gale, *1932*
36.84

VI ALFRED H. MAURER
Still Life with Cup, *c. 1929*
53.304

V

VI

VII MARSDEN HARTLEY
 Marie Ste. Esprit, *1938-1939*
 78.21.839

VIII MARSDEN HARTLEY
 One Portrait of One Woman, *c. 1913*
 78.21.64

VII

VIII

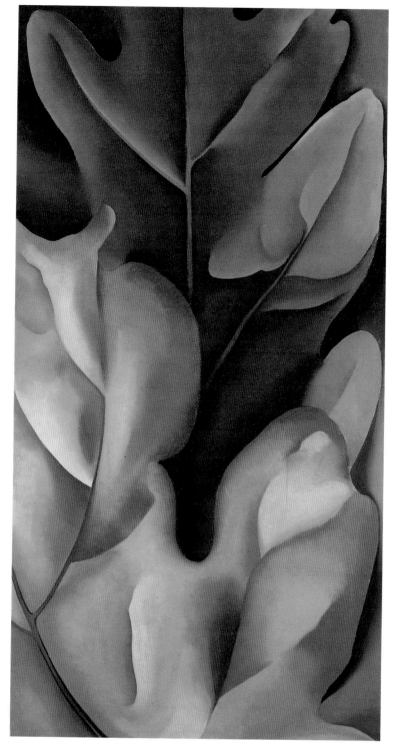

IX

IX GEORGIA O'KEEFFE
Oak Leaves (Pink and Gray), *1929*
36.85

X GEORGE B. LUKS
Portrait of My Friend, S. O. Buckner,
1926
78.21.295

X

XI MARSDEN HARTLEY
 Still Life, *1912*
 78.21.25

XII CHARLES W. HAWTHORNE
 Nellie, *1919*
 78.21.94

XIII MARSDEN HARTLEY
 Santos, New Mexico, *c. 1918-19*
 78.21.68

XI

XIII

XII

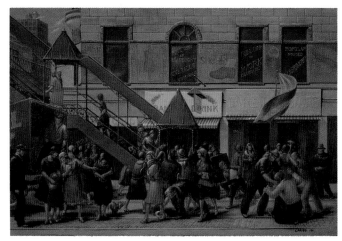

XIV

XIV EDWARD LANING
 Third Avenue El at Fourteenth Street, *1931*
 82.4

XV STANTON MACDONALD-WRIGHT
 Cañon Synchromy (Orange), *1919-1920*
 73.19

XV

XVI ALFRED H. MAURER
 Girl in White, *c. 1901*
 53.307

XVI

XVII

XVII THOMAS P. ROSSITER
Minnesota Prairie, *1858-1859*
73.8.3

XVIII ROBERT GWATHMEY
Nobody Around Here Calls Me Citizen,
1943
78.21.34

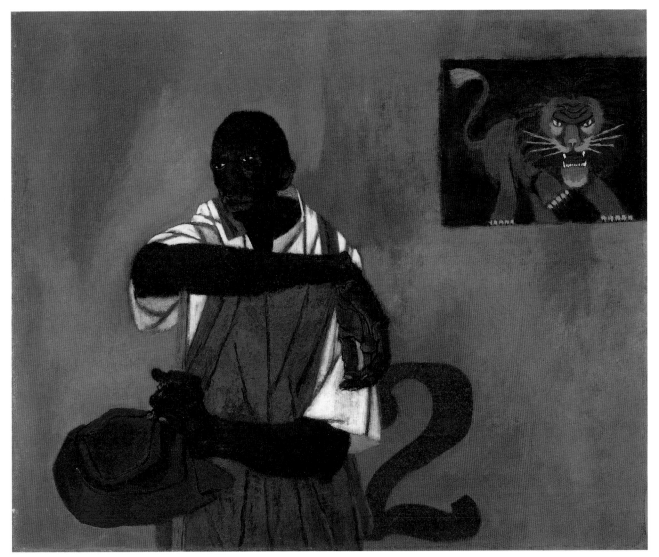

XVIII

XIX ILYA BOLOTOWSKY
 Study for World's Fair Mural, *1938*
 82.6

XX PHILIP EVERGOOD
 Wheels of Victory, *1944*
 78.21.830

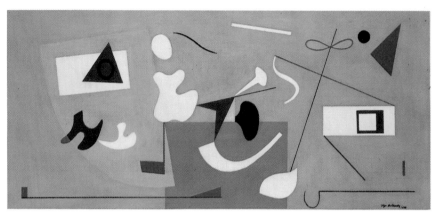

XIX

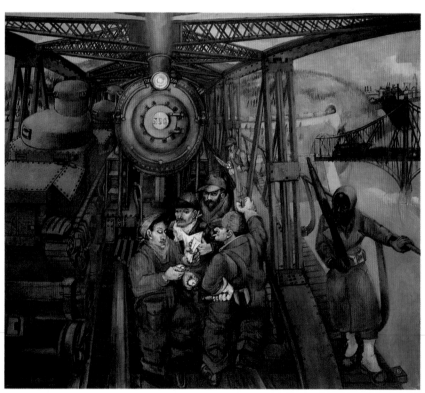

XX

XXI IRENE R. PEREIRA
Blue Predominates, *1945*
78.25.2

XXII LYONEL FEININGER
Dröbsdorf I, *1928*
39.97

XXI

XXII

XXIII GEORGIA O'KEEFFE
Oriental Poppies, *1928*
37.1

XXIII

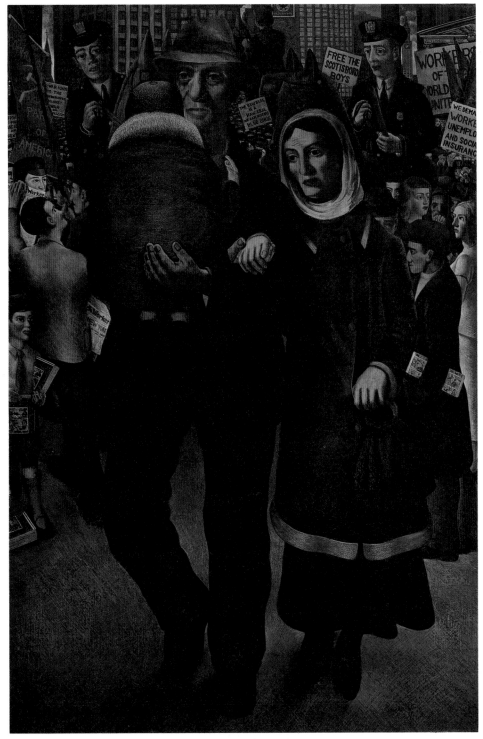

XXIV JOSEPH PANDOLFINI
Unemployed, *c. 1932-37*
38.52

XXIV

XXV CAMERON BOOTH
 Halloween, *1957, 1961*
 66.73

XXVI MARSDEN HARTLEY
 Elsa, *1916*
 78.21.46

XXVII MARSDEN HARTLEY
 Portrait, c. *1914-1915*
 78.21.234

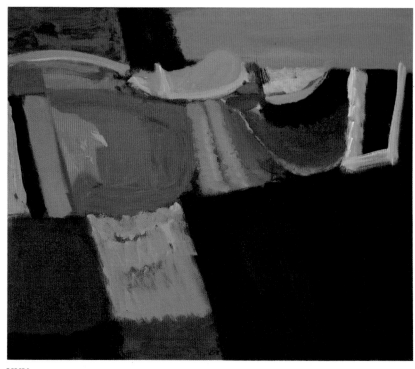

XXV

XXVII

XXVI

XXVIII ALFRED H. MAURER
 Self-Portrait, *1897*
 53.301

XXIX B.J.O. NORDFELDT
 Blue Gull, *1951*
 72.8

XXVIII

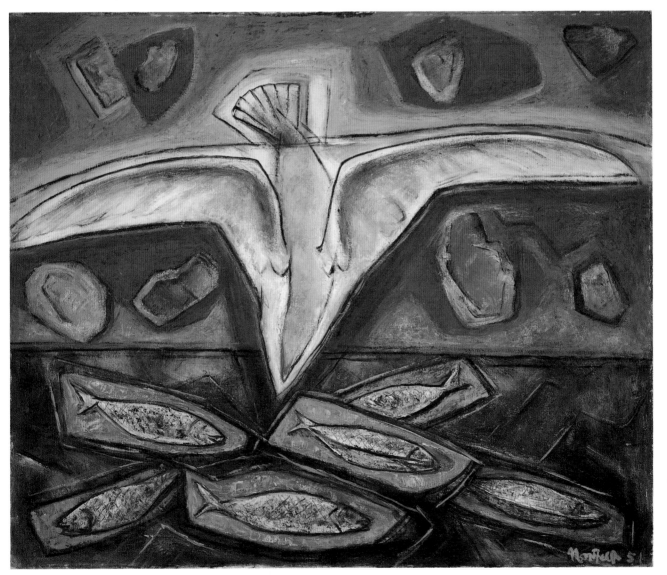

XXIX

XXX WALTER W. QUIRT
 Protection of White Womanhood, *1934*
 82.11.1

XXXI ROBERT MOTHERWELL
 Mural Fragment, *1950*
 52.17

XXX

XXXI

Dispossessed (Morning), *c. 1939*

Oil on masonite, 18⅜ x 20¼
(46.7 x 51.4 cm.)
Signed verso in pencil: Mervin Jules
'Morning'
Bequest of Hudson Walker from the Ione
and Hudson Walker Collection
78.21.225
Illustration: Appendix

EXHIBITIONS: *Selections from the Collection
of Mr. and Mrs. Hudson D. Walker*, 1950 ▪
Drew Fine Arts Center, Hamline University,
St. Paul, *Exhibition of Paintings by Some
American Individualists*, 1950.

PROVENANCE: Ione and Hudson Walker

The sense of heightened perspective and the title suggest that this panel was probably shown in the first or second exhibition of Jules's work at the Hudson D. Walker Gallery. The artist's sympathy for the poor was a dominant theme in both exhibitions.

Men of Ill Will, *c. 1939*

Oil on masonite, 14½ x 16¾ in.
(36.8 x 42.5 cm.)
Signed lower right: Jules
Bequest of Hudson Walker from the Ione
and Hudson Walker Collection
78.21.113
Illustration: Figure 68

EXHIBITIONS: The St. Paul Gallery and
School of Art, *Exhibition*, 1951 ▪ *Selections
from the Permanent Collection*, 1968.

PROVENANCE: Ione and Hudson Walker

With its caricatured forms and kaleidoscopic perspective, this panel is stylistically similar to paintings from Jules's second one-man show at the Hudson D. Walker Gallery in February, 1939. Critics compared his panels in this exhibition to Daumier's lithographs because they mixed biting satire with a sense of burlesque. Jules often painted politicians; he showed them riding on an endless merry-go-round in *Diplomats* (1938), and in *Liberators* (1938) they are seen crawling precariously out on the dead limb of a tree.

Men of Ill Will, *c. 1939* • *Figure 68*

Tomorrow Will Be Beautiful, *c. 1939*

Oil on gesso on wood, 33¼ x 43⅞ in.
(84.5 x 111.4 cm.)
Signed lower right: Jules
Bequest of Hudson Walker from the Ione
and Hudson Walker Collection
78.21.308
Illustration: Appendix

REFERENCE: "Bosch-esque Satire by Mervin
Jules," *Art Digest* (15 February 1939): 17.

PROVENANCE: Ione and Hudson Walker

This painting was shown in Jules's second one-man exhibition at
the Hudson D. Walker Gallery. Except for a few searing reds, the
color scheme is predominantly monochromatic. In tonality and
theme, this work is similar to others by Jules focusing on the
victims of the Depression, yet it was viewed as one of his more
optimistic; as one reviewer wrote, "For all the fierce satire in his
work, Jules turned in one hopeful picture, *Tomorrow Will Be
Beautiful*, in which, pictured in the distance from a foreground
mountain of debris, is the city of tomorrow, shining golden on the
horizon and well serviced by a huge hydroelectric development
among other good things in life" (*Art Digest*, p. 17).

226

Self-Portrait, *1940*

Oil on canvas, 23⅛ x 13⅞ in.
(58.7 x 35.2 cm.)
Signed verso: Self portrait 1940 oil/Mervin
Jules/299 Depot Rd. Huntington Station,
NY
Bequest of Hudson Walker from the Ione
and Hudson Walker Collection
78.21.197
Illustration: Appendix

REFERENCE: "Reviews," *Art News* (18 May
1940): 10.

EXHIBITIONS: Hudson D. Walker Gallery,
New York, *Mervin Jules*, 1940 • *Hudson D.
Walker: Patron and Friend*, 1977, cat. 45.

PROVENANCE: Ione and Hudson Walker

The attenuated features in this work match those of the figures in Jules's social realist panels. This painting was shown in the artist's third one-man show at the Hudson D. Walker Gallery and elicited the following comment: "…the humor with which Jules has represented his own fixed and searching gaze has made itself felt throughout the show. Rarely does one encounter such keen understanding in so young an artist" (*Art News*, p. 10).

Woman Ironing, *c. 1940*

Oil on composition board, 16 x 13¾ in.
(40.6 x 34.9 cm.)
Signed lower right: Jules
Bequest of Hudson Walker from the Ione
and Hudson Walker Collection
78.21.317
Illustration: Appendix

REFERENCE: "Reviews," *Art News* (18 May
1940): 10.

EXHIBITION: Tweed Museum of Art,
University of Minnesota-Duluth, *A Survey
of American Painting*, 1955.

PROVENANCE: Ione and Hudson Walker

This painting was probably shown in Jules's third one-man show at the Hudson D. Walker Gallery. Although it is titled *Woman Ironing*, it may have been called *The Laundress* in 1940 and alludes to the compositions of Degas and Picasso. *Art News* described it as "*Laundress*, with its effort and strain in one figure and motionless vacuity of the other" (*Art News*, p. 10).

The use of a single figure in a painting was atypical of Jules, who usually worked with several figures and exaggerated the sizes of limbs and facial features. *Boy Picking Apples* has more in common with work he completed after 1943, when critics felt that his biting social commentaries had mellowed. The lone figure of a small boy holding a snowball and silhouetted against a snowbank and a water hydrant in *Snow Bird* obliquely communicates his sympathy for the urban poor.

Boy Picking Apples, *c. 1945*

Oil on masonite, 8½ x 9½ in.
(21.6 x 24.1 cm.)
Signed lower right and lower left: Jules
Bequest of Hudson Walker from the Ione and Hudson Walker Collection
78.21.37
Illustration: Appendix

PROVENANCE: Ione and Hudson Walker

Snow Bird, *c. 1945*

Oil on composition board, 12 x 9 in.
(30.5 x 22.9 cm.)
Signed verso: Snow Bird Jules
Bequest of Hudson Walker from the Ione and Hudson Walker Collection
78.21.103
Illustration: Figure 69

PROVENANCE: Ione and Hudson Walker

Kids at Play, *c. 1945*

Oil on masonite, 13 x 18⅛ in.
(33 x 46 cm.)
Unsigned
Bequest of Hudson Walker from the Ione and Hudson Walker Collection
78.21.842
Illustration: Appendix

PROVENANCE: Ione and Hudson Walker

Jules continued to paint social themes after 1940, but his content was less explicit. In 1947 he painted a similar subject, *Playground*, in which fairly well-dressed children are crowded into a small recreational area. Jules explained, "I paint in human terms about people.... We have all realized the inadequacy of play space in our cities" ("Exhibition ACA Gallery," *Pictures on Exhibition*, November 1947, p. 32).

Snow Bird, *c. 1945* ▪ *Figure 69*

WILLIAM JURIAN KAULA
1871-1953

SELECTED BIBLIOGRAPHY: *Who's Who in American Art* (Washington, D.C.: American Federation of Arts, 1938-39) ▪ Mantle Fielding, *Dictionary of American Painters, Sculptors, and Engravers* (Philadelphia: Scribners, 1926; revised edition Greensfarms, Connecticut: Modern Books and Crafts, 1974), both 195.

Born in Boston, William Jurian Kaula attended the Normal and Cowles art schools there. He also studied with the French artist R. Collin in Paris. A member of the Guild of Boston Artists, Kaula exhibited his landscapes, which usually focused on New England scenery, with the Guild and at the Copley Society. *L.A.A.*

Oil on canvas, 18⅛ x 22⅛ in.
(46.1 x 56.3 cm.)
Signed lower left: William J. Kaula 1909
Gift of John E. Larkin, Jr.
79.9.4
Illustration: Appendix

EXHIBITIONS: *Selected Gifts and Acquisitions*, 1979 ▪ *The First Fifty Years 1934-1984: American Paintings and Sculpture from the University Art Museum*, 1984

PROVENANCE: John E. Larkin, Jr.

Clearing Weather, *1909*

Clouds play a prominent role in this painting, casting shadows across parts of an expansive landscape. Nature in all of her undisturbed glory is a major motif in Kaula's paintings. Here the emerging sunlight illuminates the lush green vegetation of the rolling hills.

Oil on canvas, 30 x 48¼ in.
(76.3 x 122.8 cm.)
Signed lower left: William J. Kaula
Gift of John E. Larkin, Jr.
76.20.2
Illustration: Figure 70

PROVENANCE: John Castano; John E. Larkin, Jr.

Vermont Hills in Autumn *(formerly* New Hampshire in Autumn*), c. 1900-1910*

The title of this painting was changed from *New Hampshire in Autumn* when the inscription *Vermont Hills in Autumn* was found on the stretcher. A bright light emanates from the distant middle ground, bringing out the vivid colors of this brilliant fall scene. Kaula delighted in portraying the natural beauty of the New England countryside.

Vermont Hills in Autumn *(formerly* **New Hampshire in Autumn***), c. 1900-1910* ▪ *Figure 70*

PAUL KELPE

1902-

SELECTED BIBLIOGRAPHY: Martha Candler Cheney, *Modern Art in America* (New York: McGraw-Hill Book Company, Inc., 1939), 83 • Peter Walch, "American Abstract Artists," *Art Journal* (Fall 1977): 46-48.

Born in Minden, Germany, Paul Kelpe began to study architecture in Hanover but switched to painting when he became interested in the work of abstract artists Wassily Kandinsky, László Moholy-Nagy, Kurt Schwitters, and Vordemberge Gildenart. After immigrating to the States in 1925 he lived for a year in Chicago. He then moved to near Princeton, New Jersey and exhibited in local shows as well as group shows with the Society of Independent Artists in New York between 1927 and 1931.

Returning to Chicago in the early 1930s, Kelpe began exhibiting constructions comprised of pieces of wood and found objects such as telephone insulators, old doorknobs, and mousetraps. In 1935 he moved to New York City and joined the WPA/FAP mural program, completing (among other works) a large mural painting for the Williamsburg Housing Project in Brooklyn. He exhibited with Josef Albers and Werner Drewes at the Delphic Studios (New York) in 1936 and was part of the group of artists who founded the American Abstract Artists. He took part in their first show at the Squibb Galleries (New York) in 1937 and exhibited with them through 1944 and again from 1953 to 1977.

During the 1930s his work evolved from three-dimensional assemblages to two-dimensional compositions on canvas. In the mid-1930s these were made up of geometric shapes painted with varying textures and arranged tastefully within a composition; in the late 1930s his canvases contained illusionistically painted three-dimensional shapes that appeared to float in space. Kelpe wrote that these paintings were not intended to represent reality, but were built with form and color by a method similar to that used by a composer of music.

Kelpe entered graduate school in art history at the University of Chicago in 1944, receiving his M.A. in 1948 and his Ph.D. in 1957. He taught art history at the University of Texas at Austin from 1948 to 1954, at Howard University from 1957 to 1960, and at East Texas State Teachers College from 1960 until his retirement in 1969. Meanwhile, in 1950, he resumed painting. His new canvases contained "a kind of irregular linear arrangement, sometimes resembling transparent crystalline formations" (Letter from Paul Kelpe to Mark Kriss at the University Gallery, 17 November 1978). *M.T.S.*

Composition *(formerly* Design for a Mural*), c. 1927-1930*

Oil on canvas, 20 x 36 in.
(50.8 x 91.4 cm.)
Signed lower right: Paul Kelpe
Purchased from the Federal Art Project,
Central Allocations Division, New York
39.112
Illustration: Appendix

PROVENANCE: Federal Art Project, Central
Allocations Division, New York

Formerly thought to be painted during the middle 1930s, *Composition* was, according to the artist, actually created in the 1920s. The title was changed from *Design for a Mural* because *Composition* was the standard name Kelpe used for his works from that period. He painted it either in Chicago or Princeton, more likely the latter.

Because, as he notes, "my abstract paintings were not accepted," he later "made up some scheme of geometric design in which the various forms represented sections of machines, etc. However, that was not considered satisfactory either. Therefore I gave up and moved to New York where there was a special section for abstract artists" (Letter from Paul Kelpe to Mark Kriss at the University Gallery, 17 November 1978). It has been suggested that Kelpe's machine-like forms may have influenced David Smith's later *Cubi* series (Walch, p. 48).

EARL C. KERKAM
1890-1965

SELECTED BIBLIOGRAPHY: "Kerkam's
Portraits," *Art Digest* 18:7 (1 January
1944): 19 ▪ Elaine de Kooning, "Kerkam
Paints a Picture," *Art News* (February
1951): 42-45, 65-67 ▪ Martica Sawin,
"Profile of Earl Kerkam," *Arts* 31 (March
1957): 27-29 ▪ Thomas Hess and Gerald
Nordland, *Earl Kerkam* (Washington, D.C.:
Washington Gallery of Modern Art, 1966).

Widely respected by his artist-contemporaries, Earl Kerkam was almost unknown to the public during his lifetime. Born in the District of Columbia, he contracted spinal meningitis in infancy which left him with hand tremors. As a child he was a loner, and drawing became his private world. By age eight he had already won a gold medal for drawing from the Richmond *Times Dispatch*.

Moving with his mother and stepfather to New York, Kerkam studied art at the Rand School, the Art Students League, and the School of Design. He also studied at Robert Henri's studio and later worked at the Pennsylvania Academy of the Fine Arts and the Institute of Art in Montreal.

By 1911 Kerkam was living in Philadelphia and supervising a shop for Stanley Theaters which produced signs for movie exteriors and displays for lobbies. He also contributed political cartoons to liberal magazines and became the art editor for *Progress*. When he was drafted into the army in World War I, he became the art editor of the official tank corps magazine and published cartoons in the *New York World* under the title "Barracks Sports."

After the war Kerkam went to work for Warner Brothers Pictures designing movie posters. Several trips to Paris in the 1920s persuaded him to leave commercial art and try his hand at painting. During one of those trips he decided to stay in Paris to study at the Grand Chaumière, sketch from the models, and visit museums and galleries. He had his first one-man exhibition in that city.

When Wall Street crashed, he went back to America to run a poster shop and manage theaters in Atlantic City, saving up for a return trip to Paris. He arrived there in 1932 and set about trying to simplify his drawing and find his own style. He accepted an invitation from André Derain to participate in a two-man exhibition, and he also showed his work at the Salon d'Automne, the Bernheim-Jeune, and the Tuilleries Galleries.

His savings depleted once again, Kerkam went to Philadelphia to paint murals and do caricatures for the New York *Herald Tribune* and the Brooklyn *Eagle*. Moving to New York, he had his first one-man show in America at the Contemporary Arts Gallery in 1933, and in 1935 he joined the WPA/FAP easel project. It was during the 1930s that he became friends with Milton AVERY, Arshile Gorky, Willem de Kooning, Jackson Pollock, and Franz Kline; he would share a studio with Kline in the early 1950s.

Using Cézanne as a guide, Kerkam attempted to simplify his paintings and drawings by emphasizing structure and expression. He worked from models, often placing a single figure in a nebulous environment and dissecting spatial volumes with shafts of light. Later self-portraits were labeled *Compositions* and done as parts of a series.

Kerkam exhibited with the J.B. Neumann Gallery in the 1930s, the Charles Egan Gallery and Harold Wacher's Chinese Gallery in the 1940s, and the Poindexter Gallery (all New York) in the 1950s.
M.T.S.

Jugglers, *c. 1935-1940*

Oil on canvas, 36 x 30¼ in.
(91.4 x 76.8 cm.)
Signed upper right: Kerkam
Purchased from the Federal Art Project,
Central Allocations Division, New York
39.101
Illustration: Figure 71

EXHIBITION: *Original Paintings from the University Collection*, 1946, cat. 95.

PROVENANCE: Federal Art Project, Central Allocations Division, New York

Kerkam completed this painting while working on the WPA/FAP easel project. Ballet dancers, the female nude, and one or two lone figures in an ambiguous environment were frequent subjects in his paintings throughout the early 1930s and 1940s. Figures were modeled in thickly painted dark colors to give the illusion of three-dimensionality.

Jugglers, *c. 1935-1940* ▪ *Figure 71*

Self-Portrait, *c. 1935-1940*

Oil on canvas board, 18⅜ x 12¼ in.
(46.7 x 31.1 cm.)
Unsigned
Bequest of Hudson Walker from the Ione
and Hudson Walker Collection
78.21.35
Illustration: Appendix

EXHIBITION: Drew Fine Arts Center,
Hamline University, St. Paul, *Exhibition*,
1952.

PROVENANCE: Ione and Hudson Walker

Thomas Hess wrote that Earl Kerkam had "one big subject, the only patient sitter—himself. I can't help but feel that his still-lifes and nudes were warm-ups for, or relaxations from, or experiments alongside the self-portraits. And, for that matter, practically all his pictures are self-portraits—even the apples. His self-image had become the paint stroke" (*Earl Kerkam*, 1966, p. 3). Kerkam's portraits of others were always vigorous likenesses, but he achieved the greatest impact with his own self-portraits. Influences ranging from Rembrandt to Cézanne can be seen in his depersonalized yet emotionally charged faces. Even when Kerkam began working on portraits of another model, he continued to use his own facial features or figure. During the last ten years of his life he began a series of compositions based on the parts of the head. In these the face was broken into geometric shapes and became increasingly abstracted.

In his use of traditional subject matter, Kerkam veered between realism and abstraction throughout his career. Although the size of his canvases and panels was small, his works achieved monumentality due to his direct and simple placement of the objects. Critics described his quiet still-lifes as extremely modest, using backgrounds which "loom important in hues of rose, blue, and yellow" and become subtly active behind quiet arrangements of flowers or other objects ("Reviews," *Art News*, June 1948, p. 50). His brushwork was often compared to that of Corot.

Still Life *(1), c. 1935-1940*

Oil on composition board, 14¼ x 11 in.
(36.2 x 27.9 cm.)
Signed lower right: Kerkam
Bequest of Hudson Walker from the Ione
and Hudson Walker Collection
78.21.130
Illustration: Appendix

PROVENANCE: Ione and Hudson Walker

Oil on cardboard, 8 x 15 in.
(20.3 x 38.1 cm.)
Signed lower left: Kerkam
Bequest of Hudson Walker from the Ione
and Hudson Walker Collection
78.21.843
Illustration: Appendix

EXHIBITION: Drew Fine Arts Center,
Hamline University, St. Paul, *Exhibition*,
1952.

PROVENANCE: Ione and Hudson Walker

Still Life *(2), c. 1935-1940*

Oil on composition board, 6½ x 14⅝ in.
(16.5 x 37.1 cm.)
Signed upper right: Kerkam
Bequest of Hudson Walker from the Ione
and Hudson Walker Collection
78.21.102
Illustration: Appendix

PROVENANCE: Ione and Hudson Walker

Violin, *c. 1935-1940*

ARNOLD N. KLAGSTAD
1898-1954

SELECTED BIBLIOGRAPHY: Jamie Besso,
"August Klagstad: Norwegian-American
Artist," unpublished paper, University of
Minnesota, Minneapolis, 1975 •
Minneapolis History Collection,
Minneapolis Public Library.

Arnold Klagstad enjoyed the distinction of being the first
Minneapolis painter to sell his work to the Metropolitan Museum
of Art. Born in Marinette, Wisconsin, he moved with his family to
Minneapolis and attended Dunwoody Institute in 1921, meaning to
become an electrician. Instead, he went on to study with Morris
Davidson and Anthony Angarola at the Minneapolis School of Art.
After spending several years with the altar-painting firm of his
artist-father AUGUST KLAGSTAD, he enrolled in France's
Fontainebleau School of Art in 1931 and worked for three months
with Jean Despujols, Gaston Balande, and André Strauss. He joined
Despujols's class in Paris for another three months, spending his
evenings sketching at the Academy Colarossi.

During the Depression the altar-painting and church furnishings business declined and Klagstad enrolled in the WPA/FAP easel program. After the PWAP ended in April of 1934, he and six other project artists (Elof WEDIN, Stanford FENELLE, Syd FOSSUM, Dewey ALBINSON, Cameron BOOTH, and Erle LORAN) were hired by the University to paint landscape scenes of various campus buildings and sites. Ten of the paintings by Klagstad in the University Art Museum collection were all completed during the summer of 1934.

His work from the 1930s has been described as having "serenity of composition and mellow color harmonies" ("Arnold Klagstad's Oil is Picked by Famed New York Gallery," *The Minneapolis Star Journal*, 14 January 1940). His competent handling of brush and color was evident in the prize-winning landscapes he showed at the State Fair exhibitions in 1932, 1933, and 1934. He particularly admired the paintings of Poussin, Corot, and Constable; the broadly painted geometric shapes of the buildings in his paintings of campus sites are similar to what Corot painted in Rome during the early nineteenth century. Learning from Corot (and probably Cézanne as well), he seemed to see beneath the surface to the basic geometric forms of buildings and landscapes.

Klagstad sold *Industrial Scene* (1937) to the Metropolitan Museum of Art in 1940. Typical of works completed during the Depression in its objective exploration of urban life, it was one of several paintings he did of the milling district along the Mississippi River.

After serving in the Navy during World War II, Klagstad returned to Minneapolis and a partnership with his brother in the Klagstad Studios. Although he continued to occasionally sketch landscapes in watercolor at his family lake cabin, he painted only altarpieces after 1946.

Klagstad participated in the annual Local Artists Exhibitions at the Minneapolis Institute of Arts and the Minnesota State Fair exhibitions from 1928 to 1942. He became a charter member of the Minnesota Artists Association in 1937 and chaired its finance committee in 1942. *M.T.S.*

Administration Building, *1934*

Oil on canvas, 17⅞ x 22 in.
(45.5 x 55.9 cm.)
Unsigned
University of Minnesota Commission
34.132
Illustration: Appendix

EXHIBITIONS: *Original Paintings from the University Collection*, 1946, cat. 99 •
Alumni Club, Minneapolis, *75th Anniversary Exhibition*, 1979.

PROVENANCE: the artist

Now named Morrill Hall after James Lewis Morrill, University president from 1945 to 1960, this building stands directly south and east of Northrop Auditorium on the Minneapolis campus.

Burton Hall, *1934*

Oil on canvas, 18⅛ x 20⅛ in.
(46 x 51.1 cm.)
Unsigned
University of Minnesota Commission
34.133
Illustration: Figure 72

EXHIBITIONS: Tweed Gallery, University of Minnesota-Duluth, *Accomplishments: Minnesota Art Projects in the Depression Years*, 1976, cat. 38 • Minneapolis College of Art and Design, Minneapolis, *The Urban Muse: Painters Look at the Twin Cities*, 1977 • Alumni Club, Minneapolis, *75th Anniversary Exhibition*, 1979-1980

PROVENANCE: the artist

Today this building houses education offices and classrooms on the East Bank of the Minneapolis campus.

Burton Hall, *1934 • Figure 72*

239

Campus Gates No. 1, *1934*

Oil on canvas, 18⅛ x 22 in.
(46 x 56 cm.)
Unsigned
University of Minnesota Commission
34.134
Illustration: Appendix

PROVENANCE: the artist

The gates shown in this painting face Fourteenth Avenue S.E. and University Avenue directly across from Dinkytown on the University's East Bank.

Campus Gates (No. 2), *1934*

Oil on canvas, 18 x 22 in.
(71.1 x 91.4 cm.)
Signed lower left: Arnold Klagstad '34
University of Minnesota Commission
34.135
Illustration: Figure 73

PROVENANCE: the artist

Campus Gates No. 2, 1934 • *Figure 73*

Campus Knoll, *1934*

Oil on canvas, 18 x 22 in.
(45.7 x 55.9 cm.)
Unsigned
University of Minnesota Commission
34.136
Illustration: Appendix

PROVENANCE: the artist

This group of store buildings is located directly across from the St. Paul campus.

Farm Dining Hall, *1934*

Oil on canvas, 16 x 20 in.
(40.6 x 50.8 cm.)
Unsigned
University of Minnesota Commission
34.137
Illustration: Appendix

EXHIBITION: *Original Paintings from the University Collection*, 1946, cat. 100.

PROVENANCE: the artist

Now demolished, this hall occupied the present site of the St. Paul Student Center. To the right is Coffey Hall.

Nurses' Home, *1934*

Oil on canvas, 19 x 16 in.
(48.3 x 40.6 cm.)
Unsigned
University of Minnesota Commission
34.138
Illustration: Appendix

PROVENANCE: the artist

This building is located near the University Hospitals and still houses student nurses.

Power House, *1934*

Oil on canvas, 18 x 22 in.
(45.7 x 55.9 cm.)
Unsigned
University of Minnesota Commission
34.139
Illustration: Appendix

EXHIBITION: Tweed Gallery, University of Minnesota-Duluth, *Accomplishments: Minnesota Art Projects in the Depression Years*, 1976, cat. 39.

PROVENANCE: the artist

This building is still located on East River Road near the Campus Gates.

Tennis Courts No. 1, *1934*

Oil on canvas, 29¼ x 36¼ in.
(74.3 x 92.1 cm.)
Signed lower right: An Klagstad '34
University of Minnesota Commission
34.140
Illustration: Figure 74

EXHIBITIONS: *Original Paintings from the
University Collection*, 1946, cat. 102 ▪
Tweed Gallery, University of Minnesota-
Duluth, *Accomplishments: Minnesota Art
Projects in the Depression Years*, 1976, cat.
40.

PROVENANCE: the artist

These courts were located between Washington Avenue S.E. and
Arlington Street S.E., behind Appleby Hall on the Minneapolis
campus.

Tennis Courts No. 1, *1934* ▪ *Figure 74*

Oil on canvas, 16⅛ x 20¼ in.
(41 x 51.4 cm.)
Unsigned
University of Minnesota Commission
34.141
Illustration: Appendix

PROVENANCE: the artist

Tennis Courts No. 2, *1934*

Second Avenue South, *c. 1935-1940*

Oil on canvas, 18 x 19¼ in.
(45.7 x 48.9 cm.)
Unsigned
WPA Art Project, Minneapolis
43.766
Illustration: Appendix

EXHIBITION: *Original Paintings from the University Collection*, 1946, cat. 101.

PROVENANCE: WPA Art Project, Minneapolis

This view can be seen on Twelfth Street, looking down Second Avenue toward downtown Minneapolis. The building is now called the Ivory Tower Office Building.

AUGUST KLAGSTAD
1866-1949

SELECTED BIBLIOGRAPHY: August Klagstad, *Portraits in Oil* (St. Paul: Webb, c. 1925).

One of the most prominent portrayers of Minnesota dignitaries in the first third of the twentieth century, August Klagstad was born in Bingen, Norway. He came to America at age five when his parents immigrated to northern Michigan. He received his education in the Manistique, Michigan public schools, at the Normal School and Business Institute in Valparaiso, Indiana, and the Art Institute of Chicago and the Chicago Academy of Fine Arts.

As a young man, Klagstad worked for brief periods in Chicago, Brooklyn, Boston, and Marinette, Wisconsin. In 1915 he moved to Minneapolis where he specialized in painting portraits, genre pictures, and altarpieces. He is said to have painted over 3,000 of the latter; while this figure is undoubtedly inflated, his output truly was prodigious.

Clients for Klagstad portraits included "Empire Builder" James J. Hill; Norwegian author and national anthem writer Bjørnstjerne Bjørnsen; and Agnes Theodora Melby, the first woman graduate of St. Olaf College and for many years its dean of women. August Klagstad was the father of artist ARNOLD KLAGSTAD, who worked for the PWA in Minnesota in the 1930s and became well-known as a painter of industrial landscapes in the Twin Cities area. *R.N.C.*

Professor Gisle Bothne, *c. 1910*

Oil on canvas, 31¼ x 24 in.
(79.4 x 61.0 cm.)
Unsigned; written in pen on stretcher,
"Prof. Gisle Bothne" Klagstad, August
Transfer from University of Minnesota
Archives
79.14.2
Illustration: Appendix

PROVENANCE: University of Minnesota
Archives

The son of noted scholar and writer Thord J. Bothne, Gisle
Christian Johnson Bothne was born in Frederickshald, Norway. He
came to the United States in 1876, attended Luther College in
Decorah, Iowa, and graduated in 1878. In subsequent study at
Northwestern University and Johns Hopkins he pursued his
scholarly interest in Scandinavian languages and literature. In 1881
he was called back to Luther College to teach Scandinavian
languages and remained there until 1907, when he was invited to
head the Scandinavian Department at the University of Minnesota,
a post he held until his retirement in 1929. Bothne was the author
of a history of Luther College and of a book and numerous articles
on the language of modern Norway.

Klagstad's portrait is an accomplished one, conveying a sense of
immediacy and personal recognition as the scholar, shown at half-
length, faces the viewer. There is also an undeniable air of dignity
and importance.

KARL KNATHS
1891-1971

SELECTED BIBLIOGRAPHY: *Karl Knaths*,
introduction by Duncan Phillips, essay by
Paul Mocsanyi (Washington, D.C.: Phillips
Gallery, 1957) • *Four American
Expressionists: Doris Caesar, Chaim Gross,
Karl Knaths, Abraham Rattner*, essay by
Lloyd Goodrich (New York: Whitney
Museum of American Art, 1959) • *Karl
Knaths* (Washington, D.C.: Phillips Gallery,
1967) • Isabel Patterson Eaton and Charles
Edward Eaton, *Karl Knaths, Five Decades
of Painting: A Loan Exhibition*
(Washington, D.C.: International
Exhibitions Foundation, 1973).

Studio and landscape environments on Cape Cod were distilled into
angular symbols in the canvases of Karl Knaths. Born in Eau Claire,
Wisconsin, he was encouraged to attend the Art Institute of
Chicago school by regionalist novelist Zona Gale. When the
Armory Show came to Chicago in 1913, Knaths was at first
shocked and confused but soon realized that the volume and color
in Cézanne's paintings structured a new world for his own work.

He moved to New York for a brief time after World War I but left after a friend convinced him that Provincetown was both cheap and stimulating for an artist. Knaths settled there permanently in 1919 and stayed until his death over half a century later. He never traveled to Europe, but he painted in the style of the School of Paris. He easily assimilated fauvist color and cubist structure in his early paintings, several of which he sold to collector Duncan Phillips in 1922. Phillips remained his sole patron for years, encouraging others to look at his canvases.

Knath's paintings explored Cape Cod through the 1930s. He often incorporated a spiritual presence in the objects he painted by placing them in a kind of mysterious space; this may have been an outgrowth of his exploration of Swedenborgian philosophy. He adapted and used the ideas of Klee, Kandinsky, Mondrian, and Severini in the six-week course he taught at the Phillips Gallery in Washington each year throughout the 1940s and 1950s. He also taught at Bennington College in Vermont and the American University in Washington, D.C. *M.T.S.*

Cabbage, *c. 1937*

Oil on canvas, 30¼ x 40⅛ in. (76.8 x 101.9 cm.)
Unsigned
WPA Art Project, Washington, D.C.
43.728
Illustration: Appendix

EXHIBITIONS: *Original Paintings from the University Collection*, 1946, cat. 104 • *Selections from the Permanent Collection*, 1954.

PROVENANCE: WPA Art Project, Washington, D.C.

Knaths used Wilhelm Ostwald's color classification system from 1930 until his death. He calculated precisely measured colorful intervals and the proportion of all shapes in his paintings, mixing his colors in empty quahog shells. His painting process gradually revealed motifs from nature, even though he first began with the canvas design. He wrote that "systems are only bricks and lumber—of themselves they cannot encompass the immeasurable spiritual qualities that go into a successful picture. The unlooked-for things that happen in the process of work are the important ones" (*Four American Expressionists*, 1959, p. 18). This painting was completed while Knaths was part of the WPA/FAP easel project.

ROBERT KOEHLER
1850-1917

SELECTED BIBLIOGRAPHY: Rena Coen, *Painting and Sculpture in Minnesota, 1820-1914* (Minneapolis: University of Minnesota Press, 1976), 4, 108-110, 134.

Robert Koehler was born in Hamburg, Germany but raised in Milwaukee, where his family moved in 1854. At age 15 he was apprenticed to a firm of Milwaukee lithographers, but in 1871 he moved first to Pittsburgh, then to New York to attend evening classes at the National Academy of Design and the Art Students League. In 1873 he left for Munich and enrolled in the Royal Academy. Lack of funds forced him to return home in 1875; four years later, backed by a wealthy New York brewer, Koehler returned to Munich where he spent the next 13 years.

He became active in the local artists' association, introducing American art to Munich by organizing the American section of the international art exhibitions held there in 1883 and 1888. By 1892 he had returned to New York, and in 1893 he accepted an invitation to come to Minnesota. After teaching for a year at the Minneapolis School of Art (now the Minneapolis College of Art and Design), Koehler was named director of the school, succeeding Douglas Volk. He remained in Minneapolis the rest of his life.

Koehler brought with him to Minneapolis a picture called *The Strike* which he had painted in Germany several years earlier. One of the first paintings by an American artist to depict the early struggles of the labor movement, it was based on Koehler's recollection of a railroad workers' strike which had taken place in Pittsburgh in 1877. The Minneapolis Society of Fine Arts bought the painting in 1901 and presented it to the city—its well-to-do members seemingly unaware of the subject's full implications. *The Socialist*, which Koehler exhibited in 1885 at the National Academy of Design, further emphasized his sympathies with working people. *R.N.C.*

Dean Frederick J. Wulling, *1903*

Oil on canvas, 42 x 27 in.
(106.7 x 68.6 cm.)
Signed middle right: Robertus Koehler
MCMIII
Gift of University of Minnesota College of
Pharmacy Alumni Association
44.33
Illustration: Figure 75

PROVENANCE: University of Minnesota
College of Pharmacy

During his years in Minneapolis, Koehler seems to have abandoned his earlier social and political themes, focusing instead on still-lifes, landscapes, and portraits. Among the latter is a three-quarter length portrait of Dean Frederick J. Wulling, founder of the School of Pharmacy at the University of Minnesota.

Born in Brooklyn, New York in 1866, Wulling became one of the nation's outstanding educators in that branch of medical science. A man of insatiable intellectual curiosity, he studied law at night while directing the College of Pharmacy during the day, receiving his law degree from the University of Minnesota in 1896. He also had a genuine love of the arts, an interest no doubt stimulated by his friendship with Thomas Barlow Walker, Minnesota's first true patron of art and artists, whom Wulling met in 1895 or 1896. Wulling served on the board of directors of the Minneapolis Institute of Arts and created a receptive climate at the University of Minnesota for the eventual establishment of an art department and the University Gallery, to which he contributed 25 works from his own collection.

Wulling's portrait was commissioned from Robert Koehler by the College of Pharmacy Alumni Association, who presented it to the University in 1904. Accession records indicate that the work was exhibited at the convention of the Minnesota State Pharmacological Association in Minneapolis in 1904, at the Minneapolis Society of Fine Arts, at the Minneapolis Main Library, and at several medical conventions from 1904 to 1907.

Wulling was 37 years old when this portrait was painted, a diminutive person of fastidious habits and appearance. Koehler shows him as still youthful, intelligent, and thoughtful, his hands clasped in front of him as he glances downward in quiet contemplation. The well-drawn and beautifully modeled head projects the very essence of the scholar-teacher. In its revelation of personality and character, this portrait deserves comparison with the work of Thomas Eakins.

Dean Frederick J. Wulling, *1903* ▪ *Figure 75*

In the early days of the College of Pharmacy, Dean Wulling conceived the idea of a portrait gallery of prominent historical figures in that discipline. He believed that such a collection would be of valuable assistance in teaching the history of pharmacy. He was so convinced of this that when no University funds could be found for the project, he decided to proceed anyway at his own expense. Wulling commissioned one portrait a year for several years, hoping that the University would eventually be in a position to step in and assume the costs. When this never happened, Wulling was eventually forced to discontinue the commission.

Of the portraits in this series, four were painted by Robert Koehler: *Dr. Charles Rice, Edward Parrish, Peter Wendover Bedford*, and *William Proctor, Jr.* Dr. Rice (1841-1900) of New York was a distinguished professional pharmacist and classical scholar. Professor Parrish (1820-1872) wrote the first American textbook on pharmacy and was on the faculty at the Philadelphia College of Pharmacy. Professor Bedford (1836-1892) was professor of theory and practice at the College of Pharmacy at the City of New York (now Columbia University) and the foremost professional pharmaceutical educator and editor of his time. Professor Proctor (1817-1872) was the first American professor of pharmacy and taught at the Philadelphia College of Pharmacy; according to Wulling, this portrait was exhibited in 40 cities across the United States as part of a traveling exhibition that originated in New York in 1903 or 1904 (Letter from Frederick Wulling to University President W.C. Coffey, 25 May 1942).

It is believed that at least some of these were painted from photographs supplied by Wulling, a not uncommon practice at the time. This would help explain the "hardness" of the drawing and the rather lifeless appearance of some of the sitters.

For a portrait of another important figure in the history of pharmacy, see Herbjørn GAUSTA's *Dr. Edward Robinson Squibb*. L.A.A.

William Proctor, Jr., *c. 1893-1903*

Oil on canvas, 20 x 24 in.
(50.8 x 61 cm.)
Signed verso: Robert Koehler
Gift of Frederick J. Wulling
44.31
Illustration: Appendix

PROVENANCE: Frederick J. Wulling

Peter W. Bedford, *c. 1895-1915*

Oil on canvas, 20 x 24 in.
(50.8 x 61 cm.)
Signed verso: Robert Koehler
Gift of Frederick J. Wulling
44.30
Illustration: Appendix

PROVENANCE: Frederick J. Wulling

Edward Parrish, *c. 1895-1915*

Oil on canvas, 20 x 24 in.
(50.8 x 61 cm.)
Signed verso: R. Koehler
Gift of Frederick J. Wulling
44.32
Illustration: Appendix

PROVENANCE: Frederick J. Wulling

Dr. Charles Rice, *c. 1895-1915*

Oil on canvas, 20 x 24 in.
(50.8 x 61 cm.)
Signed verso: Robert Koehler
Gift of Frederick J. Wulling
44.34
Illustration: Appendix

PROVENANCE: Frederick J. Wulling

BENJAMIN D. KOPMAN
1887-1965

SELECTED BIBLIOGRAPHY: David Ignatoff, *Kopman* (New York: E. Weyhe, 1930) ▪ Milton A. Brown, *American Painting from the Armory Show to the Depression* (Princeton, New Jersey: Princeton University Press, 1955), 148 ▪ *Benjamin Kopman, Paintings and Drawings* (New York: World House Galleries, 1958).

Oil on canvas, 17¼ x 23½ in.
(43.8 x 59.7 cm.)
Unsigned
Bequest of Hudson Walker from the Ione and Hudson Walker Collection
78.21.54
Illustration: Appendix

EXHIBITION: *Selections from the Collection of Mr. and Mrs. Hudson D. Walker*, 1950

PROVENANCE: Alfred Stieglitz; Ione and Hudson Walker

Fanciful visions and nightmarish dreams executed in a primitive style characterize the painting of Russian-born Benjamin Kopman. His Jewish heritage and cabalistic sensitivity served as springboards for his emotional and expressionistic work. He studied at the traditional National Academy of Design, but his paintings reflected modernistic tendencies reminiscent of Marc Chagall and Hendrick Campendonk, and he was briefly associated with Alfred Stieglitz and his 291 Gallery (New York).

Despite the moodily romantic nature of much of his work, Kopman occasionally exhibited a sense of humor. A writer and illustrator as well as a painter, he illustrated editions of *Crime and Punishment* in 1944 and *Frankenstein* in 1948—subjects well-suited to the dark colors he preferred. *P.N.*

Landscape, *c. 1910-1920*

Abrupt disjunctions of scale and dark, moody colors contribute to the mysterious, surreal quality of this work and hint at Kopman's more macabre paintings. Although cows were popular symbols of pastoral tranquility during the nineteenth century, the one in the foreground of this painting is an unearthly beast that overpowers the landscape and the house in the distance. The primitively rendered landscape has been reduced to its barest essentials, creating a confusing spatial arrangement that challenges the viewer to examine the relationship between animate and inanimate forms. Probably an early work, *Landscape* once belonged to Alfred Stieglitz, as indicated by the collector's stamp on the back of the painting.

CHET HARMON LA MORE
1908-1980

SELECTED BIBLIOGRAPHY: "Reviews," *Art Digest* (15 November 1944): 13 • "Reviews," *Art News* (February 1950): 47.

Perhaps inspired by his interest in children's art as well as surrealism, Chet La More painted angular, imaginative animals in the 1940s and sculpted them in the 1950s and 1960s. Born in Dane County, Wisconsin, he studied at the Colt School of Art in Madison from 1926 to 1928 and received a B.A. in 1931 and an M.A. in art history and criticism in 1932 from the University of Wisconsin.

On a commission from the U.S. Treasury Department, he completed a mural in 1934 for the Polytechnical Institute of Baltimore titled *The History of Sports*. Known initially as a printmaker and muralist, he turned to easel painting in the late 1930s but continued to work with prints throughout his career. He participated in the "Pictures for Children" exhibitions at the Museum of Modern Art in the early 1940s, and together with Mervin JULES he exhibited color prints for children in shows which toured nationally from 1941 to 1944 under the sponsorship of the American Federation of Arts.

La More's prints and paintings contain elements of fantasy and allusions to social problems. Forms are simplified and distorted into triangular shapes which float in spaces resembling land and seascapes. This same combination of biomorphic and geometric shapes appears in his semi-abstract sculpture pieces, which he constructed of welded bronze and sheetmetal cutouts and showed in New York through the mid-1960s.

La More started painting again in 1969, exhibiting 16 large panels at the Rackham Galleries at the University of Michigan in Ann Arbor in 1975. He taught studio art at the University of Wisconsin, Ohio State University, and the Albright Art School in Buffalo, New York before returning to the University of Michigan, where he taught from 1947 until his retirement in 1973. *M.T.S.*

Spring Day, *1942*

Tempera on composition board, 6 x 8⅞ in.
(15.2 x 22.5 cm.)
Signed lower right: La More
Bequest of Hudson Walker from the Ione
and Hudson Walker Collection
78.21.104
Illustration: Figure 76

REFERENCE: Letter from Chet La More to
Sue Kendall at the University Gallery, 19
June 1979.

EXHIBITIONS: ACA Galleries, New York,
Chet La More, 1942 • Drew Fine Arts
Center, Hamline University, St. Paul,
Exhibition, 1952.

PROVENANCE: ACA Galleries, New York;
Ione and Hudson Walker

La More's canvases from the period 1942 through 1950—fantastic environments inhabited by amoebic creatures—are often compared to the works of Joan Miró and Paul Klee. Of this particular piece, the artist himself wrote, "During the winter and spring of 1941-42 I did a group of egg tempera paintings on gesso (masonite) panels. All of these were small (under 10") and many were miniatures…. *Spring Day* was in this group and, I think, one of four dealing with the seasons….Hudson Walker must have bought *Spring Day* from the ACA *[gallery in New York, where La More had his first one-man show in 1941. Ed.]*. I know that he liked the show which was a lighthearted affair, fanciful and satirical. He bought it for the children" (La More to Kendall, 19 June 1979).

Spring Day, *1942 • Figure 76*

253

EDWARD LANING
1906-1981

SELECTED BIBLIOGRAPHY: Edward Laning, "Spoon River Revisited," *American History* 22 (June 1971): 17 and passim • Francis O'Connor, *The New Deal Art Projects, An Anthology of Memoirs* (Washington, D.C.: Smithsonian Institution Press, 1972), 79-113 • Howard S. Wooden, *Edward Laning, American Realist, 1906-1981, A Retrospective Exhibition* (Wichita: Wichita Art Museum, 1982).

Born on April 26 in Petersburg, Illinois, Edward Laning was destined to have a difficult childhood. His mother died when he was 12, after which his father took the family to Oklahoma and deserted them the following year. Edward returned to Petersburg to live with his maternal grandparents. In 1924 he attended the summer session of the Art Institute of Chicago, and in 1925 he entered the University of Chicago as a freshman.

Soon after, art became a passion for him. He left Illinois, traveled to New York City, and took classes at the Art Students League from 1926 through 1929, where his teachers included Realists Kenneth Hayes Miller and John Sloan and Regionalist Thomas Hart Benton. Laning went to Europe in 1929 and studied mural painting with Miller on his return in 1930. The two became close friends and journeyed to Europe together the following year; when Miller went on sabbatical, Laning took over teaching his classes at the Art Students League.

Laning participated in the first Whitney Museum Biennial exhibition in 1932 and joined the roster of American artists associated with the newly formed Midtown Galleries (New York). The Whitney Museum purchased his *Fourteenth Street* that same year. During the Depression Laning worked on the New York City Emergency Work Bureau projects, executing a mural for St. Illuminator's Armenian Cathedral and another for the Hudson Guild Settlement House. In 1935 he was chosen to participate in the WPA/FAP, and it was for this project that he completed a series of murals for the Ellis Island immigrant dining area. He also painted murals for the Rockingham, North Carolina Post Office under the Section of Painting and Sculpture of the Treasury Department and received the commission to paint *The History of the Written Word* for the New York Public Library, a series of murals completed in 1940. Under the Treasury Section he also completed another Post Office mural for Bowling Green, Kentucky in 1941.

In World War II Laning was assigned by the War Department Art Unit to Alaska, where he portrayed events in the Aleutians for the government and, later, for *LIFE* magazine. In 1944 *LIFE* sent him to Italy and North Africa as an art correspondent. Following the war he received both a Guggenheim Fellowship and a grant from the American Academy of Arts and Letters and accepted a teaching

position at the Kansas City Art Institute, where he stayed through 1950. From 1950 to 1952 he traveled and painted in Italy on two Fulbright Fellowships. Upon completing the fellowships, he was named an instructor of painting at the Art Students League and taught there until 1975.

Meanwhile he was elected to the National Academy of Design in 1958, and in 1959 he was chosen to paint a series of murals for the Sheraton Dallas Hotel. His first book, *Perspectives for Artists*, was published in 1967. In 1969 he was elected president of the National Society of Mural Drawings, a post he held until 1974. A second book, *The Act of Drawing*, was published in 1972, the same year that his Ellis Island murals were salvaged and installed in Brooklyn.

Laning was an active muralist until the end of his life, executing commissions for the National Bank of Petersburg, Illinois (1975-1976), the Railroad Museum in Ogden, Utah (1977-1980), and the Dewitt Wallace Periodicals Room of the New York Public Library (1981). The latter remains incomplete; he was still working on it when he died.

A major retrospective of Laning's works was held at the Wichita Art Museum, September 11-October 17, 1982. *R.L.G.*

Third Avenue El at Fourteenth Street, *1931*

Tempera on gessoed masonite, 20 x 30 in. (50.9 x 76.3 cm.)
Signed lower right: Laning - '31
Gift of funds from the Class of 1930
82.4
Illustration: Colorplate XIV

This painting was exhibited at the Midtown Galleries (New York) in 1933 as *Street Scene* and at the Danenberg Galleries (New York) in 1969 as *Fourteenth and Sixth*. It is clear, however, that the scene depicted is of the vicinity of Fourteenth Street in lower Manhattan. That part of New York became the haunt for a group of American artists known as the "Fourteenth Street School" that gathered around Laning's teacher and friend Kenneth Hayes Miller. Taking their cue from the urban environment, this group elected to depict contemporary reality but invest it with all the monumentality and grandeur of classical antiquity and Renaissance ideas of perspective, proportion, and harmony. Thus *Third Avenue El at Fourteenth Street* shows the viewer a working-class commercial center crowded with ordinary people—but the people are posed in compact, symmetrical arrangements across a shallow, stagelike space in the manner of a classical frieze. The three main groupings (at left,

EXHIBITIONS: Montclair Art Museum, Montclair, New Jersey, *The Post-Armory Decades*, 1969 ▪ *Images of the American Worker 1930-1940: An Undergraduate Honors Seminar Exhibition*, 1983 ▪ *The First Fifty Years 1934-1984: American Paintings and Sculpture from the University Art Museum Collection*, 1984 ▪ *New York and American Modernism*, 1984 ▪ *The First Fifty Years 1934-1984: Recent Acquisitions and Promised Gifts to the University Art Museum*, 1984.

PROVENANCE: Midtown Galleries, New York; Dudensing Galleries, New York; Kennedy Galleries, New York

center, and extreme right) divide the canvas into a triptych with each group forming a triangular unit—the ideal shape for conveying stable, solid forms. Each group is further posed with a variety of figures, some facing the viewer and others with their backs turned.

The source for such an arrangement derives from classical and Renaissance depictions of the Three Graces. In this way Laning subtly suggests that ditch diggers and office girls, harried commuters and busy shoppers all possess dignity and beauty. The bright color scheme of the shoppers' wardrobes unifies the composition and helps carry the eye through the canvas. The commercial building in the background further flattens the scene into a stagelike space.

Note Laning's insistence on carefully depicting billboards and other signs of commercialized, industrialized America. We can purchase rubber boots and shoes, hats, umbrellas, raincoats or shirts at a "bargain store"; we can slake our thirst with orange drink or an ice-cream soda; we can buy a new collar for our white shirt or a pair of blue denim workers' overalls. The emphasis on consuming must have seemed ironic in 1931, when this picture was painted and the American economy was grinding to a halt. Yet Laning never moralizes or condemns urban life; rather, his painting seeks to celebrate the vibrancy of the city and the dignity of the average person who lives there.

DOROTHEA LAU
(dates unknown)

SELECTED BIBLIOGRAPHY: "Twenty-Third Annual Twin City Art Show," *Bulletin of the Minneapolis Institute of Arts* 26 (16 October 1937), 130 ▪ Minneapolis History Collection, Minneapolis Public Library.

Dorothea Lau studied at the Minneapolis School of Art (now the Minneapolis College of Art and Design). She completed a work under the WPA for Southwest High School in Minneapolis, but it has since been lost or removed from the building. In October 1937, Lau exhibited *Shoppers*, described as a "social scene," in the Twenty-Third Annual City Art Exhibit at the Minneapolis Institute of Arts. *M.T.S.*

Stormy Beach, *c. 1935-1940*

Oil on canvas, 20 x 24⅛ in.
(50.8 x 61.3 cm.)
Unsigned
WPA Art Project, Minneapolis
43.773
Illustration: Appendix

PROVENANCE: WPA Art Project, Minneapolis

With its storm-tossed boat, bending trees, and darkened sky, *Stormy Beach* is a work within the American romantic tradition of Albert Pinkham Ryder and Winslow Homer. Content, however, is derived from the American scene.

Workers—Five O'Clock, *c. 1935-1940*

Oil on canvas, 23¾ x 30 in.
(60.3 x 76.2 cm.)
Unsigned
WPA Art Project, Minneapolis
43.774
Illustration: Figure 77

EXHIBITIONS: Tweed Museum of Art, University of Minnesota-Duluth, *Accomplishments: Minnesota Art Projects in the Depression Years,* cat. 44 • *Contact: American Art and Culture 1919-1939,* 1981, cat. 6 • Alumni Club, Minneapolis, *75th Anniversary Exhibition,* 1979-1980 • *Images of the American Worker 1930-1940: An Undergraduate Honors Seminar Exhibition,* 1983.

PROVENANCE: WPA Art Project, Minneapolis

The muscular workers appear to loom monumentally in front of their excavated work field. Derivative of the hard-edged style used in painting figures and environment in murals during the Depression, the canvas also resembles the crystalline forms and figural placement of Everett SPRUCE.

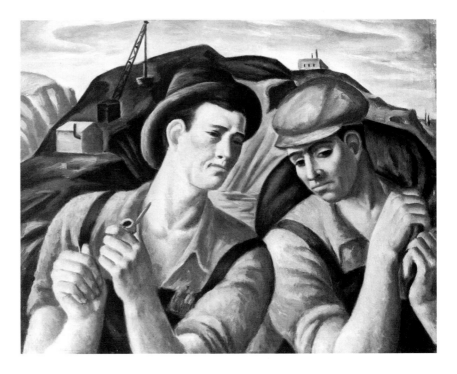

Workers—Five O'Clock, *c. 1935-1940 • Figure 77*

257

JACOB LAWRENCE
1917-

SELECTED BIBLIOGRAPHY: Aline B. Saarinen, *Jacob Lawrence* (New York: American Federation of Arts, 1960) • Milton W. Brown, *Jacob Lawrence* (New York: Whitney Museum of American Art, 1974) • *The Legend of John Brown, Jacob Lawrence: John Brown, 22 Gouaches, Robert Hayden: John Brown, A Poem,* Introduction by Ellen Sharp (Detroit: Detroit Institute of Arts, 1978) • Avis Berman, "Jacob Lawrence and the Making of Americans," *ARTnews* 83:2 (February 1984): 78-86.

For Jacob Lawrence, reality is caricature or the heightened gesture. His paintings are essentially narrative and were often done in series. Simple, intensely colored shapes define his figures and their environment.

Born in Atlantic City, New Jersey, Lawrence moved with his mother to New York in 1924. He went to Utopia Children's House after school, where he was first given poster paints and other art materials. Living in an imaginary world, he created masks and play sets which formed and colored his mature style. He was tutored by the artist Charles Alden at Utopia House and attended art classes in the 135th Street Public Library and the Harlem Art Workshop. In 1937 he received a scholarship to the American Artists School, where he studied with Anton REFREGIER, Sol WILSON, and Eugene Moreley. He claims that after this period he was most strongly influenced by the work of Pieter Bruegel, Käthe Kollwitz, Arthur DOVE, and the Mexican muralists Diego Rivera and José Clemente Orozco.

In 1937 Lawrence began to work on *Toussaint L'Ouverture*, the first of several series dealing with the history of blacks in America which repeated motifs and used a similar pattern. In paintings from these series and most later works, Lawrence used color in flat forms and achieved spatial depth by color juxtaposition and exaggerated perspective.

Lawrence joined the WPA/FAP easel section late in 1939 and worked for the next two years on the project. After receiving a Rosenwald Fellowship in 1940, he began to work on his *Migration* series. His first important one-man show, the result of a growing interest in black art fostered by the federal art projects, came in 1941 when Edith Halpert exhibited his work at the Downtown Gallery.

A public relations officer in the Coast Guard, Lawrence painted servicemen and port scenes which were exhibited at the Museum of Modern Art in 1944. After his discharge from the service, he received a Guggenheim fellowship in 1946 and began a cycle of paintings related to the theme of war; from 1947 to 1949 he

focused on genre scenes in the South. He illustrated institutional life following a mental breakdown in 1949 and, after his hospitalization, went on to paint a series centering around performances from 1950 to 1955, and the history of the American people in the *Struggle* series. After the early 1960s he dealt with the theme of civil rights struggles in the South and the growth of black nationalism.

Lawrence taught at Pratt Institute from 1956 to 1966, at the New School for Social Research from 1966 to 1969, and the Art Students League from 1967 to 1969. He has taught at the University of Washington in Seattle since 1971. *M.T.S.*

Dancing Doll, *1947*

Commissioned by *Fortune* magazine in 1947 to do a series of paintings on the postwar South, Lawrence infused these works with detailed observations of black life in both the North and the South. Compositions were crowded with fragmented shapes and figures. Lawrence wrote that this painting, like his other genre scenes, was "mostly autobiographical in content, pertaining to and about my own personal experiences.... It is a street scene of peddlers selling dolls which dance. The doll dances as it is manipulated by an invisible string" (Lawrence to Kriss, 18 November 1978).

Gouache on composition board, 20¼ x 24⅛ in.
(51.4 x 61.3 cm.)
Signed and dated lower right: Jacob Lawrence 1947
Bequest of Hudson Walker from the Ione and Hudson Walker Collection
78.21.288
Illustration: Figure 78

REFERENCE: Letter from Jacob Lawrence to Mark Kriss at the University Art Museum (18 November 1978).

EXHIBITIONS: Drew Fine Arts Center, Hamline University, St. Paul, *Exhibition*, 1952 • *Selected Works from the Collection of Ione and Hudson Walker*, 1959 • *Art and the University of Minnesota*, 1961 • *Hudson D. Walker: Patron and Friend*, cat. 46.

PROVENANCE: The Downtown Gallery, New York; Ione and Hudson Walker

Dancing Doll, *1947* ▪ *Figure 78*

ERNEST LAWSON
1873-1939

SELECTED BIBLIOGRAPHY: Guy Pène du Bois, *Ernest Lawson* (New York: Whitney Museum of American Art, 1932) ▪ Bennard B. Perlman, *The Immortal Eight: American Painting from Eakins to the Armory Show (1870-1913)* (New York: Exposition Press, 1962), 131-133, passim ▪ Henry and Sidney Berry-Hill, *Ernest Lawson, American Impressionist, 1873-1939* (Leigh-On-Sea, England: F. Lewis Publishers, Ltd., 1968) ▪ D.R. Anderson, *Ernest Lawson: A Retrospective* (New York: ACA Galleries, 1976) ▪ Adeline Lee Karpiscak, *Ernest Lawson, 1873-1939* (Tucson: University of Arizona Museum of Art), 1979.

An American Impressionist and member of The Eight, Ernest Lawson painted scenes of the Hudson and Harlem Rivers in New York City. Although he was reputed to have been born in San Francisco while his parents were sailing on his grandfather's clipper ship, he was probably born in Halifax, Nova Scotia. Raised by relatives there until age 15, Lawson then went to live with his parents in Kansas City. When they moved to Mexico City, he studied art at the Santa Clara Art Academy. Arriving in New York in 1890, he studied at the Art Students League and at Cos Cob, Connecticut in the summer school of John Twachtman and Julian Alden Weir.

260

He traveled to Paris in 1893 and studied at the Académie Julian under Jean Paul Laurens and Benjamin Constant. He wrote letters home praising Whistler's painting, recounting his meeting with Alfred Sisley, and explaining his own experiments with pointillism. Two paintings from this period were shown in the 1894 Salon des Artistes Français; another was exhibited at the National Academy of Design in 1897.

Lawson returned to New York in 1897 and settled in Washington Heights, where he painted many scenes of the agrarian landscape surrounding the Harlem and Hudson Rivers. The Macbeth Gallery was his early dealer and served as a meeting place for him and other members of The Eight who exhibited there as a group in 1908. Lawson's delicately brushed impressionist landscapes, the dreamscapes of Arthur B. Davies, and the muted land and cityscapes of Maurice Prendergast were decidedly different from the dark racism of the city scenes portrayed by The Eight's other five members.

Elected an associate of the National Academy in 1908 and a full member in 1917, Lawson continued to paint scenes of New York and New England through the 1930s. His forms remained clearly defined within an impressionist palette that one critic compared to crushed jewels. He taught sporadically throughout his career: at Columbus, Georgia in 1917; at the Kansas City Art Institute in Kansas City, Missouri in 1926; and at the Broadmoor Academy in Colorado Springs, Colorado in 1927. He spent the last nine years of his life painting intermittently and living in Florida and Colorado. *M.T.S.*

Excavation—Penn Station, *c. 1906*

Oil on canvas, 18⅛ x 24¼ in. (46 x 61.6 cm.)
Signed lower left: E. Lawson
Bequest of Hudson Walker from the Ione and Hudson Walker Collection
78.21.845
Illustration: Figure 79

Influenced by his association with The Eight, this canvas is typical of Lawson's early depictions of city scenes. The excavation of Penn Station, an architectural landmark and a major transportation center for the city of New York, began in 1906. Lawson has captured this event in the stippled brushstrokes of Impressionism, but his pervasive brown palette and theme of workers hewing the earth reflected the architectural urbanscapes of the period.

EXHIBITIONS: *100 Paintings, Drawings, and Prints from the Ione and Hudson D. Walker Collection*, 1965, cat. 62 • *Selections from the Permanent Collection*, 1968, 1969, 1970, 1975 • The Minneapolis Institute of Arts, Minneapolis, *American Arts: A Celebration*, 1976 • *Hudson D. Walker: Patron and Friend*, 1977, cat. 47 • *Selections from the Permanent Collection*, 1980 • Minnesota Museum of Art, St. Paul, *American Style: Early Modernist Works in Minnesota Collections*, 1981, cat. 43 • *The First Fifty Years 1934-1984: American Paintings and Sculpture from the University Art Museum Collection*, 1984.

PROVENANCE: Babcock Galleries, New York; Ione and Hudson Walker

Excavation—Penn Station, *c. 1906* • *Figure 79*

MYRON LECHAY
1898-

SELECTED BIBLIOGRAPHY: "Reviews," *Art Digest* (1 April 1947): 8 • "Reviews," *Art News* (April 1947): 42.

Born in Russia near Kiev, Myron Lechay immigrated to New York and studied for a short period at the National Academy of Design. His early paintings were influenced by the urban realism of Robert Henri's Ash Can school, but by the mid-1920s his canvases of buildings, streets, and harbors were composed with geometrically shaped color patterns. Paintings from the late 1920s and early 1930s resembling those of Dufy and Utrillo laid the groundwork for his later decorative cityscapes of New York and New Orleans. During the Depression, Lechay worked on the WPA/FAP easel project in New Orleans.

Whether painting views of excavations or factory lots, Lechay used pastel hues to cover over scenes that most social realists depicted with a somber palette. In canvases completed during the late 1940s he applied pastel washes in small, Seurat-like patches. Lechay's work was the subject of a retrospective at the Valentine Gallery (New York) in 1947. *M.T.S.*

262

These scenes, which give the impression of being veiled by a thin gauze or muslin curtain, were painted while Lechay was part of the WPA easel project in Louisiana. In 1942 Piet Mondrian came to view Lechay's canvases, which were being exhibited at the Valentine Gallery. After having the gallery owner turn them upside down, Mondrian pronounced them compositionally sound ("Reviews," *Art News*, p. 23).

Roofs, *c. 1936*

Oil on canvas, 20¾ x 26½ in. (52.7 x 67.3 cm.)
Signed lower left: M. Lechay
WPA Art Project, Washington, D.C.
43.727
Illustration: Figure 80

PROVENANCE: WPA Art Project, Washington, D.C.

Roofs, *c. 1936* ▪ *Figure 80*

Landscape #3, *1938*

Oil on canvas, 30 x 20 in. (76.2 x 50.8 cm.)
Signed lower right: Myron Lechay 38
WPA Art Project, Washington, D.C.
43.726
Illustration: Appendix

PROVENANCE: WPA Art Project, Washington, D.C.

Oil on canvas, 30 x 25 in.
(76.2 x 63.5 cm.)
Signed verso: Myron Lechay Feb. 24 '40
New Orleans
WPA Art Project, Washington, D.C.
43.725
Illustration: Appendix

PROVENANCE: WPA Art Project,
Washington, D.C.

Entrance, *1940*

MAC LESUEUR
1908-

SELECTED BIBLIOGRAPHY: *LeSueur So Far,
1930-1944*, exhibition catalogue
(Minneapolis: Walker Art Center, 1944) •
"Mac LeSueur," *Art News* (1 August
1944): 13 • Minneapolis History Collection,
Minneapolis Public Library.

At age 20 Mac LeSueur found himself with an extra $200 and decided to invest it in a sculpture course at the Minneapolis School of Art. Claiming that the teacher disapproved of his radical ideas, he was expelled from that class but did go on to complete the school's three-year painting course in 1932.

LeSueur was born in San Antonio, Texas into a family originally from the Midwest. After moving to Minneapolis and graduating from the Minneapolis School of Art, he went to Mexico for three months in 1933 to sketch, making extra money by painting murals in speakeasies in Santiago and Sacramento. He returned to Minneapolis to teach drawing and painting at the Minneapolis Art Center, then a part of the WPA/FAP, from 1934 to 1938. The canvases he completed in the 1930s illustrated scenes of local workers and gently satirized the political situation. LeSueur was a member of the Minnesota Artists Union and served as its president for a term during the 1930s.

From 1940 to 1950 he was director of the Art School of the Walker Art Center. During that time he painted in styles ranging from social realism to surrealism and used images which bordered on caricature. Over 100 paintings, drawings, and pastels representing 15 years of work were featured in a retrospective at Walker Art Center in 1944.

LeSueur taught at the St. Paul School of Art from 1950 to 1962 and lived and painted in Georgia in 1958. His paintings, always based on landscape scenes he had seen on sketching trips, evolved into colorful abstractions which barely alluded to their origins in nature.

LeSueur has had 22 one-man shows and was featured in group exhibitions at the California Palace of the Legion of Honor in San Francisco and the Art Institute of Chicago and in many of the Local Artists Exhibitions at the Minneapolis Institute of Arts. *M.T.S.*

Six of the nine paintings by LeSueur in the University Art Museum's collection were shown in the LeSueur retrospective at Walker Art Center in 1944. In his Introduction to the exhibit catalog, director D.S. Defenbacher wrote, "His work now is brilliant, sure, and very creative." In his Commentary, he went on to say that "...LeSueur uses his head. [He] is constantly studying the grammar and technique of his art, mulling over the problem that confronts him, seeking new habits of seeing and setting things down rather than resting content with the perfectly adequate old ones.... There is no pigeonholing of LeSueur" (*LeSueur So Far*, no page numbers). John K. Sherman, longtime art and drama critic for the Minneapolis papers, advised that "the show should be seen by all who assume too glibly that good artists either die young or go East. LeSueur represents homegrown originality" (*Art News*, p. 13).

The Individual, *1938*

Oil on canvas, 30⅛ x 36 in.
(76.5 x 91.4 cm.)
Signed lower right: LeSueur
WPA Art Project, Minneapolis
43.699
Illustration: Appendix

EXHIBITIONS: Walker Art Center, Minneapolis, *LeSueur So Far, 1930-1944*, 1944, cat. 55 ▪ Tweed Museum of Art, University of Minnesota-Duluth, *Accomplishments: Minnesota Art Projects in the Depression Years*, 1976, cat. 46.

PROVENANCE: WPA Art Project, Minneapolis

Yellow Rocker, *1939*

Oil on canvas, 30⅛ x 36 in.
(76.5 x 91.4 cm.)
Signed lower right: LeSueur
WPA Art Project, Minneapolis
43.696
Illustration: Appendix

EXHIBITIONS: Walker Art Center, Minneapolis, *LeSueur So Far, 1930-1944*, 1944, cat. 57 ▪ Walker Art Center, Minneapolis, *Modern Painting in Minnesota*, 1949.

PROVENANCE: WPA Art Project, Minneapolis

House on a Hill, *1940*

Oil on board, 21⅞ x 30 in.
(55.6 x 76.2 cm.)
Signed lower right: LeSueur
WPA Art Project, Minneapolis
43.784
Illustration: Appendix

PROVENANCE: WPA Art Project, Minneapolis

North Side, *1940*

Oil on canvas, 22 x 32 in.
(55.9 x 81.3 cm.)
Unsigned
WPA Art Project, Minneapolis
43.783
Illustration: Appendix

EXHIBITIONS: Walker Art Center,
Minneapolis, *LeSueur So Far, 1930-1944*,
1944, cat. 66 ▪ Tweed Museum of Art,
University of Minnesota-Duluth,
*Accomplishments: Minnesota Art Projects
in the Depression years*, 1976, cat. 50 ▪
Alumni Club, Minneapolis, *75th
Anniversary Exhibition*, 1979-1980.

PROVENANCE: WPA Art Project, Minneapolis

Old Mine, *1940*

Oil on canvas, 30 x 36 in.
(76.2 x 91.4 cm.)
Signed lower right: LeSueur
WPA Art Project, Minneapolis
43.765
Illustration: Appendix

EXHIBITIONS: Walker Art Center,
Minneapolis, *LeSueur So Far, 1930-1944*,
1944, cat. 75 ▪ Tweed Museum of Art,
University of Minnesota-Duluth,
*Accomplishments: Minnesota Art Projects
in the Depression Years*, 1976, cat. 48.

PROVENANCE: WPA Art Project, Minneapolis

Pipes, *1940*

Oil on canvas, 20⅛ x 28 in.
(51.1 x 71.1 cm.)
Signed lower left: LeSueur
WPA Art Project, Minneapolis
43.697
Illustration: Appendix

EXHIBITIONS: Walker Art Center,
Minneapolis, *LeSueur So Far, 1930-1944*,
1944, cat. 67 ▪ *Original Paintings from the
University Collection*, 1946.

PROVENANCE: WPA Art Project, Minneapolis

Boy with a Rabbit, *c. 1940*

Oil on canvas, 25⅛ x 17¾ in.
(63.8 x 45.1 cm.)
Signed verso
WPA Art Project, Minneapolis
43.700
Illustration: Figure 81

EXHIBITION: Tweed Museum of Art,
University of Minnesota-Duluth,
*Accomplishments: Minnesota Art Projects
in the Depression Years*, 1976, cat. 47.

PROVENANCE: WPA Art Project, Minneapolis

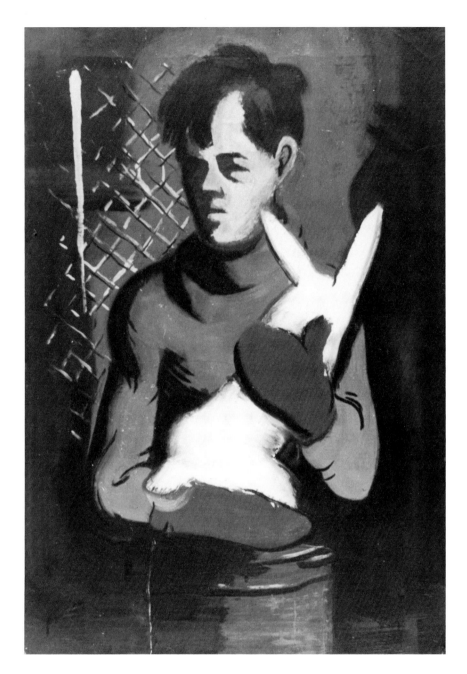

Boy with a Rabbit, *c. 1840* ▪ *Figure 81*

267

Old Mill, *c. 1940*

Oil on canvas, 30⅛ x 40 in.
(76.5 x 101.6 cm.)
Signed lower right: LeSueur
WPA Art Project, Minneapolis
43.698
Illustration: Appendix

PROVENANCE: WPA Art Project, Minneapolis

Boogie Woogie, *1943*

Oil on canvas, 71½ x 48⅛ in.
(181.6 x 122.2 cm.)
Signed lower left: LeSueur 43
Gift of Dr. and Mrs. M.A. McCannel
54.36
Illustration: Appendix

EXHIBITION: Walker Art Center,
Minneapolis, *LeSueur So Far, 1930-1944,*
1944, cat. 106.

PROVENANCE: D.S. Defenbacher; Dr. and
Mrs. M.A. McCannel

ROY LICHTENSTEIN
1923-

SELECTED BIBLIOGRAPHY: John Coplans, *Roy Lichtenstein*, (Pasadena: Pasadena Art Museum, 1967) • Diane Waldman, *Roy Lichtenstein* (New York: The Solomon R. Guggenheim Foundation, 1969) • Diane Waldman, *Roy Lichtenstein* (Milan: Gabriele Mazzotta Editore, 1971) • John Coplans, *Roy Lichtenstein* (New York: Praeger Publishers, 1972) • David Schaff, "A Conversation with Roy Lichtenstein," *Art International* 23:9 (January-February 1980): 28-38 • Jack Cowart, *Roy Lichtenstein, 1970-1980* (New York: Hudson Hills Press in association with the St. Louis Art Museum, 1981) • David Deitcher, "Lichtenstein's Expressionist Takes," *Art in America* 71:1 (January 1983): 84-89 • Lawrence Alloway, *Roy Lichtenstein* (New York: Abbeville Press, 1983).

New York City native Roy Lichtenstein was fascinated by the visual problems in comic strips long before he used them in paintings. His early interest in the psychology of vision was fostered by his education at the School of Fine Arts at Ohio State University, where he received his M.F.A. in 1949. Lichtenstein had come to Ohio in 1942, having decided that the regionalist interest at the Art Students League offered him little stimulation. He went back East in 1957 when he was appointed assistant professor at New York State University at Oswego. He then taught at Rutgers University from 1960 to 1964, at which point he decided to paint full time. His paintings—abstract expressionist in content and technique—gradually changed in the early 1960s due to his association with Allan Kaprow, with whom he discussed American consumer culture and events.

Lichtenstein's first pop paintings, whose subjects were recognizable characters from comic-strip frames, were drawn onto canvas using oil painting methods and advertising techniques such as benday

dots, lettering, and balloons. In 1963 he developed a technique for transferring drawings to canvas with an opaque projector, which resulted in harder edges, fewer mistakes, and a reduced need for pencil lines. His comic images were divided into three main groups: war and violence, love and romance, and science fiction. Portrayals of women appeared more brittle in the mid-1960s as their masklike faces and hair became independent compositional elements. The three to four colors used in his images functioned simply as primary hues in a colorbook format of black lines.

Lichtenstein's art contains no obvious personal references, yet his content and style often parody earlier styles. This is evident in the fake Mondrians he created in the *Non Objective* series from 1964, the optically mixed dots of color in his *Rouen Cathedral* lithographic series from the early 1970s, and his painting and sculpture based on the art of the 1930.

After resigning from Rutgers, Lichtenstein exhibited regularly at the Leo Castelli gallery in New York. His work has been the subject of two retrospectives: one in 1967 at the Stedelijk Museum in Amsterdam, and the other, featuring work from 1961 to 1969, at the Solomon R. Guggenheim Museum. *M.T.S.*

World's Fair Mural, *1964*

Oil on plywood, 240 x 192 in.
(609.6 x 487.7 cm.)
Unsigned
Gift of the artist
68.7
Illustration: Figure 82

REFERENCE: Philip Johnson, "Young Artists at the Fair," *Art in America* (4 November 1964): 113.

EXHIBITION: Special viewing, University Gallery, 1966.

PROVENANCE: the artist

Lichtenstein's panel was one of several that architect Philip Johnson commissioned from several artists to line the exterior of the circular building he designed for the 1964 New York World's Fair. About these works, Johnson wrote, "It is a pleasure to see several of our mid-generation artists handle the same sized space next to one another in the same building....Developments that surprised me...[were] the mournful dignity of Rauschenberg. The carrying power of the 'pop' Lichtenstein" (Johnson, p. 112).

Similar to Lichtenstein's other canvases from the mid-1960s portraying comic-strip women, this shows hands expressively used to evoke a mood. When in place, the composition must have seemed to burst through the structural confines of the building in a conscious and humorous attempt to break up the wall space of Johnson's pavilion.

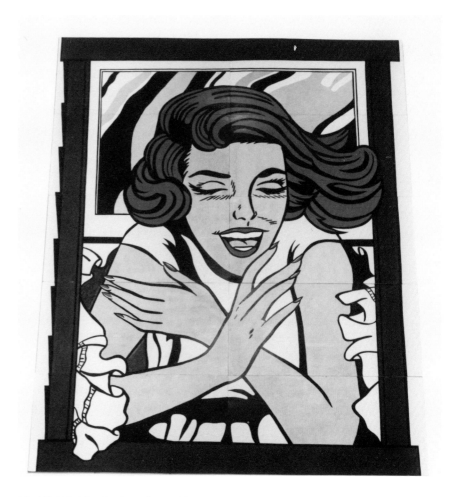

World's Fair Mural, *1964 ▪ Figure 82*

JONAS LIE
1880-1940

SELECTED BIBLIOGRAPHY: Rose V.S. Berry, "Jonas Lie: The Man and His Art," *The American Magazine of Art* (February 1925): 58-66 ▪ F. Newlin Price, "Jonas Lie, Painter of Light," *International Studio* (November 1925), 102-107 ▪ Royal Cortissoz, "Commemorative Tribute to Jonas Lie," *The American Academy of Arts and Letters: Academy Notes and Monographs* (American Academy of Arts and Letters publication 96, 1940), 21-27 ▪ Henry Geldzahler,

Jonas Lie was born in Moss, Norway to an American mother and a Norwegian father, a civil engineer and member of a distinguished family of writers, musicians, and painters. After his father's death in 1892, Jonas lived for a year in Paris with his cousin and namesake, the Norwegian writer Jonas Lie. He received special art instruction in a Parisian school and became personally acquainted with Henrik Ibsen, Georg Brandes, and Edvard Grieg, who frequently called on his cousin.

American Painting in the Twentieth Century (New York: The Metropolitan Museum of Art, 1965), p. 21 ▪ Mary Towley Swanson, *The Divided Heart: Scandinavian Immigrant Artists, 1850-1950* (Minneapolis: University of Minnesota Gallery, 1982), 25.

In 1897 he immigrated to Plainfield, New Jersey with his mother and two sisters. He designed calico patterns in a cotton factory to support his family while attending night classes at the National Academy of Design and later the Art Students League. By the time he began to paint professionally in 1906 he had a backlog of thumbnail sketches and city scenes done during lunch breaks and commuting trips to New York City.

Throughout his career, Lie incorporated both city and landscapes, figure studies, and flower pieces into his subject matter. Three days after Lie had seen a movie featuring the ongoing excavation of the Panama Canal, he left New York for Panama to paint a series of dramatic scenes of the canal site and workmen which was completed in 1910. His early paintings, shown in 1912 at the Art Institute of Chicago, were described as "covering vigorous renderings of New York, both city and river front, flower arrangements in brilliant color, and harmonious, low-toned marines and landscapes" (*Bulletin of the Art Institute of Chicago*, October 1912, p. 19). A versatile painter, Lie was especially interested in working with optical color effects when depicting landscapes.

He won several prizes during his lifetime and was voted an associate of the National Academy of Design in 1912 and a member in 1925, serving as president from 1934 to 1939. He was also active in Norwegian ethnic activities and exhibitions. His entry in the Armory Show of 1913 was a decorative panel featuring folkdancing Norwegians in costumes. *M.T.S.*

Clearing in the Woods, *c. 1915-1925*

Oil on canvas, 22½ x 18¼ in.
(57.2 x 46.4 cm.)
Signed lower right: Jonas Lie
Gift of John E. Larkin, Jr.,
76.20.1
Illustration: Figure 83

PROVENANCE: John E. Larkin, Jr.

Although Lie was famous for his snowy landscapes and scenes of sailboats against an open sea (both popular motifs with American academic painters in the 1920s), trees were a specialty; as one writer noted, "Lie's trees are not like anyone else's; his trees have personality....Lie catches the things they say—the spirit of their response to movement and the joy of their being....[He] uses them all the time for what they are, delightful pattern" (Berry, p. 65).

The silken, shimmering bark seen on the trees in the foreground was a hallmark of Lie's forest scenes. In painting these, the artist generally used a design which placed a predominant frontal silhouette of several trees against a nearly empty background.

271

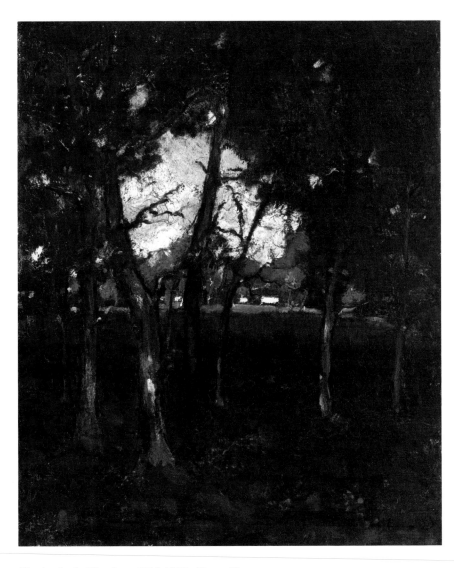

Clearing in the Woods, *c. 1915-1925* ▪ *Figure 83*

ERLE LORAN
1905-

SELECTED BIBLIOGRAPHY: Nancy A. Johnson, *Accomplishments: Minnesota Art Projects in the Depression Years* (Duluth, Minnesota: Tweed Museum of Art, 1976), no page numbers ▪ "The Watercolor Series: Erle Loran," *American Artist* (March 1950): 52-53, 61 ▪ Francis V. O'Connor *et al.*, *New Deal Art: California* (Santa Clara, California: De Saisset Art Gallery and Museum, University of Santa Clara, 1976), no page numbers.

Born in Minneapolis, Erle Loran Johnson legally shortened his name to Erle Loran in the early 1930s. He attended the University of Minnesota from 1922 to 1923 and graduated from a three-year course at the Minneapolis School of Art in 1926. Awarded the $6,000 John Armstrong Chaloner prize in 1926, he lived for two years in the Aix-en-Provence studio of Paul Cézanne. His studies of Cézanne's landscape and still-life compositions led to the publication of an article, "Cézanne's Country" (*The Arts*, April 1930) analyzing the master's design. It was later expanded into a book, *Cézanne's Composition*, published in 1944.

Returning to Minnesota in 1930, he exhibited often in local artists shows. He became one of approximately 30 artists who were paid for a weekly allotment of paintings under the auspices of the Public Works of Art Project (PWAP) in early 1934, and his Minneapolis scenes were exhibited periodically in public buildings and in galleries of the Minneapolis Institute of Arts. He was also employed by the WPA/FAP, which followed the PWAP a year later. During the mid-1930s he taught painting under the FAP.

Recommended for the position by his mentor, Cameron BOOTH, Loran taught at the University of California, Berkeley from the late 1930s until his retirement in the early 1980s. He was San Francisco correspondent for *Art News* magazine and published articles there and in other national art periodicals over a 30-year period.

Regionalist tendencies can be seen in his series on Nevada ghost towns from the late 1930s. He also attempted to incorporate Cézanne's formal ideas, writing in 1930 that "the artists' conscious thinking should be along the lines of organization of the plastic elements....However, even a landscape should contain elements of mood, association, and particulars of place and region represented" [quoted in Martha Cheney, *Modern Art in America* (New York: McGraw-Hill Book Company, Inc., 1939), p. 14]. It has been suggested that his facile brushwork from this period recalls Cézanne less than it does Japanese painting.

Loran primarily saw landscapes as designs in squares and rectangles of bright color. By the early 1950s his figures barely resembled natural objects, a progression toward abstraction that was reinforced by his study with Hans Hofmann in Provincetown during the summer of 1954. In the mid-1960s his works combined hard-edged areas and geometric symbols with irregularly splashed areas of paint. By the early 1970s these geometric areas evolved into heroic-sized female nudes whose anatomical forms were accented by rectangles of saturated color. *M.T.S.*

These two paintings were completed in 1934, while Loran was on the rolls of the PWAP. Approximately 30 Twin Cities artists brought in a weekly allotment of oils, gouaches, and watercolors. A technical committee consisting of Edmund Kopietz, Cameron BOOTH, and Alexander Masley evaluated the works and assigned a weekly pay scale. Completed paintings were shown in continually changing exhibitions at private galleries, public buildings, and galleries of the Minneapolis Institute of Arts. Several of Loran's paintings, possibly including these scenes, were shown at the Minneapolis Institute of Arts in March of 1934. A reviewer remarked that Loran's canvases were "executed in somewhat flattened colors lately characteristic of this artist, [and that] they reveal the impersonal beauty of industrial units" (Johnson, p. 28).

Crossroads, *1934*

Oil on canvas, 36½ x 30 in.
(92.7 x 76.2 cm.)
Signed lower right: Erle Loran '34
Public Works of Art Project (PWAP),
Minneapolis
34.142
Illustration: Appendix

EXHIBITIONS: *Original Paintings from the University Collection*, 1946, cat. 109 • Walker Art Center, Minneapolis, *Modern Painting in Minnesota*, 1949 • Tweed Museum of Art, University of Minnesota-Duluth, *Accomplishments: Minnesota Art Projects in the Depression Years*, 1976, cat. 51 • Minneapolis College of Art and Design, Minneapolis, *The Urban Muse: Painters Look at the Twin Cities*, 1977.

PROVENANCE: Public Works of Art Project (PWAP), Minneapolis

Oil on canvas, 35⅝ x 29¾ in.
(90.5 x 75.6 cm.)
Signed lower right: Erle Loran '34
Public Works of Art Project (PWAP),
Minneapolis
34.143
Illustration: Figure 84

EXHIBITIONS: *Original Paintings from the
University Collection*, 1946, cat. 110 ▪
Minnesota State Fair, St. Paul, *Exhibition*,
1949 ▪ Tweed Museum of Art, University of
Minnesota-Duluth, *Accomplishments:
Minnesota Art Projects in the Depression
Years*, 1976, cat. 52 ▪ Minneapolis College
of Art and Design, Minneapolis, *The Urban
Muse: Painters Look at the Twin Cities*,
1977 ▪ Alumni Club, Minneapolis, *75th
Anniversary Exhibition*, 1979-1980 ▪
Carleton College, Northfield, Minnesota,
*American Abstraction: 20th Century
American Paintings from the University of
Minnesota*, 1983.

PROVENANCE: Public Works of Art Project
(PWAP), Minneapolis

Flour Mills, *1934*

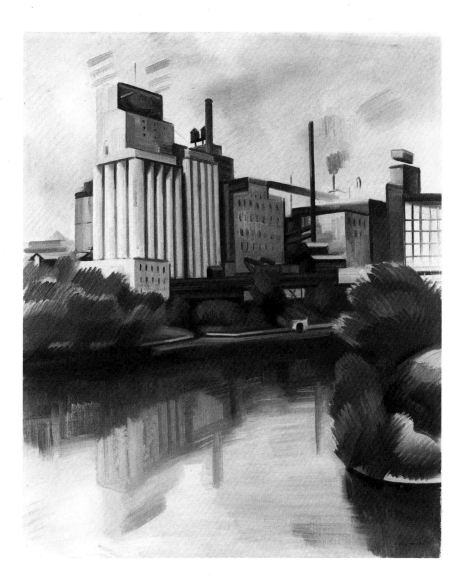

Flour Mills, *1934* ▪ *Figure 84*

GEORGE LUKS
1867-1933

SELECTED BIBLIOGRAPHY: Elisabeth Luther Cary, *George Luks* (New York: The Whitney Museum of American Art, 1931) • Bennard B. Perlman, *The Immortal Eight: American Painting from Eakins to the Armory Show (1870-1913)* (New York: Exposition Press, 1962), 74-80, passim • *George Luks, 1866-1933: An Exhibition of Paintings and Drawings Dating from 1889 to 1931*, with essays by Ira Glackens and Joseph S. Trovato (Utica, New York: Museum of Art, Munson-Williams-Proctor Institute, 1973) • Mahonri S. Young, "George Luks 1866-1933, Chicago Whitey," *The Eight, The Realist Revolt in American Painting* (New York: Watson-Guptill, 1973), 110-125.

George Luks was born in Williamsport, Pennsylvania to a German-American family. Both his father and brother were doctors, and the rest of the family were very artistic. Luks began studying art at the Pennsylvania Academy of Fine Arts and later traveled to Düsseldorf, where he stayed for 10 years and studied with Lowenstein, Jensen, and Gambrinus. On his return to Philadelphia in 1893 he became a staff artist on *The Press*. He roomed with Everett Shinn, also an artist for the paper, and through him became acquainted with painter and teacher Robert Henri. Along with Shinn, William Glackens, and John Sloan, Luks became a regular at Henri's on Tuesday evenings, where he sketched and discussed art.

Sent to Cuba in 1896 as a war correspondent for *The Evening Bulletin*, Luks produced drawings of battle scenes from the Spanish-American War. Upon returning to New York he landed a job on *The New York World* drawing "The Yellow Kid." He also found jobs on the paper for his friends, Glackens and Shinn, and the group reassembled in New York to form The Eight, who exhibited at the Macbeth Gallery in 1908 to protest the National Academy of Design's jurying process.

Henri, Luks, Shinn, Sloan, and Glackens painted what were then revolutionary scenes of urban landscape and street life. Luks's flamboyant style, which resembled Henri's, was based on techniques of Frans Hals and Manet; he was the only one of The Eight to continue to paint in the manner of Henri throughout his life, heeding his friend's admonition to translate life into paint. A facile draftsman who sometimes painted with two hands at one time, Luks claimed that he could paint with a shoestring dipped in lard. A heavy drinker and boisterous braggart, he called himself "Chicago Whitney," maintaining that he had once been a boxing champion.

Luks participated in over 200 major exhibitions during his lifetime and was represented by the Kraushaar Galleries from 1912 to 1924 and later by the Frank M. Rehn galleries until his death. *M.T.S.*

Portrait of My Friend, S.O. Buckner, *1926*

Oil on canvas, 20⅛ x 16⅛ in.
(51.1 x 41 cm.)
Signed lower right: George Luks
Bequest of Hudson Walker from the Ione
and Hudson Walker Collection
78.21.295
Illustration: Colorplate X

EXHIBITIONS: Tweed Gallery, University of
Minnesota-Duluth, *A Survey of American
Painting*, 1955 • *Selections from the
Collection*, 1957 • *Selected Works from the
Ione and Hudson Walker Collection*, 1959 •
Art and the University of Minnesota, 1961 •
*100 Paintings, Drawings, and Prints from
the Ione and Hudson D. Walker Collection*,
1965, cat. 63 • *Selections from the
Permanent Collection*, 1968, 1969, 1970 •
St. John's University/College of St. Benedict,
Collegeville, Minnesota, *University of
Minnesota Art Exhibit*, 1971 • *Selections
from the Permanent Collection*, 1975 •
Hudson D. Walker: Patron and Friend,
1977, cat. 49.

PROVENANCE: Ione and Hudson Walker

A member of the National Association of Portrait Painters, Luks received many portrait commissions during his career, but some of his better portraits were the ones he did for himself. He relied mainly on impulse when confronting his subject and attempted to achieve a vibrant sense of immediacy through bold and fluid application of paint. The technique evident in this portrait of S.O. Buckner predicts that seen in his later portraits which, although freely painted, contain forms of greater weight and solidness. Buckner was one of Luks's few patrons; others included Gertrude Vanderbilt Whitney and Edward Root.

STANTON MACDONALD-WRIGHT
1890-1973

SELECTED BIBLIOGRAPHY: William C. Agee,
*Synchromism and Related Color Principles
in American Painting, 1910-1930* (New
York: M. Knoedler and Co., Inc., 1965) •
Stanton Macdonald-Wright, "The Artist
Speaks," with a note on synchromism by
Barbara Rose, *Art in America* (May 1967):
70-73 • *The Art of Stanton Macdonald-
Wright*, with an introduction by David W.
Scott (Washington, D.C.: National
Collection of Fine Arts, Smithsonian
Institution, 1967) • John Alan Walker,
"Interview: Stanton Macdonald-Wright,"

One of the leading modern artists of his generation, Stanton Macdonald-Wright was to gain international acclaim for starting a new artistic movement: *synchromism*. A native of Virginia, he was raised in California, where he was a student and later a teacher at the Art Students League of Los Angeles. He went to Paris in 1907 and three years later had his first exhibition, at the Salon d'Automne. While in Paris he attended classes at the Sorbonne, the Académie des Beaux-Arts, the Académie Julian, and the Académie Colarossi. He also studied the optical theories and color technology of Michael Chevreul, Hermann von Helmholtz, Ogden N. Rood, and Charles Blanc. This study was to provide a basis for the development of a new stylistic approach, an answer to the monochromism of the cubists.

American Art Review (January-February 1974): 59-68 • Gail Levin, *Synchromism and American Color Abstraction, 1910-1925* (New York: Whitney Museum of American Art, 1978).

In 1913, Macdonald-Wright and Morgan Russell, a friend he had met in Paris two years earlier, introduced synchromism at exhibitions in Munich and Paris. As Macdonald-Wright explained, "Synchromism simply means 'with color' as symphony means 'with sound,' and our idea was to produce an art whose genesis lay, not in objectivity, but in form produced by color" (Walker, p. 59). Their theoretical and technical basis for synchromism included the following concepts: Color is a creator of form; colors fluctuate depending upon their surrounding colors; as nature recedes from the eye, it becomes violet, while as it advances it becomes warmer and more orange; and colors vary in their power to suggest material density and transparency.

Radically abstract, synchromism was developed in parallel with the orphism of Robert Delaunay. Central to both was the idea that color tone is related to musical tone in its ability to suggest mood, depth, and resonance and to affect the subconscious. The two also shared a circular, interwoven compositional structure.

In 1914 Macdonald-Wright and Russell exhibited their works in New York to a poor critical reception. Less than a year later the two friends separated. Macdonald-Wright then encouraged his brother, art critic Willard H. Wright, to take up the synchromist cause. The result was *Modern Painting*, published in 1915, in which W.H. Wright extols the virtues of his brother's achievement. By 1916 Stanton Macdonald-Wright's work was recognized as among the most advanced in America. He was represented in the Forum Exhibition and in 1917 had a one-man show at Stieglitz's 291 gallery. Two years later he left New York for California but in 1923 moved again, this time to Japan to pursue his new interest in oriental philosophy. In 1924 he wrote a treatise on color for the students of his alma mater. *P.N.*

Synchromy 3, *c. 1915-1916*

Following 1913 synchromist exhibitions with Morgan Russell, Macdonald-Wright eliminated literal subject matter from his painting. He translated the optical effects of color into swirling triangular wedges influenced by cubist principles of pictorial construction. In *Synchromy 3* he liberated color from its traditional descriptive role and let it be both the subject and the theme of the painting.

A square format—like the one the artist used here—is a difficult shape for compositional organization and is best suited to abstraction. It requires evenness, balance, and control, qualities Macdonald-Wright achieved by organizing the color patches around

Oil on canvas, 28⅛ x 28⅛ in.
(71.4 x 71.4 cm.)
Unsigned
Bequest of Hudson Walker from the Ione and Hudson Walker Collection
78.21.65
Illustration: Figure 85

EXHIBITIONS: *Selections from the Permanent Collection*, 1954 • Tweed Gallery, University of Minnesota-Duluth, *A Survey of American Painting*, 1955 • American Federation of Arts Traveling Exhibition, *Pioneers of American Abstract Art*, 1955-1956 • *Selected Works from the Collection of Ione and Hudson Walker*, 1959 • *Selections from the Permanent Collection*, 1970 • *Hudson D. Walker: Patron and Friend*, 1977, cat. 50 • Whitney Museum of American Art (New York) Traveling Exhibition, *Synchromism and American Color Abstraction, 1910-1925*, 1978-1979, cat. 109 • *Selections from the Permanent Collection*, 1980 • *Abstract USA/1910-1950*, 1981.

PROVENANCE: Alfred Stieglitz; Ione and Hudson Walker

a central vortex and extending them to the edges of the canvas so they seem to continue out into space. The interaction of the color wedges creates spatial depth and a circular movement expressive of the expanding universe.

Macdonald-Wright envisioned his paintings as tonal harmonies and constructed them with color chords composed from a twelve-tone color scale in which each color was a fixed note. Refrains of light and color produced the rhythm.

As indicated by the stamp on the verso, *Synchromy 3* was once owned by Alfred Stieglitz.

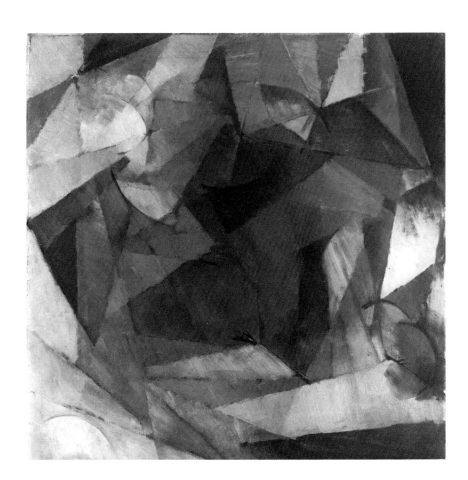

Synchromy 3, *c. 1915-1916* • *Figure 85*

Cañon Synchromy (Orange), *c. 1919-1920*

Oil on canvas, 24⅛ x 24⅛ in.
(61.3 x 61.3 cm.)
Unsigned
Gift of Ione and Hudson Walker
73.19
Illustration: Colorplate XV

EXHIBITIONS: Museum of History, Science,
and Art, Los Angeles, *Exhibition of
Paintings by American Modernists*, 1920,
cat. 66 • Drew Fine Arts Center, Hamline
University, St. Paul, *Exhibition*, 1952 •
Brooks Memorial Union, Marquette
University, Milwaukee, *75 Years of
American Painting*, 1956 • Los Angeles
County Museum of Art, *A Retrospective
Showing of the Work of Stanton
Macdonald-Wright*, 1956, cat. 58 •
Selections from the Collection, 1957 •
Minnesota State Fair, St. Paul, *American
Art of the Twentieth Century from the
University Gallery, University of Minnesota*,
1957 • College of St. Theresa, Winona,
Minnesota, *The American Twenties*, 1958 •
*Selected Works from the Collection of Ione
and Hudson Walker*, 1959 • *Art and the
University of Minnesota*, 1961 • *100
Paintings, Drawings, and Prints from the
Ione and Hudson D. Walker Collection*,
1965, cat. 64 • National Collection of Fine
Arts, Smithsonian Institution, Washington,
D.C., *The Art of Stanton Macdonald-
Wright: A Retrospective Exhibition*, 1967,
cat. 25 • *Selections from the Permanent
Collection*, 1968, 1969, 1970, 1972 •
Committee on Institutional Cooperation
Traveling Exhibition, *Paintings from
Midwestern University Collections, 17th-
20th Centuries*, 1973-1975, cat. 45 •
Minneapolis Institute of Arts, *American
Arts: A Celebration*, 1976 • San Francisco
Museum of Modern Art and the National
Collection of Fine Arts, Smithsonian
Institution, Washington, D.C., *Painting and
Sculpture in California: The Modern Era*,
1976-1977, cat. 34 * *Hudson D. Walker:
Patron and Friend*, 1977, cat. 51 • Whitney
Museum of American Art (New York)
Traveling Exhibition, *Synchromism and*

This painting was exhibited at the Los Angeles County Museum in 1956 with an attributed date of 1950, but its similarity to a series of landscape synchromies Macdonald-Wright produced between 1916 and 1920 clearly places it in that earlier phase. *Cañon Synchromy (Orange)* may be interpreted as a view of the California canyons to which the artist returned in 1919 after a stay in Paris and a season in New York. By 1920, in response to what he perceived as an escalating personal academicism evolving from his exploration of synchromism, he had removed himself from the art world.

The pale washes of color that comprise this work mark Macdonald-Wright as the most subtle and sophisticated artist associated with the synchromist style. His choice of orange as the color key for the composition can be seen as a literal representation of the predominant color of the canyons. It was also a favorite of his colleague Morgan Russell, whose *Synchromy à la Forme (Orange)* was one of his most important paintings of 1913-1914. Orange complements the pervasive blue of the landscape, forms the focal point for the composition, and defines the foreground plane of the painting. In his 1924 *Treatise on Color*, Macdonald-Wright wrote, "Orange is the most blatant braggart of all; the most intense light and the loudest voiced, in its inherent saturation. But toned down, it becomes more mellow and softer, more akin to red. Thus it has two sides to its character, the loud and brilliant-hued, and the soft and thoughtful" [Stanton Macdonald-Wright, *A Treatise on Color* (Los Angeles: self-published by the author, 1924), p. 20].

The harmonious blues, greens, violets, yellows, and oranges weave throughout the composition in an exploration of the color spectrum. While the painting may be read as a two-dimensional surface, the darker, cooler colors also provide a measure of spatial recession. In perceiving color as a translation of light, Stanton Macdonald-Wright was akin to Cézanne; he was also influenced by the French artist's fascination with form and movement in nature. Like Cézanne, Macdonald-Wright depicted the mountain as a prismatic planar triangle; its massive permanence is in marked contrast to the shifting colors and patterns produced by the sun.

American Color Abstraction, 1910-1925, 1978-1979, cat. 119 ▪ Detroit Institute of Arts Statewide Services Program Traveling Exhibition, *Paris and the American Avant-Garde, 1900-1925,* 1980-1981 ▪ Minnesota Museum of Art, St. Paul, *American Style: Works from Minnesota Collections,* 1981, cat. 51 ▪ Carleton College, Northfield, Minnesota, *American Abstraction: 20th Century American Paintings from the University of Minnesota,* 1983 ▪ *The First Fifty Years 1934-1984: American Paintings and Sculpture from the University Art Museum Collection,* 1984.

PROVENANCE: Ione and Hudson Walker

EMILY DANA MCMILLAN
1860-1953

SELECTED BIBLIOGRAPHY: R.I. Holcombe and William H. Bingham, *History of Minneapolis and Hennepin County, Minnesota* (Chicago: 1914) ▪ *The Minneapolis Tribune* (9 September 1953) ▪ *The Minneapolis Sunday Tribune* (10 December 1961): 4-5.

Emily Dana McMillan was born in Vermont but spent part of her childhood on a large sheep ranch her father owned in Argentina. A local insurrection and the death of his wife in a cholera epidemic proved too much for her father, who gave up the ranch and returned to the United States with his young daughter. In 1872 they moved to Minneapolis, where he later remarried.

The memory of the exciting times in Argentina may have left Emily with a sense of independence and a taste for adventure, for she was later known as the rebel of the family. She graduated from the University of Minnesota in 1882 and by the 1890s had decided to pursue a career in painting. As early as 1888 two of her paintings had been exhibited at the National Academy of Design in New York. Perhaps this inspired her to travel to Paris, where she is said to have studied in James Abbot McNeill Whistler's studio, later coming to know and admire the post-impressionists Pierre Bonnard and Edouard Vuillard. In a role reminiscent of that played by Mary Cassatt, she was able to influence her brother, Putnam Dana McMillan, to acquire an outstanding collection of post-impressionist paintings. She was, in fact, the guiding spirit behind one of the most important art collections ever formed in Minnesota; it was eventually given to the Minneapolis Institute of Arts.

On her return from Europe, Emily McMillan studied briefly with Robert Henri in New York. Back in the Twin Cities she established a reputation as an accomplished portrait painter. She specialized in portraits of Minnesota's political and professional leaders, including Governor John S. Pillsbury, Drs. William and Charles Mayo, and numerous University of Minnesota personalities. After an active life, curtailed only by the loss of her sight when she was in her 80s, she died in Minneapolis at the age of 93. Today she is largely forgotten, or if she is remembered it is as the sister of her philanthropist and art collector brother Putnam. *R.N.C.*

William Watts Folwell was the first president of the University of Minnesota. Born on a farm near Romulus, New York in 1833, he graduated from Hobart College in Geneva, New York in 1857 and then made the European grand tour. After the outbreak of the Civil War he enlisted in the Army of the Potomac, where he rose to the rank of Lieutenant Colonel. Following the war he moved to Ohio, where he engaged briefly in business before accepting a professorship in mathematics at Kenyon College. In 1869 he was chosen to head the newly established University of Minnesota.

Despite the University's modest beginnings, Folwell envisioned a great state university which would function as a federation of schools and stress both science and the humanities. He proposed a university museum, a great library, a department of public health, a state geological survey, a program for training legislators and administrators, and other services far ahead of his time. When he died in 1929 at the age of 96, he had succeeded in making these early dreams realities.

Emily Dana McMillan's early portrait (1) of the scholar-teacher-administrator is a head and shoulder study of Folwell at age 61. He looks far younger than his age, for the portrait projects an image of youthful strength and vitality. The head is strongly illuminated and well modeled with broad brushstrokes that suggest the sitter's restless character and eager, inquiring mind. The later portrait (2), painted when Folwell was 88, is more formal; seated, he wears his academic robe and hood and shows his years. But while his physical strength has ebbed, his glance is still direct and inquiring, full of dignity and keen intelligence.

Oil on canvas, 27⅝ x 21⅛ in.
(70.1 x 53.7 cm.)
Signed lower right: Emily McMillan 1894
Gift of the University of Minnesota Alumni
Association of Chicago
51.52
Illustration: Appendix

PROVENANCE: University of Minnesota
Archives

Oil on canvas, 42 x 34½ in.
(106.7 x 87.6 cm.)
Signed upper right: Emily McMillan 1921
Gift of the Class of 1882
39.98
Illustration: Figure 86

EXHIBITION: Alumni Club, Minneapolis,
75th Anniversary Exhibition, 1979.

PROVENANCE: University of Minnesota
Archives

William Watts Folwell *(1), 1894*

William Watts Folwell *(2), 1921*

William Watts Folwell *(2), 1921* ▪ *Figure 86*

Perry H. Millard, *c. 1890-1897*

Oil on canvas, 28 x 24 in.
(71.1 x 61 cm.)
Signed lower left: Emily McMillan
Anonymous gift
53.339
Not illustrated

Dr. Perry H. Millard was born in New York in 1848 and began his medical practice there in 1872. After further study in London from 1881 to 1882, he became one of the five initial members of the University of Minnesota medical faculty in 1883 and later served as the first dean of the College of Medicine and professor of surgery from 1892 until his death in 1897. Admired for his skills as an administrator and organizer, Millard is perhaps best known for consolidating medical teaching in Minnesota at the University. In 1906 the regents voted to name Millard Hall, a medical facility on the main campus, in his honor.

A solemn and formal figure, Millard gazes intently out of the right side of the canvas, looking like the man of vision his contemporaries felt him to be. *S.M.B.*

Frank Fairchild Wesbrook, *c. 1906-1913*

Oil on canvas, 52 x 36 in.
(132.1 x 91.4 cm.)
Signed upper left: Emily McMillan
Gift of Fanny M. Leversee
53.340
Not illustrated

PROVENANCE: Fanny M. Leversee

A native Canadian, Frank Fairchild Wesbrook was born in Ontario in 1868 and completed his medical studies at Manitoba University in 1890, with additional training in Dublin, at Cambridge University, and in London. Renowned for his skills as a bacteriologist and pathologist, Wesbrook was appointed Professor of Pathology, Bacteriology, and Public Health at the University of Minnesota in the fall of 1895 at the age of 28. Eleven years later he became dean of the University's medical faculty and director of the State Board of Health. Wesbrook left the University in 1913 to become the first president of the University of British Columbia, a post which he held until his death in Vancouver in 1918.

In this portrait Emily Dana McMillan has portrayed Wesbrook in his academic robes, distinguished but approachable. Wesbrook Hall at the University of Minnesota was named for this well-liked and respected scholar. *S.M.B.*

John Florin Downey, *c. 1910-1915*

Oil on canvas, 28½ x 22¾ in.
(72.4 x 57.8 cm.)
Signed lower left: E. McMillan
Gift of the artist
48.29
Illustration: Appendix

PROVENANCE: the artist

A native of Hiramsburg, Ohio, where he was born in 1846, John Florin Downey later moved to Michigan where he graduated from Hillsdale College in 1870. In 1880 he was invited to the University of Minnesota to teach astronomy and mathematics, and in 1894 he became the head of the math department. Appointed Dean of the School of Liberal Arts in 1903, he held that office until his retirement 11 years later.

Wearing a mortarboard and academic gown, Dean Downey is portrayed with the broad, impressionistic brushstrokes and high color palette typical of McMillan's style. Many colors are combined to give a glowing vitality to the fleshtones and a sense of spontaneity to the portrait.

Thomas Sadler Roberts, *c. 1915-1925*

Oil on canvas, 34 x 30 in.
(86.4 x 76.2 cm.)
Signed lower center: E. McMillan
Transfer from the University of Minnesota Archives
79.14.3
Illustration: Appendix

PROVENANCE: University of Minnesota Archives

Dr. Thomas Sadler Roberts is best known today as the author of the two-volume *Birds of Minnesota*, published in 1932, but he was also a practicing physician and, later in life, the director of the University of Minnesota's James Ford Bell Museum of Natural History.

Roberts was born near Philadelphia in 1858 but came to Minnesota with his family at age 9. From his earliest years he showed an interest in natural history, especially ornithology. He entered the University of Minnesota in 1877 and stayed two years until symptoms of tuberculosis forced him to leave. In search of a healthy outdoor life, he worked as a land examiner for the railroads. By 1882 he was sufficiently recovered to enroll in the University of Pennsylvania medical school. After receiving his M.D. three years later, he returned to Minnesota and established a medical practice in Minneapolis. In 1887 he was appointed chief of staff of St. Barnabas Hospital, and from 1901 to 1913 he served on the faculty of the University of Minnesota Medical School.

In 1915 Dr. Roberts gave up most of his successful medical practice to devote himself full time to the study of natural history and ornithology. He accepted the position of director of the newly founded Bell Museum. In addition to his *Birds of Minnesota*, he published 253 articles on natural history. He died in Minneapolis in 1946 at the age of 88.

Emily McMillan's portrait shows Dr. Roberts as a man of professional demeanor, looking out at the observer with his hand resting on the pages of an open book.

The Old Greek Professor, *c. 1920-1930*

Oil on canvas, 28⅛ x 23 in. (71.4 x 58.4 cm.)
Signed left center: E. McMillan
Gift of the artist
48.28
Illustration: Appendix

PROVENANCE: the artist

Emily McMillan's portrait of John Corrin Hutchinson (1849 - 1934), "the old Greek professor," conveys a more poetic mood than most of her other works. One of the best-loved faculty members of the University of Minnesota, a man as devoted to his students as he was to scholarship, Hutchinson was born in 1849 on the Isle of Man. Educated as a child in England, he immigrated to the United States in 1867 and received his degree from the University of Minnesota in 1876. Hired as an instructor in Greek and mathematics that same year, he was appointed professor of Greek in 1891.

Hutchinson peers out from underneath the broad brim of a soft felt hat. His glance is somehow poetic and pragmatic at the same time, fitting the personality of this gifted teacher.

View of Santa Barbara, *c. 1935*

Oil over graphite on canvas, 17 x 21 in. (43.2 x 53.3 cm.)
Unsigned
Gift of Mrs. Mathilde Elliott
82.36
Not illustrated

EXHIBITION: *The First Fifty Years 1934-1984: Recent Acquisitions and Promised Gifts to the University Art Museum*, 1984.

PROVENANCE: Mrs. Mathilde Elliott

CLAIRE MAHL

Active 1930-1960

SELECTED BIBLIOGRAPHY: "Reviews," *Art Digest* (5 September 1947): 25 • "Reviews," *Art Digest* (May 1952): 21 • Helen A. Harrison, "Subway Art and the Public Use of Art Committee," *Archives of American Art Journal*, 21:2 (1981): 3-12.

Oil on canvas, 36¼ x 29¾ in. (92.1 x 75.6 cm.)
Signed upper right: C. Mahl
Bequest of Hudson Walker from the Ione and Hudson Walker Collection
78.21.221
Illustration: Appendix

EXHIBITIONS: St. Paul Gallery and School of Art, *Exhibition*, 1951 • Drew Fine Arts Center, Hamline University, St. Paul, *Exhibition*, 1952.

PROVENANCE: Ione and Hudson Walker

Claire Mahl was trained at the Art Students League under Thomas Hart Benton and Harry Wickey, later studied with Fernand Léger, and worked at the Siqueiros workshop in New York City in the 1930s. During this period she also received a MacDowell fellowship.

After winning the ACA Gallery's open competition, she held her first solo show there in 1946 and a second in 1947. Her abstractions of 1946 changed in 1947 into semi-abstract compositions of people and objects in interiors. Her paintings that year were small and patterned, but by 1952 had returned to bold, abstract configurations. In the 1960s her colored drawings described landscapes and interiors with earthen-hued textures.

Mahl has participated in group exhibitions at the Brooklyn Museum, the San Francisco Museum of Art, the Art Institute of Chicago, and the California Palace of the Legion of Honor in San Francisco. *M.T.S.*

Red Bike, *c. 1946-1947*

This abstracted interior is representative of the large, flatly patterned canvases which Mahl showed at the ACA Gallery in 1947, hence the attributed dates. With a vigorous handling of paint, she depicted people, objects, and landscapes using abstract shapes.

CLARA MAIRS
1878-1963

SELECTED BIBLIOGRAPHY: Rebecca L. Keim, *Three Women Artists: Gág, Greenman and Mairs* (Minneapolis; University Art Museum, 1981), 24-33.

Born in Hastings, Minnesota to a family whose ancestors had established the first grain mill on the Vermillion River, Clara Mairs was interested in art from earliest childhood. She began her formal training at the Institute of Art in St. Paul and from there she traveled east, continuing her studies at the Pennsylvania Academy of the Fine Arts under Philadelphia landscape painter Daniel Garber.

Returning to Minnesota in 1918, Mairs settled in St. Paul, where she was active in the Nimbus Club, a local art group organized to provide artists with affordable opportunities to draw and paint from live models. At this time she began distinguishing herself primarily as a decorative artist, creating gold-and-silver leaf screens and wall hangings, but dissatisfaction with the limited possibilities afforded by the decorative arts soon caused her to seek more formal art training. In 1923 she journeyed to Paris, where she took various courses at the Académie Montparnasse, the Académie Colarossi, and the Académie Julian. She also began experimenting with printmaking, favoring the techniques of softground etching and aquatint.

In 1925 Mairs returned to Minnesota and spent much time in the region of the Kettle River in Pine County, where she painted scenes of the local landscape and its rural inhabitants. By the 1930s she began winning recognition in her native state. In 1930 she won first prize for portraiture at the State Fair, and she received awards for her etchings from the Minneapolis Institute of Arts in both 1931 and 1936.

After 1940 she worked increasingly in oils, and in 1951-1952 she began experimenting with glazed ceramics in order to translate her favorite themes into three-dimensional form. Her illustration for a Polish poem by Adam Mickiewicz titled "Romanticism" was selected for inclusion in an international exhibition held in 1955 in both New York and Warsaw.

Although confined to a wheelchair since 1960, Mairs spent the last three years of her life painting and drawing. *R.L.G.*

Abby Swinging on a Vine, *c. 1915*

Oil on canvas board, 9⅛ x 6⅜ in.
(23.2 x 16.2 cm.)
Unsigned
Gift of the Abby Weed Grey Trust
84.10.8
Illustration: Appendix

PROVENANCE: Benjamin and Abby Weed
Grey

Mairs often delighted in depicting the antics of children at play. This little painting captures the carefree abandon of a tomboyish young girl who uses her wits and the resources at hand to enjoy a free ride on a swing improvised from a pair of hanging vines.

The painting is executed in a thin wash, the ground of the canvas board clearly visible over the entire composition. The young girl may well be Abby Weed Grey, who once owned this painting.

Child with Doll, *c. 1915-1920*

Oil on masonite, 23¾ x 19⅞ in.
(60.3 x 50.5 cm.)
Unsigned
Gift of the Abby Weed Grey Trust
84.10.3
Illustration: Figure 87

PROVENANCE: Benjamin and Abby Weed
Grey

This study of a little girl is both charming and direct in the manner of earlier Ash Can School artists. The subject sits squarely in the center of the picture and gazes directly, if somewhat warily, at the viewer. Her bright red dress and hair ribbon, as well as the doll tossed casually into the lower left corner of the frame, hint at the youthful exuberance hidden behind a mask of propriety as she demurely poses for the artist.

Girl in Garden, *c. 1915-1920*

Oil on wallpaper on board, 8⅛ x 5¾ in.
(20.6 x 14.6 cm.)
Signed lower right: C. Mairs
Gift of the Abby Weed Grey Trust
84.10.4
Illustration: Figure 88

PROVENANCE: Benjamin and Abby Weed
Grey

A tiny, impressionistic study executed on common wallpaper, this painting bears a close resemblance both in form and content to Renoir's *Girl with Watering Can* in the National Gallery of Art. Both depict young girls dwarfed by a brightly lit flower garden, posing beside brilliantly blooming flowers. Mairs has eliminated the watering-can motif of Renoir's painting, focusing instead on her diminutive subject, who shyly clasps both hands before her smock. Sunlight streams onto her high-buttoned shoes and stockings and catches the highlights of her hair. The garden setting is indicated by a series of highly impressionistic strokes of paint that culminate in huge bulbs whose petals unfold in the sun.

Child with Doll, *c. 1915-1920* ▪ *Figure 87*

Girl in Garden, *c. 1915-1920 ▪ Figure 88*

Girl with Boy, Watering Plant, *c. 1915-1920*

Oil on wallpaper on board, 8⅝ x 6 in.
(21.9 x 15.2 cm.)
Signed lower left: C. Mairs
Gift of the Abby Weed Grey Trust
84.10.6
Illustration: Appendix

PROVENANCE: Benjamin and Abby Weed
Grey

Executed on the same ground as *Girl in Garden*, this painting is akin to it in several other respects. Both depict children in natural environments, although in this work the garden motif has been simplified into two plants resting in flower pots on a square stand. The little boy is seen from the back and appears almost doll-like in his pageboy haircut and bloomers. The focus of his attention appears to be the plant, which his older sister is carefully watering. Also like *Girl in Garden*, this painting emphasizes the bright sunlight, which in this case streams into the picture from the righthand side and lands on the front of the girl's smock.

Parade, *c. 1915-1920*

Oil on canvas board, 6 x 10¾ in.
(15.2 x 27.3 cm.)
Signed lower left: C. Mairs
Gift of the Abby Weed Grey Trust
84.10.2
Illustration: Figure 89

EXHIBITION: *The First Fifty Years 1934-1984: Recent Acquisitions and Promised Gifts to the University Art Museum*, 1984.

PROVENANCE: Benjamin and Abby Weed
Grey

A procession of school children marches across the stagelike space of this canvas, holding flags from the Allied powers from World War I. Dressed in their Sunday best, these young people possess a naive innocence that is highlighted by the colorful juxtaposition of their clothing with the flags fluttering gently in the breeze. By flattening out the background space to include only a few strokes indicative of flowers, Mairs evokes the decorative effects of an oriental folding screen.

Parade, *c. 1915-1920* • *Figure 89*

Untitled, *c. 1915-1920*

Oil on board, 18 x 23⅞ in.
(45.7 x 60.6 cm.)
Signed lower right: Clara Mairs
Gift of the Abby Weed Grey Trust
84.10.1
Illustration: Appendix

PROVENANCE: Benjamin and Abby Weed
Grey

A favorite and recurring theme in Mairs's work is the leisure activity of young children. The focus here is on the group of youths watching an artist at work on a landscape composition. The boys stand and sit behind the self-important looking painter garbed in a formal coat, tie, and hat and smoking a pipe. His right arm makes a dramatic gesture that is playfully mimicked by one of the boys, who leans against another for support. His playmates stare off into the distance, as if to compare the handiwork of nature with what is appearing on the artist's canvas.

Untitled (Girl in Bedroom), *c. 1915-1920*

Oil on canvas board, 8⅞ x 6¾ in.
(22.5 x 17.1 cm.)
Signed lower left: C. Mairs
Gift of the Abby Weed Grey Trust
84.10.12
Illustration: Appendix

PROVENANCE: Benjamin and Abby Weed
Grey

Mairs creates an interesting composition by focusing on a young girl seen from behind. The subject appears to gaze at an abstract jumble of colors in the background; that she is really staring at the rumpled sheets of an unmade bed is clear from the prominent and ornately carved bedpost in the painting's left foreground. A large, oblong picture on the wall frames the girl's head and calls attention to the immense bow in her hair. In this painting Mairs comes closer to achieving a study of purely formal compositional elements than in any of her other works in the Museum's collection.

LEO MANSO
1914-

SELECTED BIBLIOGRAPHY: Gordon Brown,
Leo Manso (Syracuse: Everson Museum,
1976).

A summer resident of Provincetown, Massachusetts since 1947, Leo Manso was a cofounder of the 256 group there which included Will BARNET, Peter Busa, and Byron BROWNE. He was also friendly with John HELIKER and Milton AVERY. In 1958 he established the Provincetown Workshop School.

Although his earliest paintings were subjective and autobiographical, Manso worked in an abstract style in the late 1940s. In 1948 he joined the American Abstract Artists. He was also a member of the Formations Group in New York City. Interested in collage since 1956, he has drawn heavily on his experiences in India and Nepal to create these works. He has also been influenced by Persian miniatures, which are similar to his work in their miniature scale, brilliant color, and delicate detail.

Manso was born in New York City and studied at the National Academy of Design and the New School for Social Research. He was on the faculty of Cooper Union during the late 1940s and has taught at New York University since 1950; in 1953 he lectured at Columbia University. In 1961 he designed a mural for the public library in Lincoln, Nebraska, and in 1975 he became a member of the faculty of the Art Students League. *P.N.*

Solar Image No. 1 (Provincetown), *c. 1950*

Oil on board, 5¾ x 7¾ in.
(14.6 x 19.7 cm.)
Signed lower right: Manso
Bequest of Hudson Walker from the Ione and Hudson Walker Collection
78.21.847
Illustration: Figure 90

PROVENANCE: Ione and Hudson Walker

Within the small format of this painting, Manso has created dramatic movement through a series of arcs of contrasting color. The abstract nature of the imagery and the tones of blue and yellow suggest the distortion of visual perception one experiences when looking directly into the sun: the sky stays blue, but the eyes tingle and lose their ability to focus, and shapes are transformed and blurred as pulsating rays of light. The abstract and expressive nature of this work reflects the major artistic developments in America during the 1950s. It also demonstrates the artistic process of painting: the individual brushstrokes, the direction in which they were applied, and the artist's personal touch are clearly present.

Solar Image No. 1 (Provincetown), *c. 1950* ▪ *Figure 90*

HERMAN MARIL
1908-

SELECTED BIBLIOGRAPHY: Olin Dows, "Herman Maril," *American Magazine of Art* (July 1935): 406-411 • F. Getlein, *Herman Maril: A Monograph* (Baltimore: Baltimore Museum of Art, 1967).

Herman Maril has created peaceful, poetic scenes with delicate color harmonies and simple forms since he began painting in the early 1930s. Although form and color appear to be reduced to create the essence of a scene, they are carefully integrated into complex design structures which project a studied tranquility.

Born in Baltimore, Maril studied at the Maryland Institute of Fine Arts from 1926 to 1928. He taught at the Cummington School of the Arts in Massachusetts, the King-Smith School of the Arts in Washington, D.C., the Washington Workshop of the Arts, the Philadelphia College of Art, and the Jewish Community Center in Baltimore before accepting a position at the University of Maryland, which he held until his retirement.

Olin Dows observes of his work from the 1930s that "Maril transcribes fact. He does not paint either sunlight or moonlight, or a scene as it happens. He takes away the memory of a thing observed and gives us an interpretation of this memory as it has settled and assimilated itself in him" (Dows, p. 408). Influenced by Picasso and Matisse, Maril also studied the paintings of early Italian Renaissance masters, particularly those of Piero della Francesca. Using only a few closely hued colors, he added subtle textures to landscapes and buildings with a variety of brushstrokes. The same subtle color harmonies and painterly textures have remained constants in Maril's design for over 40 years. In his most recent canvases of the Cape Cod landscape, large areas of color are broken only by small, intense color accents.

Paintings completed while Maril worked on the PWAP were selected for exhibitions at the Museum of Modern Art and the Corcoran Gallery in 1934. Between 1936 and 1940 the Public Buildings Administration commissioned him to paint murals for post offices in Alta Vista, Virginia and West Scranton, Pennsylvania. He won a grant for Creative and Performing Arts from the University of Maryland in 1966, the Stefan Hirsch Memorial Award for Audubon Artists at the National Academy of Design in 1972 and 1974, and an award for painting at the American Academy/Institute of Arts and Letters in 1978. *M.T.S.*

Victorian, *1938*

Oil on gesso panel, 12 x 8¾ in. (30.5 x 22.2 cm.)
Signed lower right: Herman Maril 38
Bequest of Hudson Walker from the Ione and Hudson Walker Collection
78.21.193
Illustration: Appendix

EXHIBITION: St. Paul Gallery and School of Art, *Exhibition*, 1951.

PROVENANCE: Ione and Hudson Walker

In Maril's paintings from the 1930s, only a variety of brushstrokes differentiated objects from backgrounds of similar color. Maril said in 1935 that his goal was "to reduce ideas felt or seen to as simple a statement and as thorough an organization as possible" (Dows, p. 407).

Sentinel, No. 1, *c. 1940-1950*

Oil on panel, 8⅛ x 10⅛ in. (20.6 x 25.7 cm.)
Signed lower left: Herman Maril
Bequest of Hudson Walker from the Ione and Hudson Walker Collection
78.21.848
Illustration: Figure 91

EXHIBITIONS: *Hudson D. Walker: Patron and Friend*, 1977, cat. 52.

PROVENANCE: Ione and Hudson Walker

Critics have often compared Maril's panels to the tranquil compositions of Milton AVERY and Karl KNATHS in that closely valued pastel colors have comprised his palette since the 1930s. Although tightly organized, his compositions appear spare and almost effortless. An illusion of deep space in his broadly brushed skies is juxtaposed with the two-dimensionality of a flat shape—a compositional device also found in the works of other American expressionist painters before the advent of abstract expressionism.

Sentinel, No. 1, *c. 1940-1950* ▪ *Figure 91*

ALFRED HENRY MAURER
1868-1932

SELECTED BIBLIOGRAPHY: Elizabeth McCausland, *A.H. Maurer* (New York: A.A. Wyn for Walker Art Center, 1951) ▪ *A.H. Maurer's Statement* (New York: Babcock Galleries, 1963) ▪ Peter Pollack, *Alfred Maurer and the Fauves: The Lost Years Rediscovered* (New York: Bernard Galleries, 1973) ▪ Sheldon Reich, *Alfred H. Maurer 1868-1932* (Washington, D.C.: National Collection of Fine Arts, 1973) ▪ William I. Homer, editor, *Avant-Garde Painting and Sculpture in America, 1910-1925* (Wilmington, Delaware: Delaware Art Museum, 1975), 100-101 ▪ Percy North, *Hudson D. Walker, Patron and Friend* (Minneapolis: University of Minnesota Gallery, 1977), 12-13, 39-45 ▪ Judith Zilczer, *Alfred H. Maurer* (Washington, D.C.: Hirshhorn Museum and Sculpture Garden, 1979).

Thanks to a major bequest from Hudson Walker, the University Art Museum holds the world's largest collection of works by one of the most enigmatic artists America has ever produced. The wealth of the Museum's collection makes it the best place possible to study and appreciate the broad range of Alfred Henry Maurer's work.

Maurer did not routinely sign his paintings, and he rarely dated them. As the two major biographical and critical studies of him (by Elizabeth McCausland and Sheldon Reich) have indicated, it is very difficult to date his paintings and organize them into any kind of logical sequence. Thus it seems best to consider them thematically and stylistically, as Reich did in his catalogue for the Maurer retrospective at the National Collection of Fine Arts in 1973.

Although he was best known as a figure painter, Maurer produced a varied oeuvre that encompassed the major themes and stylistic directions in American art from 1890 to 1930. Female figures were his earliest and latest subjects, but he also produced landscapes, still-lifes, a few genre scenes, abstractions, and at least two self-portraits. He began his career as a very accomplished and successful painter of traditional figure pieces; he is best remembered today for his intellectual excursions into advanced twentieth-century modes of expression inspired by fauvism, cubism, and expressionism.

It is most instructive to categorize Maurer's stylistic directions according to four basic artistic styles—romantic realism, fauvism, cubism, and expressionism—although he frequently mingled cubism and expressionism, particularly in his paintings of nudes and some late large female heads. Associated with his earliest paintings of romantic female figures is a small group of genre scenes done in Paris around 1902 that may have been influenced by his association with Robert Henri. He produced landscapes during his fauvist period only, which began after 1905 and ended with his return to New York in 1914. Cubist-inspired abstractions appeared after 1914; in addition to cubist fragmentation, Maurer was intrigued by cubist collage and developed two personal methods of collage and simulated texture, one involving the use of dress fabric as a medium on which he superimposed figures, and the other simulating a doily stencilled onto the canvas. The female figure remained his primary means for expressing his personal emotional response to contemporary life.

Perhaps the most intriguing (and certainly the most overlooked) aspect of Maurer's work is its possible social, emotional, and intellectual implications. Although Maurer told baffled friends that they should be able to see the meaning in his paintings without his having to explain it, the sheer curiousness of some of his works—particularly the female heads—has been ignored in favor of formalist critical evaluations. Unfortunately there is little primary source material on Maurer. He was reputed to have written few letters, and after his death his friends refused to discuss his life, the most reasonable explanation for their reticence being the desire to shield aspects of the artist's personality from a public that might consider it offensive or shocking.

The few known facts about Maurer's life have been repeated many times. He was born in New York City, one of three children of successful Currier and Ives lithographer Louis Maurer. Compulsive and introspective, young Alfred lived in the shadow of his father's success; his lesser-known brother Charles was also a painter. Following a brief tenure in his father's lithography firm and training at the National Academy of Design, Alfred escaped to Paris in 1897. He was 29.

He was the first of his generation to seek refuge and inspiration in Paris, and he stayed there longer than any of his contemporaries. Like many young Americans, he studied briefly at the Académie Julian, but he preferred the freedom of copying paintings in the Louvre. Maurer's earliest works in Paris were traditional late nineteenth-century images of elegantly attired women—symbols of indolence, grace, and style—done in the manner of James Abbott McNeill Whistler and John Singer Sargent. During a visit to the United States in 1901 he exhibited some of his realistic female figure paintings at the Carnegie Institute in Pittsburgh and won the gold medal. Spurred on by this recognition and acclaim, he participated in a group show with Robert Henri and exhibited in the major European salons.

After 1904 Maurer associated with the coterie of artists who gathered around Leo and Gertrude Stein in Paris. On visits to their apartment, he saw works by the modern French masters. Some time after his meeting with the Steins and after the radical 1905 exhibition at the Salon d'Automne, Maurer changed his painting style. Stein made mention of him in her *Autobiography of Alice B. Toklas*, but she did not purchase any of his paintings.

Maurer is known to have been a jaunty and rakish figure in Paris, and there are speculations (but no reliable facts) about his personal life during his European sojourn. When the outbreak of World War I forced him to return to the United States in 1914, he went back to his family home, which he shared with his father until Louis's death in 1932. During his remaining years in New York, Maurer painted in a small studio at home, except for brief periods when he rented a studio in town and vacationed in Marlborough, New York. Having been the first American painter exhibited at Alfred Stieglitz's 291 gallery (in 1909, with John Marin), Maurer was included in all of the modernist exhibitions in New York in the second decade of the century: Younger American Painters at 291 in 1910; the Armory Show in 1913; the Forum Exhibition in 1916; and the 1917 Society of Independents Exhibition. He continued to show with the Independents and was made an officer of the society in 1919.

In 1924 Maurer was given the great honor of having the entire contents of his studio purchased by bookseller and gallery owner E. Weyhe. The pleasure this gave him was offset in 1925 by the sale of the contents of his Paris studio for back rent; Maurer had never managed to go back there, as he had planned to do. Weyhe continued to be Maurer's dealer, giving him yearly exhibitions and purchasing from him through the 1920s. Shortly after his father's death at the age of 100, Alfred Henry Maurer hanged himself in his studio. *P.N.*

Self-Portrait, *1897*

Oil on canvas, 28¾ x 21 in. (73.2 x 53.4 cm.)
Signed upper right: A.H. Maurer/97
Gift of Ione and Hudson Walker
53.301
Illustration: Colorplate XXVII

REFERENCES: Thomas Hess, "Alfred Maurer Memorial," *Art News* (September 1949): 24 • Emily Genauer, "Maurer Memorial—Reminiscence, Controversy, and Applause," *Art Digest* (15 November 1949): 7 • Elizabeth McCausland, *A.H. Maurer* (New York: A.A. Wyn for Walker Art Center, 1951), 55 • Sheldon Reich, *Alfred H. Maurer* (Washington, D.C.: National Collection of Fine Arts, 1973), 21 • Katherine Harper Mead, editor, *The Preston Morton Collection of American Art* (Santa Barbara, California: Santa Barbara Museum of Art, 1981), 236.

EXHIBITIONS: Walker Art Center, Minneapolis, and the Whitney Museum of American Art, New York, *A.H. Maurer, 1868-1932*, 1949, cat. 2 • Tweed Gallery, University of Minnesota-Duluth, *A Survey of American Painting*, 1955 • *Selections from the Collection*, 1957 • Temple of Aaron, St. Paul, *Dedication Exhibit*, 1957 • Michigan State University, East Lansing, *College Collections: An Exhibition Presented on the Occasion of the Dedication of the Kresge Art Center*, 1959 • *Art and the University of Minnesota*, 1961 • Babcock Galleries, New York, *A.H. Maurer's Statement*, 1963 • Tweed Gallery, University of Minnesota-Duluth, *Dedicatory Exhibition Honoring Mrs. Alice Tweed Tuohy*, 1965, cat. 35 • Tyler Museum of Art, Tyler, Texas, *American Paintings, 1900-Present*, 1971 • National Collection of

Youthful concern for fashion was reflected in Maurer's paintings of women as well as in his personal life while he lived in Paris. He was known for his stylish clothing and his dashing personality. His early paintings reveal facets of his personal life as well as contemporaneously topical ideas.

Intrigued by female faces and physiques throughout his career, Maurer produced few paintings of men, among them at least two self-portraits. This one is dated 1897, the year he left for Paris. That it is dated at all is notable, since so few of his paintings are; the style, too, is remarkable in that it is so different from other works of this period. About this stylistic problem, Sheldon Reich wrote, "Two possibilities come to mind: first, that this is but one of many lost works of the pre-1897 epoch reflecting Maurer's training at the National Academy of Design and his attraction to the work of the Munich painters; second, that the painting was misdated and was actually completed in 1898, illustrating the new direction his art was taking" (Reich, p. 21). It is also possible that Maurer simply felt freer painting himself.

Self-Portrait shares with *Girl in White* a flamboyant brush treatment and muted color harmony in keeping with the somber quality of contemporary clothing and interiors. However, the former is brighter and livelier than his studies of women completed around that time. The rakish moustache, tousled hair, searching glance, and deep shadows reflect his romantic vision and youthful personality. As elegant and glamorous as the women he was painting almost simultaneously, Maurer appears here as a descendant of Eugène Delacroix and James Abbott McNeill Whistler. The waist-length figure pivots conversationally toward the

Fine Arts, Smithsonian Institution, Washington, D.C., *Alfred H. Maurer, 1868-1932*, 1973, cat. 1 • *Alfred H. Maurer: American Modernist*, 1973 • *Selections from the Permanent Collection*, 1975 • *Hudson D. Walker: Patron and Friend*, 1977, cat. 53.

PROVENANCE: Ione and Hudson Walker

Oil on wood panel, 24 x 19⅜ in. (61.1 x 49.3 cm.)
Signed lower right: A.H. Maurer
Gift of Ione and Hudson Walker
53.307
Illustration: Colorplate XVI

REFERENCE: Sheldon Reich, *Alfred H. Maurer* (Washington, D.C.: National Collection of Fine Arts, 1973), 24-25.

EXHIBITIONS: Art Institute of Chicago, *Half a Century of American Art*, 1939-1940 • Tweed Gallery, University of Minnesota-Duluth, *A Survey of American Painting*, 1955 • *Selected Works from the Ione and Hudson Walker Collection*, 1959 • The Renaissance Society of the University of Chicago, *An Exhibition of Paintings by Alfred Maurer*, 1960, cat. 3 • Babcock Galleries, New York, *A.H. Maurer's Statement*, 1963, cat. 2 • *100 Paintings, Drawings, and Prints from the Ione and Hudson D. Walker Collection*, 1965, cat. 65 • *Selections from the Permanent Collection*, 1968, 1969, 1970 • Tyler Museum of Art, Tyler, Texas, *American Paintings 1900-Present*, 1971 • Bernard Danenberg Galleries, New York, *Alfred Maurer and the Fauves*, 1973, cat. 52 • *Selections from the Permanent Collection*, 1975 • *Hudson D. Walker: Patron and Friend*, 1977, cat. 54 • Hirshhorn Museum and Sculpture Garden, Washington, D.C., *Alfred H. Maurer*, 1979 • *Selections from the Permanent Collection*, 1980 • *The First Fifty Years 1934 - 1984: American Paintings and Sculpture from the University Art Museum Collection*, 1984 • *New York and American Modernism*, 1984.

PROVENANCE: Ione and Hudson Walker

viewer, backlit by the halo glow from a window—a device popular in portraiture since the Renaissance because it has the effect of extending the composition's space. A canvas hangs on the wall to Maurer's left, its swashbuckling, indistinguishable shapes alluding to his future artistic direction.

Maurer reveals himself as a stylish bourgeois, a personal vision and pose that altered drastically on his return to the United States. Walker Art Center owns a later *Self-Portrait* that demonstrates the artist's increasing introspection. *P.N.*

Girl in White, *c. 1901*

Maurer's earliest paintings reveal his interest in a pervasive late nineteenth-century tradition of painting lovely women as objects of beauty and contemplation. Although the forms and methods of his work changed drastically throughout his life, his fascination with women never subsided. *Girl in White* and a pastel portrait of Maurer's sister Eugenia, also in the Museum collection, aptly represent the early stage of his painting activity.

The muted Whistlerian tonalities, the graceful, stylish clothing, and the genteel pose of *Girl in White* display Maurer's concern with fashion and manners. Even though the girl is a dress mannequin—a model—rather than a deeply perceived human being, she conveys a pensive mood that prefigures Maurer's late introspective female heads. She also typifies the sheltered life of bourgeois American women at the turn of the century. The strict lines of the interior and the fact that she is crowded against a doorway make symbolic reference to the strictures of her social milieu; she is, in effect, trapped in her class. Her elegant white dress, popular attire of the period, emphasizes her angelic aloofness from life's basic anxieties.

Girl in White is more than an exercise in style and grace. It indicates Maurer's understanding of formal contrast and the development of a three-dimensional figure in space. The twisted volumetric body of the woman, accentuated by the broad, visible brushstrokes, contrasts with the flat rectilinear patterning of the background. Painted while Maurer was living in Paris, this piece is similar in style to *An Arrangement*, for which he won the gold medal at the Carnegie Institute's International Exhibition. *P.N.*

Landscape (1), 1908

Oil on wood panel, 8 x 10 in.
(20.3 x 25.4 cm.)
Signed lower right: A.H. Maurer
Gift of Ione and Hudson Walker
53.298
Illustration: Appendix

REFERENCE: Percy North, *Hudson D. Walker: Patron and Friend* (Minneapolis: University of Minnesota Gallery, 1977), 40.

EXHIBITION: *Hudson D. Walker: Patron and Friend*, 1977, cat. 55

PROVENANCE: Alfred Stieglitz; Ione and Hudson Walker

One of the first Americans to understand and appreciate the innovations of French modernism, Maurer turned from painting genre scenes and romantic stylish women in muted tones to a more colorful and painterly style in which he focused on landscapes and still-lifes. Presumably influenced by the works of Henri Matisse and his followers, which were being shown in well-publicized exhibitions, Maurer's first innovative paintings produced after 1905 are primarily small, lively sketches of unpopulated pastoral landscapes painted on easily portable 8¼ x 10½-inch thumb box panels. Since most of these were included in the 1925 liquidation of his Paris studio, they are the least known and most intriguing of his career.

A small panel, *Landscape* is probably similar to the generically titled sketches in oil included in Maurer's first show in 1909 at Stieglitz's 291 gallery. Like his American contemporaries Arthur CARLES and Marsden HARTLEY, Maurer flattened the landscape and reduced it to a collection of large, bright, unmodulated areas of color to indicate a rapid impression of a sun-dappled scene. While the basic techniques of this style had already been introduced into French painting by the Impressionists, the fauvist paintings of Maurer and his contemporaries were freer in their application of more highly keyed paint. No longer confining and heavily symbolic, the landscape was an open oasis, a retreat from the city and a haven from human presence.

In 1908 Maurer accurately assessed his new style of painting in a statement for the *New York Times* in which he said that his work was in a transitional stage. Following his return to New York in 1914 he increasingly moved away from the joyous exuberance of his Paris paintings. *P.N.*

Landscape (**Autumn**) (also called *Landscape with Trees*), 1909

Oil on canvas, 25½ x 31¾ in.
(64.9 x 80.8 cm.)
Signed lower right: A.H. Maurer
Gift of Ione and Hudson Walker
53.299
Illustration: Figure 92

REFERENCES: Oliver Larkin, "Alfred Stieglitz
and '291,'" *Magazine of Art* XL (May
1947): 183 • Sheldon Reich, *Alfred H.
Maurer* (Washington, D.C.: National
Collection of Fine Arts, 1973), 43.

EXHIBITIONS: *100 Paintings, Drawings, and
Prints from the Ione and Hudson D.
Walker Collection,* 1965, cat. 73 • National
Collection of Fine Arts, Washington, D.C.,
Alfred H. Maurer, 1868-1932, 1973, cat.
19 • *Abstract USA/1910-1950,* 1981. *
Carleton College, Northfield, Minnesota,
*American Abstraction: 20th Century
American Paintings from the University of
Minnesota,* 1983.

PROVENANCE: Ione and Hudson Walker

Similar to the smaller fauvist *Landscape* of 1908, this one reiterates the compositional techniques and undulating pattern of trees and hills that characterize Maurer's Parisian landscape sketches. The anonymity of the landscape evident in the first work is only slightly challenged here by the presence of two small buildings and irregular thumb-shaped trees. The trees, rhythmically aligned to define a distinct middleground plane, dominate the buildings and the distant hillside, perhaps inspiring Oliver Larkin's alternate title for the painting, *Landscape with Trees.* Larkin claims that the painting was included in Stieglitz's 1910 Younger American Painters exhibition at the 291 gallery, which might account for its still being in the United States. *P.N.*

Landscape (Autumn), *1909 • Figure 92*

303

Landscape with Trees, *1909*

Oil on composition board, 31⅞ x 24⅜ in.
(81.1 x 62 cm.)
Signed lower right: A.H. Maurer
Gift of Ione and Hudson Walker
53.321
Illustration: Figure 93

REFERENCE: Percy North, *Hudson D. Walker: Patron and Friend* (Minneapolis: University of Minnesota Gallery, 1977), 40, 45.

EXHIBITIONS: New York Historical Society, *Exhibition*, 1952 • Cincinnati Art Museum, *Pictures for Peace*, 1944 • Tweed Gallery, University of Minnesota-Duluth, *A Survey of American Painting*, 1955 • Brooks Memorial Union, Marquette University, Milwaukee, *75 Years of American Painting*, 1956 • Joslyn Art Museum, Omaha, *Notable Paintings from Midwestern Collections*, 1956-1957 • Minnesota State Fair, St. Paul, *American Art of the Twentieth Century from the Collection of the University Gallery, University of Minnesota*, 1957 • Amherst College, Amherst, Massachusetts, *The 1913 Armory Show in Retrospect*, 1958, cat. 36 • *Selected Works from the Ione and Hudson Walker Collection*, 1959 • The Renaissance Society of the University of Chicago, *An Exhibition of Paintings by Alfred Maurer*, 1960, cat. 4 • Isaac Delgado Museum of Art, New Orleans, *1910*, 1960 • *Art and the University of Minnesota*, 1961 • Babcock Galleries, New York, *A.H. Maurer's Statement*, 1963, cat. 3 • *100 Paintings, Drawings, and Prints from the Ione and Hudson D. Walker Collection*, 1965, cat. 66 • *Selections from the Permanent Collection*, 1968, 1969, 1970 • Bernard Danenberg Galleries, New York, *Alfred Maurer and the Fauves*, 1973, cat. 46 • *Hudson D. Walker: Patron and Friend*, 1977, cat. 56 • Detroit Institute of Arts Traveling Exhibition, *Paris and the American Avant-Garde, 1900-1925*, 1980-1981.

PROVENANCE: the artist; Ione and Hudson Walker

The largest of Maurer's landscapes in the Museum's collection, *Landscape with Trees*, defined in a pointillist style that had earlier intrigued Henri Matisse, has a more active paint surface than his smaller landscapes. In this painting the artist left areas of the canvas bare to highlight and isolate individual strokes of paint, a technique introduced by Cézanne which was frequently criticized for looking "unfinished." Maurer used the small touches of paint to active the composition and to imbue the landscape with a lively anthropomorphism. Although two strongly vertical trees frame the central space, dividing the composition into a triptych, the varied directional dabs of paint make it difficult for the viewer to focus on any particular area. The emotional unease of the painting prefigures the tension in Maurer's later figure studies. *P.N.*

Landscape with Trees, *1909* • *Figure 93*

304

Still Life *(1), c. 1910*

Oil on gesso on cardboard, 21⅜ x 17⅞ in.
(54.3 x 45.4 cm.)
Unsigned
Bequest of Hudson Walker from the Ione
and Hudson Walker Collection
78.21.3
Illustration: Figure 94

REFERENCE: Sheldon Reich, *Alfred H.
Maurer, 1868-1932* (Washington, D.C.:
National Collection of Fine Arts, 1973), 62-
63.

PROVENANCE: Ione and Hudson Walker

Although the placement of kitchen pottery in rumpled table linens bears an obvious debt to Cézanne, this painting is a more direct representation of the visual world than the still-lifes by the French master. The Cézannesque source of the imagery and the use of bright colors are hallmarks of Maurer's early modernist period, a time during which he produced his most lyrical paintings. *P.N.*

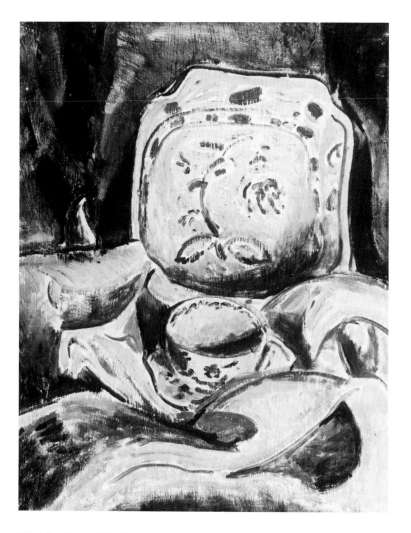

Still Life *(1), c. 1910* ▪ *Figure 94*

305

Landscape (2), 1916

Oil on paper on cardboard, 21¾ x 18 in.
(55.3 x 45.8 cm.)
Signed lower left: A.H. Maurer
Bequest of Hudson Walker from the Ione
and Hudson Walker Collection
78.21.159
Illustration: Appendix

EXHIBITIONS: *Maurer Retrospective*, 1952 •
*Selected Works from the Ione and Hudson
Walker Collection*, 1959 • The Renaissance
Society of the University of Chicago, *An
Exhibition of Paintings by Alfred Maurer*,
1960 • Babcock Galleries, New York, *A.H.
Maurer's Statement*, 1963 • *100 Paintings,
Drawings, and Prints from the Ione and
Hudson D. Walker Collection*, 1965, cat.
68 • Bernard Danenberg Galleries, New
York, *Alfred H. Maurer and the Fauves*,
1973, cat. 47 • Carleton College, Northfield,
Minnesota, *American Art, 1900-1940*, 1977
• University of Kansas Museum of Art,
Lawrence, *Inaugural Exhibition—Spencer
Museum of Art*, 1978.

PROVENANCE: Ione and Hudson Walker

The pastoral lane bordered by two trees and a red-orange building is a reworking of the three-part compositional framing device of the earlier *Landscape with Trees*. This painting is more controlled and carefully composed than that one, however. It incorporates subtle cubist planar fragments as a foretaste of Maurer's later mode of painting but continues his exploration of the varied effects of brilliant sunlight on both shapes and colors. *P.N.*

Yellow Pear and Roll, *c. 1920*

Oil on composition board, 18⅛ x 21¾ in.
(46.1 x 55.3 cm.)
Signed upper right: A.H. Maurer
Gift of Ione and Hudson Walker
53.305
Illustration: Appendix

REFERENCES: Sheldon Reich, *Alfred H.
Maurer, 1868-1932* (Washington, D.C.:
National Collection of Fine Arts, 1973), 67
• Katherine Harper Mead, editor, *The
Preston Morton Collection of American Art*
(Santa Barbara, California: Santa Barbara
Museum of Art, 1981), 238-239.

EXHIBITIONS: *Selections from the Collection
of Mr. and Mrs. Hudson D. Walker*, 1950 •
Babcock Galleries, New York, *Hartley—
Maurer—Still Life*, 1964 • *100 Paintings,
Drawings, and Prints from the Ione and
Hudson D. Walker Collection*, 1965, cat.
84.

PROVENANCE: Ione and Hudson Walker

In this still-life Maurer introduced the overlapping planar backgrounds that were to become the hallmark of his late cubist style at the end of the decade. The curvilinear shapes of the croissant and pear contrast with the rectilinear background. *P.N.*

Girl in a Brown Dress, *1920-1924*

Oil on gesso on composition board, 26½ x
18 in.
(67.4 x 45.8 cm.)
Signed lower left: A.H. Maurer
Bequest of Hudson Walker from the Ione
and Hudson Walker Collection
78.21.57
Illustration: Appendix

PROVENANCE: Alfred Stieglitz; Ione and
Hudson Walker

Stylistically, this work is related to a series of portraits Maurer painted in the environs of Marlborough-on-the-Hudson, New York, which are based upon actual observations of young women the artist knew and met. Its closest parallel appears to be *Portrait of a Girl* (*c.* 1923) in the collection of Mr. and Mrs. Meyer P. Potamkin of Philadelphia. In both paintings Maurer has chosen to show a three-quarter-length view of a young girl in a dark-colored dress framed by a collar and standing against a nondescript background space. In *Girl in a Brown Dress* he has paid careful attention to the fullness of his subject's face and has emphasized the muscles in her elongated neck. In contrast to the large, almond-shaped eyes that dominate his later female portraits, the eyes of this woman are rather small and narrow; their glassy, unfocused stare convey a sense of introspection.

Several critics have commented on the meaning of the large, staring eyes in Maurer's female portraits, noting their similarity to African masks or ancient Mesopotamian figures. Maurer certainly knew and appreciated African art and was greatly taken by the use of African motifs in the works of European avant-garde painters, but whether he intended the eyes he painted to express the sitter's mental state or his own inner turmoil is a question which defies resolution. *R.L.G.*

Girl *(1), 1921-1924*

Casein on canvas on composition board,
26¼ x 18⅛ in.
(66.8 x 46.1 cm.)
Signed lower right: A.H. Maurer
Bequest of Hudson Walker from the Ione
and Hudson Walker Collection
78.21.84
Illustration: Figure 95

PROVENANCE: Ione and Hudson Walker

The largest group of Maurers in the University Art Museum is a series of expressionistically rendered heads of women and girls. Maurer produced these in large quantities in a variety of media during the decade preceding his death. They are the most personal of works and have been the least understood and appreciated.

Maurer was obsessed by a particular vision of woman, for he repeated a stereotypical figure with only slight variations—it became increasingly abstract, and it aged as he aged. The women, girls, or "street girls" (as Elizabeth McCausland calls them) he painted appear singly or in groups silhouetted against an indeterminate interior space reminiscent of a photo booth, or against a window on a landscape. The claustrophobic spaces push the figures toward the viewer. All of the figures wear simple round-neck dresses covering lumpish, broad-shouldered, unfeminine bodies, and their heads are perched on long, sinuous necks. The most striking and universally similar element in all of these paintings is the large, staring eyes, haunting and self-conscious—as if the sitter were posing warily before a mirror.

The melancholy intensity of the paintings gives them the psychological depth of a self-portrait. At least one critic has noted that Maurer's heads appear to be thinly disguised self-portraits: the mournful eyes, long, thin noses, wide mouths, and simple hairstyles emphasizing high foreheads are similar to Maurer's own, as is evident in his late self-portrait in Walker Art Center (Minneapolis).

A chronology of Maurer's figures is difficult to establish due to generic titles and paltry internal or external evidence. The first was exhibited in the 1921 Independents Exhibition, and the gallery dealer E. Weyhe bought one in 1922. The works can be grouped loosely by their titles to indicate some chronological progression. The "Portrait" designation, for example, seems to refer to a group of early works, while the abstract heads seem to be among the latest. Although there are some obvious examples that do not fall into either category, this does seem a useful means for organizing the works in the University Art Museum. Thus the following rough ordering is suggested: 1921-1924, portraits and girls; 1925-1926, heads; 1927-1930, expressionist heads; 1930-1932, cubist abstractions and abstract heads. (Note: Many of Maurer's "girls" look young and childlike, but the word "Girl" in a painting title should be taken as an indication of gender, not age.)

Girl (1) is one of the least well-defined of the early figures and has the most obviously masculine flapper hairstyle. Although the abstract painting behind her head is similar to that in the female figures painted on dress fabric exhibited in 1924 and now in the Museum collection, the flatness of the figure is similar to that of *Girl in a Brown Dress* which Elizabeth McCausland places in 1920. *P.N.*

Portrait of a Girl *(1), 1921-1924*

Oil on canvas on composition board, 26 x 18 in.
(66.2 x 45.8 cm.)
Signed upper right: A.H. Maurer
Bequest of Hudson Walker from the Ione and Hudson Walker Collection
78.21.199
Illustration: Appendix

EXHIBITION: *Selected Works from the Ione and Hudson Walker Collection*, 1959.

PROVENANCE: Addison Gallery; Mr. Fernandez; Ione and Hudson Walker

During the early 1920s Maurer codified an intensely mournful vision of a woman isolated in a neutral setting. A number of these early works, like *Portrait of a Girl* (1), he designated as individualized portraits, but through repeated interpretation they evolved into a stylized type. Elizabeth McCausland referred to these "girls" as symbols, but unfortunately she did not go on to explain her idea of what they meant. Perhaps they express the artist's attempt to explore the inner turmoil and alienation he felt as a result of his neuroses and homosexuality.

Although McCausland's suggested early date of 1921 for this painting would accord with her date of 1920 for *Girl in a Brown Dress*, both works are closely related to *Girl*, to which she gave the date of 1924. A span of 1921 to 1924 may be the most limited we can ascribe to these paintings. *P.N.*

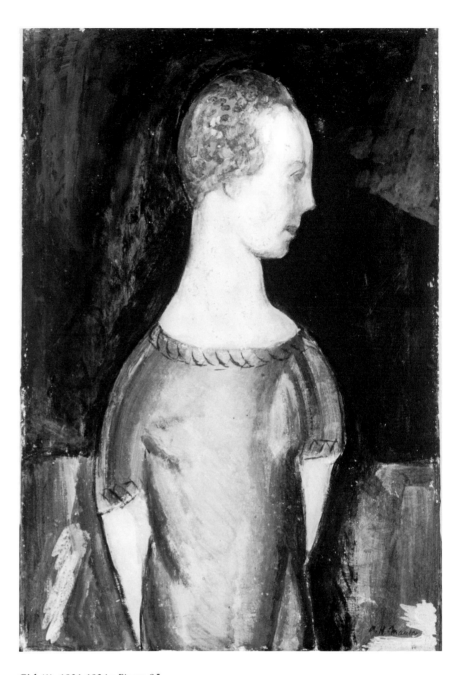

Girl *(1), 1921-1924* ▪ *Figure 95*

This series of compositions illustrates how Maurer managed to employ a representational style of painting within his chosen theme—portraits of women—while simultaneously experimenting with elements of form and composition. In all three of these paintings the figures have been arbitrarily cropped slightly below the waist, with their hands and arms falling out of the picture plane. This was not even then a new technique; Maurer had certainly seen it in the works of such French impressionists as Degas. In Maurer's paintings, however, the faces appear as flat forms with only the rudiments of modeling and shadow brushed in. In their effect and function, these shadows are as decorative as they are functional and serve to highlight the outlined forms of lips, noses, and eyes.

The artist has also borrowed a technique from cubist collage, gessoing ordinary commercial dress fabric onto composition board. But unlike the European cubists, who arbitrarily placed bits of real objects upon their canvases, Maurer lets the fabric perform its intended function and organizes his composition around it. Also unlike the cubists, who broke down objects in an attempt to analyze form, Maurer is able to suggest the two-dimensionality of his painting while retaining an integral figure in the composition. In *Portrait of a Girl* (2), for example, he skillfully enhances the bold black circles of the fabric by framing the sitter in a dark block of paint, thereby emphasizing the flatness and pattern while helping focus our attention on the figure. He uses a similar technique in the other two portraits in this series, with a twist: in *Portrait of a Girl* (3) he uses the checked fabric to suggest a figure at rest, while in *Portrait of a Girl* (4) he uses the same fabric to impart a sense of movement. *R.L.G.*

Portrait of a Girl *(2), 1924*

Casein on figured fabric gessoed to cardboard, 26 x 18 in.
(66.2 x 45.8 cm.)
Unsigned
Bequest of Hudson Walker from the Ione and Hudson Walker Collection
78.21.164
Illustration: Appendix

PROVENANCE: Ione and Hudson Walker

Portrait of a Girl *(3), 1924*

Casein on gesso on printed fabric on
cardboard, 26 x 18⅛ in.
(66.2 x 46.1 cm.)
Signed upper left: A.H. Maurer
Bequest of Hudson Walker from the Ione
and Hudson Walker Collection
78.21.167
Illustration: Appendix

PROVENANCE: Ione and Hudson Walker

Portrait of a Girl *(4), 1924-1925*

Casein on gesso on printed fabric on
cardboard, 26¼ x 18¼ in.
(66.8 x 46.4 cm.)
Signed upper left: A.H. Maurer
Bequest of Hudson Walker from the Ione
and Hudson Walker Collection
78.21.166
Illustration: Appendix

PROVENANCE: Ione and Hudson Walker

Portrait of a Girl in a Flowered Dress, *1924*

Casein on figured fabric gessoed to
composition board, 25⅞ x 17⅞ in.
(65.8 x 45.5 cm.)
Signed lower right: A.H. Maurer
Gift of Ione and Hudson Walker
53.214
Illustration: Figure 96

REFERENCE: Elizabeth McCausland, *A.H.
Maurer* (New York: A.A. Wyn, 1951), 164.

EXHIBITIONS: *100 Paintings, Drawings, and
Prints from the Ione and Hudson D.
Walker Collection*, 1965, cat. 74 •
University of Maryland Fine Arts Gallery,
College Park, *Arthur Dove: The Years of
Collage*, 1967 • National Collection of Fine
Arts, Smithsonian Institution, Washington,
D.C., *Alfred H. Maurer, 1868-1932*, 1973,
cat. 45 • *Alfred H. Maurer: American
Modernist*, 1973 • *Hudson D. Walker:
Patron and Friend*, 1977, cat. 59.

PROVENANCE: Buchholtz Gallery, New York;
Ione and Hudson Walker

A classic example of Maurer's female figures of the 1920s, this
work exhibits his personal form of collage. Elizabeth McCausland
explained the artist's technique: "He glued cloth to 26 x 18" panels
and painted over the cloth, allowing the textile to show where
surface texture and design would enhance his picture. About a
dozen of these dress-goods covered panels survive....He painted in
heavy tempera, with considerable impasto, so that the unpainted
areas offer a strong textural contrast" (McCausland, p. 169).
Maurer used the dress fabric in a dual fashion: as a surface for
painting, and as a dress for the painted figure. The printed pattern
implies Maurer's concern about the role of design and artifice in
painting.

Maurer's women painted on dry goods were first exhibited in the
1924 Independents Exhibition. *P.N.*

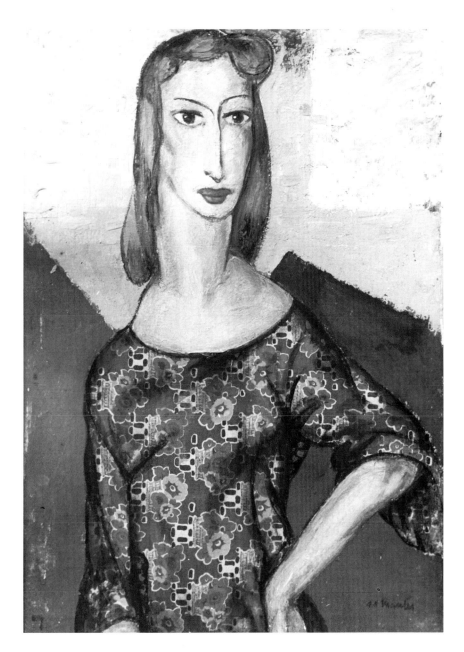

Portrait of a Girl in a Flowered Dress, *1924* ▪ *Figure 96*

313

These two portraits bear a striking resemblance to Maurer's works in gouache dated from this same period. In the gouache portraits, shown at the Weyhe Gallery (New York) in November 1924, the figures are distinguished by their flat, expressionless faces set against equally flat background spaces. The chalklike quality of their features contrasts with their fully modeled figures and lends the paintings a sense of unreality. Like paper cutouts, the girls appear devoid of feeling or emotion.

The two *Portraits* included here convey the same effect. The flat, milky surfaces of the faces stand out sharply against the dark background areas. While this technique focuses attention on the heads, it also emphasizes the flatness of the entire picture surface. *R.L.G.*

Casein on gesso on cardboard,
25⅞ x 18 in.
(65.8 x 45.8 cm.)
Unsigned
Bequest of Hudson Walker from the Ione and Hudson Walker Collection
78.21.163
Illustration: Appendix

PROVENANCE: Ione and Hudson Walker

Portrait of a Girl *(5), 1924-1925*

Casein on fabric gessoed to cardboard attached to a wood frame, 26¼ x 18⅛ in.
(66.8 x 46.1 cm.)
Signed upper left: A.H. Maurer
Bequest of Hudson Walker from the Ione and Hudson Walker Collection
78.21.165
Illustration: Appendix

PROVENANCE: Ione and Hudson Walker

Portrait of a Girl *(6), 1924-1925*

Two Heads *(1), 1924-1925*

Oil on gesso on composition board, 36 x 25½ in.
(91.6 x 64.9 cm.)
Signed upper right: A.H. Maurer
Bequest of Hudson Walker from the Ione and Hudson Walker Collection
78.21.302
Illustration: Appendix

PROVENANCE: Ione and Hudson Walker

At his first exhibition at the Weyhe Gallery (New York) in 1924, Maurer included several paintings of paired women. The juxtaposition of two almost identical faces extends the range and meaning of his single figures, obvious sources for the characteristic type of the earliest twinned women.

During the last years of the 1920s until his death, Maurer increasingly distorted the human form until it resembled the cubist shapes of his contemporaneous still-lifes. The literal legibility of *Two Heads* (1), similar in type to *Head of a Girl* (3), indicates that the painting is an early one in the series. The docile introspective or vapid nature of the earliest paired women turned to fury in the later works, which are virtually unrecognizable as depictions of human beings.

The inherent similarity of the figures in the double portrait caused Elizabeth McCausland to refer to them as "sisters." The figures in *Two Heads* (1) are so close (in appearance and proximity) that they might be more appropriately described as Siamese twins. The obsessive repetition of such similar faces seems to express the concept of intellectual and emotional duality, an idea that is reinforced throughout the development of the series. As in the later variations, the women wear the same expression, their eyes are aligned along an axis, and the two heads can be inscribed in a single circle. The women's facial characteristics are also similar to those of Maurer's *Self-Portrait* (Colorplate XXVII). *P.N.*

Hyacinth, *c. 1925*

Oil on composition board, 21¾ x 18⅛ in. (55.3 x 46.1 cm.)
Unsigned
Gift of Ione and Hudson Walker
53.325
Illustration: Figure 97

EXHIBITIONS: *Selected Works from the Ione and Hudson Walker Collection*, 1959 • The Renaissance Society of the University of Chicago, *An Exhibition of Paintings by Alfred Maurer*, 1960.

PROVENANCE: Ione and Hudson Walker

Maurer's painting of this aromatic flower is a link between his earliest fauvist still-lifes of fruit, flowers, and kitchen objects and his later flamboyant floral compositions. The simple arrangement—a flower in a vase, resting on a small table—is characteristic of his still-lifes. Maurer always eschewed extraneous details and insisted on shallow spaces so as to focus on the object at close range.

In *Hyacinth* the vase tips forward toward the viewer against the vertical alignment of the flower paralleling the picture plane. Maurer gleaned this technological point of view and perspective from Cézanne as a way to heighten pictorial tension and stimulate the viewer's curiosity. The triangular shape of the hyacinth and its leaves are accentuated by the active brushstrokes that create a sort of halo around the arrangement and increase the rhythmic action of the supposedly still composition. *P.N.*

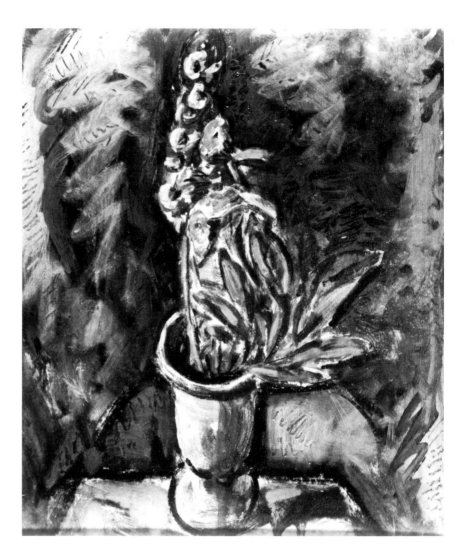

Hyacinth, *c. 1925* ▪ *Figure 97*

Still Life *(2), c. 1925*

Casein on gesso on composition board,
21¾ x 18⅛ in.
(55.3 x 46.1 cm.)
Signed lower right: A.H. Maurer
Bequest of Hudson Walker from the Ione
and Hudson Walker Collection
78.21.190
Illustration: Appendix

This arrangement of a pitcher, a sugar bowl, and an apple nestled
in agitated drapery is from a series of still-life paintings that Maurer
produced during the 1920s. About the series, Sheldon Reich wrote,
"There are a number of pictures, probably executed about 1925,
that depict a white pitcher. Maurer is said to have painted quickly;
but these particular still lifes are rendered in a finished manner with
a rich impasto. In muted hues, they recall the Hartleyesque still
lifes. The relative objectivity of these paintings compares favorably

REFERENCE: Sheldon Reich, *Alfred H. Maurer, 1868-1932* (Washington, D.C.: National Collection of Fine Arts, 1973), 68.

EXHIBITION: Babcock Galleries, New York, *Hartley—Maurer—Still Life*, 1964.

PROVENANCE: Ione and Hudson Walker

Gouache on canvas on composition board, 26 x 17⅞ in.
(66.2 x 45.5 cm.)
Signed upper right: A.H. Maurer
Bequest of Hudson Walker from the Ione and Hudson Walker Collection
78.21.86
Illustration: Appendix

PROVENANCE: Ione and Hudson Walker

Oil on gesso on composition board, 17½ x 13¾ in.
(44.5 x 35 cm.)
Signed upper left: A.H. Maurer
Bequest of Hudson Walker from the Ione and Hudson Walker Collection
78.21.114
Illustration: Appendix

PROVENANCE: Ione and Hudson Walker

to the same quality in the flower pieces we know were being done at this time" (Reich, pp. 66-67). In this painting Maurer utilized his favored high vantage point and Cézannesque distortions to introduce spatial tension. Aggressive drapery engulfing the inherently still forms enhances the tension that is characteristic of his late paintings. *P.N.*

Girl *(2), 1925-1926*

The use of solid outlines, flatness of modeling in the arms (as opposed to the fully modeled torso), and a unique facial type consisting of an oval head, recessive hairline, and vacuous stare characterized Maurer's "girl" paintings throughout the mid-1920s. It was then that he arrived at the less sharply outlined figure characteristic of his portraits from about 1926-1927. This evolution in his style helps to place the present work at about 1925-1926.

The positioning of the girl before a curtained background space— as if she were standing before an open window—is an important feature of this painting, although it is not known precisely why the artist chose to use it. The window-like backdrop first manifested itself in Maurer's Paris paintings of the 1890s. As a device, it recalls Renaissance prototypes; however, Maurer's use of this theme appears to have more in common with the experiments in form and composition practiced by such artists as Picasso. *R.L.G.*

Girl's Head, *1925-1926*

During the mid-1920s Maurer's obsession with the female was refined in a group of works generically called "heads" or "girl's heads." For him, the use of portrait nomenclature became too specific, and he eliminated extraneous details to concentrate on faces as reflections of inner emotional states. Since the portraits were not designated as individuals, they were probably meant to be portraits of individual mental states rather than unique physical types. They symbolize the range of human intellectual experience, although Maurer evidently preferred the contemplative to the cheerful.

The repeatedly stylized images may have been intended as studies in mood of a single individual. This might account for the limited range of physical types—but the emotional range the figures express is also relatively limited. As he aged, Maurer emphasized

317

intellectual turmoil over external sensory experiences. Like Théodore Géricault, he mirrored emotional turbulence in tortured faces. He portrayed the anxiety-producing complexities of modern society as the most characteristic aspect of twentieth-century life.

Less calm and introspective than the earlier portraits, the heads are defined by active lines and are frequently (although not in this instance) surrounded by active space echoing the mental activity. In typical Maurer fashion, the subject of *Girl's Head* glances warily at the viewer over her exceptionally elongated neck. *P.N.*

Head of a Girl *(1), 1925-1926*

Oil on gesso on composition board, 35⅞ x 25½ in.
(91.6 x 64.9 cm.)
Signed upper right: A.H. Maurer
Bequest of Hudson Walker from the Ione and Hudson Walker Collection
78.21.304
Illustration: Appendix

PROVENANCE: Ione and Hudson Walker

Although Maurer's heads demonstrate a relatively limited range of expression—primarily wary and melancholic—*Head of a Girl* (1) is coy and demure. Most of the women in his later paintings avert the direct gaze of the spectator, seeming to look inward; even the earlier portraits carried this same air of sadness. *P.N.*

This group of paintings demonstrates the type of female face which evolved in Maurer's paintings by the mid-1920s. By then he had developed a simplified vocabulary of forms and shapes which combine to produce an emotionally expressive image while retaining a purely decorative function.

In *Head of a Girl* (2) and (3), the artist has created a striking image by setting off the light-complexioned face against a dark, impenetrable background. This skillfully causes the viewer to focus on the face and its central feature: the haunting, almond-shaped eyes. By making the eyes the dominant feature in an otherwise nondescript head, Maurer established a powerful rapport between viewer and subject and lent his canvas a haunting psychological presence.

The artist's gradual development of this head type is seen by examining all three of these paintings in sequence. *Head of a Girl* (2) displays the first tentative unfolding of the psychological dialogue; the eyes, while enlarged, have not yet increased dramatically in scale, and the subject's glance is averted. *Head of a Girl* (3) represents the mature style, where the eyes become the painting as they fill the face and stare directly out from the picture plane. In *Head* (1), painted only two years later, Maurer has added another dimension by lightening the background with active, curling lines of paint that set off and parallel the contours of the woman's face and hair. In doing so he creates an active surface which imitates in its function the cerebral and psychic energy evident in her powerful, staring eyes. *R.L.G.*

Head of a Girl *(2), 1925-1926*

Oil on gesso on composition board, 36 x 25½ in.
(91.6 x 64.9 cm.)
Signed upper left: A.H. Maurer
Bequest of Hudson Walker from the Ione and Hudson Walker Collection
78.21.118
Illustration: Appendix

PROVENANCE: Ione and Hudson Walker

Head of a Girl *(3), 1925-1926*

Oil on gesso on composition board, 36 x 25½ in.
(91.6 x 64.9 cm.)
Signed upper right: A.H. Maurer
Bequest of Hudson Walker from the Ione and Hudson Walker Collection
78.21.303
Illustration: Figure 98

PROVENANCE: Ione and Hudson Walker

Head *(1), 1927*

Oil on gesso on canvas on composition board, 30⅛ x 19⅞ in.
(76.5 x 50.1 cm.)
Signed upper left: A.H. Maurer
Gift of Ione and Hudson Walker
53.322
Illustration: Appendix

PROVENANCE: Ione and Hudson Walker

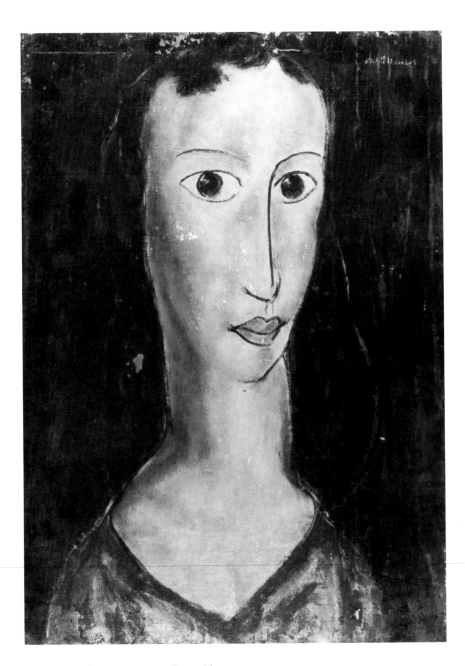

Head of a Girl *(3), 1925-1926 ▪ Figure 98*

Heads, *1926-1927*

Casein on canvas on composition board,
29⅞ x 19⅞ in.
(76 x 50.6 cm.)
Signed upper left: A.H. Maurer
Bequest of Hudson Walker from the Ione
and Hudson Walker Collection
78.21.93
Illustration: Appendix

REFERENCE: Sheldon Reich, *Alfred H. Maurer, 1868-1932* (Washington, D.C.: National Collection of Fine Arts, 1973), 96.

PROVENANCE: Ione and Hudson Walker

This painting of primitively flattened figures belongs to a series of double portraits in interiors that Maurer had begun by 1924. About this series, Sheldon Reich wrote: "In truth the multiple portraits are more nearly partial figure studies than heads: the artist has given much effort to the bodies with their simple dresses and their relationships to one another. The women in the respective paintings often resemble one another; thus Miss McCausland refers to them as sisters" (Reich, p. 96). These women also display the facial stylizations found in Maurer's own late self-portrait. They appear to be two variations of the same figure—one seated, the other standing. The turmoil of the space behind them reinforces the agitation of their gazes.

The reverse of the painting bears a label from the Society of Independent Artists, where it was undoubtedly exhibited. *P.N.*

Maurer first displayed his double portraits of women at his 1924 Weyhe Gallery exhibition. Their appearance provoked much commentary from critics, one of whom described them as possessing "a strange realism, veiled by a repellent conception of form, a kind of forced naiveté" [*New York Tribune* (27 January 1924), quoted in Reich, p. 96]. The notion that these works are naive may derive from Maurer's interest in Italian Quattrocento art, where the female face is shown nearly always in profile and pressed up against the picture plane—an arrangement that veils the sitter's true emotions while revealing all of her physical characteristics. In *Two Heads* (2) Maurer has altered this arrangement by turning the face to a nearly three-quarter view and reproducing not one but two faces. Blown up to nearly three times life size, they become huge mirror images of each other, their emotional state no more revealed in this strange new format than in the single profile images of Italian Early Renaissance art.

Maurer also painted two figures face-to-face, as in *Two Figures of Girls*. (This work is also known as *Two Sisters*, a title which purports to resolve the relationship between these identical-looking women by assuming they are related; it probably did not originate with Maurer.) One has the feeling that the painting really shows one woman looking at her distorted reflection in a mirror, or at her alter ego.

In both cases, the uncanny resemblance of the heads contributes to the disturbed feeling one has upon looking at these pictures. *R.L.G.*

Two Figures of Girls (also called *Two Sisters*), 1926-1927

Oil on composition board, 36 x 25½ in. (91.6 x 64.9 cm.)
Signed upper left: A.H. Maurer
Gift of Ione and Hudson Walker
53.326
Illustration: Appendix

EXHIBITION: *100 Paintings, Drawings, and Prints from the Ione and Hudson D. Walker Collection*, 1965, cat. 80.

PROVENANCE: Ione and Hudson Walker

Two Heads (2), *c. 1928*

Oil on gesso panel, 48 x 39⅛ in. (122.1 x 99.6 cm.)
Signed upper right: A.H. Maurer
Bequest of Hudson Walker from the Ione and Hudson Walker Collection
78.21.298
Illustration: Appendix

REFERENCES: Elizabeth McCausland, *A.H. Maurer* (New York: A.A. Wyn, 1951), 209 ▪ Elizabeth McCausland, "A.H. Maurer," *Magazine of Art* XLIV (October 1951): 252 ▪ Sheldon Reich, *Alfred H. Maurer, 1868-1932* (Washington, D.C.: National Collection of Fine Arts, 1973), 100.

EXHIBITIONS: Walker Art Center, Minneapolis and the Whitney Museum of American Art, *A.H. Maurer*, 1949, cat. 57 ▪ *Selected Works from the Ione and Hudson Walker Collection*, 1959 ▪ The Renaissance Society of the University of Chicago, *An Exhibition of Paintings by Alfred Maurer*, 1960, cat. 13 ▪ *Selections from the Permanent Collection*, 1969 ▪ *Hudson D. Walker: Patron and Friend*, 1977, cat. 62 ▪ Museum of Art and Archaeology, University of Missouri-Columbia, *Six from Minneapolis*, 1978.

PROVENANCE: Ione and Hudson Walker

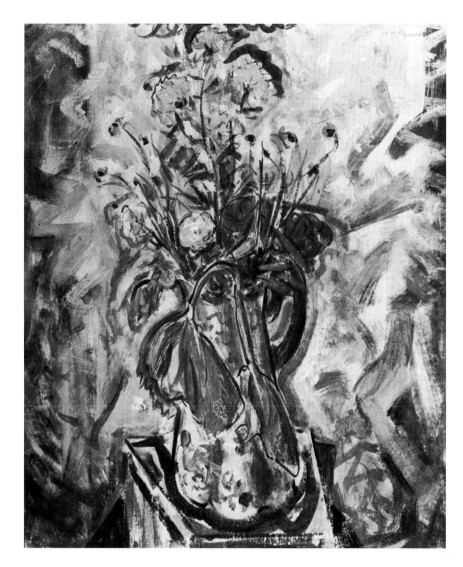

Still Life *(3), c. 1927* ▪ *Figure 99*

Still Life *(3), c. 1927*

Casein on gesso on composition board,
21⅞ x 18⅛ in.
(55.3 x 46.1 cm.)
Signed upper right: A.H. Maurer
Gift of Ione and Hudson Walker
53.210
Illustration: Figure 99

PROVENANCE: Ione and Hudson Walker

The decade of the 1920s was Maurer's most creative period in the United States. He concentrated on still-lifes and female figure paintings, infusing the still forms with activity and presenting the supposedly living forms as if they were inanimate objects. Two forms of still-life dominated this period: kitchen utensils and fruit, and exuberant bouquets of flowers. Although the pitchers, bowls, and fruit are carefully controlled studies of volumes, the lavish bouquets are a riot of color and interlacing lines. Both types of still-life share the same compositional organization, with the images

323

pushed close to the picture surface within shallow spaces usually seen from above. The two types, however, form a contrast of color and emotional effusiveness. Both exhibit intense pictorial tension, but in distinctly different ways. The flowers, retaining the lush colors of Maurer's fauvist phase, spread to the edges of the canvas in undulating patterns and are surrounded by actively moving lines. Nothing is still and there is no point of visual rest in these works. The lively images transcend a traditional image of fragile and cultivated floral shapes elegantly arranged; instead, they insist on the vibrancy of nature. Even the decorative floral pattern on the vase reiterates the activity of the flowers of the bouquet. *P.N.*

Brass Bowl (also called *Still Life with Brass Bowl and Yellow Drape*), 1927-1928

This still-life composition is among Maurer's most ambitious and complicated. As a study of pattern and pictorial representation of three-dimensional forms, it is indicative of his continuing debts to Cézanne and Matisse in its use of tilted planes and varied points of view of decorative drapery surrounding kitchen objects that pose visual challenges for the viewer. The pictures resting on the drapery are key elements that insist on the inherent two-dimensionality of the medium even though all of the other pictorial elements intimate three-dimensional volume. As a challenge to the generic "still-life" title, the excessive busyness of the pattern produces a frenetic activity similar to that in Maurer's contemporaneous floral pieces. *P.N.*

Oil on gesso on composition board, 21⅛ x 18⅛ in.
(54.4 x 46.1 cm.)
Signed upper left: A.H. Maurer
Gift of Ione and Hudson Walker
53.320
Illustration: Appendix

REFERENCE: Sheldon Reich, *Alfred H. Maurer* (Washington, D.C.: National Collection of Fine Arts, 1973), 72.

EXHIBITIONS: Babcock Galleries, New York, *A.H. Maurer's Statement*, 1963 ▪ Babcock Galleries, New York, *Hartley—Maurer— Still Life*, 1964 ▪ National Collection of Fine Arts, Smithsonian Institution, Washington, D.C., *Alfred H. Maurer, 1868-1932*, 1973, cat. 71.

PROVENANCE: Ione and Hudson Walker

Nude, 1927

Maurer was obsessed with the pictorial representation of women, yet he rarely emphasized their sexual identities. He initially depicted women as figures of grace and style, transforming them later into deeply psychological entities. His relatively rare paintings of nudes, therefore, represent an interesting sidestep in his oeuvre.

After renting a private studio in the Lincoln Square Arcade at 66th Street (New York) in 1927, Maurer worked from the live model weekly during the winter and spring of 1927-1928. Most of his nudes appear to be studies rather than fully conceived works. Most were painted on composition board—and many have been defaced.

Oil on composition board, 39¼ x 24 in.
(99.9 x 61.1 cm.)
Signed upper right: A.H. Maurer
Bequest of Hudson Walker from the Ione and Hudson Walker Collection
78.21.299
Illustration: Figure 100

REFERENCES: Elizabeth McCausland, *A.H. Maurer* (Minneapolis: Walker Art Center, 1949), 19, 22 ▪ Elizabeth McCausland, *A.H. Maurer* (New York: A.A. Wyn, 1951), 196, 199 ▪ William H. Gerdts, *The Great American Nude* (New York: Frederick A.

Praeger Publishers, Inc., not dated), 166 •
Sheldon Reich, *Alfred H. Maurer, 1868-1932* (Washington, D.C.: National
Collection of Fine Arts, 1973), 78.

EXHIBITIONS: Walker Art Center,
Minneapolis. *A.H. Maurer*, 1949, cat. 45 •
Walker Art Center Traveling Exhibition,
Expressionism, 1956-1957 • *Selected Works
from the Ione and Hudson Walker
Collection*, 1959 • The Gallery of Modern
Art, New York, *The Twenties Revisited*,
1965 • *Hudson D. Walker: Patron and
Friend*, 1977, cat. 60 • *The First Fifty Years
1934-1984: American Paintings and
Sculpture from the University Art Museum
Collection*, 1984

PROVENANCE: Ione and Hudson Walker

In her 1949 catalogue, Elizabeth McCausland explained, "In his last years Maurer painted out the nudes of 1927-1928, as if deliberately to erase an entire category of subject matter" [Elizabeth McCausland, *A.H. Maurer* (Minneapolis: Walker Art Center, 1949), p. 19]. Although he obliterated other works as well, his nudes were made even more scarce by this procedure. He may have been embarrassed by them and considered them personal statements; still, they were exhibited during his lifetime.

The illogical location of the voluptuous, volumetric nudes in irregular, rectilinear environments was at least partially explained by Sheldon Reich: "The tendency to compose with rectangular subdivisions becomes particularly acute here and may be owing in part to Maurer's concern with Jay Hambidge's theory of dynamic symmetry" (Reich, p. 78). Maurer restructured the traditional theme of the expressive, recognizable naked female figure by placing her in a totally ambiguous spatial context.

In *Nude* the identifiable unclothed form is contrasted with cubist tilted and overlapping space. Maurer seems to be trying to merge his deeply felt expressionism with the intellectual methodology of cubist space. The erratic pattern of the floor tile distorts the sense of space and is translated into a decorative pattern similar to designs the cubists used in their synthetic paintings. The nude figure twists and turns in an ungainly pose reminiscent of Degas's bathers, but there is no external logic for the contorted posture. The logic emanates from Maurer's desire to capture the figure at an oddly stressful angle. The massive curvaceous body contrasts startlingly with the flat angular interior; the tension of the pose is intensified by the tilting planes and angles of the background.

Sensuality is conspicuously absent in Maurer's nudes. In this work, for example, the hulking female appears more tortured (emotionally and physically) than alluring and invites pity, not lust. Thus the nudes form a link between Maurer's earliest full-length clothed figures, his abstract compositions, and his late expressive heads.

One curious aspect of Maurer's nudes is that they are shown with their feet covered. Although Elizabeth McCausland claimed that this was due to the artist's inability to render feet, Sheldon Reich later contended that Maurer was perfectly adept at them. Surely his drawings of nudes, some of which are in the University Art Museum collection, attest to his skill at rendering the whole figure.

The solid cube-like block at the lower edge of this canvas, possibly meant to indicate a model stand, serves as a visual weight for the entire composition and counteracts the diagonal thrust of the background. Maurer was as reticent to define hands as he was to define feet, and it is notable that his late figure paintings are devoid of extremities. The abruptly cropped feet—a motif frequently used by Matisse to emphasize the salient rhythms of the body—produces a pictorial tension that heightens the disjunction between figure and setting. *P.N.*

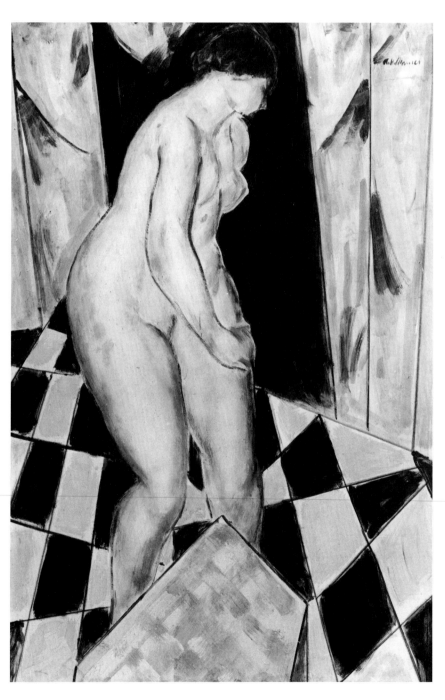

Nude, *1927 • Figure 100*

Standing Nude, *1927-1928*

Oil on gesso on composition board,
39 x 24 in.
(99.1 x 61 cm.)
Signed upper right: A.H. Maurer
Bequest of Hudson Walker from the Ione
and Hudson Walker Collection
78.21.305
Illustration: Appendix

PROVENANCE: Ione and Hudson Walker

A loosely painted twisting figure with obscured feet set against an irregularly tilted background, *Standing Nude (Figure 100)* is a pendant to *Nude* in the University Art Museum collection. Painted in yellowish tones bordered by heavy dark lines, Maurer's nudes are singular productions that bear little relationship to the ways other artists have depicted the unclothed female form. The compositional contrast of massive curving shape as solid volume silhouetted against flattened space is similar to the still-lifes that Maurer was producing during the same period. *P.N.*

Standing Female Nude (also called *Nude), 1928*

Oil on gesso on wood, 36 x 25½ in.
(91.6 x 64.9 cm.)
Signed upper right: A.H. Maurer
Gift of Ione and Hudson Walker
53.324
Illustration: Appendix

REFERENCE: Sheldon Reich, *Alfred H. Maurer, 1868-1932* (Washington, D.C.: National Collection of Fine Arts, 1973), 82.

EXHIBITIONS: New York Historical Society, *Exhibition*, 1952 • *Selected Works from the Ione and Hudson Walker Collection*, 1959 * *Selections from the Permanent Collection*, 1958 • The New York Cultural Center Traveling Exhibition, *Three Centuries of the American Nude*, 1975 • The Minneapolis Institute of Arts, *The American Arts: A Celebration*, 1976.

PROVENANCE: Ione and Hudson Walker

Throughout the mid-1920s, Maurer painted a series of panel paintings of nudes as well as gouache compositions on the same theme. He prepared for these paintings with hundreds of pencil and conte crayon drawings, many of which are also in the University Art Museum collection. Executed in a careful manner, these drawings reveal Maurer to be an excellent draftsman familiar with the academic practice of drawing from the studio model.

In *Standing Female Nude* he deliberately departed from this academic approach and focused instead on experimenting with the nude human form as a figure set within a space composed of rectangular and planar shapes. The setting suggests a typical studio interior, with the model standing on a podium before a folding screen. Yet, as in cubism, the background has been tilted forward and abstracted according to the principles of Dynamic Symmetry set forth in the writings of Jay Hambidge. Maurer has clearly positioned his model so that the posterior view also reflects the influence of planar shapes and angles preferred by Hambidge. The hem of the cloth which drops in front of her legs, for example, neatly follows the angle of the floor line and outlines a triangular wedge of space that encloses her lower torso; the posture of her legs echoes this triangular space, which is repeated again in her upper body in the position of her lowered neck and right shoulder.

Thus, in a seemingly ordinary painting of a nude, Maurer has displayed familiarity with Hambidge's theories while at the same time revitalizing a standard academic subject. *R.L.G.*

327

Contortionist, *1927-1928*

Oil on composition board, 12⅛ x 9¼ in. (30.9 x 23.5 cm.)
Signed lower center: A.H. Maurer
Gift of Ione and Hudson Walker
53.297
Illustration: Figure 101

EXHIBITIONS: *100 Paintings, Drawings, and Prints from the Ione and Hudson D. Walker Collection*, 1965, cat. 81 • National Collection of Fine Arts, Smithsonian Institution, Washington, D.C., *Alfred H. Maurer, 1868-1932*, 1973, cat. 62 • *Alfred H. Maurer: American Modernist*, 1973 • *Hudson D. Walker: Patron and Friend*, 1977, cat. 61.

PROVENANCE: Ione and Hudson Walker

Contortionist is an important link between Maurer's paintings of nudes and his figures set within interior spaces. He achieves this connection by lending to the figure an exaggerated physical gesture, setting her within a confined space and manipulating the tension implied in the viewer's odd vantage point. By reversing the expected upright human posture—this woman balances on her hands, with her feet arched over her head—Maurer challenged accepted ideas of figure composition and demonstrated the possible extremes of physical malleability. He transformed his model into an abstract sculptured pattern by emphasizing the theatrical lighting, which casts a heavy shadow onto the background plane of the picture.

Circus subjects had been popular in French painting (as well as in the work of American moderns such as Everett Shinn and Walt Kuhn), but this example appears unique in Maurer's oeuvre; it is, however, an extension of the physical contortions evidenced in his paintings of nudes. That Maurer thought of this figure essentially as a plastic torso in space is indicated in his study for this work and several smaller related drawings in the University Art Museum's collection. In these the artist concentrates on capturing the twists and bends of the woman's naked body as she executes her handstand. A further indication that Maurer meant to focus on the decorative potential afforded by the contortionist's pose is revealed by examining the background of the painting, which recalls in its technique many of the artist's flower pieces also painted at this time (Reich, p. 78). *P.N. and R.L.G.*

Head *(2) (also called Man with Glasses), 1927-1928*

Oil on gesso on composition board, 36 x 25½ in.
(91.6 x 64.9 cm.)
Signed upper left: A.H. Maurer
Bequest of Hudson Walker from the Ione and Hudson Walker Collection
78.21.301
Illustration: Appendix

PROVENANCE: Ione and Hudson Walker

Although the individual represented in this painting has been referred to as a male, the head is certainly of the same type as the other women in this series. The hairstyle may be shorter, but the neckline indicates a dress similar to the attire of the other women. The confusion surrounding the title (it has been called both *Head* and *Man with Glasses*) highlights the sexually ambivalent treatment of the human features in Maurer's late works. Although men and women ordinarily have different body shapes that easily identify their gender, human faces do not always bear such obvious sexual evidence. This may account for Maurer's increasing concentration

on the human face without obvious gender distinction. Only the hairstyles indicate the sex of the sitters, and these become increasingly summarized until they, too, could be identified as either masculine or feminine. The end result of all this sexual ambivalence is to further emphasize the universality of the internal turmoil registered on the faces. *P.N.*

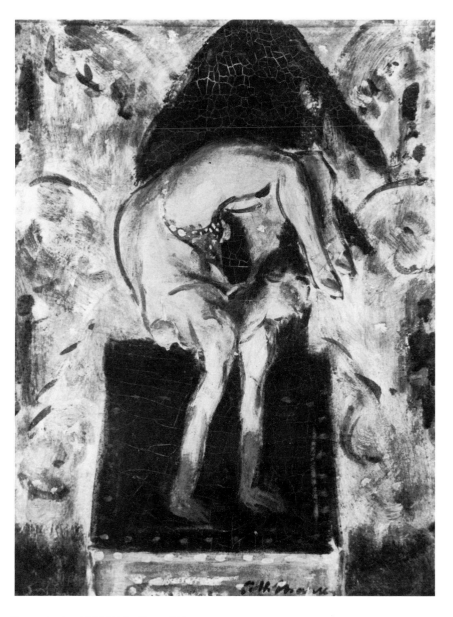

Contortionist, *1927-1928* ▪ *Figure 101*

Seated Girl, *1927-1928*

Oil on gesso on composition board, 21½ x 18 in.
(54.7 x 45.8 cm.)
Signed lower right: A.H. Maurer
Bequest of Hudson Walker from the Ione and Hudson Walker Collection
78.21.109
Illustration: Appendix

EXHIBITIONS: National Collection of Fine Arts, Smithsonian Institution, Washington, D.C., *Alfred H. Maurer, 1868-1932*, 1973, cat. 52 • *Alfred H. Maurer: American Modernist*, 1973.

PROVENANCE: Ione and Hudson Walker

A relatively rare example of a full figure in Maurer's late work, *Seated Girl* is related to his nudes of the 1920s in its depiction of a twisted figure set against a tortured, tilted interior space. It is also related to a series of interior genre scenes that Maurer was producing several years before his death. The multiple perspectives and jutting wall planes reveal his lingering debt to Jay Hambidge's system of dynamic symmetry. The looming figure dominates the claustrophobic space, while her exaggerated pose and distorted anatomy complement the illogic of the interior.

Elizabeth McCausland referred to figures like *Seated Girl* as "flappers," the embodiment of the high-spirited society of the 1920s. The woman's scanty attire links her to the sartorial freedom of the decade, but she is too contemplative and introspectively isolated to be a flapper. Her image induces anxiety and pathos rather than gaiety and may be considered a personal statement of the artist's own internal turmoil and a comment on the hollow frivolity of the era. *P.N.*

Woman with Blue Dress, *1927-1928*

Oil on gesso on composition board, 35⅞ x 25½ in.
(91.3 x 64.9 cm.)
Signed upper left: A.H. Maurer
Bequest of Hudson Walker from the Ione and Hudson Walker Collection
78.21.95
Illustration: Appendix

PROVENANCE: Ione and Hudson Walker

Maurer gave this work a more specific title than his other paintings of single heads from the 1920s. It is distinguished primarily by the coincidence of pattern in the dress and background that isolates the head in the center of the composition. *P.N.*

Still Life *(4), c. 1928*

Oil on gesso on composition board, 18⅛ x 21⅞ in.
(46.1 x 55.3 cm.)
Unsigned
Bequest of Hudson Walker from the Ione and Hudson Walker Collection
78.21.136
Illustration: Appendix

PROVENANCE: Ione and Hudson Walker

Toward the end of his career, Maurer began to experiment with a personal spatial fragmentation based on synthetic cubism. He transformed his expressive heads and still-lifes into more highly distorted and formally exploratory planar structures. He began to distance himself from the literal identity of objects and to study them as formal volumes and patterns of physical contrast. *Still Life*

(4) includes his familiar circular kitchen elements as an early example of his cubist style. It is a study in texture, pattern, and design reminiscent of the work of Picasso and Braque. *P.N.*

Two Heads with Yellow Background, *1928-1929*

Oil on gesso on composition board, 21⅝ x 18⅛ in.
(55 x 46.1 cm.)
Unsigned
Bequest of Hudson Walker from the Ione and Hudson Walker Collection
78.21.108
Illustration: Appendix

REFERENCES: George H. Hamilton, *Nineteenth and Twentieth Century Art* (New York: Harry N. Abrams, Inc., not dated), 286 ▪ Sheldon Reich, *Alfred H. Maurer, 1868-1932* (Washington, D.C.: National Collection of Fine Arts, 1973), 100.

EXHIBITION: *Selections from the Collection of Mr. and Mrs. Hudson D. Walker,* 1950.

PROVENANCE: Ione and Hudson Walker

This painting represents a transitional phase between Maurer's earliest series of women's heads and his late cubist abstract figures. These heads have less distinct features than their earlier counterparts, and Maurer's emphasis on their eyes has been shifted so that here the eyes are barely discernible. Seeming to arise from the same body, the two heads face one another in what may have been intended as a mirror image, a literal reference to two versions of the same individual. *P.N.*

Head of a Girl *(4), 1928-1929*

Oil on gesso on composition board, 36 x 25½ in.
(91.6 x 64.9 cm.)
Signed lower left: A.H. Maurer
Bequest of Hudson Walker from the Ione and Hudson Walker Collection
78.21.300
Illustration: Appendix

PROVENANCE: Ione and Hudson Walker

Another example of the way Maurer was painting women's heads at the end of the 1920s, *Head of a Girl* (4) includes the facial stylizations of the type. This painting is distinguished by the pattern of curtains that frames the head, suggesting that the figure is in an interior space even though she is silhouetted against sky and ground. This window-framing poses the role of the painting as a window on the world, just as the enlarged eyes of the faces are the windows to the soul. These ideas had been prevalent in painting since the time of the Italian Renaissance but had lost favor during the first decades of the twentieth century. *P.N.*

Head (3), 1929

Oil on gesso on composition board, 21⅞ x
18⅛ in.
(55.7 x 46.1 cm.)
Signed lower right: A.H. Maurer
Bequest of Hudson Walker from the Ione
and Hudson Walker Collection
78.21.121
Illustration: Appendix

PROVENANCE: Ione and Hudson Walker

As Maurer developed and reworked the motif of a woman's head, he moved away from a literal emphasis and exact representation of form to greater distortions and purely expressive devices. In this painting the once clearly defined oval volume of the face begins to break down into irregularly painted outlines, jagged black shadows, bulging neck and shoulder muscles, and opaque, enlarged eye sockets. Writing about works like these, James Fitzsimmons noted that the colors had "a raw, even barbaric force" [James Fitzsimmons, *Art Digest* 17 (15 November 1952), p. 21, quoted in Reich, p. 121]. Hilton Kramer concurred, noting that Maurer was attempting to display "the pressure of an experience more powerful than the form…found for expressing [them]" [Hilton Kramer, *New York Times* (20 January 1968), p. 25, quoted in Reich, p. 121]. Regardless of whether Maurer intended such expressionist effects to be read into his works, this example clearly displays an almost violent energy in the large, scratchlike patches of pigment around the figure's neck and eyes. Unlike his earlier heads, where forms and faces clearly indicated that the model was a woman, all clues of sexual identity are subordinated to an abstracted, strangely asexual physiognomy. *R.L.G.*

Head (4), c. 1929

Oil on gesso on composition board, 21⅝ x
18⅛ in.
(55 x 46.1 cm.)
Unsigned
Bequest of Hudson Walker from the Ione
and Hudson Walker Collection
78.21.139
Illustration: Appendix

PROVENANCE: Ione and Hudson Walker

The arbitrary coloration and shadows in this painting, together with the use of outline and the overall sketchy appearance of the face, indicate that Maurer painted it around 1929. The background is an indistinguishable mass of faceted shapes that surround and blend with the subject's hairline, indicated by "X"-like hatchings. The enlarged eyes, introspective and moody in earlier works, have been hastily colored in, rendering the face a flat and emotionless mask. This effect is compounded by the large smear of white pigment across its midsection. The masklike appearance jars with the agitated and nervous little strokes of paint that constitute the background, thus creating an overall tension between background space and the head pressed forward in the picture plane.

The verso of this work contains a forest landscape painted several years earlier. Many of the Maurer paintings in the University Art Museum's collection are double-sided images, indicating that the artist often reworked and reused his canvases. *R.L.G.*

Head of a Girl *(5), 1929*

Oil on gesso on composition board, 23⅛ x 19¾ in.
(58.8 x 50.3 cm.)
Signed lower right: A.H. Maurer 1929
Bequest of Hudson Walker from the Ione and Hudson Walker Collection
78.21.327
Illustration: Figure 102

EXHIBITIONS: Walker Art Center Traveling Exhibition, *Expressionism*, 1956-1957 • College of St. Theresa, Winona, Minnesota, *The American Twenties*, 1958 • Ackland Museum, University of North Carolina, Chapel Hill, Inaugural Exhibition, *American College and University Collections*, 1958 • The Renaissance Society of the University of Chicago, *An Exhibition of Paintings by Alfred Maurer*, 1960 • Art and the University of Minnesota, 1961 • Carleton College, Northfield, Minnesota, *American Art, 1900-1940*, 1977.

PROVENANCE: Ione and Hudson Walker

This painting is a particularly important one in Maurer's oeuvre. It constitutes a rare example of a composition dated and signed by the artist, which allows us to chronologically locate other Maurer works by visually comparing them with this piece. Although Maurer's work does not always follow a consistent line of progression from less abstract to more abstract, his paintings of female heads generally conform to this pattern. We can reasonably assume, then, that a head of a more conservative style than this one was probably painted earlier than 1929, while a head demonstrating more advanced abstraction was probably painted during or after 1929.

Head of a Girl (5) assumes almost cartoon proportions in the cutout nose, tiny lips, and large bulbous eyes. The artist has taken great care to silhouette his figure against what appear to be three vertical rectangles. That these may indicate open shutters framing a window space becomes clear when one compares *Head of a Girl* (5) and *Woman at Window* of 1929 from the collection of Dr. and Mrs. George P. Blendell of Rockville, Maryland. Both paintings feature a nearly identical face characterized by a long triangular nose seen in three-quarter perspective and small lips. In *Woman at Window*, there are clearly indicated shutters in the background; the shapes in this work may not be as defined, but it seems logical to see them as related. R.L.G.

Head of a Girl *(6), 1929*

Oil on gesso on cloth on composition board, 21½ x 18⅛ in.
(54.7 x 46.1 cm.)
Unsigned
Gift of Ione and Hudson Walker
53.315
Illustration: Appendix

REFERENCE: Sheldon Reich, *Alfred H. Maurer, 1868-1932* (Washington, D.C.: National Collection of Fine Arts, 1973), 102.

This painting is similar to *Head of a Girl* (5). Both depict the head and shoulders of a woman seen in three-quarter profile. Maurer has pressed the head to the extreme foreground of the picture plane, reinforcing the visual confrontation between his subject and the viewer. He has also continued to employ the characteristic triangular nose, thin lips, and rounded eyes seen in other works from this period. Here, however, he explores the spatial implications learned from the cubists but filtered through Matisse and manages to retain the figure's integral form. He achieves this by positioning the subject at the center of the painting and framing her head with a curtain-like device, beyond which appear the blue sky and brilliant green grass of a landscape background. Yet the lack of consistent modeling, the strong opaque colors layered with

EXHIBITIONS: Artmobile, Minneapolis
Institute of Arts Traveling Exhibition,
American Art: The Early Moderns, 1969-
1970 ▪ Tyler Museum of Art, Tyler, Texas,
American Paintings, 1900-Present, 1971.

PROVENANCE: Ione and Hudson Walker

decorative splashes of paint, and the thick outline surrounding the figure create an overall flatness that belies any real sense of three-dimensionality. *R.L.G.*

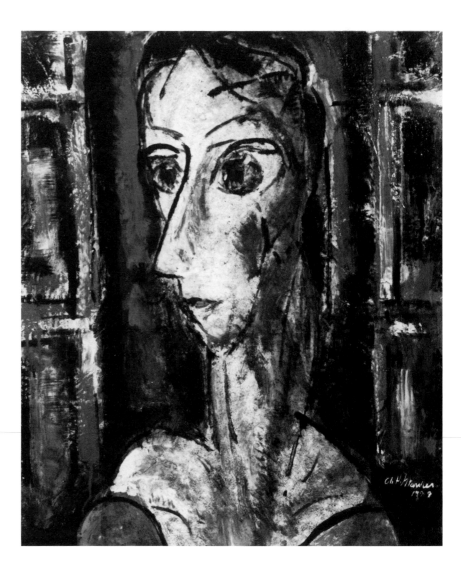

Head of a Girl *(5), 1929* ▪ *Figure 102*

Portrait of a Girl with Blue and Green Background, *1929*

Oil on gesso panel on composition board,
35⅞ x 25½ in.
(91.3 x 64.9 cm.)
Signed lower left: A.H. Maurer
Bequest of Hudson Walker from the Ione
and Hudson Walker Collection
78.21.119
Illustration: Appendix

EXHIBITIONS: *Selections from the Collection
of Mr. and Mrs. Hudson D. Walker*, 1950 •
The Minneapolis Institute of Arts, *The
American Arts: A Celebration*, 1976.

PROVENANCE: Ione and Hudson Walker

Although designated a portrait, this work is more closely related to Maurer's later series of heads in front of windows in its setting, limited range of figure, and exaggerated stylizations. For Maurer, the individualized portrait became too specific, and he evolved a female image that was more generalized and universal. This head appears to be silhouetted against a window, and the blue and green of the title are the sky and grass of the nonspecified landscape. The open window leads to possible flights of fantasy—ways to escape the intense emotional charge of the staring face. *P.N.*

Head of a Girl *(7), 1929-1930*

Oil on gesso on composition board, 21⅝ x
18 in.
(55 x 45.8 cm.)
Signed lower left: A.H. Maurer
Bequest of Hudson Walker from the Ione
and Hudson Walker Collection
78.21.125
Illustration: Appendix

EXHIBITION: *Selected Works from the Ione
and Hudson Walker Collection*, 1959.

PROVENANCE: Ione and Hudson Walker

In his later paintings of heads, Maurer began to vary the poses and to include off-center compositions in addition to the balanced central one that appeared most frequently in his earlier works. He also varied the faces from frontal to left and right three-quarter views, rarely opting for a profile. In *Head of a Girl* (7) the curtain, window frame, and ground form a wedge that draws attention to the woman's eyes—the attribute that reveals her psychological state. *P.N.*

Portrait of a Girl with Gray Background (also called *Head*), *c. 1930*

Oil on composition board, 39 x 24 in.
(99.2 x 61.1 cm.)
Unsigned
Gift of Ione and Hudson Walker
53.306
Illustration: Appendix

EXHIBITION: *Selections from the Collection
of Mr. and Mrs. Hudson D. Walker*, 1950.

PROVENANCE: Ione and Hudson Walker

Although dating to around 1930, a period when Maurer subordinated individual portrait characteristics and experimented with structure and form, this work still retains a distinct personality. This is most clearly seen in the subject's angry expression, revealed in her glaring eyes and heavily lined, scowling brow. Maurer has accentuated this impression of anger by elongating the head and placing arbitrary shadows across the left side of the face which draw even more attention to the eyes. The heavily textured background further sets off the head and lends a nervous energy to the painting. *R.L.G.*

In these two heads, painted shortly before 1930, Maurer continued to resolve problems of form and composition suggested by his study of the cubists and Henri Matisse. Positioning a woman before a framing window-like space, he began to distort and break apart the basic facial structure into abstracted shapes. *Head of a Girl* (8) has been transformed into a series of triangular shapes emphasized in the locks of hair that flow off the back of the subject's head, a pattern that is repeated in her nose, neck muscles, shoulders, jaws, and forehead. In *Head of a Girl* (9), abstracted forms of a curtained window and shutter frame a face composed of generally circular shapes which appear in the curls of hair, round eyes, and balding crown of the forehead. This painting also retains a noteworthy feature in the hatchmarks indicating eyelashes, a device that places additional emphasis on the already enlarged and globular eyes. Despite these experiments with form, Maurer has still managed to give his heads an integral shape; by the next stage in his artistic experiments, they will have become completely abstracted and faceted. *R.L.G.*

Head of a Girl *(8), 1928-1930*

Oil on canvas on composition board, 30 x 19⅝ in.
(76.3 x 49.8 cm.)
Signed upper right: A.H. Maurer
Bequest of Hudson Walker from the Ione and Hudson Walker Collection
78.21.306
Illustration: Appendix

PROVENANCE: Ione and Hudson Walker

Head of a Girl *(9), 1928-1930*

Casein on gesso on composition board, 21¾ x 18⅛ in.
(55.3 x 46.1 cm.)
Signed lower left: A.H. Maurer
Bequest of Hudson Walker from the Ione and Hudson Walker Collection
78.21.191
Illustration: Appendix

PROVENANCE: Ione and Hudson Walker

Abstract Heads *(1), c. 1929*

Casein on gesso on composition board,
21⅞ x 18⅛ in.
(55.7 x 46.1 cm.)
Signed lower right: A.H. Maurer
Bequest of Hudson Walker from the Ione
and Hudson Walker Collection
78.21.184
Not illustrated

REFERENCE: Sheldon Reich, *Alfred H. Maurer, 1868-1932* (Washington, D.C.: National Collection of Fine Arts, 1973), 107.

PROVENANCE: Ione and Hudson Walker

Throughout the 1920s Maurer compulsively produced a series of paintings of women's heads that became increasingly abstract as he grew older. These can be organized into several general categories, usually distinguishable by title. The earliest of these he referred to as "portraits"—stylized, three-quarter length figures of women in round-necked dresses silhouetted against neutral backgrounds. These figures evolved into a series of more stylized and less individualized "heads" in which the breadth of the figure was limited. At the same time he began painting groups of "double," "triple," and "quadruple heads," using the same format as the solo heads. After a decade of concentrating on images of female physiognomy, Maurer began to incorporate cubist planar fragmentation into a series of multiple heads that no longer look like women but are not defined as men. These androgynous "abstract heads" signify a complete break with the psychological isolation conveyed by the earlier works, for they participate in intimate human interaction.

Maurer's abstract heads are repetitive in pattern, with the box-shaped heads clustered in the central portion of the composition and bordered by trees indicative of an outdoor setting. Uneven paint surfaces, muted colors, and lines defining planes characterize the series. *Abstract Heads* (1) includes three images, possibly meant to suggest three aspects of a single consciousness. It probably came early in the series, as indicated by the haunting eye treatment and relatively specific handling of the trees. *P.N.*

Stylistically, all four of these oils are related in theme as well as in the advanced cubistic treatment of their subjects. In response to the works of Henri Matisse, Maurer is known to have first painted in this essentially flat, planar style around 1919, using a subdued palette and strong black outlines. Elizabeth McCausland, however, has placed these works in the early 1930s because they are similar in style and effect to Maurer's 1932 portrait of *George Washington*, now in the collection of the Portland Art Museum (Portland, Oregon). Sheldon Reich agrees with McCausland and has made the important observation that in these paintings Maurer introduces for the first time a quite unexpected and tender theme—the mother nestling her child. If he intended to exploit this theme, it is strange that the sex of the figures in these paintings cannot be determined with certainty. Rather, Maurer focuses on the intersecting planes of cubistic faces, occasionally adding lines indicating such features as eyes, noses, and mouths.

Abstract Heads (2), the most detailed of these paintings, also includes short strokes of paint indicating locks of hair. The arm cradling the child is also the most developed of any in the four works. Maurer has also experimented with placing the figure in a landscape space, indicated by the trees and forest-like background that frames the figures in three of the paintings. In *Abstract Heads* (5) the landscape background has given way to a cubist experiment with planar shapes that intersect and intrude on the figures.

Given Maurer's tendency to paint increasingly abstracted heads toward the end of his life, it is likely that the chronological sequence of these works follows the numbering system we have used here, with (2) being first and (5) being last. All four works date to around 1930. *R.L.G.*

Abstract Heads *(2), c. 1930*

Casein on gesso panel, 21⅞ x 18⅛ in. (55.7 x 46.1 cm.)
Unsigned
Bequest of Hudson Walker from the Ione and Hudson Walker Collection
78.21.189
Illustration: Figure 103

PROVENANCE: Ione and Hudson Walker

Abstract Heads *(3), c. 1930*

Casein on gesso panel, 22 x 18⅛ in. (56 x 46.1 cm.)
Unsigned
Bequest of Hudson Walker from the Ione and Hudson Walker Collection
78.21.185
Illustration: Appendix

PROVENANCE: Ione and Hudson Walker

338

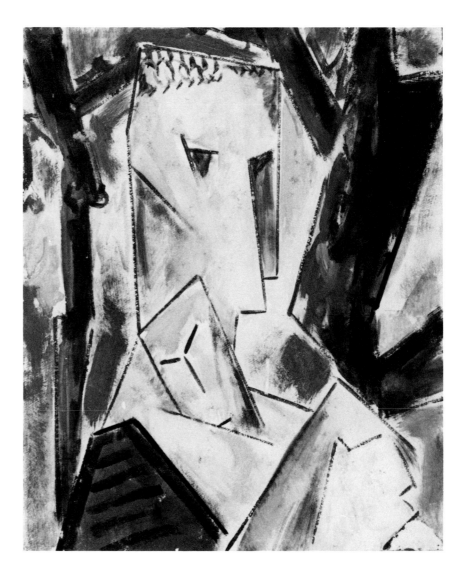

Abstract Heads *(2), c. 1930 • Figure 103*

Abstract Heads *(4), c. 1930*

Gouache on gesso on composition board,
21¾ x 18⅛ in.
(55.3 x 46.1 cm.)
Unsigned
Bequest of Hudson Walker from the Ione
and Hudson Walker Collection
78.21.186
Illustration: Appendix

PROVENANCE: Ione and Hudson Walker

Abstract Heads *(5), c. 1930*

Casein on gesso panel, 21¾ x 18⅛ in.
(55.3 x 46.1 cm.)
Signed upper left: A.H. Maurer
Bequest of Hudson Walker from the Ione
and Hudson Walker Collection
78.21.187
Illustration: Appendix

PROVENANCE: Ione and Hudson Walker

339

Pattern of Heads, *1929*

Oil on gesso on composition board, 27⅞ x
18⅛ in.
(55.7 x 46.1 cm.)
Signed upper left: A.H. Maurer
Bequest of Hudson Walker from the Ione
and Hudson Walker Collection
78.21.194
Illustration: Appendix

REFERENCE: Sheldon Reich, *Alfred H.
Maurer, 1868-1932* (Washington, D.C.:
National Collection of Fine Arts, 1973),
105.

PROVENANCE: Ione and Hudson Walker

Long before 1929 Maurer employed cubist distortions of form and
experimented with planar and multifaceted images. In this painting,
he arrived at a unique synthesis that both manages to be decorative
and carries a powerful emotional appeal. The title conveys the
artist's intent to use the forms and shapes of the human head as his
starting point for exploring the decorative potential suggested to
him by the human face. By using two different human heads, he
seems to suggest two autonomous individuals; by melding the
contours of the faces together in such a way that the two become
inseparable, however, he creates a disturbing image fraught with
psychological overtones. Like freaks or Siamese twins, these faces
literally share the same cranial space, eyes, and cheeks. The viewer
is led to ponder the bizarre and awful emotional tension resulting
from such a scheme, while simultaneously admiring the decorative
forms and shapes that result from the artist's composition. *R.L.G.*

Still Life With Cup, *c. 1929*

Oil on composition board, 18⅛ x 21¾ in.
(46.1 x 55.3 cm.)
Unsigned
Gift of Ione and Hudson Walker
53.304
Illustration: Colorplate VI

REFERENCE: Percy North, *Hudson D.
Walker: Patron and Friend* (Minneapolis:
University of Minnesota Gallery, 1977), 43.

EXHIBITIONS: *Selections from the Collection
of Mr. and Mrs. Hudson D. Walker*, 1950 •
Walker Art Center, Minneapolis,
Exhibition, 1951 • College of St. Theresa,
Winona, Minnesota, *American Art of the
1920s*, 1958 • *Selected Works from the Ione
and Hudson Walker Collection*, 1959 •
Babcock Galleries, New York, *A.H.
Maurer's Statement*, 1963, cat. 18 •
Babcock Galleries, New York, *Hartley—
Maurer—Still Life*, 1964 • *100 Paintings,
Drawings, and Prints from the Ione and
Hudson D. Walker Collection*, 1965, cat.

This is an excellent example from a late series of cubist-inspired
works in Maurer's oeuvre which incorporate a doily stencilled onto
the canvas. A similar painting, *Still Life With Doily* in the Phillips
Collection (Washington, D.C.) is the most frequently reproduced
painting from this group.

Although *Still Life With Cup* initially appears to be a form of
collage, it is actually a mixture of painting and graphic printing that
gives the illusion of the presence of an actual object. Levels of
reality are confused and challenge the viewer. Familiar objects from
Maurer's still-lifes—table, cup, and croissant—present a
juxtaposition of curves, angles, and cylindrical volumes.

Geometric reordering of still-life motifs paralleled Maurer's
increasingly abstract depiction of the human figure as he
approached the end of his career. Similar in technique to the
deformation of traditional pictorial imagery introduced by Picasso
and Georges Braque during the 1920s, these late works by Maurer
are evidence of his ongoing inquiry into innovative forms of
painting. *P.N.*

83 ▪ University of Maryland Fine Arts Gallery, College Park, *Arthur Dove: The Years of Collage*, 1967 ▪ American Federation of Arts Traveling Exhibition, *American Still Life Painting, 1913-1967*, 1968 ▪ *Selections from the Permanent Collection*, 1969, 1970 ▪ *Works from the Permanent Collection*, 1972 ▪ Committee on Institutional Cooperation Traveling Exhibition, *Paintings from Midwestern University Collections, 17th-20th Centuries*, 1973-1975, cat. 51 ▪ *Selections from the Permanent Collection*, 1975 ▪ *Hudson D. Walker: Patron and Friend*, 1977, cat. 63 ▪ Flint Institute of Arts, Flint, Michigan, *Art of the Twenties*, 1979 ▪ *Selections from the Permanent Collection*, 1980 ▪ *Abstract USA/ 1910-1950*, 1981 ▪ *The First Fifty Years 1934-1984: American Paintings and Sculpture from the University Art Museum Collection*, 1984.

PROVENANCE: the artist; Ione and Hudson Walker

All three of these paintings are more abstract and in a more flattened space than Maurer's early cubist compositions, and all three contain contrasting linear and curving elements typical of his work.

On the reverse of *Still Life* (5) is an abstraction, a not uncommon occurrence in Maurer's oeuvre. *Still Life* (6), obviously related to *Still Life With Bananas*, features a scalloped table whose curves counterbalance the shapes of the bananas; the overlapping prismatic planes form a tightly controlled central pinwheel of color. *Still Life With Bananas* juxtaposes a recognizable fruit still-life with an unknowable and challenging environment. By concentrating on the easily identifiable bananas rooted in the center of the centrifugally organized composition, Maurer denied the viewer the ability to focus on the interior setting. *P.N.*

Oil on gesso on composition board, 18⅛ x 21¾ in.
(46.1 x 55.3 cm.)
Unsigned
Bequest of Hudson Walker from the Ione and Hudson Walker Collection
78.21.135
Illustration: Appendix

PROVENANCE: Ione and Hudson Walker

Still Life *(5), c. 1930*

Oil on composition board, 18⅛ x 21⅝ in.
(46.1 x 55 cm.)
Unsigned
Bequest of Hudson Walker from the Ione and Hudson Walker Collection
78.21.138
Illustration: Figure 104

EXHIBITIONS: Walker Art Center, Minneapolis, *The Classic Tradition in Contemporary Art*, 1953 ▪ Babcock Galleries, New York, *A.H. Maurer's Statement*, 1963.

PROVENANCE: Ione and Hudson Walker

Still Life *(6), c. 1930*

Still Life *(6), c. 1930* ▪ *Figure 104*

342

Oil on composition board, 18⅛ x 21⅞ in.
(46.1 x 55.7 cm.)
Unsigned
Bequest of Hudson Walker from the Ione
and Hudson Walker Collection
78.21.137
Illustration: Appendix

EXHIBITIONS: *Selections from the Collection
of Mr. and Mrs. Hudson D. Walker*, 1950 ▪
Art and the University of Minnesota, 1961 ▪
National Collection of Fine Arts,
Smithsonian Institution, Washington, D.C.,
Alfred H. Maurer, 1868-1932, 1973, cat.
86 ▪ *Alfred H. Maurer: American
Modernist*, 1973 ▪ *Hudson D. Walker:
Patron and Friend*, 1977, cat. 64.

PROVENANCE: Ione and Hudson Walker

Oil on gesso on composition board, 21⅝ x
18⅛ in.
(55 x 46.1 cm.)
Signed upper right; A.H. Maurer 1929
Bequest of Hudson Walker from the Ione
and Hudson Walker Collection
78.21.110
Illustration: Appendix

PROVENANCE: Ione and Hudson Walker

Oil on gesso on composition board, 21½ x
18 in.
(54.7 x 45.8 cm.)
Signed upper right: A.H. Maurer
Gift of Ione and Hudson Walker
53.319
Illustration: Figure 105

EXHIBITION: *100 Paintings, Drawings, and
Prints from the Ione and Hudson D.
Walker Collection*, 1965, cat. 86.

PROVENANCE: Ione and Hudson Walker

Still Life With Bananas, *c. 1930*

Two Heads *(3), 1929*

Similar to *Two Heads* (6), the heads in this work rise on two
awkward elongated necks from a joined body. The faces, pressed
together, share a pair of eyes although they do each have a nose.
The masklike character of the representation is not highly specified,
but the heads are oddly unequal in size and seem to have masculine
and feminine hairstyles. Thus the smaller one with the longer hair
may be female, and the larger one male. The figures are no longer
mirror images of each other; instead, opposing sexual identities are
closely tied together and rise from a single body—like the
masculine and feminine qualities within each individual. *P.N.*

Two Heads *(4), c. 1930*

The most decorative and sculptural of Maurer's masklike cubist
heads, this rendition of the two heads theme is faceted in a complex
combination of small stippled and hatched fragments. Joined at the
body and forehead like *Two Heads* (5), these heads retain their
individual if sexually vague identities. As in all of Maurer's
paintings of heads, the faces are masks that hide the true spirit of
the individuals, concealing more than they reveal and serving as
barriers between people. In this painting the heads face each other
but look away. Their contact is cerebral; the greatest activity in the
painting is in the area where the heads meet, as if telepathically
transmitting ideas. *P.N.*

343

Two Heads *(4), c. 1930* ▪ *Figure 105*

Two Heads *(5), 1930-1931*

Oil on gesso on composition board, 21½ x
17⅞ in.
(54.7 x 45.5 cm.)
Unsigned
Bequest of Hudson Walker from the Ione
and Hudson Walker Collection
78.21.111
Illustration: Appendix

PROVENANCE: Ione and Hudson Walker

The still recognizable opposing planar profiles in this version of the
two heads theme are joined at the forehead and share a single
hairline. One of the heads is larger than the other, and the two have
different hairstyles, probably signifying that they are meant to be
male and female rather than women, as in the majority of Maurer's
dual heads. In a reversal from *Two Heads* (3), the larger head has
the more feminine hairstyle. The faces peer searchingly into one
another through stylized eyes that became the pattern for Maurer's
later cubist heads. The active surface of the painting heightens the
sense of contest and conflict between the sexes. *P.N.*

Two Heads (6), 1930

Oil on gesso on composition board, 25⅞ x 18⅛ in.
(65.7 x 46.0 cm.)
Signed upper right: A.H. Maurer, 1930
Bequest of Hudson Walker from the Ione and Hudson Walker Collection
78.21.123
Illustration: Appendix

EXHIBITION: Babcock Galleries, New York, A.H. Maurer's Statement, 1963.

PROVENANCE: Ione and Hudson Walker

In this late version from Maurer's series of double heads, the images have become difficult to tell apart. Sexual distinctions have been eliminated, and only the two scrawny necks indicate a dual presence. The ovoid shape rising from the necks is distorted, but eyes are discernible and a nose and eyebrow are defined by a single line. Typical of Maurer's series of heads, the images are isolated against a confusing and indeterminate background, indicating emotional and intellectual ferment that is further heightened by the acid colors. Types rather than individuals, the figures represent the ambiguity and displacement inherent in twentieth-century American life. *P.N.*

Two Heads with Green Background, *1930-1931*

Oil on gesso panel, 21¾ x 18 in.
(55.3 x 46.1 cm.)
Signed upper right: A.H. Maurer
Gift of Ione and Hudson Walker
53.313
Illustration: Appendix

EXHIBITIONS: *Selections from the Collection of Mr. and Mrs. Hudson D. Walker*, 1950 • *Selected Works from the Ione and Hudson Walker Collection*, 1959 • Babcock Galleries, New York, *A.H. Maurer's Statement*, 1963, cat. 24 • *100 Paintings, Drawings, and Prints from the Ione and Hudson D. Walker Collection*, 1965, cat. 88.

PROVENANCE: Ione and Hudson Walker

Although it is possible to discern eyes, mouths, and necks in this painting, Maurer dissolved the contours of the heads and merged them with the background space. Interior and exterior combine so that it is difficult to ascertain where the figures begin and end. The presences are intellectual and imaginative rather than substantive, emotional rather than corporeal. *P.N.*

Two Heads (7), *c. 1931*

Oil on gesso on fabric on composition board, 30 x 19⅞ in.
(76.3 x 50.6 cm.)
Unsigned
Bequest of Hudson Walker from the Ione and Hudson Walker Collection
78.21.124
Illustration: Appendix

PROVENANCE: Ione and Hudson Walker

Two Heads (7) represents the style of cubist portraiture that Maurer developed near the end of his life. Forms are completely dissolved and merged into one another so that it is difficult to determine where one head ends and the other begins. Both faces are broken down into abstract planar patterns and share a common nose, eyes, and mouth. Only the spindly little necks hint at the fact that this is, indeed, a portrait of two heads.

It is interesting to compare this work with the famous Maurer portrait of *George Washington* in the collection of the Portland Art Museum (Portland, Oregon). Maurer painted the portrait to commemorate the 200th anniversary of Washington's birth in 1932, a year which just happened to coincide with the 100th birthday of Maurer's father Louis (Reich, p. 113). Maurer's relationship with his father, a successful Currier and Ives illustrator, was a topic for constant speculation following the son's suicide in 1932. Some critics claimed that Maurer resented his father's growing fame as a living folk artist while he himself remained obscure, a fact often cited as a reason why Maurer resorted to ever more violent and distorted figures in his paintings. However, *Two Heads* (7), painted a full year before *George Washington*, displays all the familiar characteristics of the later work—planar face, opaque and circular eyes, square jaw, and spindly neck—which lends credence to those who see Maurer's progression toward greater abstraction as a natural progression in his art rather than the symptomatic expression of an angry and disturbed mind. *R.L.G.*

Two Heads with White Hair, *c. 1931*

Oil on gesso on composition board, 21¾ x 17⅝ in.
(55.3 x 44.8 cm.)
Signed upper right: A.H. Maurer
Bequest of Hudson Walker from the Ione and Hudson Walker Collection
78.21.112
Illustration: Appendix

REFERENCE: Thomas Hess, "Alfred Maurer Memorial," *Art News* XLVIII (September 1949): 25.

Although this painting is called *Two Heads with White Hair*, it is difficult to discern a double presence in the work. In 1949 critic Thomas Hess offered an explanation of this phenomenon in Maurer's oeuvre: "The poetic ambiguity of the double head—the profile fusing with the frontal view; eyes and noses merging and intersecting from separate necks—was his last and probably most successful invention. Here he could convey a complexity of allusion and allegory with the painting doctrines established by Picasso and Braque" (Hess, p. 25). The fringe of white hair makes this painting more evocative of the spirit of George Washington than Maurer's tributory portrait of him in the Portland Art Museum (Portland, Oregon). *P.N.*

EXHIBITIONS: *Selections from the Collection of Mr. and Mrs. Hudson D. Walker*, 1950 • National Collection of Fine Arts, Smithsonian Institution, Washington, D.C., *Alfred H. Maurer, 1868-1932*, 1973, cat.82 • *Alfred H. Maurer: American Modernist*, 1973 • *Hudson D. Walker: Patron and Friend*, 1977, cat. 65 • *Abstract USA/1910-1950*, 1981 • Carleton College, Northfield, Minnesota, *American Abstraction: 20th Century American Paintings from the University of Minnesota*, 1983.

PROVENANCE: Ione and Hudson Walker

Gouache on gesso panel, 21¼ x 18¾ in. (54.1 x 47.7 cm.)
Unsigned
Bequest of Hudson Walker from the Ione and Hudson Walker Collection
78.21.4
Illustration: Appendix

EXHIBITION: American Federation of Arts Traveling Exhibition, *Pioneers of American Abstract Art*, 1955-1956.

PROVENANCE: Ione and Hudson Walker

Abstraction, *1928-1931*

This late work retains elements indicating that it is the culmination of a series of paintings of women's heads that Maurer produced during the 1920s. He had used the overlapping cubist planes in a group of paintings of abstract heads to indicate a head and the background space surrounding it. This image emphasizes cerebral complexity; the subject has become the intricate, interwoven channels of abstract thought inside a human head rather than the exterior appearance Maurer had focused on earlier in his career.

Although he tried to convey emotional complexity in the anxious features of his staring abstract faces, what is communicated is mental disorder. Physiognomy is no longer the primary focus, but it is intimated in the semblance of a mouth and a fluffy curvilinear pattern suggestive of hair. *P.N.*

LOUIS MAURER
1832-1932

SELECTED BIBLIOGRAPHY: Henry T. Peters, "Louis Maurer: The Last of the Currier & Ives Artists," *Print Connoisseur* (January 1931): 38-51 • Elizabeth McCausland, *A.H. Maurer* (New York: A.A. Wyn for Walker Art Center, 1951) *passim* • Harry T. Peters, *Currier & Ives, Printmakers to the American Public* (Garden City, New York: Doubleday, Doran & Co., 1942), 19-22.

Oil on canvas, 18⅛ x 24⅛ in.
(46 x 61.3 cm.)
Signed lower left: L. Maurer. N.Y.
Purchase
68.39
Illustration: Figure 106

EXHIBITION: *Selections from the Permanent Collection*, 1970.

PROVENANCE: Old Print Shop, New York

Perhaps better remembered as the father of the modernist painter Alfred H. Maurer, Louis Maurer won renown late in his life for his Currier and Ives lithographs and his longevity; he was 100 years old when he died. Born in Germany and trained in Düsseldorf, he immigrated to the United States in 1850 or 1851 and worked for a brief period as a woodcarver. After eight years as a lithographer with Currier and Ives, he cofounded an independent lithographic business. Upon his retirement in 1884 he turned to painting, taking lessons from William Merritt Chase at the National Academy of Design.

Best known for his sporting and racing pictures, scenes of early American life, and a series documenting the life of a fireman, Maurer was given his first one-man show at the Old Print Shop in New York City in 1931. Concurrent with a revival of interest in Currier and Ives prints, he was given another exhibition—his last— the following year, and at age 100 was heralded as America's oldest living artist and the last to be associated with Currier and Ives. True to the precepts of that firm, Maurer remained a traditionalist, a realistic recorder of a passing American scene. *P.N.*

Saddle Horse, *c. 1880*

An expert horseman, Louis Maurer won the first New York Horse Show prize in 1863. It is not surprising, therefore, that he specialized in sporting and racing pictures. He designed prints of all of the celebrated horses of his time, the earliest of the series being *The Celebrated Horse Lexington* (1855). Typical of traditional English and American horse paintings and prints, *Saddle Horse* is posed saddled and bridled, with the stirrups drawn up as if the horse were being readied for a ride. Elegantly silhouetted against a stable courtyard, the regal, attentive steed is particularized by his three white stockings and the white blaze on his forehead. Maurer's precise rendering of the animal and its surroundings reveals a sensitivity to detail and reflects his training in the graphic arts.

Saddle Horse, *c. 1880* ▪ *Figure 106*

JOSEPH JOHN PAUL MEERT
1905-

SELECTED BIBLIOGRAPHY: "Adventures in Color," *Art Digest* (15 January 1949): 19 ▪ "Reviews," *Art News* (September 1967): 13.

Born in Brussels, Belgium, Joseph Meert immigrated to America and studied at the Art Students League with Boardman Robinson and Thomas Hart Benton, at the Kansas City Art Institute, and in Europe. When he returned to Kansas City, he taught at the Art Institute and entered his work in several local exhibitions, winning first prize in 1935 and the Best Kansas City prize in 1938 at the Midwestern Artists Exhibition. Under the Treasury Section program of the WPA/FAP he painted murals in post offices at Marceline and Mt. Vernon, Missouri.

Throughout his career, Meert maintained that his compositional forms were influenced by Romanesque art, cave drawings, medieval stained glass, and Byzantine mosaics. During his first New York show in 1949, critics said that his semi-abstracted forms, jewel-like colors, and loosely constructed designs were derived from his midwestern notion of space. In canvases shown in subsequent New York exhibitions, a textured arrangement of dots and webbed lines patterned the surface of semi-abstracted familiar objects placed in interiors. His experiments with crushed stained glass in the 1960s influenced the leadlike outlines and luminous color in later paintings. *M.T.S.*

Sewing Machine, *1949*

Oil on canvas, 25⅞ x 36 in.
(65.7 x 91.4 cm.)
Signed lower right: Joseph Meert '49
Bequest of Hudson Walker from the Ione and Hudson Walker Collection
78.21.313
Illustration: Appendix

EXHIBITION: Whitney Museum of American Art, New York, *1949 Annual Exhibition of Contemporary American Painting*, 1949.

PROVENANCE: Ione and Hudson Walker

Meert used tiny brushstrokes like those of Georges Seurat to build up luminous color shapes on canvases shown in his first one-man exhibition in New York at the Artists Gallery in January 1949. These forms floated within compositions, yet comprised parts of familiar objects such as this sewing machine. Although reviewers wrote that Meert's compositions combined literal reporting with imaginative composing, they also noted that his harmonious color was built up "with almost worried refinement" ["Reviews," *Art News* (January 1949), p. 46]. *Still Life on a Sewing Machine*, a painting very similar in composition and color to the canvas in the University Art Museum collection, was awarded the J. Henry Schiedt Memorial Prize in the Pennsylvania Academy of the Fine Art's 145th Annual of American Painting and Sculpture in January 1950 [Dorothy Drummond, "The Pennsylvania Academy Annual Honors Uninvited Guests," *Art Digest* (1 February 1950), p. 25].

RICHARD EDWARD MILLER
1875-1943

SELECTED BIBLIOGRAPHY: Wallace Thompson, "Richard Miller—A Parisian-American Artist," *Fine Arts Journal* (November 1912): 709-714 • Vittoria Pica, "Artisti Contemporane: Richard Emile [*sic*] Miller," *Emporium* (March 1914): 162-177 • "Richard Miller—Obituary," *Art Digest* (1 February 1943): 14 • Robert Ball and Max Gottshalk, *Richard E. Miller, N.A.: An Impression and Appreciation* (St. Louis: The Longmire Fund, 1968) • William Gerdts, *American Impressionism* (Seattle: The Henry Art Gallery, University of Washington, 1980), 87-89.

Noted for his colorful paintings of beautiful, languorous women, Richard E. Miller was one of several American expatriate artists who can be described as "decorative impressionists." Born in St. Louis, he studied at the St. Louis School of Fine Arts from 1885 to 1889, after which—like many artists of his generation—he went to Paris to complete his artistic training. He studied there at the Académie Julian under Benjamin Constant and Jean Paul Laurens. When he achieved success there—he won awards at the Paris salons of 1900 and 1904, and the French government subsequently purchased his works—he decided to stay.

Miller taught at the Académie Colarossi and held classes during the summer in Giverny, a location which had earlier attracted Claude Monet and which also drew Miller's countrymen Theodore Robinson and Frederick Frieseke. He visited the United States in 1906 and returned in 1918 to settle permanently in Provincetown.

Miller received many honors during his career, including medals at the Pan-American Exposition in 1901, the St. Louis Universal Exposition in 1904, and the Pan-Pacific International Exposition in 1915. He was also awarded France's Knight of the Legion of Honor in 1908 and was given a one-man exhibit at the Venice Biennale in 1909. Later, after returning to the United States, he was invited to paint murals for the State Capitol Building in Jefferson City, Missouri. *R.L.K.*

Reclining Nude, *c. 1942*

Oil on wood panel, 24 x 31 in.
(61 x 78.7 cm.)
Signed lower left: Miller
Gift of Louis W. Hill, Jr.
56.14
Illustration: Figure 107

REFERENCE: "Grand Central Galleries Celebrate Their Twentieth Anniversary," *Art Digest* (1 October 1942): 14.

As an impressionist, Miller preferred the female figure over landscape in his painting. His female subjects, clothed or nude, were usually portrayed in a state of repose within an interior setting, often a porch, and surrounded by material goods symbolic of a luxurious lifestyle. In *Reclining Nude*, an angularly posed woman rests upon richly colored fabrics thrown over an upholstered settee; a small table set for tea is at her side. Characteristically, the artist includes the device of slatted Venetian blinds to introduce variations of light while complementing the structure's geometric composition.

351

EXHIBITIONS: Grand Central Art Galleries, New York, *Founders Show*, 1942 • *The First Fifty Years 1934-1984: American Paintings and Sculpture from the University Art Museum Collection*, 1984.

PROVENANCE: Grand Central Art Galleries, New York; Louis W. Hill, Jr.

Like his fellow expatriate Frederick Frieseke, Miller utilized the effects of dappled sunlight to heighten the decorative quality of his works. His treatment of the figure—classical in form and delicately modeled—resembles the feminine beauties of the Boston impressionists Edmund Tarbell, William Paxton, and Joseph R. De Camp. In contrast, other elements of the setting are loosely painted. Richly applied strokes of greens, blues, and lavenders approach abstraction but ultimately coalesce to present an environment abundant in color and texture.

Reclining Nude, *c.* 1942 • *Figure 107*

ANN MITTLEMAN

1898-

SELECTED BIBLIOGRAPHY: "57th Street in Review," *Art Digest* (1 November 1954) • "Reviews," *Art News* (March 1965): 54 • Archives of American Art, Smithsonian Institution, Washington, D.C., #350.

Ann Mittleman started painting at age 48 after having worked in the field of mental health for many years. She became a painter virtually by accident: while walking past the Art Students League Viewing Gallery, she saw a painting by a visiting artist and immediately decided she wanted to meet him. The artist asked her to do a painting on the spot, determined that she had latent talent, and encouraged her to begin classes at the League, which she did. She studied for a short time with Nahum Tschacbasov, Philip EVERGOOD, Lewis Daniel, and Robert Laurent.

Mittleman had her first New York exhibition, "Unfolding the Unconscious," at the Argent Gallery in February 1954. Critics remarked that her abstract compositions and lines of paint followed the style of Jackson Pollock. Mittleman wrote that to create, she probed her subconscious, adding, "Every artist at the time of creating is, in a sense, like a psychopath—the difference being that, unlike those who have fled entirely into the world of imagination he returns to reality when he is finished with his creation" [*Unfolding the Unconscious* (New York: Argent Gallery, 1954)].

Kandinsky-like images of flowers and trees painted against dense foliage with a palette knife appeared in her works from 1958. In 1962 a solo exhibition of her paintings toured several midwestern museums, including the University Art Museum. *M.T.S.*

Red Forest, *c.* 1958-1968

Oil on canvas, 25 x 30 in.
(63 x 76.5 cm.)
Signed lower left: A. Mittleman
Gift of the artist
68.40
Illustration: Appendix

PROVENANCE: the artist

By 1958 Mittleman had introduced reality into her canvases in the form of heavily textured tree and flower forms. She wrote that she painted through a process of synesthesia: "Various sounds produced various colors, from soft tones of grey to vibrant high colors which caused my eyes to burn and flood with tears.... It became a personal language, for that which I painted was the blending of the sound together with my own physical and psychical reactions to such colors...without a moment's pause...were trees and flowers—a landscape" (Archives of American Art, #350).

HANS MOLLER
1905-

SELECTED BIBLIOGRAPHY: "Cerebral Abstraction," *Art Digest* (15 January 1948): 15 • "Hans Moller," *Art News* (January 1949): 52 • John I.H. Baur, *Nature in Abstraction* (New York: Whitney Museum of American Art, 1958), 67 • Edward Betts, *Creative Landscape Painting* (New York: Watson-Guptill, 1978).

Hans Moller was born in Germany and studied briefly at the Berlin Academy. In 1936 he came to the United States and by 1944 had become an American citizen. In that same year he began a 12-year teaching career at the Cooper Union School. An expressive painter of mood, Moller also designed stained glass and tapestries. His lyrical nature themes are noted for their rhythmic lines and beautiful color patterns. *P.N.*

Canary I, *1947*

Oil on canvas, 30 x 23¾ in. (76.2 x 60.3 cm.)
Signed lower right: moller—47
Gift of Dr. and Mrs. M.A. McCannel
54.37
Illustration: Appendix

EXHIBITION: *Selections from the Permanent Collection,* 1954.

PROVENANCE: Dr. and Mrs. M.A. McCannel

Moller's *Canary I* stares inquisitively out of the canvas, trapped behind the thin bars of his cage. Although the subject suggests a domestic still-life, it is also redolent with associations of trapped souls. The flattened composition and stylized linear emphasis reflect a form of modified abstraction popular during the late 1940s and early 1950s.

PAUL MOMMER
1899-1963

SELECTED BIBLIOGRAPHY: James Thrall Soby and Dorothy C. Miller, *Romantic Painting in America* (New York: The Museum of Modern Art, 1943), 45 • John I.H. Baur, *Revolution and Tradition in Modern American Art* (Cambridge, Massachusetts: Harvard University Press, 1951), 116 • "Reviews," *Arts* (January 1958): 53.

Like other American romantics working during the first half of this century, the self-taught painter Paul Mommer was influenced by the mysticism of Albert Pinkham Ryder. Born in the duchy of Luxembourg in 1899 to a French mother and German father, Mommer received his only formal lessons in drawing from an uncle who was an academic sculptor and woodcarver. He joined the Bavarian army during World War I but was captured by the British and interred for two years in a labor camp. To fight boredom, he began to paint. Upon his release he worked as a stoker for French and English ocean liners.

In 1922 he immigrated to New York and worked at various odd jobs to support his painting habit. During his first New York exhibition in 1936 and a subsequent one the following year, critics compared his twilight scenes and glowing flower pieces to those of Ryder and Louis EILSHEMIUS. After a sketching trip to Luxembourg in the late 1930s, his landscapes took on Maurice Utrillo-like distortions.

In the early 1940s Mommer started a beauty shop to support his family; he painted in the back room on canvases tacked to the wall. His studio became so littered with paint tubes and brushes that his neighbor, Arshile Gorky, told him that his messy palettes were more interesting than his canvases. He painted many portraits of artists and writers in the 1940s, including those of Gorky and Marsden HARTLEY. These were simple and direct, with a primitive abstract quality based on the artist's ability to achieve a psychological likeness. Canvases completed through the 1950s retained influences from Ryder while becoming increasingly abstract.

Mommer exhibited his work in Whitney Museum biennials and annual shows at the Pennsylvania Academy of the Fine Arts throughout the 1930s and at the Feragil and Passedoit Galleries, New York City, in the 1940s. In 1951 he was the subject of a retrospective exhibition at the National Arts Club (New York). *M.T.S.*

These still-life compositions were probably two of 20 Moller paintings exhibited at the Hudson D. Walker Gallery in October of 1939. Critics described his works as "sonorous in color," with backgrounds resembling deeply colored velvet which served to accentuate the glow of his still-life objects ["Reviews," *Art Digest* (1 November 1939), p. 21].

355

Oil on canvas, 30¼ x 20¼ in.
(76.8 x 51.4 cm.)
Signed (incised) lower right: P. Mommer
Bequest of Hudson Walker from the Ione
and Hudson Walker Collection
78.21.30
Illustration: Figure 108

PROVENANCE: Ione and Hudson Walker

Flowers, *c. 1939*

Flowers, *c. 1939 • Figure 108*

356

Oil on composition board, 16⅛ x 14 in. (41 x 35.6 cm.)
Unsigned
Bequest of Hudson Walker from the Ione and Hudson Walker Collection
78.21.115
Illustration: Appendix

PROVENANCE: Ione and Hudson Walker

Still Life with Pears, *c. 1939*

CARL A. MORRIS
1911-

SELECTED BIBLIOGRAPHY: *Carl Morris, A Decade of Painting in Portland* (Portland, Oregon: Portland Art Museum, 1952) • Grace L. McCann Morley, *Carl Morris* (New York: The American Federation of Arts, 1960) • Sue Ann Kendall, "Carl Morris Talks with Sue Ann Kendall," *Archives of American Art Journal* 23:2 (1983): 14-17.

Carl Morris was born in Yorba Linda, California. As a high school student he was encouraged by ceramist Glen Lukens to get a broad education in art rather than train as a craftsman. While visiting the Pomona College art department, he saw José Clement Orozco work on his *Prometheus* fresco, which further influenced him to become an artist. Morris attended Fullerton Junior College for one year and then studied for two years at the Art Institute of Chicago. Scholarships enabled him to travel in Italy and to study from 1933 to 1934 at the Kunstgewerbeschule and the Academy of Fine Arts in Vienna, and from 1935 to 1936 at the Foundation des Etats-Unis in Paris.

In 1936 he returned to the West Coast to work on motion picture sets in Los Angeles, then moved to Chicago to teach at the Art School of the Art Institute of Chicago during 1937-1938. He served as the director of the Federal Art Project's Art Center in Spokane, Washington from 1938 to 1939. In 1940 he moved to Seattle to open and teach at his own art school.

Upon winning a FAP competition for a mural on lumbering and agriculture for the Eugene, Oregon post office, Morris moved to that state in 1941. He completed the mural at night and on weekends, combining the commission with a job as an engineering draftsman in Eugene's war industries. After the war he and his wife, sculptor Hilda Grossman, built a house from scrap lumber on a tree- and boulder-covered hillside outside Portland. Although he found little time to paint until the 1940s, colors and forms in his canvases appeared to be derived from abstracted natural shapes seen on this hillside. His compositions contained abstracted human figures attempting to emerge from a rocky environment, perhaps symbolizing Morris's frustration with economic hardships and the plight of people displaced during the war years.

In the early 1970s his rough-hewn, earthen-colored forms were accentuated by a gridwork of black lines. As Morris began to work with acrylics, his application of paint layers became thinner and more subtle, and he incorporated frottage and decalcomania techniques onto the painted surface. *M.T.S.*

Song, *1946*

Oil on canvas, 36¼ x 48½ in.
(92.1 x 123.2 cm.)
Signed lower right: Carl Morris '46
Gift of Dr. and Mrs. M.A. McCannel
54.38
Illustration: Appendix

EXHIBITIONS: Portland Art Museum, Portland, Oregon, *Exhibition of Artists of Oregon,* 1949 • *Selections from the Collection,* 1957.

PROVENANCE: Dr. and Mrs. M.A. McCannel

The composition of this painting is typical of canvases Morris completed from 1946 to 1948. His memories of the bare and arid land near Spokane and the environment of his home near Portland are the basis for the man-against-nature motif found in many of his works from this period. While one reviewer described them as "emotional expressions in shattered Cubist forms" ["People in Stress," *Art News* (July 1946), p. 53], Grace L. McCann Morley suggested that the compositions symbolized personal frustrations and that Morris's use of geometric shapes to comprise a frame within a frame simply helped the viewer to concentrate on the expressive content of the painting.

ROBERT MOTHERWELL
1915-

SELECTED BIBLIOGRAPHY: Frank O'Hare, *Robert Motherwell, with Selections from the Artist's Writing* (New York: Museum of Modern Art, 1965) • E.A. Carmean, Jr., *The Collages of Robert Motherwell* (Houston, Texas: Museum of Fine Arts, 1972) • Stephanie Terenzio, *The Painter and the Printer: Robert Motherwell's Graphics, 1943-1980* (New York: American Federation of Arts, 1980) • *Robert Motherwell and Black* (Storrs, Connecticut: University of Connecticut, William Benton Museum of Art, 1980) • H.H. Arnason, *Robert Motherwell* (New York: Harry N. Abrams, Inc.; 2nd edition, revised, 1982) •

Self-taught painter Robert Motherwell is the product of both his West Coast and New York City environs. He was born in Aberdeen, Washington, and although his family moved to California shortly thereafter, they returned each summer to Aberdeen to vacation near the sea. This may help to explain the artist's lifelong preference for living near the ocean and the evocations of the sea in his abstract compositions.

Motherwell received a scholarship to study at the Otis Art Institute in Los Angeles when he was only 11; he also attended the California School of Fine Arts in San Francisco for a short time. Majoring in philosophy at Stanford, he went on to Harvard, where he became interested in the aesthetic theories of Eugène Delacroix. From 1938 to 1939 he was in Paris, studying the French symbolist theories of Charles Baudelaire and Stéphane Mallarmé and the art of the French symbolist painters.

Robert S. Mattison, "The Emperor of China: Symbols of Power and Vulnerability in the Art of Robert Motherwell during the 1940s," *Art International* 25:9-10 (November-December 1982), 8-14 • Dore Ashton and Jack D. Flam, *Robert Motherwell* (New York: Albright-Knox Gallery/Abbeville Press, 1983).

Upon returning to New York he was introduced by art historian and critic Meyer Shapiro to the community of European refugee artists. Motherwell served as a liaison between these artists - Marcel Duchamp, Max Ernst, André Masson, Piet Mondrian, Matta (Echaurren), and Kurt Seligmann, among others—and the emerging American abstract expressionists Hans Hofmann, William Baziotes, Barnett Newman, and Adolph Gottleib. Although Motherwell exhibited and maintained contact with the European surrealist painters throughout the early 1940s, he has said that they considered him too abstract. In his paintings, abstract content was always combined with surrealist automatism.

In 1943, after Peggy Guggenheim invited him to submit collages for an exhibition to be held in her gallery, he began to work in this medium. Spaces within his first collages were flat, and he used a gridwork of lines to reinforce shapes and tie them to their compositional boundaries. This layout was transferred to paintings he exhibited in his first one-man show at Peggy Guggenheim's Art of This Century Gallery in 1944. After 1944 he exhibited regularly in most of the major galleries and museums throughout America and Europe, with one-man shows at the Museum of Modern Art, the Whitney Museum of American Art, and the Metropolitan Museum of Art in New York.

Throughout his career, Motherwell has worked with themes in series, exploring the ways that shapes can be changed both deliberately and accidentally within a composition. One of his earliest series, *Elegy to the Spanish Republic*, begun in 1948 and continued through the 1970s, centered around the motif of abstract symbols resembling giant orbs placed between vertical scaffolding. In another series, *Open*, canvases contain flat planes of color set within a color field; these resemble the nearly abstract paintings of Henri Matisse and were inspired by seeing a small canvas leaning against a larger one. Although most of Motherwell's paintings are almost mural-sized, his collages are generally easel-sized (and more personal) because of the scale of the materials used.

Motherwell has taught for short periods at several eastern colleges, including Hunter, Yale, and Harvard. In 1948 he and Baziotes, Newman, Mark Rothko, and David Hare set up The Subjects of the Artist School in New York. It lasted only two years but gave birth to a Friday evening session called The Club, or Studio 35, where avant-garde artists and writers met to discuss new artistic and literary ideas.

Motherwell has written numerous articles for periodicals. He co-edited *Modern Artists in America* (1951) and wrote *The Dada Painters and Poets* (1951). M.T.S.

Mural Fragment, *1950*

Oil on composition board, 96 x 144 in.
(243.8 x 365.8 cm.)
Unsigned front; back inaccessible
Gift of Katherine Ordway
52.17
Illustration: Colorplate XXXI

REFERENCES: "Avant Garde Murals at
Kootz," *Art Digest* (1 October 1950): 11 •
H.H. Arnason, *Robert Motherwell* (New
York: Harry N. Abrams, Inc., 1977), 29 •
Letter from Robert Motherwell to Lyndel
King at the University Gallery, 26 April
1978.

EXHIBITIONS: Samuel M. Kootz Gallery,
New York, *The Muralist and the Modern
Architect*, 1950 • Architectural League, New
York, *Exhibition*, 1950 • New Haven,
Connecticut, *The Architect's
Collaborative—Walter Gropius and
Associates*, 1950 • Oberlin College, Oberlin,
Ohio, *Exhibition*, 1953 • Walker Art
Center, Minneapolis, *Classic Tradition*,
1953 • St. Paul Gallery, St. Paul, *Exhibition*,
1953 • *Selections from the Permanent
Collection*, 1954 • Tweed Gallery,
University of Minnesota-Duluth, *Exhibition*,
1956-1957 • The Minneapolis Institute of
Arts, *American Painting, 1945-1957*, 1957 •
Walker Art Center, Minneapolis, *60
American Painters*, 1960 • *Robert
Motherwell*, 1965 • *Selections from the
Permanent Collection*, 1965 • *Works from
the Permanent Collection*, 1972.

PROVENANCE: Katherine Ordway

For a 1950 exhibition in the Samuel M. Kootz Gallery, New York City, five architects supplied plans and models of buildings—existing or proposed—which could conceivably use murals. Five artists were asked to design projects which would be economically and decoratively feasible; besides Motherwell, these included William Baziotes, Adolph Gottlieb, Hans Hofmann, and David Hare. Motherwell's triptych—the largest submission—was intended for a 27 x 63-foot wall in the auditorium of a school in Attleboro, Massachusetts designed by Walter Gropius.

About the fragment in the University Art Museum collection, Motherwell wrote, "In the end there was a cost overrun and they abandoned the project, so I just painted your section for myself, at a time when I wanted to work on what, for me then, was a large scale" (Motherwell to King, 26 April 1978). It was given to the University Art Museum (then the University Gallery) in 1952 and loaned for exhibits at colleges and galleries. Then, in 1956, it was hung on the wall of the music room in the new Student Center at the University of Minnesota-Duluth—and the response was less than favorable. Students and faculty members—118 in all—circulated a petition for the removal of the "so-called painting," the "crude daub that looks like a deformed octopus alongside of two decayed dinosaur eggs" ["Students Object to Nonobjective Art," *Duluth News-Tribune* (16 August 1956)]. Curator Fred J. Triplett stood his ground, and the painting remained where it was for the duration of the exhibit. *M.T.S.*

ROLAND MOUSSEAU
1899-1980

SELECTED BIBLIOGRAPHY: Minneapolis History Collection, Minneapolis Public Library • Interview with E.W. Mousseau (the artist's brother) by Mary T. Swanson, 13 August 1980

Roland M. Mousseau was born in Minneapolis to a family of French-Canadian descent. He studied at the Minneapolis School of Art (now the Minneapolis College of Art and Design), graduating in the early 1920s; he also worked at the Art Students League under Boardman Robinson and Kenneth Hayes Miller, and later studied in Europe.

While participating in the WPA/FAP programs during the 1930s, Mousseau worked on both the Alaskan and New York easel projects and exhibited in the New Horizons in American Art show at the Museum of Modern Art in 1936. He was then living in Woodstock, New York, and continued to reside there until 1942, when he joined the Navy. In 1946 he returned to Minneapolis, where he taught at the Minneapolis School of Art until his retirement in 1962. He then moved to West Cornwall, Connecticut, to build a studio and paint scenes of landscape and cattle. When he began losing his eyesight in the early 1970s, he came back to Minneapolis to be near his family.

Mousseau's work was shown in group exhibitions at the Corcoran Gallery (Washington D.C.) and the Whitney Museum of American Art (New York City). *M.T.S.*

Landscape, *1935*

Oil on canvas, 32¾ x 24 in. (83.2 x 61 cm.)
Signed lower left: Mousseau/35
WPA Art Project, Washington, D.C.
43.723
Illustration: Appendix

EXHIBITION: *Original Paintings from the University Collection*, 1946, cat. 113.

PROVENANCE: WPA Art Project, Washington, D.C.

The Woodstock, New York area has been an artists' colony since the early part of the century. Its picturesque woods are filled with meandering lanes and studio-homes made from or resembling old barns. Since Mousseau lived and painted in Woodstock throughout the 1930s, this studio-barn was probably located in the area. He handled the trees in his canvas in a very stylized manner similar to that of Miron SOKOLE and Anton REFREGIER, who were also painting in Woodstock at this time.

JERRE MURRY

1904-

SELECTED BIBLIOGRAPHY: *American Art Today* (New York: New York World's Fair, 1939), 124 ▪ Archives of American Art, Smithsonian Institution, Washington, D.C., #LA 8, scrapbook, 1936-1941 ▪ Francis V. O'Connor, *et al., New Deal Art: California* (Santa Clara, California: De Saisset Art Gallery and Art Museum, University of Santa Clara, 1976), *passim*.

Artists ranging from Raphael to Paul Gauguin and Eugène Delacroix have influenced the work of Jerre Murry, who produced dreamlike, exotic portrayals of women in murals and canvases completed for California WPA/FAP programs.

Born in Columbia, Missouri, Murry intended to study law but changed his plans, becoming first a flying cadet and then a painter. While studying at the Detroit Academy and subsequently the Art Institute of Chicago, he supported himself by designing stage sets, painting portraits, and working as a commercial artist for Detroit newspapers. When he returned from a six-month painting vacation in the Bahamas, Stanton MACDONALD-WRIGHT saw his sketches of the island's native life and encouraged him to come out to work on the WPA/FAP in Los Angeles, where Macdonald-Wright was district supervisor.

While working on the projects, Murry completed a mural, *Sources of Water*, for the conference room on the seventh floor of the Water and Power Building in Los Angeles. One reviewer wrote that "much of his work is fantastic, with a brilliance and exotic quality of coloring and design which at times are reminiscent of the Orient" (Archives of American Art, #LA 8, unidentified clipping). Murry also exhibited in the California Artists of the FAP show, which toured California in 1937.

Murry taught painting on WPA/FAP programs in the Barnsdall Recreation Center in 1938, 1939, and 1941, and at Poinsettia Playground in Los Angeles. He left California in 1942 to become director of the Inland Empire Art Association in Spokane, Washington. Besides displaying his work in California WPA/FAP exhibitions, he also showed paintings at the University of Southern California, in the Fine Arts Building of the Paris Exposition of 1937, and at the Los Angeles Art Association. *M.T.S.*

Woman with Cello, *c. 1941*

Oil on canvas, 40 x 30 in.
(101.6 x 76.2 cm.)
Signed lower right: Murry
WPA Art Project, Washington, D.C.
43.722
Illustration: Appendix

EXHIBITIONS: En's Gallery, Los Angeles,
1941 • *Original Paintings from the
University Collection*, 1946, cat. 114.

PROVENANCE: WPA Art Project,
Washington, D.C.

Swirling movement was a recurrent design technique in Murry's works from the 1930s. Many of his canvases were also painted with flamelike brushstrokes similar to those of El Greco. When this painting was exhibited at En's Gallery in Los Angeles in May 1941, a reviewer wrote that the artist "lives in a world of ideal forms, a world in which figures move with rare rhythm, in which distances and colors have lovely measure" ["The Arts and Artists," *Los Angeles Times* (25 May 1941), part III, p. 8].

ELIAS NEWMAN
1903-

SELECTED BIBLIOGRAPHY: S.S. Kayser, *Elias Newman* (New York: The Jewish Museum, 1949) • "Reviews," *Art News* (February 1949): 48-49.

An air of mysticism and a love of rich color dominate Elias Newman's work. Born in Shashow, Poland, he immigrated to America at age 10. From 1918 to 1920 he studied at the National Academy of Design, from 1920 to 1925 at the National Alliance Art School, and during 1929 at the Académie de la Grand Chaumiére in Paris.

From 1925 to 1935 Newman divided his time between Israel and the United States, a fact that was later reflected in his subject matter, which alternated between Old Testament themes and American land and seascapes. His canvases were expressionistically executed with brushstrokes which gave them the appearance of Byzantine mosaics.

As the director of the Palestine Pavilion in the 1939 New York World's Fair, Newman developed an exhibition of Palestinian and Egyptian art. His one-man show at the Jewish Museum (New York) in 1949 was held simultaneously with an exhibition of his watercolor paintings of Gloucester, Massachusetts at the Babcock Galleries (New York). He has also shown his canvases at the Tel Aviv Museum, the American Academy of Arts and Letters in New York, and the Baltimore Museum of Art. He taught at the Education Alliance Art School in New York from 1946 to 1948 and established his own school at Rockport, Massachussetts from 1951 to 1964. He was president of Artists Equity Association of New York from 1970 to 1975. *M.T.S.*

The Garden (also called *Flowers*), *c. 1950-1955*

Encaustic on masonite, 12 x 8⅞ in.
(30.5 x 22.5 cm.)
Signed lower right: Elias Newman
Bequest of Hudson Walker from the Ione and Hudson Walker Collection
78.21.849
Illustration: Appendix

PROVENANCE: Ione and Hudson Walker

One reviewer described Newman's works as "fragments of nature seen through a film" ["Reviews," *Art Digest* (25 April 1953), 16]. The primitive patterning in these leaves and flowers is similar to that seen in his seascapes of Gloucester, Massachusetts. Hudson Walker titled this work *Flowers*.

BROR JULIUS OLSSON NORDFELDT
1878-1955

SELECTED BIBLIOGRAPHY: Van Deren Coke, *Nordfeldt the Painter* (Albuquerque: The University of New Mexico Press, 1972) • Archives of American Art, Smithsonian Institution, Washington, D.C., microfilms #D166 and D167 • Emily Abbott Nordfeldt, *Nordfeldt: Shared Nonsense from the Letters of B.J.O. Nordfeldt* (Lambertville, New Jersey: Lambertville Historical Society, 1981) • Mary Towley Swanson, "Four Swedish-American Painters: John F. Carlson, Henry Mattson, B.J.O. Nordfeldt, and Carl Sprinchorn," doctoral dissertation (University of Minnesota, 1982) • Mary T. Swanson, *The Divided Heart: Scandinavian Immigrant Artists, 1850-1950* (Minneapolis: University of Minnesota Gallery, 1982) • Edith Innes, *B.J.O. Nordfeldt: The Lambertville Years* (Trenton, New Jersey: New Jersey State Museum, 1982) • Sam Hunter, *B.J.O. Nordfeldt: An American Expressionist* (Piperville, Pennsylvania: Richard Stuart Gallery, 1984).

B.J.O. Nordfeldt spent the first 40 years of this century competently following stylistic trends. It was only in the last ten years of his life that he ventured into an individual, innovative style that reflected his deep respect for nature's innate sense of design. Born Bror Julius Olsson in Tullstorp, Skåne, southern Sweden, he immigrated with his family to Chicago at age 11. He worked as a printer's devil for the Swedish-American newspaper *Hemlandet* while attending the School of the Art Institute of Chicago. In 1899 he served as assistant to the painter Albert Herter on a mural commissioned by the McCormick International Harvester Company for the 1900 Paris Exposition; while helping with its installation, he attended the Académie Julian for a short time before setting up his own school in a small studio.

Nordfeldt left Paris in 1901 to learn the techniques of wood block printing from the English graphic artist Frank Morley Fletcher. He exhibited paintings at the Salon des Artistes Français in Paris in 1901 and at the Royal Academy Exhibition in London in 1902. When his money ran out, he moved to Sweden, where he was able to subsist on a small vegetable garden and spend most of his time painting.

After returning to Chicago in 1903 he began to use his mother's maiden name professionally. He set up a studio near Jackson Park, painting portraits of prominent Chicago citizens in a style affected by the silhouetted forms and asymmetrical compositions of James Abbott McNeill Whistler. In 1907 he left for the East Coast to paint and subsequently spent several years abroad. Under the influence of Henri Matisse and the post-impressionists, his palette brightened considerably.

In 1911 Nordfeldt moved back to Chicago, where he taught at the Art Institute and the Chicago Fine Art Academy and became active in the Little Theatre. On a trip to New York to see the Armory Show, he once again felt the lure of Europe and left for France, where he came under the sway of Cézanne. His first one-man show was held in New York in 1914. He lived there from 1914 to 1917, spending his summers in Provincetown, Massachusetts where he painted, helped found the Provincetown Players, and developed the one-block printing method which enabled him to print five or six colors in a single application.

365

During World War I Nordfeldt designed camouflage for merchant marine ships in San Francisco. On his way back to New York he stopped in Santa Fe and was so impressed with the environment that he moved his studio to New Mexico. Using a Cézannesque palette, he painted the local landscape, Mexicans, and Indians in almost abstract compositions, treating them as interesting forms within compositional arrangements. His etchings, which depicted their subjects more realistically, were sold and exhibited during this period, providing him with the means to continue painting. He further supplemented his income by taking teaching jobs during the 1930s and 1940s. In 1931 he taught at Utah State University, in 1933 at the Minneapolis School of Art, in 1934 at the Wichita Art Association, and from 1941 to 1943 at the University of Texas at Austin.

In 1932 and 1936 he traveled to Europe with his friend and fellow artist Russell Cowles. Upon returning from their second trip together, Nordfeldt set up a studio in Newburyport, Massachusettes and then in Lambertville, New Jersey. His paintings from the mid- to late-1930s appear to have been influenced by the painterly expression of fauvist Maurice Vlaminck and were shown at the Lilienfeld Galleries in 1937 and 1939 and at the Hudson D. Walker Gallery in 1940 (both New York).

While at the University of Texas he became close friends with the painter Everett SPRUCE. It is interesting to observe how the painting styles of both men changed during this period; geometric shapes of still-life objects were often silhouetted against a starkly flattened land or seascape. Nordfeldt's use of paint was more fluid, however.

In 1944 he was invited to return to the Minneapolis School of Art as a visiting artist. He moved to the city, married Emily Abbott (a former student and Minneapolis painter), and, sustained by a new confidence and a sense of security, went on to develop the more geometrically abstracted compositions that were to be his hallmark until his death in 1955. Nordfeldt's work was shown in group exhibitions at the Metropolitan Museum of Art, the Whitney Museum of American Art, the Corcoran Gallery (Washington, D.C.), and the Carnegie Institute (Pittsburgh); he had additional shows at the Passedoit Gallery (New York). He and his wife made their home in Lambertville, New Jersey to be nearer New York City. *M.T.S.*

Venice #4, *1909-1910*

Oil on canvas, 21¼ x 30½ in.
(54 x 77.5 cm.)
Unsigned
Gift of Mrs. Emily Abbott Nordfeldt
69.35
Illustration: Figure 109

REFERENCE: Unpublished manuscript
catalogue by Emily Abbott Nordfeldt,
#1
EXHIBITION: *Selections from the Permanent
Collection*, 1980.

PROVENANCE: Emily Abbott Nordfeldt

During 1908-1910 Nordfeldt traveled in France, Spain, Italy, and North Africa, making sketches of buildings and landscapes to illustrate articles written by Mary Heaton Vorse for *Harper's Magazine* and *The Outlook*. A painted sketch similar in its view of canal and sky illuminated by the lights of Venice was printed in Vorse's article, "Unusual Venice," for the November 1913 issue of *Harper's Magazine*. Nordfeldt's use of James Abbott McNeill Whistler's silver tonality and asymmetrical design is evident in this work. He completed several other sketches of the city during his stay there in the summer of 1910.

Venice #4, *1909-1910* ▪ *Figure 109*

Seated New Mexican with Light Blue Coat, *c. 1928*

Oil on canvas, 36 x 29¼ in.
(91.4 x 74.3 cm.)
Signed lower right: Nordfeldt
Gift of Mrs. Emily Abbott Nordfeldt
76.1
Illustration: Figure 110

REFERENCE: Unpublished manuscript
catalogue by Emily Abbott Nordfeldt, #60

EXHIBITIONS: University Art Museum
(University of New Mexico, Albuquerque)
Traveling Exhibition, *B.J.O. Nordfeldt, A
Retrospective Exhibition*, 1972, cat. 18 ▪
Selections from the Permanent Collection,
1975 ▪ Benedicta Art Center, College of St.
Benedict, St. Joseph, Minnesota, *B.J.O.
Nordfeldt*, 1976, cat. 1 ▪ *Selections from the
Permanent Collection*, 1980.

PROVENANCE: Emily Abbott Nordfeldt

Nordfeldt lived in Santa Fe from 1918 to 1937, where he formed a partnership in a Native American crafts enterprise with Raymond JONSON and several other Sante Fe painters. He painted Mexican-Americans and Indians, but not because of their picturesque ethnicity; instead, he saw the colors of their skin and clothing as abstract shapes and painted them almost as still-life objects. *Seated New Mexican with Light Blue Coat* is similar to his other New Mexican portraits in its straightforward pose, the way the figure dominates the foreground, and its scant detail.

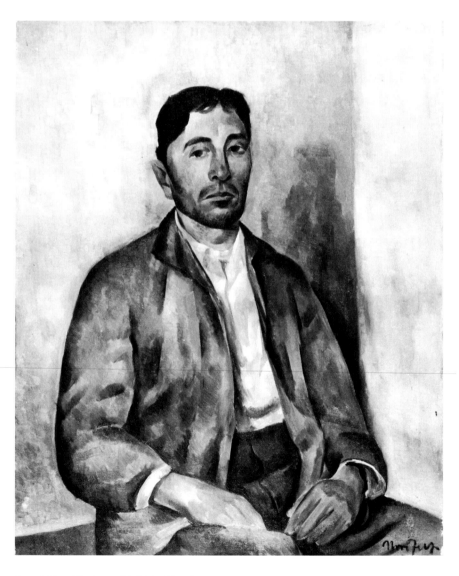

Seated New Mexican with Light Blue Coat, *c. 1928* ▪ *Figure 110*

Flowers and Fruit, *c. 1930*

Oil on canvas, 30⅛ x 34¼ in.
(76.5 x 87 cm.)
Unsigned, dated verso
Gift of Mrs. Emily Abbott Nordfeldt
77.11.2
Illustration: Appendix

PROVENCE: Emily Abbott Nordfeldt

The majority of Nordfeldt's painted during the 1920s and into the 1930s were still-life arrangements. Like Cézanne, he tilted the tabletop to fully display the objects and to set up a degree of spatial tension. In these works he often used an open window motif which resulted in a feeling of space receding deep into the picture. The New Mexican landscape visible here provides a frame for the objects on the table.

While the components in *Flowers and Fruit* are rendered in the more realistic style Nordfeldt used in the 1930s, the floor tiles and curtained background are still flattened into a series of simple geometric patterns. He may have been influenced by the flat, primitive quality of the New Mexican *santos*, (Spanish figures of saints) which he sometimes placed in the background of his still-lifes.

Road, Minnesota, *1934*

Oil on canvas, 32¼ x 40½ in.
(81.9 x 102.9 cm.)
Signed lower right: Nordfeldt
Gift of Mrs. Emily Abbott Nordfeldt
77.11.1
Illustration: Appendix

REFERENCE: Unpublished manuscript catalogue by Emily Abbott Nordfeldt, #128
EXHIBITIONS: Traveling Exhibition, *B.J.O. Nordfeldt: Seascape, Landscape and Still Life Paintings*, 1976, cat. 8 • Benedicta Art Center, College of St. Benedict, St. Joseph, Minnesota, *B.J.O. Nordfeldt*, 1976.

PROVENANCE: Emily Abbott Nordfeldt

Nordfeldt lived in Minnesota during the fall of 1933 and early winter of 1934. He and fellow artist Dewey ALBINSON often went out into the countryside surrounding Minneapolis to sketch and paint. The small hills and bare trees in this composition were painted so as to emphasize their basic geometric shapes and the overall brownish cast of a late Minnesota autumn. Nordfeldt was not interested in surface finish, but rather in his expressionistic response to a subject. *Road, Minnesota* is similar to the configuration of road, trees, and hills in his stark *Utah Road with Two Horsemen* (c. 1931), now in a private collection, and predates, yet is stylistically similar to, the more geometrically abstract landscapes which evolved from his innovative work of the 1940s and 1950s.

The Green Hills, *1935*

Oil on canvas, 30 x 40¼ in.
(76.2 x 102.2 cm.)
Signed lower right: Nordfeldt 35
Purchase, General Budget Fund
35.16
Illustration: Figure 111

REFERENCE: Van Deren Coke, *Nordfeldt the Painter* (Albuquerque: The University of New Mexico Press, 1972), 81.

EXHIBITIONS: Traveling Exhibition, *Some Individuals*, 1941-1942 • *Original Paintings from the University Collection*, 1946, cat. 115 • American Swedish Institute, Minneapolis, *Nordfeldt Retrospective*, 1956 • *Nordfeldt*, 1959 • *Art and the University of Minnesota*, 1961 • St. John's University/ College of St. Benedict, Collegeville, Minnesota, *University of Minnesota Art Exhibit*, 1971 • University Art Museum (University of New Mexico, Albuquerque) Traveling Exhibition, *B.J.O. Nordfeldt, A Retrospective Exhibition*, 1972, cat. 27 • Traveling Exhibition, *B.J.O. Nordfeldt: Seascape, Landscape, and Still Life Paintings*, 1976, cat. 10 • *Ruth Lawrence Remembered*, 1978.

PROVENANCE: Harriet Hanley Gallery, Minneapolis

Nordfeldt probably did this painting of the landscape surrounding Minneapolis in his Santa Fe studio or in Wichita, working from sketches. It may have been exhibited with a selection of his Minnesota landscapes at the Harriet Hanley Gallery (Minneapolis) in the mid-1930s. Its directly brushed shades of brownish greens and whites were influenced by Vlaminck and André Dunoyer de Segonzac (1884-1974), a late impressionist who in turn had been influenced by Cézanne and cubism. Of these two, Nordfeldt wrote, "usually I like them enormously because they are not complicated or pretentious" (Coke, 1972, p. 83).

The Green Hills, *1935* • *Figure 111*

Flowers with Shell, *1944*

Oil on canvas, 42⅛ x 36⅛ in.
(107 x 91.8 cm.)
Signed lower right: Nordfeldt
Gift of the IBM Corporation
67.17
Illustration: Appendix

EXHIBITIONS: Argus Gallery, Madison, New
Jersey, 1964 ▪ Zabriskie Gallery, New York,
B.J.O. Nordfeldt, 1965 ▪ Traveling
Exhibition, *B.J.O. Nordfeldt: Seascape,
Landscape, and Still Life Paintings*, 1976,
cat. 20.

PROVENANCE: Grand Central Galleries, New
York; IBM Corporation

The still-life compositions Nordfeldt completed in the early 1940s were as realistic as those he did in the 1930s. The application of paint was more direct and less fluid, though, and the compositions themselves were more complex. In addition, his forms became increasingly sculptural, as is particularly evident in this work in the shell at the right.

Flying Gull, *1944*

Oil on canvas, 16⅛ x 22 in.
(41 x 55.9 cm.)
Signed lower right: Nordfeldt 1944
Bequest of Hudson Walker from the Ione
and Hudson Walker Collection
78.21.23
Illustration: Appendix

EXHIBITIONS: *Selections from the Collection
of Mr. and Mrs. Hudson D. Walker*, 1950 ▪
Drew Fine Arts Center, Hamline University,
St. Paul, *Exhibition of Paintings by Some
American Individualists*, 1950 ▪ American
Swedish Institute, Minneapolis, *Nordfeldt
Retrospective*, 1956 ▪ *Art and the University
of Minnesota*, 1961.

PROVENANCE: Passedoit Gallery, New York;
Ione and Hudson Walker

In the 1940s, Nordfeldt and Everett SPRUCE appeared to develop concurrently the theme of a monumental figure, often a bird, against the backdrop of the sea or rocks. Nordfeldt's work from the late 1930s led toward a geometric simplification of form and composition. He applied paint directly, without flourishes, to achieve a dry, stucco-like surface.

While this canvas and some later landscapes may be compared to the work of Marsden HARTLEY, the two artists derived their inspiration from different sources and with different results. Nordfeldt underwent a gradual technical and compositional evolution which had its beginnings in his early use of the modified Cézannesque geometric brushstroke; this led to a progressive abstraction of forms. In contrast, while Hartley also used a Cézannesque composition and brushstroke on occasion, he appears to have been more influenced by the stark, elemental vision of Albert Pinkham Ryder (Elizabeth McCausland papers, Archives of American Art, Smithsonian Institution, Washington, D.C., microfilm #371 "The Return of the Native," lecture at the University of Minnesota, May 6, 1952).

371

Coastline, California, *1945*

Oil on canvas, 30⅛ x 40 in.
(76.5 x 101.6 cm.)
Signed lower right: Nordfeldt 45
Purchase, President's Service Fund
65.8.1
Illustration: Appendix

REFERENCE: Unpublished manuscript
catalogue by Emily Abbott Nordfeldt,
#309
PROVENANCE: Zabriskie Gallery, New York

Nordfeldt and his wife, Emily, traveled by train through Glacier Park to the West Coast in 1945. Along the way he sketched scenes of mounrtains, rivers, and the ocean, bringing many home with him to work into paintings. Here the massive rocks are echoed by the geometric cloud formations in the overcast sky, a typical compositional device used in his later works. This canvas also showed the beginnings of what would be a fascination with the movement of waves and eddies in the sea; in Nordfeldt's works from the 1950s this would develop into a form of hieroglyphic calligraphy.

Rocks and Oaks, *1945*

Oil on composition board, 32 x 40 in.
(81.3 x 101.6 cm.)
Signed lower right: Nordfeldt 1945
Purchase, President's Service Fund
65.8.2
Illustration: Appendix

PROVENANCE: Zabriskie Gallery, New York

As a teacher, Nordfeldt urged his students to reduce form to its essence and to eliminate all detail. In his compositions of 1945 and 1946 he often used trees which had been burned or twisted. Like the trees in this work, their jagged forms were outlined in dark colors and placed against simplified shapes of hills or rock formations. The critic Henry McBride had this to say about the overall strength and mood of these paintings: "He paints ruggedly and with a certain naturalness in the use of pigments, but he surely is dour" (Coke, 1972, p. 112).

Still Life with Leaves, *1947*

Oil on canvas, 40 x 52 in.
(101.6 x 132.1 cm.)
Signed lower right: Nordfeldt 47
Gift of Mrs. Emily Abbott Nordfeldt in
memory of Ruth Lawrence
58.29
Illustration: Appendix

Paintings of still-lifes comprise almost half of Nordfeldt's oeuvre. This one, although produced late in his career, is typical of the others because of these stylistic characteristics: the slightly tilted table, the window or door which acts as a frame-within-a-frame, and the sense of spatial ambiguity caused by the dominant frontal grouping silhouetted against a landscape.

EXHIBITIONS: The Minneapolis Institute of Arts, *B.J.O. Nordfeldt*, 1956 • *Nordfeldt*, 1959 • *Art and the University of Minnesota*, 1961 • *Selections from the Permanent Collection*, 1962 • Zabriskie Gallery, New York, *Nordfeldt*, 1965 • University Art Museum (University of New Mexico, Albuquerque) Traveling Exhibition, *B.J.O. Nordfeldt, A Retrospective Exhibition*, 1972, cat. 41 • Traveling Exhibition, *B.J.O. Nordfeldt: Seascape, Landscape, and Still Life Paintings*, 1976, cat. 21 • New Jersey State Museum, Trenton, New Jersey, *B.J.O. Nordfeldt: The Lambertville Years*, 1981-1982.

PROVENANCE: Emily Abbott Nordfeldt

Mandolin, *1949*

Oil on canvas, 32 x 40 in. (81.3 x 101.6 cm.)
Signed lower right: Nordfeldt 49
Gift of Mrs. Emily Abbott Nordfeldt
63.6.1
Illustration: Appendix

REFERENCE: Unpublished manuscript catalogue by Emily Abbott Nordfeldt, #340.

EXHIBITIONS: Rochester Art Center, Rochester, Minnesota, *B.J.O. Nordfelt*, 1957 • Tweed Museum of Art, University of Minnesota-Duluth, *B.J.O. Nordfeldt*, 1957 • *Music and Art*, University Gallery, University of Minnesota, and Grand Rapids Art Gallery, Grand Rapids, Michigan, 1958 • *Nordfeldt*, 1959 • Traveling Exhibition, *B.J.O. Nordfeldt: Seascape, Landscape, and Still Life Paintings*, 1976, cat. 22.

PROVENANCE: Emily Abbott Nordfeldt

Similar to Nordfeldt's bird and landscape forms in compositions from the last seven to eight years of his life, the still-life objects in his paintings began to be simplified into more basic geometric forms. Here the table, which usually performed an important spatial function in his still-lifes, is tilted to form a complete rectangle. It acts as a frame for the objects, taking the place of the window or sky which he usually made part of his setting.

Green Woods, *1950*

Oil on canvas, 40¼ x 52 in.
(102.2 x 132.1 cm.)
Signed lower right: Nordfeldt
Gift of Mrs. Emily Abbott Nordfeldt
65.8.3
Illustration: Figure 112

REFERENCE: Van Deren Coke, *Nordfeldt the Painter* (Albuquerque: The University of New Mexico Press, 1972), 117-118.

EXHIBITIONS: Passedoit Gallery, New York, *Nordfeldt*, 1952 ▪ Albright-Knox Art Gallery, Buffalo, New York, *Expressionism in Art,* 1952 ▪ Pennsylvania Academy of the Fine Arts, Philadelphia, *Exhibition*, 1953 ▪ The Minneapolis Institute of Arts, *B.J.O. Nordfeldt,* 1956 ▪ American Swedish Institute, Minneapolis, *Nordfeldt Retrospective,* 1956 ▪ *Selections from the Collection,* 1957 ▪ *Nordfeldt,* 1959 ▪ *Art and the University of Minnesota,* 1961 ▪ El Paso Museum, Texas, Traveling Exhibition, *Nordfeldt in Retrospective,* 1963 ▪ *Selections from the Permanent Collection,* 1968, 1970 ▪ University Art Museum (University of New Mexico, Albuquerque) Traveling Exhibition, *B.J.O. Nordfeldt, A Retrospective Exhibition,* 1972, cat. 47 ▪ Traveling Exhibition, *B.J.O. Nordfeldt: Seascape, Landscape, and Still Life Paintings,* 1976, cat. 12.

PROVENANCE: Emily Abbott Nordfeldt

Van Deren Coke thinks that Nordfeldt parodied his newly invented pictorial language in his painting. The artist usually sought to simplify natural objects into geometric shapes and their environment into forms which echoed the complicated interdependence of nature's grand plan. But in this work, as Coke pointed out, "he painted firmly outlined geometric shapes to represent a grove of trees flattened out in a perspective progression back into space. The refined simplicity he used failed to evoke the complexity of nature's own design. The pure language of form and the strict economy of line, particularly in the right-hand side of this painting, seem to be overly emphatic and 'mannered' in the context of the overall composition" (Coke, 1972, p. 118).

Green Woods, *1950 ▪ Figure 112*

Blue Gull, *1951*

Oil on canvas, 40 x 48 in.
(101.6 x 121.9 cm.)
Signed lower right: Nordfeldt 51
Gift of Mrs. Emily Abbott Nordfeldt
72.8
Illustration: Colorplate XXIX

REFERENCE: Van Deren Coke, *Nordfeldt the Painter* (Albuquerque: The University of New Mexico Press, 1972), 116.

EXHIBITIONS: Passedoit Gallery, New York, *Nordfeldt*, 1952 • Pennsylvania Academy of the Fine Arts, Philadelphia, *Exhibition*, 1953 • The Minneapolis Institute of Arts, *B.J.O. Nordfeldt*, 1956 • American Swedish Institute, Minneapolis, *Nordfeldt Retrospective*, 1956 • Tweed Gallery, University of Minnesota-Duluth, *B.J.O. Nordfeldt*, 1957 • *Nordfeldt*, 1959 • University Art Museum (University of New Mexico, Albuquerque) Traveling Exhibition, *B.J.O. Nordfeldt, A Retrospective Exhibition*, 1972, cat. 32 • Traveling Exhibition, *B.J.O. Nordfeldt: Seascape, Landscape, and Still Life Paintings*, 1976, cat. 3 • *The Divided Heart: Scandinavian Immigrant Artists, 1850-1950*, 1982, cat. 46.

PROVENANCE: Emily Abbott Nordfeldt

The monumental images of birds which began to appear in Nordfeldt's canvases of the early 1940s were, by the end of the decade, enclosed within geometric shapes which not only framed the figures but also set the canvas into continual motion. First frames and then shapes of birds and fish echoed and re-echoed one another, creating the hieroglyphic calligraphy Nordfeldt became known for in his later years.

Blue Sea, *1954*

Oil on canvas, 29 x 39½ in.
(73.7 x 100.3 cm.)
Signed lower right: Nordfeldt
Gift of Mrs. Emily Abbott Nordfeldt
79.13
Illustration: Appendix

In the early 1950s Nordfeldt painted several views of the sea in a form of undulating calligraphy that echoed its turbulence. Similar to *Gray Sea*, now in a private collection, also from 1954, this canvas has a muted, chalky appearance. Van Deren Coke wrote that Nordfeldt's use of the moving line in describing water "calls forth the inner response of the viewer and helps to explain the never-ending fascination of the sea in its many moods" (Coke, 1972, p. 21).

EXHIBITIONS: *Art and the University of Minnesota*, 1961 • *Works from the Permanent Collection*, 1972 • *Selections from the Permanent Collection*, 1980 • *Abstract USA/1910-1950*, 1981 • Carleton College, Northfield, Minnesota, *American Abstraction: 20th Century American Paintings from the University of Minnesota*, 1983 • *The First Fifty Years 1934-1984: American Paintings and Sculpture from the University Art Museum Collection*, 1984.

PROVENANCE: Emily Abbott Nordfeldt

SELECTED BIBLIOGRAPHY: Walter Pach, "Introducing the Paintings of George F. Of., 1876-1954," *Art News* (October 1956): 36-38, 62-63 • Betsy Fahlman, "George F. Of: 1876-1954," in William I. Homer, ed., *Avant-Garde Painting and Sculpture in America, 1910-1925* (Wilmington, Delaware: Delaware Art Museum, 1975), 106-107.

GEORGE FERDINAND OF
1876-1954

Better known during his lifetime as a picture framer than a painter, George F. Of was an early collector of modern art. He was the first patron in America to own a painting by Henri Matisse, which he purchased from Sarah Stein in 1907. Picture framing was his family's business, and while he felt obligated to continue it, he was more interested in painting. He studied with American impressionist Carroll Beckwith at the Art Students League from 1893 to 1898, and after the turn of the century he studied at the Weinhold School in Munich and the Delecluse Academy in Paris. In France he was attracted to the intense hues of fauvism, which appealed to his own expressive sense of color.

Although he was not well known as an artist, Of exhibited in many important shows including an exhibition at the Montross Gallery in 1914, the Forum Exhibition in 1916, the Society of Independent Artists Exhibition in 1917, and the Modern Americans Show at the Bourgeois Gallery (New York) in 1918. Friendly with Walter Pack and William Glackens, he was associated with many of the leading artists of his generation through his framing business. Primarily a painter, he experimented with sculpture in the 1940s. Finally he decided to leave the framing shop so he could devote himself to his art; he died shortly thereafter. *P.N.*

Boats in Sunlight, *1917*

Oil on canvas, 11¼ x 16 in.
(28.6 x 40.6 cm.)
Signed lower left: Of 17
Bequest of Hudson Walker from the Ione
and Hudson Walker Collection
78.21.44
Illustration: Figure 113

EXHIBITIONS: *Selections from the Permanent
Collection*, 1975 ▪ *Hudson D. Walker:
Patron and Friend*, 1977, cat. 67.

PROVENANCE: Alfred Stieglitz; Ione and
Hudson Walker

Of's painterly style combines characteristics of both impressionism
and fauvism. In *Boats in Sunlight* his debt to impressionism is
evident in the subject of neatly aligned boats, saturated in sunlight
and defined by short strokes of color. The emphatic sun-drenched
seascape awash in a riotous array of unmixed color also favors the
bold tonalities of fauvism. Color was paramount to George Of,
who wrote in the catalogue of the 1916 Forum Exhibition, "I have
tried to solve the problem of producing form by means of pure
color, my ambition is to create a thing of joy" (Fahlman, 1975, p.
106).

Boats in Sunlight, *1917* ▪ *Figure 113*

377

GEORGIA O'KEEFFE
1887-1986

SELECTED BIBLIOGRAPHY: Mitchell Wilder, editor, *Georgia O'Keeffe, An Exhibition of the Work of the Artist from 1915 to 1966* (Fort Worth, Texas: Amon Carter Museum of Western Art, 1966) ▪ Doris Bry and Lloyd Goodrich, *Georgia O'Keeffe* (New York: Whitney Museum of American Art, 1970) ▪ Charles Eldredge III, *Georgia O'Keeffe: The Development of an American Modern*, doctoral dissertation (Minneapolis: University of Minnesota, 1971) ▪ Georgia O'Keeffe, *Georgia O'Keeffe* (New York: Viking Press, 1976) ▪ William Innes Homer, *Alfred Stieglitz and the American Avant-Garde* (Boston: New York Graphic Society, 1977), 233-242 ▪ Alfred Stieglitz, *Georgia O'Keeffe: A Portrait* (New York: Metropolitan Museum of Art, 1978) ▪ Laurie Lisle, *Portrait of an Artist: A Biography of Georgia O'Keeffe* (New York: Seaview Books, 1980) ▪ Patterson Sims, *Georgia O'Keeffe: A Concentration of Works from the Permanent Collection of the Whitney Museum of Art* (New York: Whitney Museum, 1981) ▪ Susan Fillin Yeh, "Innovative Moderns: Arthur G. Dove and Georgia O'Keeffe," *Arts magazine* 56:10 (June 1982): 68-72.

Georgia O'Keeffe was one of the few women artists associated with modernist trends in American painting during the first half of the century. She married Alfred Stieglitz in 1924 and became his closest artistic ally. She was associated with Arthur DOVE as well and shared with him an affinity for simplicity in life and art and a reverence for nature. Although at times her work was as abstract as Dove's, she was consistent in retaining objective subject matter.

Born in Sun Prairie, Wisconsin, O'Keeffe was educated in Virginia, at the Art Institute of Chicago (1901-1905), at the Art Students League under the tutelage of William Merritt Chase (1907-1908), and at Columbia University (1915) with Arthur Wesley Dow. She taught in Virginia and then in Texas, where she supervised art in the Amarillo public schools in 1912. In 1916 she was encouraged to move to New York City after the success of her first exhibition at Stieglitz's gallery 291. Best known for her crisply painted large-scale images of flowers and southwestern landscapes, she also painted scenes of New York City while living there with Stieglitz. Although the vantage points and subjects of her Manhattan paintings are similar to those in the contemporary photographs taken by Stieglitz, her concentration on temporal changes is evident even in these.

The major themes of O'Keeffe's oeuvre concerned changing life cycles, the omnipresent reality of death in life, and the beauty, delicacy, and harmony in nature. She was especially attracted to the stark, rugged country of the American Southwest after spending a summer in Taos, New Mexico in 1929. She lived in Abiquiu, New Mexico or in nearby Santa Fe from 1945 until her death in 1986. *P.N.*

Oriental Poppies, *1928*

Oil on canvas, 30 x 40⅛ in. (76.2 x 101.9 cm.)
Unsigned
Purchase
37.1
Illustration: Colorplate XXIII

While living in New York, O'Keeffe completed a series of works exploring plant forms in which she incorporated photographic techniques, including telephoto vision, the cropping of extraneous edges, and filling the frame with the closeup image. These horticultural images—which were the first to gain O'Keeffe widespread recognition—anticipated the era of color film and instant large blowups. Her paintings of magnified flowers embody the pulsing forms of conception, birth, life, death, and decay.

REFERENCES: Dwight Kirsch, "Exhibiting and Collecting Art in the Midwest," *Magazine of Art* (October 1946): 229, illustration only • John Gruen, "Far-From-Last Judgments or Who's Overrated Now?" *Art News* (November 1977): 199, illustration only.

EXHIBITIONS: The Intimate Gallery, New York, *O'Keeffe Exhibition*, 1928, cat. 34 (as *Red Poppies*) • Art Institute of Chicago, *Fifty-first Annual American Exhibition*, 1940-1941, cat. 152 • *Original Paintings from the University Collection*, 1946, cat. 117 • Drew Fine Arts Center, Hamline University, St. Paul, *Exhibition of Paintings by Some American Individualists*, 1950 • Tweed Hall, University of Minnesota-Duluth, *Exhibition*, 1951 • *Selections from the Permanent Collection*, 1954 • Des Moines Art Center, *Communicating Art from Midwest Collections*, 1955, cat. 27 • Brooks Memorial Union, Marquette University, Milwaukee, *75 Years of American Painting*, 1956 • Minnesota State Fair, St. Paul, *American Art of the Twentieth Century from the Collection of the University Gallery*, 1957 • *Selections from the Collection*, 1957 • College of St. Theresa, Winona, Minnesota, *The American Twenties*, 1958 • Michigan State University, East Lansing, *College Collections: An Exhibition Presented on the Occasion of the Dedication of the Kresge Art Center*, 1959, cat. 64 • *Art and the University of Minnesota*, 1961 • *Selections from the Permanent Collection*, 1962 • Rochester Art Center, Rochester, Minnesota, *Minnesota Art Sources*, 1963 • Kohler Gallery, Daland Fine Arts Center, Milton College, Milton, Wisconsin, *The 12th Annual Festival of the Arts—Paintings by Georgia O'Keeffe*, 1965 • *Selections from the Permanent Collection*, 1968, 1969, 1970, 1972 • Committee on Institutional Cooperation Traveling Exhibition, *Paintings from Midwestern University Collections, 17th-20th Centuries*, 1973-1975, cat. 49 • University of California, Santa Barbara, *O'Keeffe, Marin, and Hartley in the Southwest*, 1975 •

Oriental Poppies and *Oak Leaves, Pink and Gray* (see description below) demonstrate the range in this series in the contrast between full flower and inevitable decay. A single O'Keeffe *Poppy* from 1927 is in the collection of the Museum of Fine Arts of St. Petersburg, Florida.

In *Oriental Poppies*, the luscious and sensual flowers are tinged with the mystique of their derivative, opium. Beautiful but lethal, the flowers repel as they attract; spectacular in full bloom, they have prickly stems and an uninviting odor, and they fade and lose their petals quickly, scattering their seeds.

O'Keeffe enlarged the poppies several times, giving the human viewer the vantage point of an insect—and diminishing the viewer's size and importance. Inspected at such close range, the flowers become a contrast of red and black shapes. O'Keeffe offered this explanation for her flower enlargements: "A flower is relatively small. Everyone has many associations with a flower—the idea of flowers. You put out your hand to touch the flower—lean forward to smell it—maybe touch it with your lips almost without thinking—or give it to someone to please them. Still—in a way—nobody sees a flower—really—it is so small—we haven't time—and to see takes time like to have a friend takes time. If I could paint the flower exactly as I see it no one would see what I see because I would paint it small like the flower is so small.

"So I said to myself—I'll paint what I see—what the flower is to me but I'll paint it big and they will be surprised into taking time to look at it—I will make even busy New Yorkers take time to see what I see of flowers....When you took time to really notice my flower you hung all your own associations with flowers on my flower and you write about my flower as if I think and see what you think and see of the flower—and I don't" [Georgia O'Keeffe, *Georgia O'Keeffe, Exhibition of Oils and Pastels* (New York: An American Place, 1939)].

Oriental Poppies has been exhibited and illustrated as a vertical painting since at least 1958. Recent research into the Museum's records, however, suggests that it was most likely intended to be a horizontal work, as it is reproduced in Colorplate XXIII. Ruth Lawrence, who purchased the painting for the Museum from Alfred Stieglitz, certainly would have known the work's proper orientation,

Minneapolis Institute of Arts, *American Arts: A Celebration*, 1976 • South Texas Artmobile, Dougherty Carr Arts Foundation, Corpus Christi, Texas, *The Realist Tradition in American Painting*, 1977 • Grand Rapids Art Museum, Grand Rapids, Michigan, *Two Centuries of American Art*, 1977, cat. 89 • Museum of Art and Archaeology, University of Missouri, Columbia, *Six from Minneapolis*, 1978 • *Ruth Lawrence Remembered: 1890-1977*, 1980 • *Selections from the Permanent Collection*, 1980 • Sheldon Memorial Art Gallery, University of Nebraska, Lincoln, *Paintings of Georgia O'Keeffe*, 1980, cat. 27 • *Abstract USA/1910-1950*, 1981 • Carleton College, Northfield, Minnesota, *American Abstraction: 20th Century American Paintings from the University of Minnesota*, 1983 • *Early Modernism in America: The Stieglitz Circle*, 1983 • Minnesota Museum of Art, St. Paul, *American Style: Early Modernist Works from Minnesota Collections*, 1983 • *The First Fifty Years 1934-1984: American Paintings and Sculpture from the University Art Museum Collection*, 1984 • Madison Art Center, Wisconsin, *Georgia O'Keeffe: Paintings*, 1984.

PROVENANCE: An American Place, New York

Oil on canvas, 33⅛ x 18 in. (84.1 x 45.7 cm.)
Unsigned
Purchase
36.85
Illustration: Colorplate IX

EXHIBITIONS: Traveling Exhibition, *Some Individuals*, 1941-1942 • *Original Paintings from the University Collection*, 1946, cat. 116 • Tweed Gallery, University of Minnesota-Duluth, *A Survey of American Painting*, 1955 • Rochester Art Center, Rochester, Minnesota, *Significant American Arts*, 1959 • *Art and the University of Minnesota*, 1961 • *Selections from the Permanent Collection*, 1962 • Artmobile, Minneapolis Institute of Arts Traveling Exhibition, *American Art: The Early Moderns*, 1969-1970 • South Dakota Memorial Art Center, Brookings, *Ten American Women Artists*, 1975, cat. 16 •

and the painting was shown as a horizontal work in a February 1937 article in the *Minneapolis Tribune* and in a 1946 article by Dwight Kirsch in the *Magazine of Art* (cited above). The first record of the work as a vertical painting comes from 1958, four years after Mrs. Lawrence retired from the University and moved to California. However this seeming error occurred, it was then perpetuated for several decades until research into old scrapbooks of newspaper clippings brought to light the early publications that indicated a horizontal orientation of the painting. While further research is underway to permanently resolve the matter, it seems most likely that the painting was intended to be a horizontal composition.

Oak Leaves, Pink and Gray, *1929*

To O'Keeffe, objects in nature had individual identities, and maturity was as interesting as infancy. She saw symbols of death and decay as important harbingers of rebirth, reminders of a continual process of transition undergone by all living things.

Oak Leaves, Pink and Gray was one of the first works acquired by the University Art Museum (then the University Gallery). It was purchased by curator Ruth Lawrence from Alfred Stieglitz at his An American Place Gallery in 1935. Its first installation was in the fine arts room at the Gallery—a space set aside for students for contemplation and relaxation.

Two other variations on the theme of autumn leaves by O'Keeffe are in the Phillips Collection in Washington, D.C.

*Selections from the Permanent Collection,
1975* • Art Galleries, University of
California, Santa Barbara, *O'Keeffe, Marin,
and Hartley in the Southwest*, 1975 •
Minneapolis Institute of Arts, *American
Arts: A Celebration*, 1976 • Carleton
College, Northfield, Minnesota, *American
Art: 1900-1940*, 1977 • Museum of Art and
Archaeology, University of Missouri,
Columbia, *Six from Minneapolis*, 1978 •
Ruth Lawrence Remembered, 1890-1977 •
*Selections from the Permanent Collection,
1980* • Sheldon Memorial Art Gallery,
University of Nebraska, Lincoln, *Paintings
of Georgia O'Keeffe*, 1980, cat. 28 •
*Contact: American Art and Culture, 1919-
1939*, 1981, cat. 8 • Minnesota Museum of
Art, Landmark Center, St. Paul, *American
Style: Works from Minnesota Collections*,
1981, cat. 63 • *Early Modernism in
America: The Stieglitz Circle*, 1983 •
Minnesota Museum of Art, St. Paul,
*American Style: Early Modernist Works
from Minnesota Collections*, 1983 • *The
First Fifty Years 1934-1984: American
Paintings and Sculpture from the University
Art Museum Collection*, 1984 • Madison
Art Center, Madison, Wisconsin, *Georgia
O'Keeffe: Paintings*, 1984.

PROVENANCE: An American Place, New
York

BERTRAND OLD
1904-

SELECTED BIBLIOGRAPHY: Minneapolis
Historical Collection, Minneapolis Public
Library • Bertrand Old, telephone interview
with Mary Swanson (10 August 1980).

Bertrand Old was born in St. Paul, Minnesota. He studied at the
Minneapolis School of Art for two years and then at the St. Paul
School of Art under Cameron BOOTH from 1927 to 1928. He
taught at the St. Paul School of Art from 1935 to 1941 and at
Walker Art Center from 1941 to 1944; he also taught design for a
short period at the Minneapolis School of Art. Subsequently he
worked for the Anderson Window Corporation in Stillwater,
Minnesota, until his retirement, and continued to paint on his own
time. *M.T.S.*

Oil Tanks, *c. 1935-1940*

Oil on canvas, 30⅛ x 36 in.
(76.5 x 91.4 cm.)
Signed lower right: B. Old
WPA Art Project, Minneapolis
43.751
Illustration: Appendix

PROVENANCE: WPA Art Project, Minneapolis

Old's realistic shapes form a flat pattern on the canvas. In emphasizing their geometric forms, he reveals the influence of Cameron Booth.

ARTHUR OSVER
1912-

SELECTED BIBLIOGRAPHY: Emily Genauer, *Best of Art* (New York: Doubleday and Company, Inc., 1948), 28-30 ▪ L. Nordness, editor, *Art USA: Now* (New York: Viking Press, 1963), 264-267 ▪ Kenneth E. Hudson, "Arthur Osver," essay (St. Louis, Missouri: Gallery of Loretto-Hilton Center, Webster College, 1968) ▪ Emily S. Rauh, "Arthur Osver: Mid-America Invitational," essay (St. Louis: St. Louis Art Museum, 1973).

Arthur Osver was born in Chicago. He studied at Northwestern University from 1930 to 1931 and then at the Art Institute of Chicago with Boris Anisfield. In 1936 he was awarded the James Nelson Raymond Traveling Fellowship by the Art Institute of Chicago and spent the next two years in France and Italy before settling in Cagnes sur Mer (France) to paint.

In 1938 he and his new wife, painter Ernestine Belsberg, returned to Chicago, where Osver worked for the WPA/FAP easel program. Recalling it later, he wrote that "it was very nice while it lasted....I have always had a warm spot in my heart for the WPA and the support it gave me couldn't have come at a better time" (Letter from Arthur Osver to Mark Kriss at the University Gallery, 14 November 1978).

When the program ended, he left Chicago for good and moved to New York City. He had his first one-man exhibition there in 1943 at the Mortimer Brandt Gallery. His canvases were descendants of the Ash Can School of urban realism; fluid brushwork depicted city streets and tenements. Similar urban motifs were dominant again in a series of works completed while he was in Italy from 1952 to 1954 on a Prix de Rome fellowship. Starting in the mid-1950s his works became more abstract but were still based on urban and rural landscape elements. Color and light emerge as primary elements in his paintings, while forms and textures are secondary. In the early 1970s he did a series of paintings based on photographs of the architectural structure of the Grand Palais. Beams, spandrels, bolts, and tendrils of iron were incorporated into vertical and biomorphic forms which related back to their architectural origins.

Osver taught at the Brooklyn Museum School in 1947, Columbia University from 1950 to 1951, and Cooper Union in 1955 and 1958. He was visiting critic at Yale University from 1956 to 1957 and painter-in-residence at the American Academy in Rome before coming to Washington University in St. Louis in 1960. He won the Joseph E. Temple Gold Medal in 1948 and the Henry Schiedt Memorial Prize in 1966 at annual exhibitions at the Pennsylvania Academy of the Fine Arts. In 1966 he also received a sabbatical leave grant from the National Endowment for the Arts. *M.T.S.*

Interior, *1939*

Oil on canvas, 36¼ x 30¼ in.
(92.1 x 76.8 cm.)
Signed lower right: A. Osver
WPA Art Project, Washington, D.C.
43.721
Illustration: Appendix

REFERENCE: Letter from Arthur Osver to Mark Kriss at the University Gallery, 14 November 1978.

EXHIBITION: *Original Paintings from the University Collection*, 1946, no. 121.

PROVENANCE: WPA Art Project, Washington, D.C.

All of Osver's works are based on a romantic attachment to elements of his environment. In this scene the distortion of the figure and perspective provide a haunting reaction to his tenure in the WPA/FAP program while living in Chicago. This dizzying vision of an apartment interior can be seen as an echo of the traumatic economic times. Similar methods of distortion are evident in paintings completed by other artists during the Depression. Osver wrote about this period: "…one was given canvas, paints, and even a model, if needed, plus a stipend of some ninety-four dollars a month, which in those days—hard to believe—took care of most things quite nicely….I must admit to mixed feelings concerning government intervention in the arts. I always had a feeling of being on the dole, and I was appalled by some of the freeloaders and obvious incompetents who were happily coming along for the ride at Uncle Sam's expense" (Osver to Kriss, 14 November 1978).

JOSEPH PAUL PANDOLFINI
1908-

SELECTED BIBLIOGRAPHY: Holger Cahill, *New Horizons in American Art* (New York: The Museum of Modern Art, 1936), 146 • Letter from Joseph Pandolfini to Mark Kriss at the University Gallery, 5 December 1978.

Born in Italy, Joseph Paul Pandolfini immigrated to America with his family in 1912. He studied at the Pennsylvania Academy of the Fine Arts and the National Academy of Design before going back to Italy to attend the School for Architecture and the Royal Academy of Fine Arts, graduating from the Liceo Artistico in 1933.

Returning to the States, he joined the WPA/FAP easel program. One of his canvases, *Vegetable Still Life*, was shown at the Museum of Modern Art in 1936 in the exhibit New Horizons in American Art. Pandolfini wrote that this period was "a wonderful and unforgettable experience…the 'renaissance' of American painting" (Pandolfini to Kriss, 5 December 1978). While working on the project, Pandolfini also submitted a mural sketch, *Symbols*, for the U.S. Building in the 1939 New York World's Fair. He exhibited at the Musée du Jeu de Paume in 1938, the Whitney Museum's Annual in 1940, and the Art Institute of Chicago.

From 1947 to 1948 he taught at the Brooklyn Museum Art School. After exhibiting in the Jubilee Exhibition at the National Academy of Design in 1950, he retired to paint privately for himself and friends. *M.T.S.*

Unemployed, *c. 1932-1937*

Tempera on gesso on masonite,
23⅛ x 15½ in.
(58.7 x 39.4 cm.)
Signed lower right: Pandolfini
Purchase
38.52
Illustration: Colorplate XXIV

Although *Unemployed* was purchased from the Downtown Gallery (New York), which represented Pandolfini from 1937 to 1940, its subject and signs in the background indicate that it was probably painted earlier than 1937. Posters carried by the crowd refer to unemployed workers and the Scottsboro Boys, a popular cause publicized by cartoons and articles in radical and leftist magazines in the early to mid-1930s.

EXHIBITIONS: *Original Paintings from the University Collection*, 1946, cat. 123 ▪ Tweed Museum of Art, University of Minnesota-Duluth, *A Survey of American Painting*, 1955 ▪ *Contact: American Art and Culture 1919-1939*, 1981, cat. 9 ▪ *Images of the American Worker 1930-1940*, 1983 ▪ *The First Fifty Years 1934-1984: American Paintings and Sculpture from the University Art Museum Collection*, 1984 ▪ Hubert H. Humphrey Institute of Public Affairs, University of Minnesota, *Images of the American Worker 1930-1940*, 1985-1986.

PROVENANCE: Downtown Gallery, New York

EDGAR ALWIN PAYNE
1882-1947

SELECTED BIBLIOGRAPHY: Edgar Alwin Payne, *Composition of Outdoor Painting* (Los Angeles: Elsie Palmer Payne, Distributor, 1941) ▪ Mantle Fielding, *Dictionary of American Painters, Sculptors, and Engravers*, with addendum compiled by James F. Carr (New York: James F. Carr, 1965), 273 ▪ *Edgar Payne 1882-1947, An Exhibition of Western and Marine Paintings* (New York: Kennedy Galleries, 1970) ▪ Nancy Dustin Wall Moure, *Painting and Sculpture in Los Angeles, 1900-1945* (Los Angeles: Los Angeles County Museum of Art, 1980), 20.

Born in Washburn, Missouri, Edgar Alwin Payne grew up in the Ozarks, where his passionate love for the out-of-doors was born. He studied briefly at the Art Institute of Chicago but was mostly self-taught, learning the artist's craft through his youthful experiences as a house, sign, and scenic painter. Later he received commissions to do murals as well, but he is chiefly known for his many land and seascapes painted in the broad, loose brush technique that marks him as a painter in the impressionist mode.

Payne made his first sketching trip to California in 1911, spending several months in Laguna Beach, California. He later settled there and became the founder and first president of the Laguna Beach Art Association and its gallery. He continued to travel in Europe and throughout the United States, where he was especially drawn to the majestic High Sierras. *R.N.C.*

Autumn, Illinois, *1908*

Oil on cardboard, 5⅞ x 8¼ in.
(14.9 x 21 cm.)
Signed lower right: EDGAR PAYNE
Gift of Evelyn Payne Hatcher
80.17.16
Illustration: Appendix

EXHIBITIONS: University of Minnesota
Alumni Club, Minneapolis, *Paintings by
Edgar Payne*, 1980 ▪ *Paintings by Edgar
Payne*, 1980-1981 ▪ *The First Fifty Years,
1934-1984: Recent Acquisitions and
Promised Gifts to the University Art
Museum*, 1984.

PROVENANCE: Payne Studios, Inc.,
Minneapolis

Early Fall Trees, *c. 1908-1910*

Oil on cardboard, 11¾ x 13¾ in.
(19.8 x 34.9 cm.)
Signed lower right: EDGAR PAYNE
Gift of Evelyn Payne Hatcher
80.17.11
Illustration: Appendix

EXHIBITIONS: University of Minnesota
Alumni Club, Minneapolis, *Paintings by
Edgar Payne*, 1980 ▪ *Paintings by Edgar
Payne*, 1980-1981.

PROVENANCE: Payne Studios, Inc.,
Minneapolis

Early Landscape, Illinois, *c. 1908-1910*

Oil on panel board, 8⅞ x 13 in.
(22.5 x 33 cm.)
Signed lower right: EDGAR PAYNE
Gift of Evelyn Payne Hatcher
80.17.4
Illustration: Appendix

EXHIBITIONS: University of Minnesota
Alumni Club, Minneapolis, *Paintings by
Edgar Payne*, 1980 ▪ *Paintings by Edgar
Payne*, 1980-1981.

PROVENANCE: Payne Studios, Inc.,
Minneapolis

Spring in Lincoln Park (Chicago), *1910*

Oil on cardboard, 5½ x 7⅝ in.
(14 x 19.4 cm.)
Signed lower right: E. Payne
80.17.5
Gift of Evelyn Payne Hatcher
Illustration: Appendix

EXHIBITIONS: University of Minnesota
Alumni Club, Minneapolis, *Paintings by
Edgar Payne*, 1980 ▪ *Paintings by Edgar
Payne*, 1980-1981 ▪ *The First Fifty Years,
1934-1984: American Paintings and
Sculpture from the University Art Museum
Collection*, 1984.

PROVENANCE: Payne Studios, Inc.,
Minneapolis

California Scene, *1913*

Oil on panel, 9 x 12 in.
(22.9 x 30.5 cm.)
Signed lower right: EDGAR PAYNE
Gift of Evelyn Payne Hatcher
80.17.14
Illustration: Appendix

EXHIBITIONS: University of Minnesota
Alumni Club, Minneapolis, *Paintings by
Edgar Payne*, 1980 ▪ *Paintings by Edgar
Payne*, 1980-1981 ▪ *The First Fifty Years,
1934-1984: Recent Acquisitions and
Promised Gifts to the University Art
Museum*, 1984.

PROVENANCE: Payne Studios, Inc.,
Minneapolis

Rhythmic Sea, *c. 1920-1930*

Oil on canvas board, 19¾ x 15⅞ in.
(27.3 x 40.3 cm.)
Signed lower right: EDGAR PAYNE
Gift of Evelyn Payne Hatcher
80.17.6
Illustration: Appendix

EXHIBITION: *Paintings by Edgar Payne*,
1980-1981.

PROVENANCE: Payne Studios, Inc.,
Minneapolis

Sycamores, California, *c. 1920-1930*

Oil on canvas, 25½ x 30¼ in.
(64.8 x 76.8 cm.)
Signed lower left: Edgar Payne
Purchase, Nordfeldt Fund for Acquisition of
Works of Art
80.10
Illustration: Figure 114

EXHIBITIONS: University of Minnesota
Alumni Club, Minneapolis, *Paintings by
Edgar Payne*, 1980 ▪ *Paintings by Edgar
Payne*, 1980-1981.

PROVENANCE: Payne Studios, Inc.,
Minneapolis

Painted in California in the 1920s, *Sycamores* reveals Payne's sensitivity to nature and his awareness of the formal possibilities of landscape painting. In fact, Payne wrote and published a book titled *Composition of Outdoor Painting* in which he expounded the view that the artist must continually consult nature, for "her variation in line, form, color, and ever-changing mood is infinitely beyond the variations resulting purely from invention or imagination" (Payne, 1941, p. 17). Then he added, in what almost seems a specific reference to *Sycamores*, that "trees add grace and variety both to nature and pictures....They are living, growing and expanding things that give beauty and rhythm to Pictures" (p. 17).

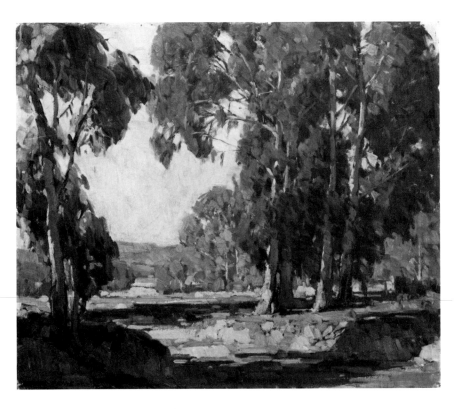

Sycamores, California, *c. 1920-1930* ▪ *Figure 114*

388

Mont Blanc, *1922*

Oil on canvas board, 12 x 14⅛ in.
(30.5 x 35.9 cm.)
Signed lower right: EDGAR PAYNE
Gift of Evelyn Payne Hatcher
80.17.7
Illustration: Appendix

EXHIBITIONS: University of Minnesota
Alumni Club, Minneapolis, *Paintings by
Edgar Payne*, 1980 ▪ *Paintings by Edgar
Payne*, 1980-1981.

PROVENANCE: Payne Studios, Inc.,
Minneapolis

Swiss Mountain Hamlet, *1923*

Oil on cardboard, 7¾ x 10 in.
(19.7 x 25.4 cm.).
Signed lower left: EDGAR PAYNE
Gift of Evelyn Payne Hatcher
80.17.17
Illustration: Appendix

EXHIBITIONS: University of Minnesota
Alumni Club, Minneapolis, *Paintings by
Edgar Payne*, 1980 ▪ *Paintings by Edgar
Payne*, 1980-1981.

PROVENANCE: Payne Studios, Inc.,
Minneapolis

Breton Town, *1924*

Oil on canvas board, 12 x 14⅛ in.
(30.5 x 35.9 cm.)
Signed lower right: EDGAR PAYNE
Gift of Evelyn Payne Hatcher
80.17.5
Illustration: Appendix

EXHIBITIONS: University of Minnesota
Alumni Club, Minneapolis, *Paintings by
Edgar Payne*, 1980 ▪ *Paintings by Edgar
Payne*, 1980-1981.

PROVENANCE: Payne Studios, Inc.,
Minneapolis

Misty Morning, Brittany, *1924*

Oil on canvas board, 12⅜ x 14¾ in.
(31.4 x 37.5 cm.)
Signed lower right: EDGAR PAYNE
Gift of Evelyn Payne Hatcher
80.17.4
Illustration: Appendix

EXHIBITIONS: University of Minnesota
Alumni Club, Minneapolis, *Paintings by
Edgar Payne*, 1980 ▪ *Paintings by Edgar
Payne*, 1980-1981.

PROVENANCE: Payne Studios, Inc.,
Minneapolis

Tuna Yawls, *1925-1929*

Oil on canvas, 20⅛ x 16 in.
(51.1 x 40.6)
Signed lower left: EDGAR PAYNE
Gift of Evelyn Payne Hatcher
80.17.1
Illustration: Appendix

PROVENANCE: Payne Studios, Inc.,
Minneapolis

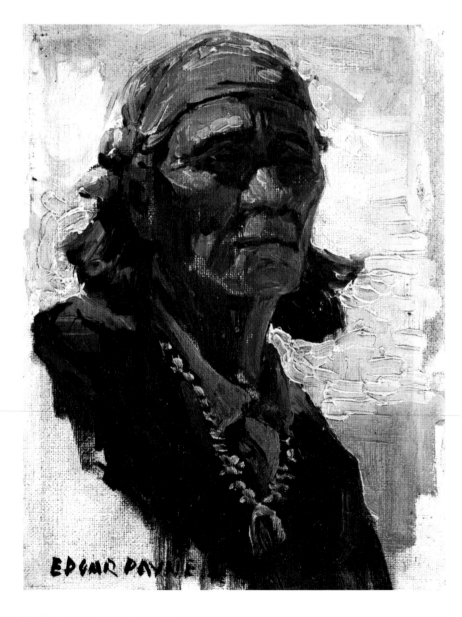

Navajo Portrait, *1930* ▪ *Figure 115*

Square Rigger, *1929-1930*

Oil on cardboard, 15 x 12⅛ in.
(38.1 x 30.8 cm.)
Signed (incised) lower right: EDGAR
PAYNE
Gift of Evelyn Payne Hatcher
80.17.18
Illustration: Appendix

EXHIBITION: *Paintings by Edgar Payne,*
1980-1981.

PROVENANCE: Payne Studios, Inc.,
Minneapolis

Navajo Portrait, *1930*

Oil on canvas board, 9½ x 7¼ in.
(24.1 x 18.4 cm.)
Signed lower right: EDGAR PAYNE
Gift of Evelyn Payne Hatcher
80.17.3
Illustration: Figure 115

EXHIBITIONS: University of Minnesota
Alumni Club, Minneapolis, *Paintings by
Edgar Payne,* 1980 ▪ *Paintings by Edgar
Payne,* 1980-1981.

PROVENANCE: Payne Studios, Inc.,
Minneapolis

Sierra, *c. 1930*

Oil on canvas board, 15¼ x 19¼ in.
(38.7 x 48.9 cm.)
Signed lower right: EDGAR PAYNE
Gift of Evelyn Payne Hatcher
80.17.8
Illustration: Appendix

EXHIBITION: *Paintings by Edgar Payne,*
1980-1981.

PROVENANCE: Payne Studios, Inc.,
Minneapolis

Western Afternoon, *c. 1930*

Oil on canvas board, 10⅜ x 13 in.
(26.4 x 33 cm.)
Signed lower right: EDGAR PAYNE
Gift of Evelyn Payne Hatcher
80.17.2
Illustration: Appendix

EXHIBITIONS: University of Minnesota
Alumni Club, Minneapolis, *Paintings by
Edgar Payne,* 1980 ▪ *Paintings by Edgar
Payne,* 1980-1981.

PROVENANCE: Payne Studios, Inc.,
Minneapolis

391

GUY PÈNE DU BOIS
1884-1958

SELECTED BIBLIOGRAPHY: Royal Cortissoz, *Guy Pène du Bois*, (New York: Whitney Museum of American Art, 1931) ▪ Guy Pène du Bois, *Artists Say the Silliest Things* (New York: American Artists Group, Duell, Sloan and Pearce, 1940) ▪ John Baker, "Guy Pène du Bois on Realism," *Archives of American Art Journal* (1977): 2-13 ▪ Betsy Fahlman, "Guy Pène du Bois: Painter and Critic," *Art and Antiques* 3:6 (November/December 1980): 106-113.

Guy Pène du Bois's satirical portrayals of fashionable American society were influenced more by the nineteenth-century French painter-illustrators Constantin Guys and Honoré Daumier than by the American realist Robert Henri, who was one of his early teachers. Pène du Bois was born to a French-American family living in Brooklyn. His father, Henri Pène du Bois, was a well-known art, music, and literary writer, and the young Pène du Bois grew up in a culturally sophisticated household. He was enrolled in the New York School of Art in 1899, studied with William Merritt Chase, Kenneth Hayes Miller, J.C. Beckwith, and Frank DuMond, and then served as a moniter in Robert Henri's class at the Art Students League for four or five years before leaving for Europe in 1905.

Returning from Paris in 1906, Pène du Bois first worked as a police reporter for the *New York American*, then as an art and music critic for the *New York Evening Post*, an assistant to art critic Royal Cortissoz on the *New York Tribune*, and later as editor for a special issue of *Arts and Decoration* magazine, published for the Armory Show of 1913. Although the magazine's articles were signed by a variety of names, many were ghostwritten by Pène du Bois. Working with George Bellows, Walt Kuhn, and members of The Eight, Pène du Bois organized the Independent Exhibition in 1910. He was also a member of the publicity committee as well as a contributor to the Armory Show of 1913.

Pène du Bois's early canvases exhibited the dark realism of the paintings of John Sloan and his teacher Robert Henri, and throughout his career Pène du Bois's style varied little from the painterly style he established before 1910 Owing more to nineteenth-century realism than to twentieth-century modernism, Pène du Bois's images were subtly satirical and his subjects were the wealthy, fashionable classes of France and the United States. He had an innate talent for characterization, and his scenes, while often critical, are anecdotal and do not suggest social reforms.

From 1924 to 1930 Pène du Bois lived in Garnes, France, devoting himself to painting. Upon his return to the United States he published monographs on John Sloan, William Glackens, Edward Hopper, and Ernest LAWSON and again contributed to literary journals and magazines. His autobiography, *Artists Say the Silliest Things* appeared in 1940.

Pène du Bois's late work relied on the studio subjects of nudes, portraits, and landscapes, and it was for this later work that he won the Benjamin Altman prize in 1936 and the second William A. Clark prize at the National Academy of Design in 1937. He taught summer art classes intermittently in Storington, Connecticut until 1952 when he again moved to France for an extended stay. He settled in Boston in 1956 where he died two years later. *M.T.S.*

A Window in the Union Club, *1919*

Oil on canvas, 24 x 20 in.
(61 x 50.8 cm.)
Signed lower left: Guy Pène du Bois 1919
Bequest of Hudson Walker from the Ione and Hudson Walker Collection
78.21.230
Illustration: Figure 116

REFERENCE: Guy Pène du Bois, *Artists Say the Silliest Things* (New York: American Artists Group, Duell, Sloan and Pearce, 1940), 189-191.

In 1919 Juliana Force invited ten artists to paint on framed canvases hung on the walls of Gertrude Vanderbilt Whitney's Studio Club, the forerunner of the Whitney Museum of American Art. Clifford Beal, Glen O. Coleman, Robert Chanler, Paul Dougherty, Walter Goldveck, Eugene Higgins, Leon Kroll, George LUKS, Luis Mora, John Sloan, and Guy Pène du Bois drew lots for the canvases and began painting. Laughter and conversation accompanied the creativity since most of the artists worked at the same time. Pène du Bois painted for almost a week to finish *A Window in the Union Club*. He wrote that "it showed an old rounder seated in a bulging shirt looking with an approach to surprise at a lily." (Pène du Bois, pp. 189-191).

EXHIBITIONS: Brooklyn Museum, *Revolution and Tradition: Fifty years of American Painting*, 1952 ▪ Staten Island Institute of Arts and Sciences, *Guy Pène du Bois*, 1954 ▪ Joslyn Art Museum, *Notable Paintings from Midwestern Collections*, 1956 ▪ Brooks Memorial Union, Marquette University, Milwaukee, *75 Years of American Painting*, 1956 ▪ Minnesota State Fair, St. Paul, *American Art of the 20th Century from the Collection of the University of Minnesota*, 1957 ▪ *Selections from the Permanent Collection*, 1957 ▪ College of St. Theresa, Winona, Minnesota, *The American Twenties*, 1958 ▪ *Selected Works from the Ione and Hudson Walker Collection*, 1959 ▪ *Art and the University of Minnesota*, 1961 ▪ *Selections from the Permanent Collection*, 1962 ▪ *100 Paintings, Drawings, and Prints from the Ione and Hudson D, Walker Collection*, 1965, cat. 7 ▪ *Selections from the Permanent Collection*, 1968, 1969, 1970, 1975 ▪ *Hudson D. Walker: Patron and Friend*, 1977, cat. 11 ▪ Corcoran Gallery of Art, Washington, D.C., *Guy Pène du Bois*, traveling exhibition, cat. 22.

PROVENANCE: Ione and Hudson Walker

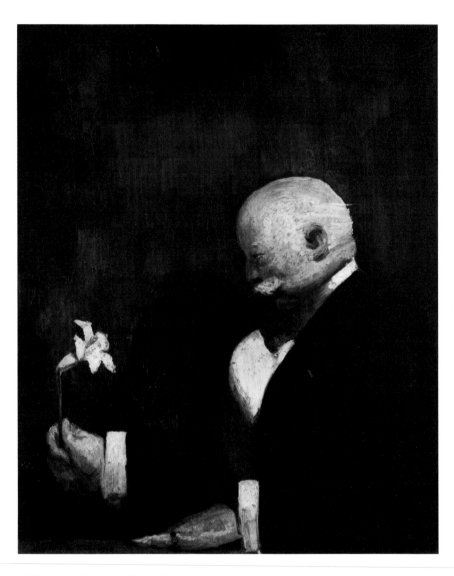

A Window in the Union Club, *1919* ▪ *Figure 116*

Blue Novel, *c. 1920*

Oil on wood panel, 20 x 15 in.
(50.8 x 38.1 cm.)
Signed verso in pen: Guy Pène du Bois
Bequest of Hudson Walker from the Ione
and Hudson Walker Collection
78.21.286
Illustration: Figure 117

REFERENCES: Letters from Betsy Fahlman,
National Collection of Fine Arts, to Percy
North at the University Gallery, 8 July
1978, 13 July 1979.

EXHIBITIONS: Whitney Studio Club, New
York, *Whitney Studio Club Annual
Exhibition of Paintings and Sculpture by
Members*, 1921, cat. 2 • Tweed Gallery,
University of Minnesota-Duluth, *A Survey
of American Painting*, 1955 • *Selections
from the Permanent Collection*, 1968, 1970
• *Hudson D. Walker: Patron and Friend*,
1977, cat. 12.

PROVENANCE: Gertrude Vanderbilt Whitney;
Ione and Hudson Walker

The back of this painting bears a label inscribed "Mrs. Whitney," suggesting that the work was owned by Gertrude Vanderbilt Whitney and may be a portrait of her. Although the figure in the painting has her back to the viewer, the hairdo is Mrs. Whitney's, and the painting was exhibited at the Whitney Studio Club in 1921. (Fahlman to North, 13 July 1978).

Early in Pène du Bois's career Mrs. Whitney was a valuable patron, and they shared a warm friendship. She lent him studio space and occasionally provided financial support, and he wrote two articles on her: "Mistresses of Famous American Collections: Mrs. Harry Payne Whitney" (*Arts and Decoration* [February 1917]: 177-182, 210) and "Mrs. Whitney's Journey in Art" (*International Studio* [January 1923]: 351-352).

The title of the painting is enigmatic. The sitter is viewed from the back and no novel is visible, though the woman's head is inclined slightly as if she were reading. The American social register, on which Mrs. Whitney certainly belonged, was sometimes called the "blue book" and the word "blue" was sometimes colloquially used to describe avant-garde literature.

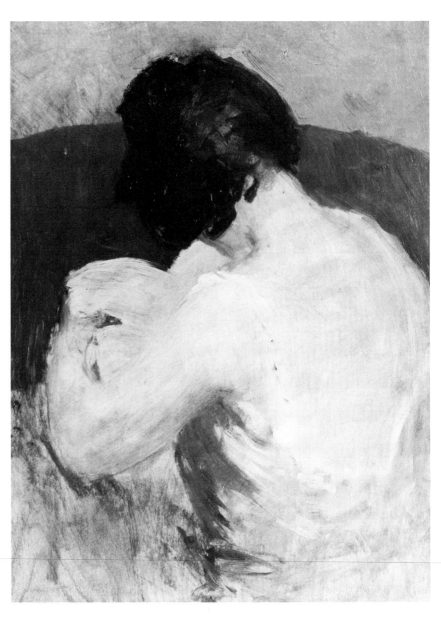

Blue Novel, *c.* 1920 ▪ *Figure 117*

JAMES PENNEY
1910-1982

SELECTED BIBLIOGRAPHY: John I.H. Baur, *Nature in Abstraction*, (New York: Whitney Museum of American Art, 1958), 58 • *Roland P. Murdock Collection* (Wichita, Kansas: Wichita Art Museum, 1972) • Letter from James Penney to Mark Kriss at the University Gallery, 19 January 1979.

Born in St. Joseph, Missouri, James Penney earned his BFA degree from the University of Kansas where he studied with Albert Bloch, Karl Mattern, and R.J. Eastwood. In 1931 he moved to New York to study at the Art Students League with George Grosz, Charles Locke, William Von Schlegell, Thomas Hart Benton, and John Sloan. As a student he helped support himself with odd jobs and at one time painted posters in exchange for a sleeping room at the Prospect Park YMCA.

He recalled that "one night in a sudden excitement, word swept through the League—they were hiring artists for the art projects tonight! A group of us dashed down to stand in a long line around 10 p.m. I went down there with Tolegian, Chas. Henry, and Jackson Pollock and we were hired" (Penney to Kriss, 19 January 1979). Penney particularly admired the murals of Diego Rivera and José Clemente Orozco which were done in the New York area. He worked with Moses Soyer on the murals for the Greenpoint Hospital in Brooklyn and then on his own in WPA projects for several high schools and the New York World's Fair of 1939.

Penney's canvases became increasingly more abstract after he left the WPA/FAP mural project, and though his titles referred to nature, only the colors and quality of light—as if filtered through trees and grass—had any connection with reality. By the mid-seventies Penney had returned to realistic portrayals of landscape scenes, creating vast spatial volumes through the use of overlapping planes of subdued colors.

Penney taught frequently over several decades: University of Kansas, 1938-1939; Hunter College, 1941-1942; Bennett College, 1945-1946; Bennington College, 1946-1947; Hamilton College, 1948; Munson-Williams Proctor Institute, 1948-1955; Vassar College, 1955-1956; and the California College of Arts and Crafts, 1960. His work has been shown in group and one-man exhibitions in major museums and galleries, including the Brooklyn Museum, the Pennsylvania Academy of the Fine Arts, the Newark Museum (New Jersey) and the Art Institute of Chicago. *M.T.S.*

West Side Freight Yards, *1938-1939*

Oil on canvas, 48¼ x 36¼ in.
(122.6 x 92.1 cm.)
Signed lower right: James Penney; dated
verso
Gift of the artist
68.30
Illustration: Appendix

REFERENCE: Letter from James Penney to
Mark Kriss at the University Gallery, 19
January 1979.

EXHIBITIONS: Hudson D. Walker Gallery,
New York, *James Penney*, 1939 • Walker
Art Center, Minneapolis, *Exhibition*, 1942.

PROVENANCE: the artist

James Penney lived near the West Side Freight yards in a studio at
the Lincoln Arcade on 65th and Broadway from 1937 to 1940. He
made numerous sketches and paintings of the area, but felt that this
painting was the best work of that period because it brought back
nostalgic memories of a trip to New York at the height of the
Depression:

"For the summer of 1933, I was asked back to the University of
Kansas to teach the summer classes in drawing and painting... . A
friend at K.U. got me a pass from the Kansas City stock yards to
ride back to New York on a freight train—in the caboose—
accompanying the shipment of a carload of hogs. It took several
days and nights. The caboose ride ended in New York City at the
West Side freight yards below 72nd Street, in the middle of the
night in the rain. I headed with my heavy bags across the dark
tracks midst dark freight cars to Broadway and 72nd Street and
took the subway to Brooklyn, where I stayed at the YMCA a few
days till I found a room and moved into New York near the
League. I had resolved at all cost to move into Manhattan to be in
the center of the art world" (Penney to Kriss, 19 January 1979).

IRENE RICE PEREIRA
1901-1971

SELECTED BIBLIOGRAPHY: John I. H. Baur,
Loren MacIver, I. Rice Pereira (New York:
Whitney Museum of American Art, 1953) •
"Print Personality," *Print* (January 1959):
34-36 • *Space, Light, and the Infinite, A
New Cycle of Paintings by I. Rice Pereira*,
(New York: Nordass Gallery, 1961) • I.
Rice Pereira, *The Nature of Space*
(Washington, D.C.: Corcoran Gallery of
Art, 1968) • I. Rice Pereira, *The Lapis*,
(Washington, D.C.: Corcoran Gallery of
Art, 1970) • Therese Schwartz,
"Demystifying Pereira," *Art in America*
67:6 (October 1979): 114-119.

Irene Pereira is noted for creating multiple surfaces on one canvas
using only color and texture. This interest in illusion and geometric
form was probably an outgrowth of her early introduction to
cubism at the Art Students League.

Pereira was born in Chelsea, Massachusetts, and moved with her
family to Boston, and then Brooklyn, in 1915. After her father died
in 1922, she telescoped several years of commercial and secretarial
courses into seven months, got a job as a stenographer, and
attended evening classes in art and literature for the next four years.

In 1927 she enrolled in classes with Richard Lahey and Jan Matulka at the Art Students League and became part of a student group which also included David Smith and Burgoyne Diller. Matulka, who often discussed the works of Henri Matisse and Picasso with the class, allowed Pereira to work in the style of synthetic cubism.

In 1931 she left the League and sailed to Europe, hoping to study modern European art movements for a year in Paris. Fascinated by the boat's mechanical parts, she avidly sketched its ventilators, anchors, and winches. Pereira worked for only a month at the Académie Moderne, then left to travel through Europe and North Africa. Returning to New York to paint full time, she created compositions based on her sketches of boat machinery and began to experiment with more abstract works, although still based on realistic images.

Pereira helped found the WPA/FAP Design Laboratory in 1936 and taught there after it was taken over by the Federation of Architects, Engineers, Chemists, and Technicians. Teaching painting, composition and design synthesis influenced her studies in texture and light and culminated in her first pure abstractions of 1937-1938. Finding that varied textures produced their own light, she began to experiment with magnesite and glyptal resin on glass and parchment to intensify this effect.

In the forties she perfected her geometrical abstract forms, using many small shapes derived from the square, usually adding a maze of thin lines onto an already textured composition. She sought deeper spatial effects and more complex designs in canvases completed into the fifties, often adding several sheets of painted and corrugated glass over her works so that illumination would change and distort forms. In 1951 she wrote that light was the sun or symbol of life and added that her lines or forms were symbols for the structure of the universe. Crumpled metal, microscopic glass beads, as well as gold and silver leaf were added to compositions to further reflect surface light. That same year she began to paint with forms which resembled automatic drawings. Over these biomorphically shaped abstractions Pereira placed rectilinear grids, which she continued to use in compositions for the next twenty years.

Enrolled in the WPA/FAP easel division in the thirties, Pereira was also active in the American Artists' Congress, the Artists League of America, and the United American Artists. She taught at the Pratt Institute and lectured at both Columbia University and Vassar. Pereira also wrote extensively about her artistic views: *Light and the New Reality* (1951); *The Transformation of Nothing and the Paradox of Space* (1955); *The Nature of Space* (1956); *The Lapis* (1957); and *The Crystal of the Rose* (1959). She died in Marbella, Spain in 1971. M.T.S.

Blue Predominates, *1945*

Oil on canvas, 30 x 40 in.
(76.2 x 101.6 cm.)
Signed lower right: Pereira 45
Gift of Ione Walker
78.25.2
Illustration: Colorplate XXI

REFERENCES: Oliver W. Larkin, *Art and Life in America* (New York: Holt, Rinehart and Winston, 1949), 456 ▪ John I.H. Baur, *Loren MacIver, I. Rice Pereira* (New York: Whitney Museum of American Art, 1953), 56.

EXHIBITIONS: San Francisco Museum of Art, *I. Rice Pereira*, 1947 ▪ *I.Rice Pereira*, 1950 ▪ Drew Fine Arts Center, Hamline University, St. Paul, *Exhibition of Paintings by Some American Individualists*, 1950 ▪ *Selections from the Collection of Mr. and Mrs. Hudson D. Walker*, 1950 ▪ Whitney Museum of American Art, New York, *Loren MacIver, I.Rice Pereira: A Retrospective Exhibition*, 1952 ▪ New York Historical Society, *Exhibition*, 1952 ▪ Tweed Museum of Art, University of Minnesota-Duluth, *A Survey of American Painting*, 1955 ▪ Brooks Memorial Union, Marquette University, Milwaukee, *75 Years of American Painting*, 1956 ▪ Minnesota State Fair, St. Paul, *American Art of the Twentieth Century from the Collection of the University of Minnesota*, 1957 ▪ *Selections from the Collection*, 1957 ▪

Although Pereira's titles were not metaphysical, they often related to her obsession with color and light. *Blue Predominates* is typical of the tightly knit surfaces of lines and shapes that she was painting in the mid to late forties. Space is deep and multilayered, often ambiguous. John I.H. Baur commented on the spatial problems in this and other works of the period:

"Take, for instance, her maze-like lines and bands of different colors in *Blue Predominates* or indeed in any of a dozen other pictures. Each band is a separate entity and exists on a separate plane. One is on top, the next is behind it, a third is obviously behind the other two and so forth. Yet the distance that separates them is seldom clear; it could be minute or it could be great" (Baur, p. 56).

Selected Works from the Collection of Ione and Hudson Walker, 1959 • *Selections from the Permanent Collection*, 1969 • *Abstract USA/1910-1950*, 1981 • *The First Fifty Years,1934-1984: American Paintings and Sculpture from the University Art Museum Collection*, 1984..

PROVENANCE: Mrs. Julius Held, New York Historical Society; Ione and Hudson Walker

Oil on canvas, 39¾ x 49⅞ in.
(101 x 126.7 cm.)
Signed lower right: I. Rice Pereira
Gift of N. Joseph Leigh
60.1
Illustration: Figure 118

PROVENANCE: N. Joseph Leigh

Substance of the Rose, *c. 1951-1960*

Although *Substance of the Rose* is undated, it was probably completed after 1951. At this time Pereira adopted a strictly rectilinear grid pattern on the painting's surface, abandoning the diagonals, trapezoids, and rhomboids which had figured in grids on earlier works. Here, too, her biomorphic textured shapes are freer, more fluid, held down by multiple levels of straight lines.

Substance of the Rose, *c. 1951-1960* • *Figure 118*

401

THEODORE C. POLOS
1902-

SELECTED BIBLIOGRAPHY: "Theodore Polos," *Art Digest*, (October 1, 1940): 10 • James Thrall Soby and Dorothy C. Miller *Romantic Painting in America*, (New York: The Museum of Modern Art, 1943), 140 • Francis V. O'Conner, *et al. New Deal Art: California* (University of Santa Clara: De Saisset Art Gallery and Museum, 1976) *passim.*

Born in Mitylene, Greece, Theodore C. Polos fled his homeland at 14 to escape an ecclesiastical education. In 1916 he was in Boston, then moved to New Hampshire, and finally settled in San Francisco in 1922 where he studied painting at the California School of Fine Arts under Xavier Martinez and Spencer Mackay.

Polos held odd jobs and painted in his spare time until he enrolled in the WPA/FAP easel project. He showed his work regularly in California throughout the 1930s, winning a Parilia purchase prize in 1937 and the Anne Bremer memorial prize in 1939 at exhibitions of the San Francisco Art Association.

The San Francisco Art Association gave Polos its first Rosenberg Traveling Scholarship in 1940, enabling him to sketch and paint for five months in Arizona, New Mexico, and Mexico. The somber tonality of these works was achieved by reliance on a limited palette which he mixed to form grayed and shadowy scenes of the Southwest.

Continuing to paint landscapes into the 1950s, Polos often shifted to watercolors to lighten his color schemes. His later works were romantic and colorful interpretations of the San Francisco area. *M.T.S.*

Country Road, *c. 1935-1940*

Oil on canvas, 17⅞ x 24 in. (45.4 x 61 cm.)
Signed lower right (incised): T. Polos; lower left: T. Polos
WPA Art Project, Washington, D.C.
43.720
Illustration: Figure 119

PROVENANCE: WPA Art Project, Washington, D.C.

During the late 1930s and early 1940s, Polos's technique involved placing a few colors directly onto his canvas, then merging them swiftly into earthen shades of brown. He would take several additional hours to adjust and rework the colors and forms, producing the eerie illumination and somber tonality evident in this work produced under the WPA/FAP program.

Country Road, *c. 1935-1940* • *Figure 119*

GREGORIO PRESTOPINO
1907-

SELECTED BIBLIOGRAPHY: Emily Genauer, *Best of Art*, (Garden City, New York: Country Life Press, 1948), 128-130 • Nathaniel Poussette-Dart, ed. *American Painting Today*, (New York: Hastings House Publishers, 1956), 105 • L.P. Sloshberg, *Three Artists View the Human Condition*, (New Jersey State Museum, 1968) • Archives of American Art, microfilm #69/21, N68/14, N68/15.

Gregorio Prestopino has always been comfortable both in his role as a social commentator and as a designer of lyrically conceived and harmoniously colored compositions portraying figures in idyllic landscapes. Born in New York City, he studied with Charles W. HAWTHORNE at the National Academy of Design. He first began to exhibit his work in group shows in the late 1930s. In 1943 his palette brightened, and he adopted the theme of workers on the job, usually incorporating their machinery and environment into the pictorial design.

His work changed again in the early fifties. Figures against and within the trolley cars and railroad engines departed and in their place were more abstract combinations of large areas of color and small figures. One reviewer remarked that "it is as though he had depersonalized himself in an attempt to keep abreast of current trends" ("Reviews," *Art News*, October 1951, p. 56). Paintings and serigraphs from the 1970s used figures and forest settings arranged in pleasing, colored patterns.

Prestopino has taught at the Veterans Art Center (New York), the Museum of Modern Art, the Brooklyn Museum School, the New School for Social Research (New York), and the American Academy in Rome. His work has been shown in Whitney Museum of American Art Annuals, at the Museum of Modern Art, the Art Institute of Chicago, and the Pennsylvania Academy of the Fine Arts. *M.T.S.*

Freight Rustler, *c. 1943*

Oil on masonite, 8 x 6 in.
(20.3 x 15.2 cm.)
Unsigned
Bequest of Hudson Walker from the Ione and Hudson Walker Collection
78.21.101
Illustration: Appendix

REFERENCE: Letter from Gregorio Prestopino to Sue Kendall at the University Gallery, 13 June 1979.

EXHIBITIONS: ACA Galleries, New York, *Gregorio Prestopino*, 1943 ▪ St. Paul Gallery and School of Art, *Exhibition*, 1951.

PROVENANCE: Ione and Hudson Walker

Although undated, this painting of chunky, blocky figures of Italian workmen was probably completed around 1943, a period in which Prestopino was exploring this theme. Using dark lines and small areas of vivid color, the artist wrote that it was "a study, one of many, that went into a large oil titled *Fulton Fish Market* which is in my collection. It was done sometime in the early forties and was in my first one-man show at the old ACA Gallery when the gallery was on West 8th Street in New York City" (Prestopino to Kendall, 13 June 1979).

WALTER W. QUIRT

1902-1968

SELECTED BIBLIOGRAPHY: *Walter Quirt* (Minneapolis: University of Minnesota Gallery, 1949) • Robert M. Coates, *Walter Quirt* (New York: American Federation of Arts, 1960) • *Walter Quirt: Use of White* (Minneapolis: University of Minnesota Gallery, 1976) • Mary T. Swanson, *Walter Quirt: A Retrospective* (Minneapolis: University of Minnesota Gallery, 1979) • Susan Ilene Fort, "American Social Surrealism," *Archives of American Art Journal* 22:3 (1982): 8-20.

Walter Quirt's frenetic line evolved from a sense of exploration and play, but it was also a device to record society's social and emotional climate. Although he was best known for the social realist and surrealist paintings done while he was in New York in the thirties and early forties, Quirt was a native midwesterner and spent the major part of his career there.

Born in Iron River, Michigan, Quirt studied at the Layton School of Art in Milwaukee from 1920 to 1923, returning to teach there from 1924 to 1928. He moved to New York in 1929 and became active in leftist politics and causes, drawing cartoons and illustrations for *New Masses*, *New Pioneer*, and *International Literature*. As secretary of the art section of the John Reed Club, he worked on committees and murals with Raphael SOYER, Nicolai CIKOVSKY, and Anton REFREGIER. He taught in the American Artists School from 1934 to 1936 and privately in his studio in the early forties.

A period of Freudian analysis from 1935 to 1938 and disillusionment with leftist ideology in the late thirties resulted in subtle changes in both Quirt's outlook and his art. Although he did not entirely abandon the small, cartoonlike panels espousing social change which gained him recognition earlier in the decade, he now occasionally painted dreamlike landscapes and amoebic figures. Friendship with the painter Stuart Davis in the early forties influenced the work of both men. Davis introduced some slightly amoebic forms into his compositions, and Quirt's designs became patterns of flat, colored shapes, a style which continued through the early fifties.

Quirt left New York in 1944 to return to teach at the Layton School of Art (Milwaukee), moved to East Lansing to teach at Michigan State University, and then in 1947 came to teach at the University of Minnesota where he remained until his death in 1968.

Horses and monumental figures of women dominated Quirt's mature work. Saturated colors or, conversely, pale pastel washes accompanied the calligraphic black lines which defined these late images. *M.T.S.*

Protection of White Womanhood, *1934*

Oil on gesso panel, 8 x 11 in.
(20.3 x 27.9 cm.)
Signed lower right: Quirt
Gift of the Quirt Family
82.11.1
Illustration: Colorplate XXX

REFERENCE: Jacob Kainen, "Revolutionary
Surrealism," *The Daily Worker* XII:49
(February 26, 1936): 7.

EXHIBITIONS: Julien Levy Gallery, New
York, *Paintings of Walter Quirt*, 1936 •
Walter Quirt: A Retrospective, 1980, cat. 6
• National Collection of Fine Arts.
Washington, D.C., *Walter Quirt: Early
Years*, 1980 • *The First Fifty Years, 1934-
1984: American Paintings and Sculpture
from the University Art Museum Collection*,
1984.

PROVENANCE: the Quirt family

Jacob Kainen described this painting as a "searing indictment of Negro persecution and the status of white womanhood" in his review for *The Daily Worker* when the work was exhibited at the Julien Levy Gallery (New York) in 1936. The metal headpiece that appears in the scene was the type used in executions in the electric chair and was seen beginning in the early thirties in illustrations of the famous Scottsboro Boys case, which involved the alleged rape of a white woman by several young black men.

Those Who Travel Too Fast, *1940*

Oil on canvas, 16¼ x 20 in.
(41.3 x 50.8 cm.)
Signed lower left: Quirt
Gift of the artist
58.30
Illustration: Appendix

EXHIBITIONS: The City Art Museum of St,
Louis, *Trends in American Painting of
Today*, 1942, cat.66 • *Selections from the
Permanent Collection*, 1968 • St. John's
University/College of St. Benedict,
Collegeville, Minnesota, *University of
Minnesota Art Exhibit*, 1971 • *Walter
Quirt: A Retrospective*, 1980, cat. 23 •
National Collection of Fine Arts,
Washington, D.C., *Walter Quirt: The Early
Years*, 1980.

PROVENANCE: the artist

Quirt's energetic line captures these cartoonlike figures of people and dogs, while his staccato brushstrokes, probably inspired by the techniques of automatic writing favored by the surrealists, envelope the entire composition. The painting is somewhat reminiscent of works by Max WEBER, whom Quirt claimed as a mentor but not an influence. During 1940 Quirt also did a series of cartoons for an animated movie that was never produced. In these cartoons he drew people and dogs with successively more fragmented lines, culminating in compositions similar to this painting.

The Mock War, *c. 1940*

Oil on gesso panel, 18⅛ x 24⅛ in.
(46 x 61.3 cm.)
Signed lower left: Quirt
Gift of Mr. and Mrs. Arthur Steig
81.5
Illustration: Appendix

EXHIBITIONS: *Walter Quirt: A Retrospective*,
1980, cat.56 ▪ *The First Fifty Years, 1934-
1984: Recent Acquisitions and Promised
Gifts to the University Art Museum*, 1984.

PROVENANCE: Arthur Steig

With its flat, intense color within cartoonlike forms, this painting parallels the animated cartoon project which Quirt planned with Arthur Steig's brother, William.

Performers Performing, *c. 1940*

Oil on canvas, 20 x 32 in.
(50.8 x 81.3 cm.)
Signed lower right: Quirt
Gift of Samuel S. Goldberg
80.15
Illustration: Appendix

EXHIBITIONS: National Hall of Art, Art
Movement, Inc., New York, *Exhibition*,
1944 ▪ *Walter Quirt: A Retrospective*,
1980, cat. 58 ▪ National Collection of Fine
Arts, Washington, D.C., *Walter Quirt: The
Early Years*, 1980 ▪ *The First Fifty Years,
1934-1984: Recent Acquisitions and
Promised Gifts to the University Art
Museum*, 1984.

PROVENANCE: Samuel Goldberg

In its use of draped figures holding staves, this painting relates sytlistically to Quirt's works from the forties but retains the grotesque quality of the figures from the murals and small panels painted in the late thirties.

Conceit, *1943*

Oil on canvas, 40 x30 in.
(101.6 x 76.2 cm.)
Signed lower right: W.W. Quirt; dated
verso
Gift of the artist
64.18.1
Illustration: Appendix

EXHIBITIONS: Durlacher Brothers, New
York, *Paintings of Walter Quirt*, 1944 ▪
Walter Quirt: A Retrospective, 1980,
cat.72.

PROVENANCE: the artist

In 1942 Quirt saw Marcel Duchamp's installation for *First Papers of Surrealism* in which the artist used twine webbing to physically tie the parts of the exhibition together. Perhaps influenced by Duchamp, Quirt has here enmeshed masked figures and their environments in webs of thick and thin ribbons of paint. The hard-edged shapes of color woven between the lines are a surrealistic adaptation of Stuart Davis's two-dimensional forms.

Origin of the Sexual Myth, *1947*

Oil on canvas, 40¼ x 44½ in.
(102.2 x 113 cm.)
Signed lower left: Quirt
Gift of the artist
64.18.2
Illustration: Figure 120

EXHIBITIONS: St Paul Gallery, St. Paul,
Minnesota, *The Artist, Nature, and Society*,
1947, cat. 12 ▪ *Selections from the
Permanent Collection*, 1969,1970 ▪ *Walter
Quirt: A Retrospective*, 1980, cat. 87 ▪
Abstract USA/1910-1950, 1981 ▪ Carleton
College, Northfield, Minnesota *American
Abstraction: 20th Century American
Paintings from the University of Minnesota*,
1983.

PROVENANCE: the artist

Exhibited with a series of eleven paintings whose titles all began with the word "origin," this work possibly relates to surrealism's preoccupation with myths and legends. One of Quirt's few totally abstract compositions, it is typical of his canvases of the late forties in its use of surrealist webbing combined with abstract geometric shapes.

Athlete Athleting, *1951*

Oil on canvas, 40⅛ x 36 in.
(101.9 x 91.4 cm.)
Signed lower right: Quirt; dated verso
Purchase
51.48
Illustration: Appendix

EXHIBITIONS: *Selections from the Permanent Collection*, 1954 • *Ruth Lawrence Remembered*, 1978.

PROVENANCE: the artist

Quirt reintroduced the figure into his work in 1950. Pale washes of color underlay the strong, black lines with which he drew both male and female figures. Quirt composed Joan Mirò-like creatures similar to these in paintings exhibited at New York's New Gallery in 1951.

Origin of the Sexual Myth, *1947* • *Figure 120*

Radiance, *1959*

Oil on canvas, 58 x 40 in.
(147.3 x 101.6 cm.)
Signed lower right: Quirt
Gift of the artist
64.18.3
Illustration: Appendix

PROVENANCE: the artist

Heavy areas of saturated color playing against frenetically brushed lines characterize images in this canvas and others completed in the late fifties and early sixties. In allowing the action of the brush as much importance as the composition, Quirt demonstrated his debt to abstract expressionism.

A Man and his Horse, *1959-1960*

Oil on canvas, 50 x 71 in.
(127 x 180.3 cm.)
Signed lower right: Quirt
Gift of the Quirt Family
82.11.4
Not illustrated

EXHIBITIONS: *Walter Quirt: A Retrospective*, 1980, cat. 113 • *The First Fifty Years, 1934-1984: Recent Acquisitions and Promised Gifts to the University Art Museum*, 1984.

PROVENANCE: the Quirt family

GLEN RANNEY
1896-1959

SELECTED BIBLIOGRAPHY: Nancy Johnson, *Accomplishments: Minnesota Art Projects in the Depression Years* (Duluth, Minnesota: Tweed Museum of Art, University of Minnesota-Duluth, 1976), no page numbers • Minneapolis History Collection, Minneapolis Public Library.

Glen Ranney was born in Hustler, Wisconsin, but later moved with his family to the prairies of North Dakota. Ranney came to Minneapolis to study at the Minneapolis School of Art under Cameron BOOTH and then went to New York to attend the Art Students League where George LUKS and Richard Lahey were his teachers.

In 1941, Ranney first exhibited his midwestern landscapes in a one-man show at the Number 10 Gallery (New York). Reviewers commented on his feeling for the land, attributing his rural subject matter to his midwestern background and the Regionalist influence on American painting. Two of Ranney's landscapes, possibly from this exhibition, were purchased by Sinclair Lewis in the early forties.

Ranney exhibited both locally and nationally from the mid-thirties through the early fifties. He was enrolled in the PWAP in 1934, later taught at the art school of the Walker Art Center, which was funded by the WPA/FAP, and at the Minneapolis School of Art from 1948 to 1951. *M.T.S.*

Twin City Sewage Station, *1936*

Oil on fabric, 28½ x 33¾ in.
(72.4 x 85.7 cm.)
Signed lower right: Glen Ranney '36
WPA Art Project, Minneapolis
43.779
Illustration: Appendix

EXHIBITION: Tweed Museum of Art,
University of Minnesota-Duluth,
*Accomplishments: Minnesota Art Projects
in the Depression Years*, 1976, cat. 68.

PROVENANCE: WPA Art Project, Minneapolis

This scene, painted on the back of a flour sack, is typical of many picturesque yet unpretentious scenes painted by American artists employed on the WPA/FAP projects in the thirties. Freight yards, factory interiors, mines, and highways all were favorite subjects for Minnesota artists.

Meadow Brook Farm, *1941*

Oil on canvas, 28 x ¼ x 33⅞ in.
(71.8 x 86 cm.)
Signed lower left: Glen Ranney
WPA Art Project, Minneapolis
43.780
Illustration: Appendix

PROVENANCE: WPA Art Project, Minneapolis

ANTON REFREGIER
1905-1979

SELECTED BIBLIOGRAPHY: Amy Robinson, "Refregier Paints a Mural," *Art News*, (October, 1949):32-34, 55-60 ▪ *Anton Refregier: Essays on the Artist Inspired by an Exhibition at the University of Virginia Art Museum* ▪ (Charlottesville, Virginia: The University of Virginia Art Museum., 1977) ▪ Anton Refregier, *Natural Figure Drawing* (New York: Tudor Publishing Co., 1960) ▪ Helen A. Harrison, "Subway Art and the Public Use of Art Committee," *Archives of American Art Journal* 21:2 (1981):3-12 ▪ Francis V. O'Connor, *et.al.*, *New Deal Art: California*, (Santa Clara, California: University of Santa Clara, 1976).

Anton Refregier believed that art produced "consciously and rationally … must be created in the interest of the people" (David B. Lawall, "Anton Refregier and Some Unpopular Aspects of American Painting, *Essays*, pp. 19-21). In murals and canvases done throughout his career, Refregier celebrated man's positive and constructive attempts at social organization, justice, and peace.

Refregier, born to a fairly well-to-do French-Russian family in Moscow, left Russia for Paris in 1920 to work for the Russian sculptor-architect Vassilief as an apprentice. When relatives in the United States encouraged him to immigrate, however, Refregier left Paris in 1920 and entered the Rhode Island School of Design, winning several scholarships and graduating in 1925. He helped support himself by working in neighboring textile factories, an experience which began his lifelong association with labor unions and his sympathy with the plight of the worker.

Refregier spent 1927 studying painting with Hans Hofmann in Munich. He returned to New York the following year to work as a decorator, painting murals in theaters, restaurants, speakeasies, and on the stage. In 1935 he taught painting, costume, and theater design at the school of theater arts on Lake George sponsored by the Yaddo Foundation. In the thirties, consistent with his identification with American workers, Refregier contributed to the *New Masses* and *The Office Worker*, published pamphlets on the Scottsboro Boys case, and was active in the Artists' Union and the American Artists' Congress. He was one of the organizers of the American Artists School in 1936, an outgrowth of the Art School of the John Reed Club, and, along with Walter QUIRT and Raphael SOYER, devised a curriculum consisting of life drawing, mural painting, and political cartooning.

Figures in Refregier's small panels and murals from the thirties and early forties were slightly distorted, tending toward caricature, and often existed in a surrealistic background of amoeba-shaped buildings and rocks. In composition and technique, they were very similar to those done by Walter Quirt within the same period.

Refregier entered the WPA mural project in 1938, painting *The Cultural Activities of the WPA* for the Federal Works Agency Building at the New York World's Fair of 1939. He also painted murals for a post office in Plainfield, New Jersey, and a series of panels for the visitors' room of Riker's Island Penitentiary in New

York. In 1941 he won a national competition to execute a 27-panel mural cycle on the history of California for the Rincon Annex of the San Francisco post office. Completed between 1946 and 1948, these murals focused primarily on the hardships and struggles of the state's early settlers, rather than on the romance and glory of California history. Refregier's realistic approach to this subject brought criticism and attempts by several congressmen to remove the murals in the early fifties, but these efforts failed.

Living in Woodstock, New York from the late thirties until his death, Refregier occasionally taught painting and/or mural painting as a visiting instructor at Stanford University, the University of Arkansas, and Syracuse University. He published *Natural Figure Drawing* in 1948; contributed illustrations to *Redbook*, *Glamour*, and *Mademoiselle* magazines; and had one-man exhibitions at the ACA Galleries at five-year intervals through 1972.

He designed murals for the Hillcrest Jewish Center on Long Island, the S.S. Independence, and S.S. Constitution and collaborated with Mexican weavers on tapestry murals for Woodstock's Rotron Manufacturing Company and the main office of the Bowery Savings Bank (New York).

Refregier was elected a member of the National Academy of Design in 1976, was the subject of a retrospective exhibition at the Museum of Fine Arts in Moscow and the Hermitage in Leningrad, and was an artist in residence in the Soviet Union at the invitation of the Artists Union of the USSR in 1973 and 1979. *M.T.S.*

Pruning, *1944*

Oil on cardboard, 10 x 7¾ in. (25.4 x 19.7 cm.)
Signed upper right: Anton Refregier; dated verso
Bequest of Hudson Walker from the Ione and Hudson Walker Collection
78.21.851
Illustration: Appendix

PROVENANCE: Ione and Hudson Walker

The stylized trees and figures in *Pruning* resemble portions of the Rincon Annex mural. Although this work may have been exhibited with the 26 paintings at the ACA Gallery in 1945, it does not deal with the chaos of war as did most of his other paintings of that time.

Woodstock Observation Post, *1944*

Oil on composition board, 10 x 8 in. (25.4 x 20.3 cm.)
Signed upper right: A. Refregier; dated verso
Bequest of Hudson Walker from the Ione and Hudson Walker Collection
78.21.36
Illustration: Figure 121

EXHIBITIONS: Drew Fine Arts Gallery, Hamline University, St. Paul *Exhibition*, 1952 ▪ *Hudson D. Walker: Patron and Friend*, 1977, cat. 68.

PROVENANCE: ACA Gallery, New York; Ione and Hudson Walker

Refregier's figures appear almost chiseled from stone, probably a result of techniques acquired while painting murals. *Woodstock Observation Post* was possibly one of 26 works exhibited at the ACA Gallery in 1945, all of which dealt rather graphically with the effects of war. In this work the statuesque woman shields her eyes as she scans the horizon, looking for the enemy aircraft illustrated on a chart beside her.

Woodstock Observation Post, 1944 ▪ *Figure 121*

414

LOUIS LEON RIBAK

1902-1980

SELECTED BIBLIOGRAPHY: Mabel Dodge Luhan, *Taos and Its Artists*, (New York: Duell, Stown and Pearce, 1947) • Donald O. Stiel, *Louis Ribak Retrospective* (Santa Fe, New Mexico: Museum of Fine Arts, Museum of New Mexico, 1975).

A native of Lithuania who immigrated to the United States at the age of ten, Louis Ribak became an American painter noted for his close ties to the Southwest. Although his family expected him to go into the hat business, young Louis at various times wanted to be an architect, a prize fighter, and an artist. In 1920 Ribak began his artistic training in earnest, first at the Pennsylvania Academy of the Fine Arts with Daniel Barger and two years later as a student of John Sloan at the Art Students League in New York.

Like Sloan, Ribak was drawn to views of everyday life—children playing near the docks along the East River, factory workers, pool players, and prize fighters and wrestlers at Stillman's Gym. His realist genre scenes from the twenties and thirties express a social concern that is sympathetic but free of political dogma.

During the thirties Ribak exhibited with "An American Group," artists such as José Clemente Orozco and Reginald Marsh whose sense of social responsibility matched his own. He later was employed by the New York section of the WPA/FAP and painted a mural for the post office in Albemarle, North Carolina.

Tired of the New York art scene by the forties, Ribak moved to Taos, New Mexico in 1944 where the rugged terrain and Indian culture inspired both a change in his palette and eventually in his imagery and style. Initially Ribak continued to depict scenes of everyday life, particularly Indian life and culture in lighter, brighter colors than he had used in the East. But, by the late forties Ribak's art underwent a transition from realist images to abstraction, and his major paintings of the fifties, sixties, and seventies are all abstract.

In 1947, to support himself, Ribak founded the Taos Valley Art School and in 1955 opened The Gallery Ribak. During his career Ribak exhibited widely throughout the United States, and in 1975 The Museum of New Mexico in Santa Fe accorded him a 50-year retrospective. *P.N.*

Berry Pickers, June, *c. 1925-1930*

Oil on canvas, 24 x 34 in.
(61 x 86.4 cm.)
Signed lower right: Louis Ribak
Bequest of Hudson Walker from the Ione
and Hudson Walker Collection
78.21.312
Illustration: Appendix

PROVENANCE: Ione and Hudson Walker

From his study with John Sloan, Louis Ribak developed an affinity for painting urban genre scenes of New York. Although better known for his early vignettes of city life and later scenes of the Southwest, Ribak also displayed a sensitivity to the rural landscapes and activities of New England in works such as *Berry Pickers, June.* Probably painted in Vermont at the end of the 1920s, the painting's lyrical charm and sketchy brushwork contrast with Ribak's more socially oriented paintings of the 1930s. But, as is the case in Ribak's New York paintings, the figures here are dwarfed by their surroundings and their collective action is more important than their individuality. Somewhat uncharacteristically Ribak has focused on the pattern of light and shadow in the idyllic landscape, a lingering suggestion of impressionism.

THOMAS ADDISON RICHARDS
1820-1900

SELECTED BIBLIOGRAPHY: Henry T. Tuckerman, *Book of the Artists* (New York: 1867; rpt. New York: James F. Carr, 1966), 254 • Clara Erskine Clement and Laurence Hutton, *Artists of the Nineteenth Century and their Works* (Boston: 1879, rpt. St. Louis: North Point, Inc., 1969), 208-209 • George C. Groce and David H. Wallace, *The New York Historical Society's Dictionary of Artists in America, 1564-1860* (New Haven: Yale University Press, 1957), 535 • Mantle Fielding, *Dictionary of American Painters, Sculptors, and Engravers*, with an addendum by James F. Carr (New York: James F. Carr, 1965), 301 • "The Romance of American Landscape: The Art of Thomas Addison Richards," *Georgia Museum of Art Bulletin* (Winter, 1983): passim.

A painter of the rural American scene, Thomas Richards was born in London and brought to America in 1831. He spent his youth in the South, mainly in Georgia and the Carolinas. At 23, Richards went North to study at the school of the National Academy of Design in New York, and this association with the Academy was to last for the rest of his life. Richards was named an associate of the National Academy in 1848, an academician in 1851, and in 1852, its corresponding secretary, a post he held for the next forty years. He also exhibited there regularly from 1861 to 1899.

Best known as a landscape painter of the Hudson River school, Thomas Addison Richards was also a successful journalist-illustrator. Under his direction, *The Knickerbocker* became an illustrated journal, and in 1857 he published *The Romance of American Landscape*, one of the first illustrated handbooks of American travel. A teacher as well as an artist, Richards was a professor of art at New York University from 1867 to 1887. He died at Annapolis, Maryland. *R.N.C.*

Landscape, c. 1882-1887

Oil on canvas, 12 x 20⅛ in.
(30.5 x 51.5 cm.)
Signed lower right: T.A. Richards
Gift of Frederick J. Wulling
44.20
Illustration: Appendix

REFERENCE: "The Romance of American Landscape," *Georgia Museum of Art Bulletin* (Winter 1983):34.

PROVENANCE: Frederick J. Wulling

This unpretentious view of a river landscape by Richards may have been painted on the Delaware River near Dingman's Ferry, a site chosen by the artist for several landscapes painted in the mid-1880s. A single boatman is seen in the foreground, while in the middle distance a substantial stone building may represent the ferry house, a typical aspect of country travel in nineteenth-century America. A bit more direct and less dramatic than many Hudson River school landscapes, this painting records the river scene with the careful observation and strong sense of place typical of American "scene painting" of this period.

LOUIS RITMAN
1892-1963

SELECTED BIBLIOGRAPHY: Peter Hastings Faulk, ed., *Who Was Who in American Art* (Madison, Connecticut: Sound View Press, 1985):520 • Mario Amaya, "Louis Ritman," *Architectural Digest* 26(September 1979):134 • Files and correspondence with Marguerita Ritman, Winona, Minnesota at the University Art Museum, Minneapolis, Minnesota.

Born in Russia in 1892, Louis Ritman immigrated to the United States and settled in Chicago while still a young man. He studied at the Art Institute of Chicago and the Ecole des Beaux-Arts in Paris and won a silver medal at the Panama-Pacific Exposition held in San Francisco in 1915. By 1930 Ritman had returned to Chicago where he maintained a studio in the Bell Building on the corner of State and Pearson Streets and taught at the Art Institute of Chicago from 1930 to 1960. He was the recipient of numerous awards, among them the Hallgarten Prize in 1918, the prestigious Logan Medal from the Art Institute of Chicago in 1930, 1932, 1940, and 1941, the Frank Prize from the National Academy of Design in 1932, and the Maynard Prize in 1952 and 1955. Throughout his career Ritman exhibited widely, and he is represented in many museum collections including the National Museum of American Art, the Art Institute of Chicago, and the Butler Institute of American Art (Youngstown, Ohio). *R.L.G.*

Estelle in White Satin, *c. 1930*

Oil on canvas, 36¼ x 36 in.
(92.1 x 91.4 cm.)
Gift of the Louis Ritman Estate
84.7.1
Illustration: Figure 122

REFERENCE: Telephone conversation between
Marguerita Ritman and Robert L.
Gambone, 25 April 1986.

EXHIBITION: *The First Fifty Years, 1934-
1984: Recent Acquisitions and Promised
Gifts to the University Art Museum, 1984.*

PROVENANCE: Estate of the artist

Estelle in White Satin depicts a pensive young woman, clothed in a lush satin evening gown, seated before a low table, listlessly dangling a white fan in her right hand. With her carefully combed hair, plucked brows, and ruby red lips, she represents the quintessential ideal of 1930s feminine glamour and beauty. Ritman chose a professional model for the sitter in this portrait (M. Ritman to Gambone, 25 April 1986) and has taken great pains to capture the sheen of the glistening satin. The still-life motif of flowers and teacup in the lower left of the canvas contrasts sharply with the beautiful evening gown and helps to focus the viewer's attention on the woman's thoughtful expression.

Estelle in White Satin, *c. 1930 ▪ Figure 122*

The Young Mother, *c. 1933*

Oil on canvas, 36 x 30 in.
(91.4 x 76.2 cm.)
Signed lower left: L. Ritman
Gift of the Louis Ritman Estate
84.7.3
Illustration: Figure 123

PROVENANCE: Estate of the artist

In *The Young Mother* Ritman employs a still-life motif to convey a lyrical mood. Here, the fruit, glasses and decanter, while occupying the center of the picture plane and commanding our attention, serve primarily as a visual introduction to the striking figure of a young woman, stylishly clad in a colorful summer dress. Her handsome features and sturdy posture connote a strength of character and purpose that underscore her role as a young mother. She advances toward the viewer, carrying her heavily laden tray toward the picnic table barely visible in the lower right corner of the painting.

The Young Mother, *c. 1933* • *Figure 123*

Still-Life Arrangement in the Garden, *1955*

Oil on canvas, 30⅛ x 36 in.
(76.5 x 91.4 cm.)
Signed lower left: L. Ritman
Gift of the Louis Ritman Estate
84.7.2
Illustration: Appendix

EXHIBITION: Art Institute of Chicago, *Sixty-Third Annual Exhibition by Artists of Chicago and Vicinity*, 1960.

PROVENANCE: Estate of the artist

Still-Life Arrangement in the Garden gathers a variety of casually arranged objects on a small wooden table in the midst of a wooded setting. The focal point of the composition is a ceramic jug and grouped around it in a semicircle are a teacup and saucer, pears and grapes, a knife, a goblet, and an open book. Ritman integrates these items by the judicious placement of a checked tablecloth. Despite the word "garden" in the title, the background is dominated by the cleft trunk of a large tree, rather than by any floral motif.

KURT ALBERT FERDINAND ROESCH
1905-

SELECTED BIBLIOGRAPHY: Kurt Roesch, *Sprig and Turfy* (Mt. Vernon, New York: Golden Eagle Press, 1938) • Sidney Janis, *Abstract and Surrealist Art in America* (New York: Reynal and Hitchcock, 1944) 68-69 • *Kurt Roesch: Paintings and Watercolors, 1950-1951* (New York: Curt Valentin Gallery, 1953).

Kurt Roesch immigrated to the United States from Germany in 1933. Having studied at the Berlin Academy of Fine Arts under Karl Hofer from 1925 to 1929, Roesch arrived in New York prepared to begin a career in teaching. He joined the faculty of Sarah Lawrence College in 1934 and taught drawing and painting there until his retirement as professor emeritus.

An abstract painter whose work encompasses a variety of themes, including mythology and nature, Roesch also specialized in etching and engraving and illustrated such literary works as Ranier Maria Rilke's *Sonnets to Orpheus* (1944) and *The Metaphysical Poets* (1945), Samuel Johnson's *Critical Remarks on the Metaphysical: An Interlude* (1945), and John Donne's *Donna Mia* (1946). *P.N.*

Celestial and Earthly, *c. 1936*

Oil on canvas, 20¼ x 23⅝ in.
(51.4 x 60 cm.)
Signed lower left: Roesch
Purchase
36.87
Illustration: Appendix

EXHIBITION: *Some Individuals*, Traveling
Exhibition, 1941-1942.

PROVENANCE: the artist

A twentieth-century allegory in the tradition of nineteenth-century academic painting, *Celestial and Earthly* alludes to the artist's struggle to balance art and life, mind and body. The viewer, like the artist, is constantly forced to choose between the intellectual and the emotional, while at the same time perceiving the two as facets of a single entity. To this effect a profile silhouette of the artist is interposed between the foreground and background in this glimpse into the artist's studio. Roesch also explores another duality in the painting's dominant images—abstraction in the female nude and realism in the literally defined landscape. The two are linked, however, in that the curvaceous, sprawling figure and its shadow echo the rolling curves of the landscape. In *Celestial and Earthly* the levels of reality have become confused, and the landscape as work of art becomes more real than the studio setting where it was produced. The painted landscape—itself half earth and half sky—is a literal interpretation of the work's title, while the female nude more metaphorically represents divine inspiration and earthly pleasures.

Indian Sunset, *c. 1936*

Oil on canvas, 17 x 26¼ in.
(43.2 x 66.7 cm.)
Signed lower left: Roesch
Purchase
36.88
Illustration: Appendix

EXHIBITION: Drew Fine Arts Center,
Hamline University, St. Paul, *Exhibition*,
1952.

PROVENANCE: the artist

The menacing mood of Kurt Roesch's *Indian Sunset* is conveyed by the dark colors, anthropomorphic hills, and a skull perched on a vertical support at the left of the canvas. A traditional reminder of the brevity of human existence, the skull is a complementary symbol to the sunset, harbinger of night and metaphoric death. The abstract curvilinear shapes can be interpreted as a western landscape, once the land of the Indians, and the nightmarish quality of the floating forms creates a pictorial tension akin to that in surrealist works.

Butterflies, *1950*

Oil on canvas, 22⅛ x 36 in.
(56.2 x 91.4 cm.)
Signed upper right: Roesch
Gift of the artist
53.44
Illustration: Appendix

EXHIBITION: Curt Valentin Gallery, New
York, *Kurt Roesch: Paintings and
Watercolors, 1950-1951,* 1953, cat. 1.

PROVENANCE: the artist

Roesch's style remained abstract into the 1950s and was linked to surrealism through the artist's interest in metamorphosis, mythology, and dream imagery. Butterflies, ancient symbols of the fragility of the soul, connote both spiritual aspirations and physical metamorphoses. Roesch's painting *Butterflies* explores the activity of these colorful insects in a series of stylized designs that break up the space of the composition. Although abstract movement is Roesch's paramount concern—the viewer has a sense of being in the midst of a meadow of fluttering wings—individual patterns can still be discerned.

In the introduction to the catalogue of his exhibition at the Curt Valentin Gallery in 1953, in which this work appeared, Roesch described his desire for a sense of amazement in the act of painting. His wonder and awe at the intricacies of nature led him to continue to explore the subject of butterflies and moths for several years during the 1950s.

JOSEPHINE LUTZ ROLLINS
1896-

SELECTED BIBLIOGRAPHY: Josephine Lutz
Rollins, *Historic Houses of Minnesota,* (St.
Paul: First Group of Banks, *c.* 1940s) •
Lawrence Schmeckebier, *Old Stillwater: An
Exhibition of Historic Landmarks,
Watercolors by Josephine Lutz* (1943) • Jo
Lutz Rollins, *Historic Buildings in
Minnesota,* (Minneapolis: University of
Minnesota Gallery, *c.* 1949) • *Josephine
Lutz Rollins: Retrospective Exhibition*
(Minneapolis: University of Minnesota
Gallery, 1962).

Josephine Lutz Rollins has spent most of her career in Minnesota. She taught art in Stillwater and Duluth and was on the faculty of the University of Minnesota from 1927 until her retirement in 1965. She received her undergraduate and graduate degrees from that institution as well, but also studied art with Cameron BOOTH and B.J.O. NORDFELDT at the Minneapolis School of Art (now the Minneapolis College of Art and Design) and spent a year at Hans Hofmann's school in Munich in 1930-1931.

Over the years, Rollins has been very active in various artists' communities. With others, she founded the Little Art Colony in Prescott, Wisconsin in 1933, and from 1935 to 1950, she was co-director of the Stillwater Art Colony. In 1964, she co-founded the West Lake Co-operative Gallery in Minneapolis, where she has frequently exhibited her work.

Many of Rollins's paintings and watercolors record historic places in Minnesota. She painted a series on Stillwater landmarks in the 1930s and 1940s, portrayed numerous historic buildings and homes from throughout the state during the 1940s, and received a Rockefeller Foundation Grant to execute a series of pictures on Minnesota at mid-century in 1950-1951. Other paintings draw their inspiration from various scenic sites Rollins has visited on her travels to California, Hawaii, Mexico, and Europe. *C.H.S.*

Girl in a Green Chair, *1930*

Oil on canvas, 24¾ x 18¾ in.
(62.9 x 27.6 cm.)
Signed lower left: Jo Rollins; dated verso
Gift of the artist
78.2.3
Illustration: Appendix

EXHIBITIONS: *Josephine Lutz Rollins: Retrospective Exhibition*, 1962 • The Saint Paul Companies, Inc., St. Paul (organized by Art Acquisitions, Inc.), Scene Painting: Minnesota Art in the 1930s and 1940s, 1982.

PROVENANCE: the artist

Early in her career, Rollins executed a number of figural subjects. *Girl in a Green Chair*, like *Old Houses in Munich*, was painted in Munich, Germany, where she was a student of Hans Hofmann. Her use of overlapping, thinly painted planes of flat, vivid colors possibly reflected his influence. The intense face of this lonely woman dominates the composition. Indeed, her head has been enlarged out of proportion to her body or the short chair, resulting in an expressionistic portrait.

Old Houses in Munich, *1930*

Oil on canvas, 16⅛ x 20 in.
(41 x 50.8 cm.)
Signed lower right: Josephine Lutz
Gift of the artist
68.299.1
Illustration: Appendix

EXHIBITION: *Josephine Lutz Rollins:*
Retrospective Exhibition, 1962.

PROVENANCE: the artist

Rollins, who is primarily a landscape painter, frequently focuses on architectural structures. Her earliest urbanscape in the Museum's collection, *Old Houses in Munich*, dates from her year of study with Hans Hofmann in 1930. Old houses became a major motif of her later compositions, when she often portrayed historical houses of her native Minnesota.

After her return from Germany, Rollins painted a number of figural subjects including *Dick* (1932) and the *Red Faced Farmer* (1933). She represented both individuals with naturalistic coloring except for their overly red faces. The structures of their heads are built up with sharp, angular planes. These unsmiling sitters gaze intensely, as though preoccupied with inner thoughts.

Nearly a decade later, Rollins executed *Portrait of a Ma*n, which appears to be a later representation of an older "Dick." Although the basic composition parallels the pose of the earlier *Dick*, Rollins has varied her technique, and has employed a palette knife to apply heavier layers of pigment. The freer contours and uneven textural surface produce a more expressionistic portrait.

Dick, *1932*

Oil on canvas, 18⅛ x 14⅛ in.
(46 x 35.9 cm.)
Signed lower left: Jo Rollins, dated verso
Gift of the artist
78.2.1
Illustration: Appendix

EXHIBITION: *Josephine Lutz Rollins:*
Retrospective Exhibition, 1962.

PROVENANCE: the artist

Oil on canvas, 28¼ x 22 in.
(71.8 x 55.9 cm.)
Signed upper left: J. Lutz; dated verso
Gift of the artist
65.11.1
Illustration: Figure 124

EXHIBITIONS: *Josephine Lutz Rollins:
Retrospective Exhibition*, 1962 ▪ The St.
Paul Companies, Inc., St. Paul (organized by
Art Acquisitions, Inc.), *Scene Painting:
Minnesota Art in the 1930s and 1940s*,
1982 ▪ Daniel Smith Gallery, Prescott,
Wisconsin, *Exhibition of Work of Josephine
Lutz Rollins*, 1984.

PROVENANCE: the artist

Red Faced Farmer, *1933*

Red Faced Farmer, *1933* ▪ *Figure 124*

Portrait of a Man, *c. 1940*

Oil on canvas, 14⅛ x 12⅛ in.
(35.9 x 30.8 cm.)
Signed upper right: Jo Rollins; dated verso
Gift of the artist
78.2.2
Illustration: Appendix

PROVENANCE: the artist

River View, *1946*

Oil on canvas, 19 x 25⅞ in.
(48.3 x 65.7 cm.)
Signed lower right: Jo Rollins '46
Gift of the artist
68.29.2
Illustration: Appendix

EXHIBITION: *Josephine Lutz Rollins: Retrospective Exhibition*, 1962.

PROVENANCE: the artist

In contrast to her later landscapes which are thinly painted idyllic scenes, *River View*, with its heavy paint application and swirling forms, portrays a dramatic view of nature. Generalized forms, devoid of detail, are depicted in earth tones with primary emphasis given to the brilliant yellow sun.

Many of Rollins's paintings were inspired by her travels. *View above Florence, Town in Spain, Mexico,* and *Paris Flower Market* present picturesque vistas of the cities and towns she visited. The overall representation of each place is rather sketchily rendered in a short-hand technique, outlining the general masses of buildings or hills and then adding a few specific details such as ornamental window grills or tiles. Even when portraying scenes which are less than idyllic, such as the *Open Pit Mine*, Rollins chooses to use bright colors and a generalized composition which obscure the ugliness of the subject.

Mexico, *c. 1954*

Casein on gesso panel, 15⅞ x 19⅞ in.
(40.3 x 50.5 cm.)
Unsigned
Gift of the artist
58.43
Illustration: Appendix

EXHIBITIONS: Winona Public Library, Minnesota, *Twelve Faculty Members*, 1958 • Walker Art Center, Minneapolis, *Paintings by Josephine Lutz Rollins*, 1959, cat. 4 • *Josephine Lutz Rollins: Retrospective Exhibition*, 1962.

PROVENANCE: the artist

View above Florence, *1956*

Casein on masonite panel, 22 x 26⅛
(55.9 x 66.4 cm.)
Signed lower right: J. Rollins
Gift of the artist
65.11.20
Illustration: Appendix

EXHIBITION: West Lake Gallery,
Minneapolis, *Exhibition*, 1967.

PROVENANCE: the artist

Town in Spain, *c. 1956*

Oil on canvas, 30 x 24 in.
(76.2 x 61 cm.)
Signed lower left: Jo Rollins
Gift of the artist
65.11.3
Illustration: Appendix

PROVENANCE: the artist

Open Pit Mine, *1957*

Oil on masonite panel, 30¼ x 42¼ in.
(76.8 x 107.3 cm.)
Signed lower right: Jo Rollins 1957
Gift of the artist
63.7
Illustration: Appendix

EXHIBITIONS: *Josephine Lutz Rollins:
Retrospective Exhibition*, 1962 ▪ *Shaping
the Land: Minnesota Landscapes 1840s to
the Present*, Traveling Exhibition, 1985-
1986.

PROVENANCE: the artist

Sunset and Hills, California (also called *California Hills*), *c. 1959*

Oil on canvas, 25½ x 39½ in.
(64.8 x 100.3 cm.)
Signed lower right: J. Rollins
Gift of the artist
65.11.2
Illustration: Appendix

EXHIBITION: *Josephine Lutz Rollins:
Retrospective Exhibition*, 1962.

PROVENANCE: the artist

427

Paris Flower Market, *c. 1959*

Oil on canvas, 22 x 27 in.
(55.9 x 68.6 cm.)
Signed lower right: J. Rollins
Gift of the artist
68.29.3
Illustration: Appendix

EXHIBITION: Catherine G. Murphy Galleries,
College of St. Catherine, St. Paul, and
Tweed Museum, University of Minnesota-
Duluth, *Josephine Lutz Rollins
Retrospective*, 1982.

PROVENANCE: the artist

Flo's Flower Pot, *1962*

Oil on canvas, 20⅛ x 36⅛ in.
(51.1 x 91.8 cm.)
Signed lower left: J. Rollins '62
Gift of the artist
68.29.4
Illustration: Appendix

PROVENANCE: the artist

RALPH M. ROSENBORG
1913-

SELECTED BIBLIOGRAPHY: Sidney Janis,
Abstract and Surrealist Art in America,
(New York: Reynal and Hitchcock, 1944),
87, 92 ▪ Robert Motherwell and Ad
Reinhardt, eds., *Modern Artists in America*,
(New York: W. Schultz, 1951), 12 -15, 61 ▪
Marticia Sawin, "The Achievement of
Ralph Rosenborg," *Arts* (November
1960):44-46 ▪ Dore Ashton, *The New York
School, A Cultural Reckoning* (New York:
The Viking Press,. 1972), 78 ▪ Grace
Glueck, "The Artists' Artists," *Art news*
81:9 (November 1982):97.

Born in Brooklyn to a Swedish immigrant family, Ralph Rosenborg
often sketched scenes of the countryside on Long Island where his
mother cooked for wealthy families. As a boy he took Saturday art
classes at the American Museum of Natural History and subse-
quently studied at the Art Students League. In the late 1920s he
became a protégé-apprentice to Henriette Reiss, a painter who had
studied with Wassily Kandinsky.

As a member of the Ten Whitney Dissenters, Rosenborg was
influenced by surrealism in the 1930s and developed a form of
hieroglyphic language, similar to that of Paul Klee's. In 1949 and
1950 Rosenborg took part in the Friday evening discussion also
known as Studio 35, where New York artists and others interested
in avant-garde painting met to discuss new movements and the
artistic environment. Although reviewers in the 1970s noted that he
had become almost a recluse, Rosenborg continued to paint
landscapes glowing with luminous color and using the violent
gestures and impastoed surfaces of the abstract expressionists.

Rosenborg taught at the Brooklyn Museum School from 1936 to 1938, at the University of Wyoming and the University of North Carolina. He has had several one-man shows in New York galleries and has shown his paintings in group exhibitions at the Corcoran Gallery (Washington, D.C.), the Whitney Museum of American Art, the Brooklyn Museum, and the Seattle Art Museum (Washington). *M.T.S.*

The Child, *1947*

Oil on composition board, 31½ x 13½ in. (80 x 43.3 cm.)
Signed lower right: Rosenborg/47
Gift of Dr. and Mrs. M.A. McCannel
54.39
Illustration: Appendix

REFERENCE: "Reviews," *Art News*, (May 1947):50.

PROVENANCE: Dr. and Mrs. M.A. McCannel

Rosenborg worked with some reference to reality throughout the 1940s, as is apparent in this abstracted image of a little boy. Describing him as a poetic colorist, critics commented: "at times little figurative symbols or objects bob out of the palette knife impasto" ("Reviews," p. 50).

JAMES ROSENQUIST
1933-

SELECTED BIBLIOGRAPHY: *Rosenquist* (Paris: Ileana Sonnabend, 1976) ▪ *James Rosenquist* (Ottawa: National Gallery of Canada, 1968) ▪ Marcia Tucker, *James Rosenquist* (New York: Whitney Museum of American Art, 1972) ▪ Elayne H. Varian, *James Rosenquist Graphics Retrospective* (Sarasota, Florida: John and Mable Ringling Museum of Art, 1979) ▪ Judith Goldman, *James Rosenquist* (New York: Viking Penguin Inc., 1985).

Although born in Grand Forks, North Dakota, James Rosenquist moved frequently in his youth until his family finally settled in Minneapolis in the late 1940s. Rosenquist attended classes at the Minneapolis School of Art on a high school scholarship and in 1952 entered the University of Minnesota to study painting with Cameron BOOTH. To help support himself during this time Rosenquist painted billboards and advertising on grain silos for a local company, an experience which had a major impact on his art.

At Booth's urging the young artist applied for a competitive scholarship to the Art Students League, which he won, and he moved to New York City in 1955. There he again took up painting billboards and designing department store windows to supplement his income. Working on the enormous billboards of Time Square introduced Rosenquist to close-up details of gigantic images and supplied the basis for his own interpretation of pop art.

Rosenquist's style reached its maturity in the late fifties and early sixties and juxtaposed fragmented and enlarged images of American popular culture—glamour girls, soft drink bottles, automobiles, and canned dinners—painted in the garish colors of sign painting, in a shallow spatial gridwork. The resulting canvases resembled a

montage of billboard sections. These images were not selected for their intrinsic meanings, however, but as metaphors, intended to stimulate the viewer's own response.

Most of Rosenquist's compositions throughout the sixties had social or political implications and demonstrated his strong feelings against war and the build-up of nuclear weapons. Titles were often puns, political statements, or descriptions of the items pictured, but they came from the artist's personal associations with the objects.

Throughout the seventies and into the eighties Rosenquist also incorporated conceptual art and color perception into his work. He constructed environments with colored panels, reflective mylar surfaces, electrically lit sculptural forms, and photographically projected spaces. His imagery, however, has always remained a personal statement.

Richard Bellamy, director of the Green Gallery (New York) and dealer in avant-garde American art, gave Rosenquist his first one-man show in 1962. Since then his canvases have been exhibited in major museums and galleries throughout the United States and Europe. The Denver Art Museum organized an important Rosenquist retrospective in 1985, and a survey of his work since 1961 was held at the Whitney Museum of American Art in 1986. *M.T.S.*

World's Fair Mural, *1964*

Oil on masonite, 240 x 240 in. (609.6 x 609.6 cm.)
Signed verso: James Rosenquist
Gift of the artist
68.8
Illustration: Figure 125

REFERENCE: Philip Johnson, "Young Artists at the Fair," *Art in America*, (August 1964):116-117.

EXHIBITION: Special viewing, 1966.

PROVENANCE: the artist

The architect Philip Johnson, who designed the New York State Exhibition at the New York World's Fair in 1964, commissioned works from several artists to be attached to the exterior of his building. Rosenquist's large mural was placed on fifteen separate panels and bolted to a wooden frame attached to the building's circular exterior. The hard edges, bright colors, and fragmented forms are typical of his compositions in the sixties. The composition itself whimsically combines images symbolic of 1964, of the World's Fair (the carnival peanuts), and of patriotism (the stripped Uncle Sam hat) in a sort of icon of American popular culture. Stenciled amid these symbols is the word "Atwater," the name of a small town in central Minnesota where Rosenquist once lived. Interestingly, this work was selected for the cover of a French textbook on American civilization—Jacques Poujol and Michele Oriano, *Initiation à la civilisation americane* (Paris: Masson et Cie, 1969).

World's Fair Mural,, *1964 ▪ Figure 125*

THOMAS PRITCHARD ROSSITER
1818-1871

SELECTED BIBLIOGRAPHY: Clara Erskine Clement and Laurence Hutton, *Artists of the 19th Century and their Works* (Boston, 1879, rpt., St. Louis: North Point, Inc., 1969), 224-225 ▪ M. and M. Karolik *Collection of American Paintings, 1815 - 1865* (Cambridge: Harvard University Press, 1949), 465 ▪ E.P. Richardson, *Painting in America, The Story of 450 Years* (New York: Thomas Crowell Company, 1956), 221, 251 ▪ George C. Groce and David H. Wallace, *The New York Historical Society's Dictionary of American Artists in America* (New Haven, Yale University Press, 1966), 548 ▪ William H. Gerdts, *Revealed Masters, 19th Century American Art* (New York: The American Federation of Arts, 1974), 111, 147.

Thomas Pritchard Rossiter, a New York-based artist, was best known as a painter of portraits and historical and religious subjects but occasionally tried his hand at landscape. Born in New Haven, Connecticut, Rossiter received his early training in portraiture under Nathaniel Jocelyn. He exhibited in the National Academy of Art in 1838 and moved to New York the following year. In 1840 Rossiter and fellow artists John F. Kensett and John W. Casilear set out on a pilgrimage to Europe with their older friend and mentor, Asher B. Durand. Rossiter, a short time later, traveled through Switzerland with Thomas B. Cole and then took up residence in Rome. He remained in Europe for six years and, after his return to New York, was elected to the National Academy of Design in 1849.

431

The artist made a second trip abroad in 1853, returning in 1856 to settle in New York City. He continued to devote most of his time to historical and religious painting, building a studio in Cold Spring, New York, in 1860 where he lived until his death. Rossiter is known to have traveled west in 1858 because he exhibited some paintings in Milwaukee in that year. *R.N.C.*

Minnesota Prairie, *c. 1858-1859*

Oil on canvas, 15⅝ x 25½ in.
(39.7 x 64.8 cm.)
Unsigned
Gift of Daniel S. Feidt
73.8.3
Illustration: Colorplate XVII

REFERENCE: Rena Coen, *Paintings and Sculpture in Minnesota, 1820 - 1914* (Minneapolis: University of Minnesota Press, 1976), 44, 46.

EXHIBITIONS: *A Bicentennial Exhibition of Art and Architecture in Minnesota*, 1976 • *Selections from the Permanent Collection*, 1980 • *The First Fifty Years, 1934-1984: American Painting and Sculpture from the University Art Museum Collection*, 1984 • *Shaping the Land: Minnesota Landscapes 1840s to the Present*, Traveling Exhibition, 1985-1986.

PROVENANCE: Kennedy Galleries, New York; Daniel S. Feidt

One of Thomas P. Rossiter's occasional landscapes, *Minnesota Prairie* was painted during a trip the artist made to Minnesota in 1858 or 1859. The trip may well have been suggested by Rossiter's friend of many years, John F. Kensett, who had himself painted Minnesota landmarks along the Mississippi River only two years earlier.

The painting depicts the new state at the beginning of the great American push westward. It is a peaceful scene, celebrating the simple, pastoral life of the pioneer homesteader in terms that recall Dutch landscapes of the seventeenth century. The broad sweep of countryside, blessed by a beneficent light, is emphasized by a low horizon line, where a rustic cottage and a rough, lean-to shed describe the settler's haven. The rude plank bridge, the hayricks lined like sentinels behind the cottage, and the fertile fields awaiting cultivation allude to a state midway between wilderness and civilization.

FELIX RUVOLO
1912-

SELECTED BIBLIOGRAPHY: Nathaniel Pousette-Dart, *American Painting Today* (New York: Hastings House Publishers, 1956), 74, 101, 127 ▪ Andrew Carnduff Ritchie, *Abstract Painting and Sculpture in America* (New York: Museum of Modern Art, 1951), 115, 155.

Although he was born in New York City, Felix Ruvolo lived in Sicily through his youth, and he first studied art in Catania, Italy. He returned with his family to America in 1926, however, settling in Chicago. Ruvolo studied at the Art Institute of Chicago and later worked on the WPA/FAP easel program during the thirties. Landscapes painted during this period were realistic, yet expressively romantic.

From 1945 to 1947 Ruvolo taught at the art school of the Art Institute of Chicago, at Mills College in 1948, and at the University of California at Berkeley from 1950 on. By 1947, the year of his first one-man exhibition at the Durand-Ruel Gallery (New York), his paintings had evolved into abstract evocations of landscapes and figures. Color dictated the forms and compositions and was intensified by its juxtaposition with velvety blacks which Ruvolo claimed were inspired by the rock formations of his boyhood home in Sicily. By the 1950s Ruvolo's paintings were completely abstract—only the titles tied his geometric forms to their landscape derivations.

Ruvolo's work has appeared in more than 175 American and international exhibitions, among them *Abstract Painting and Sculpture in America* of 1951 at the Museum of Modern Art and *Abstract and Surrealist Painting* at the Art Institute of Chicago, 1947. *M.T.S.*

Alabama Landscape, *c. 1935-1940*

Oil on canvas, 30⅛ x 40⅛ in.
(76.5 x 101.9 cm.)
Signed lower center: F. Ruvolo
WPA Art Project, Washington, D.C.
43.719
Illustration: Appendix

PROVENANCE: WPA Art Project, Washington D.C.

The painterly quality of *Alabama Landscape*, completed while Ruvolo was enrolled in the WPA/FAP easel program, continued in his more mature works. In its liquid application of paint, blurred edges, and slightly distorted forms, Ruvolo's landscape composition is similar to those of other painters during the thirties who were influenced by the romantic expressionism of Albert Pinkham Ryder. Ruvolo was later to reject his earlier realistic content, yet retain this romantic technique.

WILLIAM SALTZMAN

1916-

SELECTED BIBLIOGRAPHY: *William Saltzman: Selections* (St. Paul, Minnesota: Janet Wallace Fine Arts Center, Macalester College, 1966) • Jacques Cattell Press, ed., *Who's Who in American Art* (New York: R. R. Bowker Company, 1980).

Oil on canvas, 32 x 26⅛ in.
(81.3 x 66.4 cm.)
Signed lower left: W. Saltzman/'66
Gift of the Friends of John Williams
66.10
Illustration: Appendix

PROVENANCE: the artist

A prolific painter and sculptor, William Saltzman was born in Minneapolis and has spent most of his life in the Midwest. In 1937 he received a scholarship to study at the Art Students League in New York and in 1940 earned a B.S. from the University of Minnesota. Following service as a camouflage advisor for the U.S. Army Engineers during World War II, he became acting director of the University of Minnesota Gallery from 1946 to 1948. Then, for the next sixteen years he was director and artist-in-residence at the Rochester (Minnesota) Art Center. In 1964 he was a visiting professor at the University of Nebraska at Lincoln and since 1966 has taught at Macalester College (St. Paul, Minnesota).

He has received numerous mural, sculpture, and stained-glass commissions, including the dome of the University of Minnesota Hospitals Meditation Chapel, and awards from the Guild for Religious Architecture and the Nebraska Chapter of the American Institute of Architects. *R.L.K.*

John Harry Williams, *1966*

This portrait of Professor John Harry Williams was commissioned by his friends to commemorate the dedication of the John H. Williams Laboratory of Nuclear Physics at the University of Minnesota. Dr. Williams died at age 57, a month before the building's completion.

Born in Quebec, John Williams received degrees from the University of British Columbia and the University of California at Berkeley before coming to the University of Minnesota to teach physics in 1933. His interest in the study of x-rays led him into nuclear research, and he directed the construction of the University's first atom smasher. In 1943 he was selected deputy to the test director of the Manhattan Project at Los Alamos (New Mexico) where he assisted in the design and construction of the first nuclear weapons.

In 1946 Williams returned to the University as a full professor, but he was called into government service again in 1958, this time for the Division of Research of the Atomic Energy Commission. He subsequently became its commissioner. In 1960 Williams came back to the University of Minnesota where he taught until his death six years later.

In this seated portrait the amiable Dr. Williams pivots as if to engage the viewer in conversation. The relaxed posture tells more of Williams's personality than it does of his scientific achievements and recalls his professorial role. The painting's realism is atypical of Saltzman's usual dynamic, abstract style and demonstrates his versatility as an artist. *P.N.*

PAUL STARRETT SAMPLE
1896-1974

SELECTED BIBLIOGRAPHY: Alfred Frankenstein, "Paul Sample," *Magazine of Art* (July 1983):387-391 • "Reviews and Previews," *Art News* (Summer 1970):67 • Archives of American Art, 1972, microfilm 333-335 • Nancy Dustin Moure, *Painting and Sculpture in Los Angeles, 1900-1945* (Los Angeles: Los Angeles County Museum of Art, 1980), 57-59 • *Paul Sample* (Londonderry, Northern Ireland: Orchard Gallery, 1982).

For almost fifty years Paul Sample painted such typically American scenes as farms, corrals with horses, and seascapes. But the tightly structured compositions and hard-edged forms in his earliest canvases gave way to more spontaneously brushed images later in his career.

Sample, who was twenty-five before he decided to become a painter, was born in Louisville, Kentucky. Because his father was a construction engineer, the family moved to various cities around the country before Sample entered Dartmouth College in 1916. While serving in the navy during World War I, doctors discovered that he had tuberculosis, and Sample spent four years in a sanitarium in the Adirondacks where he began to paint as part of his therapy program. Deciding that he would become an artist, Sample moved to California in 1925. He first studied with Jonas LIE and Stanton MACDONALD-WRIGHT, then taught painting at the University of Southern California in Los Angeles. He left California in 1938 to become artist-in-residence at Dartmouth where he remained until his retirement.

435

Although it is possible to see influences from Thomas Hart Benton in Sample's work from the thirties, Sample claimed that the sixteenth-century Flemish artist Peter Brueghel the Elder was his visual mentor, and he made several trips to Europe to study Brueghel's paintings. Sample's technique changed little during the forties, but by 1958 his images were depicted with almost photographic accuracy. By the time of his last New York exhibition in the summer of 1970, however, his brushstrokes were more loosely applied to representational scenes.

Sample won the Benjamin Altman prize in exhibitions at the National Academy of Design in 1947 and 1962. He has exhibited in many group shows including the Metropolitan Museum of Art, the Art Institute of Chicago, and the Pennsylvania Academy of the Fine Arts. A retrospective of his work was held at the Lowe Art Museum, University of Miami, in 1984. *M.T.S.*

Western Landscape, *c. 1930-1938*

Oil on canvas, 30⅛ x 18¼ in.
(76.5 x 46.4 cm.)
Signed lower right: Paul Sample
Purchase
36.89
Illustration: Figure 126

REFERENCES: Letters from Paul Sample to Ruth Lawrence at the University Gallery, 21 October 1948 and 29 December 1948.

In this scene Sample used the same vantage point as Peter Brueghel the Elder might have—looking down into an airless, monumentally conceived hilly landscape against which horses, crops, animals, and a barren tree are silhouetted. *Western Landscape* is a departure from Sample's usual compositions from this period in that horses are the dominant figures instead of people.

Western Landscape, *c. 1930-1938* • *Figure 126*

437

LOUIS SCHANKER
1903-1981

SELECTED BIBLIOGRAPHY: Francis V. O'Conner, *The New Deal Art Project: An Anthology of Memoirs* (Washington, D.C.: Smithsonian Institution Press, 1972), 116-118,122,124,125,167,168 • Una Johnson, *Louis Schanker Prints: 1924-1971* (Brooklyn: Brooklyn Museum, 1974) • Susan Ilene Fort, "Art reviews: Louis Schanker," *Arts* 56:1 (September 1981):28 • Greta Berman, "Abstractions for Public Spaces," *Arts* 56:10 (June 1982):81-86.

A native of New York City, Louis Schanker studied at Cooper Union, the Art Students League, and the Educational Alliance School of Art between 1920 and 1927. Adept as a printmaker, sculptor, and painter, Schanker's artistic career was varied, and his work incorporated cubist, expressionistic, and abstract ideas. During the 1930s, Schanker was associated with the federal art programs and executed murals for the Science and Health Building at the 1939 New York World's Fair. In 1935 and 1936, he exhibited with the Ten Whitney Dissenters, and in 1936 he joined the American Abstract Artists. Schanker taught at Bard College (1949-1964) and the New School for Social Research (1943-1960). *P.N.*

Abstraction, *1945*

Oil on canvas, 20 x 24 in. (50.8 x 61 cm.)
Signed lower right: Schanker 45
Bequest of Hudson Walker from the Ione and Hudson Walker Collection
78.21.116
Illustration: Appendix

PROVENANCE: Ione and Hudson Walker

Typical of his work of the 1940s, Louis Schanker's evocative painting *Abstraction* is a collision between a lyrical landscape and the rigid geometric abstraction preferred by his friends in the group of American Abstract Artists. The linear calligraphic language of crosses, zigzags, and crosshatching is juxtaposed with the romantic mood of the soft-edged forms floating in the center of the canvas, fencing in the shimmering color and creating an ambiguous sense of space.

Enamel on canvas, 29 x 35 in. (73.7 x 88.9 cm.)
Signed verso: Schanker 1951
Bequest of Hudson Walker from the Ione and Hudson Walker Collection
78.21.284
Illustration: Figure 127

Abstraction, *1951*

EXHIBITIONS: Grace Borgenicht Gallery, New York, *Exhibition*, 1952 ▪ Tweed Gallery, University of Minnesota-Duluth, *A Survey of American Painting*, 1955 ▪ *Selections from the Permanent Collection*, 1957 ▪ Minnesota State Fair, St. Paul, *American Art of the Twentieth Century from the Collection of the University of Minnesota*, 1957 ▪ *Selected Works from the Collection of Ione and Hudson Walker*, 1959 ▪ *Art and the University of Minnesota*, 1961.

PROVENANCE: Ione and Hudson Walker

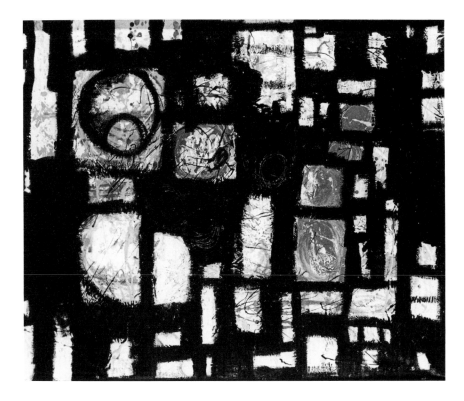

Abstraction, *1951* ▪ *Figure 127*

MIRON SOKOLE
1901-

SELECTED BIBLIOGRAPHY: Martha D. Cheney, *Modern Art in America* (New York: McGraw-Hill Book Company, Inc., 1939), 129 ▪ Henry Salpeter, "About Miron Sokole," *Esquire* (September 1945):78-79,130 ▪ Letter from Miron Sokole to Mark Kriss at the University Gallery, 7 December 1978 ▪ Letter from Miron Sokole to Sue Kendall at the University Gallery, 7 August 1979.

Miron Sokole was born in Odessa, Russia, to a family who encouraged him to sketch and paint from early childhood. In 1915 the family immigrated to the Lower East Side of New York City where Miron began to attend evening classes at the Cooper Union. He later completed his art training with Ivan Olinsky in evening classes at the National Academy of Design from 1921 to 1924.

During the early part of his career, Sokole worked as a designer of stage settings and dioramas in order to support his art. Some of his early works depicted industrial scenes, but they did not dwell on social problems. Critics, in fact, wrote that his flower paintings were his specialty because of their exaggerated color and perspective. In the mid-forties he began to use slightly geometric forms in landscape compositions, and this process of abstraction continued in his work through the 1950s. In the fifties, however, Sokole also returned to painting nostalgic landscapes, dimly lit with romantic moonlight. Painted from memory, these scenes often depicted the countryside around Woodstock, New York, where Sokole spent his summers.

Sokole taught at the American Artists School in New York from 1938 to 1940 and was the artist-in-residence at the Kansas City Art Institute from 1947 to 1951. For many years he conducted private classes in his studios in New York and Woodstock. *M.T.S*

Flowers in an Italian Vase, *c. 1932-1937*

Oil on canvas, 22 x 17⅞ in.
(55.9 x 45.4 cm.)
Signed lower right: Miron Sokole
Bequest of Hudson Walker from the Ione and Hudson Walker Collection
78.21.318
Illustration: Appendix

PROVENANCE: Ione and Hudson Walker

In the thirties and forties Sokole painted floral compositions using a combination of impastoed surfaces and thinly applied pigment. Critics found these works handsome in their use of expressionistic, almost strident color and distorted perspective.

Mountain Village, *c. 1932-1937*

Oil on canvas, 24 x 29¾ in.
(61 x 75.6 cm.)
Signed lower right: Miron Sokole
Purchased from Federal Art Project, Central Allocations Division, New York City
39.106
Illustration: Appendix

REFERENCE: Letter from Miron Sokole to Sue Kendall at the University Gallery, 7 August 1979.

EXHIBITION: *Original Paintings from the University Collection*,1946, cat. 137.

PROVENANCE: Federal Art Project, Central Allocations Division, New York City

Sokole emphasized color, form, and linear pattern and exaggerated the perspective in works such as this from the 1930s in order to create a sense of pleasurable escapism. About the origin of this scene he wrote:

"*Mountain Village* is one of a series of paintings of small typical American villages dominated by a church steeple which fascinated me in the middle thirties. I used to drive 100 miles or more from home, stopping wherever it interested me, making rough black and white sketches which served to recall the scene to me" (Sokole to Kendall, 7 August 1979).

MOSES SOYER
1899-1974

SELECTED BIBLIOGRAPHY: "A Sample of New "Deal Murals," *American Heritage*, 21:6 (October, 1970):45 • Joshua C. Taylor, *America as Art* (Washington, D.C.: National Collection of Fine Arts, Smithsonian Institution, 1976), 20 • William Kloss, *Treasures from the National Museum of American Art* (Washington, D.C.: Smithsonian Institution Press, 1985), 136-137, 234-235.

Moses Soyer and his twin brother, Raphael, were born on Christmas Day in the small town of Borisoglebsk, Russia, the oldest of six children. Although their town was poor and provincial, the Soyer household provided a cultural environment which encouraged creativity, and the three eldest boys, Moses, Raphael, and Isaac, all became professional artists.

The Soyer family immigrated to the United States in 1912, settling permanently in New York. Moses and Raphael quit high school to work as newspaper boys, clerks, and dishwashers to help support the family. They also attended free classes at Cooper Union and the National Academy of Design until 1918, at which time Moses transferred to the Educational Alliance Art School. He wanted to establish his own artistic identity and felt a need to free himself from any possible influences from his twin brother. He remained at the Educational Alliance Art School until 1924 and taught there from 1924 to 1926. He also studied briefly with Robert Henri and George Bellows, then accepted a traveling scholarship to study in Europe from 1926 to 1928.

Returning to New York, Soyer held his first one-man exhibition at the New Art Circle (New York) in 1929. During the Depression he taught at the New School for Social Research as well as working on the WPA/FAP mural project from 1935 to 1939. During the thirties and forties he had numerous solo exhibitions at the Kleemann Galleries (New York), Macbeth Gallery (New York), and at the Little Gallery in Washington D.C. He was a regular participant in the Carnegie Institute's annual exhibitions from 1943 to 1950 and in the Whitney Museum's annual show until 1963.

Throughout the sixties Soyer continued to receive various prizes and honors, including election to the National Academy of Design (1963) and membership in the National Institute of Arts and Letters (1966). A retrospective of his work was held at the Syracuse University Art Museum (Syracuse, New York) in 1972-1973. *R.L.G.*

441

Nude on a Blue Couch, *c. 1964*

Oil on canvas, 20 x 24 in.
(50.8 x 61 cm.)
Signed upper right: M. Soyer
Gift of Jane and David Soyer
84.19
Illustration: Figure 128

PROVENANCE: Estate of the artist

Nude on a Blue Couch, although painted around 1964, continues the format Soyer perfected in the 1930s: solidly modeled figures in classical poses in clearly defined spaces. Here the artist places the seminude model on a bed, the most prominent feature of which is the deep blue coverlet on which the full-bodied figure reclines. Her crossed legs add to the volumetric mass of her hips and upper thighs and create an erotic composition from what might otherwise be a typical studio subject.

This rendering of a sensual, seminude, reclining figure is reminiscent of the nineteenth-century theme of the odalisque, or harem girl; however, Soyer has modernized the subject by avoiding any hint of the exotic. The woman lies on an ordinary bed or couch, and her features mark her as a contemporary American woman, not some mysterious Near Eastern beauty. By employing elements from nineteenth-century painting while transposing them into a twentieth-century context, Soyer has created a timeless composition of freshness and vitality.

Nude on a Blue Couch, *c. 1964* ▪ *Figure 128*

RAPHAEL SOYER
1899-

SELECTED BIBLIOGRAPHY: Lloyd Goodrich, *Raphael Soyer* (New York: Whitney Museum of American Art, 1967) • Raphael Soyer, *Self-Revealment: A Memoir* (New York: Maecenas Press, Random House, 1967) • Janet A. Flint, *Raphael Soyer: Drawings and Watercolors* (Washington: National Collection of Fine Arts, Smithsonian Institution Press, 1977) • Raphael Soyer, *Diary of an Artist* (Washington: New Republic Books, 1977) • Abram Lerner, *Soyer Since 1960* (Washington: Hirshhorn Museum and Sculpture Garden, 1983) • Avis Berman, "Raphael Soyer at 80: 'Not painting would be like not breathing,'" *Art News* (December 1979):38-43.

Human figures are central to Raphael Soyer's paintings. He sees them through sensitive, compassionate eyes and records not only their physical but also their psychological presence on canvas. Raphael and his twin brother, Moses, the eldest of six children, were born in Borisoglebsk, Russia. Their mother was an expert embroiderer who illustrated Russian fairy tales with vividly colored yarns and their father was a Hebrew teacher who fostered a love of art and literature in his children. Soyer recalled:

"Our father taught us the names of Rembrandt, Raphael and Michelangelo and told us about them. We never really played—our pastimes were drawing, painting and reading. We were obsessed with becoming artists and our parents encouraged our sibling rivalry by praising one brother's work over the other's. Once Isaac made a better drawing than I did and I went away and cried." (Berman, p. 40).

Of the six children, Raphael, Moses, and Isaac became artists after immigrating to America in 1912. The boys visited the Metropolitan Museum of Art every Sunday, but worked as newspaper boys, dishwashers, and clerks during the week to help support the family. Raphael and Moses attended free classes at the Cooper Union and the National Academy of Design from 1915 to 1918, at which time Moses switched to the Educational Alliance Art School to be free of any possible influence from his twin. "Moses and I were always aware of the struggle to find our own identity, to be oneself," Raphael Soyer said. "It was always aggravating to have art critics write about us together" (Berman, p. 41).

Raphael Soyer remained at the National Academy of Design several more years and then attended classes at the Art Students League until 1922. Guy PÈNE DU BOIS was his most influential teacher at the League, encouraging him to see the possibilities of painting people in everyday situations. But Soyer considered the drawings he studied by George Grosz, Egon Schiele, Jean-Auguste-Dominique Ingres, Rembrandt, Goya, and Degas to be his real mentors. Robert Henri's ideas on social realism in art were also communicated to Raphael by his brother Moses during the early 1920s.

Soyer's paintings were first shown at the Salons of America in 1926. Due to the influence of Alexander Brook, a painter and the assistant director of the Whitney Studio Club, the Club began to purchase Soyer's work in 1927. By 1929 Soyer had his first one-man show at the progressive Daniel Gallery, and in the next decade frequently exhibited at the Curt Valentin, Frank K.M. Rehn, and Associated American Artists Galleries (all New York).

After going through a primitive phase in the 1920s, Soyer's paintings of the 1930s became more realistic, and his style has remained essentially unchanged. A humanist dedicated to close observation, he used models from his own neighborhood, capturing the moods, gestures, and postures of shop girls, the unemployed, young artists, dancers, and actors for over fifty years. During the late thirties and forties, he painted them as single figures but after 1950 he began to also work with groups of figures.

In 1950 Soyer and ten other representational artists including Edward Hopper, Yasuo Kuniyoshi, Ben Shahn, and Philip EVERGOOD met to discuss the future of realism in art, subsequently publishing *Reality—A Journal of Artists' Opinions*. Soyer has written several autobiographical books, including *Self-Revealment: A Memoir and Diary of an Artist*.

Most major American museums own his work, and he has had retrospective exhibitions at the Whitney Museum of American Art in 1967, the National Collection of Fine Arts in 1977, and the Hirshhorn Museum and Sculpture Garden (Washington D.C.) in 1980. *M.T.S.*

Portrait of a Girl, *1937*

From 1933 to 1940, Soyer frequently used this subject—a woman holding up a slip which touched the edge of her breast—in his prints and paintings. Howard Debree, the art critic of the *New York Times* in reviewing Soyer's exhibition *My Contemporaries and Elders* commented that he would title the show "There's Many a Slip" because most of Soyer's models were wearing just that (Debree, p. 17).

Oil on canvas, 26¼ x 20 in.
(66.7 x 50.8 cm.)
Signed upper right: Raphael Soyer, 1937
Bequest of Hudson Walker from the Ione
and Hudson Walker Collection
78.21.297
Illustration: Figure 129

REFERENCES: Howard Debree, "Raphael
Soyer Paints 23 Artists and Some Hungering
Shop Girls," *Art Digest* (April 1, 1941):17 •
Letter from Raphael Soyer to Paul Yule,
University Gallery, 9 January 1970.

EXHIBITIONS: *Selections from the Permanent
Collection*, 1968, 1969, 1972, 1975 • *The
American Scene: Urban and Rural
Regionalists of the '30s and '40s*, 1967, cat.
53 • *Hudson D. Walker: Patron and Friend*,
1977, cat. 70 • *Contact: American Art and
Culture, 1919-1939*, 1981, cat. 13.

PROVENANCE: Ione and Hudson Walker

Portrait of a Girl, *1937* • *Figure 129*

Portrait of Marsden Hartley, *1940*

Oil on canvas, 18⅛ x 14⅛ in.
(46 x 35.9 cm.)
Signed lower left: Raphael Soyer
Gift of Ione and Hudson Walker
55.1
Illustration: Figure 130

In 1940 Soyer painted portraits of 23 of his fellow artists, among
them Arshile Gorky, Abraham WALKOWITZ, John Sloan, Joseph
Stella, and Marsden HARTLEY. These were shown at the
Associated American Artists exhibition, *My Contemporaries and
Elders*, in 1941. Soyer still vividly recalled Hartley's sitting years
later:

REFERENCES: Walter K. Gutman, *Raphael Soyer: His Paintings and Drawings* (New York: Shorewood Publishing Company, Inc. 1961), 88 • Raphael Soyer, *Self-Revealment: A Memoir* (New York: Maecenas Press, Random House, 1967), 101-102 • Raphael Soyer, *Diary of an Artist* (Washington D.C.: New Republic Books, 1977), 244-245.

EXHIBITIONS: Associated American Artists, New York, *My Contemporaries and Elders*, 1941 • Whitney Museum of American Art, New York, *Raphael Soyer Retrospective*, 1967 • *Selections from the Permanent Collection*, 1968, 1969, 1975 • *Hudson D. Walker: Patron and Friend*, 1977, cat. 71 • *The First Fifty Years, 1934-1984: American Paintings and Sculpture from the University Art Museum Collection*, 1984 • *New York and American Modernism*, 1984.

PROVENANCE: the artist, Ione and Hudson Walker

"'Make my eyes as blue as hell,' Marsden Hartley instructed me emphatically in his quiet voice. Were I painting him today, I would follow his instruction, but I was then, alas, engrossed in naturalistic rendering, and lost emphasis of any kind in the process of many repaintings. His eyes were strikingly blue, and I should have painted them 'blue as hell.' As a matter of fact this portrait, the smaller one of the two that I made of him, was never quite finished. Hartley interrupted it himself. He came one morning, opened up a little newspaper package to disclose two dental plates of upper and lower teeth. [Hartley had traded his painting *Summer Sea Window* for the dentures.] Deftly he set them in his mouth, pointed to the portrait and said, 'Without the teeth my face was like a garbage can. Make a new one of me now, a big one'…. I preferred the small portrait I did of Hartley, with the toothless mouth like a cut in his face, and that was the one I exhibited. Hartley never forgave me. I saw him a few years later at the Rosenberg Gallery where he had his last show. He died soon after. He was then flabby, sleepy-looking, and slow moving. He put his limp hand into mine, looked at me in rebuke, and said in his peculiarly soft manner, 'Why did you exhibit that toothless image of me?'" (Soyer, *Diary of an Artist*, pp. 244-245).

The University Art Museum's portrait is the small, toothless one. Some years after he painted it, Soyer gave it to Hudson Walker, who subsequently gave it to the Museum.

Portrait of Marsden Hartley, *1940 ▪ Figure 130*

CARL SPRINCHORN
1887-1971

SELECTED BIBLIOGRAPHY: Bennard B.
Perlman, *The Immortal Eight: American
Painting from Eakins to the Armory Show
(1870-1913)* (New York: Exposition Press,
1967), passim • Vincent A. Hartgen and
Richard S. Sprague, *Carl Sprinchorn: A
Memorial Exhibition* (Orono, Maine: The
Artists of Maine Gallery, University of
Maine-Orono, 1972) • Sprinchorn Archives,
University Library, University of Maine-
Orono • Mary T. Swanson, "Four Swedish-
American Painters: John F. Carlson, Henry
Mattson, B.J.O. Nordfeldt, and Carl
Sprinchorn," doctoral dissertation,
University of Minnesota, Minneapolis, 1982
• Mary T. Swanson, *The Divided Heart:
Scandinavian Immigrant Artists, 1850-1950*
(Minneapolis: University of Minnesota
Gallery, 1982), 34.

Carl Sprinchorn was a composite of opposites; he was an extremely cosmopolitan man who enjoyed the friendship of Marsden HARTLEY and wealthy patrons in New York during the 1920s, yet who camped for years at a time with lumberjacks or lived in an isolated cabin in the woods of Maine.

Sprinchorn was born in Broby, Sweden, where his father was the keeper of a local manor house which had a collection of seventeenth-century Dutch landscape paintings as well as several works by Rembrandt and David Teniers. Four days after landing in America in 1903, Sprinchorn enrolled in the New York School of Art. Although he spoke only Swedish, he communicated with his teachers William M. Chase and Robert Henri by drawing and by gesture, and Henri, with whom he studied until 1911, became his mentor. When the canvases of Sprinchorn and four of his fellow students were rejected for the annual exhibition of the National Academy of Design in 1907, Henri pulled his paintings out in protest and began making arrangements which culminated in the exhibition of The Eight at the Macbeth Gallery (New York) in 1908.

Sprinchorn taught at the Art League School of Los Angeles from 1912 to 1913 and traveled in Sweden, England, and France from 1914 to 1915. His drawings from this period were fanciful caricatures of opera singers, dancers, and society matrons. When these were shown at the George Hellman Gallery (New York) in 1916, Marsden Hartley attended the opening with Alfred Stieglitz, and a friendship began between the two artists that was to last until Hartley's death in 1943.

From 1920 to 1922 Sprinchorn lived with lumberjacks in the forest near Monson, Maine. No longer influenced by Henri's urban landscapes, his works from this period were based on fantasy, observation, and old postcard views of lumber camps. These were exhibited in Sprinchorn's first successful one-man show at the Worcester Art Gallery in Massachusetts and the Marie Sterner Gallery in New York in 1922. That same year he took over management of the New Gallery (New York) from Marsden Hartley and worked there, often showing his own paintings, until he left in 1925 to spend a year and a half in Santo Domingo.

Sprinchorn spent the early thirties back home in Sweden, caring for his ailing mother and painting watercolor sketches of the fields and woods. He returned to New York and worked on the WPA/FAP for a short time in the mid-thirties, and finally moved to the Maine woods near Patton and then Shinn Pond where he lived from 1936 to 1952. He emerged to show his work sporadically at the Macbeth Gallery (New York) during this period, and his agent, Kathryn Freeman, was able to sell enough of his work to support him. Although his contact with Marsden Hartley after the early thirties was mainly through letters, their friendship remained strong. Sprinchorn arranged for a guide to take Hartley to sketch Mt. Katahdin (Maine) in the late 1930s and tutored Hartley via the mail to improve his figure drawing.

After 1952, when a series of strokes and heart attacks forced him to leave Maine and move into a home near his sister's family in Albany, New York, Sprinchorn continued to paint landscapes and flower still-lifes and wrote essays on contemporary artists. He died in 1971. *M.T.S.*

Three Pink Dahlias, *1943*

Oil on canvas board, 20¼ x 16 in. (51.4 x 40.6 cm.)
Signed verso: Carl Sprinchorn, Three Pink Dahlias, 1943
Bequest of Hudson Walker from the Ione and Hudson Walker Collection
78.21.107
Illustration: Figure 131

EXHIBITIONS: *100 Paintings, Drawings, and Prints from the Ione and Hudson D. Walker Collection*, 1965 • *Hudson D. Walker: Patron and Friend*, 1977, cat. 73 • *The Divided Heart: Scandinavian Immigrant Artists, 1850-1950*, 1982, cat. 62.

PROVENANCE: Ione and Hudson Walker

When Sprinchorn traveled to Santo Domingo in 1925, he was overwhelmed by the beauty of the lush tropical foliage and painted few landscapes but many flower still-lifes during the year and a half he was there. After his return to the East Coast in 1927, he began to paint a succession of flower pieces: flowers in vases, flowers growing wild on the hillside outside his home on Shinn Pond, Maine, and cultivated flowers in his garden in Selkirk, New York.

Like Herman MARIL and other romantic expressionists of the thirties and forties, Sprinchorn alternated flat areas of fluidly applied colors in an attempt to capture the spatial qualities of the blossoms and foliage.

Three Pink Dahlias, *1943* ▪ *Figure 131*

EVERETT FRANKLIN SPRUCE
1908-

SELECTED BIBLIOGRAPHY: Dorothy C. Miller, *Americans 1942—18 Artists from 9 States* (New York: Museum of Modern Art, 1942), 118-122 • John Palmer Leeper, *Everett Spruce* (New York: American Federation of Arts, 1959).

Born in Conway, Arkansas, Spruce was raised on a farm in the Ozarks. He accompanied his father on hunting, fishing, and exploring expeditions through the surrounding countryside and drew whatever he saw. A chance encounter with Olin Travis, a Texas painter trained at the School of the Art Institute of Chicago who had started an art school in Dallas, changed Spruce's life. Travis was impressed by the seventeen-year-old's sketches and encouraged the young Spruce to move to Dallas and study with him.

At the Dallas Art Institute from 1926 to 1929, Spruce was influenced by Travis and two other teachers: Tom Sell who taught Spruce an appreciation for Early Renaissance painters and Harry Carnahan who introduced him to the compositional techniques of Cézanne, Renoir, and Georges Braque. After these first years of training he began to develop his own style. Spruce initially drained color from his palette, limiting it to black, white, and earthen tones to capture the aridity of the western plains. Further influences on his art stemmed from his work at the fledgling Museum of Fine Arts in Dallas where he handled a variety of duties—teaching, curating, hanging exhibitions, writing catalogue copy—before eventually becoming the assistant director.

During the late thirties and early forties, Spruce formed the Dallas School with William Lester, Otis Dozier, Henry Bywaters, and Alexander Hogue. This regionalist group used the Texas iconography of dramatic cactus forms, wide-open prairie spaces, and isolated farm structures for their motifs. Spruce's work, which initially contained a few hard-edged plant forms silhouetted against primitive and barren hills, resembled the eerie and airless scenes of Italian surrealist Giorgio de Chirico. But from this combination of surrealist space and primitive forms in the late thirties, his compositions evolved in the early forties to more painterly and geometricized forms of birds, fish, and rocks. Earthen and chalky colors darkened to spotlight passages of luminous blues, oranges, and reds in works completed in the fifties and sixties, and a network of calligraphic lines activated flat color forms within the canvas.

In 1940 Spruce moved to Austin where he taught at the University of Texas until his retirement. He was the first Texas artist to gain a national reputation and exhibited throughout the country. His art was the subject of a traveling retrospective exhibition arranged by the American Federation of Arts under a Ford Foundation grant in 1959. *M.T.S.*

Pumpkin, *1938*

Oil on tempered masonite, 16 x 20 in. (40.6 x 50.8 cm.)
Signed lower left: E. Spruce
Bequest of Hudson Walker from the Ione and Hudson Walker Collection
78.21.227
Illustration: Appendix

PROVENANCE: Ione and Hudson Walker

Spruce had two one-man exhibitions at the Hudson D. Walker Gallery (New York) between 1938 and 1940. The scene in this painting is similar to those labeled neo-romantic and primitive by critics reviewing the first exhibition. The simplified, hard-edged shapes comprising plants were highlighted with eerie whites and silhouetted against the stage-like backdrops of fertile plains and rocks.

Maguey Plant, *1942*

Oil on gesso panel, 20 x 23¾ in. (50.8 x 60.3 cm.)
Signed lower center: E. Spruce
Gift of Mr. and Mrs. D.S. Defenbacker
54.40
Illustration: Appendix

PROVENANCE: Mr. and Mrs. D.S. Defenbacker

Soon after his move to Austin, Texas in 1940, Spruce abandoned the precise, brushless application of paint he had employed in the late thirties and began to paint more expressionistically, often creating heavily impostoed canvases. It may be that he was influenced by B.J.O. NORDFELDT who was a visiting artist at the University of Texas at Austin from 1941 to 1943. Spruce also reacted directly to the harsh forms of the land he encountered and the vegetation that grew there, such as this maguey plant. By distorting and tilting the rocky plateaus, Spruce was able to convey a sense of spatial tension within a composition which was both carefully planned and decorative.

Night Bird, *1943*

Duco on masonite, 14 7/8 x 18 7/8 in.
(37.8 x 47.9 cm.)
Signed lower right: Everett Spruce; dated
verso
Bequest of Hudson Walker from the Ione
and Hudson Walker Collection
78.21.198
Illustration: Appendix

EXHIBITIONS: *Everett Spruce*, 1950 ▪ Drew
Fine Arts Center, Hamline University, St.
Paul, *Exhibition of Paintings by Some
American Individualists*, 1950 ▪ *Selections
from the Collection of Mr. and Mrs.
Hudson D. Walker*, 1950.

PROVENANCE: Ione and Hudson Walker

After he moved to Austin, Texas, Spruce began to work with oil, gouache, and duco (an automobile lacquer) which he painted onto panels no larger than 20 x 30 inches. He worked on several panels at the same time, structuring his compositions with black lines which he filled in with warm and vigorous browns and reds. Critics referred to him as a Texan Marsden HARTLEY during these years. *Night Bird*, which was painted in this manner, was possibly shown in Spruce's one-man exhibition at the Mortimer Brandt Gallery in New York in 1943.

Fish and Birds, *1944*

Oil on composition board, 16 x 20 in.
(40.5 x 51 cm.)
Signed lower left: E. Spruce
Bequest of Hudson Walker from the Ione
and Hudson Walker Collection
78.21.290
Illustration: Appendix

EXHIBITIONS: Mortimer Levitt Gallery, New
York, *Everett Spruce*, 1945 ▪ *Everett
Spruce*, 1950 ▪ *Selections from the
Collection of Mr. and Mrs. Hudson D.
Walker*, 1950 ▪ Drew Fine Arts Center,
Hamline University, St. Paul, *Exhibition*,
1952 ▪ *Fish Forms in Art*, 1955, cat. 49 ▪
American Federation of Arts Traveling
Exhibition, *Everett Spruce Retrospective*,
1959-1961 ▪ *Selections from the Permanent
Collection*, 1968.

PROVENANCE: Ione and Hudson Walker

By 1945 Spruce's abstract birds were angular and incorporated into equally angular, brooding land and seascapes. *Fish and Birds* was shown at the Mortimer Levitt Gallery (New York) in 1945 in an exhibition in which over half of the works had birds as their main design motif.

HARRY STERNBERG

1904-

SELECTED BIBLIOGRAPHY: Carl Zigrosser, "Harry Sternberg," *The Artist in America* (New York: Alfred A. Knopf, 1942), 62-69 • *Harry Sternberg* (New York: ACA Gallery, 1971) • James C. Moore, *Harry Sternberg: A Catalogue Raisonné of His Graphic Work* (Wichita, Kansas: Edwin A. Ulrich Museum of Art, Wichita State University, 1975).

When the artist Mervin JULES painted Harry Sternberg's portrait in 1945, he placed him in front of a small canvas crowded with slum inhabitants. This image typified Sternberg, who remained sympathetic to the underdog throughout his artistic career. He was born into an extremely poor Austro-Hungarian immigrant family which lived on the lower East Side of New York City. His father worked several jobs in order to support his family and allow his son Harry to finish high school. After graduation Sternberg helped out by working at construction jobs and studied evenings at the Art Students League with Harry Wickey.

In 1927 Sternberg began to experiment with etching techniques and started to paint oils which he grouped into thematic series. Series completed during the 1930s—*Circus Group*, *Streets and Subways of New York*, *Principles*, *Musical Instruments*, and *Construction*—contained overt criticism of the relationships of individuals and groups to social and governmental agencies.

Sternberg was awarded a Guggenheim Foundation fellowship for the summer of 1936 to study the coal and steel industry. Taking his paper, pencils, and charcoal into the coal towns of Pennsylvania and a thousand feet down into the mines, he recorded the "faces with strange deep blue marks pitted in the skin…men with fingers missing…women with gaunt tired faces, thin barefooted children in overalls…. Rembrandtesque, black and white, abstract patterns of tunnel shapes, a thousand cubistic forms in the walls of black blasted coal…. It seemed all there, ready made, waiting for canvas and brush to record. Later I came to see that there was richer material for pictures…beneath the surface drama" (Zigrosser, pp. 67-68).

Because Sternberg taught lithography and etching at the Art Students League, he was not eligible to work on the WPA/FAP programs but served as an advisor to the WPA Graphics Division. He also painted murals for post offices in Sellersville and Chester, Pennsylvania, and for the Lakeview branch in Chicago. Along with other artists in the Graphics Division, he furthered the development of the silkscreen process so that it could be used as a fine arts medium.

Sternberg taught regularly at the Art Students League from 1933 to 1968 and also taught summers or for short periods at the Museum of Modern Art (1944-1948), the Idyllwild School of Music and the Arts in Idyllwild, California (1957-1968), the Country Art School, Long Island (1953-1957), and the New School for Social Research (1950-1951). He has had numerous one-man shows at the ACA Galleries in New York since 1947 and in 1960 was the subject of a traveling retrospective exhibition by the American Federation of the Arts under a Ford Foundation grant. *M.T.S.*

War, *c. 1938*

Oil on canvas, 28 x 14 in.
(71.1 x 35.6 cm.)
Signed lower right: Sternberg
Bequest of Hudson Walker from the Ione and Hudson Walker Collection
78.21.196
Illustration: Appendix

PROVENANCE: Ione and Hudson Walker

Sternberg, who abhorred war, often depicted it metaphorically as an armored knight, oblivious to the waste of life and beauty surrounding him. The painting is similar to Sternberg's serigraph *Child and War* of 1938 in which an infant is shown being held on the shoulders of an armor-clad warrior.

Insecurity—Learning, *c. 1943*

Oil on canvas, 28 x 12 in.
(71.2 x 35.6 cm.)
Signed lower right: Sternberg
Bequest of Hudson Walker from the Ione and Hudson Walker Collection
78.21.33
Illustration: Figure 132

REFERENCE: Letter from Harry Sternberg to Mark Kriss at the University Gallery, 24 November 1978.

EXHIBITIONS: *Selections from the Collection of Mr. and Mrs. Hudson D. Walker*, 1950 • Drew Fine Arts Center, Hamline University, St. Paul, *Exhibition*, 1952.

PROVENANCE: Ione and Hudson Walker

Hudson Walker, who originally owned this canvas, met Harry Sternberg in the fall of 1931 and actively corresponded with him for the next five years. When Walker opened his gallery in 1936, he and his wife, Ione, began to collect Sternberg's paintings, etchings, and lithographs. The artist wrote that his inspiration for *Insecurity—Learning* evolved out of his friendship with the Walkers: "At that time I was painting a portrait of Mrs. Hudson Walker, and the radio was giving out horror stories about the war. Mrs. Walker was quite pregnant, and my thoughts turned to the world that the next generation would face; hence this painting in the museum collection was born" (Sternberg to Kriss, 24 November 1978).

Insecurity—Learning, *c. 1943 ▪ Figure 132*

JEROME B. THOMPSON
1814-1886

SELECTED BIBLIOGRAPHY: Henry T. Tuckerman, *Book of the Artists* (New York, 1867, rpt. New York: James F. Carr, 1966), 490-491 • *M. and M. Karolik Collection of American Paintings, 1815-1865* (Cambridge: Harvard University Press, 1949), 492 • E. P. Richardson, *Painting in America, The Story of 450 Years* (New York: Thomas Crowell, 1956), 175 • George C. Groce and David H. Wallace, *The New York Historical Society's Dictionary of Artists in America, 1564-1860* (New Haven: Yale University Press, 1957), 626.

Jerome B. Thompson was the son of one artist, Cephas B. Thompson, and the brother of two others, Cephas Giovanni Thompson and Marietta Thompson—all of whom were portrait painters though Marietta specialized in miniatures. Jerome was born in Middleborough, Massachusetts, and, like his brother and sister, painted in Massachusetts, Rhode Island, and New York. In 1851 he became an associate of the National Academy of Design and in 1852 he went to Europe to study, apparently receiving a number of important portrait commissions in England.

Shortly after his return to the United States, he undertook the first of several trips to the West. While many artists traveled to the Minnesota Territory in search of adventure and novel subject matter, Thompson came as a homesteader, staking out a claim near Lake Crystal before the Civil War. He is known to have been in Minnesota intermittently from the late 1850s to the 1860s, at the same time that he maintained a studio in New York and a home at Mineola, Long Island. In the early 1860s Thompson exhibited *Prairie on Fire* and *Home in the West* at the National Academy of Design, followed by a canvas entitled *Dakota Cañon*, exhibited in 1880. *R.N.C.*

Minnehaha Falls, *1870*

Oil on canvas, 24 x 18 in.
(61 x 45.7 cm.)
Signed lower left: Jerome Thompson 1870
Gift of Daniel S. Feidt
73.8.1
Illustration: Figure 133

REFERENCE: Rena Coen, *Painting and Sculpture in Minnesota, 1820-1914* (Minneapolis: University of Minnesota Press, 1976), 40 • Lee M. Edwards, "New Discoveries in American Art: Early Jerome Thompson Genre Painting," *The American Art Journal* 14:2 (Spring, 1982):72-73 • Lee M. Edwards, "The Life and Career of Jerome Thompson," *The American Art Journal* 14:4 (Autumn, 1982):4-30.

Thompson, like so many of his contemporaries, may have been attracted to the Minnesota and Dakota territories by the romantic legends of the Indians popularized by Henry Wadsworth Longfellow. While in this area he painted such subjects as *Hiawatha's Journey* and *The Voice of the Great Spirit*, as well as the University Art Museum's *Minnehaha Falls*.

The falls of Minnehaha were, in fact, a popular tourist attraction in the second half of the nineteenth century and were recorded by many artists. Thompson's portrayal of this Minnesota landmark is unlike his usual landscapes in its emphasis on an uninhabited wilderness setting. The painterly style is also uncharacteristic of the artist and may represent the influence of John Constable, whose work Thompson had admired while in England. His fascination with the glint of bright sunlight on water, rocks, and foliage, expressed through dabs of pure color highlighted with white is

EXHIBITIONS: *Selections from the Permanent Collection*, 1975, 1980 • *A Bicentennial Exhibition of Art and Architecture in Minnesota*, 1976 • The St. Paul Companies, Inc., St Paul, Minnesota (organized by Art Acquisitions, Inc.), *The Mighty Mississippi*, 1983.

PROVENANCE: Kennedy Galleries, New York; Daniel S. Feidt

more evident in the sparkling waters of Minnehaha Falls than it is in the artist's more precisely detailed genre pictures, making this painting doubly interesting in the context of his complete oeuvre.

Minnehaha Falls, *1870 • Figure 133*

JENNINGS TOFEL
1891-1959

SELECTED BIBLIOGRAPHY: Eli Cantor, "An Appreciation of Jennings Tofel: A Critique and a Personal Statement," *Gallery* (December 1950):8-9 • Arthur Granick, *Jennings Tofel* (New York: Harry N. Abrams, 1976).

When Yehudah Toflevich arrived in New York from Polish Russia in 1905, his name was anglicized to Jennings Tofel. He attended high school in New York and was accepted into City College in 1910; it was here that he began to paint. In 1917 Tofel exhibited for the first time in a group show called *Introspective Art* at the Whitney Studio Club, and it was readily apparent that his personal and idiosyncratic style grew out of his emotional experiences.

In 1919 Tofel had his first one-man exhibition at the Bourgeois Gallery. At this time he became acquainted with Benjamin KOPMAN, with whom he occasionally shared a studio, and Alfred Stieglitz, who was to serve as his champion. With Stieglitz's aid, Tofel was able to go to Paris in the mid-1920s. When he ran out of money and was forced to return to New York, Stieglitz secured funds from donors to send him back to Europe.

In 1929 Tofel married Pearl Weissberg from his native village. They remained in Paris during the first years of the Depression, and there Tofel turned to the biblical themes he continued to explore throughout his career. In 1930 Tofel and his wife returned to the United States. Although he went to work for the WPA in 1934, his intensely personal style did not conform to the realist aesthetic of the projects, and he was constantly asked to modify his works. In 1943, however, well-known collector Joseph Hirshhorn purchased 20 of Tofel's works. *P.N.*

Landscape, No. 1, *c. 1915-1920*

Oil on canvas, 10 x 11⅛ in.
(25.4 x 28.3 cm.)
Signed lower right: Tofel
Gift of Ione and Hudson Walker
53.303
Illustration: Appendix

PROVENANCE: Alfred Stieglitz; Ione and Hudson Walker

Its pale tonalities and its numerical designation, "No. 1," place this landscape early in Tofel's career. The vantage point—a view across rooftops to a row of distant hills—and the muted green tones are reminiscent of Cézanne's studies of southern France. As a study of volumes, the composition balances the deserted architectural foreground against the hills rising in the background. The only indication of human presence is the point of view. Although this calm landscape study barely hints at Tofel's later artistic direction, it is solid evidence of his awareness of modernist modes of pictorial expression. The painting bears the stamp of Alfred Stieglitz and was probably acquired by the dealer early in Tofel's career.

Painting No. 2, Musicians, *c. 1915-1920*

Oil on canvas, 28⅝ x 36¼ in.
(72.7 x 92.1 cm.)
Unsigned
Gift of Ione and Hudson Walker
53.311
Illustration: Appendix

PROVENANCE: Alfred Stieglitz; Ione and Hudson Walker

Painting No. 2, Musicians must also be placed early in Tofel's career due to the "2" in its title, though the highly keyed palette, rugged paint surface, and primitively rendered figures bear the hallmarks of his fully developed style. Like *Landscape No. 1*, this work bears the Stieglitz stamp and, judging from a label affixed to the verso, was at one time exhibited at the Philadelphia Museum of Art.

DWIGHT WILLIAM TRYON
1849-1925

SELECTED BIBLIOGRAPHY: Charles H. Caffin, *The Art of Dwight W. Tryon: An Appreciation* (New York, 1909) ▪ Henry C. White, *The Life and Art of Dwight Tryon* (Boston: Houghton Mifflin Co., 1930) ▪ *Dwight W. Tryon: A Retrospective Exhibition* (Storrs: University of Connecticut Museum of Art, 1971) ▪ Mary Ellen Hayward, "The Influence of the Classical Oriental Tradition on American Painting," *Winterthur Portfolio* (Summer, 1979):107-142 ▪ Nicholas Clark, "Charles Lang Freer: An American Aesthete in the Gilded Era," *American Art Journal* (October, 1979):54-68 ▪ Wanda Corn, *The Color of Mood, American Tonalism* (San Francisco: M. H. DeYoung Memorial Museum, 1972), passim.

Like many of his contemporaries, Tryon was strongly influenced by the French Barbizon masters, having worked briefly with Charles François Daubigny and Henri Joseph Harpignies. Tryon was largely self-taught, however, when, in 1873, he opened a studio in his native city of Hartford, Connecticut. Three years later he sailed for Paris where he studied with Jacquesson de la Chevreuse and at the Ecole des Beaux-Arts. From 1877 to 1881, his summers were spent sketching and painting in Brittany (France), Venice, and Dordrecht (Holland). In 1881 he returned to the United States where he established a studio in New York.

Around 1885 Tryon began experimenting with a tonalist style, restricting his palette to deep toned color harmonies of browns, blues, and greens. Each picture was composed of only two or three basic hues, creating a mood which was mysterious and spiritual. Tryon was a lifelong admirer of Ralph Waldo Emerson and Henry David Thoreau, and his use of a tonalist vocabulary may have been his expression of the transcendent spirit in nature.

Most of Tryon's life was spent at Northampton, Massachusetts, where he taught art at Smith College from 1885 to 1923. In 1891 he was elected an associate of the National Academy of Design. Throughout his career, the patronage of Washington collector Charles L. Freer provided him with support and encouragement. Not surprisingly, the two main repositories of Tryon's work are the Smith College Museum of Art and the Freer Gallery in Washington, D.C. *R.N.C*

Moonlight, *c. 1890-1900*

Oil on canvas, 14⅛ x 20⅛ in.
(35.9 x 51.1 cm.)
Signed lower left: D. W. Tryon
Gift of Dr. H. Lynn Ault
81.15
Illustration: Figure 134

EXHIBITIONS: ▪ *The First Fifty Years, 1934-1984: American Paintings and Sculpture from the University Art Museum Collection,* 1984 ▪ *The First Fifty Years, 1934-1984: Recent Acquisitions and Promised Gifts to the University Art Museum Collection,* 1984.

PROVENANCE: Dr. H. Lynn Ault

This small, moonlit landscape is typical both of Tryon's work and of late nineteenth-century American tonalism. Avoiding the precise and concrete, this deeply personal interpretation of nature uses delicate lights and shadows to replace solid form and substance. Under the pale glow of a summer moon, the pond, meadow, trees, and sky are only vaguely suggested, evoking a mood of nostalgia, reverie, and quiet poetry.

Moonlight, *c. 1890-1900* ▪ *Figure 134*

NAHUM TSCHACBASOV

1899-

SELECTED BIBLIOGRAPHY: "The Liberation of Nahum Tschacbasov," *Art News* (March, 1945):1-14 • Don L. Goddard, *Tschacbasov* (New York: American Archive of World Art, 1964) • Francis V. O'Conner, ed., *The New Deal Art Projects: An Anthology of Memoirs* (Washington D.C.: Smithsonian Institution Press, 1972), 122,124-126.

Oil on masonite, 20 x 23⅞ in.
(50.8 x 60.6 cm.)
Signed upper right: Tschacbasov 46
Bequest of Hudson Walker from the Ione and Hudson Walker Collection
78.21.32
Illustration: Figure 135

Nahum Tschacbasov did not produce his first painting until 1930. Born in Baku, Russia, he lived in Chicago from 1907 to 1930 and pursued a business career as an accountant and efficiency expert. Following a brief period of study at the Art Institute of Chicago, he went to Paris in 1932 and two years later was given his first one-man show at the Galerie Zak (Paris). Returning to New York, he gained recognition as one of the original members of the Ten Whitney Dissenters, although he exhibited with his fellow independents only twice before leaving the group. An instructor at the Art Students League and the American Artists School, he eventually established the Tschacbasov School of Fine Arts in New York. Influenced by cubism, German expressionism, and Byzantine art, Tschacbasov developed his own unique style of expressionism. *P.N.*

Flying Fish, *1946*

The curious, predatory fish in Tschacbasov's painting illustrate his surreal, often horrific, imagery. These monstrous fish are out of scale in relation to the tiny ship, and the normally harmless sea creatures have been transformed into rampaging, ragged-toothed beasts, symbolizing the potential menace inherent in all living things. Horror and humor are intermingled, however, for the gaping jaws merely grasp air, and the fish out of water appear to be gasping for breath. The heavily painted, expressive forms and dark but luminous colors are typical of Tschacbasov's style of this period.

EXHIBITIONS: Drew Fine Arts Center, Hamline University, St. Paul, *Exhibition of Paintings of Some American Individualists*, 1950 • *Selections from the Collection of Mr. and Mrs. Hudson D. Walker*, 1950 • The St. Paul Gallery and School of Art, *Exhibition*, 1951 • *Fish Forms in Art*, 1955, cat. 46 • Minnesota State Fair, St. Paul, *American Art of the Twentieth Century from the Collection of the University of Minnesota*, 1957 • *Selections from the Permanent Collection*, 1957 • *Selected Works from the Collection of Ione and Hudson Walker*, 1959 • *One Hundred Paintings, Drawings, and Prints from the Ione and Hudson D. Walker Collection*, 1965, cat. 97 • Red River Art Center, Moorhead, Minnesota, *Inaugural Exhibition*, 1966 • *Abstract USA/1910-1950*, 1981

PROVENANCE: Perls Gallery, New York; Ione and Hudson Walker

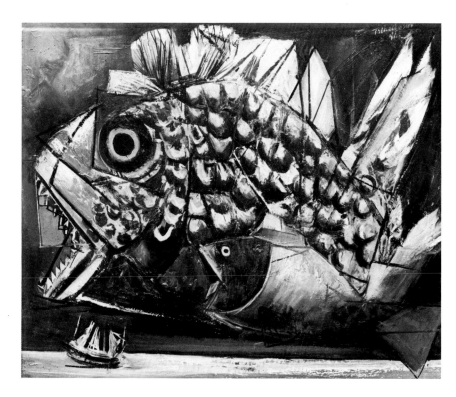

Flying Fish, *1946* • *Figure 135*

STUYVESANT VAN VEEN
1910-

SELECTED BIBLIOGRAPHY: "The Watercolors of Mural Painter, Stuyvesant Van Veen," *Art News* (October 8, 1938):12 • *Stuyvesant Van Veen, 50 Year Retrospective* (Fair Lawn, New Jersey: Maurice M. Pine Free Public Library, 1978) • Letter from Stuyvesant Van Veen to Mark Kriss at the University Gallery, 15 November 1978 • Archives of American Art, 1972, microfilms 922-924, 621.

Born in New York, Stuyvesant Van Veen has spent his entire life in an urban environment, and it has served as the inspiration for his works. He attended the Pennsylvania Academy of the Fine Arts in Philadelphia from 1927 to 1929, then studied at the National Academy of Design, the Art Students League under Thomas Hart Benton, and the College of the City of New York, where he later taught from 1949 until his retirement in 1975.

During the Depression Van Veen worked briefly on both the PWAP and the WPA/FAP programs and in 1937 won a competition sponsored by the Section of Fine Arts of the Treasury Department to decorate the newly constructed Pittsburgh Post Office-Court House. He executed the mural, *Pittsburgh Panorama*, for the post office and subsequently painted the murals *Security* and *Synthesis* for the federal courtrooms in the Philadelphia Municipal Court Building, *The Story of Pharmacy* for the 1939 World's Fair, and *Music in New York* for the Queens Public Library. He has received over 30 private mural commissions throughout the United States since then and was active for many years in the National Society of Mural Painters.

From 1935 to 1937 Van Veen also worked for Columbia University anthropology professor Franz Boas, completing 8,000 drawings for a project on the motor habits, gestures, and mannerisms of ethnic groups. This study was originally published in 1941 under the title *Gesture and Environment*.

Hudson Walker met Van Veen by chance on a train in the late twenties when Walker was still a student, and they remained friends through the years. Walker gave the artist his first one-man show at the Hudson D. Walker Gallery (New York) in 1938. Night scenes of dramatically lit factories and city streets swirling with rhythms characterized the paintings in that exhibition.

Van Veen continued to use the city's physical and psychological surroundings as themes in subsequent exhibitions. In 1956 he did a series of drawings and gouache paintings of the Third Avenue El (elevated train). The physical and mental indignities of old age were subjects for paintings exhibited at the ACA Gallery in 1968 under the title *Winter's Garden*. Later allegorical drawings and paintings dealt with the torture inflicted by human beings on each other. Usually placed within an urban setting, the content of these works was mysterious and often surrealistic in the juxtaposition of maimed figures against institutional or landscape backdrops.

Van Veen has exhibited his paintings in group exhibitions at most of the major American galleries. He won the Childe Hassam Purchase Award at the American Academy of Arts and Letters in 1961 and the Nelson Whitehead Prize at the American Society of Contemporary Artists exhibition in 1966. *M.T.S.*

The Kid in the Studio, *c. 1926*

Oil on canvas board, 23⅞ x 18 in.
(60.6 x 45.7 cm.)
Signed lower left: Stuyvesant van Veen
Bequest of Hudson Walker from the Ione
and Hudson Walker Collection
78.21.816
Illustration: Appendix

REFERENCES: Letter from Stuyvesant Van
Veen to Mark Kriss at the University
Gallery, 15 November 1978 ▪ Archives of
American Art, microfilm 621.

EXHIBITION: The Art Institute of Chicago,
*44th Annual Exhibition of American
Paintings and Sculpture*, 1931.

PROVENANCE: Ione and Hudson Walker

Van Veen remembers that *The Kid in the Studio* was painted about 1926 (Van Veen to Kriss, 15 November 1978), a date borne out by similar sketches from Van Veen's notebooks of that year. In these drawings a series of staccatolike pencil lines illustrates both skin and clothing. This technique is echoed in Van Veen's use of short, nervous brushstrokes throughout the composition of this work. In addition, sketches from the late twenties and early thirties often showed a single figure silhouetted against an interior or a landscape.

Hannah (also called *Mood*), *c. 1930-1933*

Oil on canvas, 16 x 20 in.
(40.6 x 50.8 cm.)
Signed lower right: Stuyvesant Van Veen 32
[or 33]
Bequest of Hudson Walker from the Ione
and Hudson Walker Collection
78.21.134
Illustration: Appendix

REFERENCES: Letter from Stuyvesant Van
Veen to Mark Kriss at the University
Gallery, 15 November 1978 ▪ Archives of
American Art, microfilm 621.

PROVENANCE: Ione and Hudson Walker

In the late twenties and early thirties, Van Veen's sketchbooks were filled with renderings of men and women drawn from the shoulders up. Because of their candid expressions, it is possible that Van Veen drew them while commuting on a bus or subway. The figure of Hannah is related to these sketches, but the low mountains and planes are closer to drawings of the landscape Van Veen made on a trip to Cuba in 1932.

JOSEPH VAVAK
1899-

SELECTED BIBLIOGRAPHY: *Chicago Art Institute Scrapbook*, Ryerson and Burnham Libraries 69 (August 1936-February 1937): 133,165 • "Reviews," *Art Digest* (October 1, 1942):17.

Joseph Vavak was a gentle critic of American social institutions during the Depression. Born in Vienna, Austria, he studied at the School of the Art Institute of Chicago, the Art Students League in New York, and in Andre L'Hôte's studio in Paris. Vavak enrolled in the WPA/FAP easel project while living in the Chicago area in the thirties, and his watercolor, *The Dispossessed*, was shown in the WPA/FAP exhibition *New Horizons in American Art* at the Museum of Modern Art in 1936. Chicago critics wrote that it was the most startling work done by an Illinois artist in that exhibition (*Chicago Art Institute Scrapbook*, pp. 133,165). *Women of Flint*, another of Vavak's subtle commentaries on American life during the Depression, was shown in the 1937 exhibition of Chicago area WPA/FAP painters. Described by a contemporary reviewer as a timely commentary on unemployment, the painting actually depicted the women's picket line in the 1937 strike against General Motors in Flint, Michigan. *M.T.S.*

Oil on canvas, 30 x 36⅛ in.
(76.2 x 91.8 cm.)
Signed upper right: Vavak '39
WPA Art Project, Washington, D.C.
43.715
Illustration: Appendix

PROVENANCE: WPA Art Project, Washington D.C.

Chicago Landscape, *1939*

#5966, *1941*

Oil on canvas, 40 x 30 in.
(101.6 x 76.2 cm.)
Signed lower center: Vavak - '41
WPA Art Project, Washington, D.C.
43.716
Illustration: Appendix

PROVENANCE: WPA Art Project, Washington D.C.

Vavak lived in Chicago during the 1930s and 1940s, showing in many local exhibitions. Not only did he choose poignant scenes to illustrate the lives of the city's poor, but he also used mildly humorous images to describe their urban environments. In *#5966*, an assembly line of the defense industry is incongruously intertwined with several mammoth hands, which seem to impede its operation.

466

ABRAHAM WALKOWITZ
1880-1965

SELECTED BIBLIOGRAPHY: Martica Sawin, "Abraham Walkowitz, The Years at '291': 1912-1917," master's thesis (New York: Columbia University, 1967) • Bartlett Cowdrey and Abram Lerner, " A Tape Recorded Interview with Abraham Walkowitz," *Archives of American Art Journal* (January, 1969):10-16 • Abraham Walkowitz, The Early Years: 1895-1925 (New York: Zabriskie Gallery, 1973) • William I. Homer, *Alfred Stieglitz and the American Avant-Garde* (Boston: New York Graphic Society, 1977), 138-146, 215-220 • Dale Leibson Mintz, *Abraham Walkowitz: New York Cityscapes* (Purchase, New York: Neuberger Museum, 1982) • Kent Smith, *Abraham Walkowitz: Figuration 1895-1945* (Long Beach, California: Long Beach Museum of Art, 1983).

Born in Tyumen, Siberia of Jewish heritage, Abraham Walkowitz settled on Manhattan's Lower East Side with his family at the age of nine. Nothing in Walkowitz's heritage would have suggested or encouraged him to become an artist, but he was determined to do so, attending public school during the day while taking evening art classes at the Educational Alliance Art School. He also studied at the Art Students League before departing for Paris in 1906. At the traditional Académie Julian in Paris, Walkowitz met Max WEBER whose cultural background was like his and who shared his enthusiasm for European modernism. The two young Americans, eager to experiment, turned to painting in a mode inspired by Henri Matisse's fauvism. Walkowitz and Weber, however, were subsequently to move on through a wide variety of artistic styles.

Walkowitz traveled to the major European art centers before returning to New York City in 1907 where he tried in vain to find a gallery that would exhibit his work. In despair Walkowitz turned to his friend Julius G. Haas, a picture framer. Haas gave Walkowitz his first one-man show in 1908, and the following year Walkowitz convinced Haas to do the same for the recently returned Weber. Early in 1912 Walkowitz was introduced to Alfred Stieglitz by Marsden HARTLEY, and the two became close friends. Stieglitz arranged three one-man exhibitions for Walkowitz at his 291 gallery, beginning in 1912. Active in New York art circles, Walkowitz participated in the 1913 Armory Show, the 1916 Forum Exhibition, and the 1917 Society of Independent Artists Exhibition.

In 1917 Walkowitz ended his association with Stieglitz. The basis of their disagreement is not known, but the break was detrimental to Walkowitz's career. His opportunities to exhibit were sharply diminished, affecting both his morale and his reputation. He did become the director and then vice president of the Society of Independent Artists, and in 1920 he joined the Société Anonyme. But in 1929 he was forced to move into his niece's home and remained there until his death in 1965. During the late 1930s he produced political cartoons for the leftist magazine *The Masses*.

Walkowitz was one of the first American artists to appreciate the simplicity and directness of the art of children, and he strove to achieve a childlike spontaneity and freshness of vision in his personal style. During the second decade of the century Walkowitz developed an interest in the spatial effects of cubism. His paintings of New York City reveal his attempts to reorder cubist structure and mass and to give it a greater sense of dynamism. Walkowitz's life passion, however, was to recreate the rhythmic movements of the innovative American dancer Isadora Duncan, whom he had first seen dance at a private salon in 1907. He produced thousands of drawings of her, and his work is a tribute to their mutual desire to free the human spirit from the bonds of convention. *P.N.*

Battery Park, *1895*

Oil on canvas, 14 x 35½ in.
(35.6 x 90.2 cm.)
Signed lower left: Battery Park 1895 by A. Walkowitz; 1895 A. Walkowitz
Purchase, Nordfeldt Fund for Acquisition of Works of Art
68.37
Illustration: Appendix

EXHIBITIONS: Jewish Community Center of Greater Minneapolis, *Exhibition*, 1969 • Utah Museum of Fine Arts, University of Utah, Salt Lake City and Edwin A. Ulrich Museum of Art, Wichita State University, Wichita, Kansas, *Abraham Walkowitz Retrospective Exhibition*, 1974, cat. 4 • Gallery 101, University of Wisconsin, River Falls, *The American Progression: The 1830s to the 1950s*, 1978 • *Selections from the Permanent Collection*, 1980 • Minnesota Museum of Art, Landmark Center, St. Paul, *American Style: Early Modernist Works in Minnesota Collections*, 1981, cat. 77.

PROVENANCE: Zabriskie Gallery, New York

By the time Walkowitz was fifteen years old, he had achieved sophistication as a painter of romantic landscapes, as evidenced by this scene of *Battery Park*, a place near his home on the Lower East Side. The park and the East River were frequent subjects in a series of misty landscapes produced by the artist prior to 1898. Walkowitz's earliest paintings incorporated the melancholy mood, limited tonal harmonies, and soft focus popular at the end of the nineteenth century. An admiration for the stylistic mannerisms of James Abbott McNeill Whistler can be seen in the simplification of the foggy harbor scene to a monochromatic gray blanket of mist and in the use of musically descriptive titles in other works of the series.

A Bit of Venice, *1907*

Oil on canvas, 16 x 21½ in.
(40.6 x 54.6 cm.)
Signed lower left: A. Walkowitz
Bequest of Hudson Walker from the Ione
and Hudson Walker Collection
78.21.60
Illustration: Figure 136

EXHIBITIONS: Armory, New York,
International Exhibition of Modern Art,
1913 ▪ Drew Fine Arts Center, Hamline
University, St. Paul, *Exhibition*, 1952 ▪
Tweed Gallery, University of Minnesota-
Duluth, *A Survey of American Art*, 1955 ▪
AFA Traveling Exhibition, *Pioneers of
American Abstract Art*, 1955-1956 ▪
Munson-Williams-Proctor Institute, Utica,
New York, *Armory Show—50th
Anniversary Exhibition*, 1963 ▪ *100
Paintings, Drawings, and Prints from the
Ione and Hudson D. Walker Collection*,
1965, cat. 98 ▪ *Selections from the
Permanent Collection*, 1975, 1980 ▪ *Hudson
D. Walker: Patron and Friend*, 1977, cat.
75.

PROVENANCE: Alfred Stieglitz; Ione and
Hudson Walker

Walkowitz visited Italy in the spring of 1907, traveling to Florence and then to Venice where he was joined by Max Weber. *A Bit of Venice* typifies Walkowitz's interest in Italian scenes as subjects for his paintings as well as his monotype prints. His provocative new style, consisting of thin washes of arbitrary color emphasizing the effects of light on the flat, rectilinear walls of the buildings, utilized techniques gleaned from Henri Matisse in Paris. Carefully framed and almost claustrophobic in its sense of space, the painting suggests a photographic view of Venice and, in this sense, contrasts with the artist's increasingly modernist application of paint and the elimination of details. Interestingly enough, there is no indication of the picturesque canals for which Venice is so famous. Although freer in technique than his American landscapes, *A Bit of Venice* still includes a typically American narrative element in the placement of a small female figure as a focal point against the blank walls of the building. The verso of the painting bears the Stieglitz stamp, indicating that it was once in the possession of the collector.

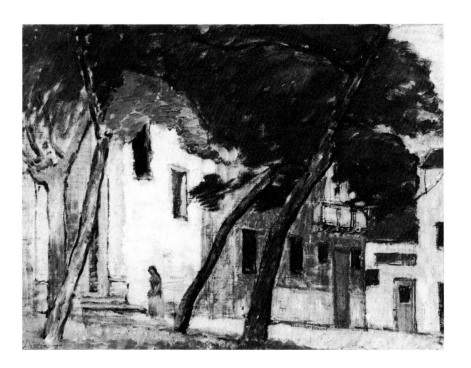

A Bit of Venice, 1907 ▪ *Figure 136*

469

Boats, *c. 1913*

Oil on composition board, 10 x 12 in.
(25.4 x 30.5 cm.)
Signed lower right: A. Walkowitz; verso:
Congratulations for a happy birthday A.
Walkowitz, [second line] Kitty Stieglitz
September 27-1913
Bequest of Hudson Walker from the Ione
and Hudson Walker Collection
78.21.39
Illustration: Appendix

EXHIBITIONS: AFA Traveling Exhibition,
Pioneers of American Abstract Art, 1955-
1956 ▪ Jewish Community Center of
Greater Minneapolis, *Exhibition*, 1969 ▪
Selections from the Permanent Collection,
1969, 1980 ▪ *Hudson D. Walker: Patron
and Friend*, 1977, cat. 76 ▪ *Early
Modernism in America: The Stieglitz Circle*,
1983.

PROVENANCE: Alfred Stieglitz; Ione and
Hudson Walker

The small painting *Boats* is inscribed on the reverse as a birthday present to Alfred Stieglitz's young daughter Kitty with the date of "September 27-1913." The frame of the painting also bears the Stieglitz stamp, indicating that it was once a part of the Stieglitz collection. The simplified forms of the seascape and joyful luminous color reflect a childlike spontaneity suitable to a young girl's fantasies. The boat, imaginatively rendered in carnival colors, related more to Walkowitz's earlier fauve period than to the color abstractions and city scenes that he was painting in 1913. The tiny format, arbitrary color, sun-drenched landscape, and heavy paint application suggest that *Boats* may have been painted by Walkowitz at an earlier date and merely inscribed to Kitty Stieglitz in 1913.

WILLIAM WALTEMATH
1877-death date unknown

SELECTED BIBLIOGRAPHY: "He Worked at
Night," *Art Digest* 11 (January 15,
1937):12 ▪ "Reviews," *Art News* 35
(January 30, 1937):16.

William Waltemath was 60 years old and a printer by trade when he had his first one-man exhibition at the Hudson D. Walker Gallery in 1937. By the time he was 18, he was working as a printer but spent his spare time learning to paint. When the printing business failed, he came to New York, found a part-time job, and studied with William M. Chase and Robert Henri.

None of Waltemath's earlier canvases have survived because, as soon as a painting was finished, he would paint over it to save the expense of buying new canvas. When Hudson Walker became his dealer, Walker would quickly take the freshly painted canvases to his gallery before Waltemath could use them again. A critic commented on Waltemath's perseverance after seeing his exhibition

in 1937: "For years this determined painter accepted only night jobs in order to have the daylight hours for painting. Sundays in the summer he would take a 3 a.m. train out of town, usually reaching his destination about 6. He then slept until 11 and painted until the light failed. On Monday he took the noon train back to New York, spent the rest of the day at art exhibitions then returned to his night work" (*Art Digest*, p.12). *M.T.S.*

The two men in *Bill Gilbert* and *My Neighbor* appear to be related or possibly are the same man. Waltemath's facile brushstrokes show a possible technical influence from Robert Henri, while *Vegetables* is painted in an impressionistic style. The *Nude* is probably a studio study. Its broadly painted forms, barely faceted into geometric shapes, seem to be derived from Henri's admonition to paint the gesture of a figure, not the exact pose.

Oil on gesso panel, 20 x 16 in.
(50.9 x 40.7 cm.)
Unsigned
Gift of Ione and Hudson D. Walker
78.21.316
Illustration: Appendix

PROVENANCE: Ione and Hudson Walker

Bill Gilbert, *c. 1938-1940*

Oil on gesso panel, 16⅛ x 12 in.
(41 x 30.5 cm.)
Signed lower right: Waltemath
Gift of Ione and Hudson D. Walker
78.21.319
Illustration: Appendix

PROVENANCE: Ione and Hudson Walker

My Neighbor, *c. 1938-1940*

Oil on canvas board, 27¼ x 22 in.
(70.6 x 56 cm.)
Signed lower left: Waltemath
Gift of Ione and Hudson D. Walker
78.21.311
Illustration: Appendix

PROVENANCE: Ione and Hudson Walker

Nude, *c. 1938-1940*

Oil on panel, 14 x 18 in.
(35.6 x 45.8 cm.)
Signed lower right: Waltemath
Gift of Ione and Hudson D. Walker
78.21.326
Illustration: Appendix

PROVENANCE: Ione and Hudson Walker

Vegetables, *c. 1938-1940*

MAX WEBER
1881-1961

SELECTED BIBLIOGRAPHY: Lloyd Goodrich, *Max Weber: Retrospective Exhibition* (New York: Whitney Museum of Art, 1949) ▪ William Gerdts, *Max Weber* (Newark: Newark Museum, 1959) ▪ Ala Story, *Max Weber* (Santa Barbara: The Art Galleries of the University of California, 1968) ▪ Alfred Werner, *Max Weber* (New York: Harry N. Abrams, Inc., 1975) ▪ Percy North, *Max Weber: American Modern* (New York: The Jewish Museum, 1982).

Max Weber is recognized as one of the most innovative and accomplished artists of the first generation of American modernists. Born in Bialystok in Russian Poland, he was brought to New York City when he was ten years old. Although Weber was raised in an orthodox Jewish household where images of any sort were forbidden, he decided at an early age that he wanted to become an artist. He secured a teaching degree from Brooklyn's Pratt Institute where he studied design with Arthur Wesley Dow and then taught for several years in Virginia and in Duluth, Minnesota to earn enough money to travel to Europe. Weber stayed in Europe from 1905 to 1909. In Paris, he came to know many avant-garde artists, including Picasso, the fauves, and Henri Rousseau with whom he became close friends. He studied with French academician Jean Paul Laurens, but a class with Henri Matisse in 1908 confirmed his commitment to modernist principles.

When Weber returned to New York in 1909, his work immediately encountered harsh criticism. After an exhibition in 1909 at Julius Haas's small framing shop where his friend Abraham Walkowitz had exhibited the previous year, Weber was included in Alfred Stieglitz's *Younger American Painters* show in 1910. A year later he had a one-man show at Stieglitz's 291 gallery. Weber had brought some of the most progressive European ideas to the New York art scene, and his perspicacity and inventiveness impressed Stieglitz. But a clash of their volatile personalities was almost inevitable, and the final break came just after Weber's last exhibition at 291 in 1911.

Although Weber was not represented in the Armory Show in 1913, he exhibited 11 works with the Grafton Group in London that year. From 1917 to 1919 he was director of the Society of Independent Artists, and during the 1920s he taught for several years at the Art Students League. Weber also wrote poetry and a series of essays on art. He produced some of the earliest abstract sculpture in America and was skilled as a graphic artist.

Weber well understood the underlying bases for cubism, fauvism, futurism, and expressionism. His early career is characterized by its variety and inventiveness, his use of urban themes, and his attempts to define space in new and different ways in order to achieve a personal form of expression. A more lyrical, romantic form of expressionism emerged in his mature style from the experiments of his early years. *P.N.*

Landscape, *1925*

Oil on canvas, 16¼ x 20¼ in.
(41.3 x 51.4 cm.)
Signed lower right: Max Weber; signed verso: à mon ami Mr. Rothbart, Max Weber, Nov. 12, 1925
Gift of Ione and Hudson Walker, by exchange
70.17
Illustration: Figure 137

EXHIBITIONS: Tweed Gallery, University of Minnesota-Duluth, *A Survey of American Painting*, 1955 • *100 Paintings, Drawings, and Prints from the Ione and Hudson D. Walker Collection*, 1965, cat. 99 • *Selections from the Permanent Collection*, 1970, 1975, 1980 • *Hudson D. Walker: Patron and Friend*, 1977, cat. 78 • The Jewish Museum, New York, traveling exhibition, *Max Weber: American Modern*, 1982-1983, cat. 57.

PROVENANCE: Frank Kleinholtz; Sol Wilson; Babcock Galleries, New York

Like Pablo Picasso, Max Weber became a more realistic painter during the third decade of the twentieth century. By 1920 Weber had abandoned his abstract style and was concentrating on more traditional landscapes and figure paintings. He moved to Long Island to escape the congestion of New York City and frequently incorporated the beauty and pleasures of rural life into his canvases. *Landscape* demonstrates the directness and simplicity of Weber's rural scenes of the twenties. The landscape elements themselves are reduced to simple planes, and the colors are Cézannesque hues of blue, green, and tan. Only the boat breaks the stillness of the scene, but it is placed at a distance and serves merely as a compositional motif. The view is quiet, calm, and pretty, conveying the beauty of the American countryside.

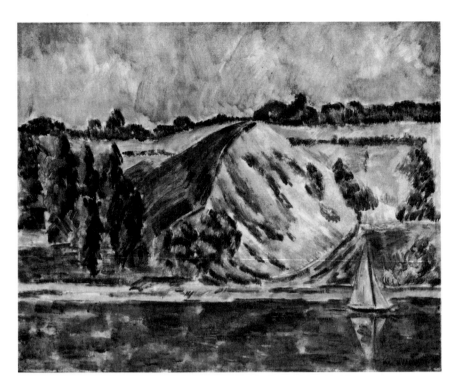

Landscape, *1925 ▪ Figure 137*

ELOF WEDIN
1901-1983

SELECTED BIBLIOGRAPHY: "Elof Wedin: A Talented Minneapolis Artist," *Art News* (28 November 1936):16 ▪ "American Boilermaker Builds Well Upon Cézanne," *Art News* (16 September 1939) ▪ Vivian Thorpe, "Artist Elof Wedin Makes Boilermaker Wedin Angel of His Successful Career in Painting," *Minneapolis Times-Tribune* (10 June 1940):116 ▪ Elof Wedin, interview with George Reid at the University Gallery, 22 September 1977 ▪ Mary Towley Swanson, *The Divided Heart: Scandinavian Immigrant Artists*, 1850-1950 (University of Minnesota Gallery, Minneapolis, 1982), 36 ▪ Minneapolis History Collection, Minneapolis Public Library.

Wedin was born in Hornosend, Ångermanland, Sweden and immigrated to the United States in 1919. He studied first at the School of the Art Institute of Chicago and then at the Minneapolis School of Art (now the Minneapolis College of Art and Design). He had his first one-man show at the Hudson D. Walker Gallery (New York) in 1936 and a second one there in 1939. Wedin completed murals for post offices in Mobridge, South Dakota, and Litchfield, Minnesota, when he worked for the Treasury Department's Section

of Fine Arts in the late thirties and was employed [along with Cameron BOOTH, Dewey ALBINSON, Syd FOSSUM, Arnold KLAGSTAD, Erle LORAN, and Stanford FENELLE] for six weeks by the University of Minnesota during the summer of 1934 to paint scenes of the campus. Ten of Wedin's works in the Museum's collection date from this period.

In 1949 Wedin abruptly abandoned his Cézannesque landscape style and began to paint views of Stillwater, the St. Croix Valley, and Lake Superior's North Shore that were slightly abstracted into geometric shapes with overlays of black lines. His color, which had always been muted, now became more intense, and by the 1960s his compositions barely alluded to actual scenes. Colors and lines were built up with layers of paint laid on with a palette knife and brush in jagged, diagonal forms.

Wedin made several trips back to Sweden to sketch the woods and lakes of his home province. Many of the oil paintings worked up from these sketches as well as paintings of scenes from the Rockies and Minnesota were shown at the American Swedish Institute (Minneapolis, Minnesota) in 1957 and 1962 and at the Walker Art Center (Minneapolis) in 1962. His works were the subject of a retrospective exhibition at Bethesda Hospital in St. Paul, Minnesota in 1979. *M.T.S.*

Old Farm in Ångermanland, *1933*

When Wedin traveled back to Sweden, he sketched scenes such as this of his native province and turned his sketches into larger oil paintings when he returned to Minnesota.

Oil on canvas, 22⅛ x 30 in.
(56.2 x 76.2 cm.)
Signed lower right: E. Wedin
Gift of Elmer Edwin Young in memory of his wife, Verda Karen Young
80.20.1
Illustration: Appendix

Exhibition: *The Divided Heart: Scandinavian Immigrant Artists 1850—1950*, 1982, cat 66.

Provenance: Elmer Edwin Young

Wedin completed ten paintings in the Museum's collection through a program funded by the University of Minnesota during the summer of 1934. Besides Wedin, the other artists employed were Arnold Klagstad, Stanford Fenelle, Syd Fossum, Dewey Albinson, Cameron Booth, and Erle Loran. Wedin commented: "We painted scenery around the campus... .all were easel paintings... . .and we got about $35 a week and they got all the paintings" (Transcript of interview between Elof Wedin and George Reid at the University Gallery, 22 September 1977, p. 3).

Business School, *1934*

Oil on canvas, 20¼ x 24 in.
(51.4 x 61 cm.)
Signed lower right: E.Wedin
University of Minnesota Commission
34.146
Illustration: Appendix

PROVENANCE: the artist

This is a view of Eddy Hall, looking east from Burton Hall on the Minneapolis campus of the University of Minnesota.

Children's Clinic, *1934*

Oil on canvas, 21¾ x 23¾ in.
(55.2 x 60.3 cm.)
Unsigned
University of Minnesota Commission
34.155
Illustration: Appendix

PROVENANCE: the artist

Concrete Mixer, *1934*

Oil on canvas, 20 x 23¼ in.
(50.8 x 59.1 cm.)
Signed lower left: E. Wedin
University of Minnesota Commission
34.147
Illustration: Appendix

PROVENANCE: the artist

In focusing on a homely, industrial subject, Wedin's canvas is similar to other works of Americana painted at the height of the Depression. This plant, now torn down, was located to the west of the University's Minneapolis campus near the banks of the Mississippi River.

Fourteenth Avenue, *1934*

Oil on Canvas, 20⅛ x 24 in.
(51.1 x 61 cm.)
Unsigned
University of Minnesota Commission
34.148
Illustration: Appendix

EXHIBITION: *Original Paintings from the University Collection*, 1946, cat. 147

PROVENANCE: the artist

This view, although now somewhat modified by new signs and awnings, is still recognizable beyond University Avenue looking across the railroad tracks toward Fourteenth Avenue S.E. in Dinkytown, a shopping area just north of the University's Minneapolis campus.

Oil on Canvas, 20½ x 24 in.
(52.1 x 61 cm.)
Unsigned
University of Minnesota Commission
34.149
Illustration: Figure 138

PROVENANCE: the artist

Mississippi Bridge, *1934*

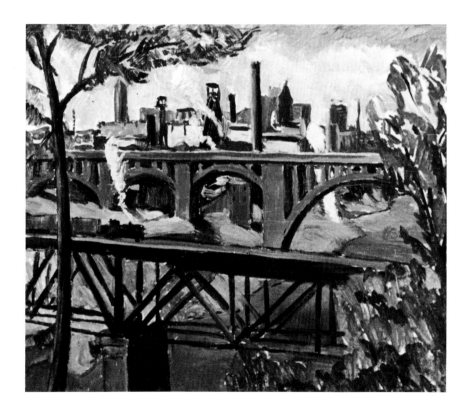

Mississippi Bridge, *1934* ▪ *Figure 138*

Power Plant, *1934*

Oil on canvas, 20⅛ x 24 in.
(51.1 x 61 cm.)
Unsigned
University of Minnesota Commission
34.150
Illustration: Appendix

PROVENANCE: the artist

This view was possibly painted from Nicollet Island in Minneapolis, looking west down the Mississippi River.

These are views of the same river boats, although *River Boats (No. 1)* is painted more broadly and with less detail than *River Boats (No. 2)*. They were painted from a spot on the banks of the Mississippi River that is now below Coffman Union and close to the site where the University Showboat is moored.

River Boats (No.1), *1934*

Oil on canvas, 18 x 21¾ in.
(45.7 x 55.2 cm.)
Signed lower left: Wedin
University of Minnesota Commission
34.151
Illustration: Appendix

PROVENANCE: the artist

Oil on canvas, 30 x 36 in.
(76.2 x 91.4 cm.)
Signed lower right: E. Wedin
University of Minnesota Commission
34.152
Illustration: Appendix

EXHIBITIONS: *Original Paintings from the University Collection*, 1946, cat. 149 •
Tweed Gallery, University of Minnesota-Duluth, *Accomplishments: Minnesota Art Projects in the Depression Years*, 1976, cat. 81.

PROVENANCE: the artist

River Boats (No. 2), *1934*

Stiffey's—No. 2, *1934*

Oil on canvas, 30¾ x 36 in.
(78.1 x 91.4 cm.)
Signed lower right: Wedin
University of Minnesota Commission
34.153
Illustration: Appendix

EXHIBITION: *Original Paintings from the
University Collection*, 1946, cat. 150.

PROVENANCE: the artist

This view of Dinkytown, a shopping area located directly across from and north of the University's Minneapolis campus, shows the corner of Fourteenth Avenue S.E. and University Avenue.

Washington Avenue Bridge, *1934*

Oil on Canvas, 20⅛ x 24¼ in.
(51.1 x 61.6 cm.)
Signed (incised) lower left: Wedin
University of Minnesota Commission
34.154
Illustration: Appendix

EXHIBITIONS: *Original Paintings from the
University Collection*, 1946, cat. 151 •
Tweed Gallery, University of Minnesota-
Duluth, *Accomplishments: Minnesota Art
Projects in the Depression Years*, 1976, cat.
82 • Minneapolis College of Art and Design,
Minneapolis, Minnesota, *The Urban Muse:
Painters Look at the Twin Cities*, 1977.

PROVENANCE: the artist

This view, south of Washington Avenue S.E., looks west toward downtown Minneapolis and what is now the west bank of the University's Minneapolis campus.

Both of these works are portraits of Wedin's wife whom he often painted because of her beautiful bone structure. Wedin commented: "Merely pretty people don't make the best pictures. They've got to be interesting, and there's something interesting in anyone....Now, take my wife. I never get tired of painting her; she's never the same person twice" (Thorpe, p. 116).

Girl's Head, *1934*

Oil on canvas, 20 x 16 in.
(50.8 x 40.6 cm.)
Unsigned
Public Works of Art Project, Minneapolis
34.145
Illustration: Appendix

REFERENCE: Vivian Thorpe, "Artist Elof Wedin Makes Boilermaker Wedin Angel of His Successful Career in Painting," *Minneapolis Times-Herald* (10 June 1940):116.

EXHIBITIONS: *Original Paintings from the University Collection*, 1946, cat. 148 • *Elof Wedin: Portraits*, 1968.

PROVENANCE: the artist

Girl in a Yellow Sweater, *1935*

Oil on canvas, 30 x 24 in.
(76.2 x 61.0 cm.)
Unsigned
Bequest of Hudson Walker from the Ione and Hudson Walker Collection
78.21.100
Illustration: Appendix

REFERENCE: Vivian Thorpe, "Artist Elof Wedin Makes Boilermaker Wedin Angel of His Successful Career in Painting," *Minneapolis Times-Herald* (10 June 1940):116.

EXHIBITIONS: Minneapolis Insitute of Arts, *Twenty-first Annual Exhibition, Twin Cities Artists*, 1935 • *Elof Wedin: Portraits*, 1968.

PROVENANCE: Ione and Hudson Walker

Man with Mandolin, *c. 1935*

Oil on canvas, 34 x 25¼ in.
(86.4 x 64.1 cm.)
Unsigned
Bequest of Hudson Walker from the Ione
and Hudson Walker Collection
78.21.96
Illustration: Appendix

PROVENANCE: Ione and Hudson Walker

This portrait of an anonymous young man was possibly included in Wedin's first one-man exhibition at the Hudson D. Walker Gallery in November of 1936.

Portrait of Hudson Walker, *c. 1935*

Oil on canvas, 32⅝ x 25 in.
(82.9 x 63.5 cm.)
Unsigned
Bequest of Hudson Walker from the Ione
and Hudson Walker Collection
78.21.818
Illustration: Appendix

REFERENCE: Transcript of interview between
Elof Wedin and George Reid at the
University Gallery, 22 September 1977, p.
10.

EXHIBITIONS: *Elof Wedin: Portraits*, 1968 ▪
Hudson D. Walker: Patron and Friend,
1977, cat. 79.

PROVENANCE: Ione and Hudson Walker

This painting was probably completed for Wedin's 1936 one-man exhibition at the Hudson D. Walker Gallery. It is related stylistically to his *Man with Mandolin* which may also have been in that exhibition.

Dr. Andrew A. Stromberg, *1941*

Oil on canvas, 36 x 28¼ in.
(91.4 x 71.8 cm.)
Signed upper right: E.Wedin 41
Gift of Alumni and Friends
42.74
Illustration: Appendix

EXHIBITION: *Elof Wedin: Portraits*, 1968.

PROVENANCE: the artist

Dr. Andrew A. Stromberg was a professor of Scandinavian languages at the University of Minnesota from 1907 to 1939. This portrait was presented in 1941 by alumni of the University and of Gustavus Adolphus College where Stromberg taught before coming to the University. Other contributors to the commission were the American Swedish Institute, Scandinavian campus organizations, the Swedish Cultural Society, and the Swedish Society.

North Shore Boats, *1957*

Oil on canvas, 28 x 48 in.
(71.1 x 121.9 cm.)
Signed upper right: Elof Wedin, 1957
Gift of Miriam and Angelo Cohn
84.3
Not illustrated

EXHIBITIONS: *The Divided Heart: Scandinavian Immigrant Artists 1850-1950,* 1982 ▪ *The First Fifty Years, 1934-1984: Recent Acquisitions and Promised Gifts to the University Art Museum Collection,* 1984.

PROVENANCE: Miriam and Angelo Cohn

North Shore Boats depicts a scene typical of Minnesota's Lake Superior waterfront. The artist portrays a group of eight small sailboats moored together for protection as they ride out the rough, choppy waters of a summer squall. The style is typical of Wedin's work of the 1950s. *R.L.G.*

WORTHINGTON WHITTREDGE
1820-1910

SELECTED BIBLIOGRAPHY: "The Autobiography of Worthington Whittredge," repr. in John I. H. Baur, ed., *Brooklyn Museum Journal* (1942): 5-66 ▪ *Worthington Whittredge (1820-1910), A Retrospective Exhibition of an American Artist,* into. by Edward H. Dwight (Utica, New York: Munson-Williams-Proctor Institute, 1969) ▪ Anthony F. Janson, "The Western Landscapes of Worthington Whittredge," *American Art Review* (November/December 1976): 58–60 ▪ Anthony F. Janson, "Worthington Whittredge: The Development of a Hudson River Painter, 1860-1868," *The American Art Journal* (April 1979): 71-84.

Woodland scenes with dappled sunlight filtering through dense foliage—this was the pictorial domain that Worthington Whittredge made particularly his own. He knew, as few artists did, the forest's moods and seasonal cadences, for he had been born in a log cabin on the Little Miami River near Springfield, Ohio, then at the very edge of the American frontier.

Largely self-taught, Whittredge left the family farm to become an artist in Cincinnati, the artistic capital of the new West. He worked first as a house painter, then as a portrait painter, but soon realized that his talents were better suited to depicting nature. By 1843 he had decided to devote himself entirely to landscape painting and managed to interest local patrons in financing a period of study and travel in Europe.

From 1849 to 1856 he traveled extensively, studying at the academy in Düsseldorf for nearly seven years and in Paris. Whittredge settled in Rome in the fall of 1856 but three years later became homesick and, in 1859, returned home. He took up residence in a building on Tenth Street in New York where a number of other well-known

painters also had their studios. Fond of travel and adventure, he joined General John Pope's 1866 tour of inspection through the Missouri Territory to the Rocky Mountains and New Mexico, returning over the pioneer Old Santa Fe and Cimarron Trails. In Santa Fe, Whittredge met Kit Carson, an encounter which he related at length in his subsequent autobiography.

He undertook at least two more trips to the Far West, one in 1870 in the company of two other American landscapists, John F. Kensett and Sanford R. Gifford. Elected president of the National Academy of Design in 1874, Whittredge died in Summit, New Jersey, his home for the last 30 years of his life. *R.N.C.*

Boys Nutting in a Woodland, *c. 1860-1865*

Oil on canvas, 19⅞ x 23⅞ in.
(50.5 x 60.6 cm.)
Unsigned
Gift of Frederick J. Wulling
44.12
Illustration: Figure 139

EXHIBITION: Tweed Museum of Art, University of Minnesota-Duluth, *A Survey of American Painting*, 1955.

PROVENANCE: Frederick J. Wulling

Boys Nutting in a Woodland uses the activity of the children as a pretext for painting a forest interior. In the shadowy depths of the woods, the ancient trees form a huge, overarching canopy through which intermittent rays of the sun glint on the solid trunks of the trees and on the small boys gathering autumnal fruit on the woodland floor.

Like other forest scenes by Whittredge, this painting may be a complex realization of William Cullen Bryant's poetry, which the artist much admired. The hoary, "forlorn trees leaning toward each other like the vaulted nave of a cathedral" reflect Bryant's belief that "the groves were God's first temples" created as a "fit shrine for the humble worshipper to hold communion with his maker" (William Cullen Bryant, "A Forest Hymn," in *American Poetry and Prose*, Norman Foerster, ed. [Cambridge, Massachusetts, 1952]: 164). In this context the nut-gathering children may symbolize childhood innocence and human activity harmoniously at one with nature.

Boys Nutting in Woodland, *c. 1860-1865* ▪ *Figure 139*

SOL WILSON
1896-1974

SELECTED BIBLIOGRAPHY: Harry Salpeter, "Sol Wilson," *American Artist* (April 1950): 26-30, 73 ▪ "Reviews," *Arts* (May 1966): 72.

Sol Wilson was called an expressive realist with a tendency to romanticize nature. His stormy views on the ocean near Cape Ann and Gloucester, Massachusetts may have stemmed from his fear of the sea since, as a young immigrant, he was almost swept overboard in a storm while crossing the Atlantic.

Wilson was born in Vilno in Russian Poland. When he settled in America, he took on several jobs simultaneously in order to pay for his art studies: he was an apprentice polisher in a jewelry factory, a doll face-painter and eye-inserter, and a photographic apprentice specializing in developing and retouching. In order to study in evening art classes at Cooper Union, Wilson also monitored classes at the National Academy of Design during the day. He studied with Robert Henri and later at the Ferrer School with George Bellows, who inspired him to look at views creatively rather than with a photographic vision.

In 1927 he first visited Rockport, Massachusetts, which was to become the inspiration for his coastal scenes and remained his summer home throughout his life. He soon became a part of a group of artists known in the 1930s as the Cape Ann School and painted canvases depicting massive rocks and stormy seas in grayed hues, heavy pigment, and chalky whites. Throughout the forties he continued to use thick, impastoed surfaces to define rocks and sea, but his palette lightened to allow a few intense, jewel-like colors to shine out of the grayed backgrounds. Wilson painted from memory and laid down sketches with large abstract areas of color before putting finishing details in with brushes, palette knives, rags, and even fingers. He continued to paint scenes of weather conditions in New York City and the coastal areas until his death in 1974.

Because he considered teaching as a process of clarification and stimulation of ideas both for himself and for students, Wilson often taught classes from his studios. He received a grant from the National Institute of Arts and Letters in 1950 and won awards for his work in annual exhibitions of the National Academy of Design and the Cape Cod Arts Association.

The Destroyed Wharf, *1949*

Oil on canvas, 16¼ x 20¼ in.
(41.3 x 51.4 cm.)
Signed lower right: Sol Wilson
Bequest of Hudson Walker from the Ione and Hudson Walker Collection
78.21.224
Illustration: Figure 140

EXHIBITION: St. Paul Gallery and School of Art, *Exhibition*, 1951.

PROVENANCE: Ione and Hudson Walker

Wilson painted seascapes, harbor scenes , and the lives of the fishermen on Cape Ann and Cape Cod for nearly 50 years. His expressionistic portrayals of rocks and sea life are similar to works by B.J.O. NORDFELDT and Everett SPRUCE during this same period. Here, however, he has turned his attention to the abstract patterns of rotting wood and nets on a damaged pier.

The Destroyed Wharf, *1949* ▪ *Figure 140*

KARL ZERBE
1903-1972

SELECTED BIBLIOGRAPHY: Horst W. Janson, *Karl Zerbe* (New York: The American Federation of Arts, 1961) ▪ Horst W. Janson, "Karl Zerbe, 1903-1972," *Art Journal* (Fall 1973):486 ▪ Piri Halasz, "Figuration in the '40s: The Other Expressionism," *Art in America* 70:11 (December 1982):110-119, 145-147.

Karl Zerbe was a successful young painter in Germany before he immigrated to Boston in 1934. Although he spent the first ten years of his life in Paris, where his father was an engineer for a German electrical machinery plant, he was born in Berlin. Shortly before the outbreak of World War I, Zerbe's family moved back to Germany where he was raised in the climate of freedom and internationalism engendered by the early years of the Weimar Republic.

Zerbe initially studied to be a chemist at the Technische Hochschule of Friedberg, then quit in 1921 to study painting at the Debschitz School in Munich were Josef Eberz was his mentor. He had his first one-man exhibition at the Gurlitt Gallery in Berlin in 1923, then traveled and painted in Italy on a fellowship until 1926. Upon returning to Germany, he was influenced by the neo-objectivist movement which added a detailed realism to his views of city

streets and parks. Two years spent in France—1931 to 1933 — produced a synthesis of neo-objectivism, German expressionism, and post-impressionism in his styles, resulting in freer brushstrokes and a greater responsiveness to light and color in his landscape paintings.

Just after Hitler came to power in 1934, Zerbe immigrated to Boston at the suggestion of some American friends. His first American one-man exhibition was held in the Marie Sterner Gallery, New York, in May of that year. From 1935 to 1937 he taught at the Fine Arts Guild in Cambridge, Massachusetts, and from 1937 to 1955 was head of the painting department at the Boston Museum School. During his years in Boston he was designated by critics as the leader of the Boston school of expressionists which also included Jack Levine and Hyman Bloom. In 1937 Zerbe first experimented with duco enamel, an automobile lacquer used in the 1930s by Picasso and David Siqueiros, which he combined with tempera. Still searching for a medium which would produce optimum color and surface effects, he revived the ancient technique of painting in wax, or encaustic, in the early 1940s. With this medium he produced densely painted views of Boston, Paris, and Charleston and symbolic still-life compositions.

When an allergy to encaustic led to deteriorating health, Zerbe was forced to work with acrylics. His works in the medium included collaged objects in compositions which featured racial themes and tropical plants and animal motifs.

Zerbe exhibited widely in the East, and his work was shown nationally in a retrospective exhibition circulated by the American Federation of Arts in 1961-1962. He was professor of art at Florida State University from 1954 to 1970, retiring just two years before his death. *M.T.S.*

Head of Trojan Horse, 2, *1948*

Encaustic and tempera on composition board, 8 x 11¾ in.
(20.3 x 29.8 cm.)
Unsigned; dated verso
Bequest of Hudson Walker from the Ione and Hudson Walker Collection
78.21.220
Illustration: Figure 141

Zerbe's still-life compositions from the 1940s frequently contained unusual juxtapositions of objects which had personal symbolic meanings. These resembled the ambiguous iconography of Max Beckmann, whose portrait Zerbe painted the same year he completed this head of a Trojan horse. In this and other paintings from 1948, Zerbe showed a tendency to dissipate forms with an overlay of weblike lines. This work was possibly shown in Zerbe's one-man exhibition at the Downtown Gallery (New York) in November of 1948.

EXHIBITIONS: St. Paul Gallery and School of Art, *Exhibition*, 1951 ▪ The Institute of Contemporary Art, Boston, *Karl Zerbe*, 1951-1952 ▪ Tweed Gallery, University of Minnesota-Duluth, *A Survey of American Painting*, 1955 ▪ *Selected Works from the Collection of Ione and Hudson Walker*, 1959 ▪ *Art and the University of Minnesota*, 1961 ▪ *100 Paintings, Drawings, and Prints from the Ione and Hudson Walker Collection*, 1965, cat. 100 ▪ *Hudson D. Walker: Patron and Friend*, 1977, cat. 80.

PROVENANCE: The Downtown Gallery, New York; Ione and Hudson Walker

Head of a Trojan Horse, 2, *1948* ▪ *Figure 141*

NICOLA V. ZIROLI
1908-

SELECTED BIBLIOGRAPHY: *Chicago Art Institute Scrapbook* (August 1936-February 1937):100-101 ▪ "Reviews," *Art Digest* (15 November 1948):24.

Nicola Ziroli won several prizes for his still-lifes, figurative work, and landscapes of the Chicago area during the 1930s. Born in Montenero, Italy, Ziroli came to Chicago with his parents in 1914. He received his diploma from the School of the Art Institute of Chicago in 1931 after studying for nine years in day and evening classes.

In the summer of 1936 his paintings of Chicago and Taxco, Mexico were shown at the Art Institute of Chicago. He also exhibited in the *Annual Exhibitions of Artists of Chicago and Vicinity* from 1913 to 1941. Ziroli's paintings are in the collection of the Corcoran Gallery (Washington, D.C.), Whitney Museum of American Art (New York), and the Albright-Knox Gallery (Buffalo, New York). He taught at the University of Illinois in Urbana. *M.T.S.*

488

And Twine, *1939*

Oil on canvas, 30 x 36 in.
(76.2 x 91.4 cm.)
Signed lower right: N. Ziroli '39
WPA Art Project, Illinois
41.81
Illustration: Appendix

EXHIBITION: *Original Paintings from the University Collection*, 1946, cat. 156.

PROVENANCE: WPA Art Project, Illinois

During the 1930s, Ziroli painted several still-lifes which critics felt showed the influence of the modern French painters, specifically Maurice Vlaminck and André Dunoyer de Segonzac. Often Ziroli's canvases contained items which referred to the mysterious presence of a woman, such as the gloves and flowers in this painting.

JACQUES ZUCKER
1900-1981

SELECTED BIBLIOGRAPHY: Harry Salpeter, "Jacques Zucker: Modern Romantic," *Esquire Magazine* (October 1938):59-61, 181-185 • "Reviews," *Art News* (May 1959):52 • Claude Roger-Marx, *Jacques Zucker* (Paris: Editions Paul Pétridès, 1969).

Jacques Zucker's paintings of sun-dappled landscapes and groups of women and children are impressionistic in both technique and content. Born in Radom, Poland, Zucker ran away from home at 13 to live in Palestine. There, in 1914, he began studying at the Bezalel Art School in Jerusalem under Professor Boris Schatz, learning the processes of lithography, modeling in silver, and carving jewelry. Although he won a scholarship to Paris later that same year, he was unable to go because of the outbreak of World War I. There was no work and no food, and Zucker lived under very difficult circumstances until the British arrived in Palestine in 1917 and he was able to join a Jewish legion under the command of the British army.

After the war ended, he went to Paris to study at the Académie de la Grande Chaumière, then immigrated to America where he worked as a commercial artist in jewelry design. Returning to Paris in 1925, he opened a studio and had several one-man exhibitions before he went back to New York in the mid-thirties and joined the WPA/FAP program there.

Zucker's figure and landscape paintings from the 1930s seemed to be bathed in a crimson haze, but his palette lightened during the 1940s under the influence of his favorite painters, Maurice Utrillo, Chaim Soutine, and Renoir. In canvases of landscape scenes from France and Italy painted throughout the fifties, Zucker used pleasing colors on heavily painted surfaces.

Zucker has shown his paintings in group exhibitions at the Worcester Museum, the Pennsylvania Academy of the Fine Arts, the Art Institute of Chicago, and the Whitney Museum of American Art and had many one-man exhibitions both here and abroad. *M.T.S.*

Girl with a Balalaika, *c. 1935-1938*

Oil on canvas, 30 x 24¼ in.
(76.2 x 61.6 cm.)
Signed upper left: Zucker
Purchased from the Federal Art Project, Central Allocations Division, New York City.
39.110
Illustration: Appendix

REFERENCE: Letter from Jacques Zucker to Mark Kriss at the University Gallery, 13 November 1978.

PROVENANCE: Federal Art Project, Central Allocations Division, New York City

Girl with a Balalaika was painted while Zucker was on the WPA/FAP in New York City, and the easel project possibly supplied this model. Zucker wrote that "when the depression came I found myself in a very precarious position with my family, and the WPA project gave me a chance to survive as an artist. It was not very much financially, but I received paints, canvas and models....so that I could continue freely as a creative artist. To me it was a true manifestation of the spirit of democracy" (Zucker to Kriss, 13 November 1978).

THE SCULPTURE

PETER AGOSTINI
1913-

SELECTED BIBLIOGRAPHY: Martin Friedman, "Mallary, Segal, Agostini: The Exaltation of the Prosaic," *Art International* (October, 1963): 70-71 ▪ Max Kozloff, "American Sculpture in Transition," *Arts* (May, 1964):20-22 ▪ Peter Agostini and Robert Mallary with Martin Friedman, "Is Sculpture a Step Child?: A Colloquy," *Art News* (September, 1964):40-42 ▪ *Twentieth Century Sculpture* (Minneapolis: Walker Art Center, 1969):72 ▪ Judith Stein, "Peter Agostini at the Comfort Gallery, Haverford College," *Art in America* (July/August, 1974):94.

A former student at the Leonardo da Vinci Art School in New York, Peter Agostini is an innovative sculptor who constantly challenges traditional notions of material and technique. Well known for his plaster casts of found objects, he frequently combines these plaster forms into surrealist-inspired still-lifes that dazzle with their whiteness while providing a vehicle for the artist's lyricism and humor. Agostini has taught at Columbia University (1961-1966) and the University of North Carolina at Greensboro (1966) and has received a Guggenheim fellowship. *P.N.*

A Windy Autumn Day, *1964*

Plaster, 120 x 180 in.
(304.8 x 457.2 cm.)
Unsigned
Gift of the artist
68.5
Illustration: Appendix

REFERENCES: Philip Johnson, "Young Artists at the Fair and at Lincoln Center," *Art in America* (August, 1964):118-119 ▪ "Plaster Cornucopia," *Time* (13 November 1964): 96, 99.

EXHIBITION: New York State Exhibit Building, New York World's Fair, 1964-1965.

PROVENANCE: the artist

A relief of dozens of cast balloons, *A Windy Autumn Day* is typical of Agostini's challenge to traditional perceptions. The whiteness of the sculpture suggests marble, but Agostini has taken plaster, for centuries an intermediate material in the casting process, and used it as his primary medium. The plaster casts also do not have a marble-like smoothness but reveal the textures of the balloons and cloth used to construct them. Although the various parts of the composition are not joined physically, the bubbles, clustered like helium-filled models of atomic molecules, are visually unified through their uniform whiteness and rhythmic organization.

ALEXANDER ARCHIPENKO
1887-1964

SELECTED BIBLIOGRAPHY: Alexander Archipenko, "Machine and Art," *Machine-Age Exposition* (New York, 1927):13-14 • Alexander Archipenko, *Archipenko: Fifty Creative Years, 1908-1958* (New York: Tekhne, 1960) • *Alexander Archipenko* (Los Angeles: UCLA Art Galleries, 1967) • Donald Karshan, ed., *Archipenko, International Visionary* (Washington, D.C.: Smithsonian Institution Press, 1969) • *Alexander Archipenko: The American Years, 1923-1963* (New York: Bernard Danenberg Galleries, 1970) • Donald Karshan, *Archipenko: The Sculpture and Graphic Art* (Boulder: Westview Press, 1975) • Katherine Janszky Michaelson, *Archipenko: A Study of the Early Works, 1908-1920* (New York: Garland Publishers, 1977).

By the time he arrived in the United States in 1923, Alexander Archipenko had established an international reputation as a prolific and inventive sculptor and as a teacher. Uninspired by traditional art instruction—he was expelled from the art school in Kiev in his native Russia and lasted only two weeks at the Ecole des Beaux-Arts in Paris—he opened his own art schools, first in Paris (1912), then in Berlin (1921) and New York (1923), and later a summer school in Woodstock, New York (1924). He also taught at Mills College (California), the New Bauhaus in Chicago, and the University of Kansas.

Archipenko established his reputation as a great experimenter, often combining media and techniques to create unique forms. In 1912 he invented sculpto-painting, a name he devised to describe his revolutionary method of combining painting and sculpture. He conceived of sculpture in terms of movement through space and in 1924 invented a machine called the "Archipentura" which he believed showed painting in motion. He was one of the first sculptors to illuminate plastic forms from within to demonstrate the role of light in the creation of sculpture. From 1920 to 1940 Archipenko espoused the virtues of the age-old sculptural method of direct carving, an approach which involved the artist as both the technician and the craftsman as well as the designer.

Archipenko participated in major American and European exhibitions, including the Armory Show, the Parisian Salon des Indépendents, and Salon d'Automne. While in Paris he was a member of the cubist group, Section d'Or. Although he had more than 115 one-man exhibitions, Archipenko was never awarded a major public commission and, thus, never had the opportunity to work on a monumental scale. The artist was, however, a major influence in leading American sculpture from the traditional aesthetic of the nineteenth century into the experimental realm of the twentieth. *P.N.*

Two Bodies (also called *Two Figures*), *1936*

Terra cotta and polychrome, 28 x 12¾ x 8¾ in.
(71.1 x 32.4 x 22.2 cm.)
Signed bottom back: Archipenko 1936
Purchase
38.20
Illustration: Figure 142

REFERENCE: Alexander Archipenko, *Archipenko: Fifty Creative Years, 1908-1958* (New York: Tekhne, 1960), pl. 32 (as *Two Figures*).

EXHIBITIONS: Minneapolis Institute of Arts, *Modern Sculpture from Twin City Collections*, 1951 ▪ *Selections from the Permanent Collection, 1957, 1962* ▪ *Art and the University of Minnesota, 1961.*

PROVENANCE: Gillette and Meagher Insurance Company

Archipenko frequently presented the female figure in different guises. Here the two barely recognizable, intertwined bodies are a contrast of curved and straight lines with each figure acting as a counterpoint to the linear motif of the other. Although the texture of the work simulates a carved surface, the sculpture is terra cotta, a fragile medium. The rippled surface blurs the distinction between carving and modeling, while the polychromy of the work fuses the techniques of painting and sculpture.

Two Bodies, *1936* ▪ *Figure 142*

SAUL L. BAIZERMAN
1889-1957

SELECTED BIBLIOGRAPHY: Julius S. Held, *Saul Baizerman* (Minneapolis: Walker Art Center, 1953) ▪ Saul Baizerman, "The Journal, May 10, 1952," ed. by Carl Goldstein, *Tracks* (Spring, 1975):8-23 ▪ Carl Goldstein, "The Sculpture of Saul Baizerman," *Arts* (September, 1976):121-125 ▪ Tom Armstrong et al., *Two Hundred Years of American Sculpture* (New York: Whitney Museum of American Art, 1976), 257-258.

Like many of the avant-garde American artists of his generation, sculptor Saul Baizerman was born in Russia. Before fleeing his native country and coming to the United States in 1910, he had studied art for a year. In New York City he enrolled at the National Academy of Design but after one year transferred to the Beaux-Arts Institute, studying under Solon Borglum. His early realistic bronze figure studies reflected his academic training.

Throughout the 1920s Baizerman was influenced by cubism, and during the first five years of that decade he began to experiment with hammered metal to develop a distinct individual style. In 1931 a studio fire destroyed much of his early work. Initially Baizerman hammered on cast pieces of metal but later abandoned the casting process, preferring to hammer metal sheets into sculptures. Although the répoussé technique is an ancient one, Baizerman, unlike his predecessors, retained the tiny hammer blows to lend texture to the finished work. This rippled surface reveals the actual physical process of the artist's creation.

In 1924 and 1925 Baizerman worked in England and Russia and even offered the Russian government a monument to Lenin, an offer that was never accepted. He was awarded a Guggenheim fellowship in 1952.

Although technically innovative, Baizerman remained traditional in his choice of the human figure as subject matter. It was the female nude that appeared again and again, particularly in his later works. A prolific writer, Baizerman produced numerous articles, poetry, plays, stories, and a book on art. *P.N.*

Silence, *1936*

Hammered copper, 14¼ x 11 x 10⅝ in. (dia.)
(36.2 x 27.9 x 27 cm.)
Signed left side of neck: S. Baizerman 1936; also left base of neck: Baizerman
Purchase, John Rood Sculpture Collection Fund
53.188
Illustration: Appendix

Silence demonstrates Baizerman's technique of hammering directly on copper, and its title challenges the cacophony that must have accompanied its production. The disembodied, introspective female head with its closed eyes and enigmatic smile represents silence in the abstract—golden, remote, timeless, and contemplative.

REFERENCE: "Modern Sculpture in Minnesota," *The Minneapolis Institute of Arts Bulletin* (Spring, 1959):2.

EXHIBITIONS: Walker Art Center, Minneapolis, *Saul Baizerman,* traveling exhibition, 1953 ▪ Temple of Aaron, St. Paul, *Dedication Art Exhibit,* 1957 ▪ *Selections from the Permanent Collection,* 1957, 1962, 1965, 1968, 1969, 1970, 1972, 1980 ▪ Minneapolis Institute of Arts, *Minnesota Collects Modern Sculpture,* 1959 ▪ Walker Art Center and University of Minnesota Gallery, Minneapolis, *John and Dorothy Rood Collection, John Rood Collection at the University of Minnesota,* 1960, cat. 58 ▪ *Art and the University of Minnesota,* 1961 ▪ Rochester Art Center, Rochester, Minnesota, *Minnesota Art Sources,* 1963 ▪ *The First Fifty Years 1934-1984: American Paintings and Sculpture from the University Art Museum Collection,* 1984.

PROVENANCE: The New Gallery, New York

PATROCINIO BARELA
1908-1964

SELECTED BIBLIOGRAPHY: Mildred Crewes, Wendell Anderson, and Judson Crewes, *Patrocinio Barela: Taos Wood Carver* (Taos, New Mexico: Taos Recordings and Publications, 1962) ▪ Vernon Hunter, "Concerning Patrocinio Barela" in Francis V. O'Conner, ed., *Art for the Millions* (Greenwich: New York Graphic Society, 1973), 96-99, 269-270 (Appendix A).

Of Mexican-American descent, Patrocinio Barela was born in Bisbee, Arizona and spent his life in the American Southwest. He was unschooled and worked initially as an itinerant laborer. After helping one of his friends repair a wooden church figure, he turned to carving in 1931.

A simple man, Barela produced primitively carved wooden figures inspired by the *santos,* or holy figures, of the Southwest and by the patterns of his daily life. He was associated with the WPA/FAP project in Taos, New Mexico under the direction of Vernon Hunter from 1936 until the project ended in 1943. Barela's work was included in the 1939 New York World's Fair. *P.N.*

Saint, *1943*

Wood, 14 x 3⅞ x 3 in.
(35.6 x 9.8 x 7.6 cm.)
Signed bottom: Pat Bar
WPA Art Project, Washington, D.C.
43.602
Illustration: Appendix

PROVENANCE: WPA Art Project,
Washington, D.C.

Patrocinio Barela's *Saint*, produced while the artist worked for the WPA/FAP in Taos, New Mexico, bears resemblances to traditional religious carvings of the Southwest in its use of wood as a medium and its primitive style of carving. The female figure appears to kneel on a low base with her arms extended, though only her torso is represented in the carving. She seems to wear both the wimple of a nun and the crown of Mary, mother of Christ and queen of heaven, and has a rosary around her neck. Christian folklore held that Mary became a hermit nun—Our Lady of Solitude—after the ascension of Christ, and she was sometimes represented as a nun in nineteenth-century New Mexican carvings. An articulated gash in the Barela figure's lower torso may be intended to suggest the female genitalia or the spear wound given to Christ at the crucifixion. Our Lady of Solitude was traditionally not only the patroness against loneliness but also a reminder of the wounds of Christ. *L.K.*

HARRY BERTOIA
1915-1978

SELECTED BIBLIOGRAPHY: June Kompass Nelson, *Harry Bertoia, Sculptor* (Detroit: Wayne State University Press, 1970) ▪ Beverly H. Twitchell, *Harry Bertoia* (Allentown, Pennsylvania: Allentown Art Museum, 1976) ▪ "Harry Bertoia and his Tonal Sculpture," *The Cranbrook Quarterly* (Winter 1976):6-7.

Harry Bertoia is probably best known for his furniture designs for Knoll Associates (New York), especially the wire shell chair that bears his name. Although born in Italy, he immigrated to the United States with his father in 1930. He studied at the Society of Arts and Crafts in Detroit before receiving a scholarship to Cranbrook Academy of Art (Bloomfield Hills, Michigan) where he later taught in the department of metal craft and graphic arts from 1937 to 1941.

The ideals of Cranbrook were similar to those of the German Bauhaus and involved all areas of design activity, integrating the roles of architect, artist, craftsman, and designer. This wide range of training was reflected in Bertoia's multifaceted career. He produced

audible kinetic "sculptural soundings"—his term for them—as well as mute sculptural works, graphics, jewelry, furniture, paintings, and large metal screens that are a combination of sculpture and architecture.

Considering himself a craftsman rather than an artist, he never signed his works and rarely titled them. He was fascinated by the possibilities inherent in technology, and he attempted to make the environment more pleasant by merging creative design with technological advances. His commissions for monumental metal sculptures include works in the Manufacturers Trust Company Bank, New York; General Motors Center, Detroit; the Dallas Library, Texas; the Massachusetts Institute of Technology Chapel, Cambridge; and Southdale Shopping Center, Minneapolis. *P.N*

The Pod, *1956*

Steel, Bronze, nickel, silver, 25½ x 25½ x 8 in. (64.8 x 64.8 x 20.3 cm.)
Unsigned
Purchase, John Rood Sculpture Collection Fund
59.11
Illustration: Appendix

REFERENCE: "Modern Sculpture in Minnesota," *The Minneapolis Institute of Arts Bulletin* (Spring, 1959):2.

EXHIBITIONS: *New Acquisitions, 1959* ▪ Minneapolis Institute of Arts, *Minnesota Collects Modern Sculpture*, 1959 ▪ Walker Art Center and University of Minnesota Gallery, Minneapolis, *John and Dorothy Rood Collection, John Rood Collection at the University of Minnesota*, 1960, cat. 61 ▪ *Art and the University of Minnesota*, 1961 ▪ *Selections from the Permanent Collection*, 1962, 1965, 1968 ▪ Rochester Art Center, Rochester, Minnesota, *Minnesota Art Sources*, 1963 ▪ Artrain, Inc., Detroit, Michigan, *Creative Impulse*, 1984.

PROVENANCE: the artist; John Rood

This welded bronze sculpture, a spiny heart-shaped pod protecting a cluster of seeds, is related to an entire series that Bertoia produced of plants, trees, and bushes. These botanical forms are the most realistic images he ever created and invite symbolic interpretations. Bronze rods, welded side by side, spring from the work's central core, producing the impression of mass through their dense grouping. Their density, however, changes with variations in light and the position of the viewer. In welding bronze, Bertoia frequently combined other metals with the bronze, as he did in this piece, to produce a wide range of color.

ROBERT M. CRONBACH
1908-

SELECTED BIBLIOGRAPHY: John I. H. Baur, *Revolution and Tradition in American Art* (Cambridge, Massachusetts: Harvard University Press, 1959) • Robert Cronbach, "The New Deal Sculpture Projects," in Francis V. O'Conner, ed., *The New Deal Art Projects, An Anthology of Memoirs* (Washington, D.C.: Smithsonian Institution Press, 1972), 133-154 • Jacques Cattell Press, ed., *Who's Who in American Art* (New York: R.R. Bowker Company, 1982), 201 • Helen A. Harrison, "Subway Art and the Public Use of Art Committee," *Archives of American Art Journal* 21:2 (1981):3-12 • Paul Cummings, *Dictionary of Contemporary American Artists*, 4th ed. (New York: St. Martin's Press, 1982), 166.

A figurative sculptor influenced by Jacques LIPCHITZ, Robert Cronbach developed a dramatic, expressionistic form of sculpture, working principally with hammered and welded metals. He attended the St. Louis School of Fine Arts (1925-1926) and the Pennsylvania Academy of the Fine Arts (1927-1930) where he studied with Charles Grafly and Albert Laessle, then traveled to Europe as a Cresson scholar in 1929-1930. In 1930 he also was an assistant in Paul Manship's studio.

At the outset of his career in the 1930s, Cronbach, like many American artists of the period, used urban and regional themes in his work. He won a WPA/FAP competition in 1936 and was employed on government-sponsored art projects in New York until 1939. In 1940 he was awarded the commission to produce two freestanding bronze sculptures for the Section of Fine Arts, but these were never completed. During the next two decades he executed numerous private and public commissions. Then, in 1963, he again worked for the government, producing a fountain for a federal office building in St. Louis.

Cronbach's first one-man exhibition was held at the Hudson D. Walker Gallery (New York) in 1939; many solo and group exhibitions followed. Cronbach was an instructor at Adelphi University from 1948 to 1962 and a visiting associate professor there in 1974 and 1975. *P.N.*

Under the El, *c. 1939*

Bronze, 15¼ x 3¼ x 6¾ in. (dia.)
(38.7 x 8.3 x 17.1 cm.)
Signed: Cronbach
Bequest of Hudson Walker from the Ione and Hudson Walker Collection
78.21.215
Illustration: Figure 143

Under the El's small scale, smooth surfaces, and enigmatic urban theme are typical of Cronbach's style of the 1930s. The presence of the city is suggested only by the sparse architectural elements. The focus of the work is a single female figure, leaning morosely against a pillar that supports an I-beam. The enlarged eyes appear soulful, and her distended stomach and pointed breasts hint that she may be pregnant. But her provocative slouch might also suggest that she is a prostitute.

EXHIBITIONS: *Selections from the Collection of Mr. and Mrs. Hudson D. Walker, 1950* ▪ The Minneapolis Institute of Arts, *Modern Sculpture from Twin City Collections, 1951* ▪ *Selections from the Permanent Collection, 1957* ▪ *Images of the American Worker, 1930-1940, 1983* ▪ *The First Fifty Years, 1934-1984: American Paintings and Sculpture from the University Art Museum Collection, 1984* ▪ *New York and American Modernism, 1984.*

PROVENANCE: Ione and Hudson Walker

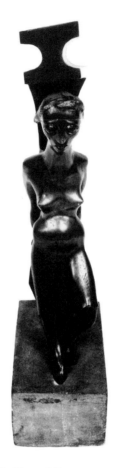

Under the El, *c. 1939* ▪ *Figure 143*

PAUL THEODORE GRANLUND
1925-

SELECTED BIBLIOGRAPHY: *Sculpture by Paul Granlund* (Minneapolis: Walker Art Center, 1956) ▪ Paul Granlund, Kathryn Christenson, and Kelvin W. Miller, eds., *Granlund: The Sculptor and His Work* (St. Peter, Minnesota: Gustavus Adolphus College, 1978).

A native of Minneapolis, Paul Granlund has been sculptor-in-residence at his alma mater, Gustavus Adolphus College in St. Peter, Minnesota since 1971. After receiving his B.A. in 1952, he spent a year majoring in sculpture at the University of Minnesota and then received a year's scholarship to Cranbrook Academy (Bloomfield Hills, Michigan) in 1953-1954. A Fulbright Grant enabled him to travel in Italy in 1954-1955 and a Guggenheim Fellowship in 1957-1958 allowed him to return there to study.

In 1959 Granlund was a fellow at the American Academy in Rome where his work was exhibited for the first time. A figurative sculptor who works primarily in bronze, Granlund frequently bases his expressionistic works on religious themes. He has created six monumental public works for Gustavus Adolphus College, as well as many public monuments in Minneapolis and St. Paul, including works for Westminster Presbyterian Church, the Federal Reserve Plaza, and the Lutheran Social Services Building. *P.N.*

Standing Figure (also called *Figure on One Foot*), 1956

Although the sensuous position of Granlund's *Standing Figure* could be considered provocative and enticing, it is counterbalanced by the rugged handling of the bronze surface and the sagging proportions of the woman's anatomy. Granlund has here contrived a demanding posture from which to study the torsion of the female figure as it pivots in space, creating an ever-changing silhouette.

Bronze, 17¼ x 6 x 6⅛ in.
(43.8x 15.2 x 15.6 cm.)
Signed on base: Granlund 56
Purchase, John Rood Sculpture Collection Fund
58.33
Illustration: Appendix

REFERENCE: Paul Granlund, Kathryn Christenson, and Kelvin W. Miller, eds., *Granlund, The Sculptor and His Work* (St. Peter, Minnesota: Gustavus Adolphus College, 1978) cat. 72 (as *Figure on One Foot*).

EXHIBITIONS: Carleton College, Northfield, Minnesota, *Exhibition*, 1958 ▪ Lutheran Society for Worship, Music, and the Arts, *Exhibition*, 1958 ▪ Walker Art Center and University of Minnesota Gallery, Minneapolis, *John and Dorothy Rood Collection, John Rood Sculpture Collection at the University of Minnesota*, 1960, cat. 64 ▪ *Art and the University of Minnesota*, 1961 ▪ Smithsonian Institution Traveling Exhibition, *John and Dorothy Rood Collection*, 1961 ▪ *Selections from the Permanent Collection*, 1962, 1965, 1968, 1969, 1970, 1972 ▪ Minneapolis Institute of Arts, Artmobile Traveling Exhibition, *American Art, 1930-1970*, 1972 ▪ Artrain, Inc., Detroit, Michigan, *Creative Impulse*, 1984.

PROVENANCE: the artist

DUAYNE HATCHETT
1925-

SELECTED BIBLIOGRAPHY: Robert Pincus-Whitten, "Duayne Hatchett, Royal Marks Gallery," *Artforum* (April, 1966): 51 • Maurice Tuchman, *American Sculpture of the Sixties* (Los Angeles: Los Angeles County Museum, 1967), 245 • Colin Naylor and Genesis P. Orridge, *Contemporary Artists* (New York: St. Martin's Press, 1977), 387-388 • Paul Cummings, *Dictionary of Contemporary American Artists*, 4th ed. (New York: St. Martin's Press, 1982), 273.

A professor of sculpture at the State University of New York at Buffalo since 1968, Duayne Hatchett received his BFA and MFA degrees from the University of Oklahoma and has been teaching ever since, first at his alma mater and then at Oklahoma State University, the University of Tulsa, and Ohio State University before going to Buffalo.

Hatchett's powerful, abstract forged metal sculptures are related to the earlier totemic works of David SMITH and sometimes look like parts of a mammoth machine. During the 1970s several of his sculptures were expanded to monumental scale and erected in parks in Michigan and New York. Hatchett has exhibited widely throughout the United States, notably at the Whitney Museum of American Art and the Los Angeles County Museum of Art, and his works are in many private, corporate, and public collections. *P.N.*

Stainless #10, *1966*

Stainless steel, 7⅜ x 14⅝ x 6 in. (18.7 x 37.1 x 15.2 cm.)
Signed on base: Hatchett 66
Purchase, Fine Arts Fund
68.43
Illustration: Appendix

EXHIBITIONS: Royal Marks Gallery, New York, 1966 • *Selections from the Permanent Collection*, 1969, 1972.

PROVENANCE: Royal Marks Gallery, New York

Stainless #10 relates to a group of works that Hatchett created during the late 1960s. Like other works in the series, *Stainless #10* was meant to be viewed from a pedestal and was designed as a study for a large outdoor piece now at the Whitney Museum of American Art (New York). The artist chose stainless steel as his medium because of its durability in harsh weather. The crisp, clean silhouette of the piece as well as the use of steel, an industrial material, reinforces its machinelike appearance.

ALONZO HAUSER
1909-

SELECTED BIBLIOGRAPHY: *Alonzo Hauser*
(Minneapolis: Walker Art Center, 1946) ▪
"Alonzo Hauser: The Man and His
Works," *Select Magazine* (June, 1960):20-
23 and (July, 1960):18-21 ▪ *Alonzo Hauser
at the Kilbride-Bradley Gallery*
(Minneapolis: Kilbride-Bradley Gallery,
1965) ▪ Marie Donohue, *Hauser* (St. Paul:
Kramer Galleries, 1966).

Alonzo Hauser was born in LaCrosse, Wisconsin, the son of early
settlers to the region. He originally trained as a teacher at LaCrosse
State Teachers' College (1926-1927) but quickly changed to art and
art history at the Layton School of Art in Milwaukee (1927-1929)
and at the University of Wisconsin (1929-1930). He also studied at
the Art Students League in New York with William Zorach, in
addition to independent study in France. He had his first one-man
exhibition at the ACA Gallery in New York in 1936.

Hauser taught at the Layton School of Art, Milwaukee (1940-1942)
and Carleton College in Northfield, Minnesota (1944-1945) before
founding the art department at Macalester College in St. Paul in
1945. He served as chairman there until 1949. From 1957 to 1969
he was a visiting critic at the University of Minnesota School of
Architecture. An adventuresome personality, Hauser has worked as
a carnival barker for Gypsy Rose Lee (He did a portrait bust of her
in 1940.) and as an outdoor laborer for the WPA in Greendale,
Wisconsin.

Hauser is an expressionistic sculptor who elongates and distorts the
human figure for emotional emphasis. His sculptural oeuvre is
composed primarily of portrait busts and nude female forms
executed in bronze. Among his public sculpture commissions are
two fountains in St. Paul, one in Rice Park and one near the
Veterans' Service Building on the State Capitol grounds. *P.N.*

Balanced, *1962*

Bronze, 6 x 2⅞ x 2⅛ in.
(15.2 x 7.3 x 5.4 cm.)
Signed on base: Hauser
Purchase, John Rood Sculpture Collection
Fund
63.10
Illustration: Appendix

EXHIBITION: *Selections from the Permanent
Collection*, 1965.

PROVENANCE: the artist

Alonzo Hauser introduced his 1960 exhibit at the St. Paul Gallery
and School of Art with the comment, "The theme of humanity, the
face and the figure has been a particular choice of the statue maker
since prehistory. My humble aspiration is to be remembered as a
part of this tradition. This is my effort."

Among Alonzo Hauser's many portrayals of women, *Balanced*
displays his emphasis on the expressive attributes of the human
figure. The contorted pose of this small figure calls attention to the
problem of balance, and there is tension in the circular pivoting
motion of the bather, caught in a stop-action pose. Hauser's bather
is in the tradition of the small figures of women in similar poses
produced by French nineteenth-century painter and sculptor Edgar
Degas toward the end of his career.

503

DAVID HOSTETLER
1926-

SELECTED BIBLIOGRAPHY: Phillip D. Adams, *David Hostetler, The Carver from Coolville Ridge* (Kalamazoo, Michigan: School of Graduate Studies, Western Michigan University, 1967) • Nicholas Roukes, *Masters of Wood Sculpture* (New York: Watson-Guptill, 1980), 36-43.

After receiving his MFA at Ohio University, Athens, Ohio in 1948, David Hostetler became an instructor of sculpture and ceramics there. Working primarily in wood, Hostetler is best known for his figures of the American woman as a fashionable representation of the New World. He has had over 90 one-man shows throughout the United States and was chosen to exhibit in the United States Pavilion at the 1967 Montreal Expo. *P.N.*

American Man, *1962*

Painted wood, 40¼ x 10½ x 10½ in. (102.4 x 26.7 x 26.7 cm.)
Signed on base: Dave Hostetler/Athens, Ohio/American Man/Feb. 1962
Gift of John and Dorothy B.A. Rood
74.4.2
Illustration: Appendix

REFERENCE: Phillip D. Adams, *David Hostetler, The Carver from Coolville Ridge* (Kalamazoo, Michigan: School of Graduate Studies, Western Michigan University, 1967), 14.

EXHIBITION: *The First Fifty Years, 1934-1984: American Paintings and Sculpture from the University Art Museum Collection,* 1984.

PROVENANCE: John and Dorothy B.A. Rood

American Man pays homage to the idea of America as a nation of ethnic diversity. The austere image of the full-bearded Amish man attired in a broad-brimmed hat and simple clothing is a testimony to traditional rural American values of honest labor and simple living. Hostetler's technique of leaving the marks of the carver's tools visible in the wood, combined with his painting of the piece in simple colors, gives it a primitive, folk art appearance. This is in keeping with the subject matter though it belies the sculptor's background as a highly trained academic. The work was purchased by John Rood from Hostetler's first major exhibition in New York.

ALEXANDER LIBERMAN
1912-

SELECTED BIBLIOGRAPHY: Alexander Liberman, *The Artist in His Studio* (New York: Viking Press, 1960) • Lawrence Alloway, *Alexander Liberman* (New York: Betty Parsons Gallery, 1962) • Sam Hunter, *Alexander Liberman: Recent Sculpture* (New York: The Jewish Museum, 1966) •

Alexander Liberman was born in Kiev, in Ukrainian Russia, and studied painting in Paris with André L'hote from 1929 to 1931 and architecture with Auguste Perret at the Ecole des Beaux-Arts from 1930 to 1932. He was art editor of the picture magazine *VU* from 1933 to 1937 and in 1936 produced a color film, "La Femme Française," in collaboration with the Louvre Museum in Paris.

Alexander Liberman: Painting and Sculpture, 1950-1970 (Washington, D.C.: Corcoran Gallery of Art, 1970) ▪ Barbara Rose, *Alexander Liberman* (New York: Abbeville Press, 1981) ▪ Donna Harkavy, "Alexander Liberman's Recent Collages and Gate Constructions," *Arts* 57:10 (June, 1983):74-77.

Liberman joined the staff of *Vogue* magazine in New York in 1941 and two years later was named art director; he subsequently became art director and editorial editor for Conde-Nast publications.

Liberman is best known for his monumental geometric steel sculptures, many of which are painted red. Liberman was working in a hard-edged style of painting as early as the 1950s. His sculptures translate the minimalist aesthetic to a monumental sculptural scale.

Liberman had his first one-man show of painting and sculpture at the Betty Parsons Gallery (New York) in 1960 after working relatively unnoticed for a decade. He quickly became prominent and has had more than 40 one-man exhibitions worldwide. In 1978 he was among a group of prestigious international artists commissioned to produce works for the new East Wing of the National Gallery of Art in Washington, D.C.

In addition to his career in publishing and as a painter and sculptor, Liberman has written widely about art in magazines and has published several books. *P.N.*

Prometheus, *1964*

Painted aluminum, 240 x 240 in. (sight)
(609.6 x 609.6 cm.)
Unsigned
Gift of the artist
68.6
Illustration: Appendix

REFERENCES: Philip Johnson, "Young Artists at the Fair and at Lincoln Center," *Art in America* (August, 1964):114 ▪ Barbara Rose, *Alexander Liberman* (New York: Abbeville Press, 1981), 289.

EXHIBITION: New York State Exhibit Building, New York World's Fair, 1964-1965.

PROVENANCE: the artist

Liberman's monumental hanging metal sculpture reiterates the most characteristic aspect of the story of the Greek mythological figure of Prometheus. In mythology, Prometheus was a member of a giant race who stole fire from heaven and gave it to the human race, thus giving man superiority over all other animals. As punishment, Zeus had him chained to the side of a mountain where he was constantly preyed on by a vulture.

In Liberman's interpretation, Prometheus is translated into a disk shape framed by two semicircular bands, which suggest Prometheus's bonds, all of which are intended to be suspended from the side of a building. The abstract geometry is typical of Liberman's sculptures. Prometheus was the first work Liberman executed as a specific public commission. It was made for the New

York State Exhibit at the 1964 New York World's Fair and was given to the Museum by the artist shortly thereafter. It is installed at the University of Minnesota on the sheer face of Blegen Hall, a reddish brick building on the West Bank of the Minneapolis campus.

JACQUES LIPCHITZ
1891-1973

SELECTED BIBLIOGRAPHY: A.M. Hammacher, *Jacques Lipchitz, His Sculpture* (New York: Harry N. Abrams, 1961) ▪ H.H. Arnason, *Jacques Lipchitz: Sketches in Bronze* (New York: Frederick A. Praeger, 1969) ▪ A.M. Hammacher, translated by James Brockway, *Jacques Lipchitz* (New York: Harry N. Abrams, 1970) ▪ Jacques Lipchitz with H.H. Arnason, *My Life in Sculpture* (New York: Viking Press, 1972) ▪ Deborah A. Scott, *Jacques Lipchitz and Cubism* (New York: Garland, 1978).

Jacques Lipchitz is the sculptor most successful in transposing the principles of cubism into three-dimensional form. Although he was born in Lithuania, he went to Paris in 1909 to study at the Injalbert Studio, the Ecole des Beaux-Arts, and the Académie Julian. He was forced to return to Russia in 1911 to fulfill his mandatory military service, but was rejected at the recruiting center because of health problems. He remained in St. Petersburg (Leningrad) until 1913 and associated with the Donkey's Tail group formed by Vladimir Tatlin, Kasimir Malevich, Natasha Goncharova, and Mikhail Larionov, and the Blue Rose group which included David and Vladimir Burliuk.

A part of the avant-garde scene in Paris in the first decades of the twentieth century, Lipchitz was well acquainted with cubists Picasso, Juan Gris, and Georges Braque and with the intellectual art patron, Gertrude Stein. In 1914 he traveled to Spain with the Mexican muralist Diego Rivera and others. He was caught in Spain by the outbreak of World War I and remained there for six months before he was able to return to France.

He was enthusiastic over the revolution in his homeland, an enthusiasm which persisted until he visited the Soviet Union in 1935. In 1940, with the German invasion of France, he left Paris and finally, in 1941, fled to the United States. He established a studio on Washington Square South in New York.

Lipchitz's works from 1914 to 1921 reflect experimentation and discovery within the structure of cubism. Although his subject matter was still legible, he used faceted planes and geometric forms to express mass and volume.

His work from 1915 to 1917 attained the highest degree of abstract simplification. From 1918 to 1920 he worked on a series of still-lifes in low relief, some of which were painted and approximate synthetic cubism in a three-dimensional medium. By 1928, however, Lipchitz had evolved a sculptural style that encompassed surrealism. Lipschitz was honored with a retrospective exhibition at the Museum of Modern Art in 1954, and in 1958 he received an honorary degree from Brandeis University. *P.N.*

Head, *1914*

Bronze with brown patina, 8¾ x 3⅞ x 4½ in.
(22.2 x 9.8 x 11.4 cm.)
Signed on back of neck: J. Lipchitz 4/7; a plate attached to the base of the sculpture reads "The Seventeen Magazine Amy Award to Dayton's June 1965, Head 1914 Jacques Lipchitz."
Gift of Dayton's Department Store, Minneapolis
66.9
Illustration: Appendix

EXHIBITIONS: Marlborough-Gerson Gallery, New York, 1963 ▪ *Selections from the Permanent Collection*, 1970 ▪ Artrain, Inc., Detroit, Michigan, *Creative Impulse*, 1984.

REFERENCES: H.H. Arnason, *Jacques Lipchitz: Sketches in Bronze* (New York: Frederick A. Praeger, 1969), 6 ▪ A.M. Hammacher, translated by James Brockway, *Jacques Lipchitz* (New York: Harry N. Abrams, 1970), 37-38 ▪ Jacques Lipchitz with H.H. Arnason, *My Life in Sculpture* (New York: Viking Press, 1972), 24 ▪ Deborah A. Scott, *Jacques Lipchitz and Cubism* (New York: Garland, 1978), no. 10 in Appendix II.

PROVENANCE: Dayton's Department Store, Minneapolis

Head typifies the cubist sculpture produced by Lipchitz during the second decade of the twentieth century. The reduction of the volume of the head into a series of flat planes shows his debt to the cubist painters and his awareness of the formal properties of African masks which inspired them. The stylized features of the austere visage—fan-shaped forehead, elongated nose, and widespread eyes—suggest a universal model in which formal aspects take precedence over psychological ones. Lipchitz distinguished between his portrait busts and his abstract heads. Portraits, he said, were quite different and required an intimate knowledge of the sitter—they had to be realistic. This work quite definitely falls into the category of Lipchitz's abstract heads rather than his portrait busts.

Portrait of Marsden Hartley, *1942*

Bronze, 15 x 9¼ x 13 in.
(38.1 x 23.5 x 33 cm.)
Signed at back of neck: J. Lipchitz
Bequest of Hudson Walker from the Ione
and Hudson Walker Collection
78.21.944
Illustration: Figure 144

REFERENCES: "Modern Sculpture in
Minnesota," *The Minneapolis Institute of
Arts Bulletin* (Spring, 1959):9 •
Jacques Lipchitz with H.H. Arnason, *My
Life in Sculpture* (New York: Viking Press,
1972), 151-152 • Marsden Hartley, "Posing
for Lipchitz," in Marsden Hartley, *On Art*,
Gail Scott, ed. (New York: Horizon Press,
1982), 229-234.

EXHIBITIONS: *Selections from the Collection
of Mr. and Mrs. Hudson D. Walker*, 1950 •
The Minneapolis Institute of Arts, *Modern
Sculpture from Twin City Collections*, 1951
• Museum of Modern Art, New York,
Traveling Exhibition, *Jacques Lipchitz
Retrospective*, 1954-1955 • Museum of
Modern Art, New York, Traveling
Exhibition, *Three Modern Painters:
Feininger, Hartley, and Beckmann*, 1955-
1957 • University of Nebraska Art Galleries,
Lincoln, *Man and Mountain*, 1957 •
*Selected Works from the Collection of Ione
and Hudson Walker*, 1959 • The
Minneapolis Institute of Arts, *Minnesota
Collects Sculpture*, 1959 • The University
Galleries of the University of Southern
California at Los Angeles and the University
Art Museum at the University of Texas at
Austin, *Marsden Hartley—Painter/Poet*,
1968-1969, cat. 103 • *Selections from the
Permanent Collection*, 1970, 1972 • The
Metropolitan Museum of Art, New York,
The Life and Work of Jacques Lipchitz,
1972 • *Hudson D. Walker: Patron and
Friend*, 1977, cat. 48 • *The First Fifty Years,
1934-1984: American Paintings and
Sculpture from the University Art Museum
Collection*, 1984 • *New York and American
Modernism*, 1984.

PROVENANCE: Buchholz Gallery, New York;
Ione and Hudson Walker

In his late style, Lipchitz turned from a cubist orientation to a more humanized expression. Moving away from rectilinear form, he began to research classical mythology as a means of expressing essential elements of human experience. The life-size head of Marsden HARTLEY exemplifies Lipchitz's late expressionism with its active surface and dramatic, psychologically probing image.

Lipchitz met Hartley at an opening of an exhibition at Helena Rubenstein's and decided that he would like to make a portrait of Hartley's "typical American face" as an advertisement of his talent as a portrait sculptor. Lipchitz had just arrived in the United States and saw portrait commissions as a way to make some money.

Through an intercessor, Lipchitz convinced the artist to sit for a portrait. Lipchitz did not continue his program of commissioned portraits after he completed three portraits of Hartley because his other works began to sell well, largely through the efforts of the New York dealer Curt Valentin.

Lipchitz emphasized the painter's expansive forehead, twisted eyebrows, and prominent nose, a physiognomy that bore the wear of his difficult sixty-five years and at the same time revealed his strength of character and his creative energy. When the sittings were over, Hartley is supposed to have remarked to Lipchitz that now he would be able to die because he was immortalized in bronze. He died the next year. Another cast of the portrait is in the Hirshhorn Museum and Sculpture Garden in Washington, D.C.

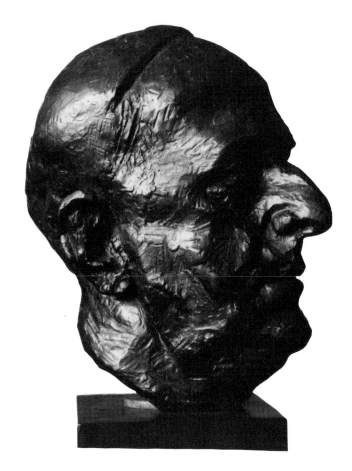

Portrait of Marsden Hartley, *1942* ▪ *Figure 144*

KATHERINE E. NASH
1910-1982

SELECTED BIBLIOGRAPHY: Eugene Kingman with Duard and Laging, "A Young Sculptor in Metal ... Katherine Nash," *Art in America* 44 (Winter 1956-1957):38-39, 66-67 ▪ Carol Lacy, "Fair to Receive Nash Sculpture," *St. Paul Pioneer Press* (August

Katherine Nash was a pioneer in establishing large-scale sculpture as a woman's medium. A feminist artist decades before the ideas of feminism became commonplace, she was as undaunted by the difficulties of working in welded steel or cast concrete as she was by the prejudices of the art world against women.

509

24, 1975) ▪ Gareth Hiebert, "She Sculpts by Computer," *St. Paul Pioneer Press* (September 24, 1977):4 ▪ *Katherine Nash: A Sculptor's Legacy* (Minneapolis: University Art Museum, 1984) ▪ Minneapolis History Collection, Minneapolis Public Library.

Born in Minneapolis, Nash studied drawing and sculpture at the Minneapolis School of Art (now the Minneapolis College of Art and Design) from 1926 to 1928, then received a B.S. degree in art education from the University of Minnesota in 1932. She worked in advertising until 1947 when she taught at a private school in Minneapolis for a year, and then left to become head of the sculpture department at the University of Nebraska-Lincoln from 1948 to 1953. While she was in Lincoln, she attended specialized courses in foundry and pattern making, developing the skills she needed to create large-scale sculptures.

In both 1963 and 1964 Nash taught sculpture at the University of Minnesota during the winter while John ROOD was on leave, and by September 1964 her place on the faculty was secure. She quickly established herself as a sculptor capable of articulating her ideas in cast iron, steel, copper, and aluminum, and her vigorous commitment to her art as a viable means of expression for women produced a new attitude and grudging respect in the male-dominated art department.

An inspiring teacher, Nash won the Morse-Amoco Teaching Award for outstanding contributions to undergraduate education in 1975. That same year she presented a sculpture commemorating International Women's Year to the Minnesota State Fair where the work became a permanent outdoor monument. Her works appeared in numerous group and one-person exhibitions throughout the United States.

Illness forced Nash's retirement from the University in 1976, and she was named professor emeritus. In 1979 the Regents of the University approved naming the Katherine E. Nash Gallery in the West Bank Union in her honor. *S.M.B.*

A Man Caught in a Web, *c. 1966*

Steel rods, welded; braised in some areas,
25 x 18¾ x 18 in.
(63.5 x 47.6 x 45.7 cm.)
Unsigned
Gift of Mr. and Mrs. Julius E. Davis
84.16.2
Not illustrated

REFERENCE: Lyndel King, "Foreword,"
Katherine Nash: A Sculptor's Legacy
(Minneapolis: University Art Museum,
1984):5.

PROVENANCE: Mr. and Mrs. Julius E. Davis

The mid-sixties, shortly after she began teaching at the University of Minnesota, was Katherine Nash's most prolific period. This work is one of several from that era which reflects a concern with aggression and violence.

ARNOLD RÖNNEBECK
1885-1947

SELECTED BIBLIOGRAPHY: *Who's Who in American Art* (1940-1947), 394 ▪ Archives of American Art, Records of American Artists Group, Inc. papers, microfilm NAG7, 383-436 ▪ Archives of American Art, correspondence in J. B. Neumann Papers, NJBN2, 129 ▪ Archives of American Art, gallery literature with reproductions, filmed from originals in Prints Division, New York Public Library, N105, 822-830.

Arnold Rönnebeck, a young German sculptor from Berlin, met Marsden HARTLEY in Paris and became one of the painter's close friends. Rönnebeck served as Hartley's translator when they visited Robert Delaunay and Wassily Kandinsky, and it was he who accompanied Hartley on his first trip to Germany.

The son of an architect from Nassau, Germany, Rönnebeck was a Prussian lieutenant during World War I. He was wounded during the winter of 1914-1915 and was subsequently awarded the Iron Cross First Class by Kaiser Wilhelm II for valor on the battlefield in Russia. Gail Levin has noted that Rönnebeck may have been a partial inspiration for Hartley's series of paintings relating to the pageantry of the German military.

After the war Rönnebeck worked as a sculptor, painter, lithographer, and etcher and trained in Paris under the sculptors Aristide Maillol and Antoine Bourdelle in the tradition of the great late nineteenth-century French sculptor Auguste Rodin. Rönnebeck immigrated to the United States in 1920, and in 1925 he had his first important one-man exhibition at the Weyhe Gallery (New York). This exhibition subsequently toured the United States for over a year. From 1926 to 1930 Rönnebeck was the director of the Denver Art Museum and later became a professor at the University of Denver. *P.N.*

Head of Hartley, *1923*

Terra cotta, 21½ x 19½ x 10 in.
(54.6 x 24.1 x 25.4 cm.)
Signed on back of base: A. Rönnebeck 1923
Bequest of Hudson Walker from the Ione
and Hudson Walker Collection
78.21.296
Illustration: Appendix

PROVENANCE: Weyhe Gallery, New York;
Ione and Hudson Walker

Rönnebeck's life-size terra cotta bust of Marsden Hartley is an idealized likeness of the painter that makes him look younger than his 46 years. The artist softened the harshness of Hartley's striking features and indicated the painter's style consciousness by depicting him in formal attire. The idealization was probably due more to Rönnebeck's desire to flatter his long-time friend than to his particular style; it may have even been intended specifically as a gift for the painter.

JOHN ROOD
1902-1974

SELECTED BIBLIOGRAPHY: John Rood,
Sculpture in Wood (Minneapolis: University
of Minnesota Press, 1950) • *Sculpture and
Drawings by John Rood* (Minneapolis:
Walker Art Center, 1954) • Bruno
Schneider, translated by Desmond and
Louise Clayton, *John Rood's Sculpture*
(Minneapolis: University of Minnesota
Press, 1958) • John Rood, *Sculpture with a
Torch* (Minneapolis: University of
Minnesota Press, 1963) • *Works by John
Rood: A Memorial Exhibition*
(Minneapolis: University of Minnesota
Gallery, 1974).

John Rood came to the University of Minnesota in 1944 to teach sculpture in the art department. After his marriage four years later, Rood and his wife Dorothy determined to find a way to strengthen the teaching facilities of the department. Their initial gesture was to underwrite the publication of a catalogue, but the following year they decided to establish a study collection of contemporary sculpture for students of art history and the fine arts. They donated an annual sum for the purchase of works which today form the core of the University Art Museum's sculpture collection.

Born near Athens, Ohio, John Rood was a multitalented creative personality whose early interests were music and literature. Trips to Europe in 1927 and 1933 proved very influential, exposing him to the literary and artistic avant-garde. From 1933 to 1936 he and his first wife edited and published the literary magazine, *Manuscript*. It was during this period that he began carving in wood, and in 1936 he left publishing to pursue a career in sculpture. The following year he had his first one-man exhibition in New York.

Rood's early works were primitive, simplified shapes in wood due both to his as yet incomplete mastery of the medium and his appreciation for African art. Nevertheless, a strong innate sense of form can be discerned in even these pieces. He was subsequently drawn to folk themes for their ability to mirror American myths and traditions. This interest is evident in an early series of carvings titled *Folk Music*. The year he came to Minneapolis, 1944, Rood published his book *Sculpture in Wood*. He also began working in other media—clay, alabaster, and marble—feeling that his wood pieces were beginning to be repetitive.

After 1950 the motivation behind his art was a fascination with the "metaphoric principle"—the transmutation of matter and organic change. It was this concern which triggered his move to metal sculpture in the early 1950s. Among the more innovative works produced at this time were metal and stained glass "structa-chromes" and a series of highly textured metal sculptures cast from styrofoam blocks which Rood had melted into intricate shapes with a torch. Shortly before his death in 1974, Rood returned to creating painted, rectilinear wood constructions, echoing his earlier structa-chromes, but he did not have the opportunity to develop this new direction in his work. *P.N.*

The Moon, *1949*

Indiana limestone, 50 x 42 x 28 in.
(127 x 106.7 x 71.1 cm.)
Unsigned
Gift of Mr. and Mrs. Julius E. Davis
75.9.3
Illustration: Appendix

REFERENCE: Interview between John Rood and Charles Eldredge, 7 December 1973.

PROVENANCE: Mr. and Mrs. Julius E. Davis

Feeling that he was repeating himself in his wood carvings, John Rood began to work in stone during the 1940s. The new medium required him to change his techniques as well as his subjects. Rood allowed the grainy surface of the stone block to remain, abandoning the smooth finish of his late wood carvings. Throughout the decade his sculptures became increasingly simplified and abstract and his themes more universal. Rood claimed that he did "not think it is possible for a sculptor ever really to be worthy of the name without having worked in one of the materials you have to cut, and stone is the basic one. The form you get in stone is absolute, much more so than in wood" (Rood to Eldredge, 7 December 1973).

Rood's carved limestone sculpture *The Moon* is a symbolic, rather than a literal representation. The curving masses of the work are pierced by circular openings that imitate the moon's spherical shape, adding to the ambiguity of reading the masses and voids.

513

The Mourner's Bench, *1949*

Walnut, 18¾ x 7½ x 6⅜ in.
(47.6 x 19.1 x 16.2 cm.)
Signed under base: Rood XXXVII
Gift of John and Dorothy B. A. Rood
65.1.2
Illustration: Appendix

REFERENCE: Bruno Schneider, *John Rood's Sculpture* (Minneapolis: University of Minnesota Press, 1958), 48.

EXHIBITIONS: Tweed Museum of Art, University of Minnesota-Duluth, *Sculpture and Drawings by John Rood*, 1964 • *Selections from the Permanent Collection*, 1965.

PROVENANCE: John and Dorothy B.A. Rood

Belonging to Rood's *Folk Music* series, *The Mourner's Bench* reflects his interest in religious subject matter in the early years of his career. The pose of the woman with her arms raised over her head is derived from an ancient pose of mourning, yet the title of the work alludes to the front row of seats in some revivalist churches reserved for those who are going to make professions of penitence. Thus, the grieving woman mourns for her sins rather than for the death of a loved one.

The subject is one well-suited to the medium of wood and testifies to Rood's belief that wood carving expressed the humble origins and rough strength of the American people. The simple volumes and textured surface mark this piece as an early work in Rood's career.

Seated Figure, *1949*

Alabama limestone, 40 x 35¾ x 22 in.
(101.6 x 90.8 x 55.9 cm.)
Signed near base: 19 Rood 49
Gift of Mr. and Mrs. Julius E. Davis
75.9.1
Illustration: Appendix

PROVENANCE: Mr. and Mrs. Julius E. Davis

The sculptural relationship between the figure and its environment as a contrast of positive and negative spaces was Rood's primary concern in *Seated Figure*. A consciousness of the medium itself is evident in the figure merging into the stone as well as the striated marks left by the carving tools.

Temptation of St. Anthony, *1949*

Polychromed myrtle wood, 17 x 12 x 4 in.
(43.2 x 30.5 x 12.7 cm.)
Signed on underside: 19 Rood 49
Gift of John and Dorothy B. A. Rood
65.1.3
Illustration: Appendix

EXHIBITION: Tweed Museum of Art, University of Minnesota-Duluth, *Sculpture and Drawings by John Rood*, 1964.

PROVENANCE: John and Dorothy B. A. Rood

Although contemporaneous with Rood's *Mourner's Bench*, *The Temptation of St. Anthony* is a more sophisticated sculptural image. The sensuous delights of the flesh arrayed to tempt the saint have become stylized patterns in a contrast of smooth and striated textures. The incorporation of masklike faces juxtaposed at sharp angles reflects Rood's interest in African wood carving at this time.

Sketch for Persephone, *1952*

Gesso on mahogany, 24 x 15 x 14¼ in.
(61 x 38.1 x 36.2 cm.)
Signed under base: 19 Rood 52
Gift of John and Dorothy B. A. Rood
65.1.4
Illustration: Appendix

EXHIBITION: Tweed Museum of Art,
University of Minnesota-Duluth, *Sculpture
and Drawings by John Rood*, 1964.

PROVENANCE: John and Dorothy B.A. Rood

John Rood frequently used subjects from classical Greek mythology to express themes basic to human experience. In this model for a monumental sculpture for Wellesley College (Massachusetts), Rood translated the mythological story of Persephone into an abstract, three-dimensional symbol. The myth of Persephone afforded the ancient Greeks a rationale for the cyclical change of the seasons in a narrative that involved passion, fear, loss, and rebirth. The pierced, curvilinear form of this sculpture contrasts the void of Persephone's life in the underworld with the lushness of vegetation that develops with her reemergence each spring.

The Forest, *1955*

Horton stone on brass pins, 20¼ x 12 x
10 in.
(51.4 x 30.5 x 25.4 cm.)
Signed on stone: Rood
Gift of John and Dorothy B.A. Rood
65.1.11
Illustration: Appendix

REFERENCE: Bruno Schneider, *John Rood's
Sculpture* (Minneapolis: University of
Minnesota Press, 1958), 23-24.

EXHIBITIONS: Tweed Museum of Art,
University of Minnesota-Duluth, *Sculpture
and Drawings by John Rood*, 1964 • *Works
by John Rood: A Memorial Exhibition*,
1974, cat. 19.

PROVENANCE: John and Dorothy B.A. Rood

Even after he had begun to work with metal in the 1950s, Rood continued to explore the possibilities of stone. In *The Forest*, he combined stone, metal, and wood and denied the inherent weight of the stone by floating it on thin metal supports, leaving the rough stone surface to approximate the irregular texture of trees.

Burning Bush, *1956*

Walnut, 39½ x 35½ x 21 in.
(100.3 x 90.2 x 53.3 cm.)
Signed: Rood
Gift of John and Dorothy B.A. Rood
65.1.5
Illustration: Figure 145

REFERENCE: Bruno Schneider, *John Rood's Sculpture* (Minneapolis: University of Minnesota Press), 24-25.

EXHIBITION: Tweed Museum of Art, University of Minnesota-Duluth, *Sculpture and Drawings by John Rood*, 1964 ▪ Stout State University, Menomonie, Wisconsin, *Festival of Religion in the Arts*, 1966 ▪ *Works by John Rood: A Memorial Exhibition*, 1974, cat. 20.

PROVENANCE: John and Dorothy B.A. Rood

In 1944 John Rood carved a figure of God appearing to Moses in the center of the burning bush, his first major work after coming to Minneapolis. Twelve years later he returned to the theme, abandoning the primitive stylizations and literal narrative of the early work for a more abstract, simplistic conception. Bruno Schneider, in his book on Rood, has attempted to explain the artist's fascination with this theme: "The 'burning bush' of the Old Testament, the miraculous thorn bush which burns without being consumed, here stands for the eternal fertility of nature which begins the cycle of life again while death and destruction are still at work."

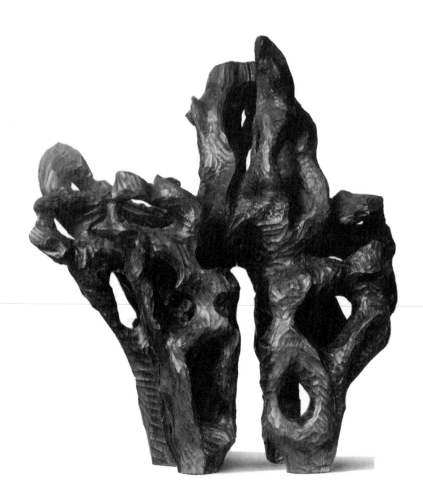

Burning Bush, *1956* ▪ *Figure 145*

Metaphoric Figure, *1956*

Bronze, 25 x 8½ x 7 in.
(63.5 x 21.6 x 17.8 cm.)
Signed center reverse: Rood
Gift of John and Dorothy B.A. Rood
65.1.6
Illustration: Appendix

REFERENCE: Bruno Schneider, *John Rood's Sculpture* (Minneapolis: University of Minnesota Press), 26.

EXHIBITION: Tweed Museum of Art, University of Minnesota-Duluth, *Sculpture and Drawings by John Rood*, 1964.

PROVENANCE: John and Dorothy B.A. Rood

After 1950 the theme of metamorphosis became dominant in Rood's work. The artist envisioned himself as part of an endless metamorphic chain of birth, death, and resurrection that encompassed all creation, and this concept facilitated Rood's rethinking of sculptural subjects and processes. *Metamorphic Figures* is one of a series of works in which the artist explored the idea of human and sculptural transformation, and its ambiguity suggests the effects of age on the human body as well as the erosion of sculptural materials—a weathering that is constant and universal.

Railway Station II, *1958*

Steel and glass; 27¼ x 51½ x 15 in.
(69.2 x 130.8 x 38.1 cm.)
Unsigned
Gift of John and Dorothy B.A. Rood
65.1.7
Illustration: Appendix

EXHIBITIONS: Tweed Museum of Art, University of Minnesota-Duluth, *Sculpture and Drawings by John Rood*, 1964.

PROVENANCE: John and Dorothy B.A. Rood

During the 1950s John Rood experimented with an imaginative series of works he called "structachromes," integrating painting and sculpture through an amalgamation of wrought iron and stained glass. *Railway Station II* is from this series.

Scroll II, *1958*

Copper and welded bronze, 17¾ x 31 x 3¾ in.
(45.1 x 78.7 x 9.5 cm.)
Unsigned
Purchase, John Rood Sculpture Collection Fund
59.10
Illustration: Appendix

REFERENCES: *Design Quarterly* 47 (1950):21-25 ▪ John Rood, *Sculpture with a Torch* (Minneapolis: University of Minnesota Press, 1963), 54.

Welding bronze was another step in Rood's exploration of methods and materials toward developing a personal and expressive style. The rough surface of the metal can almost be read, as if it contained some undeciphered script. This work is a smaller version of the outdoor sculpture Rood created for the Minneapolis Public Library.

EXHIBITIONS: *New Acquisitions*, 1959 ▪ Walker Art Center and the University of Minnesota Gallery, Minneapolis, *John and Dorothy Rood Collection, John Rood Sculpture Collection at the University of Minnesota*, 1960, cat. 74 ▪ Smithsonian Institution Traveling Exhibition, *John and Dorothy Rood Collection*, 1961 ▪ *Art and the University of Minnesota*, 1961 ▪ *Selections from the Permanent Collection*, 1962, 1965, 1968, 1969, 1970 ▪ Tweed Museum of Art, University of Minnesota-Duluth, *Sculpture and Drawings by John Rood*, 1964 ▪ *The First Fifty Years, 1934-1984: American Paintings and Sculpture in the University Art Museum*, 1984.

PROVENANCE: the artist

Welded bronze, 83 x 46 x 36 in.
(210.8 x 116.8 x 91.4 cm.)
Signed on horse's breast: Rood
Gift of Mr. and Mrs. Julius E. Davis
75.9.2
Illustration: Appendix

REFERENCE: John Rood, *Sculpture with a Torch* (Minneapolis: University of Minnesota Press, 1963), 76.

EXHIBITION: *Art and the University of Minnesota*, 1961.

PROVENANCE: Mr. and Mrs. Julius E. Davis

Welded steel, 42 x 30 x 9 in.
(106.7 x 76.2 x 22.9 cm.)
Signed on lower right back: Rood
Gift of John and Dorothy B.A. Rood
65.1.8
Illustration: Appendix

REFERENCE: John Rood, *Sculpture with a Torch* (Minneapolis: University of Minnesota Press, 1963), 60.

EXHIBITIONS: Tweed Museum of Art, University of Minnesota-Duluth, *Sculpture and Drawings by John Rood*, 1964 ▪ *Works by John Rood: A Memorial Exhibition*, 1974, cat. 26.

PROVENANCE: John and Dorothy B.A. Rood

Don Quixote, *1960*

Landscape with Mesas, *1960*

Rood's attempt to translate the pictorial subject of the landscape into sculptural form has a precedent in the linear sculptural landscapes of David SMITH. The density and rippled texture of Rood's *Landscape with Mesas* contrasts with Smith's delicate linear abstractions based on landscape motifs. While both artists strove to produce a uniquely American expression of the landscape, Smith, however, chose the industrial and high-rise cities of the East and Rood the massive mounds of the southwestern desert.

Palace of Neptune, *1961*

Cast aluminum, 53 x 21 x 12 in.
(134.6 x 53.3 x 30.5 cm.)
Signed lower front left corner: Rood
Gift of John and Dorothy B.A. Rood
65.1.9
Illustration: Appendix

EXHIBITIONS: Tweed Museum of Art,
University of Minnesota-Duluth, *Sculpture
and Drawings by John Rood*, 1964 • *Works
by John Rood: A Memorial Exhibition*,
1974, cat. 28.

PROVENANCE: John and Dorothy B.A. Rood

Palace of Neptune is one of a series of works which Rood cast from styrofoam blocks that had been modeled with a torch. The wavy lines, bubbled texture, and craggy forms of the work simulate the forms of Neptune's watery realm and are characteristic of the aluminum casting process.

Bird, *1961*

Welded steel, 53 x 44½ x 33¾ in.
(134.6 x 113 x 85.7 cm.)
Unsigned
Gift of Mr. and Mrs. Julius E. Davis
75.9.5
Illustration: Appendix

PROVENANCE: Mr. and Mrs. Julius E. Davis

When Rood began to create welded steel sculptures, he followed the lead of David SMITH whose early welded pieces frequently incorporated bird imagery. The delicate skeletal framework of these creatures and their ability to soar were the aspects emphasized by both artists.

Bronze and brass, cast and welded, 87½ x
77 x 57½ in.
(222.3 x 195.6 x 146.1 cm.)
Signed on cloud: Rood
Gift of Mr. and Mrs. Julius E. Davis
75.9.4
Illustration: Appendix

PROVENANCE: Mr. and Mrs. Julius E. Davis

Cloud and Bird Fountain, *c. 1961*

Steeple Chase, *1962*

Steel, welded and brazed, 39¼ x 56 x
26 in.
(99.7 x 142.2 x 66 cm.)
Unsigned
Gift of John and Dorothy B.A. Rood
65.1.10
Illustration: Appendix

PROVENANCE: John and Dorothy B.A. Rood

Although it had been a popular subject for nineteenth-century painters, the horse race is a rare subject in twentieth-century sculpture. *Steeple Chase*, however, afforded Rood the opportunity to deal with an image in motion, a major concern of later twentieth-century sculptors, and he employed a series of repeated shapes to suggest both the movement and energy of the horses.

Architectural Construction, 1974

Stainless steel, welded, 99½ x 36 x 36 in.
(252.7 x 91.4 x 91.4 cm.)
Unsigned
Purchase, John Rood Memorial Fund
76.29
Illustration: Appendix

EXHIBITION: *Works by John Rood: A Memorial Exhibition*, 1974 cat. 63.

PROVENANCE: Constructed posthumously from the artist's model by Bodecks, Minneapolis

The stainless steel cage of Rood's *Architectural Construction* demonstrates his understanding of the concepts of later twentieth-century architecture. Spatial volume is implied rather than delineated by the metal grid, and the open spaces are as important as solid mass had been in sculpture prior to the Second World War.

DAVID SMITH
1906-1965

SELECTED BIBLIOGRAPHY: *David Smith by David Smith* (New York: Holt, Rinehart and Winston, 1968) • Rosalind Kraus, *Terminal Iron Works: The Sculpture of David Smith* (Cambridge, Massachusetts: M.I.T. Press, 1971) • Garnett McCoy, ed., *David Smith* (New York: Praeger, 1973) • Rosalind Kraus, *The Sculpture of David Smith, A Catalogue Raisonné* (New York: Garland Publishers, 1977) • E. A. Carmean, Jr., *David Smith* (Washington, D.C.: National Gallery of Art, 1982) • Edward F. Fry and Miranda McClintic, *David Smith, Painter, Sculptor, Draftsman* (New York: George Braziller, Inc., in association with Hirshhorn Museum and Sculpture Garden, Smithsonian Institution, Washington, D.C., 1982).

Although he is best known as a sculptor, David Smith was also proficient as a painter and draftsman, and the large number of works he produced in media ranging from oil to steel to ceramics to photography were all interdependent aspects of his creativity. Smith himself saw everything he did as a continuum, not as distinct pieces, saying: "If you prefer one work over another, it is your privilege, but it does not interest me. The work…comes from a stream, it is related to my past works, the three or four works in process and the work yet to come" (McCoy, p. 84).

Born in Indiana, Smith studied briefly at Ohio University (Athens, Ohio), Notre Dame University (South Bend, Indiana), and George Washington University (Washington, D.C.) before going to New York in 1926. While at South Bend he had a summer job as a welder in a Studebaker factory, an experience which served him well when he began to weld metal and found objects into sculptures in the early thirties. He enrolled at the Art Students League in New York in the fall of 1926 and studied painting with Richard Lahey, John Sloan, and Jan Matulka for the next five years. Matulka, especially, was influential in introducing Smith to the ideas of European modernism.

During a trip to the Virgin Islands in 1931-1932, Smith carved his first sculptures out of coral, and when he returned to New York in mid-1932 he set up a studio at the Terminal Iron Works in Brooklyn where he made his first welded steel sculptures, a series of heads, later that year. These first sculptures, produced under the influence of Picasso and cubism, already display the open, linear construction that was to characterize his works for the next several decades.

Smith went to Europe in 1935-1936. This was his first direct contact with avant-garde French art, and he was particularly interested in the works and techniques of the surrealists, an influence which appeared initially in his paintings and then in his sculpture. Upon his return to the States he joined the WPA/FAP as a sculptor and remained with the program until 1939. During this same period he also created his *Medals of Dishonor*, medallions which protested both war and capitalism.

In 1941 Smith moved permanently to rural Bolton Landing in upstate New York where he had bought a farm in 1929. Here he worked in isolation for the rest of his life, and from his isolation evolved a very personal, very American iconography and style, one influenced both by his early contact with European modernism and by the ideas of abstract expressionism of the late 1940s, but a statement that was his own. Smith had his first one-man exhibition at Marian Willard's East River Gallery (New York) in 1938, and throughout the forties and early fifties recognition grew for both his sculpture and his painting and drawing. He received Guggenheim Fellowships in 1950 and 1951 and began to lecture and teach throughout the country. Smith was killed in an automobile accident near Bennington, Vermont in 1965. *S.M.B.*

Star Cage, *1950*

Various metals, welded, painted dark blue,
44⅞ x 51¼ x 25¾ in.
(114 x 130.2 x 65.4 cm.)
Signed on base: David Smith 1950
Purchase, John Rood Sculpture Collection
Fund
53.189
Illustration: Figure 146

REFERENCES: "Modern Sculpture in
Minnesota," *The Minneapolis Institute of
Arts Bulletin* (Spring, 1959):13 ▪ Jane
Harrison Cone and Margaret Paul, " The
Sculpture of David Smith: A Handlist," in
David Smith 1906-1965, A Retrospective
(Cambridge, Massachusetts: Fogg Art
Museum, 1966): 71 ▪ H. H. Arnason,
History of Modern Art (New York: Harry
N. Abrams, Inc., n.d.), 559, ▪ Edward F.
Fry, *David Smith* (New York: Solomon R.
Guggenheim Foundation, 1969) no. 36 ▪
Rosalind E. Kraus, *The Sculpture of David
Smith: A Catalogue Raisonné* (New York:
Garland Publishers, 1977), 48 ▪ Sarah Booth
Conroy, "Something Borrowed, Something
New: The House that Joan Mondale
Decorated," *Art News* (Summer, 1977):59 ▪
Edward F. Fry and Miranda McClintic,
David Smith, Painter, Sculptor, Draftsman
(New York: George Braziller in association
with the Hirshhorn Museum and Sculpture
Garden, Smithsonian Institution, Washing-
ton, D.C., 1982), 14, 97, 139 ▪ Jonathan
Silver, "The Classical Cubism of David
Smith," *Artnews* 82:2 (February, 1983):
100-103 ▪ Robert Storr, "David Smith,
Heroic or Protean?" *Art in America* LXXI
(October, 1983):152 ▪ Stanley E. Marcus,
David Smith: The Sculptor and His Work
(New York: Cornell University Press, 1983),
39-41 ▪ *David Smith, Skulpturen,
Zeichnungen* (Munich: Prestel-Verlag,
1986), no. 20.

EXHIBITIONS: Willard Gallery, New York,
David Smith, 1951, cat. 1 ▪ Museum of
Modern Art, São Paulo, Brazil, *I Bienal*,
1951, cat. 93 ▪ Walker Art Center,
Minneapolis, *Sculpture and Drawings by
David Smith*, 1952 ▪ Walker Art Center,

This was the first work purchased from the fund set up by John and Dorothy B.A. Rood to establish a sculpture collection at the University of Minnesota. The Roods and H. Harvard Arnason, then head of the University's Art Department and a friend of David Smith, mutually decided to start the collection with a piece by Smith, and Arnason picked out "Sky Cage" [*sic*] from a group of slides Smith left with him after giving several lectures in Minneapolis in 1952. At that time the piece was more expensive than the Sculpture Collection fund could afford, but Smith and his dealer Marian Willard agreed to lend it to the University indefinitely. *Star Cage* arrived at the University in February 1953, and although a note in the file says "we will not be purchasing it," funds were apparently found shortly thereafter to complete the acquisition of what has become the most important American sculpture in the Museum's collection.

According to Edward Fry, the inspiration for *Star Cage* came from a drawing, perhaps of the night sky at Bolton Landing, by Smith's first wife, the painter Dorothy Dehner (Fry, p. 66).
It is a further exploration of the theme of earth and sky which Smith pursued in the early 1950s, and the energetic lines show some relationship to abstract expressionism and the works of Jackson Pollock, whom Smith met in 1937. A metaphoric universe, *Star Cage* seems to trace the paths of moving stars in a dynamic interweaving pattern of dark blue metal rods, while the shiny pyramidal base ties the suspended galaxy to the earth. As in other of Smith's linear works, the voids encompassed by the welded metal "cage" are as important as the mass which is the focus of the sculpture.

Minneapolis, *The Classic Tradition of Contemporary Art*, 1953, cat. 132 • *A Selection of Contemporary American Sculpture*, 1955 • Minnesota State Fair, St. Paul, *American Art of the Twentieth Century from the Collection of the University of Minnesota*, 1957 • *Selections from the Permanent Collection*, 1957, 1962, 1970, 1972, 1975, The Minneapolis Institute of Arts, *Minnesota Collects Modern Sculpture*, 1959 • Walker Art Center and the University of Minnesota Gallery, Minneapolis, *John and Dorothy Rood Collection, John Rood Sculpture Collection at the University of Minnesota*, 1960, cat. 77 • *Art and the University of Minnesota*, 1961 • Solomon R. Guggenheim Museum, New York, *David Smith Retrospective*, 1969, cat. 36 • Hirshhorn Museum and Sculpture Garden, Washington D.C. and San Antonio Museum of Art, *David Smith: Painter, Sculptor, Draftsman*, 1982-1983, cat. 107 • • *The First Fifty Years, 1934-1984: American Paintings and Sculpture in the University Art Museum Collection*, 1984 • Whitney Museum of American Art, New York, *Abstract Expressionism: The Third Dimension*, Traveling Exhibition, 1984-1985 • Kunstsammlung Nordrhein-Westfalen, Düsseldorf, West Germany, *David Smith*, Traveling Exhibition, 1986-1987.

PROVENANCE: Willard Gallery, New York

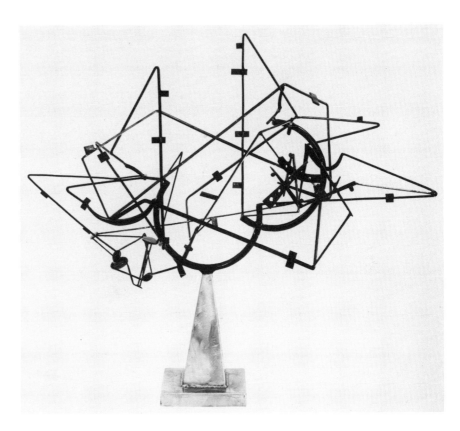

Star Cage, *1950* • *Figure 146*

HAROLD TOVISH
1921-

SELECTED BIBLIOGRAPHY: H.H. Arnason, "Recent Art of the Upper Midwest: Universities as Centers of Art," *Art in America* (Winter, 1954): 41-43 • *Harold Tovish* (New York: Guggenheim Museum, 1968) • Colin Naylor and Genesis P. Orridge, *Contemporary Artists* (New York: St. Martin's Press, 1977) • Paul Cummings, *A Dictionary of Contemporary American Artists*, 4th ed. (New York: St. Martin's Press, 1982), 560-561.

Born in New York City, Harold Tovish studied with Andrew Berger at the WPA Art School from 1938 to 1940 before entering Columbia University where he was a student under Oronzio Maldarelli from 1940 to 1943. He taught at the New York State College of Ceramics from 1947 to 1949. In 1949 he went to Paris for two years to study with Ossip Zadkine. Here he met his future wife, the sculptor Marianna Pineda who was also studying with Zadkine. Tovish remained another year to study at the Académie de la Grande Chaumière. After his return to the United States in 1951,

he taught at the University of Minnesota until 1954, and the first one-man exhibition of his work was held at the Walker Art Center in Minneapolis in 1953.

Tovish lived in Italy from 1954 to 1957 and returned to teach at the Boston Museum Art School. He was visiting professor at the University of Hawaii from 1964 to 1970. *P.N.*

Ancient Place, *1952*

Bronze and aluminum, 37 x 33 x 8 in. (94 x 83.8 x 20.3 cm.)
Signed on right side: H. Tovish 52
Purchase, John Rood Sculpture Collection Fund
55.4
Illustration: Figure 147

REFERENCE: H.H. Arnason, "Recent Art of the Upper Midwest: Universities as Centers of Art," *Art in America* (Winter, 1954):42.

EXHIBITIONS: Walker Art Center, Minneapolis, *Exhibition*, 1953 ▪ The Art Institute of Chicago, *Sixty-first American Exhibition: Painting and Sculpture*, 1954 ▪ *A Selection of Contemporary American Sculpture*, 1955 ▪ Walker Art Center and the University of Minnesota Gallery, Minneapolis, *John and Dorothy Rood Collection, John Rood Sculpture Collection at the University of Minnesota*, 1960, cat. 78 ▪ *Art and the University of Minnesota*, 1961 ▪ *Selections from the Permanent Collection*, 1965 ▪ Watson Gallery, Wheaton College, Norton, Massachusetts, *Twenty Years of Sculpture and Drawing by Harold Tovish*, 1967 ▪ Solomon R. Guggenheim Museum, New York, *Harold Tovish Exhibition*, 1968.

PROVENANCE: Dorothy B.A. Rood

Tovish's bronze and aluminum sculpture *The Ancient Place* juxtaposes the smooth curvilinear form of the background against the textured, segmented shapes that appear to float in its center. The nearly circular object can be viewed from any direction. Its enigmatic title has numerous associations, but it may refer to the cliff dwellings in the American Southwest, an interpretation reinforced by the geometric segmented shapes in the central portion of the work.

Ancient Place, *1952* ▪ *Figure 147*

APPENDIX

ANONYMOUS
Landscape with a Stream,
mid-19th century 44.15

ANONYMOUS
Floral Composition *(1), late 19th century*
43.738

ANONYMOUS
Floral Composition *(2), late 19th century*
43.739

ANONYMOUS
Unknown Man in Uniform, *c. 1880-90*
36.82

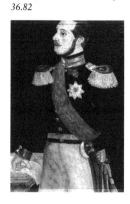

ANONYMOUS
Samuel W. Melendy, *early 20th century*
44.28

GERTRUDE ABERCROMBIE
White Horse, *1938*
43.736

GERTRUDE ABERCROMBIE
The White Plume, *c. 1933-41*
41.78

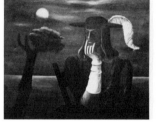

DEWEY ALBINSON
1000 University Avenue, *1934*
34.130

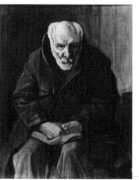

DEWEY ALBINSON
River Flats, *1934*
34.129

DEWEY ALBINSON
University Bridge, *1934*
34.131

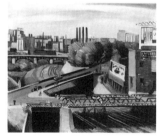

ADAM ALBRIGHT
Children of the Desert, *c. 1910*
56.2

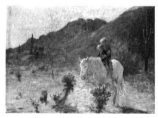

ARTHUR ALLIE
Study of an Old Man, *c. 1933-43*
56.17

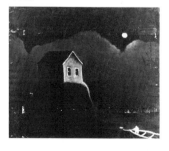

JOHN E. ANDERSON
The Slide Rule, *1951*
78.21.244

JOHN E. ANDERSON
Railroad Crossing, *1953*
82.15

JOHN E. ANDERSON
Untitled, *1964*
78.21.919

MATTHEW BARNES
Nocturne, *c. 1935*
43.735

JENNIE E. BARTLETT
Old Main, *1876*
51.46

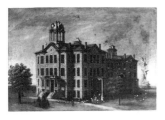

DAVID BEKKER
Strange Interlude, *c. 1936*
43.734

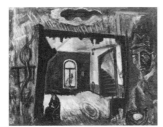

BEN BENN
Self-Portrait, *1926*
78.21.307

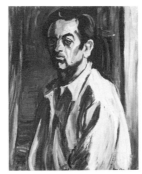

BEN BENN
Landscape, *1936*
78.21.823

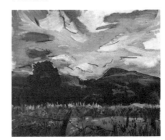

BEN BENN
Dahlias, *1948*
78.21.228

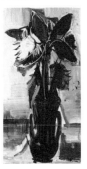

BEN BENN
Still Life with Fruit, *1948*
78.21.29

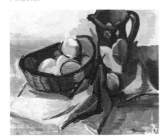

BEN BENN
Hudson D. Walker, *1955*
79.7.2

LOUIS BETTS
George E. Vincent, *c. 1917-18*
39.114

LOUIS BETTS
Under Flickering Leaf Shadows,
c. 1934 56.4

LEE (LELAND) BJORKLUND
Durations I, *1971*
72.12

HYMAN BLOOM
Untitled *(Boxer),* *c. 1935*
78.21.902

FREDERICK WILLIAM BOCK
Old Minneapolis River Front, *c. 1936*
43.771

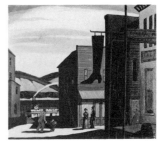

CAMERON BOOTH
William Watts Folwell, *1925*
41.80

CAMERON BOOTH
Julia Anna Norris, *1942*
43.737

CAMERON BOOTH
Still Life: Flowers, *c. 1940-45*
78.21.231

CAMERON BOOTH
Vespers, *1952*
79.19.4

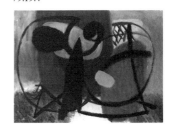

527

CAMERON BOOTH
Everett Fraser, *1953*
57.1

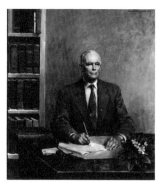

CAMERON BOOTH
Silver Black Configuration, *1954*
66.7.1

CAMERON BOOTH
June Day, *1955*
66.7.2

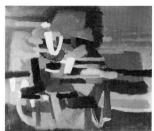

CAMERON BOOTH
Beyond, *1957*
79.19.1

CAMERON BOOTH
Fourth of July, *1957*
79.19.2

CAMERON BOOTH
Red and Green, *1957*
79.19.3

CAMERON BOOTH
Yellow and White, *1957*
79.19.5

CAMERON BOOTH
Mid-Summer, *1958*
66.7.4

CAMERON BOOTH
Mauve, *1960*
66.7.6

CAMERON BOOTH
Untitled *(No. 9), 1960*
66.7.7

CAMERON BOOTH
Black and Green, *1961*
66.7.8

CAMERON BOOTH
Red with Embellishment, *1958, 1960-61*
66.7.9

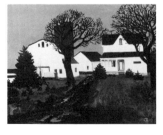

CAMERON BOOTH
Red and Blue, *1961-62*
66.7.11

CAMERON BOOTH
Dairy Herd, *1959, 1966*
79.9.2

CAMERON BOOTH
White Sox, *1974*
76.20.4

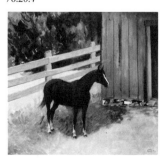

CAMERON BOOTH
Spring *(After Rain), 1975*
78.4

JESSIE ARMS BOTKE
White Peacock on Fountain, *c. 1925*
56.5

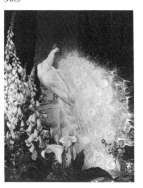

ALVAH BRADISH
Edward D. Neill, *1870*
51.49

SAMUEL BRECHER
Figure Study No. 1, *1939*
78.21.106

SAMUEL BRECHER
Backyards, *c. 1945*
78.21.825

SAMUEL BRECHER
Carnival *(Clown), c. 1950*
78.21.826

SAMUEL BRECHER
Hudson D. Walker, *1949*
79.7.1

RAYMOND BREININ
The Speaker, *1940*
43.732

THEODORE BRENSON
Upsurging, *c. 1952*
78.21.810

S. CHATWOOD BURTON
Untitled *(Wharf), 1917*
54.45

GIORGIO CAVALLON
Abstraction No. 2, *1938*
39.111

EDWARD CHAVEZ
Dead Bluejay in Snow, *c. 1937-40*
78.21.827

HOWARD CHANDLER CHRISTY
Summer Orchard, *1925*
79.9.3

ALEXANDER CORAZZO
Abstraction, *c. 1936*
43.713

ALEXANDER CORAZZO
Abstraction No. 6, *c. 1936*
43.712

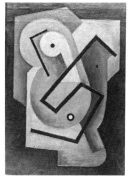

ALEXANDER CORAZZO
Abstraction No. 10, *c. 1936*
43.762

ALEXANDER CORAZZO
Abstraction No. 12, *c. 1936-37*
43.711

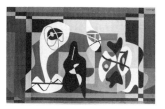

529

ALEXANDER CORAZZO
Abstraction No. 13, *1937*
43.710

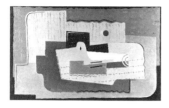

ALEXANDER CORAZZO
Abstraction No. 16, *1937*
43.709

EDWIN M. DAWES
Evening, *c. 1930*
79.17.2

EDWIN M. DAWES
Trees by a Stream, *c. 1930*
79.17.1

JULIO DE DIEGO
Meeting in the Unknown, *1944*
54.34

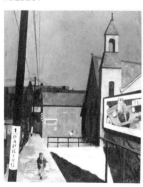

JOSEPH DE MARTINI
Industrial Landscape, *c. 1938-39*
78.21.120

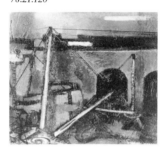

MAYNARD DIXON
Blackfeet Camp, *1917*
56.8

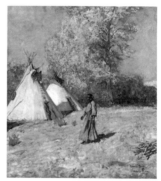

MAYNARD DIXON
Split Mountain, *1917*
56.10

PHILIP C. ELLIOTT
Children at Play, *1947*
78.21.314

PHILIP EVERGOOD
The New Maid, *c. 1949*
79.8.4

REMO MICHAEL FARRUGGIO
Nostalgia, *1937*
43.731

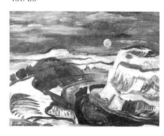

STANFORD FENELLE
Mining Pit, *1937*
43.760

LOUIS GOODMAN FERSTADT
David, *1926*
38.51

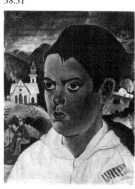

EMIL FOERSTER
John Nicols, *1851*
51.51

SYDNEY GLEN FOSSUM
View of Duluth, *1939*
43.756

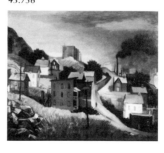

FREDERICK LYDER FREDERICKSON
Still Life, *c. 1939*
78.21.122

HERBJØRN GAUSTA
Dr. Edward Robinson Squibb, *1923*
44.29

LLOYD GILCHRIST
Northern Minnesota Landscape, *1940*
43.752

LLOYD GILCHRIST
Night Scene No. 1, *c. 1940*
43.755

LLOYD GILCHRIST
Tearing Down the Circus, *c. 1940*
43.785

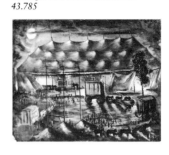

ALBERT GOLD
Three Men in Disguise, *c. 1940*
43.730

DAVID M. GRANAHAN
Untitled *(Factory and Stream),* *1932*
78.21.820

DOROTHY GROTZ
Elizabeth McCausland, *c. 1981*
83.27

MARSDEN HARTLEY
Summer, *1908*
78.21.239

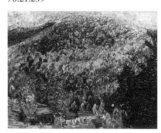

MARSDEN HARTLEY
Autumn *(1), 1908*
78.21.238

MARSDEN HARTLEY
Autumn *(2), 1908*
78.21.98

MARSDEN HARTLEY
Late Autumn *(1), 1908*
78.21.19

MARSDEN HARTLEY
Late Autumn *(2), 1908*
78.21.252

MARSDEN HARTLEY
Trees in Autumn, *1908*
78.21.240

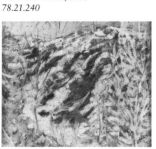

MARSDEN HARTLEY
Landscape #18, *1908*
78.21.41

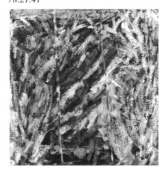

MARSDEN HARTLEY
Songs of Winter, *c. 1908*
78.21.834

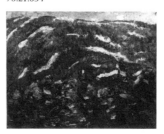

MARSDEN HARTLEY
Landscape #36, *c. 1908-09*
78.21.66

MARSDEN HARTLEY
Landscape #14, *1909*
78.21.43

MARSDEN HARTLEY
Landscape #28, *1909*
78.21.42

MARSDEN HARTLEY
Flowers, *1910*
78.21.293

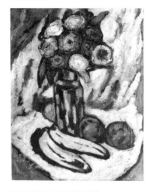

MARSDEN HARTLEY
Waterfall, *1910*
78.21.835

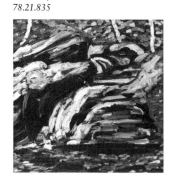

MARSDEN HARTLEY
Landscape #10, *1911*
78.21.40

MARSDEN HARTLEY
Pears, *1911*
78.21.18

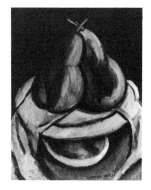

MARSDEN HARTLEY
Still Life: Fruit, *1911*
78.21.117

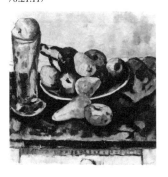

MARSDEN HARTLEY
Woods, *1911*
78.21.241

MARSDEN HARTLEY
Painting #2, *1913*
78.21.67

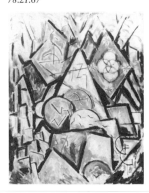

MARSDEN HARTLEY
Movement #11, *c. 1917*
78.21.47

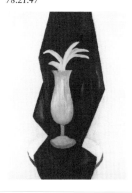

MARSDEN HARTLEY
Floral Life: Debonaire, *c. 1920*
78.21.50

MARSDEN HARTLEY
Rubber Plant, *c. 1920*
78.21.237

MARSDEN HARTLEY
Still Life #7, *1920*
78.21.71

MARSDEN HARTLEY
Pears in White Compote, *1923*
78.21.265

MARSDEN HARTLEY
Still Life, *1923*
78.21.53

MARSDEN HARTLEY
Still Life with Flowers, *1923*
78.21.232

MARSDEN HARTLEY
Paysage, *1924*
78.21.99

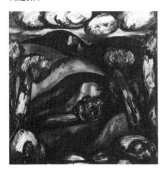

MARSDEN HARTLEY
Four Red Fish, *1924*
78.21.254

MARSDEN HARTLEY
**Three Blue Fish with Lemons
and Limes,** *1924* *78.21.253*

MARSDEN HARTLEY
Still Life with Artichoke, *1924-25*
78.21.233

MARSDEN HARTLEY
Still Life #14, *1926*
78.21.62

MARSDEN HARTLEY
Peasant's Paradise, *1926-27*
78.21.20

MARSDEN HARTLEY
Dogtown, *1934*
78.21.840

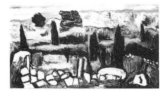

MARSDEN HARTLEY
Dogtown Common, *1936*
61.5

MARSDEN HARTLEY
Dahlias and Crab, *1936*
78.21.833

MARSDEN HARTLEY
Squid, *1936*
78.21.127

MARSDEN HARTLEY
North Atlantic Harvest, *1938-39*
78.21.249

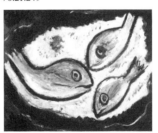

MARGO HOFF
Burnt Landscape, *c. 1945*
47.34

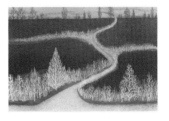

EDWIN HOLM
Forgotten City, *c. 1937*
43.705

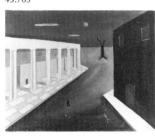

EDWIN HOLM
The Dancer, *c. 1938*
43.704

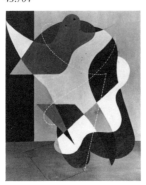

EDWIN HOLM
Desolation, *1938*
43.706

EDWIN HOLM
Mirage, *1938*
43.702

EDWIN HOLM
Melancholia, *c. 1939*
43.701

EDWIN HOLM
Reflections, *c. 1939*
43.707

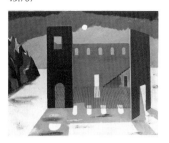

HENRY G. HOLMSTROM
Near the Elevator, *c. 1939*
43.761

HENRY G. HOLMSTROM
Old Farmyard, *c. 1938*
43.764

CARL ROBERT HOLTY
Evening, *1957*
73.17.2

ALICE HUGY
Tiger Lilies, *c. 1933*
43.750

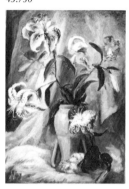

MIRIAM IBLING
The Park, *1939*
43.778

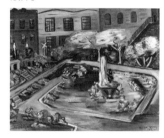

MIRIAM IBLING
Still Life with White Objects, *1939*
43.758

RAYMOND JONSON
Polymer No. 8, *1968*
70.2

MERVIN JULES
Dispossessed *(Morning), c. 1939*
78.21.225

MERVIN JULES
Tomorrow Will Be Beautiful, *c. 1939*
78.21.308

MERVIN JULES
Self-Portrait, *c. 1940*
78.21.197

MERVIN JULES
Woman Ironing, *c. 1940*
78.21.317

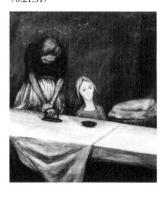

MERVIN JULES
Boy Picking Apples, *c. 1945*
78.21.37

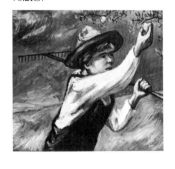

MERVIN JULES
Kids at Play, *c. 1945*
78.21.842

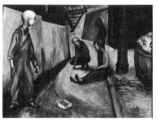

WILLIAM J. KAULA
Clearing Weather, *1909*
79.9.4

PAUL KELPE
Composition, *c. 1927-30*
39.112

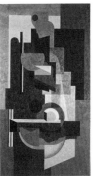

EARL C. KERKAM
Self-Portrait, *c. 1935-40*
78.21.35

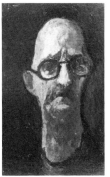

EARL C. KERKAM
Still Life *(1), c. 1935-40*
78.21.130

EARL C. KERKAM
Still Life *(2), c. 1935-40*
78.21.843

EARL C. KERKAM
Violin, *c. 1935-40*
78.21.102

ARNOLD N. KLAGSTAD
Administration Building, *1934*
34.132

ARNOLD N. KLAGSTAD
Campus Gates No. 1, *1934*
34.134

ARNOLD N. KLAGSTAD
Campus Knoll, *1934*
34.136

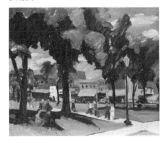

ARNOLD N. KLAGSTAD
Farm Dining Hall, *1934*
34.137

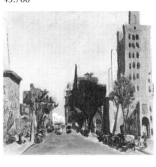

ARNOLD N. KLAGSTAD
Nurses' Home, *1934*
34.138

ARNOLD N. KLAGSTAD
Power House, *1934*
34.139

ARNOLD N. KLAGSTAD
Tennis Courts No. 2, *1934*
34.141

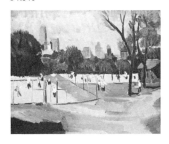

ARNOLD N. KLAGSTAD
Second Avenue South, *c. 1935-40*
43.766

AUGUST KLAGSTAD
Professor Gisle Bothne, *c. 1910*
79.14.2

KARL KNATHS
Cabbage, *c. 1937*
43.728

ROBERT KOEHLER
William Proctor, Jr., *c. 1893-1903*
44.31

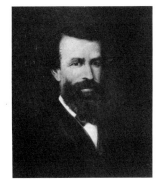

535

ROBERT KOEHLER
Peter W. Bedford, *c. 1895-1915*
44.30

ROBERT KOEHLER
Edward Parrish, *c. 1895-1915*
44.32

ROBERT KOEHLER
Dr. Charles Rice, *c. 1895-1915*
44.34

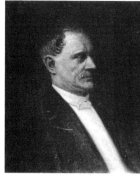

BENJAMIN D. KOPMAN
Landscape, *c. 1910-20*
78.21.54

DOROTHEA LAU
Stormy Beach, *c. 1935-40*
43.773

MYRON LECHAY
Landscape #3, *1938*
43.726

MYRON LECHAY
Entrance, *1940*
43.725

MAC LESUEUR
The Individual, *1938*
43.699

MAC LESUEUR
Yellow Rocker, *1939*
43.696

MAC LESUEUR
House on a Hill, *1940*
43.784

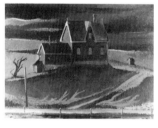

MAC LESUEUR
North Side, *1940*
43.783

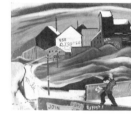

MAC LESUEUR
Old Mine, *1940*
43.765

MAC LESUEUR
Pipes, *1940*
43.697

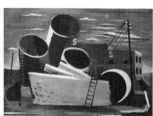

MAC LESUEUR
Old Mill, *c. 1940*
43.698

MAC LESUEUR
Boogie Woogie, *1943*
54.36

ERLE LORAN
Crossroads, *1934*
34.142

536

EMILY DANA McMILLAN
William Watts Folwell, *1894*
51.52

EMILY DANA McMILLAN
John Florin Downey, *c. 1910-15*
48.29

EMILY DANA McMILLAN
Thomas Sadler Roberts, *c. 1915-25*
79.14.3

EMILY DANA McMILLAN
The Old Greek Professor, *c. 1920-30*
48.28

CLAIRE MAHL
Red Bike, *c. 1946-47*
78.21.221

CLARA MAIRS
Abby Swinging on a Vine, *c. 1915*
84.10.8

CLARA MAIRS
Girl with Boy, Watering Plant,
c. 1915-20 *84.10.6*

CLARA MAIRS
Untitled, *c. 1915-20*
84.10.1

CLARA MAIRS
Untitled *(Girl in Bedroom),* *c. 1915-20*
84.10.12

HERMAN MARIL
Victorian, *1938*
78.21.193

ALFRED HENRY MAURER
Landscape *(1), 1908*
53.298

ALFRED HENRY MAURER
Landscape *(2), 1916*
78.21.159

ALFRED HENRY MAURER
Yellow Pear and Roll, *c. 1920*
53.305

ALFRED HENRY MAURER
Girl in a Brown Dress, *1920-24*
78.21.57

ALFRED HENRY MAURER
Portrait of a Girl *(1), 1921-24*
78.21.199

ALFRED HENRY MAURER
Portrait of a Girl *(2), 1924*
78.21.164

537

ALFRED HENRY MAURER
Portrait of a Girl *(3), 1924*
78.21.167

ALFRED HENRY MAURER
Portrait of a Girl *(4), 1924-25*
78.21.166

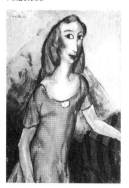

ALFRED HENRY MAURER
Portrait of a Girl *(5), 1924-25*
78.21.163

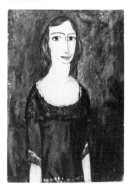

ALFRED HENRY MAURER
Portrait of a Girl *(6), 1924-25*
78.21.165

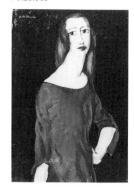

ALFRED HENRY MAURER
Two Heads *(1), 1924-25*
78.21.302

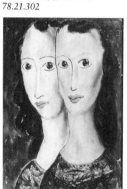

ALFRED HENRY MAURER
Still Life *(2), c. 1925*
78.21.190

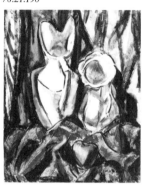

ALFRED HENRY MAURER
Girl *(2), 1925-26*
78.21.86

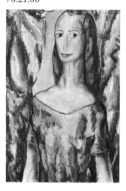

ALFRED HENRY MAURER
Girl's Head, *1925-26*
78.21.114

ALFRED HENRY MAURER
Head of a Girl *(1), 1925-26*
78.21.304

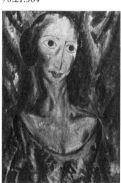

ALFRED HENRY MAURER
Head of a Girl *(2), 1925-26*
78.21.118

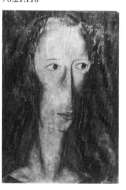

ALFRED HENRY MAURER
Head *(1), 1927*
53.322

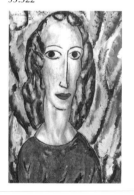

ALFRED HENRY MAURER
Heads, *1926-27*
78.21.93

ALFRED HENRY MAURER
Two Figures of Girls, *1926-27*
53.326

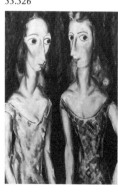

ALFRED HENRY MAURER
Two Heads *(2), c. 1928*
78.21.298

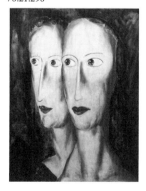

ALFRED HENRY MAURER
Brass Bowl, *1927-28*
53.320

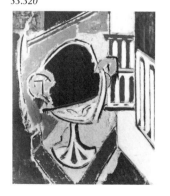

ALFRED HENRY MAURER
Standing Nude, *1927-28*
78.21.305

ALFRED HENRY MAURER
Standing Female Nude, *1928*
53.324

ALFRED HENRY MAURER
Head *(2), 1927-28*
78.21.301

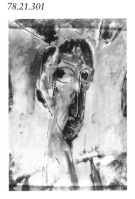

ALFRED HENRY MAURER
Seated Girl, *1927-28*
78.21.109

ALFRED HENRY MAURER
Woman with a Blue Dress, *1927-28*
78.21.95

ALFRED HENRY MAURER
Still Life *(4), c. 1928*
78.21.136

ALFRED HENRY MAURER
Two Heads with Yellow Background,
1928-29 78.21.108

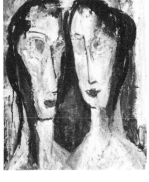

ALFRED HENRY MAURER
Head of a Girl *(4), 1928-29*
78.21.300

ALFRED HENRY MAURER
Head *(3), 1929*
78.21.121

ALFRED HENRY MAURER
Head *(4), c. 1929*
78.21.139

ALFRED HENRY MAURER
Head of a Girl *(6), 1929*
53.315

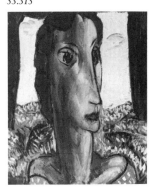

ALFRED HENRY MAURER
**Portrait of a Girl with Blue and Green
Background,** *1929 78.21.119*

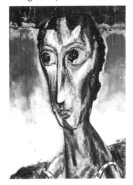

ALFRED HENRY MAURER
Head of a Girl *(7), 1929-30*
78.21.125

ALFRED HENRY MAURER
**Portrait of a Girl with Gray
Background,** *c. 1930 53.306*

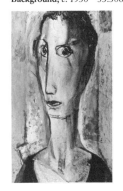

ALFRED HENRY MAURER
Head of a Girl *(8), 1928-30*
78.21.306

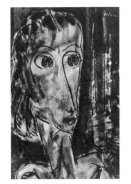

ALFRED HENRY MAURER
Head of a Girl *(9), 1928-30*
78.21.191

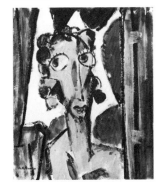

ALFRED HENRY MAURER
Abstract Heads *(3), c. 1930*
78.21.185

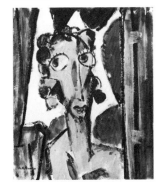

539

ALFRED HENRY MAURER
Abstract Heads *(4), c. 1930*
78.21.186

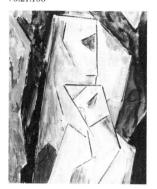

ALFRED HENRY MAURER
Abstract Heads *(5), c. 1930*
78.21.187

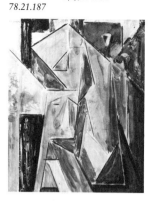

ALFRED HENRY MAURER
Pattern of Heads, *1929*
78.21.194

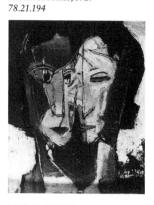

ALFRED HENRY MAURER
Still Life *(5), c. 1930*
78.21.135

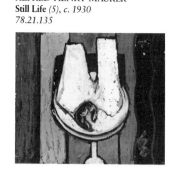

ALFRED HENRY MAURER
Still Life with Bananas, *c. 1930*
78.21.137

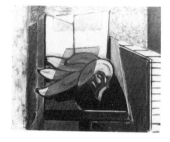

ALFRED HENRY MAURER
Two Heads *(3), 1929*
78.21.110

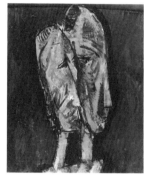

ALFRED HENRY MAURER
Two Heads *(5), 1930-31*
78.21.111

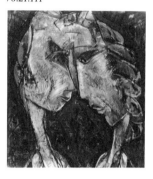

ALFRED HENRY MAURER
Two Heads *(6), 1930*
78.21.123

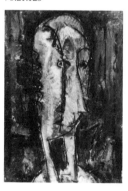

ALFRED HENRY MAURER
Two Heads with Green Background,
1930-31 53.313

ALFRED HENRY MAURER
Two Heads *(7), c. 1931*
78.21.124

ALFRED HENRY MAURER
Two Heads with White Hair, *c. 1931*
78.21.112

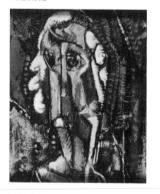

ALFRED HENRY MAURER
Abstraction, *1928-31*
78.21.4

JOSEPH JOHN PAUL MEERT
Sewing Machine, *1949*
78.21.313

ANN MITTLEMAN
Red Forest, *c. 1958-68*
68.40

HANS MOLLER
Canary I, *1947*
54.37

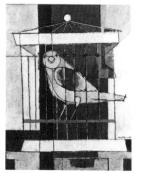

PAUL MOMMER
Still Life with Pears, *c. 1939*
78.21.115

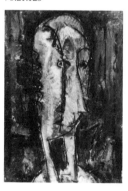

540

CARL A. MORRIS
Song, *1946*
54.38

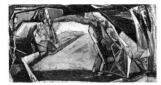

ROLAND MOUSSEAU
Landscape, *1935*
43.723

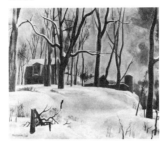

JERRE MURRY
Woman with Cello, *c. 1941*
43.722

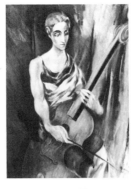

ELIAS NEWMAN
The Garden, *c. 1950-55*
78.21.849

B.J.O. NORDFELDT
Flowers and Fruit, *c. 1930*
77.11.2

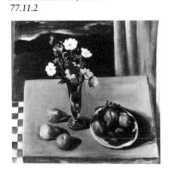

B.J.O. NORDFELDT
Road, Minnesota, *1934*
77.11.1

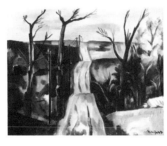

B.J.O. NORDFELDT
Flowers with Shell, *1944*
67.17

B.J.O. NORDFELDT
Flying Gull, *1944*
78.21.23

B.J.O. NORDFELDT
Coastline, California, *1945*
65.8.1

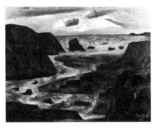

B.J.O. NORDFELDT
Rocks and Oaks, *1945*
65.8.2

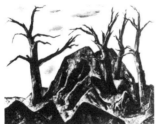

B.J.O. NORDFELDT
Still Life with Leaves, *1947*
58.29

B.J.O. NORDFELDT
Mandolin, *1949*
63.6.1

B.J.O. NORDFELDT
Blue Sea, *1954*
79.13

BERTRAND OLD
Oil Tanks, *c. 1935-40*
43.751

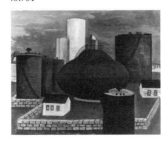

ARTHUR OSVER
Interior, *1939*
43.721

EDGAR ALWIN PAYNE
Autumn, Illinois, *1908*
80.17.16

EDGAR ALWIN PAYNE
Early Fall Trees, *c. 1908-10*
80.17.11

EDGAR ALWIN PAYNE
Early Landscape, Illinois, *c. 1908-10*
80.17.4

EDGAR ALWIN PAYNE
Spring in Lincoln Park (Chicago), *1910*
80.17.5

EDGAR ALWIN PAYNE
California Scene, *1913*
80.17.14

EDGAR ALWIN PAYNE
Rhythmic Sea, *c. 1920-30*
80.17.6

EDGAR ALWIN PAYNE
Mont Blanc, *1922*
80.17.7

EDGAR ALWIN PAYNE
Swiss Mountain Hamlet, *1923*
80.17.17

EDGAR ALWIN PAYNE
Breton Town, *1924*
80.17.5

EDGAR ALWIN PAYNE
Misty Morning, Brittany, *1924*
80.17.4

EDGAR ALWIN PAYNE
Tuna Yawls, *1925-29*
80.17.1

EDGAR ALWIN PAYNE
Square Rigger, *1929-30*
80.17.18

EDGAR ALWIN PAYNE
Sierra, *c. 1930*
80.17.8

EDGAR ALWIN PAYNE
Western Afternoon, *c. 1930*
80.17.2

JAMES PENNEY
West Side Freight Yards, *1938-39*
68.30

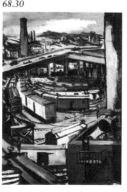

GREGORIO PRESTOPINO
Freight Rustler, *c. 1943*
78.21.101

WALTER W. QUIRT
Those Who Travel Too Fast, *1940*
58.30

WALTER W. QUIRT
The Mock War, *c. 1940*
81.5

WALTER W. QUIRT
Performers Performing, *c. 1940*
80.15

WALTER W. QUIRT
Conceit, *1943*
64.18.1

WALTER W. QUIRT
Athlete Athleting, *1951*
51.48

WALTER W. QUIRT
Radiance, *1959*
64.18.3

GLEN RANNEY
Twin City Sewage Station, *1936*
43.779

GLEN RANNEY
Meadow Brook Farm, *1941*
43.780

ANTON REFREGIER
Pruning, *1944*
78.21.851

LOUIS LEON RIBAK
Berry Pickers, June, *c. 1925-30*
78.21.312

THOMAS ADDISON RICHARDS
Landscape, *c. 1882-87*
44.20

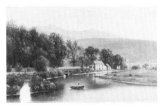

LOUIS RITMAN
Still-Life Arrangement in the Garden,
1955 84.7.2

KURT ALBERT FERDINAND
ROESCH **Celestial and Earthly,** *c. 1936*
36.87

KURT ALBERT FERDINAND
ROESCH **Indian Sunset,** *c. 1936*
36.88

KURT ALBERT FERDINAND
ROESCH **Butterflies,** *1950*
53.44

JOSEPHINE LUTZ ROLLINS
Girl in a Green Chair, *1930*
78.2.3

JOSEPHINE LUTZ ROLLINS
Old Houses in Munich, *1930*
68.299.1

JOSEPHINE LUTZ ROLLINS
Dick, *1932*
78.2.1

JOSEPHINE LUTZ ROLLINS
Portrait of a Man, *c. 1940*
78.2.2

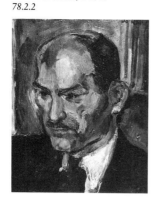

JOSEPHINE LUTZ ROLLINS
River View, *1946*
68.29.2

JOSEPHINE LUTZ ROLLINS
Mexico, *c. 1954*
58.43

JOSEPHINE LUTZ ROLLINS
View above Florence, *1956*
65.11.20

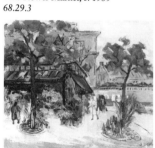

JOSEPHINE LUTZ ROLLINS
Town in Spain, *c. 1956*
65.11.3

JOSEPHINE LUTZ ROLLINS
Open Pit Mine, *1957*
63.7

JOSEPHINE LUTZ ROLLINS
Sunset and Hills, California, *c. 1959*
65.11.2

JOSEPHINE LUTZ ROLLINS
Paris Flower Market, *c. 1959*
68.29.3

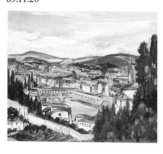

JOSEPHINE LUTZ ROLLINS
Flo's Flower Pot, *1962*
68.29.4

RALPH M. ROSENBORG
The Child, *1947*
54.39

FELIX RUVOLO
Alabama Landscape, *c. 1935-40*
43.719

WILLIAM SALTZMAN
John Harry Williams, *1966*
66.10

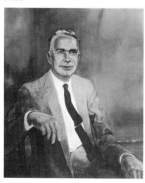

LOUIS SCHANKER
Abstraction, *1945*
78.21.116

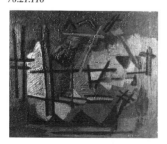

MIRON SOKOLE
Flowers in an Italian Vase, *c. 1932-37*
78.21.318

MIRON SOKOLE
Mountain Village, *c. 1932-37*
39.106

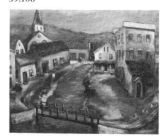

EVERETT FRANKLIN SPRUCE
Pumpkin, *1938*
78.211.227

EVERETT FRANKLIN SPRUCE
Maguey Plant, *1942*
54.40

EVERETT FRANKLIN SPRUCE
Night Bird, *1943*
78.21.198

EVERETT FRANKLIN SPRUCE
Fish and Birds, *1944*
78.21.290

HARRY STERNBERG
War, *c. 1938*
78.21.196

JENNINGS TOFEL
Landscape, No. 1, *c. 1915-20*
53.303

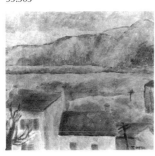

JENNINGS TOFEL
Painting No. 2, Musicians, *c. 1915-20*
53.311

STUYVESANT VAN VEEN
The Kid in the Studio, *c. 1926*
78.21.816

STUYVESANT VAN VEEN
Hannah, *c. 1930-33*
78.21.134

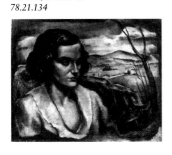

JOSEPH VAVAK
Chicago Landscape, *1939*
43.715

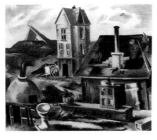

JOSEPH VAVAK
#5966, *1941*
43.716

ABRAHAM WALKOWITZ
Battery Park, *1895*
68.37

ABRAHAM WALKOWITZ
Boats, *c. 1913*
78.21.39

WILLIAM WALTEMATH
Bill Gilbert, *c. 1938-40*
78.21.316

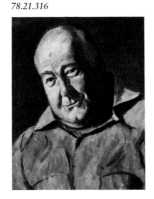

WILLIAM WALTEMATH
My Neighbor, *c. 1938-40*
78.21.319

WILLIAM WALTEMATH
Nude, *c. 1938-40*
78.21.311

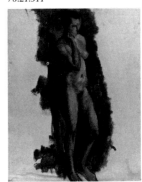

WILLIAM WALTEMATH
Vegetables, *c. 1938-40*
78.21.326

ELOF WEDIN
Old Farm in Ångermanland, *1933*
80.20.1

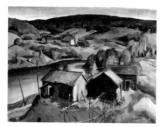

ELOF WEDIN
Business School, *1934*
34.146

ELOF WEDIN
Children's Clinic, *1934*
34.155

ELOF WEDIN
Concrete Mixer, *1934*
34.147

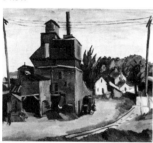

ELOF WEDIN
Fourteenth Avenue, *1934*
34.148

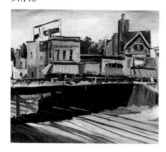

ELOF WEDIN
Power Plant, *1934*
34.150

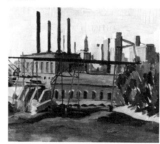

ELOF WEDIN
River Boats (No. 1), *1934*
34.151

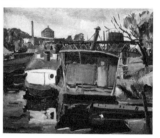

ELOF WEDIN
River Boats (No. 2), *1934*
34.152

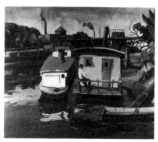

ELOF WEDIN
Stiffey's—No. 2, *1934*
34.153

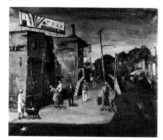

ELOF WEDIN
Washington Avenue Bridge, *1934*
34.154

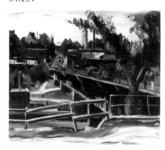

ELOF WEDIN
Girl's Head, *1934*
34.145

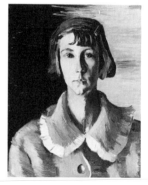

ELOF WEDIN
Girl in a Yellow Sweater, *1935*
78.21.100

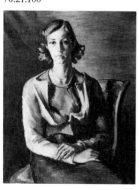

ELOF WEDIN
Man with Mandolin, *c. 1935*
78.21.96

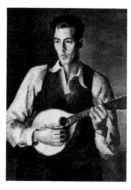

ELOF WEDIN
Portrait of Hudson Walker, *c. 1935*
78.21.818

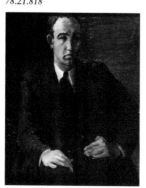

ELOF WEDIN
Dr. Andrew A. Stromberg, *1941*
42.74

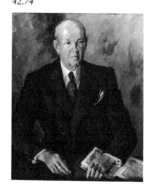

NICOLA V. ZIROLI
And Twine, *1939*
41.81

JACQUES ZUCKER
Girl with a Balalaika, *c. 1935-38*
39.110

PETER AGOSTINI
A Windy Autumn Day, *1964*
68.5

SAUL L. BAIZERMAN
Silence, *1936*
53.188

PATROCINIO BARELA
Saint, *1943*
43.602

HARRY BERTOIA
The Pod, *1956*
59.11

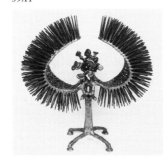

PAUL THEODORE GRANLUND
Standing Figure, *1956*
58.33

DUAYNE HATCHETT
Stainless #10, *1966*
68.43

ALONZO HAUSER
Balanced, *1962*
63.10

DAVID HOSTETLER
American Man, *1962*
74.4.2

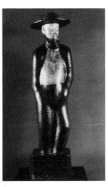

ALEXANDER LIBERMAN
Prometheus, *1964*
68.6

JACQUES LIPCHITZ
Head, *1914*
66.9

ARNOLD RÖNNEBECK
Head of Hartley, *1923*
78.21.296

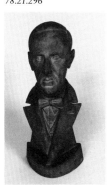

JOHN ROOD
The Moon, *1949*
75.9.3

JOHN ROOD
The Mourner's Bench, *1949*
65.1.2

JOHN ROOD
Seated Figure, *1949*
75.9.1

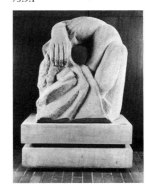

JOHN ROOD
The Temptation of St. Anthony, *1949*
65.1.3

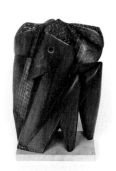

JOHN ROOD
Sketch for Persephone, *1952*
65.1.4

JOHN ROOD
The Forest, *1955*
65.1.11

JOHN ROOD
Metaphoric Figure, *1956*
65.1.6

JOHN ROOD
Railway Station II, *1958*
65.1.7

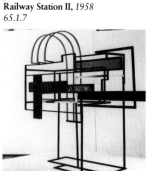

JOHN ROOD
Scroll II, *1958*
59.10

JOHN ROOD
Don Quixote, *1960*
75.9.2

JOHN ROOD
Landscape with Mesas, *1960*
65.1.8

JOHN ROOD
Palace of Neptune, *1961*
65.1.9

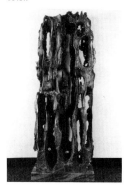

JOHN ROOD
Bird, *1961*
75.9.5

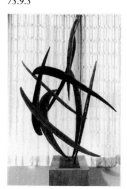

JOHN ROOD
Cloud and Bird Fountain, *c. 1961*
75.9.4

JOHN ROOD
Steeple Chase, *1962*
65.1.10

JOHN ROOD
Architectural Construction, *1974*
76.29

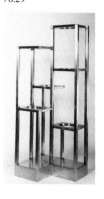

SUPPLEMENTARY LIST
OF AMERICAN PAINTINGS
AND SCULPTURE

PAINTINGS

ANONYMOUS, *20th century*
Franklinia (or Gordonia) and Nymphea Odorata
Oil on canvas, 28 x 23 in.
(71.7 x 58.4 cm.)
Unsigned
Bequest of Hudson Walker from the Ione and Hudson Walker Collection
78.21.289

ANONYMOUS, *19th century*
Portrait of Man with a Beard
Oil on canvas, 48⅜ x 33⅞ in.
(122.9 x 86 cm.)
Unsigned
Transfer from University of Minnesota Archives
51.54

ANONYMOUS, *late 19th century*
Portrait of a Bearded Man
Oil on canvas, 27½ x 23¼ in.
(69.9 x 59.1 cm.)
Unsigned
Anonymous gift
79.18.1

ANONYMOUS, *19th century*
Seascape
Oil on canvas, 24⅞ x 41 in.
(63.2 x 104.1 cm.)
Unsigned
Gift of Frederick J. Wulling
44.26

ANONYMOUS, *19th century*
Young Man in Evening Dress
Oil on canvas, 34⅛ x 27 in.
(69.9 x 59.1 cm.)
Unsigned
Gift of Frederick J. Wulling
44.21

ANONYMOUS (formerly attributed to Albert Bierstadt), *19th century*
Mountain Scene
Oil on canvas, 33¼ x 52 in.
(84.5 x 132.1 cm.)
Unsigned
Gift of Frederick J. Wulling
44.27

ANONYMOUS (formerly attributed to Chester Harding), *19th century*
Portrait of an Unknown Man
Oil on canvas, 27½ x 23¼ in.
(69.9 x 59.1 cm.)
Unsigned
Gift of Frederick J. Wulling
44.13

EMILY ABBOTT *(1900-)*
Flour Mills, *1937*
Oil on canvas, 21⅞ x 27 in.
(55.6 x 68.6 cm.)
Signed lower right: Abbott; dated verso
Gift of the artist
82.5

FREDERICK NIEL ANDERSON *(1917-)*
Still Life, *1954*
Oil on canvas, 26 x 20¼ in.
(66 x 51.4 cm.)
Signed verso: Fred Anderson Dec 1954
Gift of the artist
55.2

STEVEN ANDERSON *(20th century)*
Lake Superior
Acrylic on canvas, 40 x 47 in.
(101.6 x 119.4 cm.)
Signed verso on stretcher: Steven G. Anderson
Gift of Carl D. Sheppard
80.2

JERZY BARANOWSKI *(20th century)*
Still Life: Flower Vase and Chinese Figurine
Oil on canvas, 34⅛ x 29 in.
(86.7 x 73.7 cm.)
Signed lower left: Jerzy Baranowski
Gift of Louis W. Hill, Jr.
56.3

WILLIAM A. BARTSCH *(20th century)*
Sleepers, *1960*
Oil on canvas, 50 x 49⅞ in.
(127 x 126.7 cm.)
Signed lower right: Bartsch 1960
Gift of the artist
67.28.3

TOM BATES *(1951-)*
Harvest Farm, *1981*
Oil on canvas, 20 x 30 in.
(50.8 x 76.2 cm.)
Signed lower right: Bates
Gift of the artist
82.25.4

ALICE BENJAMIN BOUDREAU *(20th century)*
The Idle Plow, *1977*
Acrylic on canvas, 29¾ x 23⅞ in.
(75.6 x 60.6 cm.)
Signed lower right: Boudreau/77
Gift of Josephine Lutz Rollins
83.14

EDWARD VINCENT BREWER *(1883-death date unknown)*
Portrait of William Hopkins Crawford, *1948*
Oil on canvas, 30⅛ x 25 in.
(76.5 x 63.5 cm.)
Signed lower left:
Edward V. Brewer 1948
Gift of the Class of 1923 to the University in 1949, transferred to the University Art Museum
53.331

EDWARD VINCENT BREWER *(1883-death date unknown)*
Portrait of Elias Potter Lyon, *1936*
Oil on canvas, 42 x 32 in.
(106.7 x 81.3 cm.)
Signed lower left:
Edward Brewer 1936
Anonymous gift
53.332

EDWARD VINCENT BREWER *(1883-death date unknown)*
Portrait of Edward Everett Nicholson, *1940*
Oil on canvas, 50⅜ x 38⅛ in.
(128 x 96.8 cm.)
Signed lower right:
Edward V. Brewer '40
Anonymous gift
42.75

FLOYD E. BREWER *(1899-)*
Still Life
Oil on gesso panel, 27⅜ x 17¾ in.
(69.5 x 45.1 cm.)
Signed lower left: Floyd E. Brewer
Bequest of Hudson Walker from the Ione and Hudson Walker Collection
78.21.821

NICHOLAS RICHARD BREWER *(1857-1949)*
Portrait of John Sargeant Pillsbury
Oil on canvas, 62⅞ x 42⅞ in.
(159.7 x 108.9 cm.)
Signed lower left: N. R. Brewer
Anonymous gift
58.22

NICHOLAS RICHARD BREWER *(1857-1949)*
Portrait of James Paige
Oil on canvas, 62⅞ x 42⅞ in.
(101.6 x 81.3 cm.)
Signed lower left: N. R. Brewer
Anonymous gift
53.333

RON BRODIGAN *(1938-)*
No. 85, *1967*
Vinyl copolymer resin on canvas,
96 x 85 in.
(243.8 x 215.9 cm.)
Unsigned
Gift of the artist
68.25

WILLIAM BUKOWSKI *(1954-)*
Tabletop with Brown Teapot, *1981*
Oil on canvas, 35 x 43¼ in.
(88.9 x 109.9 cm.)
Signed lower right: Bukowski
Gift of the artist
82.24.3

VICTOR CAGLIOTI *(1935-)*
Persian Garden—14th Century, *1969*
Acrylic on unprimed canvas,
24⅛ x 36⅛ x 5 in.
(61.3 x 91.8 x 12.7 cm.)
Signed verso: caglioti
Gift of Abby Grey
79.11.3

CRAIG L. CHRISTENSEN *(1954-)*
Countermoves, *1982*
Oil on canvas, 49 x 63½ in.
(124.5 x 161.3 cm.)
Signed lower center: CC82
Gift of the artist
83.15

HENRIETTE CLOPATH
(*birth date unknown-1936*)
At the door of a country church in Poland, after Poshivalski
Oil on canvas board, 23½ x 17½ in.
(59.8 x 44.5 cm.)
Signed lower left: H. Clopath/Poshivalski
Gift of the artist to the University of Minnesota Department of Home Economics, 1935, transferred to the University Art Museum
58.27

HENRIETTE CLOPATH
(*birth date unknown-1936*)
By the River
Oil on canvas, 15 x 9 in.
(38.1 x 22.9 cm.)
Signed lower right: H. Clopath
Gift of the artist to the University of Minnesota Department of Home Economics, 1935, transferred to the University Art Museum
58.21

HENRIETTE CLOPATH
(*birth date unknown-1936*)
Churning
Oil on canvas, 26¼ x 19¾ in.
(67.9 x 50.2 cm.)
Signed lower right: H. Clopath
Gift of the artist to the University of Minnesota Department of Home Economics, 1935, transferred to the University Art Museum
58.3

HENRIETTE CLOPATH
(*birth date unknown-1936*)
First Snow in the Wood, Switzerland
Oil on canvas, 17½ x 29 in.
(44.5 x 73.7 cm.)
Signed lower right: H. Clopath
Gift of the artist to the University of Minnesota Department of Home Economics, 1935, transferred to the University Art Museum
58.11

HENRIETTE CLOPATH
(*birth date unknown-1936*)
Forest Interior
Oil on canvas, 25½ x 18 in.
(64.8 x 45.7 cm.)
Signed lower right: H. Clopath
Gift of the artist to the University of Minnesota Department of Home Economics, 1935, transferred to the University Art Museum
58.9

HENRIETTE CLOPATH
(*birth date unknown-1936*)
Her Cup of Coffee—Old Brittany Woman
Oil on canvas, 18¼ x 21½ in.
(46.4 x 54.6 cm.)
Signed lower right: H. Clopath
Gift of the artist to the University of Minnesota Department of Home Economics, 1935, transferred to the University Art Museum
58.10

HENRIETTE CLOPATH
(*birth date unknown-1936*)
Interior of St. Severin, Paris
Oil on canvas, 34¼ x 26¼ in.
(87 x 66.7 cm.)
Signed lower right: H. Clopath
Gift of the artist to the University of Minnesota Department of Home Economics, 1935, transferred to the University Art Museum
58.4

HENRIETTE CLOPATH
(*birth date unknown-1936*)
La Salle á Manger
Oil on canvas 11¼ x 16⅛ in.
(29.8 x 41 cm.)
Signed lower right: H. Clopath
Gift of the artist to the University of Minnesota Department of Home Economics, 1935, transferred to the University Art Museum
58.25

HENRIETTE CLOPATH
(*birth date unknown-1936*)
Moonlight in Ville Close, Brittany
Oil on canvas, 19⅛ x 14 in.
(48.6 x 35.6 cm.)
Signed lower left: H. Clopath
Gift of the artist to the University of Minnesota Department of Home Economics, 1935, transferred to the University Art Museum
58.14

HENRIETTE CLOPATH
(*birth date unknown-1936*)
Mosque at Landing Place on Asiatic Shore
Oil on canvas, 19 x 15¼ in.
(48.3 x 38.7 cm.)
Signed lower right: H. Clopath
Gift of the artist to the University of Minnesota Department of Home Economics, 1935, transferred to the University Art Museum
58.14

HENRIETTE CLOPATH
(*birth date unknown-1936*)
The Narrows, Colorado
Oil on canvas, 28 x 22 in.
(71.1 x 55.9 cm.)
Signed lower right: H. Clopath
Gift of the artist to the University of Minnesota Department of Home Economics, 1935, transferred to the University Art Museum
58.5

HENRIETTE CLOPATH
(*birth date unknown-1936*)
Old Granite House, Concarneau, Brittany
Oil on canvas, 12⅜ x 16 in.
(31.4 x 40.6 cm.)
Signed lower right: H. Clopath
Gift of the artist to the University of Minnesota Department of Home Economics, 1935, transferred to the University Art Museum
58.12

RODGER P. CROWELL
(*20th century*)
Summer's Blast, *1961*
Oil on canvas, 64 x 54 in.
(162.6 x 137.2 cm.)
Signed verso top stretcher: rodger crowell
Purchase
62.14

WILLIAM DABELSTEIN
(*20th century*)
Study for a Mural
Oil on canvas, 10¾ x 67¾ in.
(27.3 x 172.1 cm.)
Signed lower right: W. Dabelstein
Gift of Louis W. Hill, Jr.
56.7

BERTIL M. DAHLMAN
(*20th century*)
Painting, *1951*
Oil on canvas, 30 x 48 in.
(76.2 x 121.9 cm.)
Signed lower right: Bert Dahlman
Gift of the artist
52.24

JEAN-PAUL DARRIAU
(*20th century*)
Abstraction, *c. 1952-1953*
Oil on illustration board, 40 x 30 in.
(101.6 x 76.2 cm.)
Signed verso: Darriau
Gift of the artist
53.327

BRAD DAVIS (*1942- *)
Game Series #1, *1966*
Polymer on canvas, 80 x 90 in.
(203.2 x 228.6 cm.)
Signed verso: Brad Davis
Gift of the artist
69.37

ELEANOR DE LAITTRE (*1911- *)
Abstraction, *1949*
Oil on canvas, 10 x 33 in.
(25.4 x 83.8 cm.)
Signed lower right: De Laittre - '49
Bequest of Hudson Walker from the Ione and Hudson Walker Collection
78.21.218

MARY ALEXIA DEMOPOULOS
(*20th century*)
Fish, *1951*
Oil on canvas, 26 x 22 in.
(66 x 51.9 cm.)
Signed verso: demop's
Gift of the artist
52.21

ORVAL L. DILLINGHAM
(*20th century*)
Painting, *1950*
Oil on canvas, 30 x 38 in.
(76.2 x 96.5 cm.)
Unsigned
Gift of the artist
52.28

ORVAL L. DILLINGHAM
(*20th century*)
Painting 27, *1951*
Lacquer on composition board, 48 x 44¾ in.
(121.9 x 113.7 cm.)
Signed lower left: Dillingham 51
Gift of the artist
52.26

ORVAL L. DILLINGHAM
(*20th century*)
Provocation, *1951*
Lacquer on composition board, 40 x 48⅛ in.
(101.6 x 122.2 cm.)
Signed lower center: Dillingham '51
Gift of the artist
52.27

TOD A. DOCKSTADER
(20th century)
Seated Figures, *1952*
Oil on canvas, 30⅛ x 25⅞ in.
(76.5 x 65.7 cm.)
Signed lower right: Dockstader 52
Gift of the artist
53.328

FRANK VIRGIL DUDLEY
(1868-death date unknown)
Through the Cedars
Oil on canvas, 34 x 38 in.
(86.4 x 96.5 cm.)
Signed lower left: Frank V. Dudley
Gift of Louis W. Hill, Jr.
56.11

BENJAMIN OSRO EGGLESTON
(1867-1937)
Portrait of Pillsbury
Oil on canvas, 63 x 43½ in.
(160 x 110.5 cm.)
Signed lower left: Benj. Eggleston
Gift of the St. Paul Campus Library
54.43

EDWARD S. EVANS, JR.
(20th century)
Patriot, *1969*
Acrylic on canvas, 80 x 62½ in.
(203.2 x 158.1 cm.)
Unsigned
Gift of the artist
72.15

BEN FOSTER *(1852-1926)*
The Last Gleem
Oil on canvas, 30¼ x 25 in.
(76.8 x 63.5 cm.)
Signed lower center: Ben Foster
Gift of the estate of Mary Effie Brand
67.1

G. FRANCIS *(20th century)*
Landscape at Sunset Time
Oil on canvas, 22 x 36 in.
(55.9 x 91.4 cm.)
Signed lower right: G. Francis
Gift of Frederick J. Wulling
44.17

CAROL HOORN FRASER
(20th century)
Mr. Miles' Field
Oil on canvas, 54½ x 72 in.
(138.4 x 182.9 cm.)
Signed lower right: C. Fraser
Gift of the Art Section, Faculty
Women's Club
61.9

ARNOLD FRIEDMAN
(20th century)
Self Portrait
Oil on plywood, 12 x 11½ in.
(30.5 x 29.2 cm.)
Signed upper left: Friedman
Gift of Mrs. Elizabeth Cless
79.2

FRANK GERVASI *(1895-)*
Fish, *1946*
Oil on board, 12⅛ x 17¼ in.
(30.8 x 43.8 cm.)
Signed verso: (indecipherable) 1946
Bequest of Hudson Walker from the
Ione and Hudson Walker Collection
78.21.222

MARK GOULD *(1951-)*
Still Life with Dummy, *1981*
Acrylic on canvas, 28¼ x 46⅛ in.
(71.8 x 117.8 cm.)
Gift of the artist
82.25.10

FREDERICK G. GRAY
(20th century)
California Landscape
Oil on canvas, 26¼ x 30 in.
(66.7 x 76.2 cm.)
Signed lower right: Gray
Gift of Louis W. Hill, Jr.
56.12

FREDERICK G. GRAY
(20th century)
Landscape: Eucalyptus Tree
Oil on canvas, 34⅛ x 28 in.
(86.7 x 71.1 cm.)
Signed lower right: Gray
Gift of Louis W. Hill, Jr.
56.13

FRANK RUSSELL GREEN
(1856-death date unknown)
Landscape
Oil on canvas, 20 x 30 in.
(50.8 x 76.2 cm.)
Signed lower right: Frank Russell
Green ANA
Gift of Frederick J. Wulling
46.30

RICHARD JOHN HAAS *(1936-)*
Red and Orange
Oil and collage, 67¼ x 52½ in.
(170.8 x 133.4 cm.)
Unsigned
Purchase
64.14

HELEN MARY HALEY *(1916-)*
Basilica of St. Mary, *1947*
Oil on canvas board, 13⅞ x 17⅞ in.
(35.2 x 45.4 cm.)
Signed (incised) lower right: Haley 47
Gift of Edward J. Haley
66.8.2

JOHN J. HAMMER *(1842-1884)*
Young Woman Praying
Oil on canvas, 46⅛ x 28⅝ in.
(117.2 x 72.7 cm.)
Signed lower left: John J. Hammer
Gift of Frederick J. Wulling
44.11

ARTHUR HOWARD HANSEN
(20th century)
Interior, *1957*
Oil on canvas, 36⅛ x 24 in.
(92.4 x 61 cm.)
Signed lower right: AH '57
Purchase
58.1

EDWARD C. HARRINGTON
(20th century)
Frailest Substance, *1963*
Oil on canvas, 67 x 55 in.
(170.2 x 139.7 cm.)
Unsigned
Purchase
64.16

LOIS WILDE HARTSHORNE
(20th century)
Portrait of Professor Norman Wilde,
1935
Oil on canvas, 36⅛ x 30⅛ in.
(91.8 x 76.5 cm.)
Signed lower right: LWH 1935
Gift of Richard Hartshorne in
memory of Lois Wilde Hartshorne
and her father, Professor Norman
Wilde
83.28

REID HASTIE *(1916-)*
Baseball Players, *1965*
Casein on board, 15⅛ x 28⅝ in.
(38.4 x 72.7 cm.)
Signed lower right: Hastie, 1965
Gift of Professor and Mrs. Samuel H.
Popper
79.8.7

REID HASTIE *(1916-)*
Old House, *1947*
Oil on board, 25⅛ x 30⅛ in.
(63.8 x 76.5 cm.)
Signed lower right: Hastie '47
Gift of Professor and Mrs. Samuel H.
Popper
79.8.10

JOHN A. HAWKINS *(20th century)*
Abstract No. 2, *1956*
Oil on canvas, 26 x 32 in.
(66 x 81.3 cm.)
Signed lower right: Hawkins 56
Purchase
58.2

LLOYD HERFINDAHL
(20th century)
Pickeral Lake, *c. 1970*
Acrylic on canvas, 19 x 23¼ in.
(48.3 x 59.1 cm.)
Signed lower right: Lloyd Herfindahl
Gift of Milton C. Lund
84.45

LLOYD HERFINDAHL
(20th century)
Rainy Night, *c. 1950*
Acrylic on canvas, 17¾ x 23⅝ in.
(45.1 x 60 cm.)
Signed lower right: Lloyd Herfindahl
Gift of Milton C. Lund
84.44

H. HOLTZ *(20th century)*
Landscape
Oil on canvas, 38 x 25 in.
(96.5 x 63.5 cm.)
Gift of Frederick J. Wulling
44.19

CHARLES SYDNEY HOPKINSON
(1869-1962)
Portrait of William Reynolds Vance,
1945
Oil on canvas, 40 x 32 in.
(101.6 x 81.3 cm.)
Signed lower right: Charles
Hopkinson
Purchased with Alumni Contributions
53.336

ELIZABETH HOW *(20th century)*
Crucifixion
Oil on canvas, 20¼ x 16⅛ in.
(51.4 x 41 cm.)
Signed lower right: HOW
Gift of Dr. Morton and Dr. Ilene
Harris
82.14.1

DON JENSEN *(1937-)*
Les Fleurs de Mal, *1965*
Oil on canvas, 18 x 15 in.
(45.7 x 38.1 cm.)
Signed lower left: Jensen '65
Gift of Abby Grey
79.11.6

ROBERT G. JOHNSON *(1941-)*
Night Wind (from *Incantation
Series*), *1980-1981*
Acrylic on canvas, 46 x 46 in.
(116.8 x 116.8 cm.)
Unsigned
Gift of Suzanne Trumbull
83.31

MIRIAM KANEL *(20th century)*
Still Life, *1941*
Oil on canvas, 12 x 18 in.
(30.5 x 45.7 cm.)
Signed lower right: Kanel 41
Gift of Dr. and Mrs. M. A.
McCannel
54.35

MINER KILBOURNE KELLOGG
(1814-1889)
Unknown Lady
Oil on canvas, 39½ x 30½ in.
(100.3 x 77.5 cm.)
Unsigned
Gift of Frederick J. Wulling
44.10

REATHEL KEPPEN *(20th century)*
Roses
Oil on canvas, 20 x 24 in.
(50.8 x 61 cm.)
Unsigned
WPA Art Project, Minneapolis
43.763

ROBERT LEO KILBRIDE *(1924-)*
Table Top
Oil on masonite, 18⅛ x 26⅜ in.
(45.7. x 67 cm.)
Signed lower right: Kilbride
Gift of the artist
70.8

CATHERINE KLEINERT
(20th century)
Morning Glory
Oil on composition board,
18 x 23½ in.
(45.7 x 59.7 cm.)
Unsigned
Purchase
35.15

JOHN FREDERICK KUTZIK
(20th century)
Flowers of the Spring, *1959*
Oil on canvas, 48 x 40 in.
(121.9 x 101.6 cm.)
Signed lower right: JFK 59
Purchase
64.3

JEANNETTE MAXFIELD LEWIS
(20th century)
Pepper Tree
Oil on canvas, 17⅞ x 19⅞ in.
(45.4 x 50.5 cm.)
Signed lower right: Jennie Lewis
WPA Art Project, Washington, D.C.
43.724

FAITH M. LOWELL *(20th century)*
Path through the Wood
Oil on canvas, 18 x 26 in.
(45.7 x 66 cm.)
Signed lower right: Faith Lowell
Purchase
76.6

BERNARD A. LUND *(20th century)*
Cyclamen, *1947*
Egg tempera on canvas, 27 x 19¼ in.
(68.6 x 48.9 cm.)
Signed lower left: B. Lund '47
Purchase
47.36

GRACE E. McKINSTRY
(20th century)
Portrait of William W. Pattee
Oil on canvas, 54 x 40 in.
(137.2 x 101.6 cm.)
Signed lower left: G.E. McKinstry
Purchased with Alumni Contributions
53.337

GRACE E. McKINSTRY
(20th century)
Portrait of Maria Louise Sanford
Oil on canvas, 28½ x 40½ in.
(72.4 x 102.9 cm.)
Signed upper right: G. E. McKinstry
Anonymous gift
39.113

IRVING E. MARCUS *(20th century)*
Painting, *1950*
Oil on canvas, 28 x 36¼ in.
(71.1 x 92.1 cm.)
Signed (incised) lower right:
MARCUS
Gift of the artist
52.22

ROBERT R. MICHENER
(20th century)
Prophet, *1961*
Oil on canvas, 50⅛ x 75 in.
(127.32 x 190.5 cm.)
Signed lower right: Michener 61
Purchase
62.15

WILLIAM E. MISFELDT
(20th century)
Land Forms: Nocturne, *1963*
Oil on canvas, 62⅜ x 45¼ in.
(158.4 x 116.2 cm.)
Signed lower right: Misfeldt 1963
Purchase
64.7

GOPAL C. MITRA *(20th century)*
Fall '59, *1960*
Oil on canvas, 47⅞ x 72 in.
(121.6 x 182.9 cm.)
Signed lower right: G. Mitra '60
Purchase
64.1

GUY MOORE *(20th century)*
Mississippi Street, *1940*
Oil on canvas, 20 x 24 in.
(50.8 x 61 cm.)
Signed lower right:
Guy Moore—40—
WPA Art Project, Minneapolis
43.776

GRACE MORGAN *(1887- death
date unknown)*
Portrait of John Black Johnston,
c. 1955
Oil on canvas, 24 x 20⅛ in.
(61 x 51.1 cm.)
Unsigned
Gift of Mrs. J. B. Johnston
62.11

FREDERIC M. MUÑOZ *(1931-)*
Personnage Noir, *1960*
Oil on canvas, 48 x 33½ in.
(121.0 x 85.1 cm.)
Signed (incised) lower right:
Muñoz 60
Gift of the artist
62.2

GIUSEPPE NAPOLI *(20th century)*
The House, *1954*
Oil on wood, 11¼ x 16 in.
(28.6 x 40.6 cm.)
Signed (incised) top center: Napoli
Gift of Phillip A. Bruno, Stempfli
Gallery, New York
62.16

GERALD ALBIN OLSON
(20th century)
Woman Before Mirror, Winter, *1964*
Oil on canvas, 62¾ x 56½ in.
(159.4 x 143.5 cm.)
Signed lower right: G A Olson 65
Purchase
64.17

IGOR PANTUHOFF *(20th century)*
Ventilators No. 3
Oil on canvas, 25 x 29¾ in.
(63.5 x 75.6 cm.)
Unsigned
Purchased from the Federal Art
Project, Central Allocations Division,
New York City
39.104

FRANK PEARSON *(1933-)*
Red Eye, *1964*
Oil on linen, overall: 76 x 81¼ in.
(193.207.6 cm.)
main panel: 76 x 39¾ in.
(193 x 101 cm.)
two side panels each: 21 x 21 in.
(53.3 x 53.3 cm.)
Unsigned
Purchase
65.44

FRANK PEARSON *(1933-)*
Untitled, *1965*
Acrylic on canvas, 44⅝ x 44⅝ in.
(113.3 x 113.3 cm.)
Signed back stretcher:
Frank Pearson, 1965
Gift of Carl and Patricia Sheppard
78.22.5

BARBARA BREWER PEET *(1916-)*
Portrait of Malcolm Moos, *1975*
Oil on canvas, 48⅛ x 38⅛ in.
(122.2 x 97.5 cm.)
Signed lower right: Barbara Peet
Gift of the Class of 1925
82.33

BELA PETHEO *(1934-)*
**Double Portrait (Mr. and Mrs.
Melis)**, *1973*
Oil on canvas, 40⅛ x 34⅛ in.
(101.9 x 86.7 cm.)
Unsigned
Gift of the artist
83.32.1

MICHAEL PODULKE (20th century)
Environmental Pressures
Oil on canvas, 36 x 30 in.
(91.4 x 76.2 cm.)
Signed lower right: Podulke
Purchase
47.37

MARY ELLEN PONSFORD
(20th century)
Dancers in White, 1963
Oil on canvas, 60⅛ x 49 in.
(152.7 x 124.5 cm.)
Signed lower left: mep 63
Purchase
64.8

CONSTANTINE C. POUGIALIS
(1894-)
Head
Oil on canvas board, 16½ x 13½ in.
(41.9 x 34.3 cm.)
Signed lower left: C. Pougialis
Purchase
36.86

CARL WENDELL RAWSON
(1884-death date unknown)
Portrait of William R. Appleby
Oil on canvas, 14½ x 14½ in.
(37 x 37 cm.)
Signed lower right: Carl W. Rawson
Purchase
38.53

CARL WENDELL RAWSON
(1884-death date unknown)
Portrait of Lotus Delta Coffman,
1938
Oil on canvas, 14¾ x 14¾ in.
(37.5 x 37.5 cm.)
Signed lower right: Carl W. Rawson
Purchase
39.100

CARL WENDELL RAWSON
(1884-death date unknown)
Portrait of Henry J. Fletcher, 1929
Oil on canvas, 38 x 32 in.
(96.5 x 81.3 cm.)
Signed lower right: Carl W. Rawson
Purchased with Alumni Contributions
53.341

CARL WENDELL RAWSON
(1884-death date unknown)
Portrait of Guy Stanton Ford
Oil on canvas, 14½ x 14½ in.
(36.8 x 36.8 cm.)
Signed lower right: Carl W. Rawson
Purchase
38.54

CARL WENDELL RAWSON
(1884-death date unknown)
Portrait of Melvin E. Haggerty
Oil on canvas, 15 x 15 in.
(38.1 x 38.1 cm.)
Signed lower right: Carl W. Rawson
Purchase
39.115

CARL WENDELL RAWSON
(1884-death date unknown)
Portrait of John Black Johnston
Oil on canvas, 14½ x 14½ in.
(36.8 x 36.8 cm.)
Signed lower right: Carl W. Rawson
Purchase
38.55

CARL WENDELL RAWSON
(1884-death date unknown)
Portrait of Edward Everett
Nicholson, 1939
Oil on canvas, 15 x 15 in.
(38.1 x 38.1 cm.)
Signed lower right:
Carl W. Rawson 39
Purchase
39.116

CARL WENDELL RAWSON
(1884-death date unknown)
Portrait of Frederick John Wulling
Oil on canvas, 14½ x 14½ in.
(36.8 x 36.8 cm.)
Signed lower right: Carl W. Rawson
Purchase
38.56

CARL WENDELL RAWSON
(1884-death date unknown)
View of Scott Hall, 1925
Oil on board, 9⅞ x 11⅞ in.
(25.1 x 30.2 cm.)
Signed lower right:
Carl W. Rawson '25
Gift of Mr. and Mrs. Parker Kidder
81.9

RUTH REEVES (1892-1966)
Seed Pods
Oil on composition board, 29 x 23½ in.
(73.7 x 59.7 cm.)
Signed lower right: Ruth Reeves
Bequest of Hudson Walker from the
Ione and Hudson Walker Collection
78.21.850

ROY RENDAHL (1951-)
Egg Wash, 1972
Acrylic on canvas, 24 x 32 in.
(61 x 81.3 cm.)
Signed lower right: Roy Rendahl 72
Gift of Abby Grey
79.11.7

HARVEY RETZLOFF (20th century)
Lifter, 1951
Oil on canvas, 30 x 35¾ in.
(76.2 x 90.8 cm.)
Signed verso: RETZLOFF
Gift of the artist
52.25

HARVEY RETZLOFF (20th century)
Still Life, c. 1952-1953
Oil on canvas, 24 x 27⅞ in.
(61 x 70.8 cm.)
Unsigned
Gift of the artist
53.329

STEPHEN RONAY (1900-)
Race Track
Oil on canvas, 30¼ x 36 in.
(76.8 x 91.4 cm.)
Signed lower right: Ronay
Purchased from the Federal Art
Project, Central Allocations Division,
New York City
39.102

WAYNE E. RUSSELL (20th century)
Look on the Table, 1952
Oil on composition board,
28⅛ x 44 in.
(71.4 x 111.8 cm.)
Signed lower right: WR '52
Gift of the artist
53.330

RICHARD SAUER (1942-)
Random Rectangles, 1970
Acrylic on canvas, 53 x 76¼ in.
(134.6 x 193.7 cm.)
Signed on stretcher: R. Sauer
Gift of the artist
72.14

HENRI-BELLA SCHAEFFER
(20th century)
Le Grand Bouquet
Oil on burlap board, 28⅞ x 21¼ in.
(73.3 x 54 cm.)
Signed lower right: H. Bella Schaeffer
Bequest of Hudson Walker from the
Ione and Hudson Walker Collection
78.21.852

AXEL EUGENE SCHAR
(1887-death date unknown)
Lake Terminal
Oil on canvas, 26 x 31¾ in.
(66 x 80.6 cm.)
Signed lower right: A.E. Schar
WPA Art Project, Minneapolis
43.757

SVERRE SIEVERTS (20th century)
Portrait of Alfred Owre
Oil on canvas, 23⅛ x 18½ in.
(58.7 x 47 cm.)
Unsigned
Gift of the Dentistry Class of 1918
38.57

ZIGRIDA OLITA SLOKA
(20th century)
Untitled, 1971
Acrylic on canvas, 72 x 73⅝ in.
(182.9 x 187 cm.)
Gift of the artist
72.13

FRED H. SMITH (20th century)
President Grover Cleveland
Oil on canvas, 30 x 25 in.
(76.2 x 63.5 cm.)
Signed lower right: F. H. Smith
Gift of Frederick J. Wulling
44.24

FRED H. SMITH (20th century)
President Benjamin Harrison
Oil on canvas, 30¼ x 25¼ in.
(76.8 x 64.1 cm.)
Unsigned
Gift of Frederick J. Wulling
44.25

S. GORDON SMYTH (20th century)
Before half an hour had passed Carty
had won her susceptible heart
Oil on canvas, 24 x 20 in.
(61 x 50.8 cm.)
Signed lower left: G.S.; signed verso:
S. Gordon Smyth from "Chandler
Stacks the Cards" by Carmen J.
Judson
Anonymous gift
79.18.2

S. GORDON SMYTH (20th century)
She laughed, Miss Chandler, and told me to get off the earth
Oil on canvas, 20 x 24 in.
(61 x 50.8 cm.)
Unsigned; signed verso: "She laughed, Miss Chandler, and told me to get off the earth!/Chandler Stacks the Cards"/by Carmen J. Judson/S. Gordon Smyth
Anonymous gift
79.18.3

DAVID L. SNEAD (20th century)
Painting, 1951
Oil on tempered masonite, 28⅞ x 48 in. (73.3 x 121.9 cm.)
Signed verso: SNEAD
Gift of the artist
52.19

LENORA DICKSON SNYDER (20th century)
Portrait of Daniel Webster
Oil on canvas, 16½ x 19¾ in.
(41.9 x 50.2 cm.)
Unsigned
Gift of the Fred Snyder Estate
51.55

JACOB THEODORE SOHNER (1906-1962)
Portrait of Alfred Otto Carl Nier, 1956
Oil on canvas, 34¼ x 28 in.
(87 x 71.1 cm.)
Signed upper right: Sohner 56
Gift of the friends of Dr. Nier
58.28

G. SOLLBAMMY (20th century)
Portrait of Harry Parks Ritchie
Oil on canvas, 30 x 25 in.
(76.2 x 63.5 cm.)
Signed lower left: G. Sollbammy
Anonymous gift
53.342

FRANCESCO SPICUZZA (1883-1962)
Forest Scene, c. 1920
Oil on canvas, 25 x 20⅛ in.
(63.5 x 51.1 cm.)
Signed lower left: F. Spicuzza
Anonymous gift
83.12.1

MAYBELLE STAMPER (1907-)
Blue Sky Surrounding
Oil on plywood, 14¼ x 11 in.
(36.2 x 27.9 cm.)
Signed lower left: Blue Sky Surrounding, Maybelle Stamper/ Captiva 1966
Gift of Abby Grey
79.11.9

ROBERT STOCKTON (1913-1978)
Mexican Pitcher, c. 1941
Oil on canvas, 22 x 26 in.
(55.9 x 66 cm.)
Unsigned
WPA Art Project, Minneapolis
43.775

STANLEY SUTTER (1939-)
On the Beach, 1965
Oil on canvas, 56 x 85½ in.
(142.2 x 217.2 cm.)
Unsigned; dated on stretcher
Purchase
65.36

JOSEPH SWAN (1914-)
Country Gas Tanks, 1940
Oil on canvas, 30 x 40⅛ in.
(76.2 x 101.9 cm.)
Signed lower left: Joe Swan 1940
WPA Art Project, Minneapolis
43.753

BENNET A. SWANSON (1900-)
Afternoon, Mississippi Street, 1941
Oil on canvas, 24 x 30 in.
(61 x 76.2 cm.)
Signed lower right: Bennet Swanson Jan 1941
WPA Art Project, Minneapolis
43.782

BENNET A. SWANSON (1900-)
Robert Street Bridge
Oil on canvas, 34¼ x 39 in.
(88.3 x 99.1 cm.)
Signed lower right: Bennet Swanson
WPA Art Project, Minneapolis
34.144

MARY TOWLEY SWANSON (1939-)
Figures in Landscape III, 1964
Oil on canvas, 56 x 65½ in.
(142.2 x 166.4 cm.)
Unsigned
Purchase
64.21

PATRICK TACCARD (1879-1941)
Beach near Bridge
Oil on masonite, 17 x 26 in.
(43.2 x 66 cm.)
Signed lower right: P. Taccard
Bequest of Hudson Walker from the Ione and Hudson Walker Collection
78.21.21

PATRICK TACCARD (1879-1941)
The Old Homestead, 1938
Oil on masonite, 13¾ x 20⅛ in.
(34.9 x 51.1 cm.)
Signed lower right: P. Taccard; dated verso
Bequest of Hudson Walker from the Ione and Hudson Walker Collection
78.21.853

LUCY M. TAGGART (20th century)
Carnival, 1925
Oil on canvas, 50¾ x 40 in.
(128.9 x 101.6 cm.)
Signed lower right: Lucy Taggart, 1925
Gift of Louis W. Hill, Jr.
56.16

JEANNE TAYLOR (20th century)
Scandia General Store, 1938
Oil on canvas, 30 x 36 in.
(76.2 x 91.4 cm.)
Signed lower right: Jeanne Taylor - 1938
WPA Art Project, Minneapolis
43.754

JEANNE TAYLOR (20th century)
Spring Planting, 1939
Oil on canvas, 32 x 27¾ in.
(55.9 x 70.5 cm.)
Signed lower right: Jeanne Taylor 1939
WPA Art Project, Minneapolis
43.777

JEANNE TAYLOR (20th century)
Summer Landscape, 1938
Oil on canvas, 24⅛ x 28⅛ in.
(61.3 x 71.4 cm.)
Signed lower right: Jeanne Taylor - 1938
WPA Art Project, Minneapolis
43.786

ALICE McNAIR TENNEY (1912-)
Doll in a Box
Oil on canvas, 18⅛ x 22 in.
(46 x 55.9 cm.)
Unsigned
Gift of Dr. and Mrs. M. A. McCannel
54.51

ALICE McNAIR TENNEY (1912-)
Halloween
Oil on canvas, 10 x 8 in.
(25.4 x 20.3 cm.)
Unsigned
Bequest of Hudson Walker from the Ione and Hudson Walker Collection
78.21.192

ADRIAN TROY (20th century)
Doomsday
Oil on canvas, 30 x 40 in.
(76.2 x 101.6 cm.)
Signed lower right: AT
WPA Art Project, Washington, D.C.
43.718

BAYARD HENRY TYLER (1855-1931)
Landscape with a Boat on a River
Oil on canvas, 31 x 37⅞ in.
(78.7 x 96.2 cm.)
Signed lower right: Bayard H. Taylor
Bequest of Marshall W. Alworth
81.21.6

ALLEN ULLMAN (20th century)
Lighthouse
Oil on canvas, 14 x 18 in.
(35.6 x 45.7 cm.)
Signed lower right: Allen Ullman
Bequest of Hudson Walker from the Ione and Hudson Walker Collection
78.21.226

MICHAEL MARIUS URSULESCU (1913-1960)
Portrait of a Girl with a Green Feathered Hat
Oil on canvas, 21¼ x 20¼ in.
(61.6 x 51.4 cm.)
Unsigned
WPA Art Project, Washington, D.C.
43.717

ROBERT VAN ROSEN (1904-1966)
Checkerboard in Ward Eleven, *1938*
Oil on canvas, 24⅛ x 30 in.
(61.4 x 76.2 cm.)
Signed lower left:
R van Rosen—1938
Purchased from the Federal Art
Project, Central Allocations Division,
New York City
39.107

HERMAN VOLZ (1904-)
Bolts and Barrels
Oil on panel, 21¼ x 30¼ in.
(61.6 x 76.8 cm.)
Signed lower right: H. Volz
WPA Art Project, Washington, D.C.
43.714

LOLITA WADMAN (1908-)
Mr. Johnson, *1936*
Oil on canvas, 26¼ x 22¼ in.
(66.7 x 56.5 cm.)
Signed lower right:
Lolita Wadman 1936
Bequest of Hudson Walker from the
Ione and Hudson Walker Collection
78.21.815

DONALD J. WEYDT (*20th century*)
Billboard, *1950*
Oil on canvas backed with wood,
29⅞ x 23¼ in.
(75.9 x 59.1 cm.)
Signed lower right: WEYDT '50
Gift of the artist
52.23

FORBES J. WHITESIDE
(*20th century*)
Painting, *1951*
Oil on canvas, 22 x 18 in.
(55.9 x 45.7 cm.)
Signed lower left: Whiteside
Gift of the artist
52.18

CHARLES WIMMER (*20th century*)
Eserogato II, *1964*
Oil on canvas, 60 x 60 in.
(152.4 x 152.4 cm.)
Signed verso: Charles Wimmer
Purchase
65.33

PAUL H. WINCHELL (*20th century*)
The Fruit Tree
Oil on canvas, 46¼ x 60½ in.
(117.5 x 153.7 cm.)
Signed lower left: Winchell
Gift of Louis W. Hill, Jr.
56.16

MEYER WOLFE
(*1897-death date unknown*)
Vermont Ruin
Oil on canvas, 19½ x 28½ in.
(49.5 x 72.4 cm.)
Signed lower right: Meyer Wolfe
Gift of the New York World's Fair
Corporation
40.60

MILTON LABAN WOLSKY
(*20th century*)
**Cities of the Northern Plains—
Minneapolis**
Oil on canvas board, 18 x 21 in.
(45.7 x 53.3 cm.)
Signed lower left: Wolsky
Gift of the President of Northern
Natural Gas Company, Omaha,
Nebraska
56.19

ELMER EDWIN YOUNG
(*20th century*)
A Day in February, *1923*
Oil on canvas, 28⅜ x 30⅛ in.
(72.1 x 76.5 cm.)
Signed lower right: Elmer Young
Gift of the artist in memory of Verda
Karen Young
80.20.4

ELMER EDWIN YOUNG
(*20th century*)
Portrait of My Friend Carl Wise,
1930
Oil on canvas, 25 x 16⅛ in.
(63.5 x 41 cm.)
Signed lower right: Elmer Young;
dated verso
Gift of the artist in memory of Verda
Karen Young
80.20.3

PATRICIA ZONTELLI
(*20th century*)
Transmigration
Oil on canvas, 87¾ x 75¾ in.
(222.9 x 192.4 cm.)
Signed verso: Zontelli
Purchase
65.40

SCULPTURE

DOROTHY ALPHENA BERGE
(*1923- *)
The River is Queen, *1958*
Welded bronze on copper; stone
base, 40 x 24¾ x 9 in.
(102.2 x 62.9 x 22.9 cm.)
Unsigned
Purchase, John Rood Sculpture
Collection Fund
60.3

DORIS PORTER CAESAR (*1892-
death date unknown*)
People Waving Goodbye,
c. 1935-1940
Bronze, 12 x 9⅝ x 5⅜ in.
(30.5 x 24.4 x 13.7 cm.)
Unsigned
Anonymous gift
47.31

TIM CRANE (*1938- *)
Remains, Winter, *1964*
Bronze, 3 x 8½ x 3½ in.
(7.6 x 21.6 x 8.9 cm.)
Unsigned
Purchase
64.15

JANE C. CURTIS (*20th century*)
Dog, *1951*
Ceramic, 3¼ x 13½ x 8¾ in.
(8.3 x 34.3 x 22.2 cm.)
Signed on bottom in ink on adhesive
tape label: Jane Curtis/Art 101
Gift of the artist
52.9

JOHN K. DANIELS (*20th century*)
Bust of Charles Mayo, *1937*
Bronze, 23 x 10 x 13 in.
(58.4 x 25.4 x 33 cm.)
Signed bottom back: John K. Daniels
37 sc; stamped below: THE
GORHAM CO. FOUNDERS
Gift of the Mayo Clinic, Rochester,
Minnesota
38.21

JOHN F. FLANAGAN (*1865-1952*)
Augustus Saint-Gaudens, *1934*
Bronze relief, 2½ x 1⅞ x ¼ in.
(16.4 x 4.8 x .6 cm)
Signed lower left: MCM JF XXXIV
Gift of the Medallic Art Company,
New York
38.14

LAURA GARDIN FRASER
(*1889-1966*)
**The Sesquicentennial Medallion of
the United States Military Academy,
West Point**, *1952*
Bronze, 3 x ½ in. (dia.)
(7.6 x 1.3 cm.)
Signed lower center: LGF SC
Gift of Major General Frederick A.
Irving, Superintendent, on behalf of
the U.S. Military Academy, West
Point
53.160

JEROME GATES (*20th century*)
Fish, *1951*
Plaster, 16¾ x 30 x 7 in.
(42.5 x 76.2 x 17.8 cm.)
Unsigned
Gift of the artist
52.15

DOROTHEA S. GREENBAUM
(*1893- *)
Sturdy Girl, *1975*
Bronze, 25¾ x 10⅛ x 5¾ in.
(65.4 x 25.7 x 14.6 cm.)
Signed on left side of base:
Greenbaum 75
Purchase, Nordfeldt Fund for
Acquisition of Works of Art
76.32

LAWRENCE HANSON (*1936- *)
Draped Torso, *1961*
Bronze, 17½ x 12 x 10½ in.
(44.5 x 30.5 x 26.7 cm.)
Unsigned
Purchase
62.17

LYLE HENDRICKS (*20th century*)
Wire Construction, *1951*
Wire, 20¾ x 6⅝ x 6⅝ in.
(52.7 x 16.8 x 16.8 cm.)
Unsigned
Gift of the artist
52.14

HAROLD KERR (*20th century*)
Space Interruption, *1977*
Polished aluminum, 19¾ x 16 x 10¾
in. (not including base)
(50.2 x 40.6 x 27.3 cm.)
Unsigned; brass plate affixed to base:
KERR
Gift of the artist
78.23.4

HAROLD KERR (20th century)
The Warrior #1, 1977
Cast iron, 13¾ x 8¾ x 4⅞ in. (not
including base)
(34.9 x 22.2 x 12.4 cm.)
Unsigned; brass plate affixed to base:
KERR
Gift of the artist
78.23.1

HAROLD KERR (20th century)
The Warrior #2, 1977
Cast iron, 17⅞ x 7¾ x 4⅛ in. (not
including base)
(45.4 x 19.7 x 10.5 cm.)
Unsigned; brass plate affixed to base:
KERR
Gift of the artist
78.23.2

HAROLD KERR (20th century)
The Warrior #3, 1977
Cast iron, 15 x 7¾ x 4⅜ in. (not
including base)
(38.1 x 19.7 x 11.1 cm.)
Unsigned; brass plate affixed to base:
KERR
Gift of the artist
78.23.3

ALAN KRANING (20th century)
**Small Feeder Station: Hogshead
Studio Props**, 1965-1969
Vinyl plastisol; 2 small pigs, each
10¼ x 14⅛ x 6⅜ in.
(26 x 35.9 x 16.2 cm.);
5 worms, each ⅜ x 5⅛ x 1⅞ in.
(1 x 13 x 4.8 cm.);
4 apples, each 3⅞ x 3 x 2¼ in.
(9.8 x 7.6 x 7 cm.);
1 large pig, 19 x 28½ x 9¾ in.
(48.3 x 72.4 x 24.8 cm.)
Unsigned
Purchase
69.33

PETER LAFON (20th century)
Standing Woman
Bronze, 15½ x 6¼ x 3¾ in.
(39.4 x 15.9 x 9.5 cm.)
Signed underside of base: Lafon
Standing Woman
Gift of Abby Grey
79.11.31

HAROLD REED LANGLAND
(1939-)
Woman Fixing her Hair, 1963
Bronze, 18¾ x 9 x 5¾ in.
(47.6 x 22.9 x 14.6 cm.)
Unsigned
Purchase
64.20

NILS LOU (20th century)
Untitled
Glass, silvered aluminum,
11 x 2½ in.
(27.9 x 6.4 cm.)
Unsigned
Gift of Abby Grey
79.11.32

WILLIAM MAYER (20th century)
Hand #3, 1974
Glass and metal, 7 x 29½ x 12 in.
(17.8 x 74.9 x 30.5 cm.)
Unsigned
Purchase
75.4

MARIANNA PINEDA (1925-)
Mother and Child, 1952
Bedford stone, 17⅛ x 12 x 9½ in.
(43.5 x 30.5 x 24.1 cm.)
Unsigned
Purchase, John Rood Sculpture
Collection Fund
65.23

RICHARD KENNETH RANDELL
(1929-)
The Big Grabber, 1963
Welded steel, 24 x 15 x 4 in.
(61 x 38.1 x 35.6 cm.)
Signed on base: R.K.R. 1963,
stamped on circular base: No. 10
Purchase, John Rood Sculpture
Collection Fund
65.2

JOHN ROGERS (1829-1904)
**Scene from William Shakespeare's
Merchant of Venice, "Is it So
Nominated in the Bond?"** 1880
Cast plaster, 23 x 19¼ x 11½ in.
(58.4 x 48.9 x 29.2 cm.)
Incised on base: John Rogers, New
York 1880; front of base: Antonio,
Bassanio, Portia, Shylock; rim of
base: Is it so nominated in the bond?;
back top of base: Patented June 18,
1880
Purchase, Fine Arts Fund
69.3

DOUGLAS ROSS (1937-)
Coalescence # 3, c. 1965
Metal and painted wood,
32½ x 41 x 20 in.
(82.6 x 104.1 x 50.8 cm.)
Unsigned
Purchase
65.32

DONALD SCHULE (1938-)
Kendo Man IV, 1966
Bronze, 8 x 2⅞ x 2⅝ in.
(20.3 x 7.3 x 6.7 cm.)
Signed on side of base: Schule 66
Gift of the artist
67.25

KENT SMITH (1943-)
Circle #57, 1975
Cast aluminum, 12½ x 12⅞ x ⅝ in.
(31.8 x 32.7 x 1.6 cm.)
Unsigned
Gift of the artist
76.5

SYLVIA STONE (20th century)
Untitled, 1970-1971
Plexiglas and paint, 36 x 78 x ½ in.
(91.4 x 198 x 1.3 cm.)
Unsigned
Gift of Mr. and Mrs. Julius E. Davis
79.22.1

ANN WOLFE (20th century)
Portrait of Marc Chagall, 1947
Bronze, 11½ x 9¼ x 9½ in.
(29.2 x 23.5 x 24.1 cm.)
Signed along neck: Ann Wolfe 1947
Gift of the artist
73.20

Typography: Sabon Bold, Roman and Italic
Printing: Offset Lithography
Photography: Jerry Mathiason
 Sally Wheaton-Hushcha
 Gary Mortenson
 Ron Forth: Colorplate XIII
Design: Avchen & Jacobi, Incorporated, Minneapolis
Typography: The Type House + Duragraph, Minneapolis
Printing: Bolger Publications/Creative Printing, Minneapolis
2,500 copies printed in the United States of America